THE PHOTOGRAPHY

ENCYCLOPEDIA

THE PHOTOGRAPHY ENCYCLOPEDIA

Gloria S. McDarrah, Fred W. McDarrah, and Timothy S. McDarrah

Schirmer Books
New York

Schirmer Books
1633 Broadway
New York, New York 10019

Cover and Interior Design:
Tomek Lamprecht Studio
New York, NY

Library of Congress Catalog Number: 98-46084

Printed in the United States of America

Printing number
 2 3 4 5 6 7 8 9 10

Library of Congress Cataloging-in-Publication Data

McDarrah, Fred W., 1926-
 The photography encyclopedia / Fred W. McDarrah and Gloria S. McDarrah
cm.
 Includes index.
 ISBN 0-02-865025-5 hardcover; 0-02-865483-8 paperback
Photography—Encyclopedias. I. McDarrah, Gloria S.
 II. Title.
 TR9.M39 1999
 770' .3—dc21 98-46084
 CIP

This paper meets the requirements of ANSI/NISO Z.39-1992 (Permanence of Paper).

Cover Illustration:
Jerry N. Uelsmann
Copyright 1982
Untitled

C O N T E N T S

The authors wish to acknowledge with thanks the generous assistance and counsel given by the following individuals and organizations in developing this work: Harry N. Abrams, Inc., book publishers; The Trustees of the Ansel Adams Publishing Trust, Eddie Adams, photographer; Jane Andrassi, Macmillan Library Reference USA; Larry Armstrong, Los Angeles Times; Vincent Alabiso, The Associated Press; Richard Avedon, photographer; Niki Barrie, Picture Professional magazine; Eric Browner, Man Ray Trust/ADAGP, Janet Borden Inc.; Richard Carlin, Schirmer/Macmillan; Catherine Carter, Macmillan Reference; Henri Carter-Bresson, Magnum Photos Inc.; Stephen Cohen Gallery; Center for Creative Photography; Mark Cohen, photographer; A. D. Coleman, syndicated columnist; John F. Collins, photographer; Paula Cooper Gallery; John Coplans, photographer; Evelyne Z. Daitz, Witkin Gallery; James Danziger Gallery; Keith de Lellis Gallery; the Detroit News; Eastman Kodak; Mary Engel, Ruth Orkin Photo Archive; Mitch Epstein, photographer; David Fahey, Fahey/Kline Gallery; Nat Fein, photographer; Larry Fink, photographer; Flint Michigan Journal; Charles Henri Ford, photographer; Don Forst, *The Village Voice;* Robert Frank, photographer; Gerald H. Gay, photographer; the Gilman Collection, Metropolitan Museum of Art; Frank William Gohlke, photographer; Howard Greenberg Gallery, Inc.; Ed Grazda, photographer; Jan Groover, photographer; Meg Handler, *The Village Voice;* Hasselblad USA, Inc.; G. Ray Hawkins Gallery Inc.; Ellen Handy International Center of Photography (I.C.P.); Jim Hughes, Camera Arts; Estate of Peter Hujar; Birney Imes, photographer; Linda Benedict-Jones, photographer; Kimberly Jones, PaceWildensteinMacGill; Chante King, New York Filmworks; Hans P. Kraus Jr. Gallery Inc.; Elliott Landy, photographer; Brian Lanker, photographer; Neil Leifer, photographer; Arthur Leipzig, photographer; Annie Leibovitz, photographer; Library of Congress; Leica Camera, Inc.; *Life* magazine; Mary Ann Liuchak, Photographer's Place; *Los Angeles Times;* Harry Lunn, photography collector; The Wendell MacRae Trust; Gerard Malanga, photographer; Sally Mann, photographer; Karen Marks, Bonni Benrubi Gallery, Inc.; Jim Marshall, photographer; Patrick J. McDarrah, Good Machine; Metro Pictures; Metropolitan Museum of Art; Joel Meyerowitz, photographer; Wayne F. Miller, photographer; Barbara Millstein, Brooklyn Museum; Minneapolis Star Tribune; Linda S. Morrison, Esq.; Starr Ockenga, photographer; National Portrait Gallery; New York Public Library; Kenneth P. Norwick, Esq., Norwick & Schad; Olympus America, Inc.; Laura Giammarco, Time-Life Syndication; *Palm Beach Post;* Helaine Pardo,

ACKNOWLEDGMENTS

Commerce Graphics, Ltd., Inc.; Elizabeth Parella, Typing Unlimited; Sylvia Plachy, *The Village Voice; Pittsburgh Post-Gazette;* Allen Reuben, Culver Pictures; Joseph Rodriguez, photographer; Peter Rohowsky, Christie's Images; Joe Rosenthal, photographer; Raeanne Rubenstein, photographer; Eva Rubenstein, photographer; Naomi Savage, photographer; Lynn Saville, photographer; Schomburg Center for Research in Black Culture; William Seaman, photographer; Brian Seed, photographer; Andres Serrano, photographer; Cindy Sherman, photographer; Sandy Skoglund, photographer; Marvin Smith, photographer; Tania Sochurek, Howard Sochurek Collection; Eddie Sollinger, New York Filmworks; Eve Sonneman, photographer; Jan Staller, photographer; Louis J. Stettner, photographer; Norma Stevens, Richard Avedon Studio; Alfred Stieglitz Collection, Metropolitan Museum of Art; Abner Symons, photographer; Topeka *Capitol-Journal;* Arthur Tress, photographer; Valentine Museum, Richmond; Jerry N. Uelsmann, photographer; Virginia Historical Society; John Walden, reference staff, East Hampton Public Library; William Wegman, photographer; Susan Arthur Whitson, Edwynn Houk Gallery; Artemis Willis, filmmaker; YIVO Institute for Jewish Research; Metro Pictures; Eelco Wolf, Magnum Photos, Inc.; Zabriskie Gallery; Harvey Zucker, Photographer's Place.

Special thanks to **Tom McGovern,** who contributed significantly to this encyclopedia. He is an artist whose photographs have been in 12 solo exhibits and more than 20 group exhibits. He has taught photography at the International Center of Photography (New York City), Union College (Schenectady, New York), and California State University (Fullerton). His work is in the collections of the Museum of Fine Arts, Houston; the Brooklyn Museum; the Baltimore Museum of Art; the Library of Congress; the Museum of the City of New York; and the Schomburg Center for Research in Black Culture. McGovern was photo editor for *The Village Voice* newspaper from 1992 to 1994, where he received awards for excellence in photo editing from *American Photography* and the Society of Newspaper Design. He reviews photography exhibitions for *Artweek* magazine, and his first book, *Bearing Witness (to AIDS),* was sponsored by Visual AIDS/Art Resources.

The authors have made every attempt to contact copyright holders of the photographs reproduced in this book. For all those who have granted permission to reproduce their work or photos in which they are the custodian, the authors wish to extend their deepest appreciation.

Cameras don't really go *snap!* anymore. And encyclopedias aren't multivolume sets crammed with unintelligible information that make the shelves on your bookcase sag. Look at this book as a top-of-the-line sureshot camera. It has all the technical proficiency and makes the same beautiful pictures as a Hasselblad without all the messy attachments, lenses, flashes, wires, and motordrives.

The Photography Encyclopedia is intended to give the young reader (or his or her teacher or parents) a comprehensive overview of the medium in a single, illustrated, easy-to-use volume. Beyond the traditional collection of facts, this book is designed to aid readers in their own photographic efforts, from finding a nearby gallery featuring photos to buying equipment, seeing a museum show, or entering a prestigious national photo contest.

In addition to the format, this differs from an old-fashioned encyclopedia in the most important area: content. The bulk of the book consists of biographical and glossary entries. But there are also important sections on awards, galleries and museums, magazines, booksellers, manufacturers, films, and book reviews. There's also a time line of photography.

The entries provide a tight list of important names and provides factual detail and insight into the life and work of each individual selected. They also facilitate the further opportunity to

INTRODUCTION

learn more about each of these important people. The function of the biographical sketches is twofold: They strive to inform the reader about the world of photography as well as about the individuals populating it. So, in addition to the people snapping the photos, the authors have included others whose contributions to the field have proved vital to its growth, advancement, and popularity—people such as important curators, gallery owners, photography dealers, technicians, museum directors, archivists, collectors, historians, writers, authors, critics, auctioneers, inventors, and businesspeople. There are also some artists traditionally associated with other media (Andy Warhol, Ed Ruscha, Lucas Samaras, the Starn twins, David Hockney) whose work encompasses photography to such an extent as to warrant their inclusion.

There are of course thousands of "professional" photographers, millions of amateurs, and many more who work in photographic fields. The criterion for entry into this volume was fairly simple: people with a mature body of work and a track record of exhibitions, books published, and recognition within the community. *Mature* does not mean old. There are people included here who were born after 1960. People riding a wave of fad were not included in this edition. But if their career stands the test of time, they will be included in future editions. Preference was given

to photographers whose work has endured and will continue to endure, rather than to those who have merely been successful in the world of commerce. One hot ad campaign or poster does not a career make. Most of the 600 biographical entries are in fact of photographers, but the importance and existence of others cannot and should not be denied. There are also a handful of inventors, chemists, physicists, and others, mainly from the nineteenth century, whose contributions are less known than those of such pioneers of the medium as Daguerre, Niepce, or Fox Talbot, but equally important.

In a one-volume work, the length of entries must necessarily be somewhat limited. But within the allotted space, the authors have diligently worked to be both thorough and concise. The authors also worked to make the entries understandable to both the newcomer and to the professional photographer. While the intended audience here is of students, *young* does not mean anything less than intelligent.

Each of the sections has a clear and definite purpose: to enhance readers' knowledge of photography.

The listings of museums and galleries provide readers with a list of places that might give them the opportunity to explore an interest in photography more fully. There are places that may be in a hometown, or may be found on a trip, to view original prints of an artist's work. There is no listing of exhibitions, as they are transitional in nature. An encyclopedia lists things with some degree of permanence. While a museum or gallery can certainly close, they are for the large part not going anywhere, while exhibitions are by definition displayed for only a set, brief period. The listed institutions have permanent collections, not all of which are necessarily on display at any one time. Beyond public showings, a serious student of photography can usually arrange for a private showing of a museum or gallery collection.

That same reasoning can be applied to the sections featuring booksellers and book reviews. Listed is a selection of stores that feature art and photography books, as well as a select list of reviews of some of the best books on and about photography ever published. Readers looking for more detailed information than can be found in a biographical sketch may turn to one of these books for a larger picture.

Some of the books are one of many done by a photographer; sometimes it is his or her only work. The criterion for inclusion here was whether or not the book is important or significant in any manner, and if it adds to the discourse in the field. Inclusion in any section in this book was subjective based on the authors' selections. However, based on many years of experience in the field, it is with confidence that we selected the entries to be included in *The Photography Encyclopedia*.

In the interests of space and usefulness, the magazine section listings have been limited to those journals that center on photography and are reputable. Some delve into history, and many peer into the future, with exciting articles on

digital cameras and imaging, handheld equipment, and electronic pictures.

The manufacturers section provides the reader with a concise look at some of the major companies producing photographic equipment. This can be used as a tool when shopping for a camera, repairing equipment, or conducting general research in the field.

Both amateur and professionals may benefit from the awards section. It is a selective listing of the names and sponsors of the major photographic industry honors.

The time line is a quick visual method of gauging the development of photography.

Many photographers have diverse creative, professional, and personal interests. Earlier, many were also painters. Later in the twentieth century, many were also filmmakers and videomakers. Included in the films section is a listing of many of the short and feature-length productions created by or about the photographers found in this book.

Finally, there are the photographs themselves. This volume contains perhaps the greatest print assemblage of photographs ever collected. The range and depth of the images on these pages provide an education in the history and development of photography. The authors attempted to obtain a selection of photographs that would not only appropriately illustrate the work of the photographers but would show historical perspective and beauty as well as the unimaginable variety of imagery inherent in the medium.

There is a selection of Pulitzer Prize-winning photos and nearly 100 portraits of prominent photographers and industry leaders taken by the authors. There are examples of decades-old daguerreotypes and cutting-edge color art photography. There are public works, like America through the eyes of the Farm Security Administration photographers, and private images, like Starr Ockenga's intimate portraits of women.

The photographs here are proof of the adage "A photograph is worth a thousand words." The classic—and future classic?—photos accompanying the biographical entries give a sense of the photographer's work that mere words cannot convey. Seeing such famous and indelible images as Mathew Brady's "Portrait of Ulysses Grant," Edward Weston's "Pepper," Dorothea Lange's "Migrant Worker," Edward Steichen's "Flatiron Building," Richard Avedon's "Dovima with Elephants," or Ansel Adams's "Mount Williamson, Sierra Nevada" adds to the understanding of these artists in an immeasurable way.

Seeing less famous but equally important photos by individuals who may not be household names adds again to the reader's photography education. Also included are many works by lesser-known photographers, artists whose works are not commonly reproduced in other reference books, like Jan Staller, Arthur Leipzig, Sylvia Plachy, Francis Bruguière, and Joseph Rodriguez. In the cases of famous names, the authors have also tried to include images that, while still representing the photographer's style, have not been reproduced *ad nauseam*.

The pictures are intended to enhance the understanding of each photographer's work. With the words and photos taken as a whole, we hope to illustrate the birth and growth of photography and illustrate its many forms, techniques, and development.

Every effort has been made to make the information here as up to date as possible. As you are looking through this book, you may come to a similar discovery as did the authors: Photographers tend to live to a ripe old age. As of summer 1998, the birth dates of the photographers were entirely accurate, using information provided by the George Eastman House, which maintains a constantly updated electronic database of names, nationalities, and birth dates of photographers. Maybe it is the smell of the chemicals, but for some reason, a large number of photographers live well into their tenth decade. Typical is Ilse Bing, who passed away—at age 99—as the book was going to press. She had just finished hanging a 100-year retrospective when she was called to the great darkroom in the sky.

Timothy S. McDarrah

July 1998

A–Z

James Abbe. *Fred and Adele Astaire, in the musical* The Love Letter, *New York, 1921.*
Collection of the authors.

Abbe, James (1883–1973)

American photojournalist.

Noted both for his celebrity portraits and his work as a photojournalist, Abbe was born in Maine. He moved with his family to Newport News, Virginia, where, at the age of 15 he acquired his first camera, a $1 box Brownie. He photographed the battleship *Maine,* anchored in the James River before her departure for Cuba in 1898. When the battleship was blown up near Havana at the start of the Spanish–American war, his photographs were much sought after.

Abbe worked as a photojournalist in the Washington, D.C., area until 1917, when he moved to New York City. He opened a photo studio in the Hotel des Artistes, and his photographs of society figures and entertainers appeared in the *New York Times,* the *Ladies' Home Journal,* and other major publications. His photograph of the actress Jeanne Eagels was the first photo to appear on the cover of the *Saturday Evening Post.* Such glamorous stars of the 1920s as John Barrymore and his brother, Lionel, Mae West, Rudolph Valentino, and Theda Bara were world-famous subjects.

Having achieved a reputation in New York as the photographer of stars, Abbe moved to Hollywood, where he impressed the director D. W. Griffith and was hired to shoot publicity stills of his movies. He went to Europe in 1923 to shoot stills for the director Henry King and stayed abroad for the next eight years, living in Paris and photographing stage plays and musical variety stars.

Abbe began to move away from the movies and theater, renewing his interest in photojournalism and writing. He covered news events in Mexico and was the first foreign correspondent to photograph and interview the Russian dictator Joseph Stalin, in 1932. In 1933 he did a memorable series of photographs of Adolf Hitler.

Abbe moved back to the United States in 1934 but returned to Europe in 1936 to cover the Spanish Civil War. During World War II he worked as a radio commentator in the San Francisco Bay area and then became a television columnist for the *Oakland Tribune* until he retired in 1961.

Abbott, Berenice (1898–1992)

Pioneering female American photographer

One of the titans in the history of American photography, Abbott had a long and illustrious career that can be divided into three major phases—the first as a studio portraitist, the second as an architectural and documentary photographer of New York City in the 1930s and 1940s, and last as a scientific photographer.

Born in Ohio, Abbott went to Paris to study sculpture. She began her work in photography as an assistant to the legendary **Man Ray** in his portrait studio and quickly began taking portraits herself. She immersed herself in the social and intellectual world of Paris in the 1920s, opened her own studio, and mounted her first solo show in 1926. Her brilliant portraits of such cultural figures as the writers James Joyce, Jean Cocteau, and Edna St. Vincent Millay and the artists Max Ernst and Edward Hopper assured her photographic reputation. But she was active in other photo ventures, too.

Abbott met the photographer **Eugène Atget** in Paris shortly before his death in 1927. Greatly moved by his vast archives containing his lifelong documentary studies of Paris, she rescued his prints and negatives from oblivion, eventually publishing and promoting them.

Returning to the United States in 1929, she was enchanted by New York City and struck by the physical modernization then underway. She embarked on a project she called "Changing New York," which evolved into a classic Federal Art Project (FAR), Works Project Administration-sponsored book of the same name. She

received a weekly salary of $145 while doing the book. The FAP also provided her with a staff, acknowledging that she could not work like a news photographer who rushes up to a fire but that she needed time, and sometimes permission, to select her subjects. She also needed help physically, to aid in carrying her 50 or more pounds of equipment through city streets. The resulting work has become the classic study of Depression-era New York.

Discussing her mission in photographing the city, she said, "The concern is not with the architectural renderings of detail, the buildings of 1935 overshadowing all else, but with a synthesis which shows the skyscraper in relation to the less colossal edifices which preceded it: city vistas, waterways, highways and means of transportation; areas which peculiarly urban aspects of human living can be observed; city squares where the trees die for lack of sun and air; narrow and dark canyons where visibility fails because there is no light; litter blowing about a waterfront slip; relics of the age of General Grant and Queen Victoria where they have survived; the onward march of the steam shovel—all these things and many more comprise New York City in 1935." Her 1949 *Greenwich Village Today and Yesterday* stands alongside *Changing New York* as a benchmark work.

For the next two decades, science photography preoccupied her. She became picture editor of *Science Illustrated,* joined the Massachusetts Institute of Technology's Physical Science Study Committee, made images to illustrate high school textbooks, and collaborated on several books for younger readers.

As one of the first female photographers, she was a trailblazer not only in her work but also in her lifestyle. In an interview in 1989 she said, "Women did not wear slacks then; they wore skirts. When I photographed New York, I put on ski pants. Truck drivers yelled at me, 'Lady, take that off.' It bothered me, it even bothered me when people gathered around as I was setting up my camera in the street. But I found the best way is to ignore them, as if they weren't there."

No one, though, could ignore Abbott. Working strictly in large-format black and white, she had a passion for documentation. After New York, she moved to Maine, where she produced *A Portrait of Maine,* a book-length study of one of the nation's least developed states, a striking contrast to her works on New York, one of the most developed pieces of real estate on earth. She lived to her mid-nineties, a passionate and determined advocate of her art every step of the way.

aberration: An imperfection in **lens** performance. One of the primary criteria for lens performance is how accurately it represents what is in front of it. Poor quality lenses have many aberrations, such as an inability to produce sharpness or making a straight line appear to curve. The best lenses are those able to keep their aberrations to a minimum, but no lens is perfect.

abstract photography: A style of photography in which the subject photographed may or may not be recognizable. The photograph is not simply a representation of a real object or person but may include unfamiliar angles, close-up or distant views, unusual lighting, and odd color that produce an entirely unfamiliar view of a familiar object or person.

acetate: A sheet of crystal-clear material used for art overlays and with copy machines to produce copies on a clear base. Technically called cellulose acetate, it is used as a support base for film and as a "cel" for motion picture animation.

acetic acid: An **acid** that is diluted and used as a **stop bath** in photographic film developing and printing.

acid: A chemical compound that is the opposite of **alkaline** and is represented on the pH scale in numbers less than 7. (Water, which is neutral, registers 7 on the pH scale. Compounds that register above 7 are alkaline.) Acid is characterized by a cleansing or cutting action. Very strong acid is able to damage metals and other hard substances, but many weak acids, such as vinegar, are commonly used in the home. In photography, an acid bath is often used after a **developer** (which is alkaline) to stop the developer's action. (See also **acetic acid; stop bath**.)

Berenice Abbott. *Pennsylvania Station,* July 14, 1936. Courtesy Commerce Graphics Ltd., Inc.

action photography: Photography of fast-moving subjects, particularly of sports events, in which either the subject or the background can be blurred. This technique conveys the feeling of motion to the viewer. A blurred subject is achieved simply by using a slow **shutter** speed. **Panning or moving** the camera in the same direction as the subject is moving keeps the subject in focus but produces a blurred background.

Adams, Ansel (1902–1984)
American photographer, environmentalist, and writer
During his lifetime Adams was arguably the world's most famous photographer, with reproductions of his works hanging everywhere from college dorm rooms to museum galleries the world over.

As an artist, as a teacher, as a master of photographic technique, he had an influence that has been felt by succeeding generations of American photographers. He published numerous books, and few photographers have had their work exhibited as widely. Some of his outstanding works, such as *Death Valley, Images 1923–1974, The Tetons and the Yellowstone, Photographs of the Southwest,* and *The Portfolios of Ansel Adams,* epitomize his life's mission—the preservation of natural beauty in both form and substance.

Born in San Francisco, he was introduced to two of his great loves—photography and mountaineering—during a family vacation when he was 14. A privileged youth, he was tutored at home and studied to be a classical concert pianist. Photography and the wilderness landscape, however, became his passions.

Adams's prints of breathtaking scenes in the Sierra Nevadas launched his photographic career, specifically his 1927 awe-inspiring image *Monolith, Face of Half Dome,*

Ansel Adams. *Mount Williamson, Sierra Nevada, from Manzanar, California, 1944.*
Copyright by the Trustees of The Ansel Adams Publishing Rights Trust. All Rights Reserved.

when he visualized the finished print before the exposure of the negative—not how it appeared in reality, but his emotional response to the scene. Shortly thereafter, he had a meeting with **Paul Strand** and decided to turn his attention to photography full time.

In 1932 he met **Alfred Stieglitz**, who helped Adams get his first solo exhibit at the DeYoung Memorial Museum in San Francisco. With **Edward Weston**, **Imogen Cunningham**, and others, he founded **f/64**, a group "devoted to the expressive potentials of **straight photography**." After directing the Golden Gate International Exposition in 1940, he helped **Beaumont Newhall** and David McAlpin found the first curatorial department devoted to photography, at the Museum of Modern Art in New York. Adams served two years as vice chairman of the photo department there before heading back out west to head the photo department at the California School of Fine Arts. In 1942 he took what many critics call his most famous image, *Moonrise, Hernandez, New Mexico*.

During World War II, he provided both text and images for *Born Free and Equal*, a testament to the plight of incarcerated Japanese-Americans.

Adams served as a director of the Sierra Club from 1934 to 1971; the U.S. Department of the Interior presented its Conservation Service Award to him in 1968.

He shared his technical expertise with literally tens of thousands of workshop students both in books, beginning with *Making a Photograph* (1935), and at the annual Ansel Adams Yosemite Photography Workshop, which was founded in 1955. Adams received three **Guggenheim fellowships,** was a Chubb fellow at Yale, and received several honorary degrees.

Forever proud of all he accomplished and grateful that his commitment is credited with helping to protect the environment, he admitted to some concern in his later years that his pictures may have led to an increase in tourism at some out-of-the-way places. His images of the Galapagos, for example, might have stimulated an increase in visitors to those ecologically fragile islands. "It's bad in a sense, but so long as it helps the general idea of protection, I think it is worthwhile," he said.

Adams, Eddie (1934–)

American photojournalist

Adams snapped one of the most memorable images to come from the Vietnam War, showing Brigadier General Ngoc Loan firing a bullet into a Vietcong pris-

Pages 6 – 7: Eddie Adams. Working for the Associated Press, Adams won the 1969 Pulitzer Prize for Spot News for this photo showing the street execution of a suspected Viet Cong commando. From *Flash! The Associated Press Covers the World.* © The Associated Press. 1998. Edited by Vincent Alabiso, Kelly Smith Tunnen, and Chuck Zoler. Courtesy Harry N. Abrams, Inc.

Robert Adamson. *Sleeping Girl.* c. 1850. Historical Picture Archive, Corbis/Bettmann.

oner's head. Adams was covering Vietnam for the **Associated Press** when his shocking photo won the 1969 **Pulitzer Prize** and the World Press Photo Grand Award.

Born in New Kensington, Pennsylvania, Adams began his career working for the *New Kensington Dispatch* and later the *Philadelphia Bulletin*. He was a photographer for the Associated Press from 1962 to 1972. He also worked for *Time* magazine from 1972 to 1976 before returning to the AP as a special correspondent until 1980. Since then he has continued to work as a freelance photojournalist. He created an annual **photojournalism** workshop for talented young photographers, sponsored by Eastman Kodak and Nikon, that has met annually since 1988.

Adams has been honored with numerous awards, including the prestigious **George Polk Award** of Long Island University in 1969, 1978, and 1979; the Magazine Photographer of the Year University of Missouri-**National Press Photographers Association** 1975; and the **Robert Capa** Memorial Award in 1978.

Adams, Robert Hickman (1937–)

American nature photographer

After earning a doctorate in English and becoming a college professor, Adams decided to shift careers and focus on his true love, photography, in 1970. Since then, he's made a name for himself with more than 20 books, mainly chronicling the American West, particularly the Colorado landscape, in and around Denver. He attributes his affinity for the Western landscape to boyhood adventures such as hiking, river rafting, and camping. His black-and-white photographs of characteristically spare landscapes have brought him two **National Endowment for the Arts** Photography fellowships (1973, 1978), a Guggenheim award (1973), and a MacArthur fellowship (1994).

Adamson, Robert (1821–1848)

Pioneering Scottish photographer and chemist

One of photography's first great practitioners, Adamson was a chemist by trade in Edinburgh, Scotland, until he began working with **David Octavius Hill** as a camera operator and darkroom technician. Collaborators for only five years before Adamson's death at the age of 27, the pair took more than 1,500 pictures using the **calotype** process and were considered to be among the finest portrait photographers of their time.

Hill was an accomplished **lithographer** and had published a series of Scottish landscapes and a series of paintings illustrating the poems of Robert Burns. In 1843 Hill was commissioned to portray, on a monumental canvas, the 470 minister-delegates who had resigned from the Church of Scotland to establish the Free Church of Scotland. A British physicist, Sir David Brewster, introduced Hill to Adamson, saying that the two men could produce calotype portraits of the ministers that Hill could use as models for his painting. While the painting is now considered a mediocre work, the photographs are noted for their beauty and are considered brilliant examples of the calotype process, demonstrating a mastery of form, composition, and lighting. In addition to portraits, Hill and Adamson produced memorable cityscapes, landscapes, and scenes of village life.

Adelman, Bob (1930–)
American photojournalist
A freelance photojournalist and documentary photographer, Adelman has published photographs in *Time, Newsweek, Esquire, Camera, Popular Photography, New York,* Germany's *Stern,* and countless other publications, as well as several gritty street-themed books. In the 1960s he was one of the photojournalists who covered the civil rights struggles, including the 1963 March on Washington and Dr. Martin Luther King Jr.'s "I have a dream" speech. One of the few photographers, if not the only one, with a master's degree in philosophy (from Columbia University), Adelman won a **Guggenheim fellowship** in 1964.

Adobe Photoshop: See **Photoshop.**

advertising photography: Photographs taken for the purpose of selling a product or service to convey information or to promote a company or organization. Advertising photos appear in newspapers and magazines and on posters, billboards, wall murals, in-store displays, packages, and other media. Many types of photos may be used in advertising, including **portraits,** action photos, **still life**s, and **landscapes**.

Some ad photos are taken on assignment from an advertising agency or directly from the client; others may be purchased from a photographer or **stock photo** agency.

aerial photography: Photographs taken from an airplane or other aircraft of the land below. Typically, aerial views are used for map making (cartography), surveys of the landscape, views of natural disasters and catastrophic events such as floods, tornadoes, and hurricane damage, and for military surveillance. In recent years numerous books have been published featuring aerial views. Recent manned and unmanned spacecraft showing views of the planets, stars, and earth (see **space photography**) have produced the most innovative images in aerial photography. Homeowners sometimes commission aerial views of their property.

aesthetics: A branch of philosophy that explores what is considered beautiful and why we consider it so by discussing (in photography) **composition,** tone, color, and subject matter. The question of what is beautiful is probably as old as humankind, but the philosophy of aesthetics is usually associated with the ancient Greek philosophers Plato and Aristotle.

afterimage: An image that remains visible after the original image is no longer in plain view. A commonly occurring afterimage is seen after we look at a bright **light**. Although we may look away from the bright light, or even if the light source is removed, we continue to see spots. *Afterimage* is also the name of a photography journal published by the **Visual Studies Workshop** in Rochester, New York.

AGFA: A company that makes photographic materials—**films, photo paper,** and **chemicals**—that are widely available. AGFA was a pioneering manufacturer in the marketing and distribution of commercially available color film and color film technology.

agitation: In photography, agitation means movement and refers to keeping photographic chemicals in motion

at regular intervals to achieve even **development** of film and paper. Without agitation the development of the image would be uneven and could mar the quality of the final photograph.

Aigner, Lucien (1901–)

American photojournalist

Born in Hungary, Aigner achieved prominence as a photojournalist in Paris, where he lived from 1925 to 1938. Working for a Hungarian newspaper under the pseudonym "Aral," he recorded history in the making during the turbulent 1930s. His candid photographs, taken with a Leica, of Benito Mussolini, Winston Churchill, Fiorello LaGuardia, and Leon Blum were widely published by major European magazines and newspapers. He also photographed personalities of the stage and literary and scientific worlds—including Marlene Dietrich, Albert Einstein, and Yehudi Menuin.

In 1938, he emigrated to the United States, leaving behind a suitcase containing some 50,000 negatives. For the next 30 years, he carved out a career as a *Life* photographer, Voice of America announcer, and portrait photographer. In 1969, his suitcase of negatives surfaced; it had miraculously escaped the ransacking of his Paris apartment by the Germans. Two **National Endowment for the Arts** grants (1975, 1977) helped him catalogue his work, which continues to be exhibited in the United States and Europe, growing in popularity because of its unique historical and documentary value.

airbrushing

airbrushing: Painting with pigment propelled by air through a device called an airgun. This technique is characterized by a subtle blending of colors and shades and by the capability for fine edges, depending on the ability of the artist. In photography, airbrushing is used for **retouching** by adding elements like clouds or removing unwanted objects or areas in a photograph.

Alabiso, Vincent (1946–)

Photo editor

Alabiso, who oversees more than 400 photojournalists as executive photo editor of the **Associated Press**, is one of the most important people in the world of photography. Under his direction, the AP chooses and circulates the photographs that will be picked up by newspapers around the country, thus shaping the way the American reading public will view news events.

He first joined the respected news service in 1975. He left a few years later to run the photo desk at *The Star,* the national celebrity supermarket weekly. He returned to the AP in 1981 as Boston photo editor and then served as photo editor for the New England region from 1983 to 1987. From 1987 to 1990 he was director of photography at the *Boston Globe.* He returned to the helm of the AP in 1991 and led it to six **Pulitzer Prizes** in the following seven years.

Each day he oversees the transmission of more than 250 photos to 1,100 newspapers in the United States and abroad. He also has started a push for more extensive photo essays on subjects like animal poaching in South Africa and child labor worldwide, which he personally edited. Alabiso is also an editor of *FLASH! The Associated Press Covers the World* (1998).

album: A book of blank pages on which photographs are mounted for display and safekeeping. An album can be a valuable photo document of family life that will be treasured for generations. The usefulness and interest of the album is enhanced when the photos are dated and the subject is identified. Wedding albums are among the most popular type of contemporary album and may be elaborate presentations with handcrafted leather covers compiled and sold by commercial wedding photographers.

albumen processes: Albumen is the white of an egg. A Frenchman, **Louis Blanquart-Evrard,** discovered the process whereby albumen is used to coat paper and glass that is then sensitized with **silver nitrate**. The silver nitrate is absorbed into the albumen and, when exposed to light, turns dark, thus forming the photographic image. The advantage of using this medium to hold the silver nitrate is that it can be used on glass (as well as paper) and can hold a large amount of the silver nitrate, making for a much sharper image than what might be obtained without it. Albumen on glass had a tendency to crack and flake and was replaced by

collodion on glass in the 1850s but was effectively used on paper to make prints until it was replaced by **gelatin** on paper in the 1890s. Most photographs from the 1800s are albumen prints.

Alinder, Jim (1941–)

American photographer and arts administrator

Alinder's best-known work, taken with a panoramic camera, typically contrasts a figure dwarfed by a looming landscape or building. The exaggerated perspective of the panoramic, 150-degree angle of view accounts for this unusual juxtaposition of human figure and mysteriously oversized landscape. Since 1977 Alinder has been executive director of **Friends of Photography** in Carmel, California, as well as editor of the group's quarterly, *Untitled*. Previously he spent ten years as director of the photography program at the University of Nebraska. He earned his master of fine arts in 1968 after studying with **Van Deren Coke** at the University of New Mexico.

alkali: Alkali is the opposite of **acid** and represented by a pH of more than 7. (Water, which is neutral, is pH 7. Acids have a pH of less than 7.)

Alland, Alexander Sr. (1902–1989)

American photographer and historian

Alland is best known for his efforts to salvage and bring to the public the **documentary photography** of **Jacob A. Riis**, whose remarkable photos of slum dwellers exposed the misery and despair of poor immigrants to the United States.

Born in Russia, Alland studied photography as a boy in Sevastopol. By 1920 he had moved to Turkey, where he set up his first studio, before emigrating to New York in 1923. Alland served as supervisor of the Murals Section of the Federal Art Project, then produced photo murals for the 1939 New York World's Fair.

Alland, himself an immigrant, was reading Riis's autobiography and noticed references to picture taking. Alland began a five-year-long search for Riis's glass negatives, which he eventually discovered in the attic of an old family home on Long Island. Alland made a selection of prints from the faded **glass plates** for an exhibit and later wrote

his classic *Jacob A. Riis: Photographer and Citizen* (1974).

Alland was awarded a medal by the Museum of the City of New York for his efforts in finding and preserving Riis's work for posterity.

allegorical photographs: Photographs that portray costumed subjects in poses or tableaux that refer to well-known literary works or theatrical productions, classical figures of Greek or Roman mythology, cultural subjects, or biblical scenes. This type of photography was highly popular in the mid- to late 1800s and was considered one of the first genres of "art" photography because of its similarity to contemporary paintings that dealt with the same themes. Two prominent practitioners of the style were **Henry Peach Robinson** (1830–1901) and **Oscar G. Rejlander** (1813–1875). Though the allegorical style portrayed by these two may seem stagy and dated, with their heavily made-up, elaborately costumed models, allegory remains a powerful means of expressing emotion and conveying ideas. More recent allegorical photos offer greater degrees of subtlety in, for example, models echoing ancient Greek heroes, and they continue to convey effectively the photographer's message in a picturesque, narrative style.

all rights reserved: A statement indicating that the **copyright** owner retains all rights pertaining to his or her material. This statement can be in a book, magazine, or newspaper or attached to the back of a photograph or drawing, as a reminder and warning that permission must be obtained to reproduce the work.

amateur photography: An amateur is one who does something simply for his or her own enjoyment and receives no payment for the pastime or hobby. Photography began not as a profession but as a leisure-time activity, usually practiced by people of means who could afford the time and money to have a darkroom, chemicals, and equipment. In modern times, the apparatus and equipment for taking photographs are available to the majority of people, whether they take pictures for their own enjoyment or professionally. Sometimes the term *amateur* is used in a derogatory way, implying that

someone is not skilled enough to be paid for his or her work, but the term does not denote quality, only whether one receives payment.

ambrotype: An ambrotype is a photographic image on glass, popular in the 1850s, and less expensive and less toxic to make than the **daguerreotype**. It was typically made to look like the more expensive daguerreotype by putting it into an ornate case. The ambrotype is actually a negative image that when viewed on a black background (paint, cloth, or paper) is seen as a positive. An English inventor and sculptor, **Frederick Scott Archer,** invented this process in 1851. Archer also invented the wet-**collodion** photographic process, which replaced the daguerreotype and **calotype** processes. The ambrotype is made by applying a thin coat of collodion to glass and sensitizing it with **silver nitrate**. While still wet, the plate is exposed and developed. This yields a high-quality photographic negative. Archer and Peter Fry discovered that if the negative had a low density and was viewed against a black background, it appeared as a positive, which Archer called an ambrotype. Mercuric chloride was added to the developer to bleach the silver and enhance the brightness of the image.

American Photographic Historical Society: Founded in New York in 1969, it has 500 members, including historians, collectors, curators, and authors. It operates a speakers' bureau, conducts educational programs, has a library, and issues the annual Rudolf and Hertha Benjamin Photo History Award.

American Society of Media Photographers (ASMP): A professional society of mostly **freelance** photographers founded in 1944, it has 5,000 members. ASMP works to elevate trade practices for photographers in communications fields. It also provides business information to photographers and promotes ethics and the rights of members. In addition, it holds educational programs and seminars on pricing, negotiating fees, contracts, copyright, electronic media, and marketing.

American Society of Photographers: Founded in 1937, it has 500 members who have earned the degrees of Master of Photography, Photographic Craftsman, and Photographic Specialist through the Professional Photographers of America. It sponsors an annual traveling exhibit of Masters' photographs and an annual National Student Competition and Exhibit.

An American Place: A gallery of modern painting and photography founded by **Alfred Stieglitz** at 509 Madison Avenue in New York City that operated from 1929 until his death in 1946.

anastigmat: A **lens** made so as to correct for distortion. All lenses for photography are of this type. The **Zeiss** Optical Firm introduced the first anastigmat lens in 1889.

Eadweard James Muybridge's studies of animal and human locomotion resulted in the publication of an 11-volume set in 1887.
This series photograph, *Equestrian*, was taken in 1887.

animal and human locomotion: Photography played a major role in the scientific investigation into how humans and animals move. In 1872, **Eadweard Muybridge** (a leading photographer in the American West) was hired by Leland Stanford (a former governor of California and owner of a horse-breeding ranch) to photograph a horse in motion to determine whether at any time during running all four hooves were off the ground. The commission was prompted by a $25,000 bet that Stanford made with Fredrick MacCrellish that at some point in running the horse was indeed off the ground. Muybridge's earliest efforts, though not very successful as photographs, did show that in fact, at some point the horse does not touch the ground. Having won the bet, Stanford commissioned Muybridge to continue his studies, and in 1877 the studies became successful. Soon his records were world renowned, and he continued his studies of animal and human locomotion at the University of Pennsylvania until 1887. Other photographers investigating this area were **Etienne Jules Marey** in France and Ottomar Anschutz in Germany. Prior to these discoveries, artists' depictions of animals in motion were considerably less accurate.

animation: The optical illusion that something that is inanimate moves. In photography, photographing an object repeatedly and moving it slightly each time achieves this result. When the sequence of photographs is projected or presented in rapid fashion, the object appears to move. This is the way most cartoons and other forms of animation (such as Claymation figures, like Gumby) were done until the advent of digital technology.

Annan, James Craig (1864–1946)
Scottish portrait photographer
Annan worked with his father, **Thomas Annan**, in his Glasgow studio and, like his father, specialized in portraiture. Noted for his rediscovery of the work of **David Octavius Hill** and **Robert Adamson**, Annan made new gravure prints from their **calotypes** that were exhibited in 1898 at the **Royal Photographic Society** and, in 1905, in New York City at **291**, the gallery of the

Photo-Secessionist movement. In 1904, Annan became the first president of the International Society of Pictorial Photographers.

Annan, Thomas (1829–1887)
Scottish portrait photographer
Annan, a copper plate engraver in Glasgow, took up photography in 1855, when he opened his first studio, specializing in reproductions of artworks. Among the paintings he photographed was **David Octavius Hill**'s massive *Disruption,* showing all the ministers who resigned from the Church of Scotland.

Annan was commissioned in 1868 by the Glasgow City Improvement Trust to document slum areas slated for demolition. At the time of this commission Glasgow was described as having the worst urban deprivation and inner-city poverty in Britain. His major work has been recognized as a powerful early example of the use of photography in both an architectural historical and social historical context. His photographs of life in Glasgow, including natural, straightforward portraits of local citizens, are similar in style to the portraits taken by his compatriots Hill and **Robert Adamson**. Annan's son, **James Craig Annan**, was also a noted photographer. Today in Glasgow T. and R. Annan, the photo studio, remains in business.

Ansco: The first photographic-supply company in the United States. Begun in 1842 by **Edward Anthony** in New York City and later joined by Henry Anthony, the company conducted the world's first photo contest in 1853.

Anthony, Edward (1818–1888)
American photographer and manufacturer
Having learned about the **daguerreotype** process from **Samuel F. B. Morse**, Anthony, with his brother, Henry, engaged in the manufacture of materials used in that process. Their business was so successful that it became one of the largest photo-supply houses in the country. Anthony was also active as a photographer. He participated in a photographic survey of the boundary separating the state of Maine from Canada and later took

Edward Anthony. *Abraham Lincoln.* Stereo bust portrait no. 2969,
from "Anthony's Prominent Portraits" series, 1865. Collection of the authors.

a complete set of portraits of all the members of Congress. His **stereographic** action photos showing people walking on the streets of New York were among the first photos of movement ever taken.

aperture: An aperture is the size of a circular opening. In photography the term applies to the size of the opening of a **lens,** which is adjustable (on better lenses) to allow a greater or lesser amount of light into the camera. The size of the aperture is also referred to as the **f-stop** and has a numerical value. Also, the size of the aperture affects how much of the final picture is in **focus** (see **depth of field**).

aquatint: This is another name for a nonsilver printing process usually referred to as **gum bichromate.**

Arbus, Diane (1923–1971)
American photographer noted for her off-beat portraiture
Arbus's best-known work, portraits done in a square format, included images of circus performers—people in the costumes of their profession, at festivals and other public and private gatherings. Some of her most powerful images were what she termed her "freaks," which included images of a Russian midget, a Mexican dwarf, a

Jewish giant, and a hermaphrodite with a dog in a carnival trailer.

Daughter of a wealthy New York City department store owner, Arbus grew up in privilege. At 18, she married the actor Allan Arbus, then an assistant to the advertising director at her father's Fifth Avenue store, Russeks. She received a gift of a 2¼ x 3½ Graflex camera from her husband and started to tinker with it while he was off fighting during World War II. After the war, the couple was hired by her father to photograph and create newspaper advertisements. They were later hired by *Vogue* and *Glamour* as well. Neither aimed for a career as a fashion photographer, but they enjoyed some artistic and financial successes; one of their images was selected by **Edward Steichen** for his exhibition "**The Family of Man**" at the Museum of Modern Art in 1955. Shortly thereafter, the couple separated, and they were divorced in 1969.

At the same time, Arbus began to create her own work. Her formal training was limited. She had attended some of **Berenice Abbott**'s classes in the 1940s and **Alexey Brodovitch**'s Design Laboratory in 1954, where she was first exposed to the work of **Robert Frank**, **Weegee**, **Louis Faurer**, and others. From 1955 to 1957 she studied with **Lisette Model**; their personal

and professional relationship was the springboard for her illustrious career as an artist.

She started to frequent Hubert's (a Times Square "freak" show), Coney Island, tattoo parlors, and wax museums. In July 1960, Harold Hayes and Robert Benton of *Esquire* published Arbus's photo essay "The Vertical Journey," which portrayed "examples of the spectrum within New York's social structure." The next year, *Harper's Bazaar* published "The Full Circle," six portraits of eccentrics.

From that point on she continued to work on a freelance basis, her images appearing in a wide variety and number of publications. In 1962 she switched from a 35mm camera to a **Rolleiflex**, generally thought of as an exclusive tool of the fashion trade. She once said, in accounting for the shift, that she had grown impatient with the grain and wanted to be able to decipher in her pictures the actual texture of things. The 2¼ format contributed to the refinement of a deceptively simple, formal, classical style that has since been recognized as one of the distinctive features of her work.

In 1963 and 1966 Arbus won **Guggenheim fellowships** for projects on American rites, manners, and customs and spent several summers during that period traveling across the United States, photographing people participating in what she described as part of "the considerable ceremonies of our present." "These are our symptoms and monuments," she wrote in her original application. "I want simply to save them, for what is ceremonious and curious and commonplace will be legendary."

Selections from these projects were exhibited at the Museum of Modern Art in New York in 1967, in a three-person show with **Garry Winogrand** and **Lee Friedlander** called "New Documents" that established a new mode of social documentary photography. Artistically, her career was prospering, but to support her family she had to take a series of teaching jobs at Parsons School of Design and the Rhode Island School of Design, and master classes at Westbeth, the artists' cooperative in Greenwich Village, where she lived with daughters Doon and Amy.

In 1970 she made a limited-edition portfolio of photographs, printed, signed, and annotated by her, which was to be the first of a series. Concurrently, at a home for retarded people, she made some of her most powerful images, later known as "The Untitled Series."

Diane Arbus committed suicide in 1971. In July 1972 she was the first American photographer to be exhibited at the Venice Biennale, and her work continues to be prominently featured in museum and gallery shows throughout the world.

archaeological photography: Photographs taken at an archeological site, documenting the area before, during, and after excavation, and of artifacts found at the site. These photographs provide scholarly, scientific evidence. Due to the scientific nature of the photographs, they must be free of distortion, well lit, and must include a scale for accurate measurement of the discovered objects and site.

Archer, Frederick Scott (1813–1857)
English inventor
Trained as a silversmith in London, in 1848 Archer invented the wet-**collodion process** now known as Archerotype, by which finely detailed glass negatives were produced. He also invented the **ambrotype**; introduced pyrogallic acid as a developer; devised a camera within which plates could be exposed, **developed** and **fixed**; came up with a method of whitening collodion positives upon glass, and constructed a triple **lens** to shorten the focus of a double combination lens.

Both **William Henry Fox Talbot** and **Gustave Le Gray** tried to sue Archer, claiming he was creating a variant of their inventions, but the suits were never carried out. Archer is generally accepted as the creator of the process that replaced **daguerreotype**s. It was popular from about 1855 to 1880, when the dry collodion process gained acceptance.

architectural photography: Photographs of the built environment, including buildings—their exteriors, interiors, and details—as well as other human-made structures such as bridges, towers, and monuments. Unlike **archaeological photography,** which is

An example of architectural photography; Warren Weaver Hall, New York University. © Fred W. McDarrah.

purely documentary, architectural photography also serves as an expressive art form in itself. It is usually distinguished by a high degree of detail and natural perspective (that is, it is free of distortion) and is a popular field of **commercial photography** for architects and magazines. Architectural photography is usually done with a **view camera,** which uses a large negative for greater detail and can be adjusted to correct for distortion in perspective. This form of photography has been invaluable in the study of historical structures and the appreciation of landmarks by a wide audience.

archival processing: To apply archival processing is to treat a photograph and/or **film** in such a way as to ensure its longevity. It is important to treat all material properly and **wash** all residual chemicals from the finished product. If not, film and the paper photographs can fade, stain, and otherwise disintegrate over a short period of time. The use of archival processing implies that the photograph and film have been processed well and have been fully washed and handled in a way that will prolong their lives and not contaminate other photographic material through close contact. Archival processing entails **fixing** with fresh chemicals, an initial wash followed by a bath in **hypo clearing agent** and a final wash in fresh running water. For photographs printed on fiber-based paper, a final 20-minute wash is recommended.

Archive Photos: This is the leading source of historical images worldwide with over 20 million photographs covering world history, U.S. history, Hollywood, politics, sports, the arts, and current events. Almost every major 20th-century event is represented. Archive also represents the Reuters Photo Archive, selections from the

New Times Photo Library, the Museum of the City of New York, and *Sporting News.*

aristotype: A printing-out photographic **paper** used in the late 1800s and early 1900s that used light-sensitive silver chloride to form the image. The image made on such paper can also be called an aristotype. Printing-out paper is used by **contact printing** the negative in sunlight. **Eugène Atget's** famous photographs of old Paris from the early 1900s are aristotypes.

Arnold, Eve (1913–)
American photojournalist
A member of the famous **Magnum Photos** agency, Arnold made her name in a series of essays for *Life* and *Look* that focused on everything from small-town America to the actress Joan Crawford.

Arnold studied at The New School under **Alexey Brodovitch** and then trained herself in the action-intensive environment of Harlem and Times Square. Much of her career was spent living in London shooting for a variety of publications. Her landmark book *In China* was the result of two long trips there in 1979 and showed, in 170 brilliant color photographs, the people, landscape, work, and life from Beijing to Mongolia. Other notable works by Arnold are her remarkable photographic investigation of how it feels to be a woman, *The Unretouched Woman,* and *Flashback! 50s,* a visual documentation of what Arnold calls "that decade of despair."

(Peter) Arnold, Inc.: A medium-sized **stock photo** agency specializing in highly individualized service with a collection of some 400,000 color and 20,000 black-and-white images. Specialty topics include nature and wildlife, medical, science, and high technology, particularly in the areas of light and electron microscope imaging.

art photography: Photography that is done as a fine art—that is, done to express the artist's perceptions and emotions and to share them with others. All styles of photography can be used in the service of art without regard to whether they are successful or not. Often photography is not done as art but later is recognized as art by subsequent generations. On the other hand, sometimes photographs that have been taken with artistic intent may later be seen as clichéd or silly. As with all art, much is in the eye of the beholder and the intent of the maker. Attempting to characterize one photograph as art and another as not is at best a difficult task.

ASA: Abbreviation for the American Standards Association. In photography the ASA (or **ISO**) is a standardized numerical value indicating how sensitive a **film** (or **paper**) is to **light,** commonly referred to as the "film speed." The higher the numerical value, the more sensitive the film. Thus, ASA 3200 film is much faster (five times) than ASA 100 film.

ASMP: Abbreviation for the **American Society of Media Photographers**.

assignment: A commission to take photographs for a client, usually a newspaper, magazine, or agency. Assignments require successful completion of the job and the delivery of the film and/or photographs to the client by a certain time, called a **deadline**.

Associated Press: The world's oldest and largest news-gathering service, founded as a cooperative in 1848 by six New York newspapers to pool efforts for collecting international news and to offset the prohibitive costs of transmitting news by telegraph. Today the Associated Press transmits photographs and news articles to print, broadcast, and **online** media worldwide on a constant basis. There are 1,700 U.S. newspaper members, plus 6,000 U.S. radio and television stations and networks. Worldwide the AP serves more than 15,000 newspaper, radio, and television outlets. AP photographers have won many **Pulitzer Prizes** for their combat coverage, especially from World War II and Vietnam, and their images of breaking news events are on the covers of major metropolitan newspapers virtually every day.

The Associated Press Honor Roll—photographers killed in pursuit of the story: 1965–Bernard Kolenberg

died in the collision of two fighter-bombers during the Vietnam War; 1965—Huynh Thanh My was killed while covering a battle in the Mekong Delta in South Vietnam; 1968—Klaus Frings died two days after being struck in the head by a rock during a clash between police and students at a demonstration outside the Munich offices of the newspaper Bild-Zeitung; 1969—Oliver Noonan was killed when the evacuation helicopter he boarded to carry wounded American soldiers was shot down over the jungle about 30 miles south of Da Nang; 1971—Henri Huet was killed when his helicopter was shot down over Laos in Southeast Asia—three other photographers, **Larry Burrows** of *Life,* Kent Potter of the UPI, and freelancer Keisaburo

Shimamoto, were also riding and were killed with Huet; 1993—Hansjoerg (Hansi) Krauss was killed by a Somali mob while covering the civil war near Mogadishu; 1993—Andrei Soloviev was shot to death during a battle between Abkhazian and Georgian forces for control of Sukhumi in the breakaway region of Abkhazia; 1994—Abdul Shariff was shot to death while covering a congregation of African National Congress leaders visiting Katlehong, South Africa.

astigmatism: In a **lens,** the inability to bring vertical and horizontal lines at the edges of the picture into **focus** at the same time.

Huge Crowds Jam into Times Square on August 14, 1945, to Celebrate the Surrender of Japan, Ending World War II. © AP/Wide World Photos. Courtesy the Associated Press.

Eugène Atget. *Verrières, Coin Pittoresque (Verrières, a picturesque spot). 1922.* Collection of the authors.

Atget, Jean-Eugène-Auguste (1856–1927)

Pioneering French photographer

During his lifetime, Atget was considered an unimportant commercial photographer who walked around Paris with an old-fashioned view camera, taking straightforward pictures of storefronts, historic buildings, artisans at their trades, domestic interiors, carnivals, and cafés. He made a living by selling his pictures to the shopkeepers or anyone else who would pay for his shots. Atget's commitment to documenting the art and history of French culture led him to explore the region surrounding Paris, where many of the chateaux and parks associated with pre–Revolutionary France and the French nobility still attested to the lifestyle of the ancien régime.

Atget never exhibited his work in galleries or sold a picture for publication until a year before his death when a **surrealist** magazine, *La Révolution,* published several of his photographs. When he died in 1927 he left a vast archive of prints and negatives, all filed and catalogued, in his studio.

The American photographer **Berenice Abbott**, then living in Paris and working as **Man Ray**'s assistant, saw his published pictures and began a campaign to salvage and bring recognition to Atget's work. Abbott also was strongly influenced by Atget's self-imposed project and herself went on to document her city, New York, in a similar fashion in the 1930s.

Abbott's efforts to bring recognition to Atget achieved great success. The Museum of Modern Art in New York presented an unprecedented four-part exhibition series exploring in depth Atget's art and published in conjunction with the exhibitions four volumes of his work: *Old France, The Art of Old Paris, The Ancien Régime,* and *Modern Times.* Atget is now considered one of the greatest photographers who ever lived. Using an 18 x 24 cm. **bellows** camera, a set of rectilinear lenses with a wooden **tripod,** and **gelatin** dry plate negatives, Atget produced more than 10,000 scenes of Paris and the surrounding countryside that his fellow photographer **Ansel Adams** called "the earliest expression of true photographic art."

audiovisual: *Audio* means sound and *visual* means sight, so *audiovisual* means communication by both means. Music is audio; still photography is visual; movies are audiovisual.

Austen, Alice (1866–1952)

American documentary photographer

Alice Austen's early photographs, taken in the late 1870s and 1880s, documented the tranquil and privileged life of her family, friends, and the social milieu that revolved around her majestic Victorian home, situated on a Staten Island bluff that commanded a magnificent view of the Narrows, Brooklyn, and lower Manhattan. In the 1890s and the first decade of the twentieth century she worked beyond her immediate circle. She published a series called "New York Street Types," portraying newsboys, peddlers, and street cleaners; she photographed quarantine stations where immigrants were isolated; and she began to travel—through the Northeast, the Chesapeake Bay area, and later to Europe. Photography was Austen's hobby; she had no need to pursue a career for fame or money. But her images equal or surpass those of any photographer of her time as much for social history as for art.

After the stock market crash of 1929, Austen lost all her money. She was forced to leave her home, but the Staten Island Historical Society was able to retrieve 3,500 of her negatives when she was evicted. The rest of her life's work, another 5,500 plates, was destroyed or lost. By 1950 she was living in the Staten Island Farm Colony, a home for the indigent.

Recognition for her work began in 1950, when Oliver Jensen, one of the owners of a small publishing company, sought out photographs from local groups, including the Staten Island Historical Society, for a book on the history of American women. C. Coapes Brinley, a volunteer member of the society, showed the Austen collection to an aide of Jensen's, who immediately saw the value of her work. Publication of her work and exhibitions followed soon thereafter.

The Austen family mansion, Clear Comfort, is now owned by the city of New York and is open to the public as a museum dedicated to Alice Austen's life and work.

autochrome: Autochrome was the first color film process, patented by the **Lumière** brothers in 1904 and marketed commercially in 1907. Microscopic grains of potato starch were dyed red, green, and blue-violet, then mixed evenly and coated onto a sheet of glass. A black-and-white **emulsion** was then flowed over this layer. During exposure the grains of potato starch on each plate acted like millions of tiny filters. The light-sensitive emulsion was then reverse processed into a positive transparency. When the image was viewed, light passed through the emulsion and was filtered into the proper color by the starch grains. The resulting mosaic of glowing dots on glass gave autochromes the look of pointillist paintings. It was a very slow film, requiring a long exposure, and was made obsolete by the Kodak **Kodachrome** and Agfa Agfacolor processes in the 1930s.

automatic or autofocus camera: As the name implies, this is a camera that is easy to operate, automatically adjusting for **light** and **focus** without help from the photographer. In the past, automatic cameras were cheap and of poor quality; but today's automatic cameras can be of a very high quality, and some are used by professionals.

The Canon Sureshot Z115 is an autofocus camera with a facility to vary the lens from 38mm, wide angle, to 115 telephoto zoom lens. © Fred W. McDarrah.

automatic diaphragm: A diaphragm (usually in the **lens** of a **single lens reflex camera**) that automatically closes to a preset size just before the exposure is made, then automatically opens to its maximum size immediately after the exposure. Sometimes *automatic diaphragm*

refers to the entire activating mechanism of springs and levers in both camera body and lens.

automatic exposure: Exposure refers to how much light is allowed onto the film. Without the right amount of **light,** the **film** will not yield a good photograph. Automatic exposure is controlled by the camera, providing the proper amount of light for each photograph.

automatic flash: A flash produces a bright light to illuminate a subject. The intensity and duration of that light determine how well the film is exposed. Too much or too little light from the flash and the photograph will be of poor quality. An automatic flash determines the correct amount of light for the subject and film type.

automatic focusing: Also referred to as auto focus, automatic focusing refers to the camera **lens's** ability to **focus** without the photographer making the adjustment. This is a very popular and excellent system available on most automatic cameras.

autotype: Another name for a **carbon print.**

available light: This refers to light that is present at a scene to be photographed. Taking a picture without a flash or other light source added by the photographer is termed using available light.

Avedon, Richard (1923–)

Celebrated American fashion and portrait photographer

Over a career that has spanned more than 50 years, Richard Avedon has developed into one of the world's most eminent photographers, working in a variety of genres—as a portraitist and fashion and advertising photographer.

A native New Yorker, he was given his first camera, a **Rolleiflex**, as a gift from his father when Avedon was a student at DeWitt Clinton High School in The Bronx. After high school, he joined the Merchant Marines, where he was assigned to the photographic department; this development sparked an interest and a career. After World War II, he enrolled in the now-famous Design Laboratory that **Alexey Brodovitch** ran at The New

Richard Avedon. *Dovima with Elephants; Evening dress by Dior, Cirque d'Hiver, Paris.* August 1955. © Richard Avedon. Courtesy of the photographer.

School. He was an outstanding student, and Brodovitch recommended Avedon for the job of staff photographer at *Harper's Bazaar* in 1945. He remained there for the next 20 years, while also managing his own portrait studio. For *Harper's Bazaar* he was a regular at the Paris fashion shows and became well known for emotionally penetrating images of a succession of glamorous models from Dovima and Suzy Parker to Verushka, Twiggy, and Anjelica Huston.

His first book, *Observations* (1959), featured portraits of literary and artistic figures; it was designed by his old teacher Brodovitch and had text by Truman Capote. His second book, *Nothing Personal* (1964), with text by James Baldwin, presented a wide cross-section of images of Americans, from an elderly ex-slave to former president Dwight Eisenhower to the Everly Brothers to patients in a mental ward.

That book ended with a picture of members of the Student Nonviolent Coordinating Committee, a civil rights group that Avedon had encountered in 1963 while photographing the early events of that movement. Throughout the sixties, Avedon supplied equipment and trained young black photographers from the South to document the struggle for equality.

On a lighter side, Avedon's professional experience and reputation inspired the 1967 film *Funny Face,* with Audrey Hepburn as a bookworm-turned-model and Fred Astaire as Dick Avery, fashion photographer, a character based on Avedon.

Avedon joined *Vogue* in 1966 and remained there for the next two decades, solidifying his place in photo history. His ground breaking work in the 1970s included life-sized nude photos of members of **Andy Warhol's** Factory; larger-than-life blowups of the Mission Council, the top military and political figures from the Vietnam War; and "The Family," a 46-page portfolio published in *Rolling Stone* of powerful and influential Americans, including Gerald Ford and Jimmy Carter, Henry Kissinger, and Rose Kennedy.

His first major portrait retrospective was the show "Portraits 1945–1970" in Minneapolis. A fashion retrospective, "Avedon: Photographs 1947–1977," opened at the Metropolitan Museum of Art in New York in 1978 and toured the world for three years. Avedon turned to television work in 1980, creating the controversial Calvin Klein jeans campaign featuring Brooke Shields. It was written by Doon Arbus, daughter of another of Alexey Brodovitch's old students, **Diane Arbus**. Avedon also did TV spots for Chanel as well as other accounts.

Concurrently, Avedon was heading in a new direction with his portraits. With the sponsorship of the Amon Carter Museum in Fort Worth, Texas, Avedon spent several months each year in the American West, photographing drifters and waitresses, oil drillers and ranchers—those he described as "uncommon common men." He showed them as he did the rich and powerful: starkly, with a plain white background, framed by the unexposed black border of the negative. The resulting book was a top seller, and the show toured America's leading museums.

In 1992, Avedon was named the first staff photographer in the history of *The New Yorker* magazine.

backgrounds: The area behind a subject is the background. In **studio** photography it may be a blank wall or piece of seamless paper or cloth, or it can be a surface painted with an abstract pattern or a scene. Outside it can be a wall, natural scene, or anything that is behind the subject. Backgrounds have a strong effect in a photograph and should be chosen carefully. Some photographers, such as **Richard Avedon,** use blank white backgrounds, thereby forcing the viewer's attention to the subject; others prefer to use a background that gives a clue as to the subject's occupation, such as a library for a picture of a writer. The background can add to or distract from the photograph and should be carefully considered.

backlight: A light source coming from behind a subject. In studio **portraiture** this may be used to create a halo effect around the subject's hair. Outside it often results in the subject's front's being in shadow unless fill-in light is used.

back tilt: A **view camera** has three distinct elements: the front **standard**, which is a board with a **lens;** the back standard, which is a board with a piece of ground glass for focusing an image; and a flexible, light-tight **bellows** attaching the front and back standards. The front and back standards move independently to control perspective and **focus.** When the back standard is rotated on its horizontal axis (adjusted so it is not parallel to the front standard), it is called a back tilt.

Bafford, Edward L. (1902–1981)

American landscape photographer

Bafford was one of the few great masters of the bromoil printing process, a method that gives photographs a painterly appearance. His tranquil, pensive images taken in the Chesapeake Bay region of fishing boats, farm landscapes, and men at work are memorable for their quiet charm and artistic composition.

He began taking pictures at the age of 14, and the Baltimore Camera Club was an important part of his life. It is America's oldest continuously operated photography club, and Bafford was a member until he died. In 1935 he opened the Bafford School of Photography, an informal and irregular lecture series that featured guests whom Bafford met over the course of his career, including **Alfred Stieglitz** and **Aubrey Bodine**.

Bafford was a featured photographer at the 1939 World's Fair in New York and had several images included in the famous time capsule. His work has been widely exhibited in the United States and abroad.

Bailey, David (1938–)

British portrait photographer

In the 1960s David Bailey was ubiquitous, photographing the stars and near stars, the winners and the losers of "swinging London." Many of his pictures were taken for *Vogue* magazine, but his book *Goodbye Baby and Amen* is the complete record of his work, capturing the spirit and look of that decade with portraits of the Beatles, the Rolling Stones, actresses, politicians, artists, and writers. His photographs are as much a part of the period as miniskirts, Campbell's soup cans, and a mop-headed singer crooning "Yeah, yeah, yeah" into a microphone.

A London high school dropout, Bailey was a member of the Royal Air Force and based in Singapore before starting work as an assistant to John French in 1959. The next year he began working with *British Vogue*. Neither would ever be the same. Bailey's photographs—and films—captured the often hedonistic lifestyle and social mix of the time. The same year he published his first book of portraits (1965), *David Bailey's Box of Pin-ups,* he married the French actress Catherine Deneuve.

Edouard-Denis Baldus. *View of Paris,* ca. 1851. From the Leonard/Peil Collection, Stamford University Museum of Art, Stamford, California.

Michelangelo Antonioni's film *Blow Up* was said to be loosely based on Bailey's life.

In addition to his books, gallery and museum shows, and contributions to major magazines and regular work for *Vogue,* Bailey also made two noteworthy films, *Beaton by Bailey* (1971) and *Andy Warhol* (1973).

In 1984 he had a major retrospective at the **International Center of Photography** in New York.

Baldus, Edouard-Denis (1813–1889)
French landscape and architectural photographer
Baldus was one of the most successful photographers in France, renowned for the technical and artistic quality of his landscape and architectural views. Born in Prussia, Baldus moved to Paris in 1838 to study painting. Few details are known about his personal life, but by the end of the 1840s he had taken up photography, using nega-

tives made of paper rather than of glass or film.

Baldus received commissions from the French government for diverse projects. In 1851 he was appointed to join a survey of historical buildings and monuments in Burgundy, the Dauphine, and Provence. He was also noted for the size of his pictures—which included a panorama measuring eight feet long for one image. In one 1852 print he pieced together ten negatives to form a composite print of a cloister in Arles. He was later commissioned to photograph Paris monuments. His reputation was further enhanced by a series of photographs of the devastating floods of 1856.

To commemorate the visit of Queen Victoria to France in 1855, Baron James de Rothchild hired Baldus to prepare a lavish album of photographs of the train route the royal visit would follow, including landscape views of the tracks and railroad stations. This album

and another railroad album (1861) of the Paris–Lyon–Méditerranée line are among his greatest achievements, combining artistic landscape views with bold elements of the modern landscape—railroad tracks, stations, bridges, viaducts, and tunnels.

Baldus's work was featured in a major exhibition at New York's Metropolitan Museum of Art in 1994.

Ball, J. P. (James Presley) (1825–c. 1901)
American commercial photographer

This important nineteenth-century African-American photographer lived and worked in Ohio, producing street scenes and **daguerreotype** portraits in his Cincinnati gallery.

Ball was born in Virginia and moved north in the 1850s. He set himself the task of documenting the history of people of African ancestry. Born a free man, he was an active abolitionist who lectured against the evils of slavery. To help fellow Americans understand more about African-Americans, he published a remarkable document—Ball's *Splendid Mammoth Pictorial Tour of the United States.*

After 1871 Ball left Cincinnati, opened a studio in Minnesota in 1887, and moved on to Montana, where he and his son had a studio in Helena. While in Montana, Ball briefly edited a newspaper called the *Colored Citizen.* In 1901 he moved to Portland, Oregon.

The high esteem in which Ball's work is now held is evidenced by the record $63,800 price paid for his 1851 daguerreotype of a Cincinnati street scene at a Swann Galleries auction.

ball-and-socket head: A mechanism used to attach a camera to a **tripod**. The camera is connected to a metal ball by means of a short metal stem. The ball is secured inside a metal cup that is slightly larger than the ball. A clamp is used to lock the ball in position with the cup at an appropriate camera position.

Baltermants, Dmitri (1912–1990)
Russian photojournalist

Best known for his World War II reportage from the trenches of the Russian front, Baltermants was a corre-spondent for *Izvestiya* and the army newspaper *Na Razgrom vraga* (To destroy the enemy). He photographed the defeat of the Germans near Moscow, the defense of Sevastopol, the Battle of Stalingrad, the liberation of southern Russia, and battles in Poland. After the war Baltermants became chief press photographer for *Ogonyok* magazine, where he worked for some 30 years. Ironically, Baltermants was a pacifist before and after the war, and his work often communicates his personal philosophy.

Baltz, Lewis (1945–)
American photographer and teacher

Known for his carefully composed images of suburban buildings and industrial structures, Baltz works in 35mm black and white. Born in California, he studied art as an undergraduate at the San Francisco Art Institute, receiving a bachelor of fine arts degree in 1969 and, in 1971, a master's degree in fine art from Claremont Graduate School.

Critics have cited **Walker Evans** as one of his primary influences, and his architectural facades do show a straight-on frontality similar to Evans's. Winner of a **Guggenheim fellowship** in 1976 and several **National Endowment for the Arts** fellowships, Baltz has also published several books and is represented in American museums.

Banier, François-Marie (1947(?)–)
French writer and photographer

Banier considers himself half Hungarian, half Parisian. He took his first photograph when he was 14 and published his first novel when he was 19. The author of five novels and several plays, he kept a photographic diary for more than 30 years, of his encounters with exceptional people. His subjects include people from every walk of life, from aristocrats to eccentrics of the city, dancers at the Moulin Rouge, Nobel Prize winners, singers, and survivors of all kinds. He photographed Samuel Beckett, Princess Caroline of Monaco, the director Tim Burton, and Queen Elizabeth II of England. His portraits were published in the United States in a collection called *Past Present.*

Pages 26 – 27: Dimitri Baltermants. *Attacking the Enemy,* 1941. Citizen Exchange Council, New York.

Bar-Am, Mischa (1930–)

Israeli documentary photographer

Bar-Am has been chronicling the life of Israel since he served in the war of independence in 1948. Born in Germany, he moved with his family to Palestine in 1936. He acquired his first camera, a second-hand Leica, in 1954 and since that time has documented many important events in Israeli history, including the trial for Nazi war crimes of Adolf Eichmann and the Six Day War, the Yom Kippur war, and the assassination of Yitzhak Rabin. Bar-Am worked as Israeli correspondent for the *New York Times* from 1968 to 1992 and was a founding member of the **International Center of Photography**. A correspondent member of **Magnum Photos**, he was founder and curator for fifteen years of the Tel Aviv Museum's Photography Department.

Barnack, Oskar (1879–1936)

German inventor and photographer

Credited with the invention of the **Leica**, the first minia-ture camera, Barnack was a mechanically gifted amateur photographer whose asthmatic condition hampered him from carrying heavy equipment on field trips when he roamed on foot throughout the countryside.

Born in Linow, Brandenberg, Germany, he moved with his family to Berlin soon thereafter. He demonstrated unusual mechanical and mathematical skill in the local high school, and after graduation he was apprenticed to a manufacturer of astronomical instruments. After working as a journeyman machinist he joined the firm of **Carl Zeiss**, in Jena, in 1902 and stayed there until 1911, when he became head of a new experimental department and master machinist with Ernst Leitz, scientific instrument makers in Wetzlar. Among his original creations there was an all-aluminum motion picture camera and a precision **stereoscopic camera**.

For his own use as an amateur photographer in 1905, he had contrived an ingenious device that took 15 to 20 pictures in separate rows on a single 5 x 7-inch negative. At Leitz he pursued his interest in small-format

Oskar Barnack. *News photograph of flooded city, 1920.* Courtesy Leica Camera, Inc.

George N. Barnard. *Ruins in Charleston, S.C.,* ca. 1865. Collection of the authors.

photography and in 1914 put together an all-metal, single-shutter-speed miniature camera that used 35mm film. Thus was born the so-called Ur-Leica, the prototype for the miniature camera that would achieve worldwide popularity. World War I halted production at Leitz, and it was not until 1925 that the first six models were introduced. Barnack remained with Leitz for the remainder of his career, refining and improving Leica cameras and accessories.

Barnack's invention of a handily compact camera redefined the esthetics of photography, elevating the snapshot to an art form—a unique record of an unplanned moment in time.

Barnard, George N. (1819–1902)

Early American commercial photographer

Barnard's career as a photographer began in 1846, when he set himself up in business as a **daguerreotypist** in Oswego, New York, and it reached its high point during the Civil War, when, as a government photographer, he took a remarkable series of photographs of General William Tecumseh Sherman's campaign march from Chattanooga to the sea.

Born in Coventry, Connecticut, he moved with his family to Oswego, where he briefly co-owned and managed a hotel. Daguerreotype was just beginning to

achieve prominence in the area, and it is likely that he tinkered with the process for several years before turning to it as a profession. In 1853 Barnard's daguerreotypes of the devastating Ames Mills fire in Oswego were the only ones taken of the blaze and were widely sold.

Barnard became better known through friendships with two New Yorkers, **Edward Anthony**, owner of the largest American business devoted to the manufacture and distribution of photographic supplies, and the photographer **Mathew Brady**. He traveled to Cuba and took numerous **stereoscopic** views of Havana and environs that were later published by Anthony. Brady, also a friend of Anthony's, operated a successful studio in New York, where he took *carte de visite* portraits of political leaders, military heroes, and other celebrities of the day. In the winter of 1860–1861, Anthony assigned Barnard the task of making negatives of Brady's collection of distinguished people.

Barnard went to Washington, D.C., a few days after President Abraham Lincoln's first inauguration to work in Brady's studio there. After the start of the Civil War, Brady secured Lincoln's permission to make a photographic history of the conflict. Most of Barnard's Civil War pictures were taken on assignment for Brady and sold through his studio, along with the work of such other noted Civil War photographers as **Alexander**

Gardner, Edward Anthony, and **Timothy O'Sullivan**. It is not known how many of Barnard's photographs were simply credited "Brady Studio."

But his Sherman campaign pictures were photographed and produced by Barnard alone. These large-format pictures, printed from 12 x 15-inch negatives, showed noted battlefields, military installations, bombarded towns, and a few tranquil scenes from the top of Lookout Mountain. After the war Barnard documented the great Chicago fire of 1871, operated a studio in Charlotte, South Carolina, and worked with **George Eastman** in the promotion of the new technology of **dry plate photography**.

Barney, Tina (1945–)
American art photographer

New York photographer Tina Barney is noted for her candid and tableau photographs that focus on her upper-class social milieu. Although these photographs may appear at first glance like oversized snapshots of family life, they have several levels of meaning. The subjects, while posing in carefully furnished houses and well-tended gardens, often appear tense and anxious.

Barney studied at the Sun Valley Center for Arts and Humanities and is a recipient of a **Guggenheim fellowship**. A monograph featuring her work, *Photographs: Theatre of Manners,* was published in 1997. She lives in New York City and Rhode Island, and her photographs have been exhibited widely at museums and galleries.

Barth, Miles (1952–)
American curator and writer

A leading authority on American and contemporary photography, Barth served from 1979 to 1998 as the first Curator of Archives and Collections at the International Center of Photography. He has been involved with the research, organization, and presentation of over 225 photography exhibitions. He has written many articles and book introductions and lectured on the history and conservation of photography.

He started his work in photography at the Art Institute of Chicago in 1970, where he worked on exhibits of Aaron Siskind, the Julien Levy collections, and early photography. At ICP he was responsible for development of the acquisition policies and supervision of the ICP's permanent collection. Besides overseeing the museum's collection of more than 45,000 original photographs, he worked on special projects for ICP, public institutions around the world, and various U.S. government agencies.

He is also an advisor to the National Endowment for the Humanities, a three-time panel member of the Fulbright grants, and a consultant to the State Arts Councils of New York, New Jersey, Delaware, and Oregon. Barth's publications include *Weegee's World* (1997), *Tropism: Photographs by Ralph Gibson* (1987), and *Eyes to an Era: Four Decades of Photojournalism by Irving Haberman* (1995).

bas-relief images: A bas-relief image is one in which a foreground image is raised slightly from the background, producing a three-dimensional effect.

batteries: Portable power sources for electronic equipment such as cameras, flashes, and light meters.

battery-powered portable flash: A compact, self-contained electrical device, energized by a battery, that produces a brief, bright burst of light (flash) in **synchronization** with the opening of a camera **shutter**. The smallest versions of these devices are mounted directly on the camera while larger versions include a power pack carried in a case with a shoulder strap and a flash head that is mounted on the camera and connected to the power pack with an electrical cable. Portable flash units are used to illuminate a photographic subject under conditions that would otherwise be too dark to make a handheld exposure conveniently.

baud rate: The speed at which information is transmitted via **modem** over a telephone line. Typically used in connection with how fast a **computer** can connect and then interact with the **World Wide Web**. A baud rate of 9600 bps (bits per second) was considered lightning fast

in the early 1990s. By the end of the decade home users had modems capable of up to 56600 bps.

Baughman, J. Ross (1953–)

American photographer and writer

In 1978 Baughman won the **Pulitzer Prize** for feature photography for three photographs from guerrilla areas in Rhodesia, where he was documenting the Rhodesian civil war for the **Associated Press**. Later that year Baughman left the AP to become one of the founders of Visions, an agency specializing in investigative journalism covering high-risk situations that could put the photographer in jeopardy of bodily harm.

Born in Dearborn, Michigan, Baughman studied at Kent State University (bachelor of arts., 1975), where he was a J. Winton Lemen **Photojournalism** scholar. He worked at the *Lorain Journal* as writer and photographer from 1975 to 1977 before becoming an AP contract photographer and writer in Africa and the Middle East.

He has been a member of the faculty at The New School in New York City since 1979. He was a cofounder of the Focus Photography Symposiums in New York in the *1980s* and has published several portfolios of his work.

Bauhaus:

An academic institution founded in Germany after World War I that stressed the unified and coordinated uses of art and design—that is, all of the art and design subjects were taught as being interrelated. Classes were taught in architecture, industrial design, book design, photography, and theater design. It existed from 1919 to 1933, when the Nazis closed it down for being "subversive." One of the teachers of the German Bauhaus, **Laszlo Moholy-Nagy,** opened the New Bauhaus in Chicago in 1937, which later became the Institute of Design. Two of the most famous photographers to study there were **Harry Callahan** and **Aaron Siskind**.

Bayard, Hippolyte (1801–1887)

French inventor and photographer

Although not as well known as his contemporaries **Fox Talbot** and **Louis-Jacques-Mandé Daguerre,** Bayard was probably the earliest inventor to make direct positive photographs in the camera, producing paper photographs (1839). His photographs were the first to be exhibited publicly, in Paris on June 24, 1839, along with work of painters like Rembrandt, and they are still valuable documents recording Parisian life of the time.

Born in Breteuil-sur-Noye, a small town in the Oise Department, Bayard moved to Paris, where he worked as a civil servant in the Ministry of Finance. Long interested in the chemical action of light, Bayard heard about Daguerre's production of positive images. His own discovery, almost simultaneous with that of Daguerre and Talbot, was largely overlooked, although he was eventually awarded a prize of 3,000 francs by the Society for the Encouragement of National Industry.

About 600 of his photographs are extant, owned by the French Photography Society; not all were made by the **direct positive process**, as Bayard also took **daguerreotypes** before switching to **albumen**-on-glass and the **collodion** process.

Bayer, Herbert (1900–1985)

American photographer, painter, graphic designer, and architect

Bayer's interest in photography has taken three forms: pictures of the environment seen from fresh viewpoints, photographs of three-dimensional assemblages, and photomontages. His surreal images, strongly influenced by the **Bauhaus** movement, have been exhibited in the United States and in his native Austria.

Bayer served an apprenticeship in architecture in Linz and also studied painting with Wassily Kandinsky. He worked at the Bauhaus in Dessau, Germany, where he taught typography, before becoming an art director for *Vogue* in that city. In 1938 he moved to New York; later, he lived in California. Winner of numerous awards for art and photography, Bayer was a longtime consultant in art, architecture, and design for the Atlantic Richfield Company (ARCO).

Beals, Jesse Tarbox (1870–1942)

Pioneering American female photojournalist

Generally acknowledged as the first female press photographer, Beals produced a body of work that covered a

Herbert Bayer. *Self Portrait,* 1932. Gruber Collection, Cologne.

wide spectrum—documentaries of New York City slum children, portraits, landscapes, gardens, and architectural studies.

Born in Hamilton, Ontario, Canada, she became a schoolteacher in Massachusetts, where she opened her own portrait studio during summer vacations. She continued to teach until 1900, when she and her husband, Alfred T. Beals, decided to become itinerant photographers. In Buffalo, New York, she was hired by the local newspaper, the *Inquirer,* in 1901 and became the first American woman to work as a full-time staff photographer at a daily newspaper. In 1904 she was appointed official photographer of the Louisiana Purchase Exposition in St. Louis. After the exposition she moved to New York City, where her work was widely published in newspapers and magazines.

In a May 12, 1906 interview with a reporter for the *New York Evening Journal,* she told of the difficulty of being a working mother. However, she said, "I have to work . . . but it is not the right thing for a child."

Beals spent some time in southern California in 1926 and photographed many Hollywood stars before returning to the city. Her life story is documented in Alexander Alland Sr.'s *Jesse Tarbox Beals: First Woman News Photographer.*

Beard, Peter (1938–)

American photographer and writer

Beard's principal concern throughout his career as a photographer has been the survival of both wildlife and the native cultures of a fast-changing Africa more concerned with "progress" than with the preservation of natural beauty.

Beard was in Africa in 1955 when he started work on his first book, *The End of the Game.* After his graduation from Yale University in 1961, Beard settled in Kenya, on property adjoining that of Karen Blixen, author of the classic *Out of Africa,* using the pen name Isak Dinesen. He later wrote a tribute to her life in Kenya, *Longing for Darkness.* Beard's early photographs, mostly in black and white, tell a disturbing story of the destruction of the wilderness and the damage inflicted by hunters on the game they pursue, particularly in his images of dead and dying animals. His *African Journal* (1998) uses color photographs to document his continuing interest in the African environment.

Beato, Felice A.
(1830–1906)

Early British travel photographer

Beato's travel views are unique; the first European to take photographs in Japan (in 1862), he shot geishas, samurai warriors in full regalia, exotic temples, and scenes of everyday life in Japan that had never been viewed by Western eyes. Born in Venice, Italy, Beato was a naturalized British subject who spent his professional life traveling and photographing wars, uprisings, and newsworthy events in China, the Crimea, Egypt, Palestine, and the Sudan.

Working as assistant to **James Robertson**, he went to Malta in 1850, and the two of them photographed there using the **calotype** process. Working with Robertson, he documented the Crimean War, continuing the work begun there by the war photographer **Roger Fenton** to form a complete photo history of that conflict. Beato's pictures taken by the **albumen**-on-glass process are collector's items today.

Felice A. Beato. *Woman Using Cosmetics,* ca. 1867. The New York Public Library.

After the war he and Robertson continued their series of views of Mediterranean cities and antiquities they had started earlier. They went on to India, to photograph the Indian mutiny and later the Opium wars in China.

His *Photographic Views of Japan* was published in 1868.

Beaton, Cecil (1904–1980)
British fashion and society photographer
A bon vivant best known as the "house photographer" of the British royal family and a regular chronicler of the fashion and society circuit, Beaton was also a multiple Academy Award winner for sets and costumes, left his design imprimatur on several private clubs, and, as critics and historians agree, had few peers as a diarist.

Entirely self-taught, Sir Cecil (he was knighted in 1972) got his start in photography as a student at St. John's College in Cambridge. He dropped out of college, but he never dropped his photography. He arranged a sitting for his mother with London's leading society photographer, Hugh Cecil; Beaton studied the master's techniques and soon started taking his own portraits of his mother and sisters and selling them to smart London magazines under the nom de plume Carlo Civelli. For the next 60 years, art, photography, society and fame were Beaton's *raison d'être.*

In his glamorous career he photographed a broad range of legendary figures in the arts, from Edith Sitwell to Jean Cocteau to Gertrude Stein to Rudolf Nureyev. Much of his work was done on assignment for *Vanity Fair*, for which he started shooting in the 1920s, and *Vogue*, where he started a decade later. There was also regular work from *Harper's Bazaar* and **Life**.

Beaton was so obsessed with glamour and fame that even though he was a homosexual, he pursued and consummated a relationship with Greta Garbo. Details of that and many other encounters are found in the six volumes of his diaries, which were published in the 1960s and 1970s.

He worked in theater, film, and ballet, designing sets and costumes for numerous dance productions, Broadway shows, and operas such as *Swan Lake, Coco, The Grass Harp*, and *La Traviata*. He won an Oscar for

his work on the film *Gigi* (1959) and two more for *My Fair Lady* (1965).

Beaton photographed British royalty from 1939 to 1970, starting with the Queen Mother progressing right through to an infant Prince Andrew. His first portraits were *Vogue* assignments. But the royals so liked his work, his manners, and his British mannerisms that they started calling him on their own.

In his later years, he became known for his theatrical portraits of ballet and film stars as well as of other notables. Beaton used both color and black and white, and he worked in a variety of formats. Though he always leaned toward the decorative, after his work as a wartime correspondent his photos became less flamboyant. He worked for the Ministry of Information during World War II. Many of his war images were highly praised, the most famous being of a little girl, a victim of the London bombing raids by the Nazis, lying in a hospital bed with a bandage around her head and a doll in her arms.

After the war Beaton returned to his glamorous career as a society photographer for the rich and famous.

Becher, Bernd (1931–)
Becher, Hilla (1934–)
German industrial photographers
Husband and wife, the Bechers began collaborating in 1959 and were married in 1961. They met as students at the Staatlicke Kunstakadernie in Stuttgart and found that their interests, both personal and professional, meshed. The couple are known for their black-and-white, direct, large-format pictures of human made structures of the mundane industrial world, such as grain elevators, water towers, blast furnaces, and gas tanks. Several collections of their photographs have been published.

Bedford, Francis (1816–1894)
British landscape photographer
The son of an architect and himself trained as a lithographer, Bedford is now regarded as one of the finest photographers of the English landscape, architecture, and topography. He first started experimenting with photography in 1853. Like many photographers of his era, Bedford found exposure of skies was problematic,

so he either painted clouds onto his negatives or over-laid separate sky negatives.

In 1854 he was commissioned by Queen Victoria to photograph objects in the Royal Collection. In 1862, he was invited to document the Prince of Wales's tour of the East. As a member of the royal entourage, he was allowed access to many holy sites restricted as sacrosanct. The resulting 148-print series "The Holy Land" won every contemporary award and is still regarded as a masterpiece of early photography.

behind-the-lens meter: Also known as through-the-lens, or TTL, meter. An electrical or electromechanical device built into the body of a **single lens reflex camera**. Such a meter measures the light reflected by the subject and transmitted by the **lens** in order to determine, automatically or mechanically, the correct **shutter** speed and diaphragm opening required for the proper exposure of a particular subject/film combination.

Bellmer, Hans (1902–1975)
German surrealist photographer

Bellmer introduced the mannequin or doll as a subject for his **surrealist** photography and influenced succeeding generations of photographers who added whole new permutations to his creative concept. Forced by his father to attend an engineering school, he hated the vocation, but the instruction he received in precise technical drawing developed the aptitude for minute execution and attention to detail that was to play a role in his art.

Escaping from his home life by creating a child's fantasy world, he found that two real-life events set him on his career path. Bellmer's exposure to the extraordinary dollmaker Lotte Pritzel planted a seed that slowly germinated until in 1932, Bellmer saw the *Tales of Hoffman*. In Offenbach's opera, Coppelia, an automated doll, plays a major role. The next year he constructed a large doll that was to serve as a motif for his work. His first book with the mannequin as the focus was published in 1934. A second, more flexible doll was made in 1937. This work and both the dolls

and books, including the 1949 *Games of the Doll,* led to Bellmer's immediate embrace by the surrealists who saw the "doll" as a Freudian fetish object. Decades later, the dolls—molded and manipulated in a variety of configurations—would come to life in the work of people like **Robert Mapplethorpe**.

Bellmer fled Berlin for Paris in 1940 but was later arrested and interned in a camp near Aix-en-Provence. He survived the ordeal and lived and worked in Paris for the next 30 years, creating his often disturbing and bizarre images.

Bellocq, E. J. (1873–1949)
American documentary photographer

Bellocq's life and work, albeit a fictionalized version, were made into the 1978 Brooke Shields movie *Pretty Baby,* directed by Louis Malle. Bellocq was a busy **commercial photographer** in New Orleans from about 1895 to 1940. Little is known about his professional work beyond a 1918 commission as company photographer with a shipbuilding firm on the Gulf of Mexico. It is his relaxed, realistic pictures of prostitutes in New

E. J. Bellocq. Plate 14, *"Storyville Portraits,"* ca. 1912.
From a print made by Lee Friedlander

Orleans's infamous legal red light district for which he is best known. The images were discovered by photographer **Lee Friedlander** in 1958 (and the surviving plates were bought in 1966); the acclaimed *Storybook* was the resulting volume, culled from the 89 surviving images. He also is said to have shot the opium dens of New Orleans's Chinatown, but none of that work has survived.

bellows: A flexible and extendable light-tight material (such as plastic or cloth) that runs between a camera **lens** and the **film**. Bellows are most commonly seen on **view**

Kodak Tourist folding camera, showing open bellows, 1948.
© Fred W. McDarrah.

cameras and have an accordion-like appearance. The bellows allows the lens board (at the front of the camera) and the film area (at the back of the camera) to move independently.

Benday: A process to produce shading variations by applying layers of tint to an artwork being commercially printed. The Benday process was used by producers of low-budget publications for creating a shading or coloring effect without adding another color of ink. The process was named after Benjamin Day, an early New York printer who devised the process.

Benecke, Ernest (worked in 1850s)
Early German (?) landscape photographer
Until the discovery of 143 prints at a country auction in southern Germany in 1992, little was known about Benecke beyond the 16 prints owned by private collections and credited to "E. Benecke." Then, a German family cleaning out an attic sold cheaply an old unbound **portfolio** to some wise dealers who recognized their value—an estimated $1 million. The prints, all dated 1852, are the monthly record, from January to August, of a grand tour from the Middle East to Greece and Italy. The series, often exhibited in museums, is notable because many of the pictures depict the natives he met along the way, not the more usual ruins and landscapes most travelers photographed—placing these among the earliest surviving photographs of non-Western civilization.

Benedict-Jones, Linda (1947–)
American photographer and curator
An influential figure on the contemporary international photography scene, Benedict-Jones is curator of education at the Frick Art and Historical Center in Pittsburgh, Pennsylvania. She has also worked in Pittsburgh as guest curator of photography at Silver Eye Center for Photography, Pittsburgh Filmmakers, and the Carnegie Museum of Art. At Carnegie she was cocurator and coauthor with the photographer Charles Brodsky for *Pittsburgh Revealed: Photographs Since 1850*. Prior to moving to Pittsburgh she was curator of the Polaroid Collection in Cambridge, Massachusetts, and before that director of Polaroid's Clarence Kennedy Gallery.

Benedict-Jones has also created a substantial body of her own photographic work, concentrating on women and their role in society. She became interested in photography while living in Portugal, where her husband was a player-coach in a European basketball

Linda Benedict-Jones. *Paris*. 1975. © Linda Benedict-Jones. Courtesy of the photographer

league. She started working as a sports photographer for the *Diario de Lisboa* but changed to fine-art photography when the couple moved to France in 1973. Her work was widely exhibited in London, Amsterdam, and Paris. Her images have been used in advertising and editorial features in such publications as the *London Observer,* the *Boston Globe,* and the *British Journal of Photography.* Among the collections holding her work are the **International Center of Photography** in New York, Musée Cantini in Marseilles, France, and the Polaroid International Collection.

Benedict-Jones earned a bachelor of science degree at the University of Wisconsin at Lacrosse (1969) and a master of science degree in visual studies at the Massachusetts Institute of Technology (1982). She has taught at Vassar, Boston University, and Carnegie-Mellon University and lectured in the United States and abroad. As curator, she has mounted exhibits on such diverse topics as "Autobiographical Works by Women Photographers," "**Ansel Adams** and the Polaroid," and "New Portraits by **Dawoud Bey**, Judith Black, and Iris Parker."

Bennett, Henry Hamilton (1843–1908)

Pioneering American landscape photographer

Bennett was an early **landscape photographer** whose major body of work was done in the scenic Wisconsin Dells. Most of his photos are **stereoscopic** views, which were enormously popular in the Victorian era. His photographs of the Dells, showing such picturesque features as unusual rock formations, dark grottos, and canoeing on the quiet waters, helped popularize the unusual terrain and appeared in guidebooks that were sold across the country.

Bennett also produced mammoth **panoramas** that are among the largest **contact prints** ever made, consisting of three 18 x 22-inch plates. Bennett is credited with shooting the first documentary photo essay, "The Story of Raftsmen's Life on the Wisconsin," in 1886. Bennett was an inventor as well, making some of his own equipment, much of which is now owned by the **Smithsonian Institution**.

An early environmentalist, Bennett opposed a dam project that eventually flooded the Dells and covered many of the scenes he had photographed.

Benrubi, Bonni (1953–)

American gallery owner

With her own prestigious New York gallery, Bonni Benrubi Fine Art Photographs, Benrubi is an important figure in the contemporary American photography community.

After earning a dual bachelor of fine arts degree from Boston University and Radcliffe in 1975, and further study at the Boston Museum of Fine Arts and the Fogg Museum, she came to New York and joined the **Daniel Wolf** Gallery. She was director of the gallery, which specialized in nineteenth- and twentieth-century photography, from 1977 to 1987, when the gallery closed and its photo collection was acquired by the Getty Museum in a $22 million transaction she shepherded through. In 1987 she started working as a private dealer and opened a formal gallery in 1993. Specializing in twentieth-century vintage American photography and contemporary American photography, Benrubi has also been the curator of shows internationally, has worked to promote new photographers, and has appraised and evaluated hundreds of collections, from those of Fortune 500 companies to small individual collections. She has lectured to numerous classes and collectors' groups on photography.

Benson, Harry (1930–)

American photojournalist

Harry Benson came to the United States from Great Britain to cover the Beatles, on assignment from a Fleet Street tabloid. He never went back. He is now a successful photojournalist, having covered presidents, celebrities, and other pop culture icons for top magazines for nearly four decades.

Benson's interest in the craft stems from a Coronet Cub box camera he got for an 11th-birthday present. His first professional break came when Peter Manuel, a serial killer, allowed Benson exclusive access to photograph him on Death Row. That earned him assignments from London's famed Fleet Street.

Henry Hamilton Bennett. *Stand Rock, Wisconsin Dells.,* ca. 1890s. Witkin Gallery, New York.

Benson's most memorable shots are probably of the Fab Four, from their emerging onto the Kennedy Airport tarmac to their pillow fights at the Plaza Hotel. He has also covered every American president since John F. Kennedy, and his photographs of presidents and their families are collected in *First Families: An Intimate Portrait from the Kennedys to the Clintons* (1998). The accompanying show was to tour presidential libraries from 1998 until 2000.

Benson has been well recognized for his work: He was named Magazine Photographer of the Year by the National Press Photographers Association, is a two-time winner of the Leica Medal of Excellence, and has won the Overseas Press Club Madeline Dane Ross Award.

Bernhard, Ruth (1905–)

Berlin-born American art photographer

Known for her radiant photographs of the female nude, the Berlin-born daughter of Lucian Bernhard, "the father of the German poster," Ruth Bernhard was still busy working well into her ninth decade. Her childhood was tumultuous; her parents divorced when she was two, and her mother promptly left for the United States and a new husband, leaving Ruth in the care of her father, who spent most of his time working. Ruth was reared in a highly cultured atmosphere by two older sisters then sent to boarding school as a preteen. Her father moved to New York when Ruth was a teenager. After graduating from Berlin's Akademe der Kunst, she joined him in 1927 and became a U.S. citizen shortly thereafter.

She got a job with *Delineator* magazine but was fired for being "unenthusiastic." With her severance pay, she bought her first camera. Her first published work was in the early thirties, when she was a freelance advertising and fashion photographer. In 1934 she snapped her first female nude, a subject she would continue to use for the rest of the century. The nude work has been described as "hauntingly sensual but classically reserved." Working out of her own studio, Bernhard is known for her unusual, glowing light upon both the nude female body and common objects, from Life Savers to teapots.

The Eternal Body: A Collection of 50 Nudes was originally published in 1970, then reissued more than 20 years later. The book is dedicated to **Edward Weston**, whom she met in 1936 and followed to California that same year; she has been based there since. She has taught numerous seminars, workshops, and master classes and lectures well into her nineties.

Berry, Ian (1934–)

English photojournalist

Berry photographed all the major events in South Africa from the early 1960s to the present, as well as ordinary lives shaped by the extraordinary, often bizarre circumstances of the official government policy of apartheid, or racial segregation. He shot the first burning of the infamous passbooks, the Sharpeville riots of 1960, and the more recent free elections.

Born in Lancashire, England, Berry never even knew a black person until he moved to South Africa at the age of 18. He worked for several publications in South Africa, including *Drum,* a major magazine for the black community whose influence and prestige are comparable to those of **Life** magazine in the United States in the 1950s and 1960s. In 1962, he moved to Paris and joined **Magnum Photos** but he continued to frequent his adopted homeland. In the late 1960s he moved back to England.

Berry won the British Arts Council's first major photographic bursary in 1974 and Nikon's International Photographer of the Year award in 1977. His seminal book *Living Apart: South Africa Under Apartheid* (1996) featured a foreword by Desmond Tutu, who called Berry's work "a searing indictment and an important record to counteract amnesia—for those who forget the past are doomed to repeat it."

Bethel, Denise (1951–)

American auctioneer, administrator, writer, and lecturer

In her role as director of the Photographic Department at Sotheby's, Bethel has auctioned some of the most precious—and expensive—nineteenth- and twentieth-century photographs ever.

After earning a bachelor of arts degree in art history from Hollins College in Virginia and a master's degree in the same subject from the University of

London, Bethel embarked on the career that has made her a widely respected expert in the world of photo auctions. After a decade with a rare-book auction firm, she joined Sotheby's in 1990.

Her top sales include a set of **Edward S. Curtis**'s "The North American Indian," which at $662,500 was the most expensive photographic lot ever sold at auction (transacted in 1993); a 1854 half-plate **daguerreotype**, "United States Capitol," which sold in 1995 for $189,500, making it the record holder for any nineteenth-century photograph sold at auction; and two single prints that each sold for $266,500 in 1995 and 1998, respectively—**Man Ray's** "Glass Tears" and **Edward Weston's** "Circus Tent."

Bethel has handled a number of important photographic collections deaccessioned by museums, including the Museum of Modern Art, the Metropolitan Museum, the **George Eastman House**, and others.

A frequent lecturer, she has spoken at New York University, the **International Center of Photography**, the Virginia Museum of Fine Arts, Photo L.A., Houston Photofest, the Chicago Photographic Print Fair, and elsewhere; her writing has been published in the Eastman House's *Image, The History of Photography, The Daguerreian Society Annual,* and *The Walt Whitman Quarterly Review.*

Bettmann, Otto (1903–1998)

American archivist

Founder of the renowned Bettmann Archive, which consisted of 5 million photographic images, prints, woodcuts, posters, cartoons, and other graphic material when it was sold in 1981 to the Kraus-Thomson Organization, Bettmann came to the United States as a refugee from Nazi Germany with two trunks bulging with 25,000 images, most on negatives he had made. A scholar and writer on music, art, and literature, he also wrote or co-wrote 14 books, many of them in collaboration with well-known writers.

Born in Leipzig, he was encouraged by his father, a surgeon and a book lover himself, to pursue his interest in books and images. He began collecting as a boy; later,

he earned a doctorate from Leipzig University. Appointed curator of rare books at the Prussian State Art Library, he was dismissed for being Jewish in 1935 after Hitler came to power. He managed to emigrate to safety and arrived in New York in the heyday of photojournalism, when *Life* and *Look* were major periodicals.

He opened a **stock photo** studio, and his images were soon in demand by newspapers, advertising agencies, and book publishers. The archive grew as he collected or bought other archives, libraries, or private collections. His agency was able to supply illustrations for thousands of topics, from the civil rights movement to space exploration.

In 1990 the archive acquired a further 11.5 million images, including the photographs made for United Press International and Reuters. The archive was sold to **Bill Gates**, head of **Microsoft,** in 1995 for his **Corbis** Corporation, which is amassing a huge library of digitally stored images.

After his retirement Bettmann continued to write books. He was also curator of rare books at Florida Atlantic University in Boca Raton, where he taught. His autobiography, *Bettmann, the Picture Man,* was published in 1992.

Bey, Dawoud (1953–)

American portrait photographer

Bey is an accomplished portraitist of African-American life and has been compared to both **James Van Der Zee**, the famed Harlem photographer, and **David Hockney**, known for his colorful photo collages.

When Bey was 14 and living in Hollis, Queens (a borough of New York City), he visited the Metropolitan Museum of Art to see the classic photo exhibit "Harlem on My Mind." That show inspired him to pursue photography as a career. He had at home an inherited Argus C-3 Range Finder camera, and he used it to start taking pictures.

From 1993 to 1998 Bey worked on a project photographing American teenagers, from Cleveland to Hartford, creating 20 x 24-inch color portraits in collage form that show the different sides of each face. To take his

portraits Bey uses a 200-pound mahogany Polaroid on wheels that has been described as a cross between an armoire and a Volkswagen. Students who participated in his project received instruction on photography and an introduction to the possibilities of photography as art.

In addition to his photo skills, Bey is an accomplished writer and has won numerous grants and fellowships, including accolades from the New York State Council on the Arts and the New York State Foundation for the Arts. Bey's work is included in collections ranging from the Fogg at Harvard to the **International Center of Photography** to Harlem's Schomburg Center for Research in Black Culture.

bibliography: A list of readings on a particular subject or by a specific author or a list of source materials used for reference, usually placed at the end of a text.

bichromate processes: *Bichromate* is the common name for the chemical substance chromium salts of potassium. Bichromate is used in some old-fashioned photographic printing techniques such as **gum bichromate** and **carbon printing**.

Bing, Ilsa (1899–1998)
German-born, American art photographer

Bing was a pioneer in the photographic avant-garde, the only member of a group of artists living in Paris in the 1930s who worked exclusively with a Leica. She died in Manhattan a week before her 99th birthday, when she had been expected to attend a major retrospective, "Ilse Bing: Visions of a Century," at the Edwynn Houk Gallery honoring her unorthodox and inventive work.

She was born in Frankfurt and trained in mathematics. While doing work toward her doctoral dissertation in art history, she began photographing buildings and developed a passion for photography. In 1929 she moved to Paris after being inspired by a photo show by **Florence**

Ilse Bing. *Self-portrait with Leica, 1931.* © Estate of Ilse Bing. Courtesy Edwynn Houk Gallery, New York.

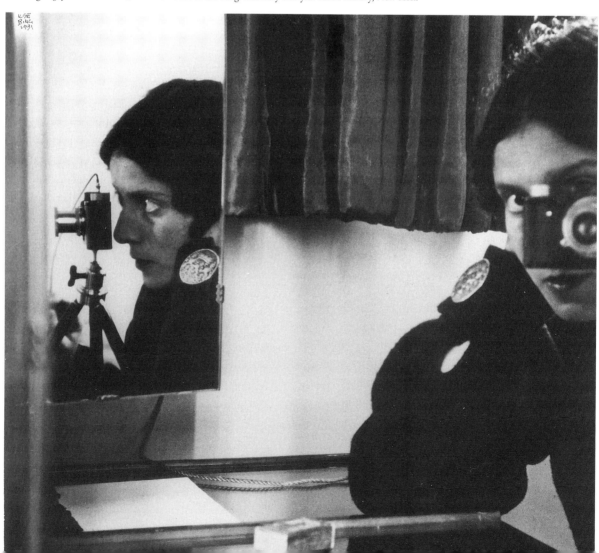

Henri, who had embraced New Photography, characterized by extreme close-ups, strange angles, high and low vantage points, and a generally nontraditional look at people, objects, and the world.

In Paris, she became caught up in the avant garde movement. With her small Leica and creative darkroom techniques, she showed subtleties of light and movement against the inky blacks of Paris at night. Widely exhibited during that decade, she was part of the first modern photography exhibition at the Louvre in 1936.

She did fashion assignments for *Harper's Bazaar* and the designer Schiaparelli, and her work was featured in *Vu, Arts et Métiers,* and *Le Monde Illustré.* In 1936 she was invited to exhibit in a group show at the Museum of Modern Art. She visited New York that year and was offered a staff photographer's job at *Life.* Not wanting to live apart from her husband-to-be, Konrad Wolff, a pianist, she declined the offer and remained in Paris. They married in 1937. Both German Jews, they were interned as enemy aliens in 1940 by the Vichy government but were freed and sailed for New York, where they remained for the rest of their lives.

Bing moved away from photography to poetry in 1959, saying she was creating "snapshots without a camera." She felt "everything moves, nothing stays and I should not hold on." She also made collages, illustrated whimsical books on etymology, and groomed dogs. Her photographic work slipped into obscurity until it was included in a group show at the Museum of Modern Art and a major exhibition at the Witkin Gallery in New York, both in 1976.

biological photography: The type of photography used by biologists for the study of plants and animals. Such photography is used for scientific purposes and should be highly informative and objective without regard to the subject or who has taken the photograph.

Bischof, Werner (1916–1954)

Swiss photojournalist

Bischof was a successful advertising and fashion photographer beginning to explore an interest in **photojournalism** when he was approached by the founding members of **Magnum Photos**, which he joined in 1950. As an early member of the legendary agency, Bischof helped set the high standards that have made Magnum the defining institution for photojournalism in the second half of the century.

Born in Zurich, Bischof moved with his family just over the Swiss border into Germany. He hoped to become a painter, but his father wanted him to follow a technical profession. As a compromise, he studied graphic arts and was introduced to photography. His intense interest impressed his teachers, and he eventually decided upon photography as way of combining his artistic expertise in the use of light and form with his own deep concern for people.

His first major assignment, in 1944, was to take all the photographs for *Du* magazine's special issue on the disabled. He traveled throughout the world for Magnum, taking photographs that combined news value and touching human drama. His work appeared in both European and American magazines including *Life, Fortune, Paris Match,* and *Picture Post.* While on assignment in Peru, he was killed when his car plunged off an Andes mountain road.

Bisson, Louis Auguste (1814–1876)
Bisson, Rosalie (1826–1900)

Early French documentary photographers

Most noted and famed today for their impressive documentations of Parisian architecture and their pioneering images of Mont Blanc in the French Alps in the 1850s and 1860s, the Bissons were best known among their contemporaries for a wide range of photographic styles, from reproductions of the works of Rembrandt and Dürer to animal studies.

The brothers had an elegant **daguerreotype** portrait studio in Paris's fashionable Madeleine district that attracted the attention of, among others, Napoleon III. He and the Empress Eugénie hired the brothers to accompany them and document a trip to Switzerland's Savoy Alps in 1860. They were also technical pioneers in the use of **filters** on lenses, being among the first to capture successfully different degrees of the whiteness of snow and ice in their images of the Alps.

black-and-white negative film: A type of photographic film that records a monochromatic image in reverse tones; what is bright in the subject is rendered dark on the film, and vice versa.

black-and-white photography: Photography that is not in color but is in monochromatic tones of gray, ranging from black to white. Black-and-white photographs might be toned to take on a color, but would still be monochromatic—that is, they would still have gradations of only one color. The black-and-white effect is caused by tiny particles of metallic silver that are in a gelatin coating on the surface of white paper. Where there is a lot of silver particles, the image is gray to black; where there are no silver particles, the white of the paper shows through.

black light: The common name for a light source that is made up of only ultraviolet rays. Typically a black light is used as a special effect to illuminate fluorescent colors, causing them to glow in an otherwise dark environment. The light emitted from a black light appears to be dark blue-purple, and white objects appear to glow with this color.

Black Star: A photography agency founded in the mid-1930s in New York, specializing in **photojournalism**. Howard Chapnick was its president from 1964 to 1989.

Blanquart-Evrard, Louis-Desiré (1802–1872)
French photographer, printer, publisher, and inventor
A true Renaissance man in terms of photography, Blanquart-Evrard is responsible for two significant advances that together had an immeasurable impact on the medium. In 1850 he developed a new kind of sensitive photographic paper made with **albumen**. This paper immediately came into popular use and for several decades remained the standard paper for prints. Previously, the process of printing paper prints was too slow and too expensive to make it commercially cost effective.

The next year, 1851, Blanquart-Evrard established the Imprimerie Photographique in Lille, France, a printing house employing as many as 40 women to do assembly line printing on a scale never before seen. He then opened a similar plant in Paris and on the Isle of Jersey in the Channel Islands.

Blanquart-Evrard contributed several other improvements to the printing and developing process, such as introducing the process of developing silver chloride paper with gallic acid, resulting in the rapid printing that allows for large editions of silver prints. He also invented the amphitype process, and he was able to reduce exposure time from minutes to seconds, among other breakthroughs.

Not only did he create a rapid printing process, but he also fixed his prints in such a way that even today, more than a century after being created, they retain an amazing degree of clarity. Among his personal work were images of monuments and cityscapes, artistic studies of trees and animals, rustic genre scenes, and reproductions of famous artworks.

bleaching: As with the household chemical, bleaching causes a whitening or fading of a **black-and-white photograph**. Actually, what it does is remove tiny metallic silver particles that, when accumulated in a print or negative, appear black. Potassium ferricyanide is a commonly used bleach for black-and-white photographs and film. Bleaching can be done to the entire print or can be done on areas of the print to enhance brightness. It is used by mixing the dry potassium ferricyanide in water (it turns a deep yellow depending on the concentration) and then applying it to a wet print. The image will appear to fade a bit, depending on the dilution and length of time left in the solution. The print is then rinsed and put into fresh **fixer,** thus causing the full effect of the bleaching to appear. Experiments should be done with a test print to determine the best dilution and time in the bleaching bath. Many photographers have used and continue to use this process to lighten local areas of their prints. **W. Eugene Smith,** a renowned photojournalist, often used it to enhance areas of his photographs. Color photography also uses bleach to remove unwanted dyes in the color process.

Louis-Auguste Bisson and August Rosalie Bisson.
Ascending Mt. Blanc, ca. 1862. The New York Public Library.

bleed: The term used by photographers and graphic designers to indicate that an **image** runs to the edge of the paper. A bleed photograph has no white edges. Most commercial color prints are an example of bleed photographs.

blindstamp: A stamped, embossed, inkless identification mark. The stamp's raised letters, which usually spell out the photographer's name or studio, are regarded as a mark of authenticity. The stamp is often found on the mount to which a photograph has been attached. Less frequently, the mark appears on the photograph itself. Commonly used during the nineteenth century, blindstamps are sometimes employed in modern commercial portraiture.

blocked highlights: In a print that has blocked highlights, the highlights—that is, the areas of very light tone, such as light grays and whites—have little or no detail or **contrast**. This occurs when film is overexposed (receives too much light) or a print is underexposed (receives too little light).

blocked out: To block out is to prevent a part of a negative from printing onto the final picture by covering some of it. For example, if you take a picture of two people and then cover half of the negative with black paper so that only one person appears in the photograph, you have blocked out the person who was omitted.

Blom, Gertrude (1901–1994)
Swiss documentary photographer
A political refugee first from Mussolini's Italy, then from Nazi Germany, Blom left the turmoil of European conflict and emigrated to Mexico in 1940. There she worked as a documentary photographer among the Ladino and Mayan peoples of Chiapas, Mexico. Her photographs, taken over a period of more than 40 years, portray women's working conditions, daily life among the Lacandon Maya people, and the plight of the underprivileged.

In 1959 she settled in San Cristobal, making her home a center for scientific studies for the state of Chiapas. Although she never considered herself a photographer as much as a writer and anthropologist, her seminal work *Gertrude Blom: Bearing Witness* (1984) reveals her remarkable vision and sympathy for a vanishing culture.

Blossfeldt, Karl (1865–1932)
German Photographer
Blossfeldt achieved recognition for his microphotographs of plants, which were first seen by the public in his book *Urformen der Kunst (The Originary Forms of Art),* published in 1928.

His book contains 120 of the almost 6,000 microphotographs he had taken since 1890, when his teacher, Moritz Meurer, assigned him to make a collection of natural forms as an inspiration. He wished to show that although nature and art are profoundly different, all forms of art have their beginning in the forms of nature. In addition to his personal work as a photographer, Blossfeldt was an art professor in Berlin.

He always considered his work as a teaching tool, not as independent works of art. The beauty of the natural forms he photographed and the objectivity and lack of sentimentality in his work readily connect him to such New Objectivity photographers as August Sander and Albert Renger-Patzsch.

blow-up: An enlarged photograph.

blueprint: Commonly used for architectural drawings, a blueprint provides a blue image on a white background. It was invented by **Sir John Herschel** in 1842 and called **cyanotype**. It is also used to make blue-toned photographs.

Blumenfeld, Edwin (1897–1969)
German art and fashion photographer
Blumenfeld had two separate and distinct phases of his legendary career—as a Dada movement photographer who worked in Paris in the 1930s and as a fashion photographer for American magazines—with a harrowing experience as a concentration camp escapee marking the dividing line between the two.

Born in Berlin, he entered the working world at the tender age of 13, when his father died. Blumenfeld bounced around from Berlin's garment district to a stint as an ambulance driver, then moved to Amsterdam to

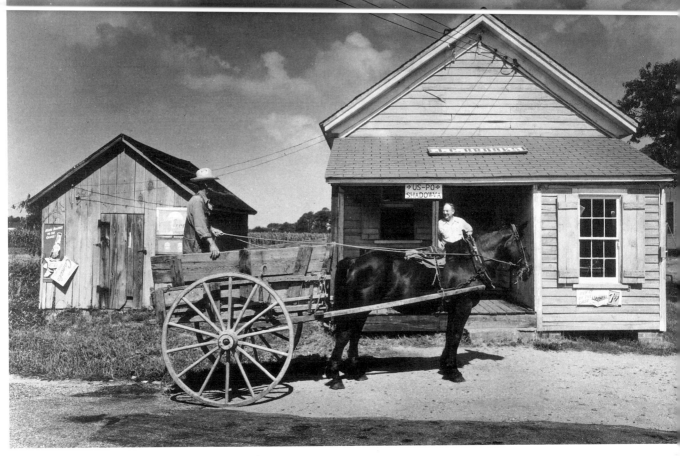

Aubrey A. Bodine. *Shadow, Va.* n.d. Courtesy Virginia Historical Society.

open a leather goods shop in 1922. For the next 13 years he ran his shop and started toying around with a camera, displaying his work on the wall among the handbags and belts of his store. When the leather store went bankrupt in 1936, he moved to Paris, where he began his career as a professional photographer. His portraits and female nude studies demonstrated the experimental techniques that marked contemporary avant-garde photography, such as multiple exposures, solarization, silhouetting, vignetting, abstraction, selective bleaching, and negative-positive combinations.

In 1938 he became a staff photographer for French *Vogue,* and his career was ready to head in a new direction. However, in Paris in 1940 he was imprisoned and sent to a concentration camp, accused of being an enemy alien and producing anti-Nazi propaganda; he miraculously escaped and emigrated to the United States, becoming a naturalized citizen. For the next 20 years he ran his own studio and became an extremely successful fashion and commercial photographer, producing more than 100

color covers for *Vogue, Harper's Bazaar, Look, Cosmopolitan,* and other magazines.

He spent his last years painting and writing, including completing his autobiography, in his native German. He died in Rome.

Bodine, Aubrey A. (1906–1970)

American photojournalist and art photographer

In his career as a photographer, Bodine was both a noted photojournalist, the longtime director of photography at the *Baltimore Sunday Sun,* and a photographic artist who favored active manipulation of negatives and prints to achieve romantic effects.

A Baltimore native, he began working for the *Sun* as messenger when he left school in the eighth grade. In the early 1920s he became a commercial photographer for that newspaper, and by 1927 he was a feature photographer.

His striking photos of life on the Chesapeake Bay and views of Virginia landscapes, historic sites, and

people at work firmly place him in the **Pictorialist** tradition. He used a variety of printing papers and nonsilver processes to achieve the softer image he sought. In 1968 Bodine gave a large body of his work to the Virginia Historical Society in Richmond and also provided captions for many of his images.

Boiffard, Jacques-André (1902–1961)
French surrealist photographer

Boiffard originally studied medicine, but the flourishing art scene in Paris in the 1920s proved to be more alluring than medical textbooks. Along with **André Breton** and other founding members of the **surrealist** movement, Boiffard contributed to the first issue of *La Révolution Surréaliste* with photos, accounts of dreams, and automatic writing. He joined the Communist Party and then became an apprentice to **Man Ray**. One of his fellow students was **Brassaï**; Boiffard, though, took an entirely different direction from either his teacher or classmate.

With another avant-garde photographer, Eli Lotar, Boiffard set up a studio financed by leading art patrons. Although it went bankrupt within three years, it did attract the attention of an American dealer, **Julian Levy**, who bought some of his photographs and included them in the landmark 1932 show "Surréalisme."

Along with others of his political bent, he traveled to Moscow and then around the world on the ship *Exir Dallen*. While photos from those adventures were widely exhibited and well received, in 1935 he abandoned photography to resume his medical studies. For 20 years starting in 1940, he was a radiologist at a Paris hospital. Concurrently, he did a limited number of art projects, including a collaboration with Jacques Prévert on a film and worked as a set photographer.

Bonfils, Felix (1831–1885)
French travel photographer

Bonfils's photographs of the Near East—its landscapes, cities, architecture, and people—are among the most telling and evocative images of that region ever produced. By sheer proliferation of images and albums directed to the mass market of tourists and scholars, Bonfils and his heirs and successors (specifically, his photographer wife, Marie Lydie Cabannis [1837–1918], son Paul Felix Adrien [1861–1929], and professional successor Abraham Guiragossian) were most responsible in influencing how the West saw the East.

Born in Alès, France, Felix Bonfils became a bookbinder by trade. In 1860 he joined an expedition to the Levant to end an outbreak of factional fighting. On his return he worked as a printer, producing **heliogravures** until 1867, when he decided to move with his family to Lebanon and make his living as a photographer. In Beirut he opened La Maison Bonfils, a photographic studio and publishing house that continued to operate well into the twentieth century. His firm published tens of thousands of prints and lantern slides of Near East culture. His masterwork is *Souvenirs d'Orient,* four folio volumes of which were published in 1877–1878.

Bonfils was also noted for his unusual technique; it included the mixed use of the Dallmeyer triplet lens, wet-**collodion glass plate** negatives, and albumen prints. He also published impressive volumes on Greece, Jerusalem, and Asia Minor.

Bonney, Therese (1894–1978)
American photographer and scholar

Bonney lived an extraordinary life with achievements ranging from helping to start UNICEF (the United Nations International Children's Fund) to establishing the first American illustrated press service in Europe. That she was a woman makes her story that much more remarkable.

Originally she wanted to become a professor, and toward that end she earned degrees from the University of California and Harvard and Columbia universities before traveling to France to attend the Sorbonne. But once in Paris at the end of World War I, she decided that she wanted to develop cultural relations between the United States and France. She began writing for magazines and then started a photo service. Disappointed in the images she was receiving, she started to take pictures herself.

She was interested in photographing people who

Pages 50 – 51: Felix Bonfils. Damascus Gate. n.d. Collection of Israel Museum.

did vital things, and she became friends with some of them. She wore a sweater Schiaparelli designed for her; Madeline Vionnet gave her a sheath woven with tiny flowers. She was immensely popular. "The people treated me like Pocahontas," Bonney said years later. "They trailed me around everywhere and called me '*La Belle et Grande Americaine*.'"

Her first major photo assignment was a behind-the-scenes series on the Vatican for *Life* magazine. In 1939, she was sent to cover the Olympics in Finland but encountered instead the outbreak of the Russo–Finnish War. Her images of children during wartime were rejected by ten publishers. She finally published *Europe's Children* herself in 1943, and the devastating pictures created a sensation. An exhibit of her photos traveled to schools throughout the United States and was the impetus for the creation of UNICEF.

After World War II, she lived in Paris until her death. Ever active, she earned a second doctorate on the aging process and lobbyed in Washington, D.C., on behalf of the elderly.

Borden, Janet (1941–)
American gallery dealer

Borden's New York gallery specializes in contemporary photographs, representing some of the major photographers of this era, including **Lee Friedlander**, **Jan Groover**, **Tina Barney**, **Sandy Skoglund**, and **John Pfahl**.

Born in Cincinnati, Ohio, Borden was graduated from Smith College and earned a master of fine arts degree in photographic museum practices from the Rochester Institute of Technology. After working at the **International Museum of Photography** at the **George Eastman House**, she moved to New York to run a new gallery, Robert Freidus, which went on to represent artists such as **Larry Clark** and Lee Friedlander. After being a private dealer for six years, she opened Janet Borden, Inc., in 1988.

Boubat, Edouard (1923–)
French photojournalist

Boubat is one of the most distinguished photographers in the post–World War II period. Praised for his remarkable reportage, he did not shoot wars and disasters but instead humankind as it exists in the "real" world.

A student of book printing, design, and typography, Boubat joined *Realities* magazine as a staff photographer in 1951; he remained there for 14 years, until 1965, traveling the world and earning a reputation as reporter without peer. His work there earned him the Kodak Prize, and he was the subject of two films. Since the mid-1960s he has been an independent photographer.

He is well known for two series of works, "The Old Breton and the Sea" about a French fisherman, and "The Indian Family," about a typical family in Bombay.

Boughton, Alice (1865–1943)
American commercial photographer

Although she was among the most active of her contemporary female photographers, such as **Alice Austen**, Boughton is not as well known today as her work justifies. In 1890 she opened her own portrait studio in New York, and her subjects were prominent literary and theatrical figures. Her studies of children, particularly her own two daughters, are also noteworthy, and she is remembered for her photographs of female nudes in allegorical or natural settings.

Born in Brooklyn, New York, she attended a private school there before going to Paris to study painting. She returned to New York the year she opened her studio, and it remained in operation for the next 40 years. She was prominently represented among the three dozen photographers included in the opening exhibition of **Alfred Stieglitz**'s Little Galleries of the Photo-Secession (commonly known as **291**).

In 1928 a collection of her portraits, "Photographing the Famous," was published. Her work is in the collections of major museums, including the Museum of Modern Art and the Metropolitan Museum of Art in New York.

bounce light: To use bounce light is to illuminate a subject indirectly by lighting a large reflective surface near it. The light is reflected onto the subject, giving it a soft-

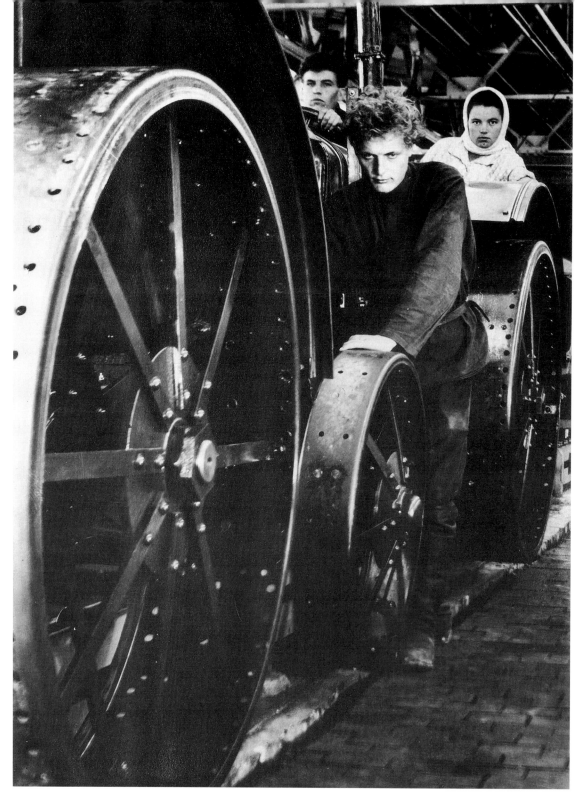

Margaret Bourke-White. *Tractorstroi* ("The New Tractor"), USSR. 1930. *Life* magazine; ©Margaret Bourke-White Estate.

er, smoother effect than that achieved by lighting the subject directly. This is generally a pleasant lighting technique used for **portraiture** and to minimize the harshness of shadows.

Bourke-White, Margaret (1904–1971)

Pioneering American female photojournalist

Margaret Bourke-White epitomized the dynamic spirit of her age and led a liberated life that was decades ahead of

its time. Undoubtedly America's most famous female photographer, she may be popularly remembered for her depiction by Candice Bergen in Richard Attenborough's 1982 Oscar-winning film *Gandhi*. However, her time in India was relatively brief and her other accomplishments far reaching.

A native New Yorker who studied at Columbia University and was graduated from Cornell University, Bourke-White obtained her first staff job at Henry Luce's new *Fortune* magazine in 1929. He discovered her running her own Cleveland, Ohio, studio, shooting industrial and architectural assignments. Four years later, she moved to Luce's new *Life* magazine as one of four original photographers. She shot *Life's* first cover, of Montana's Fort Peck dam, and remained a staffer and contributor there until 1969.

She was generally the "first woman photographer" at whatever it was she was covering, and she covered most of the important news events of the mid-century. As the first female photographer attached to the U.S. armed forces, she covered Buchenwald when General George S. Patton arrived to release the prisoners, India during Mahatma Gandhi's fight for independence, racial and labor unrest in South Africa, and the Korean War.

With the author Erskine Caldwell, to whom she was briefly married, she produced two important books, *You Have Seen Their Faces,* about the plight of tenant farmers and sharecroppers in the American South, and *Say, Is This the USA?,* on the industrialization of the nation. She also completed an autobiography and several other photo books.

Gandhi was not her only brush with the silver screen. On the way to a 1943 assignment, her transport ship was torpedoed and she spent a night in a lifeboat; this incident is believed to be the inspiration for Alfred Hitchcock's 1944 movie *Lifeboat,* starring Tallulah Bankhead as a mink-swathed journalist. In 1960, Eli Wallach and Teresa Wright starred in *The Margaret Bourke-White Story*. The production detailed her struggle with Parkinson's disease, which essentially ended her career in the late 1950s and was the cause of her death in 1971.

Bourne, Samuel (1834–1912)
English travel photographer
Bourne started his professional life as a bank clerk but gave it up for his passion, photography. In 1863 he journeyed to Simla, India, where he formed a partnership with Charles Shepherd, who ran that nation's leading photographic firm. Bourne led three expeditions to the Himalayas, which he wrote about and photographed extensively. The photos became celebrated examples of British expeditionary photography.

He made more than 1,500 images of the Far East. Chiefly a landscape photographer, he was noted for the clarity of his images and the full range of tones expressed in his **albumen** prints.

box camera: A simple camera shaped like a box. **Kodak**'s first camera for amateur use was a box camera, also called a Brownie camera. Box cameras have no adjustments for focusing and produce images of limited quality.

bracketing: The technique of exposing a series of frames of film at slightly under and slightly over the measured exposure, employed when one is not sure of the best exposure for a given lighting situation. Exposure—that is, how much light reaches the film—has a significant effect on the quality of the final photograph. By bracketing, or trying numerous exposures for each picture, the photographer hopes to achieve at least one good photograph. While this may sound unprofessional, sometimes a lighting situation is very complicated and bracketing can be a good, quick solution to a tricky problem. The technique is sometimes necessary in order to accommodate the many variations of light, subject reflection, and film responses that make predetermining an exact exposure difficult.

Brady, Mathew B. (1823–1896)
Famed American portrait and documentary photographer
Brady, also known as "Mr. Lincoln's cameraman" for his famous images of the Civil War, is the best-known American photographer of the nineteenth century.

Born in New York, he opened his first photo studio

on lower Broadway in 1844 after learning the tools of the trade from **Samuel F. B. Morse**. Brady immediately became the city's and then the nation's most famous photographer, albeit one of the few working as a portrait artist. The social, political, and intellectual elite flocked to have Brady immortalize them with the new technology, from senators Daniel Webster and Henry Clay to the writer Walt Whitman and the showman P. T. Barnum. His memorable shot of Abraham Lincoln, taken the day of Lincoln's famous Cooper Union speech, was widely circulated. That photograph helped to establish Lincoln as a man of character and greater poise than he had previously been given credit for, and it is generally thought to have helped him get elected president.

In 1850 he published *Gallery of Illustrious Americans,* a compilation of lithographs taken from **daguerreotype** portraits. It was at this time that Brady began using a technique that the twentieth-century artists **Andy Warhol** and Mark Kostabi would later refine, using assistants to do the work and then taking full credit and even signing the finished product.

When the Civil War started, Brady established the first news picture agency and asked for and received permission for himself and his assistants, including **Timothy O'Sullivan** and **Alexander Gardner**, to accompany soldiers onto the battlefield. He published all the images under his own name, angering many of his staff and leading them to resign when they realized they were to receive no credit for their work. These photographs, no matter who actually shot them, make up a stunning, broadly described visual history of the war, the first photographic portrait ever of battlefields, camp sites, military leaders, and the like. More than 7,000 negatives were produced by the team that at times numbered more than 20 men.

During the Civil War, Brady's eyesight began to fade and that, coupled with his practice of signing the work of others, has caused many historians to argue that Brady deserves prominence more as a photo historian, collector, and publisher than as an actual photographer.

While his contemporaries traveled west to docu-

ment the frontier, he remained in New York, supervising the shooting of portraits by his staff. He eventually sold his entire collection of war images to the U.S. government and in 1872 declared bankruptcy. He died in a government hospital, obscure and penniless.

Brandt, Bill (1904–1983)
English documentary and portrait photographer
During a long and full career, Brandt excelled at many levels of photography, producing incisive social documentation during the 1930s, photo reportage of London's blitz of World War II, a celebrity pantheon of international portraits, and artistic exploration of the nude.

Born in Hamburg, Germany, Brandt was fond of saying that he was born like his father in South London. His first experience with photography came in Paris, where he was introduced by family friend Ezra Pound to **Man Ray**. As Man Ray's assistant in 1929, Brandt became interested in surrealism and the work of **Eugène Atget**, **Edward Weston**, **Brassai**, and **Henri Cartier-Bresson**. In 1931, he returned to England, where he began documenting life and mores at a time when serious photographic reportage there was almost nonexistent. His two early seminal works were a result of these years: *The English at Home* and *A Night in London*. His work of that era has been described as dark, brooding evocations of an uneasily balanced, not quite real not quite surreal dream world.

He also was a frequent contributor to leading magazines of the day, including *Verve, Harper's Bazaar,* and *Picture Post*. His macabre portraits of Pound, Dylan Thomas, Graham Greene, and René Magritte are notable from that period.

After World War II, when he served as a photographer for the British Home Office, Brandt's eye shifted to nudes and landscape images. Those pictures are marked by stark black-and-white tones, with little middle range, and a wide-angle lens used in close-ups, causing the body parts to appear distorted.

Brandt was honored with a one-man show at London's National Portrait Gallery shortly before his death in 1983, and his work continues to be widely exhibited and published.

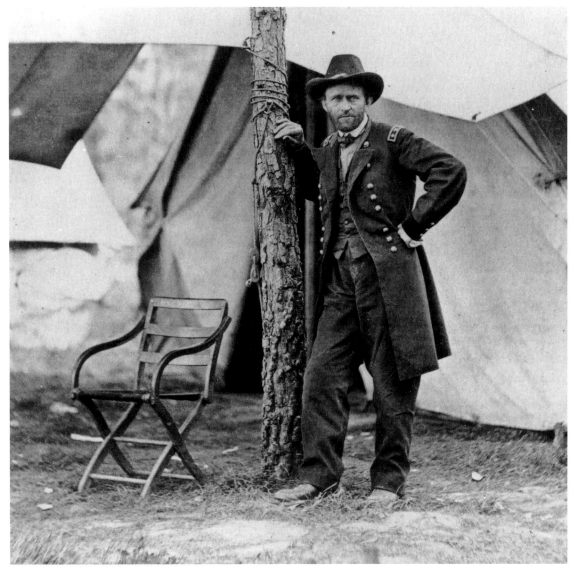

Mathew B. Brady. *Ulysses S. Grant.* 1864. National Portrait Gallery, Washington, D.C.

Brassai (b. Gyula Halasz) (1898–1984)

Renowned Hungarian documentary and portrait photographer
Brassai, who took his name from his native village of
Brasov (it literally translates to "of Brassov") in
Transylvania, was one of the most famous photogra-
phers of the twentieth century. He earned his
reputation with images of *demimonde* Paris of the 1930s
and portraits of French artists like Dali and Picasso.

After studying art in Budapest and Berlin, he
moved to Paris in 1924 and quickly fell into the art
scene, spending much of his time painting, sculpting,

and writing. In 1930, he was lent a small camera by
another Hungarian expatriate, **Andre Kertész**, and
was immediately enchanted by the medium's possibili-
ties. As **Diane Arbus** would do in America decades
later, Brassai spent the decade of the 1930s seeking out
and capturing the underbelly of Paris. The book *Paris at
Night* created a sensation when it was published; many
pictures from the series were deemed too risqué and
were not exhibited or published for decades, until the
1976 sequel, *The Secret Paris of the 1930s.* The first book
set him on a lucrative and prolific career, in particular

Brassaï. *Something to Look At*, 1935. Courtesy Madame Gilberte Brassaï.

earning him assignments from *Harper's Bazaar* from 1936 until 1965.

He shot Picasso in his studio during the war and afterward resumed his work in other arts, doing some sculpture and set design. In 1949 he published a surrealist poem, "Historie de Marie," with a preface by Henry Miller. Miller later described his friend as "the eye of Paris."

In 1956 he won a prize at Cannes for his film *Tant qu'il y aura des bêtes.* He also made a series of abstract images of graffiti etched in stone walls. In the 1950s, Brassai had a series of reputation-enhancing shows in the United States, culminating in a big 1957 show of the graffiti shots (the show marked his first visit to the States) and a 1968 retrospective, both at the Museum of Modern Art in New York. Since then, he has been exhibited more 200 times and has published numerous books.

Bravo, Manuel Alvarez (1902–)

Mexican documentary photographer

As **Eugène Atget**'s work celebrates Paris and **Ansel Adams**'s glorifies the American West, Bravo's speaks with warmth and compassionate understanding of his native Mexico. His photographs of homely activities, landscapes, unusual signs and shop fronts, walls and windows, and symbolic or metaphoric subjects show a remarkable range of images, all photographed in black-and-white.

Born in Mexico City, he felt at ease in the world of art; both his grandfather and father were painters and photographers. Self-taught, he studied briefly with the German photographer Hugo Brehme in 1923 and began taking his own images the next year.

At the suggestion of a friend, the photographer **Tina Modotti,** Bravo sent a portfolio of his work to

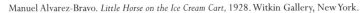

Manuel Alvarez-Bravo. *Little Horse on the Ice Cream Cart,* 1928. Witkin Gallery, New York.

Edward Weston, who encouraged him in seeking a career in photography. He worked for *Mexican Folkways* magazine, and, on assignment to photograph the country's artworks, he met many of Mexico's best known artists, including Diego Rivera, David Siqueiros, and Jose Orozco. Bravo worked as a cameraman for Sergei Eisenstein's *Que Viva Mexico* (1930–1931) and continued to exhibit as well as teach photography. A longtime member of the Mexican Film Workers Guild and founder of the Fondo Editorial de la Plasticas Mexicana, he is a **Guggenheim fellowship** winner (1975), and more than a dozen books of his work have been published.

Breitenbach, Josef (1900–1984)
German art photographer

Breitenbach's body of work, ranging from portraiture to surrealist images to erotic nudes, reflects the changing conditions and cataclysmic events that marked Europe in the twentieth century. Born in Munich, Germany, he began his career in the 1920s with tranquil scenes of pastoral landscapes. In the early 1930s he turned to portraiture, immortalizing what became a lost generation of theatrical and literary figures, many of whom would die in Nazi purges. In 1933, himself under investigation by the Nazi regime, he left for Paris. Breitenbach had visited Paris in the late twenties, where he undoubtedly was influenced by the surrealist movement and **Man Ray**.

He remained in France until war broke out, when he emigrated to New York. His reputation already established in Europe, he had little trouble getting work, and he completed assignments for *Fortune* and other magazines. There he did what he considered his best work, exploring the sensuality of the human form with nudes photographed in nudist camps in New Jersey. Breitenbach was also an inspiring teacher and worked in New York at Cooper Union and The New School until well past the usual retirement age.

Breton, André (1896–1966)
French artist, writer, and photo collagist

André Breton, a founder of the **surrealist** movement,

was a major influence on the art and literature of the twentieth century.

In his youth he decided to become a doctor. Working in a hospital during World War I, he met the anarchist Jacques Vache, who encouraged him to follow his literary and artistic dreams. After the war he worked in a mental hospital in Paris, where he became acquainted with the writings of Sigmund Freud on the power of the unconscious. At this time he met Louis Aragon, who would achieve fame as a surrealist poet, and began writing automatic poetry. In the 1920s Breton wrote the first surrealist manifesto, citing the work of such major artists as Picasso, Marcel Duchamp, and Giorgio de Chirico.

His first brush with photography came in 1922 at a Max Ernst exhibition, in which he discerned a connection between photography and the phenomenon of automation, in which he was so deeply interested. Many of his subsequent publications and projects were illustrated with photos. Breton said photography had a "valeur emotive," which made it "one of the most precious objects of exchange."

Years before his time, Breton would argue that photography was not a means for obtaining a faithful likeness of a fleeting moment but that it was subject to manipulation. Knowing nothing of the computer-enhanced and computer-generated images of the end of his century, he argued that the elements of a photograph could be combined to express a new reality.

Between the wars he became an emissary for surrealism, traveling, lecturing, and writing. One significant trip, to Mexico, took him to see the muralist Diego Rivera and his wife, the painter Frieda Kahlo, and Leon Trotsky. During World War II he served as a doctor in France until the French armistice with Germany, when he emigrated to America. Through the 1950s and 1960s he continued to promote the surrealist movement with gallery shows, organizing events and publishing magazine articles.

brightness range: The range between the lightest and darkest areas of a photograph or a scene to be photographed.

Horace Bristol. *Central Valley Boxcar Encampment,* 1938. Courtesy Stephen Cohen Gallery, Los Angeles.

Brigman, Annie (1868–1950)

American photographer and poet

A pictorial photographer, Brigman produced work that is noted for its poetic quality and her use of historical themes to suggest the harmony of the human figure in nature. She often used herself or her sister as a model, favoring nude poses against a landscape setting.

Born in Hawaii, where her missionary mother's parents were sent in 1828, Anne Wardrope Notte returned with her family to California in 1886. She married a sea captain, Martin Brigman, around 1894, and they lived in Oakland.

The first exhibit of her work was in San Francisco in 1902. The following year a print of hers was shown in the Third San Francisco Salon, where she would meet **Alfred Stieglitz** and **Edward Steichen**, who both actively promoted her work. She was included in the opening show at Stieglitz's famous **291** gallery. Much of her work was produced during her camping trips in the Sierra Nevadas, which she took every summer from 1904 to 1927.

In the 1930s her failing eyesight led to her abandoning photography, and she devoted her time to writing poetry. A volume of her poems, illustrated with her photographs, called *Song of a Pagan* was published in 1946.

Bristol, Horace (1909–1997)

American photojournalist

One of the original *Life* magazine staff photographers, joining the staff in October 1937, Bristol is best remembered for the photographs that inspired John Steinbeck's Pulitzer Prize-winning novel *The*

Grapes of Wrath and his inspiring coverage of the U.S. Navy during World War II.

Born into a publishing family in Whittier, California, he studied architecture at Stanford, married, and moved to Europe to continue his studies. In Munich, he bought a Leica and worked as a photojournalist for the rest of his years.

Returning to California, he bought a small weekly newspaper, sold it, and moved to San Francisco, setting up a portrait studio around the corner from **Ansel Adams**, with whom he became friendly. Independently, he started photographing migrant farm workers; then, after being hired by *Life,* he proposed a series on the workers for the magazine. He suggested a little-known young writer named John Steinbeck to do the text. After the success of *The Grapes of Wrath,* the pair were preparing to embark on another project, but Pearl Harbor and World War II interceded.

After the war, he moved with his family to Australia and then Japan, where he photographed the reconstruction of the war-ravaged island nation. After his wife, Virginia, committed suicide in 1956, he quit photography and burned much of his life's work.

He later married a Japanese woman and gradually began to rebuild his life, moving to Ojai, California, in 1976. One day his son Henri returned home from school with an assignment relating to *The Grapes of Wrath.* Touched that his work of decades earlier was still resonant, he embarked on a variety of photo projects, including the compiling of his work on CD-ROMs. In his eighties, he contracted with the digital photo agency **Corbis** to market his images on the **internet**.

In 1997 a retrospective of his work and accompanying book, entitled *Horace Bristol: An American View,* paid tribute to Bristol's work.

broad lighting: An even or overall illumination. In **portraiture,** the use of broad lighting means to light the side of the face that is most visible.

broadside: A page in a publication that is designed to be read sideways to accommodate graphs or charts that need a wide page. Also, a large sheet of paper that is wider than tall and is printed on one side and folded to be mailed or distributed door-to-door.

Brodovitch, Alexey (1898–1971)
American graphic designer, teacher, and art director

Brodovitch is remembered as one of the most influential photography and design teachers of the twentieth century. Among his students, predominantly at The New School in New York City, were such important photographers as **Diane Arbus**, **Irving Penn**, **Robert Frank**, **Richard Avedon**, and **Lisette Model**. Those with whom he collaborated on book and other projects included **Andre Kertész**, **Henri Cartier-Bresson**, **Brassai**, **Man Ray**, and **Bruce Davidson**.

Born in Russia, Brodovitch served in the White Russian army as a cavalry officer before emigrating to France after the Russian revolution. He and his wife, Nina, lived in Paris from 1920 to 1930, where he embarked on a career as a designer and widened his circle of friends to include avant garde figures like the artist Fernand Leger, the architect Le Corbusier, and the ballet master Nijinsky.

Brodovitch's first public recognition came in 1924, when he won a poster design contest. In 1930 he was invited to the United States to establish a new Design Laboratory department at the Philadelphia Museum of Art. Four years later, he left to become art director at *Harper's* Bazaar, where he would stay for 24 years, developing the magazine into a premiere fashion publication. In 1941, he moved his now legendary Design Laboratory classes to The New School; he continued to teach in some capacity for much of the rest of his life. His classes were known as informal, peripatetic workshops, featuring combative critiques of student work and tangential lessons on design, layout, and illustration and the interconnection between those visual arts and photography.

In 1945 he produced a book, *Ballet*, of his own photographs of the Ballet Russe. In 1949, he and Frank Zachary collaborated on three issues of the now legendary graphic arts magazine Portfolio. For the next several years he was busy teaching, freelancing, having exhibitions, working as a critic, and winning awards.

But a series of tragic mishaps occurred after 1956, when his country home in Pennsylvania burned, destroying much of his collection of work. In 1958, he was forced out of *Harper's,* and the next year his wife died. Then, he was victimized by another fire at his home in the Hamptons. His misfortunes culminated in a hospital stay for treatment of alcoholism and depression.

In 1964, Brodovtich resumed teaching at Avedon's studio, and he rebounded to finish his life in happier circumstances, before his death in France in 1971.

bromide paper: Black-and-white photographic paper used for making **enlargements**. Most black-and-white photography paper is this type because of the use of silver bromide, making the paper sensitive enough to be used for photographic enlargements.

Brooks, Milton E. (1901–1956)
American photojournalist
The 1942 **Pulitzer Prize** winner for spot news for a shot of a confrontation between striking United Auto

Milton Brooks. *Ford Motor Company Strikers Being Beaten with Clubs by Company Goons.*
The first Pulitzer Prize-winning photograph. 1942.
© *The Detroit News.*

Workers and the Ford Motor Company, Brooks had a 30-year career as a newspaper photographer before moving to commercial work.

He began his career as a photojournalist with the *Chicago Daily News,* and then moved to New York, where he worked for that city's *Daily News.* He spent the bulk of his career, 1928 to 1953, at the *Detroit News,* where he won several local and national awards.

Brownie camera. An inexpensive camera introduced by the **Kodak** company in 1900. With simple, box-like construction, it was designed to appeal to young children to introduce them to photography. The Brownie remained in production into the 1960s.

Kodak Brownie camera, model Six-20, first made in 1941. © Fred W. McDarrah

Bruehl, Anton (1900–1982)
American fashion photographer
In the 1930s and 1940s Bruehl was considered one of the world's foremost advertising and fashion photographers, with his work on the cover of *Vogue* and other major magazines.

Born in Australia, he became a serious amateur photographer, skilled in the darkroom, but he did not consider becoming a professional until he moved to the United States in 1919.

In 1923 Bruehl saw an exhibition of photographs by students of **Clarence White**, who was a member of **Alfred Stieglitz**'s **Photo-Secession**. Bruehl took classes at White's school and so impressed his teacher that White asked Bruehl to join his faculty. After White's sudden death in 1925, Bruehl decided to pursue a career as a photographer.

Along with other leading advertising photographers who had been students of White, **Paul Outerbridge** among them, Bruehl became an instant success, obtaining work even through the Depression. His work for Condé Nast magazines, with both advertising and editorial layouts, cemented his place in the pantheon of the era.

Several of his pictures were included in the landmark **Beaumont Newhall** Museum of Modern Art show "Photography 1839–1937." His book of Mexican photographs was one of his most significant achievements.

At the height of his success he retired with his wife to Connecticut to concentrate on his sailing. He invented and patented the Bruehl protractor, a navigational instrument. Later he moved to Florida and produced a book called *Tropic Patterns,* close-ups of plant life.

Bruguière, Francis (1879–1945)
American abstract photographer
Bruguière was one of the first photographers to explore extensively abstract photo imagery.

Influenced by **Stieglitz** and an early member of **Photo-Secession**, Bruguière produced what he called "light abstractions" in the 1920s, purely abstract images created by lighting cut paper. He also made *Light Rhythms,* Britain's first abstract film, in 1931. He also experimented with camera movement, multiple exposures, the Sabatier effect, bas relief, and solarization. The abstract

Anton Bruehl. *Chemical Tank,* 1927. © Estate of Anton Bruehl. Courtesy Howard Greenberg Gallery, New York

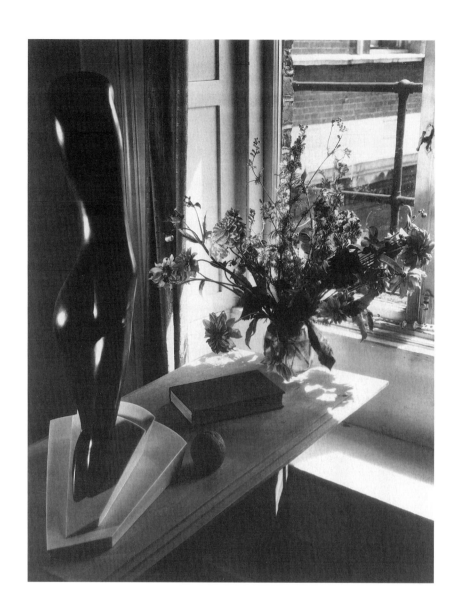

Frances Bruguière. *Still Life, Bruguière's Apartment in London,* ca. 1936–40. Collection of the authors.

and surreal qualities of his images have been traced to his interest in the psychology of C. G. Jung and its emphasis on humans' inner experience.

Bubley, Esther (1921–1998)

American photojournalist

Bubley started her career as a freelancer shooting still-lifes for *Vogue* in 1940, but she turned away from the fashion field and found her true métier as a documentary photographer. Her thoughtful, realistic portrayal

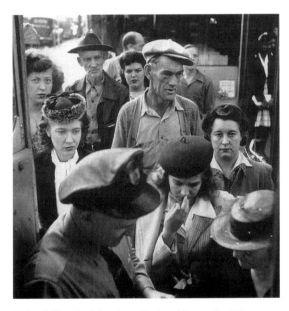

Esther Bubley. *People Boarding a Greyhound Bus at a Small Town between Chicago, Illinois, and Cincinnati, Ohio,* September 1943. Library of Congress.

of post–World War II Americans often included images of sadness, loneliness, and mystery that foreshadow the raw images of **Robert Frank** in his 1950s book *The Americans.*

Bubley studied photography and painting at the Minneapolis School of Art. After working in New York for two years as a freelancer, she moved to Washington, where she was a microfilmer of rare books at the **National Archives.** The following year she transferred to the Office of War Information, working as a darkroom technician under **Roy Stryker.** On her own she took pictures of Washington, and Stryker, having seen her work, assigned her the project of photographing the

transportation services available to servicemen and their families during World War II. Committed to taking straight, unmanipulated photos, she wanted to record compassionately objective social truth.

With Stryker as her mentor, she was able to get work from various companies and magazines. She later worked for Stryker at Standard Oil, where she did a bus series after the war, and was included by **Steichen** in his landmark "In and Out of Focus" at the Museum of Modern Art in 1948. In 1952 she was included in a group show at the Museum of Modern Art called "Diogenes with a Camera"—other photographers in the show were **Harry Callahan**, **Edward Weston** and **W. Eugene Smith**. Her work was also exhibited in the 1955 **"Family of Man"** exhibit at the museum.

She was a regular contributor to the *Ladies' Home Journal* for 12 years starting in 1948 and also was a regular in the pages of *Life* from 1951 to 1965, and her work has also appeared in *McCall's, Woman's Day, Harper's Bazaar, US Camera,* and other publications. A book of her work was in preparation at the time of her death.

Buckland, Gail Susan (1948–)

American photographic historian, academic

In her career as a photohistorian, Buckland has taught, worked as an editor, been an archivist, and curator at the **Royal Photographic Society** of Great Britain, reviewed exhibitions for the BBC, and authored several books.

Buckland studied at the University of Rochester, New York; Columbia University; and in England at Manchester University and the London College of Printing. She has taught at Pratt, Cooper Union, Columbia, and the Chicago Art Institute. Her early career was spent in London, where she organized the noted 1971 Victoria and Albert museum exhibit "From Today Painting Is Dead: The Beginnings of Photography."

Buechel, Eugene S. J. (1874–1954)

German priest, teacher, and photographer

A Jesuit priest working with the Lakota Sioux in South Dakota, Buechel took more than 12,000 photographs of reservation life, preserving for posterity images of a

culture in transition. But Buechel's career was not centered on photography.

Born in Germany, he entered the Society of Jesus in Holland in 1897 and then emigrated to the United States in 1900 to finish his Jesuit training. His first photos were believed to have been taken with an 8 x 10 view camera after he was assigned to teach at the St. Francis Mission on the Rosebud Reservation in South Dakota between 1902 and 1905.

He was a superior with the Holy Rosary Mission on the Pine Ridge Reservation from 1906 to 1916, then returned to Rosebud until 1923. The first entry in his photo diary is dated August 14, 1922; the last in his series, number 2128, is dated October 13, 1945. Many of his photos were presented as gifts to the subjects or benefactors interested in the work of the Mission.

His passion, though, lay in teaching. He studied the Lakota Sioux language, which he spoke fluently. His 30,000 vocabulary cards were the first written documents of the language. Buechel opened his own museum for his Indian artifacts and photos, prints, and diaries on his fiftieth anniversary as a Jesuit.

Seventeen years after his death, a trove of his negatives of images portraying Native American life were found stored in the museum. Prints from the Buechel Memorial Lakota Museum have since been widely lent to galleries in the United States and exhibited at the Museum of Modern Art in New York.

Bullock, Wynn (1902–1975)

American photographer, teacher, and inventor

Bullock had a successful career as a concert tenor before taking up photography in his thirties. His work has exerted tremendous influence on the craft, both in terms of artistic and technical skills.

While a student at Columbia University, Bullock performed in Irving Berlin's *Music Box Revue*. After it closed in 1924, he spent three years in Europe studying voice, music, and language. While abroad he became interested in Post impressionist art and as an amateur took up photography. Although he enrolled in 1933 in a pre-law program at West Virginia University and then at the University of Southern California Law School in

1938, his passion for photography convinced him to change professions. He left law school and enrolled at the Art Center in Los Angeles to study photography.

He had his first one-man show at the Los Angeles County Museum in 1941, earning great critical acclaim. During World War II he ran photo concessions for the military at Fort Ord and Camp Cooke, both in California. He began expanding his own philosophy as a photographer at the time he headed the Photo Department at San Francisco State College, from 1945 to 1958. He later taught or lectured at scores of institutions.

Bullock produced seascapes, landscapes, and nudes, subjects that evoked for him symbolic meaning of a personal nature. Technically, his work was masterful. Between 1946 and 1948 he received patents for his "Photographic Process for Producing Line Image," a method of controlling the line effect of solarization. He also obtained a patent for "Methods and Means for Matching Opposing Densities in Film."

His photographs were central images in **Steichen**'s exhibition and book *The Family of Man*. Critics and historians say Bullock's work is successful because it deals not with surface appearances but with multiple levels of meaning.

Bunker, Earle L. (Buddy) (1912–1975)

American photojournalist

A lifelong Omahan, Bunker won the 1944 **Pulitzer Prize** for Peacetime Photojournalism for "The Homecoming." The widely reproduced image, a wartime classic, showed a World War II veteran embracing his young daughter while his wife stood nearby, face in her hands.

He joined the *Omaha Bee-News* at 17 and stayed for eight years; he was a staffer at the *World-Herald* of Omaha from 1936 to his death, a span of 39 years.

Bunnell, Peter C. (1937–)

American scholar, curator, and museum director

Bunnell is an important figure in contemporary photography and the author of many books and articles, particularly on the life and work of **Minor White**, **Clarence White**, **Eugene Smith**, **Paul**

Strand, **Edward Weston**, and **Alfred Stieglitz**.

McAlpin Professor of the History of Photography and Art at Princeton University since 1972, Bunnell has been a Guggenheim Award winner and a director of the U.S. exhibition at the Venice Biennale.

After earning degrees from the Rochester Institute of Technology, Ohio University, and Yale University, he became a research associate at Yale's Stieglitz Archive. From there, he worked at the **George Eastman House** as a staff assistant before leaving to work at the Museum of Modern Art in New York as the photography curator before taking the post at Princeton.

Burckhardt, Rudy (1914–)

Swiss-born, American photographer, filmmaker, and artist

Born in Basel, Switzerland, to an aristocratic family of intellectual distinction—his grandfather was the noted Italian Renaissance historian Jakob Burckhardt—Rudy Burckhardt came to New York at age 21 at the urging of the poet and dance critic Edwin Denby. Over the ensuing decades he achieved recognition as a friend and documentor—via photos, painting, and film—of the artistic milieu of the New York School since the 1930s.

He focused on three main themes in his photography. The first were his own friends at work: friends like Willem de Kooning, Mark Rothko, and Jackson Pollock. Second were travel shots taken at his Maine vacation home as well as at international locales (Haiti, Naples, Greece), and finally classic New York street and architectural scenes of years gone by.

Burgett, Alfred (1887–1956)
Burgett, Jean (1882–1968)

American commercial photographers

Pioneer commercial photographers, Alfred and Jean Burgett of Tampa, Florida, belonged to a family of photographers living in the area. Their father, Samuel P. Burgett, was an itinerant photographer who moved to Florida with his wife and four sons in the mid-1880s; his photo studio was in operation at the same time that his sons started their own photo businesses.

The Burgett Brothers studio, owned by Alfred and Jean, operated in conjunction with a photo-supply shop, did portraits, and covered weddings, banquets, and events of local interest. In addition, the brothers did custom work for local businesses and retailers and supplied pictures for newspapers and other periodicals.

In their work, the Burgerts chronicled the development of the Tampa Bay area over the first half of the twentieth century and left a collection of more than 70,000 negatives, now owned by the Tampa-Hillsborough Public Library. These nostalgic images, taken by the brothers and people who worked for them, make up a rich reservoir of life in the South, recording industry, recreation, race relations, and popular culture.

Burke, John (dates unknown)

British travel photographer

Burke was a professional photographer in the Punjab in India. He was employed by the Indian government as a civilian to take pictures of the campaign in Afghanistan in 1878–1879.

From the late 1860s to 1907 Burke specialized in photographs of military groups and military operations. He provided a view of army life as well as glimpses of hostile tribal enclaves along the frontier and portraits of native and English chiefs. He made a record of the archaeological sites of Kashmir for the Superintendent of the Archeological Survey, North-Western Provinces, that was later published in Cole's *Illustrations of Ancient Buildings in Kashmir*.

Because of the slowness of the photographic process, Burke was not able to photograph actual battles. On December 23, 1879, he photographed the beginning of one of the fiercest battles of the Second Afghan War, in which the British lost 11 men, against Afghan losses of more than 3,000.

Burnett, David (1946–)

American photojournalist

Burnett started his career as a Salt Lake City high school student, freelancing for local papers. Today he is one of the country's preeminent photojournalists.

A summer internship at *Time* while earning a degree in political science at Colorado College led to a job in the magazine's Caribbean bureau in 1968. From

John Burke. *The Northwest Corner of the British Redoubt at Sherpur*. December 20, 1879. Courtesy the National Army Museum, London.

1970 to 1972 he was a contract photographer for *Life* magazine, covering the Vietnam war. When *Life* closed, he joined the **Gamma** Agency in 1973 before leaving to cofound **Contact Press Images** with editor Robert Pledge.

Burnett's coverage of the aftermath of the 1973 coup d'état in Chile earned him his first award, the Overseas Press Club **Robert Capa** Gold Medal. He won the World Press Photo Premier Award for his documentation of Cambodian refugees in 1979. His memorable shot of Mary Decker's anguished fall during the 1984 Los Angeles Summer Olympics was widely published.

Burnett has worked in more than 60 countries, publishing photo essays on subjects including the American and French presidential campaigns from

1974 to 1996, the sub-Saharan and Ethiopian droughts from 1974 to 1984, the Iranian revolution, the New York Stock Exchange, and a pre-Olympic essay prior to the 1996 games that resulted in an exhibit and book entitled *Emotion: Grace and Poetry; The Spirit of the Sport*.

Burnett has also worked as special photographer on the movie sets of *The Outsiders, Scent of a Woman,* and *In the Name of the Father*. His work is regularly published in leading periodicals in the United States and abroad, including *Time, Life, The New York Times Magazine,* and *Paris Match*.

burning in: A term used in making photographic prints to indicate covering all but a small area of the photographic paper during part of the exposure. This allows the printer to give extra exposure to part of the picture,

making it darker. For example, if a picture looks good except for a small area that is too light, the printer can burn in that area to make it darker.

Burri, Rene (1933–)

Swiss photojournalist and filmmaker

Burri, a member of **Magnum Photos** agency and creator of Magnum Films in 1965, has also achieved prominence as a filmmaker, starting his career as a teenager working for the Walt Disney Company.

Based in Paris, Burri has covered Castro's Cuba, Nasser's Egypt, Japan, Thailand, and Argentina for *Life, Look,* the *London Sunday Times, Stern,* and other major periodicals. His film *What's It All About?* won the 1967 New York Film and TV Festival Award, and he has produced films for the BBC.

In 1982 Burri was elected president of Magnum Europe and inaugurated the Galerie Magnum in Paris with the exhibition "Terre de Guerre." In 1984 he was honored at the Palais de Tokyo in Paris with a major retrospective.

Burrows, Larry (1926–1971)

British photojournalist

One of four photographers killed when a Vietnamese helicopter crashed in Laos, Burrows was eulogized by *Life* managing editor Ralph Graves as "the single bravest and most dedicated war photographer I know of."

Burrows's career began at *Life,* where at the age of 16 he worked in the photo laboratory. Soon he was taking photographs for *Life's* London bureau.

His first war coverage came in 1956, during the British invasion of Egypt. He never liked being called a war photographer, but he did his job expertly and won three **Robert Capa** Awards from the Overseas Press Club for Still Photography Requiring Exceptional Courage. He was also named the 1967 Magazine Photographer of the Year. Although he is best known for his coverage of military activity, Burrows covered other areas as well and did features on Ernest Hemingway and bullfighting, Winston Churchill, and Billy Graham's crusades.

In February 1971 he had been photographing in Calcutta when he heard that South Vietnam was poised to invade Laos. Already, he had produced for *Life* some stunning war images, including some of the first color spreads of war to appear in an American magazine. On February 9, he and three other photographers, Henri Huet of the **Associated Press**, Kent Potter of United Press International, and Keisaburo Shimamoto, a freelancer, hired a helicopter to take them to the action. On the way to the airstrip, Burrows stopped to rescue a Vietnamese soldier caught in a flaming personnel carrier. The weather was bad so they delayed their flight for a day. The next morning, airborne, the pilot got lost and headed over enemy lines where their craft was shot down.

Burson, Nancy (1948–)

American photographer and artist

Burson's specialty has been using the computer as an art medium. In her work she has been able to devise a process that uses computer-generated art to show how a person's face would change over time. Working with scientists from the Massachusetts Institute of Technology, she was granted a patent for the process in 1981. It's now a valuable law-enforcement tool for tracing missing persons. Burson originally studied painting, and her artwork has been exhibited in major U.S. museums.

Byron Collection: Now held by the Museum of the City of New York, the Byron Collection of more than 15,000 prints constitutes a rich documentation on the city between 1890 and 1910, covering street scenes, interiors, hospitals, schools, ships, sports, business firms, social events, and theater. Joseph Byron opened his New York photography studio in 1888. At the age of 14 his son Percy sold his first photograph—of the dedication of the temporary Grant's Tomb in 1893. A lavish selection of pictures of that period was included by Grace M. Mayer in her *Once Upon a City*, published by Macmillan in 1958.

The Opening of Siegel-Cooper Company, 1896 (Sixth Avenue, 18th-19th Streets, Looking south from 19th Street).
The Byron Collection, Museum of the City of New York.

cabinet photograph: A photograph (almost always a **portrait**) that was mounted on a board and measured 4½" x 6 ½". This was a highly popular form of commercial portraiture that was introduced in 1866 to replace the diminished interest in the *carte de visite* (a smaller-sized, mounted photograph) and continued until around 1890. Cabinet photographs were quite inexpensive and given as gifts and mementos, and albums were made to preserve them. Cabinet photographs (like *cartes de visite*) were also made of famous personalities, being an early form of celebrity trading cards. Usually the cardboard mount is inscribed with the photo studio's name.

cable release: A flexible cable that is attached to a studio camera to release the **shutter** without the photographer's having to touch the camera directly. A cable release is used to prevent vibration from blurring a picture during a long exposure.

Caccamise-Ash, Carla (1951–)

American curator

For more than 20 years, Caccamise-Ash has been curator of the Joseph E. Seagram and Sons art collections, in which she has amassed the work of more than 200 photographers.

Educated at Smith College, the University of Rochester, and New York University with advanced degrees from Rochester and NYU in art history, she has organized more than 50 exhibitions. Also, since Seagram took over Universal Studios in 1996, she has worked to gather and preserve the visual history of the studio. Caccamise-Ash is a founding member and longtime president of the National Association for Corporate Art Management.

Callahan, Harry (1912–)

Celebrated American art photographer

Callahan is one of America's best-known photographers. An artist of international reputation, he has had his work extensively exhibited, including a one-man retrospective at the Museum of Modern Art, and since 1961 has been in charge of the photography department at the prestigious Rhode Island School of Design.

Born in Detroit, Callahan bought his first camera, a Rolleicord 120, in 1938, to use as a hobby. At the time an accountant for Chrysler, he attended a lecture by **Ansel Adams**, where he says he first "felt free to go ahead and photograph what I wanted in the way I wanted." He shortly left the auto company and became a full-time photographer. In 1948 he met **Edward Steichen**, who took a liking to his work and exhibited it more than a dozen times.

His work has been described as "deeply personal expression": gentle nudes of his wife, Eleanor; high-contrast studies of weeds on glass; urban studies of people rushing about the dark canyon bottoms of Chicago city streets. Most of his work has been in black and white, although he started experimenting in color as early as 1948. Callahan has won a **Guggenheim fellowship,** a **National Endowment for the Arts** grant, and numerous other grants and awards. In 1996 he had a retrospective at The National Gallery of Art.

calotype: The first practical negative-positive process of photography. Capable of producing multiple copies of any given image, the calotype (also called Talbotype) was invented by **William Henry Fox Talbot** in England in 1840. An earlier Talbot invention, photogenic drawing, was also capable of creating photographic images in the camera, but it was quite slow and could not be used for photographing people or anything that moved. The process involved using a light-sensitive piece of paper that when exposed to light in a camera and developed

Pges 72 – 73: Harry Callahan. *Chicago.* 1960. © Harry Callahan. Courtesy PaceWildensteinMacGill.

became a negative. The paper negative was placed against another sensitized piece of paper and exposed to light, producing a positive image. This process vied for acceptance and commercial popularity with the **daguerreotype**; the daguerreotype won because the images it produced were sharper, clearer, and more realistic. But because of the ability of the calotype to make infinite positives from a single negative (unlike the daguerreotype, which is a one-of-a-kind original), the calotype process eventually was perfected and is the basis of what we use today—a photographic negative that can make an infinite number of photographic positives. Among the photographers who adopted the calotype process for use in the field, to photograph in foreign lands sights never before reproduced, were **Maxime DuCamp,** who produced memorable views of Egypt, and **Gustave Le Gray,** who photographed in France and Sicily.

camera: A light-proof container fitted with a **lens** that permits **light** to enter only through an **aperture** or opening regulated by a **shutter**. A photographic **image** is recorded when light **focus**ed by the lens enters through the aperture and projects an image onto the light-sensitive material, or **film,** in the compartment. Cameras come in a great variety of sizes, types, and styles for a large number of uses, both professional and amateur.

camera club: A group of people who get together to share their interest in photography. In the early years of photography, the practitioners of the medium were mainly scientists, inventors, and people of means who could afford the expense of a darkroom, chemicals, and equipment. As technological advances simplified the processes of photography and manufacturers began to mass produce the equipment, photography became more affordable as a hobby and means of creative expression. In the mid-1880s, camera clubs evolved to serve the community of interested participants by providing information about advancements in the medium. Today many clubs sponsor exhibitions by their members, provide classes for mastering new skills and equipment, and offer **darkroom** facilities. High schools and colleges often sponsor camera clubs for their students who are interested in photography. One of the oldest clubs in the United States is the Camera Club of New York, founded in the late 1800s and still in operation today.

cameraless photography: The making of **photogram**s, or images, by placing an object on light-sensitive paper, exposing it to light, and then developing and fixing the image. **William Henry Fox Talbot** called his experiments with this process "photogenic drawing," **Man Ray** used the term "rayogram," and **Laszlo Moholy-Nagy** termed the process "photogram," which has become the generally accepted designation.

camera obscura: *Camera obscura*, from the Latin, literally means "dark room." The original concept dates back to ancient Greece, when a camera obscura was actually a dark room, large enough for people to enter. There was a small hole in one wall, and the opposite wall was painted white. The small hole acted as a crude **lens,** projecting an inverted image of the scene outside onto the white wall. Early applications of the camera obscura were made by astronomers to view solar eclipses and by artists to make drawings of the landscape. Leonardo da Vinci was the first to make a diagram of camera obscura, in 1519. By that time the camera obscura had evolved into a portable box with lenses, and, instead of a white wall, a ground glass caught the projected image so that it could be traced onto paper.

camera malfunctions: Cameras are precision instruments using both mechanical and electronic functions that can break down and/or malfunction. While it is best to take a malfunctioning camera to a professional shop for repair, there are a few things the photographer can do that may correct common camera problems:

• Check the batteries: Battery failure is the single most common cause of camera malfunction. If the camera has not been used in a long time the batteries need to be replaced.

- Flash is not synchronized. First check that the shutter speed is at the correct synchronization speed. For most cameras with focal plane shutters this is 1/60 of a second. On some cameras the flash synch is set to X.

Camera Notes: A quarterly journal published by the Camera Club of New York. **Alfred Stieglitz** was the founding editor in 1897 and remained until he started his own *Camera Work* periodical in 1903. Stieglitz reproduced work by **James Craig Annan, Robert Demachy**, and other members of **The Linked Ring,** the British society identified with **Pictorialist** work. Americans whose work he published included **F. Holland Day** and **Frances Benjamin Johnston,** along with his own photographs.

camera in order to take a photo over the heads of a crowd.

Camera Work: A seminal journal of photography founded by **Alfred Stieglitz,** who served as editor and published the work of photographers associated with the **Photo-Secessionist** movement from 1903 to 1917. The reproductions in *Camera Work* were **photogravure**s, which Stieglitz considered the artistic equivalent of original photographs. Stieglitz wanted his new photographic journal to give wider currency to the ideas of the Photo-Secessionist movement and to reproduce the best work of Americans and foreign photographers. The journal exemplified the highest standards of design and typography, with covers designed by **Edward Steichen.** Fifty

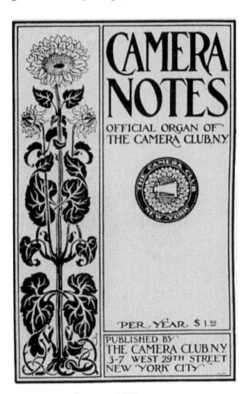

Camera Notes, cover, first issue, 1897.
Collection of the authors.

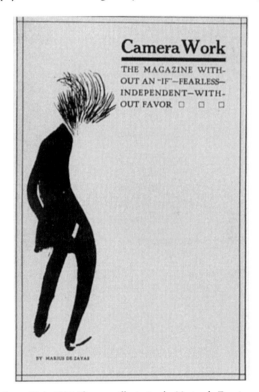

Camera Work, 1910. The cover illustration by Marius de Zaya is a caricature of Stieglitz. Collection of the authors.

camera supports: Anything that holds a camera steady is a camera support. Readily available and commonly used supports are **tripods,** three-legged devices for holding cameras. There are also **monopods,** which a photographer can use to raise the

issues of *Camera Work* were published, with diverse articles on literature and art as well as photography, featuring the work of such figures as **David Octavius Hill, Robert Demachy, Paul Strand, Frank Eugene, Alvin Langdon Coburn, Clarence H. White, Gertrude**

Kasebier, Annie Brigman, Baron De Meyer, Steichen, and Stieglitz.

Cameron, Julia Margaret (1815–1879)

Early English portrait photographer

Cameron was born in India and died in Sri Lanka, but her entire albeit brief photographic career took place while she lived in England. Nothing in her family background, class, or personal life can logically explain why at age 48, presented with a gift of a camera by her children, she avidly embraced photography. Regardless, for the next 12 years, until she and her husband retired to Ceylon in 1875, Cameron documented the Victorian life: portraits of both aristocratic friends and household help; literary, religious, and artistic movements; and illustration of poetic work, including notably her friend Alfred, Lord Tennyson's *Idylls of the King.*

Throughout her career, her work was distinguished more for its mood than for mastery of technique. Technically she was known for daring to do things entirely in her own way, ignoring the then current rules for focus, exposure, and lighting. Her large prints, which were never retouched, were frequently marred by dust, cracks, and even fingerprints on the negative.

Among her famous subjects were Thomas Carlyle, Robert Browning, Mrs. Herbert Duckworth (Virginia Woolf's mother), Henry W. Longfellow, Charles Darwin, **Lewis Carroll, Sir John Herschel,** and the Prince of Wales. However, her work passed largely into obscurity until it was enthusiastically rediscovered by **Alfred Stieglitz** and the **Photo-Secessionists** decades after her death. Today she is recognized as one of the finest portraitists of her time.

candid photography: Photography that is spontaneous and unplanned. The subject may even be unaware of being photographed.

Canon: A Japanese camera manufacturer and one of the first to market a professional auto-focus camera. The Canon EOS automatic camera system is widely used by professional photographers.

Capa, Cornell (b. Kornell Friedmann) (1918–)

Hungarian-born American photographer, museum founder, and director

Born in Budapest, Hungary, Capa has become a legendary figure in American photography as the founder and director of one of the foremost photography institutions in the world, the **International Center of Photography** (ICP). Few have had more of an impact on the growth, study, and appreciation of photography as an art or documentary form than Capa.

Cornell Capa joined his older brother, **Robert Capa**, in Paris in 1936, where Robert Capa was already immersed in his remarkable career as a photojournalist. Cornell developed and printed his brother's pictures, as well as those of two other talented young photographers, **David "Chim" Seymour** and **Henri Cartier-Bresson.** In 1937 the Capa brothers went to the United States. Robert continued taking pictures, among them some of his landmark images that have led to his renown as the world's best combat photographer. Cornell continued darkroom work, first at a picture agency, then at *Life* magazine until he joined the armed forces in the Air Force Photo Intelligence. He returned to *Life* after the war as a photographer.

His brother was killed in 1954 while covering the war in Indochina, and Cornell joined **Magnum Photos** that year, in a sense keeping the Capa name alive at the famed photo agency. He served as president of the agency in the late 1950s.

After the death of Robert and two other prominent photographers, Seymour and **Werner Bischoff**, on assignment, Cornell Capa created the Fund for Concerned Photography, Inc., a forerunner to the ICP. The Fund's first major exhibition was in 1967.

The ICP was founded in 1974, just after the heyday of American picture weekly magazines. Its purpose originally was to celebrate what Capa called "concerned photographers," who used their cameras as instruments of social change. Capa wanted to link photojournalistic images with the humanistic social documentary tradition established by **Jacob Riis, Lewis Hine,** and the **Farm Security Administration** photographers. The institution has expanded to become part museum, part school,

Julia Margaret Cameron. *Sir John Herschel.* April 1867. Courtesy Hans P. Kraus, Jr. Inc., New York.

part gallery, part photography information clearing-house, and part tribute to the craft.

Along with running the museum, most recently as director emeritus, Capa has produced more than a dozen books, acted as curator for scores of international exhibits, taught at the museum, and created several short films.

Capa, Robert (b. Andrei Friedmann) (1913–1954)

Hungarian-born American photojournalist and founding member of Magnum Photos

Capa was a cofounder of the prestigious **Magnum Photos** agency and one of the century's most famous and talented war photographers. His life was tragically cut short in 1954 while he was on assignment for *Life* magazine; he stepped on a land mine covering unrest in Indochina, becoming the first photographer to be killed in the conflict that would later evolve into the Vietnam War.

The older brother of **International Center of Photography** founder Cornell Capa, Robert was born in Budapest but went to Germany to study. His first published photo came at age 18 for a Berlin magazine. When he was 20, he moved to Paris with his companion, Gerta Taro. The pair put on their public relations hats and created the persona of Robert Capa, "the Great American Photographer." While covering the Spanish Civil War in 1936, he made some of his most memorable war images, including his most famous, *Death of a Loyalist Soldier,* which some historians believe may have been staged.

Taro died during that war; crushed to death by a Loyalist tank during a confusing retreat. In 1937, Robert and Cornell Capa moved to America, where Robert's reputation—and then, quickly, his talent—earned him a string of assignments from every prominent magazine, sending him to every corner of the earth, from Spain, to China during the Japanese invasion, to the birth of Israel, to the beaches of Normandy on D-Day. He became the most highly acclaimed war photographer of his time.

Capa had the original idea for a cooperative picture agency that would allow photographers more control and let them retain copyright ownership of their work. He convinced three friends—**Henri Cartier-Bresson**, **David "Chim" Seymour**, and **George Rodger**—with whom he was enjoying a leisurely lunch one day in 1947 at the Museum of Modern Art in New York to join the venture. They called the new agency Magnum, meaning "great," "big gun," "celebratory fizz," or a combination of the three. The agency, now more than 50 years old, has attracted the finest photojournalists in the world and continues to maintain the highest standards of photojournalism. From 1951 to 1954 Capa was Magnum's president, and he settled down to shoot artists, presidents, and celebrities. In 1954, Capa became a U.S. citizen, and at age 40 he accepted an assignment from *Life* to capture the brewing conflict in Indochina. It was his last assignment.

Capa's style was redolently immediate, gutsy, and actively pictorial. His most famous saying was "If your pictures aren't good enough, then you aren't close enough." The speed of the action that Capa shot was often faster than the shutter speed, lending many of his photos an even greater impact of spontaneous authenticity through their blurred, grainy appearance.

Caponigro, Paul (1932–)

American nature photographer and teacher

Caponigro, a Boston-born student of **Minor White**, is today one of America's most respected photography teaching professionals, as well as a gifted nature photographer.

Using large formats, he generally produces images derived from nature: flowers, water, leaves, and images of French and English landscapes, including a notable series on Stonehenge. He often abstracts details of nature by shooting in close-ups. Like the typical landscape photographer of the previous century, he approaches his subject with reverence, peace, and the absolute joy of nature's scenery.

A winner of **Guggenheim fellowships** in 1966 and 1975 and a pair of **National Endowment for the Arts** awards in 1971 and 1975, Caponigro has taught at Boston, New York, and Yale universities. He is well represented in major museums and collections and

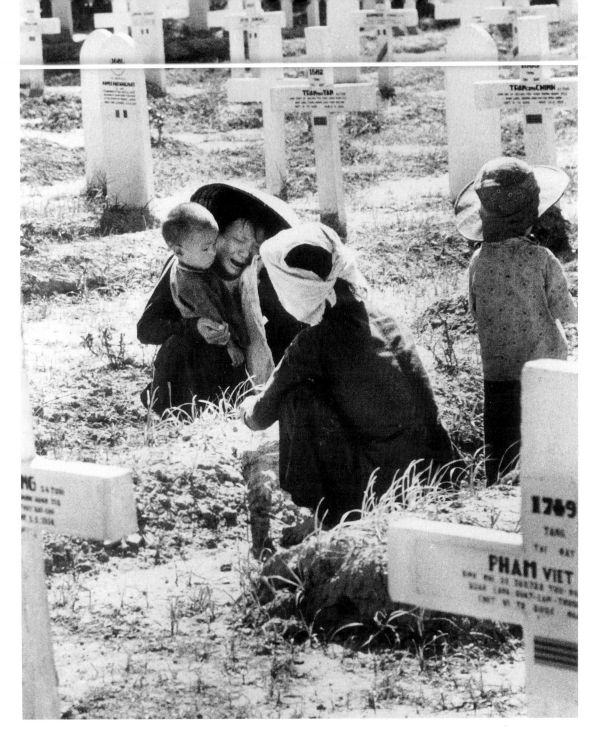

Robert Capa. *Indo-China, 1954.* © Magnum Photos.

has published several monographs of his photographs.

caption: A description of a photograph detailing the event and persons pictured. This information usually appears underneath the photograph. Art photographers who believe that photographs should stand on their own, without any documentary or factual background information, may not provide any caption data at all or just a minimal number of words to identify the work. In books of art photography, captions may appear at the back of the book.

carbon processes: Photographic processes that use carbon suspended in a **gelatin** pigment for the basis of their images. The carbon processes create monochromatic images in a variety of colors. Paper with gum arabic

Henri Cartier-Bresson. *Fortress of Peter and Paul, Leningrad* 1973. © Henri Cartier-Bresson, Magnum Photos.

and a carbon pigment **emulsion** is sensitized with potassium bichromate and exposed by contact under a negative. Exposed areas of the emulsion harden, but unexposed areas remain soluble and dissolve when the image is developed in warm water. This technique was improved by the use of gelatin emulsion carbon tissues that were available in a variety of colors. The process is quite stable, resists fading, and is permanent. Some of the carbon processes are **gum bichromate, autotype,** and **Woodbury**type. These are old-fashioned processes that some photographers still experiment with today.

carbro process: An improvement on the **carbon processes,** primarily the ability to make **enlargement**s. Such an enlargement is made from a silver print instead of a negative.

Carey, Ellen (1952–)

American art photographer

Carey has advanced degrees in print making and photography, and she combines both media in her work.

Using large format, Carey creates one-of-a-kind photographs with applied paint and is known for radical alterations on the photographs, using an airbrush, paint, and other mark-making tools. Her work has been widely exhibited and included in numerous collections.

Carjat, Etienne (1828–1906)

French portrait photographer

A master of portraiture, Carjat is remembered for his simple and incisive portraits of literary and theatrical figures that appeared in the periodicals of the time. His ability to capture the personality of his subjects was equal to that of the best photographers of his day, including **Nadar** and **Julia Margaret Cameron**, but Carjat has not enjoyed the ongoing reputation of his contemporaries.

Carjat had been an actor, a journalist, and a caricaturist before opening a photography studio in Paris in

1861. Although he achieved some recognition for his work, he was not successful financially and by 1876 had closed his studio. In addition to studio portraits, Carjat produced distinctive *cartes de visite*.

Carlin, John W. (1940–)

American archivist

In 1995, Carlin was appointed by President Bill Clinton as Archivist of the United States. He is responsible for, among other things, the cataloging, upkeep, public access to, and acquisition of all the photographs that belong to the government; the collection includes everything from the famous shot of Elvis Presley and President Richard Nixon together in the Oval Office to Mathew Brady's collection of Civil War photos.

A native Kansan, Carlin first entered public service in 1971 by winning election to the Kansas legislature. From 1978 to 1987 he served as the state's governor. Afterward, he joined the faculty of Wichita State University. He has also been chief executive officer of Midwest Superconductivity. Upon his presidential appointment he became the nation's record keeper, responsible for access to information "on which both the credibility of government and the accuracy of history depend."

Carroll, Lewis (The Reverend Charles Lutwidge Dodgson) (1832–1898)

British author, mathematician, and photographer

Lewis Carroll's fascination with children inspired his extraordinary contributions to both literature and portrait photography. Carroll is best known as the author of *Alice's Adventures in Wonderland*.

He began taking photographs in 1855; it was a popular pastime in Victorian England for those who could afford the time and expense, and it became his passion. A lecturer in mathematics at Oxford, he photographed many of his intellectual contemporaries at the university and elsewhere, including such celebrities as John Everett Millais, Ellen Terry, and Alfred, Lord Tennyson.

But he specialized in beautifully appealing photographs of little girls, including Alice Liddell, for whom his famous book was written. He posed his young subjects in simple, natural ways, sometimes in costumes and depicting tableaux for his **albumen** prints. Although Carroll is considered an amateur photographer, his skilled portraits testify to his photographic talent.

carte de visite: Translated from the French, the term means visiting card. Invented in the early 1850s by **André Adolphe-Eugène Disderi,** a creative French businessman and photographer, these small portrait cards ranged from full-length shots to close-up portraits. Inexpensive to produce, they were 3 ½" x 2 ½" paper photographs mounted on a 4 x 3 inch cardboard backing. Disderi printed the name and address of his studio on the back of the cards, and their popularity contributed to the great success of his portrait studio. In addition to their being used as calling cards, the *cartes* became all the rage as collectibles kept in albums by hobbyists. In the late 1860s their popularity began to wane, and **cabinet photographs** replaced *cartes de visite* as the object of collectors' interest. *Cartes de visite* were so numerous that they can still be found in second-hand stores for a modest price, though the ones of celebrities (actors and politicians like Abraham Lincoln), people of color, and Civil War soldiers are highly collectible.

Cartier-Bresson, Henri (1908–)

Influential French photographer and cofounder of Magnum Photos

Few photographers have exerted so great an influence over their contemporaries, articulated such a precise and coherent theory of purpose, or produced a more impressive body of work as Cartier-Bresson. Cofounding member of **Magnum Photos**, he is master of the black-and-white candid photo, capturing seemingly ordinary vignettes of daily life that reveal what he terms "the decisive moment," when the subject and the photographer are in a perfect balance. His work has inspired generations of young street photographers.

Cartier-Bresson originally wanted to be a painter. Born in Chanteloup, near Paris, France, he took lessons at the age of 16 with Jacques-Emile Blanche, the French society painter. In 1927–1928 he studied under the Cubist André Lhote before setting off on a trip to the Ivory Coast, where he acquired a camera. In 1932 he

began using the lightweight **Leica**, which sparked his lightning-quick and precise style. His early work is considered among his finest.

A member of the French underground during World War II, Carrier-Bresson recorded life in France during the occupation and filmed *Le Retour,* a documentary on the homecoming of the prisoners of war. He was one of the first photographers admitted into the Soviet Union after the war, and he documented the final months of the Chinese Nationalist government under Chiang Kai-shek.

In 1947, along with **Robert Capa**, **David Seymour**, **George Rodger**, and William Vandivert, he founded Magnum, the famous photographic agency. Cartier-Bresson's work has appeared worldwide in major picture magazines, but his many books make the strongest, most coherent statement of his brilliant images.

He acknowledges the influence of both **surrealism** and Zen in his work. He says that in his travels, he wanted to "preserve life in the act of living. . . . [T]he photographs must take life by surprise. . . . To take photographs means to record—simultaneously and within a fraction of a second—both the fact itself and the rigorous organization of visually perceived forms that give it meaning."

Since the early 1970s Cartier-Bresson has devoted himself principally to his first love, drawing.

CD (compact disc): A small disc, usually 120mm in diameter and 1.2mm thick, filled with data that is read by **laser**. The data is recorded in minute stamped indentations called pits, comparable to the grooves on vinyl records. As light is reflected off the surface, the variations in the reflected light are interpreted. Originally, CDs were similar to records and recorded only sound. However, they are also capable of storing text, graphics, and video.

CD-ROM (compact disk read only memory): An optical storage disk that can hold a large amount of text, graphics, video, and sound for playback on a computer with a commonly available CD-ROM disk drive.

Celant, Germano (1940–)

Italian-born curator, author

Celant began his career as a curator and critic in 1963, and became known as a founder and champion of the Italian Arte Povera movement, whose name he coined. He has edited or written 30 books and numerous articles on contemporary art and architecture, and curated important shows in Genoa, Milan, Venice, Paris, London, Düsseldorf, Madrid, New York, and Los Angeles. He joined the staff of the Guggenheim Museum in New York in 1988 where he has specialized in exhibits of contemporary art.

Born in Genoa, Italy, Celant earned a doctor of philosophy degree in the history of modern art at the University of Genoa. He has been curator and cocurator of exhibits worldwide on such artists as **Robert Mapplethorpe**, Claes Oldenberg, Keith Haring, Rebecca Horn, and **Andy Warhol** at such venues as the Louisiana Museum in Denmark, P.S. 1 Museum in New York, Pompidou Center in Paris, and Palazzo Grossi in Venice. Celant has been contributing editor for *Artforum* magazine and *Interview*. In 1997 he was curator of the Venice Biennale, arguably the most important international art exhibition.

celestial photography: Photography of the stars and planets.

Celluloid: The trademark name for a substance used for motion picture and X-ray film, similar to clear plastic.

Center for Creative Photography: Founded in 1975 in Tucson under the aegis of the University of Arizona, this multifaceted photography institution offers interconnected programs and holds a collection of some 60,000 fine prints, with a strong emphasis on twentieth-century American work. The prints are available for viewing both online and at the center in the Print Viewing Room. The center's research facility holds archival material, including letters, contact sheets, negatives, and memorabilia from **Ansel Adams, Edward Weston,** and **Louise Dahl-Wolfe,** among others. The original idea for establishing the center came from Adams, who thought there

should be a place where photographers could bequeath their papers and photographic material for future study. The then president of the University of Arizona, John Schaefer, himself a photographer, had studied with Adams. Schaefer called photography the language of our time and was responsible for beginning the center. The center's gallery exhibits work from the collection, new work, and some traveling shows. The library of more than 14,000 volumes includes a rare-book room with artists' books and examples of the various printing processes used for books. The publication program includes a newsletter called *On Center*, a journal called *The Archive*, and a bibliography series.

center spread: Two facing pages in the exact center of a publication (or signature—a group of pages that are folded and bound; most books are made of a group of bound signatures) that are actually one sheet of paper that is folded. Also called a centerfold or natural spread, this area is sometimes used by a publication for a special feature of photographs or text or a large advertisement.

ceramic processes: The process of applying a photographic image to ceramics or pottery. One of the modern processes is to coat a ceramic piece with a silver halide **emulsion** and expose it by either **enlargement** or **contact printing**. The piece is either submerged in developer or the developer is brushed on and then fixed and washed. A final glaze is added to protect the emulsion. **Thomas Wedgwood** and Sir Humphry Davy experimented with a ceramic process as early as 1800, 39 years before the invention of photography.

Chambi, Martin (1891–1973)
Peruvian documentary photographer
Born in Coaza, Peru, of Indian descent, Chambi photographed the milieu in which he lived, the people and landscape of Cuzco, the ancient Incan capital. His principal body of work, done from the 1920s to the 1950s, has extraordinary documentary as well as artistic merit. His images, some which were taken in his studio, portray all the social strata of the city, from the *haciendas* and festivities of the wealthy to the poverty-stricken lifestyle of his

Corbis-Bettmann. *Betty Grable Bathing Suit Pinup,* ca.1942.

fellow *campesinos.* He photographed groups of workers, schoolchildren, and ceremonial events.

As a child Chambi was sent to work in a mine, where it is believed he first saw a camera. He worked in a studio in Arequipa that specialized in family portraits. In the early 1920s Chambi moved to Cuzco, where his creative talent would evolve, both in studio portraiture and the pictorial style portraying traditional scenes of Indian culture.

After Chambi died, his children Victor and Julia continued working in his studio, and in the late 1970s his work began to achieve recognition after Edward Ranney, a photographer in Santa Fe, New Mexico, secured funding to organize Chambi's archive of some 15,000 imprinted glass plates. Chambi's photos have been exhibited widely and remain a unique photographic legacy of his highland people.

changing bag: A black bag that is light tight and used for handling **film** and other light-sensitive materials in daylight. Photographers in the field use changing bags to load or unload film from **film holders**. The bag has 2 holes fitted with elastic through which the photographer's arms can be inserted.

cheesecake: A provocative or suggestive photograph of a woman. In advertising, a cheesecake photo may be used to attract attention to a product or service that lacks appeal or inherent interest on its own. The term was originally used by Hollywood publicists and referred to pictures of young, scantily clad actresses. A famous example was a "pinup" shot of Betty Grable that was much loved by American servicemen in World War II (see p.83). A male version is called a "beefcake" shot.

chiaroscuro: The light and shade effect in a photograph, from the Italian words for light (*chiaro*) and dark (*oscuro*). When talking about a photograph with bright highlights and deep shadows, you can call that effect chiaroscuro.

chloride paper: A slow-speed photographic paper for making **contact prints**. This type of photographic paper has a very slow "speed"; that is, it is not very sensitive to light and needs a full spectrum of light, such as sunlight, for exposure. It is not suitable for making enlargements as with **bromide paper**. This type of paper is not very common but can be found at larger photography stores. **Kodak** makes a chloride paper called Azo.

Christenberry, William (1936–)
American photographer, artist, and teacher
Strongly influenced by the work of **Walker Evans**, whose Depression-era photographs literally portrayed the people and landscapes of Christenberry's native Alabama, he uses his artistic talents in a variety of media, including photography, drawing, painting, and sculpture.

Although Christenberry was born in Hale County, he was not acquainted with Evans and James Agee's book *Let Us Now Praise Famous Men* until he was in his teens. He began taking photographs, using a Brownie camera loaded with color film, simply to record images that he would later paint. Christenberry eventually met Evans, who recognized Christenberry's talent as a photographer.

Christenberry has taught at the Corcoran School of Art. He also has continued Evans's documentary tradition, photographing the commercial buildings, houses, and graveyards of his native county, using luminous color to convey a sense of nostalgia for the world of his childhood.

Cibachrome process: The name that **Ilford** called its process for making prints directly from slides. It is now called Ilfochrome.

circle of confusion: (1) The size of the largest circle that the eye cannot distinguish from a central dot. It is the primary and objective factor that determines the sharpness of an image and the limiting factor for the depth of field. (2) A camera club founded in New York City by Willard Morgan in 1932 to promote 35mm snapshot photography. Morgan introduced the Leica 35mm camera to the United States in 1928 and traveled around the country with his wife, Barbara, promoting the camera and the snapshot style to professional and amateur photographers. He went on to become the director of photography at the Museum of Modern Art in New York, where he arranged an exhibit of snapshot photography.

Clark, Larry (1943–)
American doucmentary photographer
Clark's teenage experiences in the drug culture of his native Tulsa were the inspiration for his first book, *Tulsa*. The introduction to that book set the tone for the sensational work: "i was born in Tulsa Oklahoma in 1943. when i was sixteen i started shooting amphetamine. i shot with my friends everyday for three years and then left town but i've gone back through the years. once the needle goes in it never comes out."

Clark's mother was a children's photographer, and he accompanied her from 1958 to 1961, going door to door taking portraits of babies. Clark then studied photography in Milwaukee, taking photographs of teenage sexuality and drug culture in Tulsa. He served in the army in Vietnam and published a second book, *Teenage Lust*. He later moved to New York and continues to work as a freelance photographer. Clark has lectured on photography and won a **National Endowment for the Arts** award for his photographs.

Claudet, Antoine-François-Jean (1798–1867)

Early French commercial photographer and inventor

Claudet studied the **daguerreotype** process and acquired a license from **Daguerre** to open a studio in London, where he met with great success, even becoming official photographer to Queen Victoria.

His career began in France, where he worked first in banking and later for a glass manufacturer. After working with Daguerre he opened the first daguerreotype studio in London, in 1841, on the roof of the Adelaide Gallery. He moved several times, until in 1851 he opened his most elaborate studio on Regent Street, which he called a Temple to Photography, where he took portraits of the fashionable and also displayed photographs and artifacts relating to the history of photography.

Claudet's contributions to photography include many inventions, such as the first use of painted backdrops and special lighting for portraiture, the red darkroom light, and the first daguerreotype stereographs. He was a fellow of the Royal Academy in England, and in 1863 he was awarded the Legion of Honor by the emperor of France.

Clerque, Lucien G. (1934–)

French art photographer and filmmaker

A member of the Expression Libre (Free Expression) group, founded in 1964, which sought a wider exposure of photography through various means, including university curricula, Clerque is noted for his staged studies of nudes posing in landscapes that evoke similarities to images of earth goddesses. Working principally in the south of France, he has photographed bullfights, seascapes, and landscapes in Provence in both color and black and white.

He was a founder of the Arles photography festival and has lectured in the United States and France. Several monographs of his work have been published, and his photographs are represented at major museums. Clerque's film work includes several short features and two full-length films.

Clift, William Brooks (1944–)

American landscape and portrait photographer

Clift's careful black-and-white Western landscapes, architectural studies, and portraiture have brought him recognition from major museums and collections. He studied with **Paul Caponigro** and now works as a freelance photographer. Among his assignments have been photographing Old City Hall in Boston and American courthouses for the Seagram company. Clift has won both **National Endowment for the Arts** and Guggenheim awards, and his black-and-white landscapes have been included in the anthologies *Mirrors and Windows* and *American Landscapes.*

clipping: An article or photograph cut out from a newspaper or magazine. Clipping bureaus are employed by companies or individuals to keep a record of printed notices about themselves or their clients or products.

close-up photography: A photograph taken within inches of an object, usually one requiring a special close-up lens. (See **macro photography**.)

Coburn, Alvin Langdon (1881–1966)

American abstract photographer

Working both in the United States and Britain, Coburn was an internationally recognized leader of the Modernist age, producing symbolic and abstract photographs ranging from portraits of his friends to landscapes to abstract constructions.

Influenced by his cousin, the photographer **F. Holland Day**, Coburn by the age of 21 had become a serious photographer, opening a studio in New York City in 1902. While living in New York, he took many soft-focus cityscapes, some from rooftops that created distorted perspectives and emphasized the abstract patterns of city streets.

He emigrated to London in 1904 for a commission to photograph celebrities and eventually became a British subject. He studied the art of photogravure in England, and a portfolio of his appeared in *Camera Work.* A member of **The Linked Ring** in Britain and the **Photo-Secessionist** movement in New York, he became friends with **Clarence White, Gertrude Kasebier,** and **Alfred Stieglitz.** The celebrity photos

Mark Cohen. *Untitled Photograph (Bubblegum)*, 1975. © Mark Cohen. Courtesy the photographer.

he took in London were published in book form, *Men of Mark,* in 1913.

Influenced also by Ezra Pound, one of the avant garde writers he had photographed, Coburn turned to abstraction, hoping to free the camera from "the shackles of conventional representation and attempt something fresh and untried," just as Gertrude Stein had done with literature and Igor Stravinsky had done with music. Coburn's abstract studies, called vortographs, were taken with a kaleidoscope attached to the camera.

In the early 1920s Coburn became involved with Freemasonry and thereafter did very little photography.

coffee table book: A large photography or art book that is decorative, often too large to be kept on a bookshelf and making a handsome display when left out on a coffee table or other prominent place.

Cohen, Mark (1943–)
American art photographer
Born in Wilkes-Barre, Pennsylvania, Cohen has used the surroundings of his home town for many of his avant garde photographs. Considered one of the leading contemporary art photographers, he has invented his own style, by engaging his subjects so closely that they appear

truncated, with a knee or a hand or the backdrop conveying their working-class orientation. Recognition came early for his work; before age 30, he was in shows at the Museum of Modern Art, the Pace Gallery, and the **George Eastman House**.

A two-time **Guggenheim** winner and a **National Endowment for the Arts** Fellow, Cohen has been a photography instructor at the Rhode Island School of Design, Cooper Union, the Corcoran School of Art, and The New School.

Coke, Van Deren (1921–)

American photographer, museum director, and teacher

Coke is one of America's most distinguished photography academicians; since 1979 he has served as director of photography at the San Francisco Museum of Modern Art.

Born in Kentucky, he earned undergraduate and postgraduate degrees at Kentucky and Indiana universities, then studied photography with **Ansel Adams**.

He began teaching in Florida, before moving to Arizona, Berkeley, and the University of Mexico at Albuquerque, where he established the graduate program in both the practice and history of photography. In the early 1970s he served as director of the **International Museum of Photography** at the **George Eastman House** in Rochester. From there he moved to Harvard's Fogg Art Museum, where he served as deputy director and then director; he remains associated with the museum as a curator and advisor.

Coke has been featured in more than 50 solo shows and has produced several noteworthy books, including *The Painter and the Photograph, from Delacroix to Warhol* (1964, revised and expanded 1972), *Avant Garde Photography in Germany 1919–1939* (1982), *and Joel-Peter Witkin: Forty Photographs* (1985). Coke has won Fulbright and **Guggenheim** awards and been a visiting lecturer at colleges and universities around the nation.

cold type: In photocomposition (a modern form of typesetting), a photographic strip of type copy made optically rather than by printing from hot type cast from melted metal.

Cole, Allen Edward (1893–1970)

American documentary photographer

Cole's work, which consists principally of commissioned pictures of the people and businesses of Cleveland's working-class and middle-class black community, has become a valuable historical record of the milestones of ordinary life in his mid-American milieu.

One of the first black photographers in Cleveland, Cole opened his studio in the early 1920s. His interest in photography began while he was working as headwaiter in a private club. One of the club's members offered to teach him photography in exchange for his assistance in his business, a photo studio. Cole worked for the Frank Moore studios for six years, in exchange for his lessons.

His first studio, in his home, produced photos to sell as Christmas gifts. During the Depression he subcontracted photo work from white studio owners, covering banquets, conventions, and similar events. On his own, he accepted all kinds of assignments, from weddings to funerals, and was the only black member of the Cleveland Society of Professional Photographers.

Coleman, A. D. (1943–)

American critic and author

Alan Douglas Coleman is one of the deans of American photo criticism, having been described by the *New York Times* as a "brilliant writer, critic and observer of the photography scene."

Since 1967, writing first in the *Village Voice* and more recently in the *New York Times* and a variety of art and consumer magazines, he has published thousands of controversial, pungent, influential, and no-holds-barred essays that have alternately provoked, delighted, and infuriated the photographic community. Since 1988 he has been the photo critic for the weekly *New York Observer*.

In 1976 he was awarded the first Art Critic's Fellowship from the **National Endowment for the Arts**; he has also received a Fulbright, a Getty; and in 1997 he was the Ansel and Virginia Adams Distinguished Scholar in Residence at the **Center for Creative Photography** in Tucson, Arizona.

His syndicated photo column appears in magazines in Italy, Spain, Germany, Hungary, the Czech Republic,

and elsewhere. He has lectured at many universities and published several collections of his work. Always one to embrace new technology, Coleman runs an interactive newsletter on the **World Wide Web**, "C: The Speed of Light," which can be found at www.nearbycafe.com.

collage: A combination of various cut or torn parts of separate images to form a new image. Collages are typically made from newspaper and magazine images but can be a combination of any other imagery as well, such as original photographs and drawings. The images are cut and glued to a backing to form a new image.

collecting photographica: The act of acquiring things related to photography, such as photographs and photographic equipment. This has become a highly competitive enterprise, and major auction houses such as Sotheby's and Christie's conduct auctions of photographica.

Portable Daguerrean system, 1842.
Collection of Jerry and Shirley Sprung .

Collier, John (1913–1992)
American documentary photographer
A documenter of the human condition, Collier traveled to all corners of the earth, producing some memorable images of a wide cross-section of peoples. In 1941 Collier was hired by **Roy Stryker**, head of the photographic unit of the **Farm Security Administration** to photograph in the Historical Section, and Stryker's philosophy strongly influenced the direction of Collier's career.

Calling himself an anthropologist and educator with the camera as his tool, Collier produced a two-year, 6,000-negative study of the people of Colombia conducted in the late 1940s that stands as a monumental achievement. In 1957 he conducted a similar field study of Indians in the Central Andes and in 1973 captured Eskimo education for the U.S. Office of Education. All told, his subjects have included the Amish, Portuguese fishermen, and Native Americans.

Later in his career he turned to teaching, lecturing at the San Francisco Art Institute for more than 20 years and holding a professorship in anthropology at the San Francisco State University School of Anthropology.

Collins, John F. (1888–1991)
American commercial and art photographer
Collins's career as an advertising photographer, whose work can be legitimately called art photography, began at the 1904 St. Louis World's Fair. Seeking adventure, he had left his native Ohio and traveled to the fair, where he found work pulling visitors around on rolling wicker chairs. Touring the grounds, he came upon a primitive photo booth, was fascinated by the whole process of photography, quit his job, and went to work for the man in charge of the booth.

Collins soon bought himself a Brownie camera and began to travel throughout the United States, taking photographs and living on odd jobs. He returned to Ohio and was hired to make newsreels. One of his newsreels evolved into a political film—the first commercial, perhaps, for electioneering purposes, and it was instrumental in electing the film's subject, Ohio representative Frank Hunter, to office.

John Collier. *A Widow Sits beneath Portraits of Her Family, Penasco, New Mexico.* January 1943. Photo: Library of Congress.

In 1915 Collins moved to Florida, where the early movie industry was located, to work as a cameraman. In 1916 he came to New York, where he was successful in convincing advertising agencies to use his creative photographs to sell products ranging from face creams to real estate.

When World War I broke out, Collins went overseas as a war photographer, shooting President Woodrow Wilson and General John J. Pershing, among others. After the war he lived in Syracuse, New York, where his photography came to the attention of a representative of Eastman Kodak. He was soon hired by Kodak, and he remained there as an in-house catalogue and special assignment photographer.

An artist by anyone's definition, he saw himself simply as a craftsman with the camera as his tool. "Let the art boys have their way if they want to call it an art. To me, it's a tool, a means of communication and education," he said in an interview on the eve of his 100th birthday.

collodion process: An early method for producing glass negatives. The procedure began with the use of a sticky substance that could hold the silver that produces a photographic image. The collodion process was invented by **Frederick Scott Archer** in 1851, using gun cotton soaked in a mixture of alcohol and ether and mixed with potassium iodide. His process took much less time than the **daguerreotype** or the **calotype**, resulted in clearer, sharper images, and eventually replaced the earlier discoveries. Collodion (from the Greek word for glue) allowed the light-sensitive silver salts to be coated on glass and paper, making the earlier calotype process of

negative and multiple print less practical and producing a more sharply detailed image. The first collodion processes required that the substance be used while wet, meaning that photographers had to carry **darkrooms** with them to coat the glass and develop it before the collodion dried. The Civil War photographs of **Mathew Brady** were made with the wet-collodion process, as were those made during the early westward U.S. expansion. **Roger Fenton**'s Crimean War pictures and **James Robertson**'s and **Felice Beato**'s views of the Middle East and Far East also made use of the wet-collodion process. In the 1870s, advancements were made that allowed for collodion to be used dry, although varying quality of the image and longer exposure times kept the process from achieving wide use. By the late 1880s **gelatin** replaced collodion and is still used today.

color: The quality of an object as seen by the **light** reflected from it in terms of hue, saturation, and brightness. The primary colors are yellow, red, and blue. By combining these primary colors, one produces secondary colors. Combining yellow and red produces orange, combining red and blue produces purple, and combining yellow and blue produces green. Daylight is a combination of a spectrum of colored light that produces white light. This is detectable by the rainbow effect produced by a ray of light passing through a prism. Regardless of the color of an object, the quality of light reflected from it greatly affects its appearance. Late afternoon sunlight is very orange and produces a warm, orange effect on whatever it illuminates. A red light bulb makes a room look monochromatic—that is, appear in various shades of red, even though the objects in it may be of any color and things that are actually red appear bright (because they are the same color as the light) and objects whose color is complementary (the opposite color, which is green) appear very dark.

color filter: A clear, distortion-free material that has a color tint and is used over a camera **lens** or in front of a **light** source to affect the quality of light that reaches film or paper. Color filters are often used when a natural color balance is required. **Filters** can also be used over

the lighting source in a studio to balance the color. Color filters are also used in the darkroom for printing color photographs. Color enlargers come with a pack of cyan, yellow, and magenta fillers, and the combination of yellow and magenta (cyan is rarely used) gives the photograph its color effect. Color filters are used with black-and-white photography to affect the tonal relationship of object, and in black-and-white printing to adjust contrast. An object the same color as a filter appears white and one the opposite color appears dark. A yellow filter is commonly used on a camera lens to make the blue sky appear darker with black-and-white film.

color negative film: A type of photographic film that records a full-color image in reverse tones. Specific colors are represented by their complementary colors—that is, red is reproduced as green, blue as yellow, and so forth. The colors are reversed again to their normal values when the color negative is printed on photographic paper.

color photography: Photographs in either print or slide form that record the color of a scene. Color photography was invented at the turn of the twentieth century and is today's most popular form of photography. The ability of film to record color is due to the presence of three layers of color—yellow, red, and blue—on the film. When combined, these three colors represent the majority of colors that we see.

color positive film: A type of photographic film that records a full-spectrum image in actual, rather than reversed, natural color.

color print film: A special type of color negative film for making color transparencies directly from original color negatives.

color separation: One of a set of three or four negatives or positives exposed through different filters to the same subject. A color photograph actually consists of three color layers—red, yellow, and blue. When they are viewed together, the image represents the color scene as

John F. Collins. *Comb.* 1934. © John F. Collins. Courtesy Howard Greenberg Gallery, New York.

we know it. When the layers are viewed separately, there are three separate images, one in each color. Color separations are used by printers for achieving an acceptable color balance in a color photograph and for making color prints with the dye transfer process.

commercial photography: Professional photography for advertising, communication, or other commercial purposes; photography whose purpose is to serve a commercial interest. Commercial photography is a huge field ranging from newspaper and magazine photography to fashion photography to advertising and product photography, among others.

composite photographs: An image in which more than one negative has been used. Composite photography was popular in the 1850s to make **allegorical** images as art, using many separate negatives to make a single print. Some photographers continue to make composite photographs, but digital imaging has made this labor-intensive method less desirable. A well-known contemporary photographer who uses this method is **Jerry Uelsman**. Earlier photographers using allegorical images were **Oscar G. Rejlander** and **Henry Peach Robinson**.

composition: The visual arrangement of elements of a photograph. When a picture is made, the way the shapes are arranged on the surface is its composition.

computer: An electronic device for communication and computation, capable of rapidly compiling, storing, retrieving, editing, and duplicating information. Computers have rapidly become the main form of information storage and communication on the **information superhighway**, whether used by a major corporation or an individual user. They have revolutionized our methods of communication by enabling access to massive amounts of information worldwide to anyone with a computer and a **modem** and have spawned an industry that is one of the most powerful and fastest-growing areas of the world economy.

computers for photographers: In photography, the computer and its technology have created new ways of making, storing, and printing photographs through the use of **digital imaging**. A photograph can be **scanned** into a computer and digitized—that is, copied and stored as minute bits of information that when viewed as a whole are photographs. The individual bits of information can be altered according to color, tone, and grouping to **retouch** aspects of the photographic image and/or to create new images from any number of elements from one or more photographs. Because the computer works with small bits of the image, alterations can be totally seamless and wholly realistic. It is this aspect of digital photography that has the most potential to change the way we view the medium and simultaneously threatens the traditional notion of what photographs mean. One of the most used computer programs for working with photographs is Adobe **Photoshop**. This program has a set of tools, palettes, and functions that can be used to alter photographs subtly or drastically, adding to or eliminating objects from the picture and changing its appearance in as many ways as the photographer can imagine.

Magazines, newspapers, and all print media are using computers for design and sometimes to alter existing photographs. One widely discussed instance was during the 1995 murder trial of ex-football star and celebrity O. J. Simpson. *Time* and *Newsweek* magazines both ran the same photograph of Simpson taken by the Los Angeles Police Department when he was arrested, but the *Time* cover photograph made him look much darker and, some people would argue, much more sinister. While *Newsweek* published the "mug" shot as it was, *Time* employed an artist, Matt Mahurin, to make the photograph "more artful, more compelling," in the words of *Time* spokeswoman Nancy Kearney. In this instance, the computer was used to alter the photograph in a dramatic way to make for a more interesting magazine cover.

One of the most exciting advancements in computers for photographs has been their accessibility. A reasonably inexpensive computer with the Photoshop program and an **ink jet printer** can do the same thing as a very powerful one at a major magazine, and with the continued development and popularity of the **internet,**

photographs can be sent and received all over the world, instantaneously and inexpensively.

computerized images: Photographs in which the computer is involved. Most computerized images are formed using the program Adobe **Photoshop**. An image is **scanned** (that is, fed into the computer) and can then be altered in an infinite number of ways to suit the photographer's needs, which can be blatant or subtle. One of the many advantages to computerized images is that they can be transferred from computer to computer through the phone lines, making for instantaneous pictures of events anywhere in the world. One of the major concerns for photographers about computerized images is that photographs have traditionally had an aspect of believability. Computerized images can be made to look totally believable but may in fact be total fabrications, undermining that prior aspect of believability.

conceptual photography: Photography in which a concept or idea is the subject, apart from the representational aspect of the images. In a conceptual photograph, a person or thing photographed might only be a vehicle for the photographer's real intention—conveying an emotional, political, or other message.

condenser: A lenslike apparatus used to concentrate a light source for **enlarging**. This allows for a medium-grade light source, like a 75-watt bulb, to be effective for making photographic enlargements. The condenser takes the light and focuses it onto a small area the size of the negative, making the light more intense and more efficient.

Connor, Linda S. (1944–)

American landscape and portrait photographer and teacher

A native New Yorker, Connor picked up the family's Argus C3 camera as a teenager and found her life's work. Known for landscapes, portraits, and architectural documentation, she studied under **Harry Callahan** at the Rhode Island School of Design and earned a bachelor of arts degree, then a master of fine arts degree and a masters of science in photography. Since 1969 she has been an instructor at the San Francisco Art Institute and has pursued her own work as well.

Winner of two **National Endowment for the Arts** grants and a **Guggenheim fellowship,** as well as the Photographer of the Year Award from **Friends of Photography** in 1986, Connor has been widely published and exhibited. Her later work has focused on manifestations of religious beliefs and myth in diverse cultures, the quest for which has taken her to sacred sites around the world.

conservation of photographs: The act of preserving photographs. Paper photographs are sensitive to chemicals, **acid**s, and prolonged exposure to **light**. While this is not a problem with our casual snapshots, it is with important art and artifacts. Over time, photographs can fade and disintegrate, especially when exposed to heat, humidity, light, and acidic chemicals. The use of ordinary corrugated cardboard as backings for photographs or art work can be extremely harmful. Museums that collect photographs are keenly aware of this problem and hire specialists who care for their old photographs and try to prevent damage to them. Conservation typically entails removing glue, dirt, and residual oils (such as those left by fingerprints) from a photograph. Photographs are often washed, dried, and then placed in an archival envelope and stored in a dark cabinet for safekeeping.

Contact Press Images: International photography agency specializing in **photojournalism**.

contact print or sheet: The act of making a photographic print by putting the negative and paper in direct contact. This results in an image that is the exact size of the negative and is different from an enlarged photograph. Some photographers who make large negatives, especially 8 x 10-inch ones, prefer to make contact prints because of the high degree of sharpness and tonal accuracy that results. Some photographic papers are specifically made for this purpose, such as chloride papers, also known as printing-out papers, but contact prints can also be made on the faster **bromide paper** (enlarging paper) as well.

Contact sheet. © Fred W. McDarrah

contrast: The term used to define the degree of separation between highlights and shadows. If a print has deep shadows and bright highlights, it has good contrast or high contrast. If a print is mostly gray without a deep black or bright white, then it is said to be of low contrast. *Contrast* is a relative term and is often dependent on the taste of the photographer. Contrast is determined by how intense the light is on a subject and by its tones.

Cook, George S. (1819–1902)

American portrait and documentary photographer

Cook, who might be called the **Mathew Brady** of the Confederacy, emerged as the premier photographer covering the War Between the States from below the Mason-Dixon line. While President Abraham Lincoln and the Union had Brady and his crew covering the Civil War, the South had no coordinated photodocumentation of the conflict. Instead, several individual towns and cities hired their own teams to cover the battles. Cook had actually worked as a Brady assistant and ran his New York studio.

Born in Stratford, Connecticut, Cook began his professional life as a miniaturist, painting portraits for wealthy New Orleans residents. When the **daguerreotype** process was introduced in the area in 1840, Cook

mastered the process and technique and became an expert in its use. Cook settled with his family in Charleston, South Carolina, where, by 1855, he made the transition from skilled daguerreotypist to photographer, having mastered the new **collodion** process. Cook opened several photographic studios, but as the tensions between North and South grew, he closed his northern galleries.

His Civil War photos date back to 1861, when he took his camera to Institute Hall, where the final vote for secession was taken. He photographed Fort Sumter and other famous battle sites, southern leaders, and battle scenes. Cook moved to Richmond, Virginia, in 1880, where he remained until his death, operating a successful photo studio.

In addition to surviving the war with many of his photographs, he was one of the few Southerners to emerge from the conflict a wealthy man. It was common knowledge that Cook always insisted on payment in gold, not Confederate dollars. When marauders—some in Union uniform, some not—invaded his Charleston home looking for loot, they became disgusted and eventually shot a goose and ate it for dinner, unaware that under the goose's undisturbed nest lay the family fortune—all this according to a biography written by Cook's great grandson Jack Ramsey, 80 years after his death. The book, *Photographer . . . Under Fire, is* a dramatic, well-researched account of Cook's adventures during the Civil War, as well as a fascinating family history.

The Cook collection of photographs is now owned by the Valentine Museum in Richmond.

Coplans, John (1920–)

English photographer, critic, and editor

In the first part of his career, Coplans worked as a critic and writer. He was a founder of *Artforum* magazine, wrote art criticism, and was the curator of many exhibitions of contemporary artwork. In 1984 he began his series of "Self Portraits," photographs of his headless, naked body, which have been exhibited in one-man shows at the Museum of Modern Art in San Francisco, the Art Institute of Chicago, and the Pompidou Center in Paris, among other venues.

George S. Cook. *Federal Prisoners of War at Castle Pinckney,* 1861. Courtesy Valentine Museum, Richmond, Va.

Born in London, England, he joined the military in 1938 and served in the Ethiopian and Burma campaigns. After leaving the service in 1946, he went to art school and became a painter. In 1960 he left England for San Francisco, where he became a founding editor of *Artforum* and, in 1971, its editor-in-chief. In 1965 he served as director of the art gallery at the University of California, Irvine, and senior curator of the Pasadena Art Museum in 1967. Among the many exhibitions he curated are "Pop Art USA" (1963), "Roy Lichtenstein" (1967), "Wayne Thiebaud" (1968), and "Donald Judd" (1970).

In 1978 he became director of the Akron Art Museum in Ohio and founded the Midwest art magazine *Dialog.* His books include *Cezanne Watercolors* (1972), *Weegee: Tater and Opfer* (1978), and *A Self-Portrait* (1998). The last of these was published in conjunction with a retrospective at P.S. 1 Museum in Long Island City, New York. In 1975, 1980, and 1992 Coplans received **National Endowment for the Arts** fellowships, and **Guggenheim fellowships** in 1969 and 1985. His work is represented in more than 60 museums in the United States, Canada, Japan, and Europe.

copy: Any written material—news stories, letters, articles—intended for publication or distribution in any media.

copy camera: A **large-format camera** used to reproduce documents, photographs, aerial views, or architectural drawings.

copy prints: Copies made from an existing photograph directly—that is, when a picture is made of another picture. The copy is frequently as good as the original.

John Coplans. *Eye and Nose. 1980.* © John Coplans. Courtesy of the photographer.

copyright: The right of ownership of a photograph, a book, artwork, or any other creative product. A photographer can lease a photographic print for one-time use in a magazine but retain the copyright and control the rights to how the image is used and when it is used. Copyright is designated by the symbol ©. Copyright protects the owner from having his or her artistic property appropriated. In the United States, copyright is registered by the individual owner with the Library of Congress's Copyright Office.

Corbis: An imaging company that is part of the **Microsoft** Corporation and strives to build a unique and comprehensive archive of **digital images** that can be distributed and sold over the **internet** to newspapers, advertising agencies, graphic and television agencies, and individual consumers. Founded in 1989 by Microsoft chairman **William Gates,** Corbis purchased the huge picture library of the **Bettmann** Archive, which already had more than 16 million images available in its New York office. Corbis also purchased the Hammer Leonardo Codex and nearly 4 million images, including the rights to the digital diffusion of works of art from some of the most famous museums in the world.

Corbis has taken over the task of digitizing and making the archive available online to a worldwide audience. The Corbis collection represents practically the entire visual narrative of humankind from prehistoric cave paintings to contemporary personalities and events. A catalogue with a sampling of the company's images arranged by subject, and indexed by concept as well, includes the arts, industry and science, society and events, people and animals, travel, and recreation. **Online** customers can browse the catalogue, make a specific request, preview the picture, edit, download low-resolution images, order the image, and receive a high-resolution photograph suitable for reproduction.

Cosindas, Marie (1925–)
American art photographer
One of the first photographers to use Polaroid color film as her principal medium, Cosindas, an art photographer of stature, is known for her still-lifes and portraits.

A student of **Ansel Adams** and **Minor White,** she is an expert at using various filters, development time, and temperature to create vivid colors and striking contrast. She established her reputation with a solo show at the Museum of Modern Art in *1966* before moving on to magazine work (**Life,** *Newsweek, Vogue, Esquire*) and then Hollywood, working on *The Sting, The Great Gatsby,* and others. A 1978 **International Center of Photography** solo show solidified her reputation as a leading art photographer, and she has been widely exhibited and collected since then, including a major 1994 retrospective in California.

credit line: Usually appearing below the photograph, the credit line identifies the photographer who took the image, and its current owner. Credit lines are an essential part of having a photograph published and necessary to properly identify the maker of the image.

crime photography: Photography used by law-enforcement agencies to record a crime scene for further investigation and evidence. All police departments have a photographer for this purpose.

cropping: The act of printing only certain parts of a photograph. Typically this is done in the darkroom to eliminate extraneous parts of the picture, to enhance the composition, or to spotlight a subject in the photograph, but most professional photographers object to cropping.

Culver Pictures: An agency of stock photography in New York, founded in 1926 with more than 9 million images, mostly black-and-white engravings, etchings, prints, and photographs illustrating the story of humans, the world, and the universe from the Stone Age to the Space Age, rare old theater and opera photographs, old movie stills, sheet music, and political cartoons. Culver Pictures represents the Sy Seidman Americana Collection.

Cumming, Robert (1943–)
American photographer and artist
Like his idol **Man Ray,** Cumming took up photography

to document his own and others' works of art. A conceptual artist and instructor in painting, drawing, and photography at several California institutions, he has been included in more than *50* solo and group shows.

Some of his book titles reflect the conceptual nature of his work—for example, *The Weight of Franchise Meat* (1971) and *A Discourse on Domestic Disorder* (1975). Recent projects include "Lure of the Sea," a documentation of land-based ship structures, and "Minor and Domestic Disasters," of fabricated photos and text. Funding for these works comes primarily from the government and private foundations; he is a three-time **National Endowment for the Arts** grant winner (1972, 1975, 1979) and a two-time **Guggenheim** winner (1980–1981). He also was selected to document the 1980 Los Angeles Olympics.

Cunningham, Imogen (1883–1976)

American photographer and artist

From bold, evocative nudes to starkly beautiful still-lifes, Imogen Cunningham's impressive body of work has garnered her worldwide acclaim. One of the first women to make her living as a photographer, Cunningham consistently experimented with a wide range of techniques during her amazing career, which spanned seven full decades.

She set trends decades ahead of others; Cunningham was pointing her lens at pregnant nudes eons before **Annie Liebovitz** focused in on Demi Moore for the cover of *Vanity Fair*. An idol of photography students and a paragon of her professional colleagues, Cunningham amassed portfolios that virtually encompassed the exploits of photography in the twentieth century.

One of ten children born in Portland, Oregon, Cunningham was a chemistry major whose first job was in the studio of **Edward Curtis**. After eight years there, she went to Germany on a scholarship, returning to Seattle in 1910 and establishing her own studio. She had her first solo show in Brooklyn, New York, in 1912.

Starting in the 1920s, she began making sharply focused, close-up studies of plant life and unconventional views of industrial structures and modern architecture. Concerned with light, form, and abstract

Imogen Cunningham. *Portrait of Dorothy Bokor in Doorway,* c. 1914. Courtesy Zabriskie Gallery, New York.

pattern, these photographs established her as one of the pioneers of modernist photography on the West Coast. In the 1930s, she joined the legendary San Francisco collective **f/64** with **Ansel Adams** and others.

Some of her best-known portraits were a 1931 series of the dancer Martha Graham for *Vanity Fair* and others of the actors Spencer Tracy and Cary Grant. She was prominently featured in the landmark 1937 Museum of Modern Art show "Photography 1839–1937." She continued to work voraciously as she raised three daughters and maintained friendships with such contemporaries as **Alfred Stieglitz, Edward Steichen, Minor White, Edward Weston, Ansel Adams,** and others. She shot on the street and in the studio. In the 1950s she photographed the Beats and in the '60s the Flower Power generation and Haight-Ashbury scene.

At age 87, she received a **Guggenheim fellowship** to print many of her old negatives. At the same time, she was taking a public stand against the war in Vietnam. At age 92, she started her last major project, a book of images of people over 90; it was published posthumously.

She will go down in the annals of the medium as one

who brought wit, originality, and freshness to photography—decade after decade after decade. She was a true American original.

Curtis, Asahel (1874–1941)

American landscape photographer

A talented early-twentieth-century photographer whose photographs of the great Northwest are a unique document of a bygone era, Curtis never received the critical and commercial success, respect, or acclaim that his brother, **Edward S. Curtis**, did for his documentation of Native Americans.

Asahel began as a teenage hobbyist in Seattle, opening his first professional commercial studio at age 20. His work took him throughout the northwestern United States and into nearby Canada, doing advertisements for local magazines and assignments for *National Geographic*. A seasoned and enthusiastic mountain climber, he was the first professional guide to Mount Rainier, where he made many of his life's work of 60,000 images. He also loved to photograph people—at play, at work, in the street—during the region's economic boom.

Historians credit his work for helping to develop the region, portraying the largely unknown timber country as a vibrant, thriving, viable place to live. Historians and researchers also are fond of Curtis for the fastidiously detailed records he kept of his work. His negatives were left in numbered, chronological sequence, with detailed captions, helping businesses, families, and government agencies recount the history of the area and era.

Curtis, Edward S. (1868–1954)

American portrait photographer

Edward Curtis was one of the most prolific, technically skilled, and famous photographers of his day. His younger brother, **Asahel**, documented the great Northwest; Edward's legacy is a remarkable 40-volume study of Native Americans, funded by J. P. Morgan on the advice of President Theodore Roosevelt.

Curtis was a hands-on photographer; he literally built his first camera as a schoolboy in Seattle. He started as an assistant to a commercial photographer and then acquired a part interest in a portrait studio. In 1896, he took his first photo of a Native American, and in 1898 he accompanied Edward H. Harriman on a two-month expedition to Alaska, sparking a lifelong interest in documenting tribal life. He spent the summer of 1900 on a Montana reservation, the start of three decades of devoted work.

Some of his prints were exhibited in Washington, D.C., in 1905 and caught the eye of President Roosevelt, himself an avid outdoorsman and student of Native American hunting and tracking skills. The next year Roosevelt introduced the photographer to the industrialist J. Pierpont Morgan and suggested that Morgan finance what was to become the most thorough anthropological study of North American Indian life ever attempted. With a bankroll of $75,000, a princely sum in those days, Curtis set out to cover the customs, the ceremonies. and the daily life of the tribes west of the Mississippi from New Mexico to Alaska.

Between 1898 and 1930 he produced a 40-volume work, constituting 20 text volumes and 20 print portfolios. The work was technically superior to most anything of the era. Although his style was straightforward, he tended to romanticize his subjects by posing them with various props and even wigs. Aware that he was documenting a quickly vanishing culture, Curtis used his subjects to develop a mythology that evoked their past. He dressed them in traditional garb, never in urban settings or poverty.

He first used a 7 x 14 view camera, later an 11 x 14, and finally a 6 x 8 reflex. He made platinum and silver prints as well as orotones, which were direct positives on glass plates.

At age 62, having finished what was to be the last volume, he suffered a mental and physical breakdown. In the last 20 years of his life he lost possession of his life's work to his wife in a bitter divorce proceeding and died in poverty.

cyanotype: A nonsilver photographic process invented by **Sir John Herschel** in 1842, also known as **blueprint**, characterized by a deep blue image on a white background.

Edward S. Curtis. *House Top Life — Hopi.* c. 1900. Collection of the authors.

Daguerre, Louis-Jacques-Mande (1787–1851)

French inventor and physicist

Daguerre created the **daguerreotype** process, the first commonly used, most widespread, and most practical method to **fix** the images of the **camera obscura**. It initiated the course of photography in the mid- to late-nineteenth-century and set the stage for the evolution and explosion of the medium.

First employed as a taxman—an inland revenue officer—Daguerre became a rather successful scene painter and designer for the stage. In 1822, he invented the diorama, actually an improvement on the Diaphanorama of Franz Niklaus Konig, which consisted of transparent pictures presented to the public in a darkened room by transmitted and reflected light. Daguerre exhibited his dioramas in a specially built theater in which it took ten to fifteen minutes for the audience to view a great diversity of scenic effect. The public flocked to see the dioramas, and they were copied in rival theaters throughout Europe.

No one knows exactly why Daguerre turned his attention to the idea of photography, but in 1829, he became partners with **Joseph Niepce**, who had been attempting for many years to capture permanently the image obtained in the camera obscura. Their first breakthrough came in 1831, when Daguerre found that iodized, silver-coated copper plates were light sensitive. Niepce died in 1833, and Daguerre continued their work alone. His decisive discovery came in 1835 when he saw that those plates, after exposure in a camera obscura, developed a direct positive image when subjected to the fumes of mercury.

In 1837, he was able to fix the image with a salt solution and two years later introduced a solution of hyposulphite of soda; dubbed "hypo," it is still in use today. Daguerre used a plate which measured about 6 x 8 inches, and it is from this size that other daguerreotype plates are derived. Simply, the process uses mercury vapor to develop the photographic image and a concentrated solution of sodium thiosulfate to fix it (by washing out unexposed silver iodide), thus reducing the necessary exposure time from seven or eight hours to about 20 minutes.

The first announcement of the process for making a daguerreotype was made in August 1839, at a meeting of the French Academy of Science. The date is usually considered to mark the beginning of photography. The process was patented in the United States and England on August 14 but was given by the French government "free to the world" five days later. Daguerre's invention received serious consideration early on, thanks to the support of Francois Jean Dominique Arago

Jean-Baptiste Sabatier-Blot. *Portrait of Louis-Jacques-Mande Daguerre.* 1844.

(1786–1853), director of the Paris Observatory and permanent secretary of the Academy of Science.

The invention earned its maker the Legion of Honor award and a lifetime annuity from the French government.

Daguerreian Society: Founded in 1988 and having 850 members, the Daguerreian Society is an organization dedicated to the history, science, and art of the **daguerreotype**. Many members are collectors.

daguerreotype: One of the two first photographic processes, which were both introduced in 1839, and the one that was most workable and dominant until 1850. The daguerreotype process was primarily a **portrait** medium that was executed in a **studio**. Announced in 1839 by **Jacques-Louis-Mande Daguerre,** it consisted of a copper plate coated with silver that was highly polished. The plate was then treated with iodine vapor and became light sensitive. It was then put in a camera

Daguerreotype. *Henry James, Sr., and Henry James, Jr.* James Family Photographs, Houghton Library, Harvard University, Cambridge, Massachusetts.

and a picture was taken. After the plate was developed in mercury vapor, which is highly toxic, a distinct photographic image appeared on the polished silver surface. A daguerreotype can be identified by the polished silver surface, which resembles a mirror, with an image upon it. The earliest daguerreotypes tend to have bluish or slate-gray tones; a brown-toning process called gilding came into widespread use in 1840. Daguerreotype images are very fragile and are kept under glass and typically in an ornate case, often lined with velvet.

These images are quite detailed and, being the first practical photographic process, were extremely impressive to those who saw them in the 1840s and still are today. By the 1850s, less expensive methods for making photographs were gaining popularity, and by 1860 daguerreotypes had become obsolete, though they are still considered one of the most beautiful of photographic processes and are highly collectible.

daguerreotype plates: These are terms frequently seen in auction catalogues to indicate the size of daguerreotypes: full plate is 6 ½ x 8 ½, half plate is 4 ¼ x 5 ½, quarter plate is 3 ¼ x 4 ¼, one-sixth plate is 2 ¾

The Discovery or Invention of M. Daguerre.—This method of obtaining an exact pictorial image in light and shade of any object by means of a sort of camera obscura, is pronounced on all hands, even by learned men of the French Institute, an astonishing and marvellous discovery. A Mr. Talbot (English) has made an unsuccessful attempt to share the honor with Mr. Daguerre. By the further investigations of this extraordinary apparatus, as made by those two eminent philosophers and mathematicians, Arago and Biot, it is established beyond a doubt, that pictures may thus be taken of a house, for example : reduced to the dimensions of an inch, even the tiles of the roof of which, and the panes of glass, are found by the microscope to be of an exact perfection and truth. The whole done by merely exposing the apparatus to the light of the sun for ten minutes. Arago has no doubt, as the moon's light is sufficient to act on the very sensitive surface of this apparatus, that we shall derive a perfect image of the surface of that planet. Mr. A. has recommended M. Daguerre to the patronage of the King and of the nation for this discovery, which confers such fame upon the author. M. Daguerre had been 10 years engaged in it, and it was only within the year that he could contrive a material (paste) whose ingredients possessed sufficient sensitiveness to the rays of light to have the image to be taken before a change was effected in the reflection by clouds, or other causes on the sun's disc.

Boston's *Daily Advertiser and Patriot* on September 25, 1839 published the first major announcement in America of Daguerre's discovery "for fixing images or objects by the camera obscura." Collection of the authors.

x 3 ¼, ninth plate is 2 x 2 ½, and sixteenth plate is 1 ⅜ x 1 ⅝. There were even smaller sizes for rings and amulets. Since daguerreotypes were expensive, the smaller sizes were the most popular and full plate sizes are quite rare.

Dahl-Wolfe, Louise (1895–1989)

American comemrcial photographer

One of the most celebrated photographers of the 1930s, '40s, and '50s, Dahl-Wolfe had a long and productive career as a top fashion and commercial photographer, notably her 22-year association with *Harper's Bazaar* as a staff photographer.

Born and educated in San Francisco, she became interested in photography after meeting **Annie Brigman**, an early proponent of photography as fine art. In her early twenties she moved to New York and found work as a designer of electric signs and then as a decorator. She acquired an Eastman bellows camera and took her first pictures of her mother; she then took nudes of friends and herself on a beach in the soft-focus style of Brigman.

Concentrating on photography, she moved with her husband, Mike Wolfe, a sculptor whom she had met in Tunisia in 1928, to a cabin in the Great Smoky Mountains, where she took a series of still-lifes of landscapes and mountain people. After returning to New York, she was introduced to Frank Crowninshield, the publisher of *Vanity Fair,* and he took an immediate liking to her pictures of her Tennessee neighbors and published her work.

She was hired by *Harper's Bazaar* in 1936 and evolved into one of the leading photographers of the magazine and the era. She was an early user of color and was known for her exquisite technical skills and feminine delicacy of style. After leaving *Harper's* she worked for *Sports Illustrated* and *Vogue* before retiring in 1960 to New Jersey, where she stayed active in photography until she died.

Daitz, Evelyne Z. (1936–)

American gallery director

As president and director of the Witkin Gallery, Daitz is an important figure in the contemporary photography scene. She became head of the gallery after the death of its founder, **Lee D. Witkin**, and has also been active as a lecturer on photography and juror for photo shows throughout the United States.

Born and educated in Geneva, Switzerland, Daitz worked from 1976 to 1984 as assistant to Witkin. She has participated on panels and lectured at such institutions as New York University's Tisch School of the Arts, the Rhode Island School of Design Museum of Art, and Harvard University's Carpenter Center. In 1994 she published *The Witkin Gallery 25th Anniversary Book,* a selection of 25 photographs with an introduction by **Peter C. Bunnell**.

Danziger, James (1954–)

American gallery director

Danziger's eponymous New York gallery is considered one of the top photo galleries in the nation.

After graduating from Yale University in 1975, Danziger wrote *Interviews With Master Photographers* before heading off to London to work at the Photographers Gallery and then as picture editor of the *London Sunday Times* magazine. He was subsequently the features editor of *Vanity Fair* and the first photographic consultant for *The New Yorker.* He also completed a book on **Cecil Beaton** and is an editor of the anthology *Visual Aid.*

In 1990 he opened his gallery. Danziger says his interest is in the classic traditions of photography from the nineteenth century to the present. The gallery represents a wide range of photographers from **Henri Cartier-Bresson** to **Annie Liebovitz** to the estates of John Kobal and **Harold Edgerton**.

dark cloth: An opaque cloth that is used to block extraneous light from striking the ground glass of a **view camera**. The cloth is used as a hood over the camera and the photographer.

darkroom: A light-proof room for the handling of photographic materials that are light sensitive. While film is sensitive to all types of light and must be handled in total darkness, most black-and-white photographic papers can

be handled using a **safelight,** a reddish-brown dim light, in the darkroom. This is the room where photographic printing is done.

database: a collection of data that can be quickly and easily accessed, such as names and addresses, financial information, or images. Image databases are often used for digital storage and retrieval by picture libraries. The success of an image database depends on the way that the library or photographer catalogues the collection. Most use a system of keywords that cross references attributes of the images.

Dater, Judy (1941–)
American portrait photographer
Known primarily for her emotionally intense portraits of women, Dater has produced a body of work that express-es her intuitive awareness of her own psychology and her interest in exploring the lives of people around her.

Dater studied at the University of California at Los Angeles from 1959 to 1962 and received bachelor of arts and master of arts degrees from San Francisco State University (1963, 1968). At the latter school she studied photography with Jack Welpott. Dater later worked with Welpott on a project in which they photographed the same people but each did so his or her own way. Their collaborative effort was published as *Women and Other Visions.* Dater's friendship with **Imogen Cunningham** led to another book; for this one she interviewed and photographed friends and relatives of Cunningham after her death.

Dater has won a **Guggenheim fellowship,** a **National Endowment for the Arts** grant, and a **Dorothea Lange** Award. Her work has been exhibit-ed widely in galleries and museums in the United States and abroad.

Davidson, Bruce (1933–)
American portrait and documentary photographer
Davidson's portraits and documentary photo essays brought him early recognition; he was a member of **Magnum Photos** agency before he was 30, in 1958.

Born in Chicago, he was interested in photography

as a child. In high school he worked in a camera store and later as an assistant to a photographer. At 18 he won a national **Kodak** photography competition, then studied photography at Rochester Institute of Technology. Strongly influenced by the work of **Robert Frank**, **Henri Cartier-Bresson**, and **W. Eugene Smith**, he went on to study at Yale University with Josef Albers. He was in the military from 1955 to 1957, and then Davidson joined *Life* as a freelancer in 1957. In 1966 he had a one-man exhibition at the Museum of Modern Art in New York.

He received a **Guggenheim** award to document the civil rights movement in 1962 and from 1966 to 1968 spent two years documenting a New York City block. This latter project, the first photography grant funded by the **National Endowment for the Arts**, resulted in his book *East 100th Street,* which the art critic Hilton Kramer said is "significant precisely for the extent to which it transforms the sociological cliches of 'ghetto life' into visual images of great power."

A monograph of his photos was published in 1978, and, in 1986, Davidson published *Subway,* the result of a six-year-long effort. A collection of color images of sub-way riders, on the trains or platforms, and vistas of the city from train windows, it was accompanied by Davidson's text telling about the images.

Day, F. Holland (1864–1933)
American allegorical photographer
Fred Holland Day was an eccentric, independently wealthy Bostonian who was considered a dilettante, but he actually produced an interesting body of pictorial photography. In addition to being a publisher, in part-nership with Herbert Copeland, of fine books of poetry and other literary works, Day took up photography in the 1880s.

The composition, design, and overall effect of Day's photographs were informed by his artistic interests in **allegorical** or literary themes. He often posed cos-tumed figures and employed props in the manner of pre-Raphaelite painters. He created a series of religious images in which he himself was the Christ figure, depict-ing scenes from Christ's life—the baptism, raising of

Lazarus, betrayal, crucifixion, descent from the Cross, entombment, and resurrection.

Day's discreet images of male nudes were considered less controversial, thanks to the special lenses, blurring techniques, and controlled lighting he used.

In 1895 Day was elected to membership in the exclusive British society **The Linked Ring**, and his work was exhibited at the New York Camera Club in 1898. Although he corresponded with **Alfred Stieglitz**, Day was not a member of the **Photo-Secession**, preferring to go his own way as a **Pictorialist**. Day's cousin, the photographer **Alvin Langdon Coburn**, was a contemporary.

In 1904 Day's studio was destroyed by fire, and he lost much of his work. By 1917 Day had given up photography and, suffering from severe depression, remained bedridden until his death.

daylight: Light from the sun. The light during the day. The natural light between sunrise and sunset. Film is designated as "daylight" or "tungsten" (for use with artificial light).

deadline: A due date and time for the delivery of an assigned photograph or article. In publishing, the deadline represents the latest time that a photograph can be received and still used. Failing to meet a deadline can result in losing the opportunity to work for a publication.

Deakin, John (1912–1972)

British documentary and portrait photographer

Deakin's documentary images of London, Paris, and Rome and his portraits of friends and Soho drinking companions constitute a memorable body of images remarkable for their power. Of his subjects he once wrote, "Being fatally drawn to the human race, what I want to do when I photograph it is to make a revelation about it. So my sitters turn into my victims."

He was a talented photographer with an acute and unmerciful eye, but his erratic behavior and self-destructive alcoholism marred the progress of his career. He was employed by British *Vogue* and became the only staff photographer to be fired twice by the same editors. Deakin's

images of the 1950s cover a wide range of personalities—writers, artists, beggars, fashion models, and film personalities. Among the friends he photographed were Lucian Freud, Dylan Thomas, and Francis Bacon, who used Deakin's photos as art reference for his paintings. Deakin's portraits were never idealized or romanticized. His mastery of composition, radical cropping, and lack of style was unique in his era.

Born in Cheshire to a working-class family, Deakin left school at the age of 16 to paint and travel. He enjoyed modest success as a painter and began his life's work in photography when he was living in Paris before World War II. Inspired by the work of **Eugène Atget**, Deakin followed in his footsteps, portraying scenes of daily life as Atget had done before him.

Deal, Joe (1947–)

American landscape photographer and teacher

Deal is a major contributor to the New Topographic Movement in photography, continuing the tradition of early **landscape photographers** but including in the camera's eye the human-made elements that now occupy the twentieth-century landscape. As noted by the publisher of Deal's book of Southern California photographs, 1976–1986, "Deal photographs modern urban sprawl from a vantage point which reveals a sophisticated structure in the seemingly arbitrary placement of tract houses, telephone poles, golf courses, and material trappings of urban life."

A 1970 graduate of the Kansas City Art Institute, Deal earned master and master of fine arts degrees from the University of New Mexico. He taught at the San Francisco Art Institute and the University of California at Riverside before becoming dean of the School of Fine Arts at Washington University in St. Louis in 1989. Deal's work has been exhibited widely, and he has won awards in photography from the **Guggenheim** Foundation and the **National Endowment for the Arts**.

De Carava, Roy (1919–)

American documentary photographer and teacher

The first African-American to win a **Guggenheim fellowship** (1952), De Carava has achieved recognition for

his photographs of Harlem, including street scenes, interiors, and portraits.

A native New Yorker, he originally studied to be a painter. Under the tutelage of the artist Charles White, De Carava was encouraged to focus on human concerns and social conditions in his work. De Carava started to use photography as a reference resource for his paintings. However, he became increasingly interested in photography as an art form, and it evolved into his principal medium of expression.

His first subject was Harlem, and his studies of everyday life were incorporated into the 1955 book *The Sweet Flypaper of Life,* with text by Langston Hughes. The same year, **Edward Steichen** selected many of De Carava's images for his landmark **"Family of Man"** show at the Museum of Modern Art.

From 1954 to 1956 he created and directed A Photographers Gallery in New York, one of the first galleries to show photography as fine art. His own work of this period included portraits of jazz greats like Billie Holiday, Sarah Vaughn, John Coltrane, and Duke Ellington.

In the 1960s he worked on assignments for *Look, Life, Time,* and *Newsweek* and from 1968 to 1975 was a contract photographer for *Sports Illustrated.* He also began teaching in the 1960s, first at Cooper Union and since 1975 at Hunter College, where he has been a professor of both art and photography.

In 1998, more than 200 of his images were featured in a traveling retrospective—with stops at the Corcoran in D.C. and the San Francisco Museum of Modern Art—curated by his wife, Sherry Turner De Carava, in conjunction with the Museum of Modern Art in New York City.

De Cock, Liliane (1939–)

Belgian-born, American landscape and nature photographer

Born in Belgium, De Cock emigrated to the United States in 1960 and has become known for her western landscapes and, more recently, for her photography of found objects. After a brief stay in New York City, she moved west and was hired to spot photographs for **Ansel Adams**. She worked with him until 1972, at the

Yosemite Valley Workshops, and became a trustee of **Friends of Photography**. Adams's influence is evident in De Cock's large-format black-and-white views of rural scenes, featuring brooding skies, isolated farmhouses, and stucco churches. After her marriage to Douglas Morgan, she moved east and continues to photograph as well as design and edit photography books for Morgan & Morgan publishers.

Delano, Jack (1914–)

Russian-born, American photojournalist

Working for **Roy Stryker** in the Historical Section of the **Farm Security Administration** (FSA) from 1940 to 1943, Delano traveled throughout the eastern seaboard of the United States, documenting the struggles of migrant workers before being sent to Puerto Rico on a three-month assignment. After World War II began, this socially conscious photographer continued his explorations of problems facing the country in assignments that, he hoped, would portray "ordinary working people with the same compassion and understanding that Van Gogh had shown for the peasants of Holland with pencil and paintbrush." He photographed the homefront contributions of ethnic and minority groups to the war effort.

Born in the Ukraine, at the age of nine Delano emigrated with his family to the United States. He grew up in Philadelphia and studied at the Pennsylvania Academy of the Fine Arts. After his FSA work he served three years in the army before settling in Puerto Rico with his wife, the graphic designer Irene Esser. In Puerto Rico, Delano has participated in the island's cultural life as a photographer, filmmaker, television station director, book illustrator, cartoonist, and composer. His autobiography, *Photographic Memories,* was published in 1998.

Demachy, Robert (1859–1936)

French impressionistic photographer

Working in an impressionistic, soft-focus style and known for his creative manipulation of his images, Demachy occupied in France a position similar to that of **Alfred Stieglitz** in the United States—as the leading figure of the **Pictorialist** movement.

Born into a wealthy banking family, he had the free-

dom to pursue his artistic interest in photography, music, and literature. In 1894 he started to make prints by the gum biochromate process, which allowed him to express his painterly approach to photography.

In 1895 he had his first one-man show at the Photo-Club de Paris. Many of his photos depict young girls portrayed in a romantic atmosphere. A member of the British photographic society **The Linked Ring**, he also published in Stieglitz's *Camera Work* and exhibited at the **291** gallery. After 1914, Demachy stopped shooting and turned to writing about photography. He eventually published more than 1,000 articles on photographic techniques and aesthetics, always maintaining the aesthetic view of photography as an art.

Demarchelier, Patrick (1943–)

French fashion and portrait photographer

A top-ranking fashion, commercial, and celebrity portrait photographer, Demarchelier was the first non-British photographer invited to photograph a member of the Royal Family. His photographs of the late Princess Diana with her children appeared first in the December 1989 issue of British *Vogue*.

Born near Paris, Demarchelier grew up in Le Havre, France. He acquired his first camera at the age of 17. His first full-time photographic job was in a small laboratory in northern France where he printed and retouched passport pictures. At the age of 20 he moved to Paris, taking a succession of jobs, first as a darkroom assistant and later as a photo assistant, until he became house photographer to the Paris Planning fashion agency. After a year he took another assistant position, this time with fashion photographer Hans Feurer. His own first assignments in the early 1960s were for *Elle* and *Marie-Claire*.

In 1975 he moved to New York where he worked with *Glamour, Mademoiselle, Vogue, Life, Rolling Stone*, and other periodicals. Since 1992 he has worked with *Harper's Bazaar*/Hearst. His fashion photographs are admired for their realism and spontaneity, and he has become equally sought after for his portraiture.

His photos are on the record album covers of such stars as Madonna, Elton John, Mariah Carey, and Quincy Jones. His movie and publicity campaign credits include *Bulworth, Dick Tracy*, and *Mystic Pizza*. He boasts an impressive list of commercial clients that include cosmetic companies, designers, and exclusive retailers.

Demarchelier's first book, *Patrick Demarchelier Fashion Photographs*, was published in 1989. A second collection of his photographs, *Patrick Demarchelier Photographs*, was published in 1995.

De Meyer, Baron Adolph (1868–1946)

French-born, American fashion and portrait photographer

Born in Paris, De Meyer had a long and productive career in Europe and the United States as a fashion and portrait photographer. He spent his early childhood in Germany and started taking photographs in the 1880s, when interest in photography as an art form was aided by new technical developments that permitted unprecedented effects in prints. De Meyer was influenced by **Pictorialist** techniques and by friendships with **Alfred Stieglitz**, **Gertrude Kasebier**, and **Alvin Langdon Coburn**. In 1903 he became a member of **The Linked Ring**, a British photographic society.

De Meyer exhibited at salons in Berlin before traveling to London in 1895. A very wealthy, artistic young man, he was welcomed into the highest social circles, where he would meet his wife to be, Olga, godchild of Edward VII. De Meyer documented the figures of their social set, including Sergei Diaghilev, Condé Nast, Coco Chanel, and Edward. His work was admired by Stieglitz, who exhibited De Meyer's photographs in New York at **291** gallery and published his photogravures in *Camera Work*.

In 1912, De Meyer took his classic album of photographs of Nijinsky and the Diaghilev dancers in *The Afternoon of a Faun*, in Paris at the Theatré du Châtelet. As World War I approached, the De Meyers moved to New York. He signed a contract with Condé Nast, publisher of *Vogue* and *Vanity Fair* magazines, and his celebrity portraits and elegant and romantic fashion images were immediately successful. In 1922 he left *Vogue* to write and take photographs for *Harper's Bazaar* in Paris. He was let go in 1932 because the editor, Carmel Snow, was looking for new talent. De Meyer remained in Europe until 1938,

Baron Adolphe de Meyer. *Olga.* c. 1902. Courtesy G. Ray Hawkins Gallery, Santa Monica, California.

when he returned to the United States, settling in Hollywood for the remainder of his life.

densimeter: Also called a densitometer, a device for measuring how much **light** can pass through or is reflected from a photographic negative. *Density* is a term that refers to how transparent the negative is, with the areas of least density being those that represent darkness in the image and the densest areas corresponding to the areas of brightness.

Depardon, Raymond (1942–)

French photojournalist

A cofounder of **Gamma** photo agency and later a **Magnum** photographer, Depardon has produced a varied body of work, including war photos in Vietnam and feature stories and celebrity sightings for magazines. He has also been a film director.

Born in Villefranche-sur-Saone in France, he took his first photos on his family's farm. He worked for several months as an apprentice to a photographer-optician before moving to Paris in 1958, where he worked as assistant to the photographer Louis Foucherand. He became a reporter for the Dalmas Agency in 1960 following an expedition to the Algerian Sahara. With three other photographers—Hubert Henrotte, who worked for the newspaper *Figaro*, Hugues Vassal, and Leonard de Raemy—he was a cofounder of the cooperative Gamma agency. Soon joined by a young photographer named Gilles Caron, the young agency quickly established its journalistic reputation. Depardon was imprisoned in Chad for a month in 1970, along with Caron, who later disappeared while traveling from Cambodia to Vietnam.

Like the loss of **Robert Capa** that Magnum suffered, Caron's death inspired the Gamma agency to persevere in his memory. In 1973 Depardon was awarded a Robert Capa gold medal, along with David Burnett and Chas Gerretson, for their book *Chili*. At the end of the 1970s he did an in-depth study of a psychiatric hospital in Venice called San Clemente. Depardon later left Gamma and became a member of Magnum, serving as European vice president in 1980. In 1984 he took part in the DATAR project to photograph the French rural and urban landscape. He was awarded the Grand Prix de la Photographie in 1991. His work has been published in several books, including *Raymond Depardon: Correspondence* (1986) and *San Clemente* (1984).

depth of field: The area that is in focus in a photograph. Some photographs have a large depth of field—that is, many things from the foreground to the background are in focus. Other photographs have little, or shallow, depth of field, with only a thin slice of an area in focus and the background very fuzzy. Depth of field is controlled by the size of the opening of a lens, called the **aperture**. The smaller the aperture, the more depth of field; the larger the aperture, the less depth of field.

desktop publishing: The process of home or self publishing in which text, graphics, and images are combined in an overall design concept packaged for outside distribution. Computer programs such as Quark Xpress and Adobe Pagemaker are the industry standard for desktop publishing.

Detroit Publishing: A publishing company active at the beginning of the twentieth century that produced beautiful **postcards** of the United States using the most advanced printing technology of the time. **William Henry Jackson,** the renowned landscape photographer of the American West, joined the company and, with a staff of other photographers, traveled across America making images of the people, places, industry, and scenery during the early 1900s. At its height of popularity, the company sold more than 7 million images of the United States worldwide in a single year. This important photography collection is now housed in the **Library of Congress** and the Colorado Historical Society.

developing: The term used to describe the chemical process of making an image appear on photographic film and paper. When film and paper are exposed, there is a **latent image**. The basis for the image has been created, but no image is seen until the film or paper has been developed through a series of chemicals.

diaphragm: A movable set of thin plates that create an adjustable opening in the center of a **lens.** The opening is called the **aperture,** the apparatus that creates the opening is the diaphragm.

diffraction: The tendency of light to spread slightly as it passes through an opening.

diffusion: The scattering of a direct beam of light in most directions. In photography, diffused light produces a less harsh shadow and a softer effect in the picture.

digital camera: A camera that changes visual data into electronic digital information, which then can be viewed or manipulated on a computer.

Olympus D-220L Digital Camera. Courtesy Olympus America, Inc.

digital desktop darkroom: A combination of electronic equipment, including a **digital camera,** a **scanner,** a **computer,** an **ink jet printer,** and a **modem,** that enables a user to create, process, and transmit photographs without any of the traditional photo equipment, such as paper, chemicals, and film.

digital image: An image that has been fed into a **computer,** by a process called **scanning,** becomes digital. Digital images are made up of tiny increments of tone and color, called **pixels,** which can be altered and manipulated by group or individually.

digital photography: Photography made by the use of **computer** technology in which an image is made up of

bits of information that can be duplicated without losing resolution and altered individually or in groups. Digital photography can be made by (1) **scanning** a traditionally produced photograph, negative, or slide; (2) taking a picture with a **digital camera,** which stores the information on a disk or internal hard drive; or (3) taking a picture with an electronic still video camera. The quality and resolution of the **digital image** are best when done from the traditional print or film, second best when done with the digital camera, and third best when done with the still video camera. Improvements in digital technology that computer and camera manufacturers are expected to offer include better-quality images, lower prices, and greater creative possibilities. In digital photography the most popularly used computer program for working with images is Adobe **Photoshop,** which is widely used in industry and academia and is available to anyone with a reasonably powerful computer.

dimmer: A device used to adjust the intensity of light in incremental stages, from very bright to dark and everything in between. Dimmers are usually found in photo **studio**s, where illumination needs to be adjusted to suit the situation being photographed.

DIN: The European system for designating how sensitive film is to light, just as the **ASA** or **ISO** rating is the American version. Most **films** are provided with both ASA and DIN film rating systems. Most cameras adjust automatically to the ASA film rating when the film is inserted into the camera.

diorama: A small-scale model of a scene with a painted or photographic background and assorted three-dimensional objects in the foreground to re-create a scene from nature or life. Natural history museums often use dioramas to depict scenes of ancient peoples or wild animals. Architects make table-top dioramas to show projects to prospective clients.

direct color separation: A method used in making color separations with a **halftone** screen over the copy, resulting in screened negatives directly

in one operation. Separation filters are used.

direct positive: A photographic material that produces a **positive image** directly from another positive, without the use of a negative. Slide film is a direct positive process. Ilfochrome (**Cibachrome**) is a direct positive paper for making prints directly from slides.

disc camera. An easy-to-load camera developed by the **Kodak** company in the 1980s that featured negatives arrayed on a disc; the camera was able to take 15 exposures each one $\frac{5}{16}$" x $\frac{1}{2}$". Manufactured until the early 1990s, the disc system was not especially popular.

Kodak Disc Camera negatives. © Fred W. McDarrah.

Disderi, André Adolphe-Eugène (1819–c. 1889)
French documentary and narrative photographer,
and inventor
Disderi, a successful photographer who worked in a variety of genres documenting sites and landscapes, war reportage, architectural interiors, and narrative tableaux—is best known for inventing and popularizing the *carte de visite*. He patented his invention in 1854, and his idea for affixing a portrait to a card and making the card available at reasonable cost made his product appealing to a wide audience. A creative businessman as well, he increased demand by putting the name of his studio on the back of each card.

He first worked as a **daguerreotypist** in Brest and later opened his own studio in Paris, where he produced his early *cartes de visite*. Upon their great success, he opened a second Paris branch and later opened studios abroad in Madrid and London. His success paralleled the popularity of his invention, and as public interest in the fad of collecting the *cartes de visite* waned, his business eventually failed. He spent his last years in Nice as a beach photographer.

Disfarmer, Michael (1884–1959)
American documentary photographer
Disfarmer lived in Heber Springs, a small village in Arkansas, where he produced a set of portraits of plain country people that provide a unique record of rural life in mid-America in the 1940s.

Born Michael Meyer in Indiana, he moved to Heber Springs with his mother and had a photo studio on their back porch. His mother was killed in a tornado that destroyed their house in 1940. At that time he changed his name to Disfarmer, moved into a larger studio, and concentrated on taking portraits. His sitters were cotton farmers and their families, and they came to the studio sometimes in their Sunday best, sometimes in work clothes. They were awkward and provincial, and these qualities show in the pictures.

Disfarmer's work was brought to national attention 15 years after his death by the editor of the *Arkansas Sun,* Peter Miller, who published some of Disfarmer's photographs in his weekly newspaper in Heber Springs and later collaborated with Julia Scully, editor of *Modern Photography* magazine, on a book about Disfarmer.

disposable camera: A cardboard camera with film, usually 24 exposures, already loaded. The entire camera is sent off for film processing, and only the finished prints are returned.

distortion: An unnatural representation of scale and **perspective** in a photograph, typified by a stretching or bending of things that are not so in reality. While all photographs are actually a distortion since they are two-dimensional representations of a three-dimensional world, in photography we consider distortion that which is an extreme misrepresentation, particularly one that is comical or grotesquely unreal. Both **André Kerétz** and **Weegee** created humorous distortions.

dithering: A method for making digitized images appear smoother by using alternate colors in a pattern to reproduce a new perceived color—displaying an alternate pattern of black and white **pixel**s produces gray.

Dixon, Henry (1820–1893)
Early British architectural photographer
Hired originally to print negatives taken by Alfred and John Bool for the Society for Photographing Relics of Old London, a preservation group established in 1876 to document historic architecture threatened by urban development, Dixon achieved recognition for his own architectural views. Dixon worked with his son, Thomas James, both printing and photographing for the Society's project, which remains an outstanding record of Victorian London houses, inns, and streets.

Apprenticed and trained as a printer, Henry Dixon had become a professional photographer by 1864. In 1869, he was commissioned by the city of London to photograph the building of the Holborn Viaduct. Dixon's son continued the Dixon and Son photographic business after Henry's death until the early 1940s.

documentary photography: Documentary photography is dependent on the medium's ability to portray actual fact in an unaltered way. A more accurate term is *documentary style*, indicating that it's an attempt at truthful representation while acknowledging the photographer's artistic, political, and ethical choices. Documentary photography is often used for a social or political end. Just after the Civil War, photographers went into the unexplored American West and made documentary photographs of the landscape to encourage preservation. Those photographs helped the U.S. Congress establish Yosemite as the first National Park. At the beginning of the twentieth century, **Jacob Riis** documented squalid urban living conditions and **Lewis Hine** made documentary photographs of child labor conditions in an effort to enact laws to protect children. During the Great Depression, photographers with the **Farm Security Administration** made photographs of the plight of farmers suffering from the drought and Depression. The tradition continues today, mostly in **photojournalism**, to deal with important social and political conditions.

dodging: Blocking the light on the image that is

This photograph taken with a fish-eye lens shows one example of distortion. © Fred W. McDarrah.

projected by an **enlarger** onto developing paper. Light can be hand dodged, or dodging disks may be interposed between the enlarger and the image. The purpose of dodging is to lighten dark areas. Burning is the opposite of dodging and darkens areas that are too light.

Doisneau, Robert (1912–1994)
French documentary photographer

Chronicler of the streets of Paris, Doisneau had a long and successful career capturing the *joie de vivre* of the people and atmosphere of the city he loved. His photos, apart from their intrinsic appeal as humanistic works of art, document his chosen sphere from the 1920s to the 1980s, including prewar Paris and its outlying suburbs, the Nazi occupation, street people, children, new buildings and neighborhoods, and famous and glamorous people. Among his best known images are *Baiser de 'Hotel de 'Ville,* showing a couple kissing on the street near Paris's City Hall; Picasso's croissant "fingers"; and a wedding party walking down a country road.

At his first job, as a letter engraver in a pharmaceutical firm, he was required to learn photography. He was soon convinced that he wanted to be a photographer for his life's work and entered the profession as an industrial photographer for Renault, where he took pictures of assembly lines and car parts, sometimes as publicity shots. By the time he was fired, for chronic lateness, in 1939 he had acquired his Rolleiflex and saved enough money to set up a darkroom at home. He worked as a freelance photographer until the war came, when he forged documents for the Resistance.

After the liberation of Paris, he joined the Rapho photo agency. Doisneau's work has been exhibited in galleries and museums in France and abroad. He published almost 30 books. The first, an homage to his youth called *The Suburbs of Paris,* was published in 1949 with text by Blaise Cendrars.

Dorr, Nell (1895–1988)
American portrait and art photographer

Dorr earned her living as a portrait photographer, but her best work, done on her own, portrayed the intimate feelings between mothers and children.

Born in Cleveland, Dorr learned photography from her father, John Jacob Becker, a chemist who worked on perfecting dry plates. He also was a professional photographer whose work illustrated the catalogs of the Baltimore and Ohio Railroad. Her father made her first camera for her as a seventh-birthday present, and she learned to process plates in the darkroom.

She did not turn to photography as a profession until she was in her thirties. Her family had gone through a series of personal tragedies, and her father helped her to return to a kind of expression that had been dear to her at a time when she was emotionally secure.

She started her career photographing famous men. A collection of 36 portraits constituted her first major show, at the Delphic Gallery in New York; she married one of her subjects, the noted chemical engineer Dr. John Von Nostrand Dorr.

Dorr became acquainted with **Edward Steichen** and **Alfred Stieglitz** and participated in the **"Family of Man"** show. She published several books, the most important of which was *Mother and Child,* a poignant story of the life of her daughter, who died before she turned 40.

double exposure: The term used when one negative has two separate exposures on it, resulting in a second image being superimposed on the original exposure. Double exposures may occur accidentally, when film in a camera such as a **Rolleiflex**, which requires manual advancing, does not properly advance, but some photographers double expose deliberately in order to achieve a desired artistic result.

Dow, Jim (1942–)
American documentary photographer

Dow's subjects, first in black and white and then in color, portray the American vernacular—old signs, movie theaters, diners, cars, motels, billboards, Masonic lodges, sports scenes, and barbershops and buildings—that make up the landscape of ordinary life. Influenced early by **Walker Evans**'s *American Photographs,* Dow worked for Evans as a printer after his graduation from the Rhode Island School of Design.

Pages 114 – 115: Robert Doisneau. *The Superior Animals,* 1954. © Robert Doisneau. Courtesy te Neues Publishing Co., New York.

Dow participated along with twenty-four other photographers in a survey of American courthouses sponsored by the Seagram company in 1976. Dow photographed more than 200 buildings. His multi-image panoramas of sports arenas have been reproduced in periodicals and widely exhibited. He has been on the faculty of the Boston School of the Museum of Fine Arts and won **National Endowment for the Arts**, Mellon Foundation, and Maine Photography Workshop grants.

download: The act of transmitting data (such as a photographic image) from a central **computer** or network to an individual terminal or other device such as a printer.

Draper, John William (1811–1882)
Pioneering American photographer and educator
Draper is generally regarded as the first American photographer to produce fine-quality **daguerreotypes**.

Many historians credit him with making the first successful **portrait** (subject unknown), in 1839. In 1840 he took what is believed to be the first photo of the surface of the moon, which he presented to the Museum of Natural History in 1840. He was also a friend and collaborator of **Samuel F. B. Morse**, and the two opened a photo studio together in 1840. Draper advised Morse in creating his legendary Code.

He was also a chemistry professor and later president of New York University, his association with the school stretching from 1837 until he died 45 years later.

drum scanner: A high-end scanning device for transparencies, prints, or negatives. Drum **scanner**s usually have a higher dynamic range than flatbed or film scanners, and are capable of higher resolutions, but tend to be much more expensive.

drying processes: Photographic prints can be dried using a heated roller or by sandwiching individual prints between blotting paper and letting them air dry. How the drying is done can affect the outcome of the material, particularly the surface of photographic paper, which can be dried to appear very glossy or less glossy.

dry mounting: A process for attaching a photograph or other paper to mounting board using a special dry mounting tissue with heat and pressure. The tissue is placed between the photograph and mount board and put in a press that is heated. The heat and pressure cause the tissue to bond the photograph to the board.

dry plate photography: In the nineteenth century, the **collodion process** was the most often used to produce a negative. The process entailed using a **glass plate** coated with collodion that was then sensitized and used while wet. By 1880, collodion was replaced by **gelatin,** which was used dry—hence the name, dry plate photography. For a short time there was a dry-collodion process, but it was very slow. Dry plate photography usually refers to the gelatin process.

drystamp: See **blindstamp**.

Du Camp, Maxime (1822–1894)
French travel photographer and writer
Du Camp was awarded the French Legion of Honor for his illustrated book *Egypt, Nubia, Palestine, and Syria,* published in 1852 after a two-year trip he took there with his friend the novelist Gustave Flaubert. A dilettante who enjoyed travel and writing, he obtained a government commission for his book to document the great monuments of the Near East. His **calotypes** of pyramids, the Sphinx, and other exotic subjects were critically acclaimed for their artistic composition and the clarity of the smallest detail.

Du Camp had fought in the French Revolution of 1848 and also in Italy with Garibaldi in the war to unify that nation. As founder of the *Revue de Paris,* he was able to help his friend Flaubert by publishing his novel *Madame Bovary.*

dummy: The rough draft, or preliminary **layout,** of a newspaper, magazine, or book, indicating the placement of text and illustration on each page. The dummy pages are prepared by makeup artists under the direction of the publication's art director and approved by the editors.

Duncan, David Douglas (1916–)

American photojournalist and art historian

One of his era's most prolific and thoughtful photographers, Duncan earned Photographer of the Year honors for his Vietnam War coverage in 1968. In his varied career he also wrote books about Picasso and covered political conventions for TV network news.

Duncan earned his college degree in zoology, taking up photography only as a hobby. He was assigned to photography units during World War II, covering everything from guerrilla fighting to the Japanese surrender. He earned a Purple Heart and a Distinguished Flying Cross. His work led to a staff job at *Life,* and he worked there from 1946 to 1956. He left the magazine to pursue a freelance career, working for ABC and NBC, *Life,* and *Collier's*; he also did independent work on art, nature, and travel. He had a landmark show in New York on Picasso's 100th birthday in 1981, featuring 250 of his pictures of the artist taken over several years, mostly of him at work and at leisure in the South of France.

Dunmore, John L., and George Critcherson

(active 1865–1875)

American documentary photographers

In 1869 Boston photographers Dunmore and Critcherson accompanied the marine painter William Bradford (1823–1892) on an expedition to the Arctic. Using the photographs as reference, Bradford later painted scenes of the Arctic wilderness that won great acclaim in the United States and England.

Like the landscapes of the post–Civil War geological survey photographers, the Dunmore and Critcherson images are compelling in their description of human activity against the backdrop of an awesome and beautiful nature. The polar bear kill in *Hunting by Steam* would also have aroused the Victorian passion for adventure.

Carrying unwieldy equipment (large 14 x 18-inch plates and a cumbersome **wet plate process** that required on-site preparation) and combating climatic problems (the strong reflecting light on ice and snow cre-

ated difficulties in photographing), Dunmore and Critcherson still managed to expose nearly 200 plates. In 1873, *The Arctic Region,* an album of 139 images, including both full-plate and smaller illustrations, was published in London.

duotone: A commercial printing technique for **black-and-white photographs** that uses two colors of ink. This effect can be used dramatically to create a distinctive color in the image or subtly to effect a mood. Most photographic reproductions in better books are duotones.

duplicate images: In photography, a term used to indicate that a copy has been made directly from a negative or slide, differentiating it from a copy that is made from a print. Generally, dupes are more accurate in terms of sharpness, tonality, and color.

Dust Off: The trade name for a product in an aerosol can that sprays a jet stream of air on a negative to eliminate fine particles of dust before printing.

DVD (digital video disk): A technology used for a more accurate and higher-quality reproduction of images. The DVD is the next generation of home video cassettes and comparable to compact disks. DVDs look much like traditional CDs but offer viewers high-quality images with a depth of field comparable to that on movie theater screens. To play DVD movies on a television set, one needs a separate player resembling a VCR (video cassette recorder).

dye transfer process: A process for making color prints that is fade resistant but requires considerable care and effort. It is considered the premium color process but is rarely used because of its complexity; it requires making three separate negatives in yellow, cyan, and magenta. The three negatives are then **contact printed** on the color paper.

Pages 118 – 119: Dunmore and Critcherson. *Hunting by Steam in Melville Bay in August; Killing Six Polar Bears in One Day,* 1869. From the Isaacs Collection, National Museum of American Art, Washington, D.C.

George Eastman. *Self Portrait.* February 28, 1884. Courtesy Eastman Kodak Company.

Eagle, Arnold (1910–1992)

Hungarian-born, American photojournalist,

filmmaker, and teacher

Born in Budapest, Hungary, Eagle emigrated to Brooklyn, New York, with his family in 1929. His career as a photographer began when he passed a photo studio on the Lower East Side that had charcoal images of Jewish actors in the window. He walked in and said he could draw similar pictures. But because his English was so poor, the store owner thought Eagle said he was a photo retoucher, and he was hired as one. In 1932, he bought his own first camera, a $25 Graflex, and started photographing New York. Originally he mimicked the soft-focus style of salon photography, but he soon realized that artistic subjects were of less interest to him than images that conveyed the reality of the contemporary world.

He joined the **Photo League**, where he studied and emulated the documentary work of **Lewis Hine**. For the Works Progress Administration he photographed the Second Avenue EI (elevated train) for six months. His work there led to a job with **Roy Stryker**'s Standard Oil projects, which took him not only around New York but also to the Pacific Northwest to capture the lumber industry, the Midwestern farm country, and Louisiana oil drilling operations. In Louisiana he had the opportunity to work with the celebrated filmmaker Robert Flaherty as his still photographer.

In the 1950s, encouraged by Flaherty, he started making films, some in collaboration with the Dadaist/surrealist artist Hans Richter. He also taught at The New School in New York City while continuing to exhibit his classic works of Depression-era New York.

Arnold Eagle. *Boys in New York*. ca. 1936–7. Library of Congress.

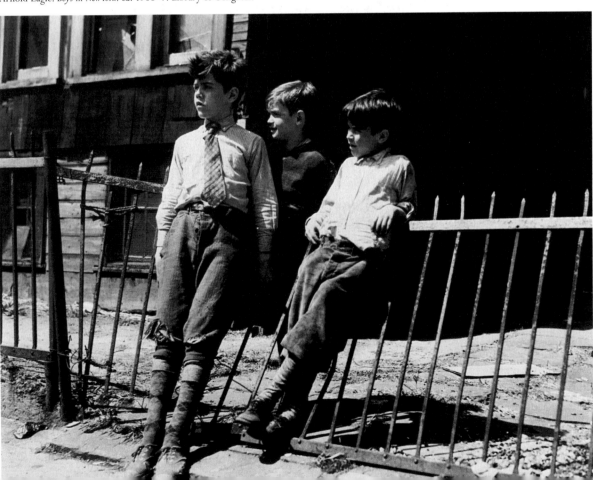

Eakins, Thomas (1844–1916)

American painter and photographer

One of America's best-known and most important nineteenth-century painters, Eakins took up photography to aid his understanding of anatomy, motion, and light. He was aware of photography's aesthetic dimension, and he created many romantic, soft-focus images that helped him move away from the realist style that marked his earlier career.

He experimented with stop-action photography and sought to record his subjects in motion with various devices, including a multi-image camera he invented. Eakins met **Eadweard Muybridge** and was avidly interested in his motion studies of people and animals.

Eakins used photos as sketches for some of his most famous paintings and also created nude studies for his students at the Pennsylvania Academy, where he taught from 1876 to 1886. Although academic studies of nudes were part of the curriculum in Paris, where he had studied, such works were frowned upon in nineteenth-century Philadelphia, and the ensuing controversy led to Eakins's dismissal from his position as a professor of painting and drawing.

easel: A device for holding photographic paper flat during the enlargement process. Speed easels are those made for a specific size of paper and are not adjustable. Adjustable easels can accommodate a few different sizes of paper and have blades that can be adjusted for centering the image and for cropping.

Eastman, George (1854–1932)

American photographic inventor and manufacturer

The founder of the **Eastman Kodak** company, Eastman introduced the Kodak **box camera** in 1888 and thereby encouraged millions of hobbyists worldwide to become photographers.

One of the most important figures in the development of photography, Eastman got the first patent for the mechanical preparation of a **dry plate**, and long before Henry Ford, he introduced assembly line work for mass production of his new cameras and introduced such revolutionary business concepts as profit sharing for employees as an incentive.

Schooled in his native Rochester, New York (still the company's headquarters), he first worked as a banker and insurance salesman before turning his attention to photography in a fairly unusual way. In 1877, President Ulysses S. Grant was planning to buy property for a naval base in Santo Domingo. Eastman, thinking of buying some surrounding land in the Dominican Republic as an investment, planned a trip to the area. A friend who had been a photographer on the John Wesley Powell Geographical Survey of the Colorado River in 1871 suggested that Eastman take camera equipment with him to document the trip. Eastman spent $1,000 on equipment but then canceled the trip when he became more interested in his new equipment than Caribbean swampland.

His first products were **gelatin** dry plates for which he introduced machine coating in 1879. In 1884 he invented the first roll film using paper negatives; in 1888 he produced **roll film** on a transparent base, still the universal standard more than 100 years later.

In 1888 the new camera and the slogan "You press the button, we do the rest" proved true to incredible success. The first cameras were returned to the company for film processing. In 1890, he introduced the Brownie camera to enable children to take pictures. Eastman proposed that his cameras be used by travelers, tourists, bicyclists, engineers, architects, artists, parents, surgeons, sportsmen, and lovers of animals. He was right. Everyone bought one.

The name Kodak, he said, was coined because it was short, easy to remember, and featured a "K"—the first letter of his mother's maiden name.

Riding a fantastic wave of success, he opened more photographic research laboratories and then moved to moving pictures. His commercial manufacture of roll film provided the basic material for cinematography. Eastman introduced 16mm **reversal film** for amateur filmmaking (and the camera and projector) in 1923. Later he developed various color photography processes for commercial applications.

His business philosophy was this: the production of products by machine, in vast quantities; for sale at the lowest possible price; local, national and international distribution; extensive advertising and lots and lots of

demonstrations to introduce the Kodak camera and its simplicity to the questioning public.

In 1932, at age 78, Eastman killed himself, leaving a note that said, "My work is done. Why wait?"

During his lifetime, he gave more than $75 million to various philanthropic projects and educational institutions, such as the University of Rochester and the Massachusetts Institute of Technology. His company still sponsors many professional, amateur, and scholastic photography awards, competitions, and scholarships. Eastman's home is now a museum of photography.

Eastman Kodak: Photographic-supply company founded in 1880 by **George Eastman** in Rochester, New York. Eastman's interest in photography dated back to 1877, when a friend suggested he record a planned vacation in the Caribbean with a cumbersome photographic setup. Appalled at all the paraphernalia he would need to carry, Eastman, a young bank clerk, decided to postpone his trip and study photography to see if he could simplify the arduous process. He began by experimenting with the making of dry plate film. He went to London, then the center of the photographic world, in 1879 and patented a plate-coating machine. He received an American patent the following year, and in 1880 he began manufacturing dry plates commercially.

He formed a partnership with Henry A. Strong, a well-to-do businessman, and in 1881 the Eastman Dry Plate Company was formed. Eastman resigned his bank position and devoted all his time to the firm and to further experiments to simplify photography. In 1884 he brought out **film** in rolls, with a roll holder that could fit into nearly every plate camera on the market. In 1888 he introduced the No. 1 Kodak camera. It was a light, portable instrument that cost just $25. Loaded with enough film for 100 exposures, it could be returned to the company, where the film would be developed, prints would be made, and new film would be inserted, all for $10. His slogan was "You Press the Button, We Do the Rest," indicating that anyone could make photographs because of the ease of use and processing and printing of the film by his company (similar to disposable cameras in use today).

In 1892 the firm's name was changed to the Eastman Kodak Company. Eastman himself coined the term **Kodak,** beginning with the letter "K," which seemed to him a strong, incisive kind of letter. He continued to work toward a camera that would operate simply and efficiently and sell for $1. His company's efforts resulted in the introduction, in 1900, of the Brownie camera. Other new products appeared as a result of the company's own laboratory research, with notable contributions in photography for the medical, scientific, educational, and entertainment fields, with the invention of color film, amateur motion pictures, X-ray and dental films, and safety film for amateur and professional use. Kodak today is a worldwide leader in photographic materials, and the name is synonymous with photography.

Eastman Kodak advertisement in *Smart Set* magazine, 1903. Collection of the authors.

Eder, Josef Maria (1855–1944)

Austrian chemist, author, historian, and teacher

Eder's discoveries in photographic chemistry and

reproduction and his massive two-volume history of the science of photography were important to the development of photographic technology. His contributions to photography led to his appointment as court expert in graphic arts by the Austrian government.

He achieved international renown and won numerous prizes, ranging from the Japanese Medal of Honor from the Friends of Photography in Tokyo to the Elliot Cresson Gold Medal awarded by the Franklin Institute in Philadelphia and the **Daguerre** Gold Medal of the Photographic Society of Berlin. In addition, he was decorated by the Austrian Republic with the Gold War Cross for civil services after World War I.

A professor of chemistry and physics in Vienna, he published numerous technical articles on his inventions in the fields of sensitometry, actinometry, spectral analysis, and spectography. His discovery of pyrocatechin as a developing agent led to its standard use for that purpose. He also made contributions to the development of more efficient printing **papers, fixing** baths, and **emulsions**.

Edgerton, Harold Eugene (1903–1990)
American scientist, inventor, and photographer
Edgerton has had a tremendous influence on the history of photography and modern visual consciousness. The acclaimed Massachusetts Institute of Technology professor pioneered stop-action photography and invented the **electronic flash** as well as the underwater photographic and sonar equipment used by Jacques Cousteau and the Woods Hole Oceanographic Team that found the *Titanic*.

After earning two advanced degrees at MIT, Dr. Edgerton started his experiments with photography, light, and movement in 1927. His lifelong quest to reveal what the unaided eye cannot see has revolutionized photography. In 1933, he invented the electronic flash, and he used it to record high-speed events. By the late 1930s, he had perfected multiflash imagery, using strobes to capture multiple exposures, such as those of a golfer swinging at a ball on a tee. His camera was then turned on every conceivable moving object, from a bird in flight to ballet dancers in full stride.

During World War II, he won a Medal of Freedom for his nighttime aerial reconnaissance photography, and he photographed the first atomic tests. His books *Stopping Time* (1989) and its predecessor *Flash!* (1939) are devoted to his own high-speed images: bullets shooting through apples, circus tumblers caught in mid-air, and the splash of a drop of milk.

Affectionately called "Doc" by his legions of MIT students, Edgerton won countless scientific and photographic awards, including a Lifetime Achievement Medal from the **International Center of Photography** in 1986, and his work, though intended as scientific research, has been exhibited and collected as fine art.

editing: The process of choosing the best from a given field. In photography, the first editing process is in choosing what to photograph. When the film is developed, the photographer edits the results to decide what is the best photograph to enlarge, publish, display, and keep. Newspapers and magazines hire professional editors to do this job, selecting the best photographs for use in the publication.

edition print: Both **vintage** and **series prints** may be published in editions. During the nineteenth century, editions of **photogravure** prints were often published as books or as albums, such as **Edward S. Curtis**'s massive record of Native Americans. In the twentieth century, many editions were published as photogravures or as signed and numbered **portfolios** such as those in *Camera Work*.

editor: The person responsible for the words or photos in a publication (as opposed to the ads, printing, circulation, distribution, marketing, publicity, and other non-editorial functions). The editor-in-chief may have many other editors working for him or her. Editors can be responsible for sections of a publication, such as a sports editor, or for whole departments, such as a photo editor, and report to the editor in chief. Editors assign stories or events to be covered and select the best photographs to use and/or help in improving an article before final publication.

Eggleston, William (1939–)

American art photographer

Eggleston is well known for distinctive color photographs of the American South, where he was born and grew up in a Mississippi Delta farming family.

He attended three colleges in Tennessee and Mississippi but was never graduated. He took his first pictures as a teenager but did not decide on photography as a career until after seeing a **Henri Cartier-Bresson** show in 1962. He was awarded a **Guggenheim fellowship** in 1974 and a **National Endowment for the Arts** photographer's fellowship in 1975. Those awards give him the opportunity to take the color images that were shown in his first solo show, in 1976 at the Museum of Modern Art in New York City, which cemented his reputation as a leading colorist.

Eggleston's work is formal in concept: For example, a picture of a Buick parked on a suburban street (*Southern Environs of Memphis*) exploits the composition's geometric and spatial relationships to evoke potent, poetic effects for the viewer.

Beyond photography, he has also branched out to other creative arts, most notably collaborating with David Byrne and the Talking Heads for their film *True Stories*. He has been widely exhibited and collected, has lectured at Harvard University and other institutions, and has published several books.

Eisenstaedt, Alfred (1898–1995)

American photojournalist

Born in Dirschau, Prussia (now Tczew, Poland), Eisenstaedt was one of the four original photographers hired by *Life* magazine, and his memorable images for the publication helped define the course of American **photojournalism**. During his 50-year career he produced more than 2,500 *Life* picture stories and 90 covers for the magazine. He is remembered for his classic images of important people in the news, as well as insightful pictures of unknown people, like his shot of an American sailor on V-J Day, kissing a nurse in a dancelike dip, which captures the essence of joy Americans felt that World War II had ended.

Elsenstaedt grew up in Berlin, where his family moved in 1906. An uncle gave him a simple folding camera when he was 14, and his interest in photography grew after his service in the German army during World War 1. Although he found employment as a button salesman after the war, he became a fanatical camera bug and was thrilled when in 1927 he made his first sale—a photograph of a tennis game in Czechoslovakia to *Der Welt Spiegel*.

Two years later he decided to pursue a career in photography, working on assignment for a picture agency owned by the **Associated Press**. He reported on news events with his camera, and this type of reportage, known as photojournalism, became an accepted form of camera work. During the 1930s Elsenstaedt covered many famous events and people, including the Nobel Prize award to Thomas Mann in Stockholm, George Bernard Shaw in his home in London, and the Emperor Haile Selassie in Ethiopia just before Italian troops invaded in 1935.

After Hitler's rise to power, Eisenstaedt, by then a photographer of international repute, emigrated to the United States, where Henry Luce invited him to join his new magazine, *Life*. Eisie, as he was known at the magazine, using an unobtrusive 35mm Leica, became known for his visually striking pictures for almost any assignment. He said his favorite subjects were nature, children, and all people. He worked for *Life* until its demise as a weekly in 1972 and continued to work on photographic projects for Time, Inc., and other publishers and for advertising agencies.

His books *Martha's Vineyard* (he visited the area for more than 35 years) and *Witness to Nature* reflect his love of nature. His photographs of people, which included such celebrities as Winston Churchill, John F. Kennedy, Marilyn Monroe, and Charlie Chaplin, were collected for his *People* book and have appeared in periodicals throughout the world and have been exhibited in group and solo exhibits, including "**The Family of Man**" at New York's Museum of Modern Art. In 1966–1967 *Life* organized a traveling exhibition in connection with his book *Witness to Our Time*.

He received many awards and honors, including the Presidential Medal of Honor and the Infinity Master of

Photography Award of the **International Center of Photography**. In 1951 he won the Photographer of the Year award given by the Yearbook of the Encyclopedia Britannica and the University of Missouri School of Journalism. Eisenstaedt continued to work until shortly before his death.

In 1997 *Life* magazine established the Alfred Eisenstaedt Awards of Magazine Photography with the inaugural awards administered by the Graduate School of Journalism at Columbia University. The awards, called the "Eisies," commemorate the life and work of one of America's greatest photojournalists.

EK print: In the motion picture industry, a release print made from the original negative that is a good-quality reproduction for special events. "EK" refers to **Eastman Kodak,** but the print can be made from any good-quality manufacturer's material.

Ektachrome: A professional-quality color reversal film for **transparencies** made by **Eastman Kodak.**

electronic camera: Also called a **digital camera,** a camera that records images on a disk or on an internal memory cell or hard drive; the images can be instantly **download**ed and viewed, altered, and transmitted with a **computer.**

electronic flash: A short, intense burst of light produced by an electronic unit for use in illuminating a situation. Unlike old-fashioned **flash bulbs,** which could be used only once, electronic flashes are powered by batteries and can be used indefinitely.

electronic mail (e-mail): Messages of text, sound, and/or images that are transmitted from one **computer** to another via the phone lines and a **modem**. These messages can then be stored on a computer or disk and printed if desired. Messages are often sent using a central service such as America Online, to recipients with an e-mail address. E-mail is a fast, low-cost method of sending and receiving messages worldwide. Because e-mail services are connected to local phone lines but are able to communicate internationally, sending an e-mail message outside a local calling area is dramatically cheaper than communicating via conventional telephone calls or surface mail. It is also more effective within a local calling area because the connection to the **online** service is almost exclusively a flat rate, not a timed connection. Computer aficionados call traditional postal services "snail mail," referring to its comparatively glacial pace.

electrophotographic process: The electronic recording of photographic images in analog or digital form. Electronic photography does not use conventional color or black-and-white film but stores the images on a disk or in the electronic camera's memory, the way a computer stores information.

Elisofon, Eliot (1911–1973)

American photojournalist, painter, and writer

Elisofon was a versatile figure who in addition to his artistic gifts invented a method of altering or distorting color by filter control that led to another career as a color consultant for Hollywood films.

After earning his degree at Fordham University, the native New Yorker got his first job as a social work-

Nikon Speedlight SB-16 electronic flash. © Fred W. McDarrah.

Eliot Elisofon. *Drummers, Yoruba tribe, Nigeria.* National Museum of African Art, Eliot Elisofon Archives, Smithsonian Institution.

er at the New York State Department of Labor. More interested in photography, he turned to commercial work and from 1935 to 1938 ran a photo studio, where his interest in photography blossomed. For the next four years he taught at the American Artists School and had a second job at the Museum of Modern Art.

During World War II he started working for *Life* magazine, and this association lasted until his death. Skilled in both black-and-white and color photography, Elisofon was a productive worker. As a photojournalist he excelled in action shots as well as pictures of quiet landscapes and still-lifes. His own special personal interest was in primitive cultures, and he assembled and wrote the catalogue for two shows on that topic. These toured extensively, including a well received stop at New York's Museum of Modern Art. He also produced and directed in the early 1970s television shows on primitive and African art and culture. Several volumes of his work have been published, and his photographs

are held by major museums.

Emerson, Peter Henry (1856–1936)

Cuban-born, British scientist, naturalist, and photographer

A doctor who gave up medicine to follow his passionate interest in photography, Emerson is known for his poetic documentary studies of East Anglia. He also was the first to argue that photography should not simply echo the sentimental images displayed in Victorian paintings but rather should be true to nature, as seen by the artist.

The Cuban-born son of an American father and an English mother was raised on his family's sugar plantation. After his father died in 1867, the family moved briefly to the United States before settling in England, where Emerson studied medicine. His first book, *Paul Ray at the Hospital,* published in 1882, was a picture of medical student life in London.

He became interested in photography as a useful method of recording his interest in birds. The unique

nature of the photographic medium, both art and science, intrigued him. On his wedding trip to Italy he began to formulate his philosophy that the finest art came in the study of nature. On his return to London, he bought his first camera. In 1883 he took his family to Southwold, Suffolk, on the North Sea coast. The local people and the mist-enshrouded landscapes he photographed became his characteristic subject matter throughout his career. His photographs of life in the region were published in a series of books, the most important being the first, *Life and Landscape of the Norfolk Broads.*

He was a founder of the Camera Club of London and was elected to the council of the Photographic Society of London. By 1886 he had decided to leave medicine and to become a photographer and writer.

In 1889 he published a statement of principles called "Naturalistic Photography," which advocated direct and honest representation in photography. According to his theory, the photograph was an art form that should approach the feeling of human vision, with the principal part of the subject in focus and the remainder of the image fading out of focus. The next year, however, he came out with "The Death of Naturalistic Photography," a controversial reversal of his earlier position. Two circumstances are thought to have altered his views: New scientific discoveries proved to him certain limitations in the technical possibilities of photography, and an unidentified "great painter" (possibly James Whistler) convinced him that photography was not art.

Although Emerson finally did not believe that photography was an art, critics today point to the artistic grace and beauty of his photographs as telling arguments for the opposite view.

He won the prestigious **Royal Photographic Society**'s silver Progress medal, and in 1924 he began writing a history of photography. However, the never-completed manuscript was lost.

emulsion: The part of photographic film and paper that is light sensitive. Emulsion is typically made of a **gelatin** material that contains the light-sensitive dyes (in color film and paper) or silver halides (in black-and-white film and paper). The emulsion gives photographic paper its surface quality—glossy, semi-glossy, or matte.

En Foco: Photography organization based in The Bronx, New York, founded in 1974, that has 525 members. En Foco aids and promotes Hispanic photographers and artists of color, mounts exhibitions, issues two publications, *Nueva Luz* and *Critical Mass*, and maintains a slide registry.

Engel, Morris (1918–)
American photojournalist
Best known for his photo essays of New York City life, particularly on Coney Island, Harlem, and the Lower East Side, and portraits of ordinary people, Engel was a regular contributor to the newspaper *PM*.

A self-taught photographer, Engel was influenced by the work of **Paul Strand** and other members of New York's **Photo League**, an organization committed to socially conscious photography. He also learned from **Edward Steichen**, under whom he served in the U.S. Navy when Steichen was director of naval combat photography. His work is in many prestigious collections, including the Museum of Modern Art and the **George Eastman House,** and his cityscapes are widely exhibited.

After World War II, Engel moved on to filmmaking. In this area he became an award-winning cinematographer of such movies as *The Little Fugitive* and *Lovers and Lollipops. Little Fugitive* was nominated for an Academy Award, won the Silver Lion at the Venice Film Festival. Francois Trauffaut claimed that the film influenced the New Wave.

enlarge: The act of making something bigger. In photography this refers to making a print from a negative and making it larger than the negative. This is done by putting the negative into an **enlarger,** a device with a light source, a place for a negative, and a **lens**. The light passes through the negative and through the lens, which focuses the image from the negative onto a piece of photographic paper at a size larger than the negative itself. This process is different from the **contact-printing** process, which places the negative directly on

the photographic paper, giving a print the same size as the negative itself. Because the final print is larger than the negative, it's called an enlargement.

enlarger: A **darkroom** instrument used to make a print larger than the size of original negative. A negative is placed into a holding frame that is inserted into the enlarger. When light passes from the top of the enlarger through the negative and a lens, vertical adjustments of the enlarger determine the size of the exposed print.

Enyeart, James L. (1943–)

American museum director, historian, and photographer

Enyeart, through his work directing some of America's premier photographic institutions, has had a profound impact on late-twentieth-century American photography.

He earned undergraduate and graduate degrees in his native Kansas and in 1968 began an eight-year stint at his alma mater as a professor at the University of Kansas as well as curator of the art museum there. During that time he received numerous grants and fellowships, including those from the **National Endowment for the Arts** and the National Endowment for the Humanities. In 1976 and 1977 he served as executive director of **Friends of Photography** in Carmel, California. For the next ten years he was director of the **Center for Creative Photography** at the University of Arizona.

From 1989 to 1995 he was director of the **International Museum of Photography** in Rochester, New York. In 1995 he was lured away by what he called a "dream project": to create the Marion Center for Photographic Arts at the College of Santa Fe. He aims to create and design an institution that redefines the standards of undergraduate photographic education.

Enyeart has written books on **Francis Bruguière** and **Edward Weston**. One of his books is *Decade by Decade: A Survey of 20th Century American Photography*.

Epstein, Mitchell (1952–)

American travel photographer and teacher

Epstein is at the forefront of new American color art photography. He is best known for his striking images of Egypt, Italy, and India that transcend the usual clichés of travel photography to provide a personal landscape of exotic beauty.

Educated at the Rhode Island School of Design and Cooper Union, Epstein was influenced by his teacher **Garry Winogrand**. Epstein achieved recognition early in his career as a freelance photographer and won a **National Endowment for the Arts** photo award at age 25. He has also received grants from the New York State Council for the Arts and the Camera Works Foundation.

He has had several one-man shows in New York City, and his work has been included in major exhibits and publications, including "The New Color Photography" (1981) and "American Independents" (1987), and is in the permanent collection of numerous museums, including New York's Museum of Modern Art and the San Francisco Museum of Modern Art. Three books of his have been published: *In Pursuit of India* (1987), *Fire Water Wind* (1995), and *Vietnam: A Book of Changes* (1996).

He has taught at the Harvard University Carpenter Center for the Visual Arts and was associate professor at Bard College in the fall of 1997. Epstein has also worked as a cinematographer and production designer on several award-winning films.

Erwitt, Elliott (1928–)

American photojournalist

Erwitt is known for his documentary projects, spot news stories—including the famous image of the 1959 "kitchen" debate between Soviet premier Nikita Khruschev and Vice President Richard Nixon—and his witty photographs of dogs, all of which seem to engage the viewer's sense of fun and wonder.

Born in Paris to Russian parents, he moved with his family to Italy and later to Southern California, where he studied at Hollywood High School and Los Angeles City College. In his collection of photographs, called *Personal Exposures*, Erwitt says he became a photographer because he discovered in high school that a camera "gets you into situations where you don't really belong. Then it was proms; now it's the White House or the Kremlin."

Pages 130 – 131: Mitch Epstein. *Fort Cochin, Kerala,* 1978.
© Mitch Epstein. Courtesy of the photographer.

At the age of 15 he found a darkroom job printing movie stars' photographs and bought himself a Rolleiflex. He admired the work of **Henri Cartier-Bresson** and also mentions **Eugène Atget** as an early influence. He achieved quick recognition after moving to New York, where **Edward Steichen** helped him get his first commercial job and **Robert Capa** became a friend. After serving in the military, Erwitt joined Capa's "little photo agency" and ever since has been a **Magnum** member, serving as president from 1966 to 1969.

Some of Erwitt's classic images were taken on the set of *The Misfits,* Clark Gable and Marilyn Monroe's last movie; others include a veiled Jackie Kennedy in stoic mourning, a slyly humorous shot of a shopkeeper and a dog, each scratching a body part, and a series of pictures taken at a nudist colony.

Erwitt has published several monographs of his work, including *On the Beach, Photographs and Anti-Photographs,* and *Son of Bitch.* He has had solo shows at the **Smithsonian Institution**, the Museum of Modern Art, and the Chicago Art Institute. He has done assignments for major news magazines and balanced commercial work with the personal, humanistic photos that reflect his own vision of photography.

Eugene, Frank (1865–1936)

American abstract photographer and teacher

Eugene has the distinction of being the first professor ever bestowed with a Chair in photography as well as being one of the first photographers to gain recognition for an expressive, nonrepresentational style that used deliberately manipulated negatives to create artistic effects.

Born Frank Eugene Smith in New York City, he studied at the City College of New York and then the Royal Bavarian Academy of Fine Arts in Munich, with the goal of becoming a painter. He took up photography as a hobby around 1885, but it wasn't until 1899 that he had his first exhibit, at the Camera Club of New York. The show was well received, and he became an "overnight" sensation. He brought his training as a painter to the darkroom, where he rubbed oil onto negatives and added cross-hatching with an etching needle to make what he called nonphotographic photographs. In some cases he scratched negatives to eliminate superfluous details and produce etchinglike prints.

He was a member of several photographic associations and in 1900 was one of the first Americans elected to **The Linked Ring**, an exclusive British photography society. He helped found the **Photo-Secession** in 1902.

In 1906, he moved to Germany and concentrated on teaching. In 1913 he was appointed Royal Professor of Pictorial Photography by the Royal Academy of the Graphic Arts of Leipzig—the first such academic position in photography and one created especially for Eugene.

Evans, Frederick Henry (1853–1943)

British architectural photographer

Evans is well known for his delicately toned and unmanipulated platinum photographs of medieval English and French cathedrals. He ran a bookshop and befriended and photographed such figures as George Bernard Shaw, William Morris, and Aubrey Beardsley, whose profile is undoubtedly Evans's most famous single image.

He took up photography as an amateur in the 1880s but did not devote himself to it as a full-time vocation until he sold his bookshop in 1898. In 1894 Evans had his first solo show at the Royal Photographic Society and was elected to **The Linked Ring**, the prestigious British group promoting photography, the same year. Although most Linked Ring members were **Pictorialists**, Evans maintained his own doctrine of straight or pure photography.

Saying that Evans was "the greatest exponent of **architectural photography**," **Alfred Stieglitz** devoted a whole issue of his quarterly *Camera Work* to Evans (1903), and Evans exhibited at **291** in 1906.

He stopped taking pictures during World War I when platinum became hard to get. He spent his later years writing about photography and organizing exhibits.

Evans, Michael (1945–)

American photojournalist

As a staffer for *Time* in 1976, Michael Evans decided to follow the presidential campaign of Ronald Reagan. It

Frederick H. Evans. *A French Chateau (Castles in the Air),* early 1900s. Courtesy Hans P. Kraus, Jr. Inc., New York.

was a losing effort—that time around—but after Reagan won in 1980, Evans was asked by the president to be his personal photographer. He worked in the White House for the next five years.

Born in St. Louis, Evans, the son of a Canadian diplomat, was a staff photographer for the *Cleveland Plain Dealer* by the time he was 21 and was hired by the *New York Times* two years later. He started with *Time* as a contract photographer in 1975.

His Washington, D.C., years are captured in *People and Power: Portraits from the Federal Village,* a collection of 500 portraits taken of influential people during the Reagan presidency. The recipient of a 1988 **Leica** Medal of Excellence for his work on the project "Homeless in America," Evans is now director of graphics and photography for the *Atlanta Constitution.*

Evans, Walker (1903–1975)

Famed American documentary photographer

Walker Evans is one of the icons of twentieth-century documentary photography. His work in the Deep South, on New York streets, and for the **Farm Security Administration** (FSA) has profoundly affected how later generations viewed the United States, particularly the Depression era. In particular, his 1941 collaboration with the writer James Agee, *Let Us Now Praise Famous Men,* which documented the life of poor southern tenant families, remains one of the clearest windows into the past—in terms of **documentary photography**—ever produced.

Born and raised in a Chicago suburb, Evans studied literature at Phillips Academy and then enrolled at Williams College. Finding college life unrewarding, in 1926 he headed off to Paris, audited classes at the Sorbonne, and discovered photography, specifically the work of **Eugène Atget**. Returning to the United States the next year, vest pocket camera in hand, he worked for New York's General Education Board, photographing African black art. From 1935 to 1938 he worked for the FSA as a roving social historian; his images from that period helped him to win a **Guggenheim fellowship** in 1940. From 1943 to 1945 he worked at *Time* as a writer. After that, from 1945 to 1965 he was a writer and photographer for *Fortune*. From 1965 until his death he taught and gave seminars at Yale University.

The essence of his achievement was embodied in the eloquent work he did for the FSA. In addition to images of rural poverty, he also took photographs of New York City subway riders with a camera concealed in his coat. Nearly 100 of those pictures, considered revealing of the mental states of their subjects, were published in *Many Are Called* and exhibited to great acclaim at the Museum of Modern Art in 1966. Five years later, MOMA mounted a massive, 200-picture retrospective of Evans's career.

Evans took great work with simple equipment. He was known for his battered old view camera with an extremely slow lens. He made his contact prints by the light of a mazda bulb and used nothing more elaborate than a few trays, a bottle of developer, and a bottle of hypo. Photography, Evans often said, isn't a matter of fancy tools or creating anything. "It's a matter of having an eye."

exhibition: A formal display of photography. Exhibitions of photography are as old as the medium itself. Almost all museums and art galleries mount exhibitions of photography at one time or another, and these displays are important for the acceptance and recognition of a photographer for his or her work. Exhibitions can be held anywhere there are walls to hang photos.

expedition photography: The use of photography on an exploratory or scientific trip to record what is seen and found. Early in the history of photography it was recognized that photographs could play a major role in recording important discoveries and sharing them with others. In the 1850s **Maxime Du Camp** photographed some of the great monuments in Egypt, and in the 1870s and 1880s photographers such as **Timothy O'Sullivan, Andrew Russell,** and **William Henry Jackson** photographed the American West as it was being explored. To this day, photographers are routinely assigned to accompany expeditions to record what they see and find.

exploded view: A photograph of the parts of a machine or other mechanical device, showing the parts separated and how they work together. Exploded views are useful for repair or assembly manuals.

exposed film: Because film is **light** sensitive, once it has been exposed to light the silver (in black-and-white photography) or dyes (in color photography) become darker. If exposed in a camera, the film will have an image on it when developed. Exposure itself produces a **latent image,** one that is there but unseen, and must be developed in order for it to be visible.

exposure index: The rating of the light sensitivity of film, usually known by its **ASA** or **ISO** number or **DIN** in Europe. The higher the number, the more sensitive the material.

Walker Evans. *Barbershop, New Orleans,* 1935.
Library of Congress.

exposure meter: An instrument used to determine the correct length of time film can be exposed to **light**. Because film has different speeds, it is important for a photographer to determine how much light should be allowed to reach the film in order for a well-exposed photograph to result. Exposure is determined by the size of the **aperture** and the speed of the **shutter,** both of which are adjustable and when combined determine the exposure to the film.

Faas, Horst (1933–)

German photojournalist

A two-time winner of the **Pulitzer Prize**, Faas is known as one of the most fearless war photographers of his time.

Born in Berlin, he secured his first photo job at age 19 when he worked as a clerk and darkroom assistant for the German Keystone Agency. In 1956, he joined the **Associated Press** and has been there ever since. Among his assignments have been wars in the Congo and Algeria, chief photographer in southeast Asia from 1962 to 1974, and London-based senior editor.

He received his Pulitzers in 1965 for his work in Vietnam and in 1972 for pictures taken of starvation in Bangladesh. In 1997 Faas, along with **Tim Page**, both photographers who worked and were wounded in Vietnam, published *Requiem,* a brilliant selection of work by the 135 photographers from all sides of the conflict who were killed there.

facsimile: Commonly referred to as a **fax,** an exact reproduction that is sent and received via the phone lines from one fax machine to another. The sending fax machine scans the original document and transmits it through the phone lines to the receiving fax machine, which prints the copy onto either regular paper or specially made fax paper.

fading: The act of an image's disappearing or losing density. In both black-and-white and color photography, images can fade because of two main reasons—being poorly processed and therefore not stable and/or being left in daylight for a long period of time.

Fahey, David (1948–)

American gallery director and curator

Active as a fine-art photography art dealer in Los Angeles

Arthur Rothstein. *Bleached Skull*, May 1936. Library of Congress.

since 1975, Fahey is a leader in the west coast photography world. Fahey with co-owner and partner Randee Klein Devlin opened the Fahey-Klein Gallery in 1987. Specializing in rare vintage and contemporary photography, the gallery represents such notable photographers as **Irving Penn**, **Joel-Peter Witkin**, **Tina Modotti**, and **Edward Weston** while exclusively representing **Herb Ritts**, **Jim Marshall**, **Alexander Liberman**, and **George Hurrell**, among others. The gallery curates an average of 35 photography exhibits a year.

Fahey served in the U.S. Army Infantry in Vietnam from 1969 to 1970 and earned a bachelor of arts degree in photocommunications in 1974 and a master of arts degree in art from California State University in Fullerton in 1978. From 1985 to 1988 he was a contributing editor of **Andy Warhol**'s *Interview* magazine. In 1983 he was cofounder of the Hollywood Photographers Archive, a nonprofit organization dedicated to the preservation of the work of the great Hollywood portrait photographers.

He has served as a photography consultant for many private and public collections and in his more than 30 years in photography has sold over $20 million worth of fine-art photography. Fahey has packaged, coordinated, and/or co-edited many photo books, including Ritts's *Pictures* and *Notorious* and Jim Marshall's *Not Fade Away.* He has also lectured extensively on the history of photography and taught the same subject at UCLA and USC extension.

Family of Man: A large photography exhibition in 1955 at the Museum of Modern Art in New York organized by **Edward Steichen**. The exhibition and accompanying publication were highly praised for celebrating the essential oneness of humankind throughout the world. It was a huge exhibit of 508 photographs from 68 countries. The

design of the exhibit was done so as to resemble the popular picture magazines such as *Life* and *Look,* with photographs printed to different sizes and mounted and bled and hung at different levels. The exhibition and book were a huge success at the time, and the book is still available.

Farm Security Administration (FSA): An agency under whose direction a massive photographic portrait of rural America in the Great Depression was assembled. First called the Resettlement Agency, the FSA was established in 1935 by President Franklin Delano Roosevelt to provide economic assistance to farmers by making low-cost loans, carrying out land renewal and reforestation projects, establishing communal farms, and sponsoring work camps for the unemployed. The Department of Agriculture absorbed the RA in 1937. Roosevelt named Rexford Tugwell, an economics professor at Columbia University, to head the FSA. Tugwell felt it was important to document his agency's activities and also to help gain national acceptance for their programs by showing the American public the dire plight of farmers during the Depression. To carry out this photographic mission, he chose a former student, **Roy Stryker**.

As head of the FSA's Historical Section, Stryker assembled and directed a talented photographic team whose work has become an impressive chapter in the history of **documentary photography**. He sent photographers into the field to investigate a specific problem or group of problems. He made sure his photographers understood the forces at work in each area, so the photographs could reflect their personal compassion and understanding of the problems. **Arthur Rothstein** and **Dorothea Lange** were with the agency from its earliest days. **Theo Jung** also joined in 1935, and **Ben Shahn,** who had been with another section of the RA, transferred to the Historical Section the same year. **Walker Evans** and **Carl Mydans** also transferred from within the RA. **John Vachon,** originally a clerk, worked as a photographer for several years before being promoted. Other important photographers of the agency were **Esther Bubley, Marion Post Wolcott, Russell Lee, Jack Delano,**

Paul Carter, John Collier, and **Gordon Parks**.

The body of work they produced, depicting poverty and hardship on farms and in small towns across the country, was unique. One of the most often reproduced FSA photographs is "The Migrant Mother" by Dorothea Lange, showing a Madonna-like mother figure in squalor with her children. Another famous image is Arthur Rothstein's photograph "Dust Bowl," showing a dusty farm during a windstorm. The agency operated from 1935 until it was incorporated into the Office of War Information in 1942. The photography unit's director, Stryker, arranged for the photographic archive, consisting of some 80,000 prints and 200,000 unprinted negatives, to be transferred to the **Library of Congress,** where it is today.

fashion photography: Photography to promote the sale of men's and women's clothing and the designers and manufacturers who create and produce it. Fashion photography is an important sales and publicity tool used by the industry in concert with the major fashion magazines—*Vogue, Harper's Bazaar, Vanity Fair*—to promote the acceptance and sales of their products. Very similar to advertising, all types of photographic techniques and schools—from **surrealism** to **Pictorialism** to modernism—may be used in fashion photography. Because clothing styles change quickly, so do the styles of photography employed to promote the designs. The fashion industry caters to a widely diverse population, from the most conservative older customers to teenagers who enjoy taking up the latest fashion fad. A list of the photographers who have excelled at fashion work includes **Baron Adolph de Meyer, Cecil Beaton, Irving Penn, Richard Avedon, Toni Frissell, Helmut Newton,** and **David Bailey**.

Faurer, Louis (1916–)
American commercial photographer
A leading practitioner of art, fashion, commercial, and street photography, Faurer had an early interest in art and photography that led to his attending the School of Commercial Art and Lettering in his native Philadelphia from 1937 to 1940.

Fashion photo of a glove shows the texture, shape, and design.
© Fred W. McDarrah.

Nat Fein. *Babe Ruth at Yankee Stadium bids formal farewell to his team mates,* June 16, 1948. Photo won the 1949 Pulitzer Prize. © Nat Fein. Courtesy Bonni Benrubi Gallery, Inc., New York.

After serving in the military during World War II, he looked for work as a photographer in New York, where his photographs were seen by **Walker Evans** at *Fortune* magazine. He landed a job as **Alexey Brodovitch**'s assistant at *Harper's Bazaar.* For 22 years starting in 1947 Faurer worked as a freelancer for Hearst, *Harper's Bazaar,* Condé Nast, Time-Life, *Vogue,* and *Fortune.* From 1969 to 1974 he lived and worked in London pursuing his own art, as he has since returning to the United States in 1975. He has also taught at Yale University, New York University, The New School, Parsons School of Design, and other institutions. A winner of a **National Endowment for the Arts** award (1978) and a pair of **Guggenheim fellowships** (1979, 1980), he has had equally long careers working for top magazines and for himself.

Working in both black and white and color, Faurer employs a variety of forms, "in accord with content, construction and feeling of the frame." His work includes many memorable images of New York City taken in the late 1940s, and he has been included in several group shows at the Museum of Modern Art, notably the "**Family of Man**" exhibit in 1955. Along with such photographers as **Robert Frank**, **Lisette Model**, and Brodovitch, Faurer is a member of the loosely defined group of photographers who lived and worked in New York City from the late 1930s to the early 1960s called the New York School.

fax: See **facsimile**.

feathering: The process whereby the edges of selected areas of images are softened, or feathered, to help blend them when combined with other images.

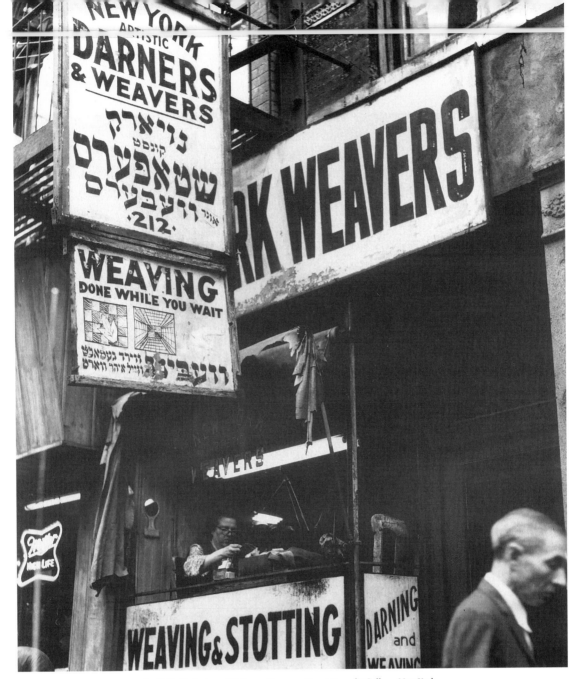

Andreas Feininger. *Lower East Side,* 1949. © Andreas Feininger, Courtesy Bonni Benrubi Gallery, New York.

Fein, Nat (1914–)

American photojournalist

Fein took one of the most famous sports images of all time: Babe Ruth's farewell to his fans. The celebrated image—a back view of the dying old ball player leaning on his bat—won the 1949 **Pulitzer Prize**.

A staffer at the *New York Herald Tribune* for more than 30 years, Fein took a wide variety of human-interest shots, ranging from a late-night subway rider warming himself at a potbelly stove on the Third Avenue El to Mayor Fiorello La Guardia conducting a Department of Sanitation orchestra. Fein's work has appeared in several museum exhibitions, including **Edward Steichen**'s famous 1955 Museum of Modern Art **"Family of Man"** show.

When the *Tribune* closed in 1966, Fein alertly took all of his negatives, rescuing a treasure trove of images of New York people, places, and things from oblivion.

Feininger, Andreas (1906–)

French-born, American documentary photographer and writer

Feininger spent his first 35 years working as an architect,

Christopher Felver. *Charades #2*, 1997. © Christopher Felver. Courtesy of the photographer.

a potter, and a cabinetmaker's apprentice. But once he focused on photography, he became one of its leading figures for the remainder of the twentieth century.

Born in Paris and raised in Germany by an American parent, the painter Lyonel Feininger, he went back and forth between the United States and Europe in search of satisfying work before getting a job with the **Black Star** Picture Agency in 1940. He was a staff photographer for *Life* from 1943 to 1962 and a freelance photographer and writer thereafter. Using both black-and-white and color, Feininger has done extensive work in the fields of telephoto and close-up photography, including many detailed nature studies. He has also concentrated on architectural forms and street scenes.

During his almost 20 years at *Life,* Feininger did 430 picture stories. He photographed trees and shells, solarized nudes, factory workers, and scenes of New York in the 1940s. He published more than 50 books, including a variety of instructional books on photographic technique. His first book, 1939's *New Paths in Photography,* was one of his most influential. His photographs have been widely exhibited and collected.

Feldman, Sandra Lee (Sandi) (1952–)

American art photographer

Feldman has achieved recognition for her richly textured photographs reflecting an interest in the human body and its adornments as well as in social groups outside the mainstream.

Educated in London and holding graduate and undergraduate degrees from the University of Wisconsin, Madison, Feldman is noted for both her art photography and commercial work in advertising campaigns and editorial assignments for art and general interest magazines.

At the invitation of the Polaroid Company, she began to use its 20 x 24-inch camera to take large-format color portraits of the Irezumi, a secretive group of people in Tokyo and Osaka who have chosen to transform themselves into living works of art with full body tattoos. Three trips to Japan later, her book documenting this cultural phenomenon, *The Japanese Tattoo,* was published.

Feldman has also taught at the University of New

Mexico and more recently at Rutgers University, and her work is in numerous private and public collections.

Felver, Christopher (1946–)

American art photographer and filmmaker

Felver, a California-based photographer and filmmaker, has used poetry and writing as a source for much of his work. He has been widely exhibited, including a solo show at the Pompidou Center in Paris.

His first book, *The Poet Exposed,* was a collection of black-and-white portraits taken over a period of six years of contemporary American and foreign poets, including such well-known names as Robert Creeley and Stanley Kunitz. With each portrait is a handwritten poem or other literary contribution by the subject. In 1984 Felver accompanied Lawrence Ferlinghetti, San Francisco's noted writer and owner of City Lights bookstore, to Nicaragua and took the photographs that appeared in a joint memoir of the trip called *Seven Days in Nicaragua Libre.*

His collection of portraits called *Angels, Anarchists & Gods* portrays an idiosyncratic array of individuals who "are not afraid of controversy or challenging the status quo." Subjects range from the poet **Allen Ginsberg** to the activist Angela Davis to the sculptor Isamu Noguchi. Felver's films include *John Cage Talks About Cows, The Coney Island of Lawrence Ferlinghetti,* and *Donald Judd's Marfa Texas.*

Fenton, Roger (1819–1869)

Early British documentary photographer

Fenton went out to photograph the Crimean War in 1855 and made some 360 images in an expedition financed by the publisher Thomas Agnew and Sons and assembled with the patronage of Queen Victoria and Prince Albert, who had befriended Fenton some years earlier. It was the first war to be covered by photographers and newspaper reporters.

Fenton studied to be a painter, but upon seeing his first **daguerreotype** is said to have proclaimed, "From today painting is dead." Before devoting his energy to photography, he studied law, thinking that he was not talented enough as an artist either to paint or to photograph. He remained interested in photography as a

Roger Fenton. *Reclining Odalisque,* 1858. Salted paper print from a collodion glass plate negative. Part of the Rubel Collection. Courtesy Hans P. Kraus, Jr. Inc., New York.

hobby and with several friends started in 1847 the Photographic Club in London. It evolved into the 1853 founding of the **Royal Photographic Society** of Great Britain.

In deference to Victorian sensibilities, Fenton's Crimean War images did not show corpses or battle scenes, but instead he posed shots of generals and troops and set up casual arrangements of men and officers.

The Crimean War images cemented his reputation, and he went on to a period of great success capturing landscapes, art, architecture, and still-lifes. Inexplicably, Fenton retired from photography in 1862 at the height of his fame and resumed the practice of law.

Fernandez, Benedict J. (1936–)

American documentary photographer and teacher
Influential longtime chair of the photography depart-

ment at Parsons School of Design/The New School, Fernandez has produced several monographs and published four books of social protest. Fernandez, who prefers to call himself a "photoanthropologist" rather than a photojournalist, documented as early as 1963 the confrontations between vocal minorities and the "quiet majority."

After growing up in Spanish Harlem, Fernandez studied at Columbia University. He worked at the Brooklyn Navy Yard as an operating engineer and crane operator until the facility closed in 1963. At that time he decided to turn his high school photography hobby into his life's work. He came to the attention of **Alexey Brodovitch,** art director at *Harper's Bazaar,* for whom he worked as chauffeur, and enrolled in Brodovitch's Design Laboratory class conducted in the studios of famous photographers like **Richard Avedon.**

After Brodovitch's death in 1971, Fernandez carried on his tradition and in 1964 got a job at The New School as a photo lab technician.

During the 1960s he was a sought-after photojournalist, shooting the riots in Newark, the civil rights marches, and many other events of that turbulent decade. He photographed Martin Luther King Jr. and his family during the last year of Dr. King's life. This portfolio is now world-famous and has been exhibited in more than 50 countries. His photo of five men burning their draft cards was the first color photograph to appear on the cover of the *New York Times Sunday Magazine*, on June 6, 1966.

He has won many awards, including a 1970 **Guggenheim fellowship,** a 1973 **National Endowment for the Arts** fellowship, and a Fulbright fellowship in 1992. In 1986 he received a fellowship from the National Academy for Arts and Sciences and went to China to lecture at the People's University.

His work is in the permanent collections of many museums worldwide, including those of the Museum of Modern Art in New York, the **Smithsonian Institution** and the Corcoran Gallery in Washington, and the San Francisco Museum of Modern Art.

Fernandez became head of The New School photography department in 1971, the same year The New School acquired Parsons School of Design, and he held that position until 1992. Fernandez has also taught in special programs at universities around the world, the University of Moscow among them.

ferrotype: An old-fashioned photographic technique, better known as the **tintype,** popular during the 1860s, that produced an image on a piece of thin metal. It was very cheap and often produced by traveling photographers, many stationed at the edge of Civil War camps. Because it was cheaply produced and sturdy, the image could be sent through the mail with little damage—perfect for the soldier away from home. Some ferrotypes are put into cases to resemble **daguerreotypes** (a much higher-quality and much more expensive photograph) and **ambrotypes**. Ambrotypes (photographs on glass) are very similar to ferrotypes and employ a similar process. Ferrotypes were used during the presidential campaigns of Lincoln and Douglas and were used as campaign buttons.

fiber optics: The transmission of light and light impulses along thin, transparent rods or fibers. Fiber optics have been replacing traditional metal wire for phone lines.

field camera: A camera that can be transported for use outside the studio. Field cameras employed during the "age of exploration" used mammoth **glass plates,** 22 x 25 inches. Large field cameras now use sheet film.

Filan, Frank (1905–1952)
American photojournalist
Filan was a staffer for the **Associated Press** from 1930 until he died, winning the 1944 **Pulitzer Prize** for his picture of Japanese bodies strewn on the battleground at Tarawa.

Under harrowing conditions—he spent 36 hours without food or water—he managed to take the award-winning photograph with a borrowed camera; his ship and all his equipment had been sunk during a battle. Filan served for three years in the Pacific as a combat photographer. He received a commendation for bravery from Admiral Chester Nimitz for his lifesaving efforts rescuing wounded Marines under enemy fire.

filing and storing photographs: To be able to find a photograph of a specific person, place, or thing, a filing and storage system is essential. Typical filing systems would be by name, subject matter, or date and correspond to a number assigned to a photograph that is stored in a filing cabinet. Professional photographers, libraries, and photography agencies rely on **computer** filing and **microfiche** storage systems to locate a single photograph quickly from the thousands they have available.

fill-in light: A secondary light source used in addition to a main light source to reduce shadows in a photograph. The fill-in light is less intense than the main light and softens what would otherwise be a deeply shadowed area.

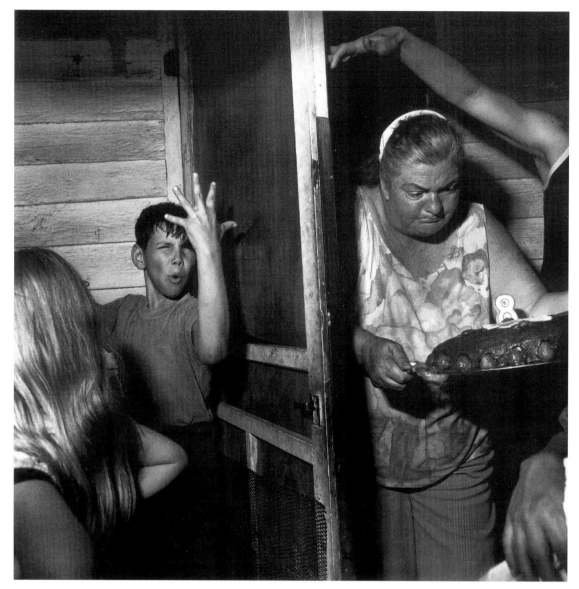

Larry Fink. *Birthday Party,* 1979. © Larry Fink. Courtesy of the photographer.

film: A sheet or roll of cellulose acetate or cellulose nitrate coated with a light-sensitive **emulsion** for taking photographs.

film holder: A light-tight container for handling photographic **sheet film,** usually in sizes of 4 x 5, 5 x 7, or 8 x 10 inches. The conventional, flat sheet-film holder has room for two separate sheets of film. The film is loaded **emulsion**-side out in complete darkness. An opaque slide covers the film for transportation to the camera back. Once secured in the camera, the slide is removed for exposure then replaced. The holder can then be turned to expose the second sheet.

film scanner: A scanner used to scan only **35mm** or medium-format film.

filmstrip: A continuous group of positive photographic images usually collected on a roll of developed film and projected onto a screen one image at a time.

Filo, John Paul (1948–)

American photojournalist

Filo won a 1971 **Pulitzer Prize** for spot news photography for one of the most famous photographs from the Vietnam war era—that of an American teenage girl weeping over the body of a student protester slain by National Guardsmen at Kent State. The photograph, which became an icon of the antiwar movement, was immortalized in the song "Ohio," by the group Crosby, Stills, Nash, and Young.

Filo, who was a photography student in 1970 when he captured the image, was graduated from Kent State in 1971. He went on to a career as a newspaper photographer, working for the **Associated Press** until 1981, when he joined the *Philadelphia Inquirer* as photo editor. He later became graphics director of the *Baltimore Sun*.

filter: Transparent material placed in a light path so that exposure takes place through it. Filters are often colored and placed over a camera **lens** to affect the results of a photograph. Yellow brings out the clouds, green turns grass white, and red turns the sky black. Filters that appear to have no color are used to remove unwanted ultraviolet.

Fink, Larry (1941–)

American photojournalist and teacher

Fink came to notice after his seminal work *Social Graces* was published, comparing and contrasting the paper-thin vanity of high society to the demeanor of a blue-collar family, both groups from the same Pennsylvania town. Thirteen years later, his 1997 book *Boxing* delved deep into the soft spots of the most brutal of sports.

Born in Brooklyn, Fink studied photography with **Lisette Model** in 1957. He has taught at Parsons School of Design, Cooper Union, Yale University, Lehigh University, the **International Center of Photography**, the City University of New York, and since 1996 at Bard College. The winner of a pair of **Guggenheim fellowships** (1976, 1979), two CAPS grants (1971, 1974), and a **National Endowment for the Arts** grant (1978), Fink has also been widely exhibited, including a 1997 show at the Whitney Museum and a 1998 effort at the Louvre in Paris. Among the private and public collections holding Fink's work are those of the Museum of Modern Art, the Boston Museum of Fine Arts, and the Corcoran Gallery.

Critics say Fink can document the absurdities, ironies, and intimacies of the rich as well as those of the working class but never intimidates the viewer with pretentious, esoteric, or contrived images. His published work also includes *Sardine Fishing in Portugal* (1996).

first generation: A film, tape, photograph, or other material that is copied directly from the original, making it the best-quality copy after the original and superior to **second-generation** or later copies.

fisheye lens: An extremely wide-angle **lens,** usually 16mm, that renders a view of approximately 180 degrees. The resulting photograph is characterized by two arches, one curving upward at the top, the other downward at the bottom. The edges of the arches meet end to end, casting the image into a shape reminiscent of a fish's eye.

fixed focus: A **lens** in which the **focus** cannot be adjusted because it is preset. **Point-and-shoot cameras** have mostly fixed-focus lenses, allowing for in-focus pictures from around four feet to infinity.

fixing: The process of removing unwanted silver halides from photographic film and paper, so that the film or paper is no longer sensitive to light. This is a stabilizing process that results in a permanent image. The chemical mixture used for fixing, commonly called **hypo**, must be fresh for the process to be effective.

Fizeau, Armand Hippolyte Louis (1819–1896)

French physicist

Fizeau in 1840 invented a process for gilding the **daguerreotype** plate to increase contrast, as well as to protect the plate.

Intrigued by **Daguerre**'s process after its announcement in 1839, he and Alfred Donne spent the next few years working on the invention of printing

photographic plates. In 1845 he made the first daguerreotype photographs of the sun.

He joined the French Academy in 1860 and was appointed superintendent of physics at the École Polytechnique in Paris in 1863.

flare: Light that does not form an image on film but exposes it to a greater or lesser degree. This typically is caused by a reflection in the **lens** or camera and reduces the contrast of the film, usually creating an unpleasant effect.

flash bulbs: Light bulbs that are used with old-fashioned flash systems to produce a short burst of bright light for exposing photographic film. Flash bulbs were good for only one flash and then thrown away, so a photographer had to carry many of them.

flash lighting: The technique of lighting a subject for photography by means of a flash—a short burst of intense light produced by an **electronic flash**.

flatbed scanner: A **scanner** used for both reflective and transparency images.

flat lighting: Lighting that produces little or no shadow and very little detail, caused from a light source coming from the **camera**. Also called front lighting. When flat lighting is used, the subject is completely illuminated without shadow detail. In **portraiture** flat lighting eliminates facial lines.

Flexichrome: A technique for converting a **black-and-white photograph** into a color image, such as hand coloring.

floodlight: A lighting unit that gives a broad, bright illumination, usually mounted in a reflector on a light stand.

floppy disk: A magnetic storage device for **computers** that is thin and housed in plastic, measuring 3 ½ inches in diameter and usually holding between 1 and 2 megabytes of information. Floppy disks come unformat-

ted to be used with either IBM and compatibles or Macintoshes or can be purchased already formatted for either system. Floppy disks are magnetic and so should be stored away from magnetic devices, and if the information stored on one is irreplaceable, a backup copy of the disk as well as a hard copy of the information should be made.

focal length: The distance from the back of the **lens** to the point where it focuses. Focal length directly influences the size and proportion of images in a photograph. A short focal length lens is wide angle, taking in a large portion of a scene; the sizes of objects in the scene are relatively small. Long focal length lenses are commonly called **telephoto** and take in a narrow portion of a scene, making objects appear large (the lens acts like a telescope). Normal focal length lenses are those that produce images in which objects appear similar in size to natural sight.

focal-plane shutter: A camera **shutter** located in front of and close to the film **aperture** and focal plane. Acting like a trap door, the shutter opens like a curtain from side to side for an adjustable length of time to allow light from the **lens** to reach the film. Visible when the camera back is removed, the focal-plane shutter will not function at all shutter speeds. Cameras with focal-plane shutters will indicate the maximum speed that is synchronized for the flash, most often 1/60 of a second. The focal plane shutter was invented by William England in 1861.

focus: Objects seen through a **single-lens reflex camera** appear to be sharp and clearly defined, as with the naked eye. In some cameras focus is achieved when a superimposed double image is adjusted to become a single image.

Focus Magazine: One of the many picture magazines that followed after the success of *Life* and *Look* magazines in the 1930s and 1940s. *Focus*, like the others, was a large-format publication (10 ½ x 13 ½ inch) that ran stories of national and international interest with lots of

Cover, *Focus* magazine cover showing an artist, painting on the features of ventriloquist Edgar Bergen's dummy Charlie McCarthy. April 1936. Collection of the authors.

FOCUS

10¢
APRIL

BIRTH OF A DUMMY

Charles Henri Ford. *The cat's name was Samson, Chania, Crete*, early 1960s. © Charles Henri Ford. Courtesy the photographer.

photographs. Sex and scandal were often the subjects of stories, as were celebrity profiles and international disasters. *Focus* was published once a month and billed itself as "a pictorial magazine of timely and topical discussions."

fogging: When unwanted **light** has affected film or paper, causing it to turn from gray to black. Fog is a veil or pattern of non-image silver on a photo film or print caused by light's accidentally reaching the **emulsion**. This happens most often when light leaks into a camera.

folding camera: A camera with a flexible **bellows** that folds up; it can be advantageous for ease of carrying and to protect the **lens** and camera body. The first Polaroid was a folding camera, as was the popular **Kodak** camera of the 1920s.

Foley, Bill (1954–)
American photojournalist
Foley won the 1983 **Pulitzer Prize** for spot news pho-

tography while working for the **Associated Press** for his moving series of pictures of victims and survivors of the massacre in the Sabra camp in Beirut.

After graduation from Indiana University, Foley joined the AP, where he stayed until 1985. Since then, he has been a contract photographer for *Time*, earning recognition for his work in the Iran–Iraq war and elsewhere.

Ford, Charles Henri (1913–)
American poet, photographer, filmmaker, painter, and publisher
A talented photographer whose work is a unique mix of surrealism based on classical references infused with a haunting sexual tension, Ford is a legendary figure in the European/American avant garde. Publisher of *View* magazine from 1940 to 1947, he filled its pages with the work of such artists as **Man Ray**, Marcel Duchamp, and Salvador Dali; fiction by Albert Camus, Henry Miller, and José Luis Borges; and poems by e. e. cummings and William Carlos Williams.

Born in Brookhaven, Mississippi, he dropped out of

high school and published a magazine called *Blues* with the film critic Parker Tyler. In 1931 he went to Paris, where he wrote poetry and became an intimate member of Gertrude Stein's circle. He met the Russian neo-romantic painter Pavel Tchelitchew in 1933 and moved with him to the United States, where they lived together for the next eighteen years.

He started *View* in 1940 and published works by avant garde American and European photographers, poets, writers, and artists. *View* pioneered the surrealist movement in the United States and included photography by **Cecil Beaton**, **George Platt Lynes**, Man Ray, and **Helen Levitt**. In the 1950s, Ford dedicated himself to photography, painting, and drawing. His work in mixed media was an important influence on **Andy Warhol**'s art. In 1969 Ford conceived, directed, and photographed his film *Johnny Minotaur*.

In 1976 he exhibited 109 postcards he had received from friends over the previous four decades. An anthology of work from his magazine, *View: Parade of the Avant-garde*, was published in 1991.

forensic photography: Photography used to provide evidence of a crime scene for the purpose of analysis, usually by law-enforcement officials. Also, medical or scientific photography that records specimens for examination later and to be used as proof of an existing situation.

Foresta, Merry A. (1950–)
American curator and writer
Foresta has been curator for photography at the **National Museum of American Art** (part of the **Smithsonian Institution**) since 1983. Prior to assuming that position, she was assistant curator in the Department of Twentieth-Century Painting and Sculpture.

Born in New York, Foresta earned a bachelor of arts degree in English literature (1971) and a master of arts degree in art history (1979) at Cornell University. At Cornell she worked at the Herbert F. Johnson Museum of Art. She has lectured widely and participated in symposia and conferences. Foresta is the author of many articles and books on photography, including *American Photographs: The First Century, from the Isaacs Collection at the National Museum of American Art* (1996), *Between Home and Heaven: Contemporary American Landscape Photography* (1992), and *Perpetual Motif: The Art of Man Ray* (1988).

Forman, Stanley J. (1945–)
American photojournalist
Forman is a rare back-to-back winner of the **Pulitzer Prize** and a veteran Boston area journalist. He won in 1976 for photos of a woman and child falling from a fire escape of a burning building and the next year for a picture of a lone black man being beaten by a group of whites with a flagstaff bearing the American flag on the steps of Boston's City Hall during a busing demonstration. Those two images earned him many other awards, from Boston Press Photographer of the Year to the World Press's Photo of the Year.

He was also the campaign photographer for Edward Brooke, the first black U.S. senator and a Nieman Fellow at Harvard in 1979. Since 1983 he has worked as a video photographer in Boston.

format: The dimensions of film, paper, and camera sizes. Commonly used 35mm film is called small format. Film that is 2 ¼ inches wide is medium format, and film 4 x 5 inch and larger is large format. Cameras that use these various sizes of film are referred to by the format.

formatting: The process of preparing a **computer** disc for the storing of information.

fotonovela: A novel made with photographs that uses captions and/or conversation balloons (like those in comic strips) that often include advertising. Fotonovelas are a popular form of entertainment in Latin American countries and have themes of the *fotonovela rosa* (virtuous heroine and her wealthy suitor), *fotonovela suave* (about the middle class), and *fotonovela roja* (about the working class).

Fox, Flo (1945–)

American documentary photographer and teacher

Being legally blind (she suffers from multiple sclerosis) has not stopped Fox from pursuing an award-winning career as a photographer and teacher. A street photographer, she has had her work shown in galleries in New York and London.

She was born blind in one eye and started a successful career as an advertising stylist and tailor. She says she was a natural photographer, because everyone has to close one eye to look through a camera. When her good eye began to fail, she turned her creative energies to photography and studied with **Lisette Model** and **André Kertész**. Now a teacher at the Lighthouse for the Blind in New York City, she describes her own work, done entirely with an auto-focus camera, as reportage that looks "for the ironic . . . a touch of humor or hard core reality."

FPG International: An international photography agency founded in 1936 with more than 6 million images ranging from historical engravings, illustrations, and photographs to contemporary photography and digital imagery.

framing: A frame is commonly a border around a picture, usually to enhance the display of it. Framing is also the act of looking through a camera to see how a particular scene appears within the viewing area.

Frank, Robert (1924–)

Celebrated American photographer and filmmaker

The Swiss-born Frank is one of the most best-known photographers of his era, having first achieved recognition on the strength of his highly influential 1959 book *The Americans*. He later turned to film, making some classic "independent" movies such as the Beat Generation classic *Pull My Daisy* with Jack Kerouac and a documentary of the Rolling Stones' 1972 tour.

His first professional job was as a photographer for Gloria Films in Zurich in 1944. After World War II he emigrated to the United States and worked for **Alexey Brodovitch** at *Harper's Bazaar*, shooting fashion photographs. At the same time, he started shooting his own independent pictures and did assignments for *Life, Look,* and *Fortune.*

In 1955, Frank became the first European-born photographer to win a **Guggenheim fellowship**. The grant allowed him to travel the United States, taking the pictures that formed the core of *The Americans,* originally published in 1958 in France before its 1959 U.S. release, with an introduction by Jack Kerouac. The book, which offered a completely original view of American life, is now an artifact of modern culture that has secured Frank's reputation as a photodocumentarian. After its publication, he turned from photography to filmmaking. His 1959 film *Pull My Daisy* is the story of a Beat-culture character and his conflicts with his family, directed by Frank and the painter Alfred Leslie, narrated by Kerouac, and starring **Allen Ginsberg,** Gregory Corso, and Peter Orlovsky, with music by David Amram.

For most of the 1960s, he concentrated on filmmaking. In 1971 he returned to still photography, with much of his important work dealing with the death in a plane crash of his and sculptor Mary Frank's daughter Andrea.

He has since developed into a somewhat mythic and reclusive icon, dividing his time between Nova Scotia and a downtown New York loft and studio, publishing several photography books and having his work exhibited in museum and gallery shows. In 1996 he won the **Hasselblad** International Photography Prize. The **National Gallery of Art** in Washington established the Robert Frank Collection with a large gift from him of negatives, contact sheets, work prints, and exhibition prints. He remains one of the world's most widely exhibited, collected, discussed, studied, and emulated photographers.

Freed, Leonard (1929–)

American photojournalist

This Brooklyn-born **Magnum** photographer has spent much of his career traveling, covering significant cultural, political, and social happenings. His honest, dramatic images include a photo of Dr. Martin Luther King Jr. shaking hands from the back of an open car that has been

Robert Frank. *Newburgh, N.Y.,* 1955. © Robert Frank. From *The Americans*, photographs by Robert Frank, introduction by Jack Kerouac, Grove Press, 1959 (previously published in 1958 by Robert Delpire editeur, Paris). Courtesy PaceWildensteinMacGill.

reproduced on numerous postcards and posters, a picture taken from the top of a staircase in a tenement hallway of a crime victim sprawled on the tile floor below, and an image of a neo-Nazi teenager shaking his fist at the world.

He has worked on assignments for *Paris Match, Stern,* and *NewYork,* and his photographs are in the collections of major American and European museums.

Freed went traveling with a camera in 1950 in Europe and North Africa, returning to New York in 1952. He studied in Amsterdam and in New York with **Alexey Brodovitch** and continued working as a freelance photographer. He covered the Six-Day War in Israel (1967) and returned there to photograph during the 1973 Yom Kippur War. He has taught at The New School and has published several monographs, including *Leonard Freed—Photographs 1954–1990.*

Freedman, Jill (1939–)

American photojournalist

Her documentary books on widely divergent topics show the range of interest and depth of feeling Freedman has for the people and events she has covered since taking up photography in 1965.

Street Cops (1981) portrays the gritty environment of New York City police; *Firehouse* (1977) is a deep look at the world of firefighters; *Circus Days* (1975) is a touching portrait of the people in the Beatty-Cole Circus, "the largest tented show on earth"; in *Old News: Resurrection City* Freedman documents the Poor People's March on Washington (1970).

Freedman was graduated from the University of Pittsburgh with a degree in sociology and worked and lived abroad in Israel, Paris, and London before returning to the United States, where she worked as an advertising copywriter before embarking on a career in photography. Her photographs are in major museum collections and have been published in magazines internationally.

freelance photography: Photography done by someone who is self employed taking photos for a variety of clients. A freelancer typically retains the rights to the

photographs, owns his or her own equipment, pays taxes separately on income, and receives little or no traditional employee benefits (like health insurance or vacation pay) from clients. Many freelancers belong to **ASMP,** which offers health benefits to its members.

Freeman, Roland Leon (1939–)

American documentary photographer

As much a social historian as a photographer, Freeman is noted for his insightful black-and-white images that capture the flavor of black life as it has changed during his lifetime.

Born in Baltimore, where he became a member of a street gang, the Young Bloods, he was sent away to a southern Maryland farm by his mother, who feared that his life would end violently if he remained in an urban environment.

At the age of 18 he returned to Baltimore, then joined the military, where he won a Brownie Hawkeye camera in a crap game and enjoyed taking photographs as a pastime. While in the service he traveled to Europe, where he met the writers James Baldwin and Richard Wright. When he returned to the United States he found the civil rights movement then gaining momentum.

After the 1963 March on Washington, Freeman found that the photographic medium was the best way for him to express his feelings about the struggle for social justice. Influenced by such black photographers as **Gordon Parks** and **Roy De Carava,** he has continued his documentary work, including his book *Southern Roads/City Pavements* and other studies of the African American experience.

Friends of Photography: Founded in 1967, an organization that has 5,000 members and is based in San Francisco, California. Friends of Photography serves as a forum for the "intersection of images and ideas," promotes visual literacy, and presents, analyzes, and interprets photography as the fundamental medium of contemporary visual experience. It also presents exhibitions of contemporary and historical photography at the **Ansel Adams** Center for Photography and offers lectures, gallery talks, and tours; sponsors awards for

excellence in photography, such as the Ferguson Award and Ruttenburg Foundation Award; and publishes *Re:View,* the organization's bimonthly newsletter, and *SEE,* a quarterly journal of photography.

Freund, Gisele (1912–)

French photojournalist

In the preface to her 1974 book *The World in My Camera,* Freund wrote: "I have been a photo-reporter and portraitist for over thirty years. I have worked for the greatest and the smallest magazines. . . . My goal has been to make my camera a witness of the time in which I live.'

Born in Berlin, she became interested in photography when her father gave her a camera when she was 15. In 1933 Freund fled Nazi Germany and moved to Paris, where she became a naturalized citizen. She studied at the Sorbonne, receiving a doctor of philosophy degree in sociology and art. Her amateur interest in photography led to her writing a doctoral dissertation on the history of photography in the nineteenth century. To pay for her studies she began to do photo stories. One of her first efforts appeared in *Life* in 1936.

She has lived in Paris for much of her life, working as a freelance photojournalist for *Paris Match, Life, Picture Post,* and other periodicals. She photographed her literary and artistic circle of friends for her own pleasure. Her portraits include those of such noted writers as André Gide, André Malraux, Paul Claudel, George Bernard Shaw, Virginia Woolf, and Katherine Anne Porter. She made a series of color photographs of James Joyce that is a unique document. On assignment from magazines she covered Latin America, from Patagonia to Mexico, and has done photo essays on English slums, Paris, and Tierra del Fuego. She has published several books of photographs, and her work has been exhibited throughout the world.

Friedlander, Lee (1934–)

American art photographer

One of the most influential of contemporary photographers, Friedlander is the recipient of numerous awards, including the John D. and Catherine T. MacArthur Foundation Award (popularly called the "genius" award),

three **National Endowment for the Arts** grants, and three **Guggenheim fellowships**.

The first collection of Friedlander's images, *Like a One-eyed Cat,* included early pictures taken on the road with Count Basie and other famous jazz musicians, nudes, landscapes, portraits of high-technology workers, self-portraits, and his renowned "American Monuments and Factory Valleys" series. His work does not fit easily into any category of photography but has remained consistent in its clear, direct style no matter what the subject matter.

Friedlander began taking photographs at the age of 14. His first sale was a picture of a dog that was used for a Christmas card in his home town of Aberdeen, Washington. After high school he enrolled briefly at the Los Angeles Art Center School, although he continued to study with one of his instructors, Edward Kaminski, who advised him to pursue his career in New York.

He soon found a place in New York's photographic community, where he worked as a freelancer doing assignments for *Holiday, Sports Illustrated,* and other major magazines. In 1967 he was included along with **Diane Arbus** and **Garry Winogrand** in the Museum of Modern Art's landmark exhibition "New Documents." Friedlander's work shows the influence of **Walker Evans** and **Robert Frank**, using the snapshot not only to reflect American culture but also to explore the boundaries of photographic perception. Among his well-received monographs are *Nudes* and *Self Portrait.*

Frissell, Toni (1907–1988)

American fashion and documentary photographer

Frissell earned a reputation for her fashion, documentary, and sports images that appeared in the top magazines. Born in New York City, she started photography while still a child and used her Brownie box camera at home and on family trips to Europe, She took up photography seriously in 1931 as a form of therapy after her older brother was lost at sea while making a documentary film in 1931.

Groomed at Miss Porter's School, she was trained as an actress, worked for a painter, and was then employed in advertising before her brother's death. Her first series,

Francis Frith. *Sculptured Gateway, Karnac,* 1857. Courtesy Prakapas Gallery, Bronxville, NY.

"Beauties at Newport," was published in *Town and Country* in 1931, which led to *Vogue*'s hiring her. She stayed until 1942. Her mentor at *Vogue* was Mr. Condé Nast, and she was advised by **Edward Steichen**, who suggested her apprenticeship with **Cecil Beaton**. She went on to work for *Harper's Bazaar* from 1941 to 1950. Her fashion work was distinguished by her insistence on doing things naturally, which included taking models out of the studio and into the outdoors, a revolutionary concept at the time.

During World War II Frissell went to England as a photographer for the Red Cross and later for the Air Force. After the war she was no longer interested in fashion photography but wanted to photograph people and events.

She was the first female photographer hired by *Sports Illustrated*. Straddling the line between artist and photojournalist, she was included in Steichen's 1955 show **"Family of Man."** Through the 1960s and 1970s her work appeared regularly in *Life* and *Look*. She was a major contributor to the **George Eastman House**'s 1977 show "History of **Fashion Photography**" at its International Museum of Photography. Her famous images include portraits of a well-groomed Duke and Duchess of Windsor, Winston Churchill, and the wedding of John F. and Jacqueline Bouvier Kennedy.

Frith, Francis (1822–1898)
British travel photographer
An adventurous Victorian, Frith is the most prominent of the early photographers of Egypt and the Holy Land. He built his own 16 x 20-inch wet-collodion plate camera, put it in his wicker camper/darkroom, and in 1856 embarked on his first trip up the Nile. The result was a series of pictures that still amaze in terms of their clari-

ty, precision, and visual impact. His direct eye-level frontal photography produced some of the most exquisitely detailed images of his day.

Born into a Devon Quaker family, he was apprenticed to a cutlery firm in Sheffield, Yorkshire, in 1838. After a succession of commercial ventures, Frith became a photographer and made the first of his professional tours of Egypt. He photographed ancient monuments from Cairo to Abu Simbel, despite difficulties with the wet-**collodion process** in the extreme heat of the desert. His first trip was such a success that he was commissioned to travel through Egypt to Syria and Palestine from 1857 to 1858. In the summer of 1859 he returned to the East, traveling 1,500 miles up the Nile from its delta.

All told, he made three trips to the Near East and between 1858 and 1862 produced eight separate photographically illustrated books containing more than 400 images. He also supplied prints to two different editions of the Bible, including the famed *Queen's Bible,* published in Glasgow by W. Mackenzie and one of the most lavishly illustrated products of nineteenth-century book design.

In 1859 Frith opened a printing establishment in Surrey that produced large quantities of **albumen** prints and illustrated books to satisfy the demand for pictures of the Near East.

front lighting: Lighting a subject from the direction of the camera that produces little or no shadow and diminished detail.

front projection: Projecting a slide or video image directly onto a screen. Front projection is also a technique for creating a background from a slide or video image for use in a photograph, typically with a person in the foreground, giving the appearance that the person is in the scene being projected. To avoid having the person in the foreground cast a shadow onto the background image a beam splitter is used. A beam splitter works like a two-way mirror. It is placed at a 45 degree angle in front of the camera and the slide or video is projected onto the mirror side, which reflects it onto the back-ground screen. The camera is positioned to take the photograph through the beam-splitter's non-mirror side. Since the camera and the projection are viewing the subject from the same angle, there is no shadow.

f/64 Group: An informal association of California photographers who promoted precisionism through the use of the large-format **view camera,** printing by contact, and using the smallest camera **aperture,** which is f/64. Among the members were **Edward Weston, Ansel Adams, Imogen Cunningham, Willard Van Dyke,** and **Consuelo Kanaga.** They were a loosely allied group from 1930 until 1935 and have had a profound impact on photographic aesthetics to this day. Exhibiting as a group only once, they generated a lively controversy with west coast **pictorialists,** who favored soft-focus, manipulated prints.

f-stop: The barrel of a **lens** is marked with a series of f-stops. When the ring on the barrel is rotated to a particular mark, the leaves inside the lens adjust to that f-stop. The higher the f-stop number the smaller the aperture opening.

full frame: This refers to reproduction of a photograph without altering or **cropping** the image. Photographers like **Henri Cartier-Bresson** forbid any manipulation whatsoever of their original images.

Fulton, Hamish (1946–)
English art photographer
Fulton is a highly regarded conceptual artist/photographer whose work documents his walking trips in the countryside. His barren, alien, panoramic views are a combination of the landscape paintings of Turner and Constable and of the early western survey photographers **William Henry Jackson** and **Timothy O'Sullivan.**

The photographs, some in triptychs, are taken with 35mm equipment and explore the influences of nature with a spiritual quality that involves the spectator. One typical journey covered 1,022 miles in 47 days and, like his other walks, is represented by photos with titles like "Barking Dogs," "Ringdom

Gompa," and "Two day walk from Dumre to Leder n Manang and back to Pokhara by way of Khudi (Nepal)."

Fulton studied sculpture in London but changed course in 1970 and became a professional photographer. His work has been widely exhibited and is represented in major museum collections in Europe and the United States.

Galassi, Peter (1951–)

American curator

As chief photo curator at the Museum of Modern Art, Galassi wields great influence in the world of contemporary photography.

Born in Washington, D.C., he holds a bachelor of arts degree from Harvard University (1972) and a doctorate from Columbia University (1986). Galassi has spent his entire professional life at the Modern, joining as an intern in 1974. He became an associate curator in 1981, ascended to curator in 1986, and replaced the retiring **John Szarkowski** as chief curator of the Department of Photography in 1991.

Among his major projects at the Museum of Modern Art have been the 1997 organization of the complete 69-photograph set of **Cindy Sherman**'s "Untitled Film Stills," which the museum bought in 1995 for $1 million; the acquisition of more than 250 **Garry Winogrand** shots from the Barbara and Eugene Schwartz collection; and a 1998 show on Alexander Rodchenko, the first U.S. retrospective ever of the Russian master.

He is the author of scores of catalogues and in 1988 won the **International Center of Photography**'s **Henri Cartier-Bresson** Award for excellence in writing on photography. He has lectured most notably at the Louvre, the Victoria and Albert Museum, the Getty Museum, and the Metropolitan Museum of Art.

Galella, Ron (1931–)

American photojournalist

Galella is a freelance **street photographer** whose candid shots of celebrities have appeared in newspapers and magazines worldwide. This kind of photographic newsgathering, sometimes resulting in a confrontation between an unwilling celebrity subject and an aggressive photographer called a *paparazzo*, has produced controversies about the celebrity's right to privacy versus the photographer's right to photograph a public figure. Galella has been an ardent defender of the photographers.

One of Galella's favorite subjects was Jacqueline Bouvier Kennedy Onassis, who finally sued him in 1972 for invasion of privacy. She maintained that once she was out of the White House she was no longer a celebrity or public figure. She felt that Galella was making a practice of following her and her children, intrusively snapping candid pictures. The New York state court decision was mixed: In Galella's favor the jurists said, "Once a public figure, always a public figure." However, they also ruled that Galella must stay 100 feet away from Mrs. Onassis and her family.

In his 1976 book *Off-Guard: A Paparazzo Look at the Beautiful People,* Galella defends *paparazzo* journalism, saying that these spontaneous, unrehearsed shots result in unique photos that better express a celebrity's personality than carefully planned publicity shots. Galella has photographed nearly every entertainment personality of the late twentieth century and continues in his role as one of the most visible *paparazzi* of his time.

Gallagher, William M. (1923–1975)

American photojournalist

Gallagher won the 1953 **Pulitzer Prize** for one of the most famous political pictures of his era: the shot of former Illinois Governor Adlai E. Stevenson with his legs crossed, showing a hole in the bottom of his shoe, taken during the 1952 presidential campaign.

As a teenager Gallagher acquired his first camera as a prize for winning a magazine subscription-selling contest, and he also won the first photo contest he entered, earning $5 for a shot of his native Detroit's skyline. He

William Gallagher. *Hole in the Shoe* (Governor Adlai Stevenson, right, and Governor Mennan Williams at a Labor Day rally.), 1952. Pulitzer Prize-winner, 1953 for the *Flint (MI) Journal*. © *Flint Journal.* Courtesy *Flint Journal.*

served in the U.S. Army during World War II and then got his first job on the *Flint Sporting News* in 1946. The next year, he joined the *Flint Journal* as a staff photographer, where he worked for the rest of his life.

gallery: An exhibition space for art. Generally an open room with white walls and well lighted for the presentation of art, it can be one room or many rooms. Galleries can be in museums or operated as commercial spaces with works for sale or operated as nonprofit ventures. Since the 1970s many galleries specialize in exhibiting contemporary and historical photography, and photojournalism as a fine art.

Gamma Liaison Inc.: This agency, specializing in international news, is the world's leading editorial photo agency. It arranges for photographers to work on assignment for a client, usually a newspaper, magazine, or corporation. It also houses a large collection of **stock** images.

Gardner, Alexander (1821–1882)
Early American documentary photographer
Working first for **Mathew Brady** and then on his own, Gardner photographed many of the most important battles of the Civil War. His two-volume *Photographic Sketch Book of the Civil War,* published in 1866, is a valuable record of such crucial battles as Antietam, Appomattox, Manassas, and Bull Run; there are scenes of Gettysburg just after the retirement of forces, as well as images of Petersburg, Richmond, and many others that provide a glimpse of the realities of the bloody conflict.

Born in Glasgow, Scotland, and trained as a jeweler, chemist, and photographer, Gardner, according to some sources, came to the United States in 1849 to set up a cooperative community in Iowa based on the socialist teachings of Robert Owen. He is supposed to have returned to Scotland and brought his family back with him, but when he discovered that the utopian community was suffering from an epidemic, he settled in New York.

There in 1856 he found work in Brady's portrait gallery, where he could put to use his training in the new

collodion process, a wet-plate technique that enabled the photographer to make multiple paper copies of an image. In 1858 Gardner moved to Washington, D.C., to manage Brady's new studio there. When the Civil War began, Brady organized a cadre of photographers, Gardner among them, to photograph the conflict, with the studio name, but not the photographer's, getting credit for the shot.

This practice angered Gardner, and by 1862 he left Brady's employ, taking with him the negatives of his own work, many of the images having previously been credited to Brady. Gardner opened his own studio and then joined the Army of the Potomac as a photographer. Other former members of Brady's crew, including **Timothy O'Sullivan** and **George Barnard,** followed Gardner,

Alexander Gardner. *President Lincoln at Antietam.* October 1862. The National Archives / Corbis.

who gave his fellow photographers the credit they deserved. Gardner himself produced 2,000 war images, including several portraits of Abraham Lincoln, whom he photographed on several occasions. In a famous sequence, Gardner photographed the hanging of the conspirators convicted of planning Lincoln's assassination.

After the war Gardner worked in his Washington studio, photographing delegations of Native Americans who flocked to the capital city to negotiate land treaties. He made several trips to the West to visit family members who had joined the planned community and to photograph the people and landscape of the western United States for the Union Pacific Railroad. In Washington he worked with the police department, taking photographs of criminals. At his death he was considered a successful man because of his skills as a photographer and his wise investments in real estate.

Gates, William H. (Bill) (1955–)

American computer entrepreneur

Gates, the world's richest man with his **Microsoft** Company and creation of the world's dominant **computer** operating system, has systematically acquired some of the world's most prominent photo archives and images and is using his computer facilities to make them available for buyers and browsers.

He now owns archives ranging from the 17 million images of **Bettmann** to the 2,500 of **Ansel Adams**, plus images from the National Gallery in London and Moscow's State Hermitage. Pictures ranging from a young John F. Kennedy Jr. saluting his father's coffin to Marilyn Monroe's skirt billowing up over a subway grate are among his holdings. All of these images are being digitally **scanned** into computers, making them readily available. His **Corbis** Corp. has an **internet** site for **online** sales. Gates believes that someday sampling and selling digital images on computer disks or over the internet will be a sizable business. He has said that his work will also be a great democratization, making history more accessible to the public.

Gatewood, Charles (1942–)

American documentary photographer

Gatewood has had a long and illustrious career documenting various aspects of contemporary culture, from scenes of Mardi Gras and, in a collaborative work with William S. Burroughs, deviant behavior to Wall Street.

Born in Chicago, Gatewood received a bachelor of arts degree in anthropology from the University of Missouri in 1963 and did graduate work there and at the University of Stockholm. A self-taught photographer, he worked on staff from 1969 to 1974, first at the *Manhattan Tribune* and then at *Rolling Stone* before embarking on a freelance career. He has been featured in more than 100 publications, ranging from the mainstream (the *New York Post, Camera 35, Popular Photography*) to the tangential (*Spazz* magazine, *Leatherfolk, Taste of Latex, Verbal Abuse*).

His books have also ranged in subject matter, from *Hellfire* (1987) to *Pushing Ink: The Fine Art of Tattooing* (1979), *Wall Street* (1984), and *Sidetripping* with Burroughs (1975). Gatewood has had more than 50 solo shows and is in public and private collections from those of the **International Center of Photography** to the Metropolitan Museum of Art. He has also taught or lectured at numerous institutions, including the Rhode Island School of Design, The New School, the San Francisco Academy of Art, and Parsons School of Design. Among his awards and honors are two Creative Artists Public Service (CAPS) fellowships (1974, 1977), a **Leica** Medal (1985), an Art Directors Club merit award, and a grant from the Photographer's Fund.

Gay, Gerald H. (1946–)

American photojournalist

Gay won the 1975 spot news **Pulitzer Prize** for his dramatic photograph of four exhausted firefighters at a Seattle-area fire.

A Seattle native, he got his first camera as a Bible school prize. A spiritual person, he considered entering the ministry, but he opted for the camera. He learned his craft at Everett Community College and then the Brooks Institute of Photography. His first job was at the *Everett Herald;* he joined the *Seattle Times* in 1972. During his long career there he won numerous local, state, and national awards, including the Pulitzer. "You don't take pictures to win contests," Gray said after the prize

Pages 162 – 163: Gerald H. Gay. 1975 Pulitzer Prize winner for spot news first published in the *Seattle Times* depicts four exhausted firemen taking a break after battling five hours to save a house that eventually burned down. © Gerald H. Gay. Courtesy of the photographer.

was announced. "You just do the best job you can."

He later worked for the *Los Angeles Times* and *Newsday* before becoming a successful freelancer, media consultant, commercial photographer, and lecturer.

Gee, Helen (1919–)
American gallery owner, curator, and writer

In her 1997 memoir *Limelight,* Gee relates the story of her founding and running the photo gallery and coffeehouse of the same name in 1954. Located in Greenwich Village, the **Limelight** was the only photography gallery in the country, and Gee early recognized and exhibited the work of such major figures as **W. Eugene Smith**, **Minor White**, **Robert Frank**, **Rudolph Burckhardt**, **Joseph Breitenbach**, **Esther Bubley**, **Imogen Cunningham**, **Robert Doisneau**, and **Louis Faurer**.

The photo gallery/coffeehouse was open for seven years and presented some 70 shows; it was a center of creative activity for actors, writers, painters, and photographers. Since the gallery closed, Gee has worked as a freelance curator. In 1979 she organized the **Stieglitz** and the **Photo-Secession** exhibits for the New Jersey State Museum, and in 1980 she wrote the catalogue and was curator for "Photography of the Fifties, An American Perspective" for the **Center for Creative Photography** in Tucson, Arizona.

Gee left home at 16 to live in Greenwich Village with Yun Gee, a Chinese modernist painter. Interested in artistic expression, Gee first considered a career as a painter. Dissatisfied with her progress, she decided to study photography, briefly with **Alexey Brodovitch**, and later with **Lisette Model**, but her commitment to photography did not take shape until she had the idea to open a coffeehouse/gallery.

gelatin: A transparent, flexible material used in photography for holding light-sensitive silver halides (in black-and-white photography) and dyes (in color photography). Gelatin is used on both film and paper.

gelatin silver print: This term is seen often in auction catalogues and on exhibition prints in galleries and museums. It is defined as a fiber-based **black-and-white photograph** that uses a solution of **gelatin** and light-sensitive silver halide to form the **emulsion**. All fiber-based black-and-white photographic papers use this gelatin-silver emulsion.

generation: The name for successive copies of information, or the number of copies removed from an original. With older analogue systems there is often some loss of data from one generation to the next, but with digital systems there should be no loss of data between generations.

genre photography: Photography about everyday life, especially from the late nineteenth and early twentieth centuries. In the early years of photography, only certain subjects and scenes were considered appropriate for picture making. Scenes of the working class and everyday life were not thought of as a good subject for art, but there was a tradition of genre painting and that influenced some photographers to pursue the subject of the everyday as well. **Peter Henry Emerson** undertook a project of photographing the life and landscape of the English countryside known as the Norfolk Broads, a working-class fishing and agricultural area. Emerson's success with this subject and his renown as an artist helped make genre photography more acceptable. Today the sentimental values of the tableaux of genre photography no longer interest contemporary photographers except as ironic subjects, as in the work of such conceptual photographers as **Sandy Skoglund**.

Genthe, Arnold (1869–1942)
German-born, American art and documentary photographer

Best known for his shots of San Francisco's Chinatown before the great earthquake and fire of 1906—as well as on-the-scene shots of the devastation—the German-born Genthe also took portraits of some of the most significant cultural and political figures of his time.

A philology scholar, Genthe earned a doctorate in the classics in Berlin before studying at the Sorbonne and moving to San Francisco in his early twenties to be a tutor to a baron's son. Genthe spoke and read eight mod-

Arnold Genthe. *Chinese man smoking a pipe*, ca. 1896–1900. Library of Congress/Corbis.

ern and ancient languages, writing his doctoral dissertation in Latin. Around the turn of the century he opened his first photo studio.

He moved to New York in 1911 and opened a portrait studio. His subjects included Theodore Roosevelt, Isadora Duncan, William Howard Taft, Woodrow Wilson, Pavlova, and scores of others. His portraits are in the soft-focus, romantic style favored by the **Pictorialists** of the era.

George Eastman House International Museum of Photography and Film: The former home of the

photography pioneer has been operated as a museum, library, and study center since 1949. The 12.5-acre house and garden site in Rochester, New York, includes an archive building and research center, galleries, and an education center. Highlights of the 4,000-piece photography collection include major collections of the work of **Ansel Adams, Alfred Stieglitz,** and **Edward Steichen**, nineteenth-century photos of the American West, early French photography, and one of the largest **daguerreotype** collections in the world. Other important pieces include copies of **Fox Talbot**'s *Pencil of Nature* and **Alexander Gardner**'s *Photographic Sketches of the [Civil] War*. The film collection includes Martin Scorsese's private collection, the world's largest silent-film collection, and the most complete collection of Warner Brothers film stills. The technology collection is an unsurpassed trove of photo and film equipment covering the histories of both still and moving pictures, from Edison and the **Lumière** brothers through lunar orbiter cameras developed for NASA.

In addition to its library and permanent collections, the Eastman House sponsors and hosts revolving exhibits, special guest lectures, workshops, curatorial talks, tours of the gardens and grounds, and a number of programs and services for children, including the hands-on Discovery Room.

Gernsheim, Helmut Erich Robert (1913–1995)

British photographer, writer, collector, and historian

Gernsheim is noted as the author, with his wife, Alison Eames, of *The History of Photography,* originally published in 1955. While researching his book, Gernsheim made several key finds: He rediscovered the photography of **Lewis Carroll** and also identified the oldest existing photograph—**Joseph Niepce**'s 1826 view of his building's courtyard.

Born in Germany, he studied art history and photography. After the Nazis' rise to power, Gernsheim fled to England in 1937. He served a wartime stint as photographer for an architectural survey at the Warburg Institute of Art in London and become a British subject in 1946. Encouraged by his fellow photohistorian **Beaumont Newhall**, Gernsheim began collecting pho-

tographs in 1945; he acquired a substantial collection, now housed at the University of Texas, Austin, where Gernsheim was a visiting professor.

Gernsheim also published biographies of Carroll, **Julia Margaret Cameron**, and **Louis Daguerre** as well as photo books about Winston Churchill and the city of London. He and his wife were contributors for the photography entries in the *Encyclopedia Britannica*.

gestalt: Coming from the German word *whole*, it means the perception of something in its entirety and how it functions as a whole, as well as acknowledging that the whole is greater than the sum of its parts.

ghost: A usually opaque object that appears to be transparent in the photographic image or unwanted markings due to lens flare, reflections, or glare.

Gibson, Ralph (1939–)

American surreal photographer

Gibson is among the best known surrealist art photographers; his well-founded reputation started with the publication of *The Somnambulist* in 1969. He has been in more than 100 exhibitions since 1962 and has won major awards, including a **Guggenheim fellowship** (1985), a Creative Artists Public Service grant (1977), and three **National Endowment for the Arts** fellowships (1973, 1975, 1986). He is also a winner of the **Leica** Medal of Excellence (1988).

Born in Los Angeles, he attended the Art Institute of San Francisco before becoming an assistant to **Dorothea Lange** in 1961. After that he moved to New York and found work as an assistant to **Robert Frank**. He founded Lustrum Press in 1969. In addition to *The Somnambulist,* he published *Deja Vu* (1972) and *Days at Sea* (1974) to great acclaim. In total, 23 collections of his work have been published, including *Light Years* (1996), a collection published in conjunction with a major retrospective exhibition.

His early work was in small-format black-and-white, while his later works embrace color but maintain his trademark surrealist, minimalist style. Describing his work, Gibson has stated, "A surrealist is someone who

prefers to live in his subconscious as a more rewarding place to be. . . . For me, surrealism has centered around a deeper perception of the nature of reality."

Gidal, Tim N. (1909–1996)
Israeli photojournalist and teacher

Author of *Modern Photojournalism: Origin and Evolution 1910–1933,* Gidal was one of the group of prominent photographers whose photo reportage contributed to the success of German illustrated newspapers in the first third of the twentieth century.

Gidal worked for the *Munich Illustrated Press* before emigrating to Palestine in 1936. He worked as a freelance photojournalist for magazines in the United States, France, and Britain before joining the staff of *Picture Post* in London. In 1947 he moved to the United States, where he was a well-regarded photojournalist whose work was widely published. He was a lecturer at The New School from 1955 to 1958.

Gidal attributed his success to the introduction of the 35mm camera, saying that its small size and portability were instrumental in the development of photo reporting as a profession and the phenomenal growth of illustrated magazines. He moved to Israel in 1971 and remained active both as a photographer and a teacher at Hebrew University in Jerusalem.

Gilman, Howard (1925–1998)
American collector

A patron of the arts and collector of photographs and other art, Gilman was the chief executive of the Gilman Paper Company and established the Howard Gilman Foundation, which gave the endowment for the Metropolitan Museum of Art's first permanent gallery devoted exclusively to photography, in October 1997.

Gilman was the third generation running his family's company operating paper manufacturing mills in southeastern Georgia. He launched the company's photography collection of more than 5,000 images, from which were chosen the 250 photographs exhibited in the landmark 1993 Metropolitan Museum show "The Waking Dream: Photography's First Century." In addition to photography, he was active in support of wildlife conservation and dance.

Gilman was born and grew up on Manhattan's Upper East Side. He received a bachelor's degree from Dartmouth and served in the Navy during World War II.

(Howard) Gilman Gallery:
The first gallery of the Metropolitan Museum of Art permanently devoted to photography, opened in 1997. The museum's department of photography, under its first curator in charge, **Maria Morris Hambourg,** acquired the collection amassed by **Howard Gilman,** president of the Gilman Paper Company. In 1993 Gilman loaned the museum 253 photographs for the landmark exhibit "The Waking Dream: Photography's First Century." Gilman not only lent his photos but went on to pay for the construction of a new gallery, which was named after him. Generally regarded as the best private collection of nineteenth-century European and American photography in America, Gilman's collection ranged from the earliest experimental paper photographs of **William Henry Fox Talbot** to the work of **Robert Frank.**

Gilpin, Laura (1891–1979)
American documentary photographer

Gilpin was a master of the soft–focus landscapes, portraits, and still-lifes that were popular before World War I and a contributor to the **Photo-Secessionists**. A documentator of the lifestyle of the Navajos and their relationship with the land, she was called by **Ansel Adams** "one of the most important photographers of our time."

Born in Colorado Springs, she was given a Kodak Brownie camera for her twelfth birthday. Encouraged by her mother and **Gertrude Kasebier,** she studied at the **Clarence White** School, where she mastered the **Pictorialist** style in vogue in 1916 and 1917. She also learned platinum printing, a technique that produced stable prints with rich tones.

Although living in New York was exciting, Gilpin was drawn more to the West and found her true subject matter in the Southwest. She returned home in 1918 and earned national and international recognition for her photographs, which increasingly focused on regional subjects. In 1924 she had first seen the cliff dwellings at Mesa

Verde, and she was fascinated by the sense of history she found there. She viewed the Indians with deep respect and understanding for their culture and published four major books on the Southwest: *The Pueblos: A Camera Chronicle* (1941), *Temples in Yucatan: A Camera Chronicle of Chichen Itza* (1948), *The Rio Grande, River of Destiny* (1949), and *The Enduring Navajo* (1968), her final and most important study.

At the age of 81 she won a **Guggenheim fellowship** and began a major study of the New Mexico and Arizona ruins of Canyon de Chelly that continued until her death at 88. She left her photographic estate to the Amon Carter Museum in Fort Worth, Texas. A definitive study of Gilpin, *An Enduring Grace,* was published by Martha A. Sandweiss in 1986.

Ginsberg, Allen (1926–1997)

American poet and documentary photographer

The foremost poet of the Beat Generation, whose "Howl!" became the literary manifesto of his generation, Ginsberg was also a remarkably talented photographer whose candid black-and-white pictures constitute a visual record of the counterculture around him from the 1950s to the end of his life.

Born in Paterson, New Jersey, Ginsberg attended Columbia College in New York, where he met Jack Kerouac and the other writers who would form the nucleus of the Beat movement. He later joined the Merchant Marines and moved to San Francisco in 1955. When "Howl!" was published it created a sensation and was the cause of an obscenity court case. He returned to the east coast, where he was active in the cause of international peace, taking part in public demonstrations, traveling widely, lecturing, teaching, and writing. Among his other poetic works, his elegy for his mother, "Kaddish for Naomi Ginsberg (1894–1956)," is considered among his finest poems.

Not a professional photographer, Ginsberg started taking photographs for the family album. In 1953 he bought a used Kodak Retina and began documenting his circle of friends, making portraits of such figures as William Burroughs, Gregory Corso, the photographers **Berenice Abbott** and **Robert Frank**, and other con-

temporary artists. He produced intimate snapshots for which he handwrote captions. Several collections of Ginsberg's photos have been published, including *Snapshot Poetics* (1993) and *Photographs* (1990).

glare/reflections: Any light or sunlight bouncing off of polished metal or shiny painted surface into the **lens** is glare. The light produced by the glare is a reflection.

glass plates: Pieces of glass used as the support for light-sensitive material. Glass became a common material for negatives and briefly for positive images called **ambrotypes**.

Glinn, Burt (1925–)

American landscape photographer

Glinn achieved national recognition for his spectacular color essays covering the South Seas, Japan, Russia, Mexico, and California, each of which was published as a complete issue of *Holiday* magazine.

He served in the Army from 1943 to 1946 before attending Harvard University, where he was picture editor of the *Crimson* in 1949. He worked for *Life* for two years before embarking on a freelance career. He first became associated with **Magnum** in 1952, and he was elected president for the first of three terms in 1972. He

Early 3 x 3 glass plate photograph of 3 Bengallee writers in Calcutta, India, produced by T. H. McAllister Manufacturing Optician, 49 Nassau Street, New York. Collection the authors.

Frank Gohlke. *Grain Elevators and Lightning Flash, Lamesa, TX.* 1975. © Frank Gohlke. Courtesy the photographer.

was reelected president in 1987. From 1974 to 1977 he was one of the original contributing editors of *New York* magazine and from 1980 to 1981 was president of the American Society of Magazine Photographers.

Glinn has published two noteworthy books in collaboration with Laurens van der Post, one on Russia and one on Japan. Later in his career he photographed corporate annual reports for such Fortune 500 firms as Pepsico, Xerox, Alcoa, General Motors, and Inland Steel.

glossy finish: Photographic papers with a shiny surface. Most photographic papers are available in glossy, semi-matte, and matte surfaces. The most commonly available glossy papers are resin coated (RC).

Gohlke, Frank William (1942–)

American landscape photographer and teacher

Gohlke achieved recognition for his stark black-and-white landscape photographs of the modern environment, incorporating such elements as grain elevators, water towers, and other human-made structures.

Born in Texas, Gohlke was graduated from the University of Texas at Austin with a bachelor of arts degree in English literature and from Yale University with a master of arts degree in the same subject. He met **Walker Evans** at Yale and became seriously interested in photography. In 1967 and 1968 he studied with **Paul Caponigro**.

Gohlke was included in the 1975 show called "The New Topographics: Photographs of a Man-Altered Landscape" at the **George Eastman House** in Rochester, along with **Lewis Baltz**, **Hilla and Bernd Becher**, and **Robert Adams**. His 1979 Museum of Modern Art show, sponsored by the **National Endowment for the Arts** and Springs Mills, introduced his work to a wider audience. His career has been on an upward trajectory ever since.

Over the past 20 years, his academic appointments have included Harvard University, where he has been a visiting professor, 1994–1996; Princeton University, visiting professor, 1995; and Yale University, visiting lecturer, 1992. From 1977 to 1988 Gohlke was a visiting artist for a month each year at Colorado College. He has

also lectured or led workshops at Bard College, the Rhode Island School of Design, Hampshire College, Friends of Photography in Carmel, California, and at institutions overseas.

He has won two **Guggenheim fellowships** (1975, 1984), two National Endowment for the Arts awards (1977, 1986), and a 1979 Bush Foundation Artist's fellowship. His books include *Measure of Emptiness: Grain Elevators in the American Landscape* (1992) and *The Sudbury River: A Celebration* (1993).

His commissions include six murals at Tulsa International Airport in 1988, where he had already done a series of 16 photographic murals in 1980–1981. He has been widely exhibited and collected by major institutions from the George Eastman House to the Seagram Collection to the National Gallery of Canada.

Gold, Fay (1932–)

American artist and gallery owner

Since 1980, when an **Irving Penn** retrospective opened her Atlanta, Georgia, gallery, Gold has pioneered and developed the most influential contemporary fine-art photography gallery in the South.

Born in Greenville South Carolina, and raised in New York City, Gold had an affinity for painting and earned her bachelor of arts degree in drama and painting from Adelphi University in 1953. She married the next year and reared three children. As they grew up, she resumed her art. In 1965, the family moved to Atlanta, where Gold opened an art school catering to children and families. In 1980 she opened her gallery. The 1982 **Robert Mapplethorpe** show she mounted featured a photo he took of Gold. She also became friendly with **Annie Liebovitz**, **Andres Serrano**, and **Sandy Skoglund**, all of whom have had work exhibited at Gold's space.

Goldbeck, Eugene (1892–1986)

American landscape photographer

Goldbeck is known for his **panoramic photographs,** taken with equipment he invented and patented himself. His introduction to photography came as a child when he snapped President William McKinley in his native San

Antonio on a victory tour through the United States. By the age of 15 he was taking pictures of his classmates and selling them for five cents each.

His first job was for an insurance company—his assignment, to get a picture of a man who had put in a disability claim working hard at his job. It took him three weeks, but he got the picture. In 1921 he founded a company called National Photo Service, which sold prints of original work, accepted special assignments, and could send by wire photos anywhere in the world.

Goldbeck, who lived and worked in San Antonio much of his career, took many of his pictures from positions no photographer had used before. He built scaffolds up to ten stories high and sought out virtually inaccessible locations to get the shot. He invented and patented some of the equipment he used. Much of his work was done with a Cirkut camera, which has a single springed motor that winds ten-inch-wide film through the exposure area of the lens at a rate matched to the rotation rate of the panning camera. By this process, the exposure produces a panoramic image on the negative up to 60 inches in length.

His scenic panoramas, many reproduced in a 1986 book, *The Panoramic Photography of Eugene Goldbeck*, include Mt. McKinley and the Grand Canyon, bathing beauties, the Denver chapter of the Ku Klux Klan, the 1922 New York Yankees, and every member of the U.S. Air Force circa 1911.

In 1977, when he was well into his eighties, he traveled to Leningrad to Peter the Great's summer palace, which he captured in spectacular color.

Goldberg, Vicki (19??–)

American writer and critic

Chief photography critic for the influential *New York Times*, Goldberg has also written or edited several well-received books on photography, including a 1986 biography of **Margaret Bourke-White** called by the American Library Association one of the best books of the year.

Born in St. Louis and holder of a master's degree in fine arts from New York University, Goldberg has taught at NYU, the City University of New York, and the New School for Social Research while pursuing her writing career at the *Village Voice, Art Quarterly, American Photographer, Saturday Review,* and other publications. In 1991 she published *The Power of Photography: How Photographs Changed Our Lives*, examining the role photographs have played in events from the Civil War to the Kent State killings, in the fields of politics, surveillance, and social reform, and the creation of celebrity and delivery of news. Goldberg has also lectured at the Metropolitan Museum of Art and other institutions.

In 1997 she was given the **International Center of Photography**'s Infinity Award for Writing and Photographic Administrators Inc. Award for Outstanding Achievement in Photographic Writing.

Goldin, Nan (1953–)

American art photographer

Goldin's camera focuses on herself and her circle of friends, disclosing a bohemian environment and alternative, sometimes self-destructive lifestyle. Her work has aroused controversy, and after a major 1997 retrospective, "I'll Be Your Mirror," at the Whitney Museum, she has been one of the most often discussed and exhibited photographers of the late twentieth century

A teenage runaway, Goldin used her life experiences for her art. She created a disturbing 700-image slide show diary, set to a rock and roll sound track, that showed explicit, deviant sexual behavior, the drug culture, and people getting tattooed and showing off bruises. Her show was played in clubs in the United States and Europe in the early 1980s. A series of these images were collected in her book *The Ballad of Sexual Dependency* in 1986. Two years later, she entered a rehabilitation center and after moving to a halfway house, did a series of harsh self-portraits dealing with the restructuring of an identity.

Her reputation was enhanced by the 1993 Whitney Museum Biennial, when she exhibited "The Family of Nan" (a wordplay on the famous "**Family of Man**" show put together by **Edward Steichen** six decades earlier), **Cibachrome** prints of people she knew, mainly sick and some afflicted with AIDS.

A winner of a **National Endowment for the Arts** award in 1990, she now lectures at Yale University

and elsewhere, is included in major photo collections, and has had solo shows at venues ranging from the Jeu de Paume in Paris to major New York City galleries.

Goodridge, Wallace (1841–1922)
Goodridge, William (1846–1891)
Goodridge, Glenalvin (before 1841–c. 1867)

Pioneering American commercial photographers

The brothers Goodridge were among America's pioneer black photographers and are credited with creating the first wallet-sized folding photographs.

Glenalvin, the eldest brother, was one of the first **daguerreotypists** and had opened his own studio in York, Pennsylvania, in a family-owned office building by 1850. His skill was recognized at the York County Fair, where he won an award for his **ambrotypes**. As the Civil War approached, the family played an important role in the Underground Railway, helping runaway slaves escape the South by providing shelter in their home.

By 1863 Confederate forces had invaded Pennsylvania and the family fled, eventually settling in Saginaw, Michigan, where the brothers operated a successful photo studio from 1866 to 1922. In addition to portraiture, they covered a variety of activities, including significant community events, landscapes, and the booming lumber business in the Saginaw Valley. Their scenic **stereoscopic** series, such as "Michigan State Views," were a major aspect of their work and were widely advertised.

Gorman, Greg (1950–)

American portrait photographer

Since the 1960s Gorman has been one of the top personality photographers of the entertainment industry as well as a successful commercial photographer with creative, technically brilliant work in advertising campaigns, editorial layouts, album covers, and music video direction.

Born in Kansas City, he studied photography at the University of Kansas and cinematography at the University of Southern California.

He first took pictures as a fan at rock concerts, snapping Jim Morrison, Janis Joplin, and Jimi Hendrix at midwestern dates in 1968. The next year he brought his camera to Washington, D.C., for peace rallies and soon thereafter fell into photography as a career. In the early 1970s he moved to Hollywood and took photos of celebrities for such graphically oriented publications as **Andy Warhol**'s *Interview.* His black-and-white portraits have been published in a monograph called *Inside Life* (1996), his third book.

In the early 1980s, he revolutionized editorial advertising with his campaign for L.A. Eyeworks, combining the color and glitz of fashion photography with celebrities wearing the product. He has produced graphics and publicity for many motion pictures, including *Dances with Wolves* and *Tootsie.*

He now serves on the Board of Advisors of the Sante Fe Photographic Workshop, where he conducts an annual seminar. He continues to live and work in California.

In the 1998 Harrison Ford film *Six Days, Seven Nights,* he played a photographer opposite Anne Heche, and played a "crazier version" of himself in the 1998 John Waters film *Pecker.*

Gossage, John R. (1946–)

American landscape photographer

Working in urban environments devoid of people, Gossage makes pictures that have been described as "complex, deliberate, densely layered, difficult and demanding—often unpleasant sometimes witty, always black and white."

Born in New York and taught by **Lisette Model**, **Alexey Brodovitch**, and **Bruce Davidson**, Gossage moved to Washington in his twenties and was immediately successful as an art photographer. His pictures of dead gardens, deserted neighborhoods, and D.C. monuments have won him three **National Endowment for the Arts** awards (1973, 1974, 1978), major museum shows, and inclusion in scores of important photography collections.

Gouraud, François (1808–1847)

French agent and promoter

At the suggestion of the inventor **Samuel F.B. Morse**, **Louis Daguerre** sent an agent to the United States to introduce his new **daguerreotype** process to the

public. Gouraud was Daguerre's agent, commissioned to establish an agency for selling Daguerre's apparatus and to hold an exhibition of his work. Gouraud also edited and published the first American photography handbook.

Gouraud arrived in New York on November 23,1839, and immediately sent out invitations for a private viewing of 30 daguerreotypes at the Hotel François on December 4. The exhibit was open for two weeks, with Gouraud giving demonstrations on the craft daily. Among the pupils who signed up for lessons was Morse, whose early efforts to make daguerreotypes were not successful. Morse's work did improve, but he said Gouraud could not take credit and, further, he accused Gouraud of degrading Daguerre's presentation by selling patent medicines at the exhibitions.

Gouraud moved on to Boston, where he again staged exhibitions and took on pupils, among them Edward Everett Hale and **Albert Southworth**.

In response to popular demand, Gouraud edited a condensed, 16-page version of Daguerre's manual explaining the process. Published in Boston in 1840, A *Description of the Daguerreotype Process; or a Summary of M. Gouraud's Public Lectures according to the principle of M. Daguerre.* can be considered the first American book on photography. Gouraud took his exhibitions around the country, to Providence, Buffalo, and New Orleans, where his collection was lost in a fire early in 1843.

Gowin, Emmett (1941–)

American art photographer and teacher

Gowin's black-and-white images of his family taken with a large-format camera can be considered a mannered, autobiographical narrative in a "backyard gothic" style. Other subjects for his exploration of photographic craftsmanship are his views, some aerial, of landscape and terrains around the world, that he calls his working landscapes.

Born in Virginia, Gowin earned a bachelor of fine arts degree from the Virginia Professional Institute and then a master of fine arts degree from the Rhode Island School of Design in 1967, where he studied with **Harry Callahan**. He was awarded a **Guggenheim fellowship** (1974) and two **National Endowment for the**

Arts fellowships (1977, 1979) and received such arts awards as the Pew fellowship (1993) and Friends of Photography Peer Award (1992).

His first major exhibit was at the Museum of Modern Art (1971) with **Robert Adams**, and he has since had solo exhibitions at the Corcoran Gallery, the Museum of Modern Art, the Chrysler Museum in Norfolk, Virginia, and the Light Gallery. His work is represented in such collections as those of the Philadelphia Museum of Art, the Metropolitan Museum of Art, and the Museum of Modern Art in New York. Gowin teaches at Princeton University and also pursues his own work as a freelance photographer.

grain focuser: A device for checking to see if a negative is properly focused in the **enlarger** during the printing process. It has a mirror that reflects a greatly enlarged area of the negative into an eyepiece. A grain focuser is placed on the enlarging surface, and, with the enlarger turned on, the printer looks into the eyepiece and focuses the "grain" of the negative until it is sharp. It is important to use a grain focuser because in the **darkroom** it is difficult to determine exact focus with the naked eye.

grant: A dispensation from an organization to an individual, nonprofit group, or other organization for either specified or unspecified use. In photography there are grants to support an individual photographer's project and/or to recognize continued excellence and for organizations that sponsor exhibitions, education, and publications of photographer's work. Some major grants are given by the **Guggenheim Foundation,** the **National Endowment for the Arts,** the Alicia Patterson Foundation, and the McArthur Foundation.

graphic arts: The general term for graphic communication and printing, including typography, illustration, photography, and design.

gray scale: A scale of gradations from pure white to pure black and the grays that fall between them. Typically a gray scale is used for reproduction purposes

Kodak Gray Scale. © Eastman Kodak Company.

to determine the accuracy of the representation of tones (meaning grays as opposed to color).

Grazda, Ed (1947–)

American surrealist photographer

Grazda is a surrealist photographer who has used scenes of Latin America and then Asia as his palette.

Born in Queens, New York, he studied under **Harry Callahan** at the Rhode Island School of Design, where he received his bachelor of fine arts degree in 1969. He says of his black-and-white work, "My work is about the real world, the surreal, and the unreal world of a photograph."

Among the institutions at which he has taught photography are Harvard University and the State University of New York at Purchase. Grazda won Creative Artists Public Service awards in 1973 and 1975, a **National Endowment for the Arts** fellowship in 1980, and a New York State Council on the Arts prize in 1996. His books include *Afghanistan, 1980–1989* (1990) and a volume on the mosques of New York, *New York Masjid* (1997). His work has been exhibited in solo and group shows in numerous venues, including the Metropolitan Museum of Art, the Museum of Fine Arts in Houston, and the Corcoran Gallery in Washington, D.C. His work is held in private and public collections, including those of the Museum of Modern Art in New York, the Hallmark Collection, and the New York Public Library.

grease pencil: A thick marker with a waxy core for writing on photographs, negatives, transparencies, and other slick surfaces without damaging them. The mark is removable with film cleaner or other solvent.

Green, Jonathan W. (1939–)

American photographer, educator, curator, and writer

Green is an influential figure in contemporary American photography by virtue of his teaching, editorial work, and personal photography.

Born in Troy, New York, Green earned a bachelor of arts degree from Brandeis University and a master of arts degree from Harvard University; he also studied at the Massachusetts Institute of Technology and Hebrew University in Jerusalem. In 1967, after Harvard, he worked with Ezra Stoller for two years and from 1968 to 1976 taught photography with **Minor White** at MIT. From 1972 to 1976 he was also an associate editor at *Aperture,* and he had his first books published. They include the award-winning titles *Camera Work: A Critical Anthology* (1973), *The Snapshot* (1974), and a collaboration with White, *Celebrations* (1974). His *Critical History of American Photography, 1945 to the Present* (1984; reprinted 1996) was the first important survey of the field.

Prior to 1976, Green photographed only in black and white. Describing his work style throughout as "straight," he shifted to color in 1977. As a critic and writer, he says that his interest lies in issues concerning the relationship of photography and American culture. He is a member of several photo organizations, and his awards include a **National Endowment for the Arts** fellowship in 1977 and AT&T's Bell System Grant "American Images," to create new color work, in 1978.

Currently director of the California Museum of

Ed Grazda. *Mujahiden at Wageeza, Afghanistan.* 1983. © Ed Grazda. Courtesy the photographer.

Photography at the University of California Gallery at Riverside, he holds joint appointments as professor in the departments of studio art and art history. Before coming to Riverside he also taught at Ohio State University, where he served as director of the University Gallery of Fine Arts.

His photographs are held by museum collections around the world, including those of the Moderna Museet in Stockholm and the Boston Museum of Fine Arts.

Greenberg, Howard (1948–)

American gallery director

Based in New York's Soho, the Howard Greenberg Gallery specializes in classic twentieth-century photography and is one of the top photography galleries in the United States in sales, inventory, and exhibitions.

Gallery owner Greenberg started in the photography business in 1972, when he moved to Woodstock,

New York, where he became a full-time working photographer. He had several exhibitions and was published in newspapers, magazines, and art journals. In 1977 he founded the Catskill Center for Photography (now the Center for Photography in Woodstock) and was its executive director until 1980. He established Photofind Gallery in 1981 in Woodstock and moved the gallery to New York City in 1986. In 1991 the Photofind Gallery became the Howard Greenberg Gallery.

Greenberg has curated numerous exhibitions, served as juror for many awards and exhibits, and spoken widely about the history of photography and collecting photographs. He has also taught photography at the university level.

The gallery is known for its holdings on the **Photo League** photographers, fashion images, *Camera Work* gravures, **Farm Security Administration** work, **Magnum** photographers, **Photo-Secession** and **Pictorialism**, and the **Clarence White** School. The

gallery roster includes exclusive representation of such photographers and estates as **Eve Arnold, Anton Bruehl, Andre Kertész, Gordon Parks, Marc Riboud**, and **Roman Vishniac**. It also has substantial collections of work by **Berenice Abbott, Robert Frank, Alfred Stieglitz**, and other twentieth-century master photographers.

Griffiths, Philip Jones (1936–)

British photojournalist

A former **Magnum** president, Jones made his name as a war photographer in Vietnam, specifically with his 1971 book *Vietnam Inc.,* a riveting glimpse at the war and its human toll.

The Welsh-born Jones took up photography as a pharmacy student in college, working as a freelancer for the *Manchester Guardian.* He left college to work as a cameraman on TV documentaries before becoming a full-time still photographer in 1961. His work appeared on both sides of the Atlantic for such publications as *Life, Look,* the *New York Times,* and London's *Sunday Times* magazine. In 1966, he joined Magnum, and he spent two extended stints in Vietnam (1966–1968 and 1970–1971) and traveled internationally for many feature stories. In 1974, he put down his 35mm camera and again picked up the TV camera, deciding that he wanted to return to documentary filmmaking.

Groover, Jan (1943–)

American art photographer

Groover's boldly formal precisionist still-lifes of kitchen objects, sea shells, and food, in bold color and large format, have established her as a leading new American photographer.

Born in New Jersey, she trained as a painter, earning a bachelor of fine arts degree from Pratt Institute in 1965. She went on to teach high school art classes in her home town of Plainfield from 1966 to 1969 and decided to continue her education at Ohio State University, where she received a master of arts degree in art education in 1970. From 1970 to 1973 she taught art at the University of Hartford. During this time she had been making black-and-white triptychs. In 1973 she switched to color and changed from modular work made up of photos taken outdoors with a small-format camera to single-image still-lifes taken in a studio with a 4 x 5 **view camera.** Her first show was in 1974, at Light Gallery, and since then she has been an important figure in contemporary art photography.

Groover won New York State Council on the Arts CAPS Grants in 1974 and 1978, a **National Endowment for the Arts** photography grant in 1978, and two more National Endowment for the Arts awards in 1990—one for photography and one artists grant—and a **Guggenheim fellowship** in 1979. In 1979, she began a 12-year stint as a teacher at the State University of New York College at Purchase, a unique educational institution focusing on the visual arts. She credits her students for enriching her own personal work, and during that period she was widely exhibited and collected. Among her supporters is the esteemed critic **John Szarkowski**, the Museum of Modern Art's former photography curator, who gave her a solo show in 1987 and wrote the introduction to her 1993 book *Jan Groover Photographs,* comparing her to photography greats **Henri Cartier-Bresson, Dorothea Lange**, and **Edward Weston**.

Grossfeld, Stan (1951–)

American photojournalist

Grossfeld holds a rare distinction: He won consecutive **Pulitzer Prizes**. In 1984 he won the spot news photography award for his series of photographs revealing the effects of war on the people of Lebanon; in 1985 he won the feature photography award for his photographs of the famine in Ethiopia and for his pictures of illegal aliens on the U.S.–Mexican border.

His first professional job was at the *Newark Star Ledger* in 1973. He joined the *Boston Globe* in 1975, where he rose through the ranks to his current position as director of photography. In addition to the Pulitzers, he has won many honors, including the Overseas Press Club prize for best photographic reporting from abroad. His travels have resulted in the books *The Eyes of the Globe* (1985) and, closer to home, *Nantucket: The Other Season* (1982).

Jan Groover. *Untitled.* 1978. © Jan Groover. Courtesy Janet Borden Gallery, NY.

Grossman, Sid (1914–1955)

American documentary photographer and teacher

Grossman is known as a cofounder of the influential **Photo League** and for a series of documentary projects he initiated under the auspices of the League and the Works Project Administration (WPA). Blacklisted as a result of the anticommunist fervor that swept through Congress in the Cold War era, he went to Provincetown, Massachusetts, where he founded and for several summers ran the Provincetown School of Photography.

Born in New York City, he suffered from heart disease since his teen years. He joined his high school camera club in 1932. He studied at the City College of New York from 1932 to 1935. In 1943 he with Sol Libsohn and several others produced a mimeographed magazine called *Naivete*. In 1936 he and Libsohn, who had been members of the Film and Photo League, founded the Photo League, an organization committed to socially conscious photography in the tradition of **Lewis Hine**. He spent 1937 working for the WPA on a street crew with a pick and shovel. In 1938 he started his first photographic project, "Chelsea Document," a documentary record he undertook with Libsohn about the Manhattan neighborhood, and began teaching at the Photo League. "Negroes in New York" was done as a Federal Art Project/WPA assignment from May through July 1939. One of the blocks he photographed was later photographed by **Aaron Siskind** for a project titled "Most Crowded Block." The next year he and his wife traveled to the Dust Bowl states Oklahoma and Arkansas, where he photographed meetings and activities of a farmers' union.

Between April 1945 and February 1946 he was stationed in Panama with the Sixth Army Air Force in the public relations section, making pictures in Panama and Guatemala. The first three years after Grossman was discharged from the army were the most productive of his career. Between 1946 and 1948 he worked concurrently on five series that would account for one-third of his life's work—"Folksingers," "Coney Island," "New York Recent," "Mulberry Street," and "Legion"—all street pictures of annual festivals and rites.

In 1949 Grossman was named in a conspiracy trial of 12 communists for having introduced one of them to the party. Also, the Photo League was named as a communist "front" organization. With these accusations Grossman was effectively blacklisted from most of his freelance photo jobs, and he resigned from the League. He sought refuge with friends, like the painter Hans Hoffman in Provincetown, and he eventually opened his own successful photo school. He spent much of the rest of his life there, recuperating from the emotional and physical damage of having been named in the trial, *Dennis et al. v. the United States*.

ground glass: A glass sheet used as a focusing screen in a **camera**. It diffuses the light, thus affecting the **contrast** of an **image** exposed with its use. Ground glass is used in **reflex** and **view cameras** to preview the image to be photographed. In view cameras the image seen on the ground glass is upside down.

Grundberg, Andy (1947–)

American writer and critic

Grundberg has served as an art critic and is now the photography critic at the *New York Times,* making him one of the most influential individuals in his field. He is a highly regarded writer, lecturer, curator, and teacher of photography and has been active in many professional photography associations.

He earned a bachelor of arts degree from Cornell University in 1969 and a master of fine arts degree from the University of North Carolina, Greensboro, in 1971. After starting as a freelance writer, he was hired as picture editor at *Modern Photography* in 1974. In 1979, he moved to the *Soho Weekly News,* an alternative weekly newspaper in Manhattan's nascent avant garde art district, where he was the photography critic and writer. In 1981, he was hired away by the *New York Times*.

From 1992 to 1997 he was the director of Friends of Photography in San Francisco. Among his book credits are *Alexey Brodovitch, Crisis of the Real: Writings on Photography 1974–1989,* and *Photography and Art: Interactions since 1946* (with Kathleen McCarthy Grauss). Grundberg has been a visiting lecturer at the Rhode Island School of Design and the San Francisco Art

Institute and an instructor at the School for the Visual Arts in New York City. In 1988 he won a **Leica** Medal as "Educator of the Year."

Guggenheim fellowship: The John Simon Guggenheim Memorial Foundation was established by Senator and Mrs. Simon Guggenheim as a memorial to a son who died April 26, 1922. The Foundation offers fellowships to scholars and artists intended to assist in their research in any field of knowledge or the creative arts, under the freest possible conditions, irrespective of race, color, or creed. Fellowships are awarded through annual competition, and are open to citizens and permanent residents of the United States and Canada. Since its inception, the Foundation has awarded over 180 million dollars to more than 14 thousand creative individuals, including a number of photographers. Many important photographic works are a direct result of Guggenheims. Robert Frank, the first European to win one, traveled America on his fellowship and produced his 1959 master work, *The Americans*.

gum bichromate process: An old-fashioned photographic printing process that uses watercolor pigment mixed with gum arabic and potassium bichromate. This mixture is coated onto paper and dried, then **contact printed** with a negative and **washed** in regular water. The areas of the **emulsion** (the mixture coated on the paper) that receive light harden and the areas that remain unexposed are washed away by the water, leaving the photographic image behind. The process was introduced in 1894, and it is sometimes still used today.

Gutmann, John (1905–1998)
German-born, American documentary photographer
Born in Breslau, Germany, Gutmann studied to be a painter before turning to photography shortly before he emigrated to the United States, where he became known for his vivid images of popular culture.

Gutmann brought a foreigner's view to the streets of California, where he saw with fresh eyes such astonishing (to him) phenomena as multiracial crowds, drive-in movies and restaurants, drum majorettes, car

parks and golf links, beauty contests, tattoo parlors, and movie marquees. He was fascinated by the status of the car as an American icon and photographed unusual license plates, decorated dashboards, decals, and hood ornaments. He also took a notable series of New York City in the 1940s.

In Germany he worked as a photojournalist for Presse Photo before his arrival in the United States, when he worked as a photojournalist for Pix, Inc. (1936–1963). A professor at San Francisco State University from 1938 to 1973, Gutmann won a **Guggenheim fellowship** in 1978. His work has been published in major periodicals and is held by such collections as those of the Amon Carter in Fort Worth, San Francisco's Museum of Modern Art, and the Seagram Collection in New York.

gutter: The space between the center margins in a publication where the binding creates a fold or crease. This space, because it folds and is usually obscured by the binding, is often left blank; but sometimes photographs are printed across the gutter and called a gutter **bleed**.

Guzy, Carol (1958–)
American photojournalist
Guzy has won two **Pulitzer Prizes**, ten years apart. As a staffer for the *Miami Herald,* Guzy won the 1986 Pulitzer Prize for spot news photography for her work covering the devastating Armero, Colombia, mudslide. She took home 1995 spot news honors as a *Washington Post* staffer for work she did in Haiti during one of the political upheavals there.

Guzy earned an associate's degree in 1978 from Northampton County Area Community College in Bethlehem, Pennsylvania. Her degree was in registered nursing. A change of interest led her to study photography at the Art Institute of Fort Lauderdale, from which she was graduated in 1980 with an applied science associate's degree in photography. While a student there, she interned at and was later hired by the *Herald*. In 1988 she moved to the *Post,* where she remains a staff photographer.

PORTRAITS OF
PHOTOGRAPHE

s

A – L

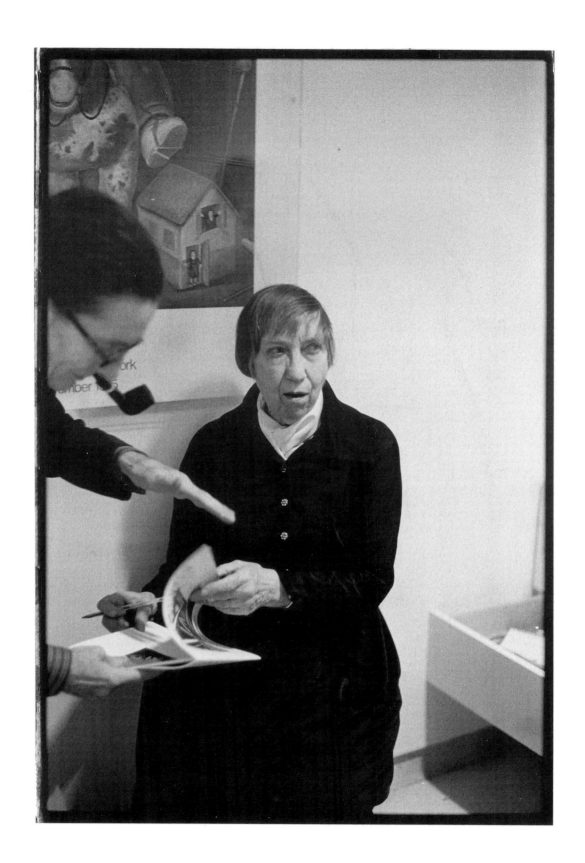

Berenice Abbott signing books at her Marlborough exhibit. January 5, 1976

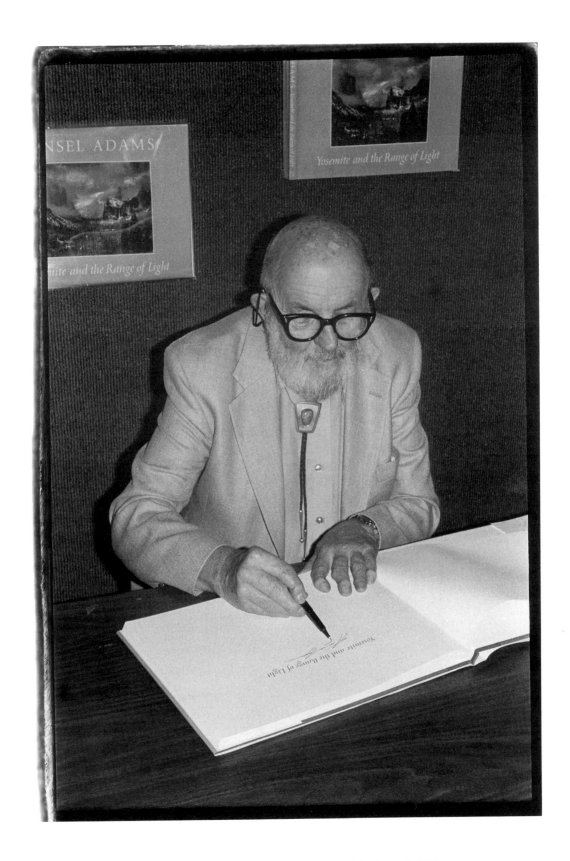

Ansel Adams signing copy of *Yosemite and the Range of Light*. October 1, 1979

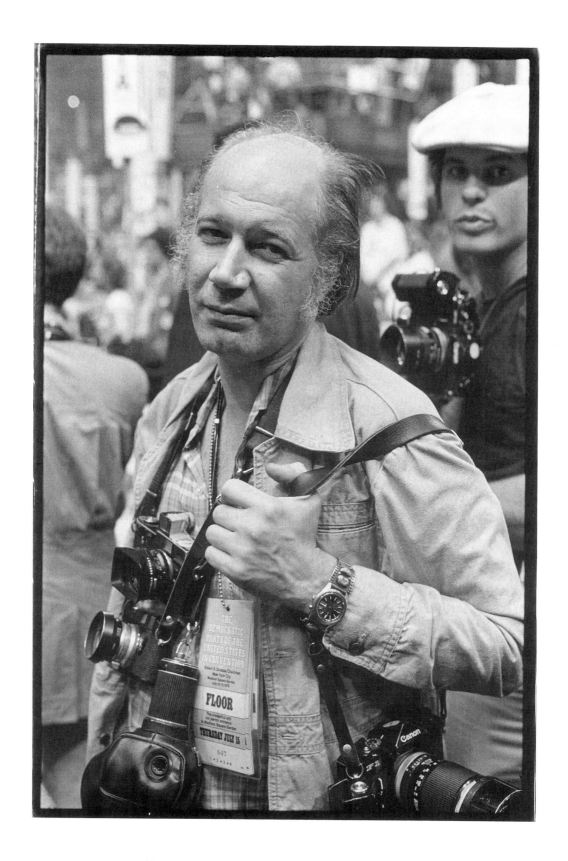

Eddie Adams at Democratic National Convention, New York. July 15, 1976

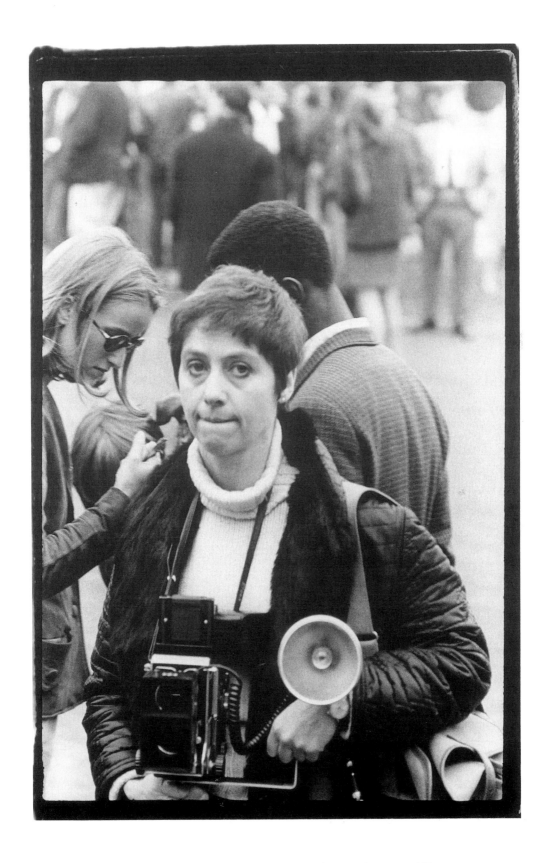

Diane Arbus attends a yippie event in Riverside Park, New York. May 14, 1967

Richard Avedon seen at his Marlborough gallery opening. September 9, 1975

David Bailey, photographed in London. April 23, 1985

Peter Beard at his one-man show, Blum & Helman Gallery. November 10, 1975

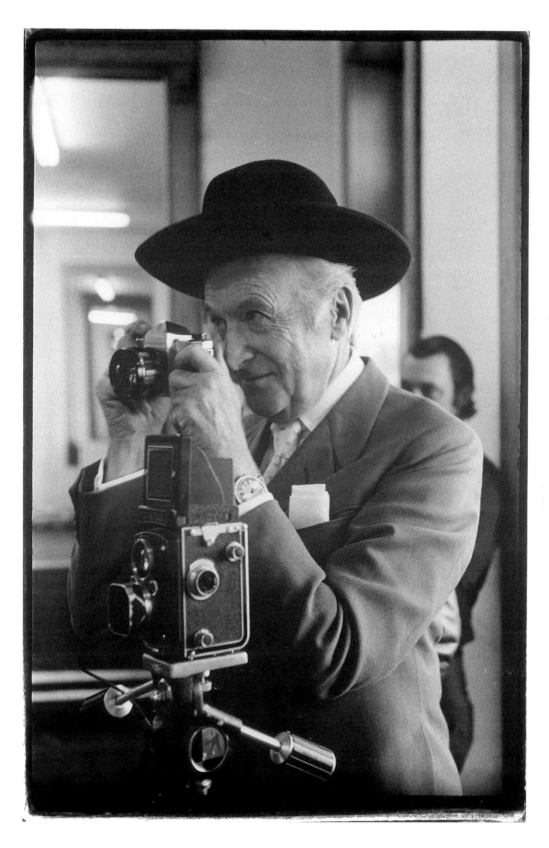

Cecil Beaton photographing at Andy Warhol's Factory. April 24, 1969

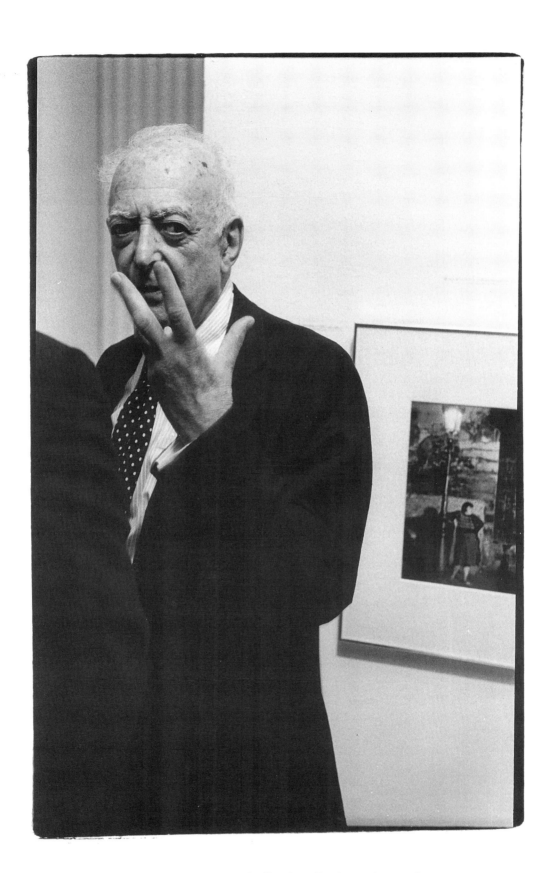

Brassai (Gyula Halasz, Jr.), at Marlborough gallery show of his photographs. September 13, 1976

Rudy Burckhardt in Guggenheim Museum during inaugural exhibit. October 19, 1959

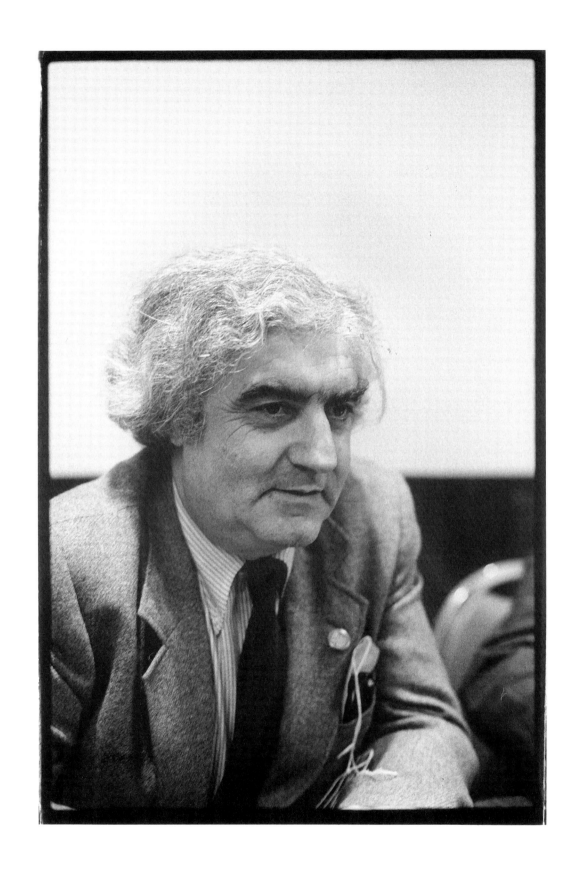

Cornell Capa in his office at the International Center of Photography. May 11, 1975

Henri Cartier-Bresson (kneeling, left) installing his exhibit "The Decisive Moment"
at the IBM Gallery, New York. January 25, 1960

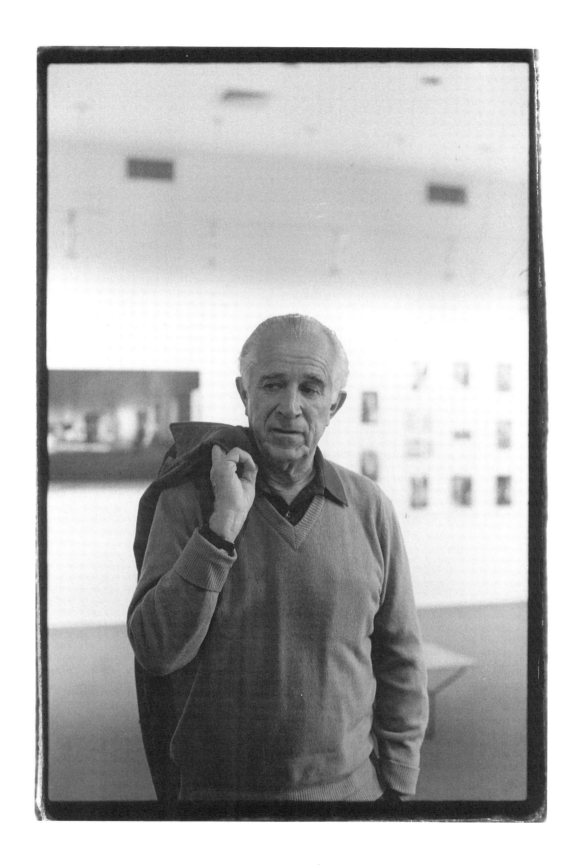

David Douglas Duncan at his Sidney Janis gallery exhibit. November 3, 1981

Alfred Eisenstaedt at his exhibit in the Time-Life building, New York. August 29, 1966

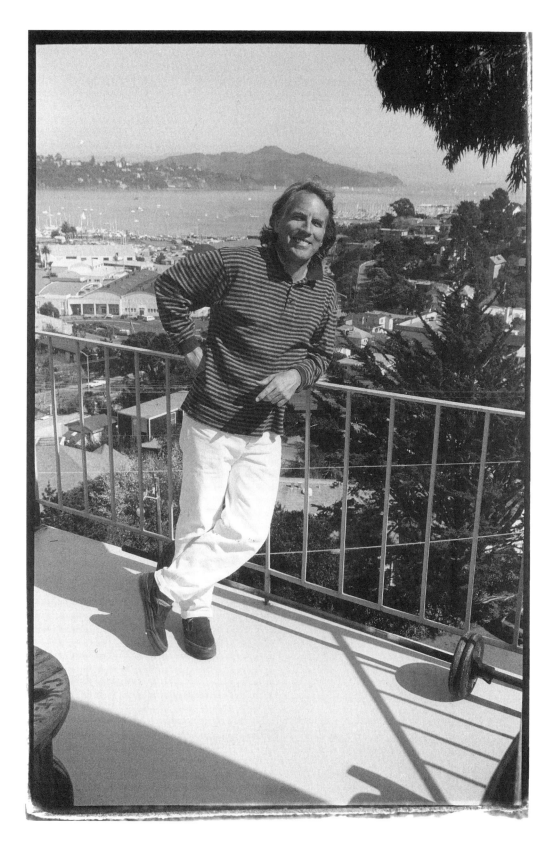

Chris Felver photographed on his terrace in Sausalito, ca. March 7, 1997

Larry Fink at John Gibson Gallery in Soho. January 16, 1976

Ruth and Charles Henri Ford at the Whitney Museum. November 20, 1979

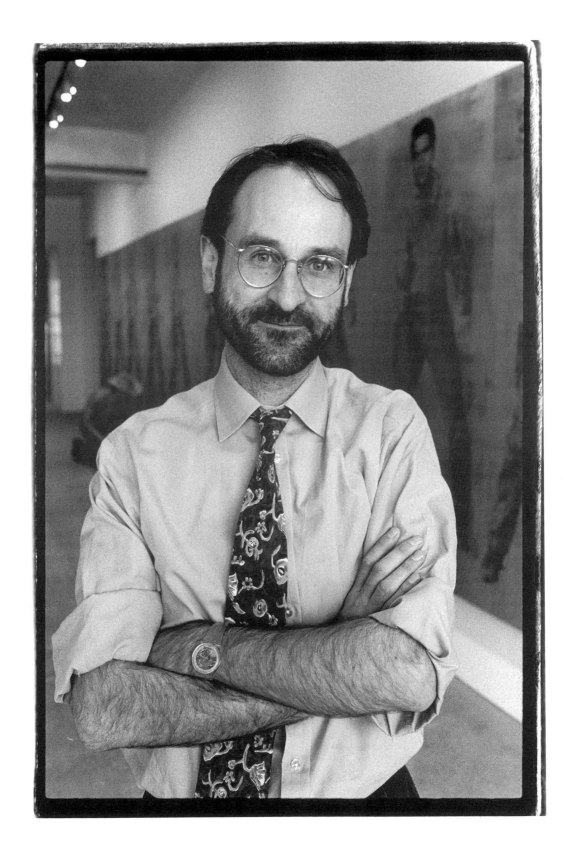

Mark Francis in Andy Warhol Museum Inaugural Exhibit, Pittsburgh. May 11, 1994

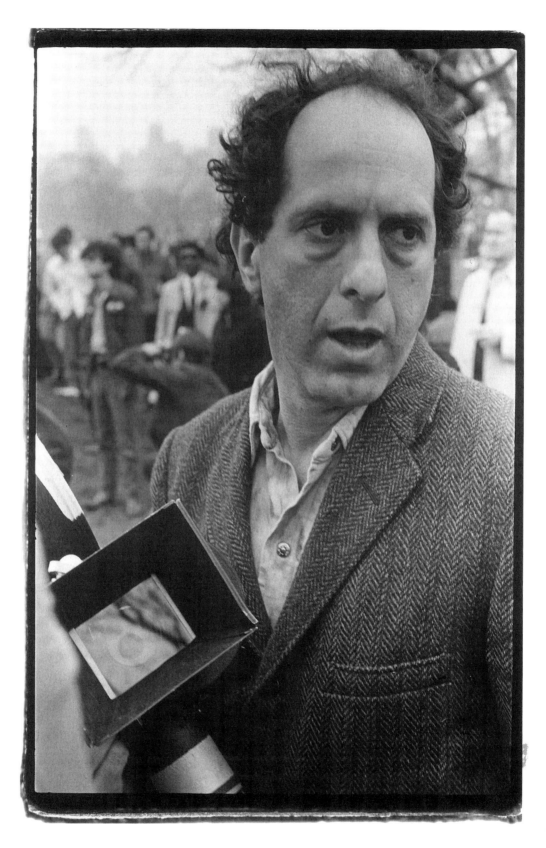

Robert Frank at Vietnam peace demonstration, Central Park. April 15, 1967

Jill Freedman at a press conference for the movie *The Wiz* in Queens. September 28, 1977

Ron Galella attending a Richard Avedon opening. September 9, 1975

Helen Gee in front of her Limelight Gallery, Greenwich Village. June 24, 1966

Burt Glinn photographing a Beatnik party in a waterfront loft for *Holiday* magazine (Banjo, Danny Barker; clarinet, Ken Davern; bass, Ahmad Abdul-Malik; trumpet, Walter Bowe; trombone, Ephram Resnick). May 25, 1959

Maria Morris Hambourg at the Metropolitan Museum of Art with Julia Margaret Cameron's "Mrs. Herbert Duckworth"
and "Sir John Herschel." March 26, 1992

G. Ray Hawkins in his Santa Monica photo gallery. February 28, 1997

Mark Haworth-Booth photographed in London at the Victoria & Albert Museum. April 22, 1985

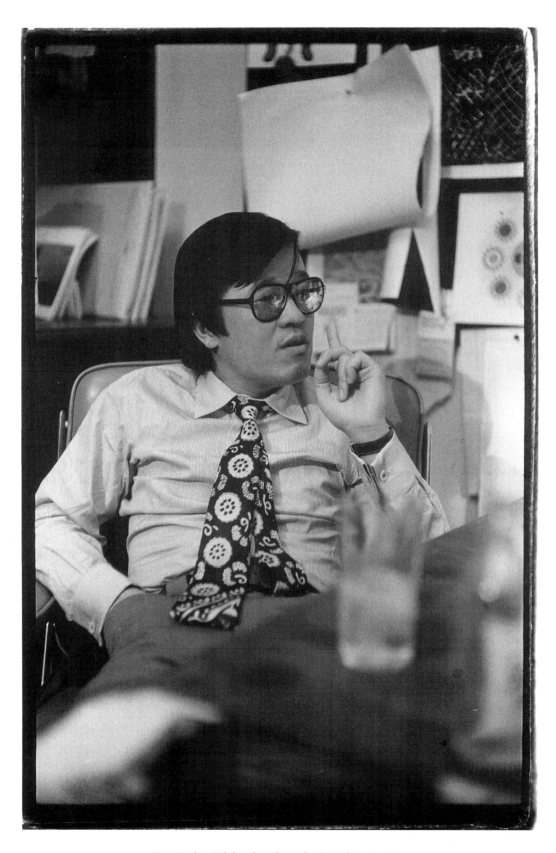

Hiro (Yasuhiro Wakabayashi) in his studio. December 13, 1969

David Hockney at Jasper Johns exhibit, Whitney Museum. October 14, 1977

Peter Hujar in a Jim Dine performance, "Theatre Rally #1." April 30, 1965

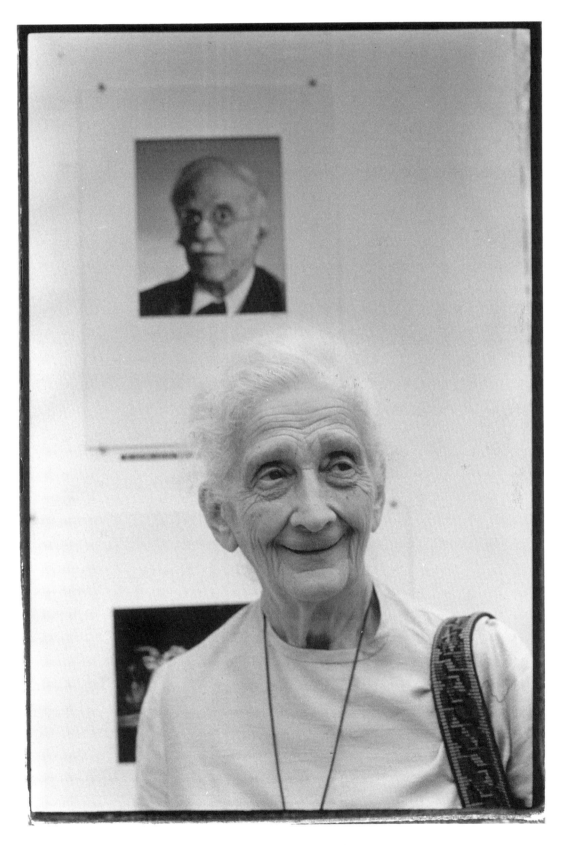

Lotte Jacobi visits a photo show at I.C.P. October 23, 1975

Yousuf Karsh attends a book party for David Hume Kennerly. October 17, 1979

President Gerald Ford and official White House photographer David Hume Kennerly in New York
to celebrate publication of "Shooter" by Kennerly. October 17, 1979

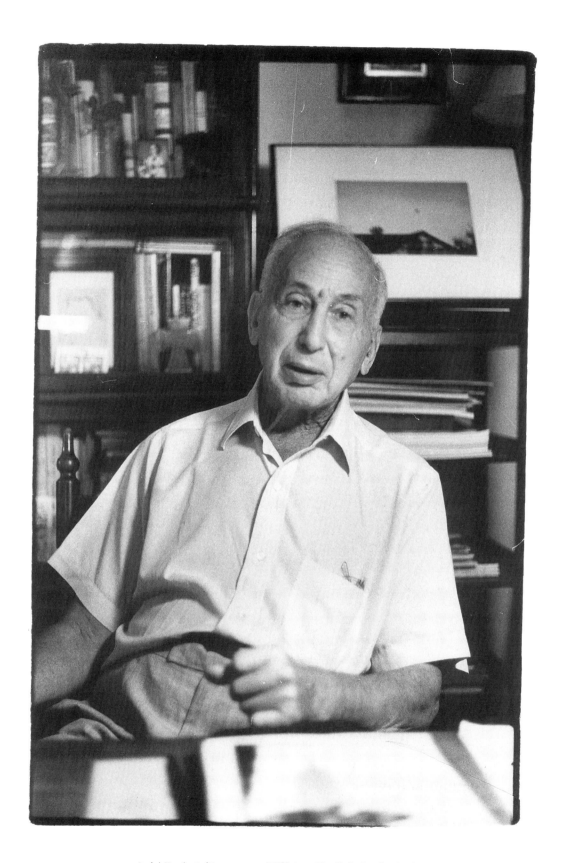

André Kertész in his apartment, 2 Fifth Ave., New York. October 9, 1972

214

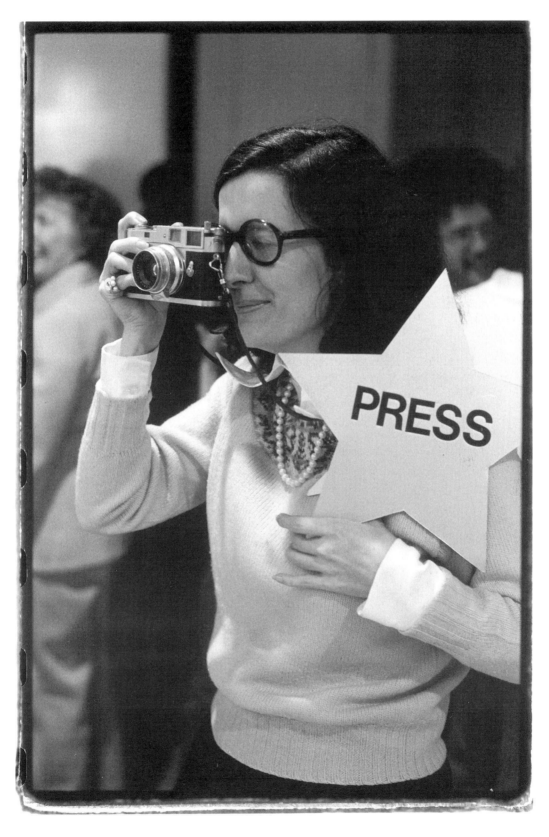

Jill Krementz attending Annie Leibovitz exhibit in Soho. November 21, 1974

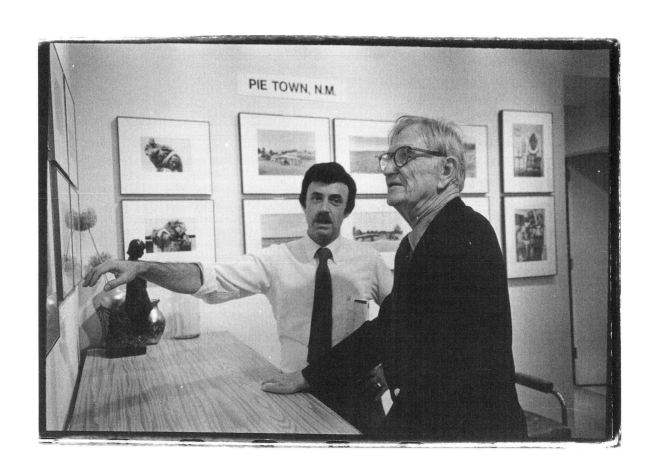

Russell Lee (right) viewing "Pie Town, New Mexico" with Lee Witkin. September 11, 1982

216

Annie Leibovitz at her Soho gallery exhibit. November 21, 1974

Alexander Liberman (center) greeting friends at his exhibition. April 4, 1960

Harry Lunn attending Brassai exhibit, Marlborough gallery. September 16, 1976

It's easy to make the Hail Mary shot if the camera has a wide-angle lens and a motor drive.
©Fred W. McDarrah.

Haas, Ernst (1921–1986)

American photojournalist

Known primarily for his beautiful color work, Haas worked as a freelance photographer throughout his career. Born in Vienna, Austria, he briefly studied medicine before turning to photography.

Haas achieved international recognition with his 1947 photo essay on Austrian prisoners of war returning to Vienna. The essay was marketed through **Magnum Photos**, to which he belonged from 1947 to 1962, becoming a contributing member in the late 1960s.

Haas came to New York in 1951 and did freelance work for *Ladies' Home Journal.* Sent to New Mexico for a Magnum project, he took a series of color images that appeared in a six-page spread in *Life* magazine. His reputation established, Haas did further work for *Life,* including an unprecedented 24-page photo essay on New York City called "Images of a Magic City." He was given a solo exhibit at New York's Museum of Modern Art in 1962.

Haas lectured and served as magazine consultant on photography and worked as a motion picture still photographer. Among his many awards are the Newhouse Award from Syracuse University and a **Hasselblad** and Leitz Camera award in 1986.

"Hail Mary" shot: Holding the camera above one's head (hence the reference to the prayer, Hail Mary) and taking a picture without looking with the hope of getting a useable image. This is done out of desperation when there's a crowd and the photographer can't see to take the picture.

half-frame format: A camera that uses only half of the normal 35mm film frame. Half-frame images measure 18 x 24mm. Full-frame 35mm images are 36 x 24mm.

halftone: A photograph with varying tones of gray reproduced from an engraving is called a "halftone plate." A halftone is obtained by photographing the original photo through a finely ruled glass screen called a "halftone screen." Halftones consist of light areas and shadows that, when printed, appear as masses of dots. The groupings and densities of the dots determine the intensity of color or darkness. Various densities of halftone screen vary the tones or shadings.

Halsman, Philippe (1901–1979)

American portrait photographer

Halsman was one of the most productive **portrait** photographers of all time, having done a record 101 *Life* magazine covers over a 30-year period. His shots of Albert Einstein and Adlai Stevenson were made into postage stamps, and his jovial collection of celebrities jumping, *Philippe Halsman's Jumpbook* (1959), was one of the first photo books to attract the wide attention of the general public.

Born in Riga, Latvia, the young Halsman was a student of electrical engineering and a photography hobbyist. In 1931, he moved to Paris and opened a photo studio that quickly achieved success based on his flattering portraits. He spent the next ten years there as a freelance photographer, securing assignments from Paris *Vogue, Voila, Vu,* and other magazines.

In 1940, with the help of Albert Einstein—who would later become one of his most celebrated subjects—he got an emergency exit visa and left occupied France for the United States. He was signed by the **Black Star** picture agency and in 1942 took his first *Life* cover. He also worked for *Look, Paris Match,* the *Saturday Evening Post,* and *Stern.*

Halsman was the first president of **ASMP** (in 1945) and served as president again in 1954. He was

also a tinkerer. He invented the Fairchild-Hausman camera, a 4 x 5 **twin lens reflex camera** that was never marketed but was copied by others.

Remembered for the honest realism of his work, he posed famous people in settings natural to their professions. A technique he used to get subjects to relax was to have them jump and down. Their reactions were so positive that he did an entire book with his subjects in mid-air—subjects like Winston Churchill, Brigitte Bardot, Jean Cocteau, Einstein, Richard Nixon, Salvador Dali, and Marilyn Monroe. His other books include *Dali's Mustache: A Photographic Interview with Salvadore Dali* and *Halsman: Sight and Insight*. He spent his later years as a master teacher at the New School for Social Research and the Famous Photographers School in Connecticut.

A retrospective book with an introduction by Mary Panzer, *Philippe Halsman*, was published in 1998.

Halsted, Thomas (1937–)
American art dealer

A prominent figure in the field of fine-art photography, Halsted has exhibited most of the major names in photography and has gone on to develop numerous museum and private collections. He represented the **August Sander** estate with Gunther Sander from 1974 to 1980 and organized major Sander shows at the Art Institute of Chicago, the St. Louis Arts Museum, and other venues.

He opened his first gallery, the 831 Gallery, in Birmingham, Michigan, in 1969 with an exhibit of **Eugène Atget's** work. When the gallery moved to a different location in Birmingham he renamed it the Halsted Gallery. In his first decade as a photography dealer he dealt with **Ansel Adams**, **Edward Weston**, **Bill Brandt**, **Andre Kertész**, and late-nineteenth-century artists/photographers such as **Julia Margaret Cameron**, **P. H. Emerson**, and **W. H. Jackson**. Halsted helped to organize the Association of International Photography Dealers in 1972 and served on its board and as president in 1980.

The Halsted Gallery also nurtures new, contemporary artists. Halsted himself has amassed a private collection of photographs, with a specialized collection of sports images.

Hambourg, Maria Morris (1950–)
American curator, historian, and author

Hambourg is the curator in charge of the Metropolitan Museum of Art department of photographs and one of the world's leading scholars on the work of **Eugène Atget**. An important figure in the international photography community, she has published extensively, often in connection with exhibitions she organized.

She first became interested in Atget and early photography as a Wellesley College student, earning a bachelor of arts degree in 1971. She continued her studies of nineteenth- and twentieth-century art at Columbia University, earning her master's there in 1974 and her doctorate in 1980, writing as her dissertation "Eugène Atget 1857–1927: The Structure of the Work."

Under the auspices of the New York State Internship Program she worked in the department of photography at the Museum of Modern Art in 1975. She organized the **Stephen Shore** photo show there and assisted in other exhibition and curatorial duties. At the Museum of Modern Art she began her study of the Atget collection. In 1977 she moved to Paris to study French photographic history. From 1980 to 1983 she assembled the Museum of Modern Art's four-volume series "The Work of Atget."

After moving to the Metropolitan in 1985, she worked with the collector Howard Gilman in establishing the museum's now-formidable presence in the photography world. Among her projects at the Metropolitan was the 1993 show and catalogue "The Waking Dream: Photography's First Century, Selections from the Gilman Paper Company Collection" and a 1995 **Nadar** exhibit. Other exhibitions Hambourg organized at the museum are "**Paul Strand** circa 1916" (1998) and "**Pictorialism** in New York 1900–1915" (1998).

Hambourg has taught at the Institute of Fine Arts of New York University and at Princeton University.

Harbutt, Charles (1935–)
American art photographer and photojournalist

Harbutt's work combines the dual traditions of photography—photojournalism and art photography. Using 35mm equipment, he is known for his black-and-white

images, some of which were collected for his book *Travelog*, winner of the Photographic Book of the Year award at the 1974 Arles festival. In 1987 he published *Progresso*, a portfolio of grainy black-and-white images taken in the Yucatan. "My photographs are both real and surreal," he has said.

Harbutt's art developed within the documentary work of such other **Magnum** photographers as **Robert Capa** and **Elliott Erwitt**. Harbutt became an associate member of the photo agency in 1963 and a full member the following year. He left Magnum in 1981 and cofounded **Archive Photos**, another cooperative for photographers.

Born in New Jersey, Harbutt studied journalism at Marquette University in Wisconsin. He was a consultant to the New York City Planning Commission from 1968 to 1970 and managed the "America in Crisis" project during that period. His work has been exhibited in museums in the United States and Europe, and he has been visiting artist at several universities.

hard disk: A **computer**'s internal memory is the hard disk or hard drive. It cannot be removed, as a **floppy disk** can, unless the computer is dismantled. Memory can be added to hard disks to increase a computer's power and storage capacity.

hardener: A chemical added to photographic **fixer** that makes the **emulsion** of film and paper hard and resistant to scratches, nicks, and fading.

hardware: The actual electronic and mechanical components that constitute a **computer** system. The programs that command the computer are the **software**.

Hare, James H. (Jimmy) (1856–1946)
American photojournalist
The news photographs of Jimmy Hare captured the turmoil and excitement of the first two decades of the twentieth century.

Born in London, the son of George Hare, a camera manufacturer, Jimmy Hare was apprenticed to his father until about 1879. Jimmy's interest in manufacturing cameras declined as differences arose between father and son about changing from the wet-collodion plates, which had been the standard of photography since the mid-1850s, to the more sensitive dry plates.

By the early 1880s the younger Hare had taken up freelance photography. He sold his pictures of public gatherings and sporting events to illustrated London journals. In 1889 he was hired as a technical advisor to the E. & H. T. Anthony Co., one of America's largest photographic manufacturers, and moved to New York. When the Long Island factory where he worked closed, Hare turned again to freelance photography, working with a large hand camera, photographing street scenes, groups, athletic meetings, ships, and military maneuvers. He also worked as a one-man factory producing cameras.

Through his camera business Hare met Joseph Byron, who worked for the *Ilustrated American*. When Byron left his job, Hare replaced him as a news photographer for three years, until the *American* closed. When the Spanish–American War was impending Hare proposed taking photos of the *Maine* for *Collier's* magazine. His outstanding pictures served as the springboard for his career in photojournalism. He photographed the Russo–Japanese war, the Mexican revolution, and World War I. Hare is given credit for many of the techniques and customs of photojournalism, particularly his use of a handheld camera, and his photo reportage or essays combined to create a greater effect than a single illustration had done in the past.

Hasselblad, Victor (1906–1978)
Swedish inventor and manufacturer
Hasselblad founded a camera factory in Goteborg, Sweden, and was the inventor of a camera that has become world famous. In 1948 he produced the Hasselblad **single lens reflex** modular camera, which used interchangeable lenses, viewfinders, and film-backs. The negative was 2¼-inches square. The camera is considered of such high quality that it was chosen for use during the *Apollo 11* moon landing in 1969.

Hasselblad and his wife, Erna, donated their entire fortune to a foundation to promote scientific research

and education in the natural sciences and photography. In 1989 the foundation established the Hasselblad Photographic Center in Goteborg, which has an ongoing exhibition program, a reference library, and a collection of photographs. The foundation also awards an annual prize for outstanding photography.

Hasselblad: A camera invented by **Victor Hasselblad** of Sweden. This medium-format camera makes a 2 ¼-inch image, and has a large variety of high-quality accessories such as lenses and film backs. The Hasselblad is considered one of the finest cameras ever made.

Hasselblad 501 CM Camera. Courtesy Hasselblad USA, Inc.

Hawes, Josiah Johnson (1808–1901)
Early American commercial photographer

In partnership with **Albert Sands Southworth**, Hawes owned a successful Boston studio whose work was representative of the best **daguerreotype** portraiture.

An apprentice carpenter, Hawes was also a part-time painter, and for many years he was an itinerant miniature portraitist. Intrigued by the new process of daguerreotypy, Hawes learned the art from **François Gouraud**, who had come to the United States to promote Daguerre's recent invention. Hawes quickly acquired skill in the new process and found work at the studio of Southworth and Joseph Pennell. Pennell died in 1845, and Hawes soon replaced him as partner in the firm.

The studio of Southworth and Hawes achieved renown for its informal, direct portrait studies and the personal attention it afforded its clients, whether they were such persons of distinction as Henry W. Longfellow and Daniel Webster or simply local residents. In addition to its portraits, the firm also produced detailed views of Boston and Niagara Falls.

Hawkins, G. Ray (1944–)
American dealer and photographer

In 1975, Hawkins opened an eponymous Los Angeles photo gallery and has developed into one of the most influential dealers in the United States. He holds the record for having received the highest price up to that time for a photograph—$250,000 for **André Kertész**'s "Chez Mondrian"—and has mounted more than 200 exhibitions.

Born in Indiana, he developed an interest in photography as a schoolboy, photo editing his high school yearbook. After receiving his diploma in 1962, he spent the next four years as a photographer and newsreel cameraman in the Navy's Pacific Fleet.

He settled in California, supporting himself by buying and selling antiques. He enrolled in Santa Monica College, then switched to UCLA, from which he was graduated with a degree in filmmaking in 1973. As a graduate student there in 1974, he took a class in creative photography with Robert Heinecken. That same year he purchased a collection of 750 photographs by **Edward S. Curtis**. The next year, with a **Man Ray** show, he inaugurated his gallery.

Hawkins became a licensed auctioneer in 1983, and his gallery was the first to hold annual auctions as part of the regular exhibition program. Many of the ensuing auctions were to benefit Focus on AIDS, a support and fundraising group Hawkins created to benefit those in the photography community with the disease.

In 1991 he founded Greystone Books, a publishing arm of the gallery, and he personally has published seven

titles. In 1995 he held the first ever photo exhibition on the **internet**. As of 1998, he had sold more than $22 million in rare, vintage, and contemporary photographs, including the record Kertész. That 1991 sale broke his own record of the $71,500 he got for **Ansel Adams**'s "Moonrise, Hernandez, New Mexico" in 1981.

Haworth-Booth, Mark (1944–)

British curator and writer

As curator of photographs in the Prints, Drawings, and Paintings Collection at London's Victoria and Albert Museum, Haworth-Booth has been one of the major figures in the contemporary photography scene.

Born in Yorkshire, England, he studied English literature at Cambridge University and the history of art at Edinburgh University. He joined the Victoria and Albert Museum in 1970 and was appointed to his present position in 1977. He has curated many exhibitions, starting with "The Compassionate Camera: Dustbowl Pictures" (1973), the first show in the United Kingdom devoted to the **Farm Security Administration** photo projects.

Among the exhibition catalogues he has edited and introduced are *The Land: 20th Century Landscape Photographs Selected by Bill Brandt* (1975), ***Hockney's Photographs*** (1984), and *The Golden Age of British Photography (1839–1900)* (1984). He has written several books on photography, including *Camille Silvy's River Scene, France* (1992) and *Photography: An Independent Art, Photographs from the Victoria and Albert Museum, 1839–1996* (1997), the latter published to celebrate the opening of the museum's new photo gallery.

Haworth-Booth is a contributing editor to Oxford University's *History of Photography* and *Aperture* and a regular contributor to *The Times Literary Supplement*. In 1997 the **Royal Photographic Society** appointed him an honorary fellow.

Haynes, F. (Frank) Jay (1853–1921)

Pioneering American landscape photographer

Haynes was appointed official photographer of Yellowstone National Park by the U.S. Department of the Interior in 1884, and he continued there for 32 years, leaving the position to be filled by his son, Jack.

Born in Michigan, Haynes began his photographic career in 1876, opening a photo studio in Moorhead, Minnesota. He was employed by the Northern Pacific Railroad to make views along the line, and he traveled throughout the northern tier. He photographed the mining town of Deadwood, Dakota Territory, and in 1878 started on a 3,000-mile expedition up the Missouri River to Fort Benton. The photographs of that trip have become an invaluable record of the region's early history.

Haynes came to Yellowstone in 1881 and decided to pursue a concession as park photographer. In 1884 he opened his own studio there and also continued traveling throughout the northwest, photographing Native Americans, survey teams, early farming and ranchlands, and military fortifications.

Heinecken, Robert (1931–)

American art photographer and teacher

Heinecken's characteristic work involves the female image, deconstructed in the form of collage or montage or manipulated through the use of lithography, photocopy, light-sensitive fabric, and emulsions. He sometimes combines the human figure with other elements or carefully rearranges the images to form unexpected puzzles that convey both beauty and tension.

Born in Colorado, Heinecken earned his bachelor's and master's degrees at the University of California at Los Angeles. He began the photography department at his alma mater in 1960 and has taught there and also at Harvard University, the Art Institute of Chicago, and the San Francisco Art Institute. He was awarded both a **National Endowment for the Arts** fellowship and a **Guggenheim fellowship**. His work is owned by major museums, including the Norton Simon in Los Angeles and New York's Museum of Modern Art.

heliography: A forerunner to the earliest photographic processes, invented by **Joseph Nicéphore Niepce** in 1822. It entails using bitumen, a material that hardens and becomes insoluble in light. Niepce had hoped to use this process to transfer images to be printed on a press. One of his early heliographs from 1827, a view from a window that required an eight-hour exposure, is

the earliest photographic image in existence. Although heliography was unsuccessful as photography, it was an early breakthrough that led to the development of the **daguerreotype**.

Henri, Florence (1893–1982)

French/American photographer

A member of the **Bauhaus** circle, Henri was an avant garde photographer who produced innovative images that treated space and shapes in unusual ways. She often used mirrors as a form of self-portraiture, revealing the photographer's presence. Henri's work was exhibited in the modernist landmark exhibition "Film und Foto," held in Stuttgart, Germany, May 18–July 7, 1929.

Henri was born in New York City to a French father and German mother from Silesia (now in Poland) and traveled extensively with her father after her mother's death. She first studied music, then painting, in Paris with Fernand Leger before enrolling at the Bauhaus in Dessau, Germany, where she came under the tutelage of **Laszlo Moholy-Nagy**. She developed an interest in photography in Germany and decided to pursue a career in the field.

She returned to Paris in 1929 and opened a studio where she worked on commissions for fashion and advertising clients, as well as continuing her portraiture. Her subjects included artists of the European avant garde who were her friends, including Wassily Kandinsky and Alberto Giacometti. In her later years Henri gave up photography and returned to her first love, painting.

Herschel, Sir John (1792–1871)

British astronomer and photographic chemist

As an astronomer, Herschel catalogued the stars and gathered for the first time data on multiple stars; as a pioneering photo chemist, he is noted for his 1819 discovery of thiosulfates and their ability to dissolve silver salts completely, which led, 20 years later, after **Daguerre** and **Fox Talbot** claimed invention of photography, to his suggestion to both inventors that sodium thiosulfate, or **hypo**, could be used as a **fixing** agent to wash away the unaltered salts after the photograph was processed.

Herschel was the son of King George III's private astronomer, Sir William Herschel. He studied mathematics at Cambridge University before he became his father's assistant and eventually carried on Sir William's work. After Daguerre and Fox Talbot's discoveries in 1839, Herschel independently invented a glass negative process. Herschel is also credited with coining the terms *negative* and *positive* as well as *emulsion* and *snapshot*. He conducted early experiments to determine how the color spectrum affected photographic emulsion.

Herschel's scientific research earned him a knighthood in 1831 and a baronetcy in 1839. He was an esteemed member of the Royal Astronomy Society and won several awards in London and Paris for his contributions to science.

Heyman, Abigail (1942–)

American documentary photographer

Heyman is a cofounder of the photographers' group **Archive Photos**, and her photographs document contemporary American life, as evidenced in her collections *Dreams & Schemes, Love and Marriage in Modern Times* and *Growing Up Female; A Personal Photojournal.*

A graduate of Sarah Lawrence College, Heyman decided to become a photographer in 1967. She has been an active freelancer in New York, with her work appearing in many magazines, including *Art Forum, Esquire,* the *New York Times Sunday Magazine,* and many others. She taught in and headed the Documentary and **Photojournalism** Department at the **International Center of Photography** in New York from 1986 to 1988. She was an associate member of **Magnum Photos** from 1974 to 1981.

Her awards include a grant from the Mexican-American Legal Defense and Education Fund to photograph the Mexican-American community and a New York Foundation for the Arts fellowship.

Heyman, Ken (1930–)

American photojournalist

One of the top photojournalists in the United States, Heyman is noted for his long and productive collaboration with the anthropologist Margaret Mead, whom he accompanied to Bali to document her field work there.

Born in New York City, Heyman was graduated from Columbia College in 1956. After his work with Mead had begun, he also published photo essays in *Life* and other magazines. His books include *Family* with Margaret Mead, *This America* with Lyndon Johnson, and *Hipshot: One-Handed, Auto-Focus Photographs by a Master Photographer*, in which all the photographs were taken from the hip, without his looking through the camera lens. His work has been exhibited at New York's Museum of Modern Art, the **Smithsonian Institution**, and the **International Center of Photography**.

high-speed photography: The use of very short exposure times when the **shutter** opens and closes in less than 1/1000 of a second. High-speed photography is often used to "freeze" action, such as in photographing a race.

Hill, David Octavius (1802–1870)
Early Scottish portrait photographer and painter
In collaboration with **Robert Adamson**, Hill worked from 1843 to 1847 to produce a body of work whose individual pieces early on were recognized as photographic masterpieces. Their subjects were village life, scenes of Edinburgh, and, most important, people—Scottish nobles, working people, fishermen, and children. Their portraiture, using the laborious **calotype** process, achieved a remarkable emotion and revelation of character that has had few equals to this day.

Hill was born in Perth, where his father ran a stationer's shop. Around 1821 Hill went to Edinburgh to study at the Trustees' Academy School of Design with Andrew Wilson, an influential painter. He learned the art of lithography there and between 1821 and 1832 published a six-part "Sketches of Scenery in Perthshire drawn

An example of a high-speed photograph of a race horse. © Fred W. McDarrah.

David Octavius Hill and Robert Adamson. *Newhaven Fisherwomen,* ca. 1845. Salted paper print from a large calotype negative. Part of the Rubel Collection. Courtesy Hans P. Kraus, Jr. Inc., New York.

from Nature and on Stone by D. O. Hill." This ambitious project was published by his father. His oil paintings, many inspired by his country's romantic scenery, achieved recognition in Scotland's artistic circles. He became secretary to the Royal Scottish Academy of Fine Arts, a position he would hold for 40 years.

Hill created illustrations for books by Sir Walter Scott, painted 14 landscapes that were used to illus-

trate *The Works of Robert Burns,* and most famously painted 61 scenes for a two-volume set called *The Land of Burns.* A commission to paint a monumental commemorative picture of 500 ministers constituting the First General Assembly of the Free Church led to his meeting Adamson. Sir David Brewster, a friend of both men, suggested to Hill that Adamson could help him obtain the huge number of portraits

John K. Hillers. *Zuni Watching,* ca. 1875. The New York Public Library.

needed as reference to complete the painting.

The collaboration was successful from the start, and the two men soon decided not to restrict themselves to the ministers' portraits. Hill was the director or stylist, and Adamson took the actual photograph. In their four-year collaboration they took some 1,500 negatives. Hill's painting skill was useful in the retouching process on landscape or clothing detail, but he never touched an image of a subject's face. They made calotypes of the most important people in Edinburgh as well as of many of Hill's relatives. They were interested in exotic scenes and made *tableaux vivants* of historical scenes. After they

had been working for a year, Hill and Adamson began to assemble their calotypes into **albums**. Three albums, completed in 1848, of portraits, groups, landscapes, fishermen, and buildings are now owned by the National Portrait Gallery in London.

Adamson died in 1848, only 27 years old, and after his death Hill, who had relied on his partner for technical expertise, gave up photography and returned to painting.

Hillers, John K. (1843–1925)
German-born, American landscape photographer
German born, Hillers was a pioneering photographer of

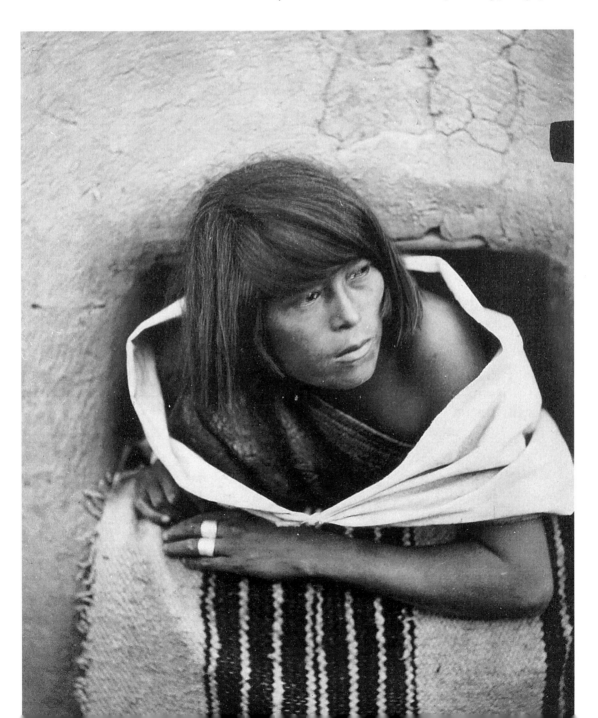

the West who accompanied Major John Wesley Powell on survey trips along the Colorado River in southern Utah and Arizona. Hillers, originally hired to row a boat and help out generally, became interested in photography on his first trip and from 1872 to 1876 and in 1878 was Powell's official photographer.

When he was 18, Hillers was drafted for service in the Civil War. He went to New York City after the war and joined the Brooklyn police force. Hillers resigned from the force to accompany his ailing brother, who hoped to recuperate in the West. In Colorado he happened to overhear Powell discussing his forthcoming second trip down the Colorado, and Hillers promptly asked for work. On the trip Hillers was fascinated by the work of the photographers, and when one of them left Hillers became an assistant. He continued to learn more about photography and eventually replaced the staff photographer. He possessed the necessary skill and talent, and his photographs soon appeared in the various survey publications.

In 1879 Powell established the U.S. Bureau of Ethnology and hired Hillers as bureau photographer. In that position he returned to the West, where he made the first of the photographic studies of Indians that would make up the greater part of his reputation. His **albumen** prints of the Southwest were carefully documented and have become an important reference source for scholars.

Hine, Lewis Wickes (1874–1940)

American documentary photographer and social reformer

Hine's compassionate vision conveyed in dynamic images social conditions in the first years of the twentieth century. He photographed newly arrived immigrants at Ellis Island and was fascinated by the life of the worker in the new industrial world. In his only published book, *Men at Work* (1932), Hine commented, "Cities do not build themselves. . . . machines do not make machines . . . back of them all are the brains and toil of Men."

Hine was born in Oshkosh, Wisconsin, and worked in a furniture factory. He experimented with various art forms, including wood sculpture, and attended the local Normal School before going off to the University of Chicago, where he first became interested in education

and social welfare. He studied sociology at Columbia College and in 1901 joined the faculty of the Ethical Culture School in New York City as a teacher of geography and nature study. The progressive school had been founded as a workingman's school, emphasizing the teaching of crafts and industrial arts. Hine made use of the camera in his classroom to record school excursions to help students remember what they saw and to sharpen their appreciation for beauty.

In his first major project, photographing immigrants at Ellis Island, he found his life's work and by 1908 had quit teaching and as a social photographer joined the staff of the National Child Labor Committee. Hine's photography took up the cause of social justice, revealing poor housing, the degradation of poverty, and the exploitation of children. Working with prominent reformers, he was invited to join the Pittsburgh Survey of *Charities and the Commons,* a journal devoted to social betterment. The survey, which took up six volumes, investigated all aspects of Pittsburgh working-class life—family life, the quality of education and recreation, housing, industrial accidents, wages, hours, and the ethnic composition of the workers. Hine's photographs appeared in every volume of the survey and made an important contribution to its success.

His photos of illegal child labor in sweatshops in the Northeast, along the Atlantic and Gulf coasts, and in the Midwest and Deep South took him into textile mills, glass factories, and cotton fields. It was dangerous work, as bosses did not want anyone to secure evidence of their child labor practices. In fact, Hine's "Breaker Boys," showing little boys huddled over their work, faces black with coal dust as they separated coal from slag for 75 cents a day, is credited with being a major influence on congressional passage of child labor laws.

When World War I broke out, Hine went overseas, doing photography for the Red Cross and investigating war damage in southeastern Europe, northern France and Belgium. When he returned to New York, his photographs were exhibited and he received glowing reviews. During the 1920s he continued to photograph men at work, but his photographs met with less and less interest. In 1930 he took more than 1,000 exposures of the construction of the Empire State Building and had

Lewis W. Hine. *Steamfitter.* 1921. Courtesy Howard Greenberg Gallery, New York.

himself suspended from the hundredth floor to film the workers in the process of construction. In 1936 he documented Tennessee Valley Authority projects under construction. Of his last pictures, the best are rural scenes, indicating his growing distance from urban life and the mechanization of society. His photographs were not highly valued, and at his death New York's Museum of Modern Art refused to house his collection.

Hine is today considered an artist of the first rank, a prime mover for social justice who changed the way Americans look at social conditions.

Hiro (Yasuhiro Wakabayashi) (1930–)

Chinese-born American fashion photographer

A master of technical precision in fashion photography, Hiro renders an object or person's unique qualities by means of a variety of innovative techniques, including startling close-ups, exotic backgrounds, or colored lighting.

Born in China, he studied at the American Institute of Graphic Arts in New York City between 1956 and 1964. Hiro's inventive approach to photography was strongly influenced by his teacher, **Alexey Brodovitch**, first as a student at The New School and later as Brodovitch's assistant; Hiro also worked as assistant to the noted fashion photographer **Richard Avedon**. He was a staff photographer for *Harper's Bazaar* from 1966 to 1974 and since then has worked as a freelancer, winning several awards for his fashion work.

Hockney, David (1937–)

British painter and photographer

In the 1960s modern artists such as Hockney, **Ed Ruscha**, and **Andy Warhol** began to use photography in conceptual or pop art. Hockney used Polaroid snapshots, which he fitted together to construct large-scale panoramic pictures with multiple points of view. This new art form, or photocollage, gave Hockney the freedom, he has said "to reconstruct the world as he sees it, and not as any single camera lens might interpret it."

Born in Bradford, Yorkshire, England, Hockney studied at the Bradford School of Art and the Royal College of Art. He made his first trip to New York in 1961. In his book *Hockney on Photography,* in collaboration with Paul Joyce, Hockney recalls taking photographs for more than 20 years, pasting prints into large albums. In the early 1970s he was experimenting with multiple images and cut-ups. He started using **Polaroid** film in 1982 and later turned to 35mm. When he used Polaroid, he composed his collages gradually, image by image; with 35mm film, he had to keep the picture in his head and wait until the film was processed in order to join the snapshots.

Hockney has also used photographs to take notes for paintings. In addition to being a gifted painter and photographer, Hockney has been involved in designing sets and costumes for operas. He has had one-man shows at New York's Museum of Modern Art and Metropolitan Museum of Art, the Tate Gallery in London, and the Stedelijk Museum in Amsterdam. He has lectured at several universities. He won the **Kodak** photography book award for *Cameraworks* (1984) and a First Prize from the **International Center of Photography** (1985). Among the books he has published are *David Hockney by David Hockney* (1976), *Cameraworks* (1983), and *That's the Way I See It* (1993).

Hofer, Evelyn (1922–)

American travel photographer

Hofer's atmospheric photographs have appeared in landmark travel books, including Mary McCarthy's *Stones of Florence,* and books by James Morris on Spain and V. S. Pritchett on Dublin, New York, and London. Her photos retracing Ralph Waldo Emerson's trip through Italy in 1832 were published in *Emerson in Italy* in 1987. Her photo essays, taken characteristically with a 4 x 5-inch **view camera,** include such subjects as ghost towns, the British impressionist J.M.W. Turner's home in England, and life in British prisons. Her work has appeared in major periodicals and many books.

Born in Germany, Hofer left the country with her family as the Nazis rose to power. As a teenager she studied music in Paris but later decided to pursue a career in photography and apprenticed at a studio in Zurich. She started her career as a freelancer in Mexico. She moved to the United States in 1947 and worked with **Alexey**

Burton Holmes. *Madeira*. 1902. Collection of the authors.

Brodovitch for *Harper's Bazaar* and later at *Vogue*.

Hofer's work is held by major museums, including the Metropolitan Museum of Art.

Holmes, Burton (1870–1958)

American photographer, author, and filmmaker

Holmes popularized foreign travel with his travelogues (a word he coined), a spectacle with words and pictures that played to full houses in cities across the United States. His photographs were powerful observations of life in exotic lands. In his long career he traveled to nearly every country on the globe.

Born to a financially secure family in Chicago, he traced his early interest in performing to hearing a travel lecture on the Passion Play at Oberammergau. He bought his first camera in 1883. By the age of 16 he had left school and accompanied his grandmother on his first trip to Europe. On his second journey with her to Europe he met John Stoddard, who had given the Passion Play lecture in Chicago, inspiring Holmes to take up a similar career as a travel lecturer.

When Holmes returned to the United States he showed Kodak negatives of his travels to fellow members of the Chicago Camera Club. At the suggestion of a member he displayed his pictures, mounted as slides, at a public gathering, and wrote an account of his trip that he read as the slides were shown. The show earned $350 and was his first travelogue.

His slides were exquisitely hand-tinted in watercolors, and the results were surprisingly realistic; but he

gained success only after he began to use motion pictures with his lectures. He had the knack for being in the right place at the right time—he was in Naples when Vesuvius erupted in 1906 and covered the building of the Panama Canal, the Boxer Rebellion in China, and the Russo–Japanese War.

He signed an agreement with Paramount Pictures to make 52 travel features a year (1915–1921) and later had a similar contract with Metro-Goldwyn-Mayer. In 1977 a collection of his photos with excerpts from his eighteen travel books was published, called *Burton Holmes: The Man Who Photographed the World, Travelogues 1892–1938*.

Holmes, Oliver Wendell (1809–1894)

American writer and physician

Holmes is credited with coining the term *stereoscope*, which he used in 1859, in the first of three articles he wrote for the *Atlantic Monthly* about photography. Holmes wrote in that article, titled "The Stereoscope and the Stereograph," about the wonderful travel pictures that could take viewers to nearly every corner of the globe. He also pointed out that "The very things which an artist would leave out or render imperfectly, the photographer takes infinite care with and so makes its illusions perfect." Holmes also recommended in his article the establishment of libraries for stereoscopic pictures.

Holmes invented in 1861 an aluminum hand viewer for stereoscopic pictures. Both practical to use and inexpensive to manufacture, it was put into production by the firm of **Underwood** and Underwood.

Born in Cambridge, Massachusetts, Holmes was only briefly a general practitioner before turning to the academic field, becoming dean of Harvard Medical School in 1847. A popular writer and lecturer, he wrote poetry ("Old Ironsides") as well as his famous series of "Breakfast-table" essays for the *Atlantic Monthly*. His son, also Oliver Wendell Holmes, was a noted justice of the Supreme Court.

holography: A form of three-dimensional photography using a **laser** that was developed for use with the electron microscope. Holograms are a form of three-dimensional-appearing images on a reflective, silvery surface with iridescent images.

Hoppe, Emil Otto (1878–1972)

British society photographer

Hoppe became known as a photographer of chic English society in the 1920s, but later in his career he abandoned portraiture to follow other photographic interests, particularly the urban environment and scenic travel photography.

Born in Munich, Hoppe was trained as a banker and joined his father's firm. Starting on a trip to China at the turn of the century, he first stopped in London, where he decided to settle in 1900. He took up photography as a hobby and joined the **Royal Photographic Society** in 1903. He worked at a bank until 1907, when his prize money from photo competitions started to parallel his banker's salary. He turned to photography full time and opened his own studio. His pictures were in the prevailing **Pictorialist** style and his work resembles that of his close friend **Alvin Langdon Coburn**.

In 1917, he had 665 people sit for portraits; 150 were published in the *Tatler*. He made his first trip to the United States in 1919. His career as a portraitist peaked in 1922 when 221 of his images were exhibited at the Groupil Gallery. He then turned to subjects closer to real life, taking simple, direct pictures of working people, tramps, and vagrants. In 1923 he went to Romania and published the first of 27 travel books, Gypsy *Camp and Royal Palace*.

In the 1920s and 1930s he continued to work both in the romantic Pictorialist style and also did strikingly modern industrial shots. His autobiography, *100,000 Exposures,* was published in 1945, and he continued to be active as a photographer until his death.

Horst, Horst P. (1906–)

German-born American fashion photographer

The German-born Horst defined modern glamour with his images of the famous, taken for Condé Nast publications in the 1930s and 1940s. His work fell out of favor in the 1950s and 1960s, but after a major retrospective at the **International Center of Photography** in 1984 his star again burned brightly and he was showered with

fashion assignments and accolades as he passed his ninetieth birthday.

Horst was an art student and then an assistant in Le Corbusier's architectural studio before turning to photography. He started with Condé Nast publications in 1932 and was made chief photographer for *Vogue* in 1934. An early champion of his work was the legendary fashion arbiter Diana Vreeland. He was still shooting for *Vogue*—and many other publications—some 60 years later.

In 1943 he became a U.S. citizen and was inducted into the Army. He was recognized for his photography and was soon shooting for various military publications.

His shots of high society and other famous figures—such as Coco Chanel, Bette Davis, Gertrude Stein, Yves St. Laurent, Noel Coward, and Ginger Rogers—were inspired by the unblemished and statuesque forms of classical antiquity. Horst is known as a master at transforming his female subjects into icons of idealized femininity.

During the 1980s he was honored or exhibited at a different prestigious international venue with regularity. He was the subject of a BBC documentary, *Horst: 60 Years and Still in Vogue,* and earned a Council of Fashion Designers of America's Lifetime Achievement Award. Since 1947 he has lived in a home of his own design in Oyster Bay, Long Island, filled with pieces given to him by Chanel, paintings by famous friends, and other works of art.

Hosoe, Eikoh (1933–)

Japanese photographer and teacher

Hosoe is at the forefront of the new wave of modern Japanese photography. Working in black-and-white and often in high contrast, he produces abstractions of the human figure and sexuality, as well as surreal landscapes, in allegorical and mysterious memory images.

A graduate of the Tokyo College of Photography, he has been a professor at the Tokyo Institute of Polytechnics since 1975. He won top Japanese awards in 1961, 1963, and 1970 and directed two segments for the 1966 film Tokyo Olympic Games.

His work is now collected on both sides of the Pacific and is in major collections, such as those of the Museum of Modern Art, the **George Eastman House**, and the Bibliothèque National in Paris. He has had several one-man exhibits and has also published monographs.

Howes, Alvah (1853–1919)
Howes, George (?–1925)
Howes, Walter (?–1945)

Early American commercial photographers

The Howes brothers were entrepreneurs whose photographs, taken from 1886 to 1906, document the social and economic conditions in western New England during the late nineteenth century. Their subjects ranged from school classes, factory crews, and shopkeepers to delivery men. They often made door-to-door calls for prospective customers, who might be well-to-do homeowners or working-class people. Typically the subjects were photographed in front of their homes, so the Howes's pictures provide a wealth of information about the people and places portrayed. They emphasized the low cost of their photographs and so were able to photograph people who would have not been able to afford a formal sitting in a photo studio.

The brothers were born in Ashfield, a village in the Berkshires of western Massachusetts. Their father was a farmer, but the small family farm could not support a family of seven children. The oldest, Alvah, began his career as an itinerant photographer around 1886–1887 with his brother Walter. In 1888 Alvah opened a studio in Turners Falls, Massachusetts, where he employed both Walter and George. More than 20,000 glass negatives taken by the Howes brothers survive. The entire Howes collection is now owned by the Ashfield Historical Society Museum.

Hoyningen-Huene, George (1900–1968)

Russian portrait and travel photographer

A baron born in the privileged world of the Russian aristocracy in Saint Petersburg—his maternal grandfather was the U.S. ambassador and his father was in the czar's inner circle—Hoyningen-Huene eventually made his way to California and is remembered for his smoothly elegant portraiture and travel photographs.

After the outbreak of World War I his father sent the family to Yalta. They later returned to St. Petersburg but the Bolshevik revolution was gathering momentum. They emigrated to London, where George enlisted in an expeditionary force that fought in Russia for one year. His family moved to the south of France after the war, but George decided to live in a more culturally stimulating environment—that of Paris. There, he knocked about in odd jobs, including stints making hat boxes and as a movie extra, before falling back on his social connections to get a job at French *Vogue,* first as an illustrator and then as a photographer. The story goes that one day a photographer did not show up for a shoot and young George filled in.

His style and technique were influenced by the artistic milieu of Paris—**Man Ray**, **Edward Steichen**, and **Baron de Meyer** were his contemporaries. He became a leading **fashion photographer,** noted for his cool, refined style and extraordinary use of light. He moved to New York to work for *Harper's Bazaar* in 1935. Working for the fashion magazines, he photographed models, designers, and film stars, among them Greta Garbo, Coco Chanel, Katharine Hepburn, Ava Gardner, Marlene Dietrich, and Sophia Loren. His interest in fashion eventually waned, and travel photography drew his attention. He published five books on travel, from Africa and Greece to the Middle East and Mexico.

In 1946 he moved to Hollywood, working full time as a color consultant to his longtime friend, the director George Cukor. He also taught at the Edward Kaminksi School of Creative Photography and at the Art Center School in Pasadena. A retrospective of his work was shown at the **International Center of Photography** in 1980, and a book titled *The Photographic Art of Hoyningen-Huene* was published in 1986.

Hughes, Jim (1937–)
American writer and editor
As editor of *Camera 35* magazine, Hughes published substantial portfolios of younger writers. He became widely known for his courage and commitment to the best in photography when he devoted 24 pages of the magazine to **W. Eugene Smith**'s "Minamata" essay, a searing indictment of environmental damage caused by chemical dumping in the waters off that Japanese fishing village. Hughes, with the assistance of his wife, Evelyn, later wrote the definitive biography of Smith, a massive research and writing effort that took 12 years to complete.

Born in Cos Cob, Connecticut, Hughes began taking photographs in grade school when he received his first camera, a Baby Brownie, as a Christmas gift. In high school he was the yearbook photographer. Hughes attended the University of Connecticut, where he photographed, wrote a column, and became managing editor of the school newspaper.

After working as a reporter-photographer at the *New Haven Register,* he moved to New York, working as editor for various trade magazines. In 1967 he became editor of *Camera 35.* With publication of Smith's Minamata picture story, the photographer won numerous awards, including the Overseas Press Club's **Robert Capa** award. When the magazine was sold in 1975, Hughes became editor of *Popular Photography Annual* and other special market photo publications. In 1980 he conceived and edited the critically acclaimed magazine *Camera Arts,* which was the first photography magazine ever to win the National Magazine Award for General Excellence, and Hughes was named editor of the year by the National Press Photographers Association in 1983. Faced with rising circulation and dwindling advertising, the magazine closed that same year.

Hughes' biography of Eugene Smith was published in 1989. Other books by Hughes include *Ernest Haas in Black and White* (1992) and *The Birth of a Century* (1994), the latter consisting of early photochroms of the United States, mainly by **William Henry Jackson**. He presently writes a column for the newly reincarnated *Camera Arts* and is working on a memoir.

Hujar, Peter (1934–1987)
American documentary and portrait photographer
Hujar has been called one of the leading photographers of the AIDS generation. His poetic and melancholy body of work includes the street life of the city, the piers, the circus, the famous, his friends,

Peter Hujar. *David Wojnarowicz.* 1981. © Estate of Peter Hujar. Courtesy James Danziger Gallery.

his friends' children, and people he barely knew.

Born in New Jersey in 1934, he began photographing at the age of 13 and learned photo technology as an apprentice in a commercial studio. He moved to a lower Manhattan loft in 1975 that became the setting and starting-off point for much of the rest of his life's work. He worked as a fashion photographer in the 1960s and 1970s before concentrating on the stark portraits that have been his major interest. He photographed members of the underworld and the avant garde art scene, sometimes in the nude; among his subjects were **Susan Sontag**, William Burroughs, Candy Darling, Divine, and John Waters.

He won a Creative Artists Public Service grant in 1976 and **National Endowment for the Arts** fellowships in 1977 and 1980. Using a large-format 16 x 20 camera, he produced his unmanipulated silver prints, which he felt were influenced by **Diane Arbus**. Many are collected in his *Portraits of Life and Death*. In 1990 he had a major retrospective at New York University's Grey Art Gallery, and his work is now held by major collections. His work has been published in two monographs, *Portraits in Life and Death* (1976) and *Peter Hujar, A Retrospective* (1994).

Humphrey, Samuel Dwight (dates unknown)

American writer

Little is known about the life of Humphrey, who edited the first photography magazine and wrote a series of handbooks on photography published in the 1850s that were widely reprinted.

In 1849 he made a memorable photograph of the moon and in the following year established himself as a **daguerreotypist** in New York City. He later became the editor and publisher of the world's first magazine devoted exclusively to photography, the *Daguerreian Journal*.

Hurley, Frank (James Francis) (1890–1962)

Australian photographer and explorer

An intrepid adventurer, Hurley took part in several expeditions to the Antarctic and also served as Australia's official war photographer during World War I; in 1939 he again became a war photographer. He published several books and is noted also for his filmmaking, particularly a documentary called *In the Grip of Polar Ice*.

Hurley had no formal schooling as a photographer but learned the trade while working for a picture-postcard firm in Sydney. He left to join Douglas Mawson's Australian Antarctic Expedition in 1911–1914, during which he was of the group that reached the South Magnetic Pole. In 1914 he set out again, with Sir Earnest Shackleton's Imperial Trans-Antarctic Expedition. He returned with memorable photographs of the wreck of the *Endurance* and scenes of Elephant Island. On that voyage he was trapped for a year, along with a party of other explorers, by ice in the Weddell Sea.

On Hurley's return in 1917 from the expedition, he went to France as a war photographer. During the next few years he lectured and traveled extensively, from the Middle East to the United States. He worked as a newspaper picture editor in Melbourne and made numerous documentary films, on topics ranging from aboriginal culture to the Holy Land. In 1929, he again joined an Antarctic expedition sponsored by a joint British, Australian, and New Zealand effort.

Hurrell, George (1904–1992)

American portrait photographer

Hurrell is the man who is usually credited with inventing the Hollywood glamour **portrait**. In a career that spanned film's golden age, his work for Warner Bros., Disney, 20th Century-Fox, and Columbia allowed him to photograph such great stars of the 1920s, 1930s, and 1940s as Norma Shearer, Joan Crawford, Greta Garbo, Clark Gable, and Jean Harlow. Among his most famous photographs are the notoriously provocative shots of Jane Russell for Howard Hughes's *Outlaw*.

Raised in Kentucky and self-taught, he found that taking pictures of other artists' paintings was more profitable than creating his own seascapes. Enchanted with the movies, he struck out for Hollywood. His big break came on his first assignment: a portrait of Ramon Novarro, then a big Hollywood star. Novarro's friend Norma Shearer, one of the top box-office draws in the 1920s, had Hurrell do her portrait. His pictures of her so

impressed her studio bosses that he was hired as a studio photographer for Metro-Goldwyn-Mayer in 1930.

He worked for the studios nonstop until 1960 (except for a short stint as a Pentagon staff photographer), when he started a freelance career. For the next 15 years he continued to work, and he produced such notable books as *The Hurrell Style.* In 1997, a collection of his life's work, *Hurrell's Hollywood Portraits,* was published.

Hyde, Scott (1926–)

American art photographer

Hyde has made inventive use of his subjects to explore the effects of color and light that occur in nature. Using black and white for the original photograph, he will then overprint several images, using a different color for each of his superimposed images.

Hyde worked for Condé Nast publications while studying at New York's Art Students League from 1947 to 1949. He also studied at Pratt Institute, Columbia University, and the Art Center of the College of Design in Pasadena, California. Since 1950 he has pursued a career as a freelance photographer. In 1965 he won a Guggenheim fellowship and CAPS grants in 1972 and 1974. His work is held by numerous collections, including those of the Cooper-Hewitt, the Metropolitan Museum of Art, the Museum of Modern Art, and the George Eastman House in Rochester, New York.

hypo: A commonly used term for photographic **fixer**, which is ammonium thiosulfate or sodium thiosulfate. Hypo is used to wash away unexposed silver in a photographic image and to make the image permanent.

Hypo Clearing Agent: A chemical made by **Eastman Kodak** that is used to remove residual **fixer** from fiber-based photographic prints for archival stability. The procedure is to **wash** the print for at least five minutes in running water (or three changes of fresh water) after fixing. Then the print is placed in a working solution of Hypo Clearing Agent with intermittent **agitation** for five minutes, followed by a final wash of running fresh water for 20 minutes, then dried. Another commonly used solution for this purpose is Perma Wash, the brand name of a similar solution made by Heico.

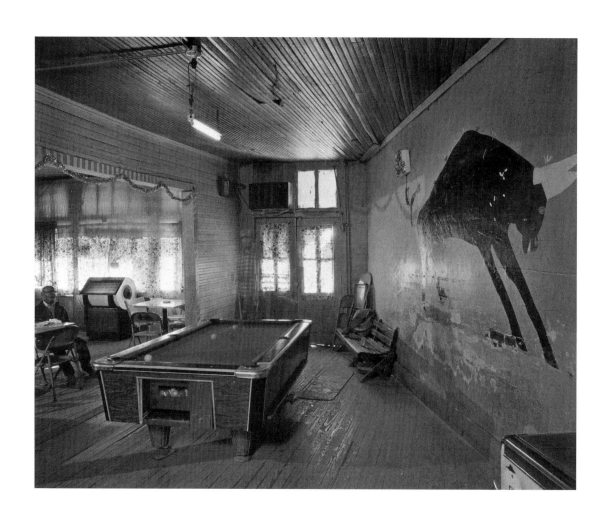

Birney Imes. *The Riverside Lounge, Shaw, Mississippi*, 1989. (Original in color).
© Birney Imes. Courtesy of the photographer.

identification (I.D.) photography: The taking of a photograph for identification purposes, such as a driver's license or passport. I.D. photos were once made in photo booths, which have been replaced by **Polaroid** cameras that take two photos simultaneously.

Ilford: A photographic-supply company that makes **paper, film,** and **digital-imaging** products. Well known for the Ilfochrome, or **Cibachrome,** direct positive process.

image: The graphic representation of a person, place, or thing. In photography, the visible surface of a photograph is the image.

Image Bank: A photography agency that maintains a large collection of stock photographs for sale to publications in its more than 70 offices in more than 35 countries.

image manipulation: The alteration of an image through physical **retouching** (such as **airbrushing** and painting) or through digital means (**scanning** the image and then altering it on the **computer**).

Imes, Birney (1951–)
American photographer
Birney Imes has been photographing in his native Mississippi for more than 20 years. He is self-taught and works in both black-and-white and color. His pictures have been collected in three books: *Juke Joint, Whispering Pines,* and *Partial to Home.* Imes's work is included in the collections of the Museum of Modern Art, and the Metropolitan Museum of Art in New York City, the Art Institute of Chicago, the Bibliothèque Nationale in Paris and numerous other public and private collections in the

U.S. and abroad. He has received the photography award from the Mississippi Institute of Arts and Letters three times, and is the recipient of two fellowships from the National Endowment for the Arts.

He now edits and manages his family's daily newspaper in Columbus, Mississippi.

incident light: Light that is falling on a subject is incident light, as opposed to light that is bouncing off a subject, which is reflected.

index print: A modern-day contact sheet, an index print is a page of small, low resolution, numbered thumbnail images used as a visual reference for the contents of a photo CD.

industrial photography: Photography that is used for the commercial production and sale of services and goods of an industry. This encompasses a broad range of types of photography, including **still-life, architectural,** and **portrait.** Basically any photography done in the service of a company can be called industrial photography.

infinity: The representation of unlimited distance—what the eye can see and beyond. In photography, the far distance in which objects all appear to be in focus. Depending on the **lens,** this is usually from about 30 feet on. The infinity symbol on a lens is the figure 8 laid horizontally.

information highway: Also called the information superhighway and the **internet,** it's the linked telecommunications systems that can be accessed by anyone with a modern **computer,** a **modem,** and the **software** to access it. The information highway links archives and

Pages 242 – 243: An oil refinery in Phillipsburg, Kansas, is an example of industrial photography. © Fred W. McDarrah.

print and broadcast media as well as personal web pages worldwide. Information is accessed through an address or can be sought through a directory service called a search engine, such as InfoSeek, Yahoo!, and Lycos, among others. Service providers such as America **Online, Microsoft,** and Netscape provide the software to link your personal or business computer to the internet. The information highway has become the most influential technological innovation of the late twentieth century, transforming the way business, education, research, communication, and entertainment are conducted. One of the most important features of it is that it is completely democratic and is uninhibited by political boundaries. Anyone can create and launch a web page with any information, including images, which can be accessed by anyone, worldwide, with a computer, modem, and software (all of which are becoming more and more affordable and increasingly commonly found).

infrared photography: Photography that records infrared radiation as opposed to visible radiation (light) by using a special infrared film. Infrared radiation is invisible to the eye and many materials reflect and transmit infrared radiation in a way different from the way light does, giving an infrared photograph unfamiliar tonal characteristics. Heat produces infrared radiation, and therefore two identical objects, one hot and one cold, would look different in an infrared photograph, with the hot one being brighter.

ink jet printer: A **computer**-controlled printer that sprays ink through very fine nozzles. The ink is water based, and so will run if it becomes wet. Ink jet technology has been rapidly advancing, and some of the finest computer output is now done with ink jet printing. IRIS ink jet prints are considered among the finest types of computer output, and can be totally photographic— undetecable from traditional photographs— and are printed on a variety of mediums, including water color paper and fabrics. Modestly priced ink jet printers capable of prints at 1440 dots per inch (dpi) are readily available for home use.

instant photography: Photography in which one gets immediate results, such as with the **Polaroid** process and with **digital photography**.

intaglio printing: A printing process in which the dark areas of an image correspond to recessed areas of the printing plate. The plate is inked and wiped clean. Ink remains where the plate is recessed, and when the plate is run through a press the inked recessed areas create the image on paper.

intensification: A process used after the initial development of film to make it more dense—that is, to have more silver built up in the **emulsion**. If an important negative is too thin to yield good results, it can be intensified to make it more printable. Intensification occurs only where there is already silver in a negative, so one that is clear (without silver) will not be affected. A widely available and commonly used intensifier made by **Kodak** is called Chromium Intensifier.

International Center of Photography (ICP): New York City's only museum of photography, established in 1974. It organizes about ten exhibitions a year and also directs a traveling exhibition service, operates adult community education programs in photography, publishes exhibition catalogues and program guides, maintains a library and biographic files on photographers, presents annual Infinity Awards, and has museum shops of photo books and photo-related items.

The museum's main building at 92nd Street and Fifth Avenue has been supplemented by ICP Midtown. In addition to exhibitions, ICP Midtown holds the museum's archives and collections, with 45,000 original prints spanning the history of photography; major holdings include the **Robert Capa** and **Cornell Capa** collections, the **Weegee (Arthur Fellig)** and **Roman Vishniac** collections, and the Daniel Cowin collection of photographs of African American history.

The idea for establishing the museum evolved from a major exhibition called "The Concerned Photographer," organized by Cornell Capa, a *Life* photographer and later the museum's first director. The exhibit was made up of

the work of three **Magnum** photographers—Capa's brother, Robert, who had died on assignment in Vietnam, **David "Chim" Seymour,** killed in the Sinai during the Six-Day War in Israel, and **Werner Bischof,** who had died in an auto accident in Peru—and **Dan Weiner** (killed in a plane crash), **André Kertész,** and the then unknown **Leonard Freed**.

Some 40,000 people attended the show, held at an out-of-the-way location (the Riverside Museum in upper Manhattan). This great public interest in the work of these six individuals led to the formation of the International Fund for Concerned Photography and the ICP, whose founding resolve was "to encourage and assist photographers of all ages and nationalities who are vitally concerned with their world and their times . . . not only to find and help new talents, but also to uncover and preserve forgotten archives and to present such work to the public."

International Museum of Photography and Film: See **George Eastman House**.

International Photography Hall of Fame and Museum: Located in the Kirkpatrick Center Museum Complex in Oklahoma City, Oklahoma, the Hall of Fame and Museum commemorates the history, science, art, people, events, and places of photography. Created by the Professional Photographers of America to promote photographic history by inducting historically significant photographers and inventors into a hall of fame, the institution is sponsored by the Photographic Art and Science Foundation. On permanent display are a 360-degree photographic mural of the Grand Canyon and **Ansel Adams**'s "Moon over Hernandez, New Mexico." The museum's collection also includes thousands of prints and pieces of antique camera equipment. Forty-nine historical figures have been inducted into the hall of fame, ranging from **Daguerre, Talbot,** and **Niepce** to **Diane Arbus, James Van Der Zee,** and **Dr. Edwin Land**. In addition to exhibitions, the International Photography Hall of Fame and Museum sponsors seminars, lectures, and adult and young people's classes, and it publishes a quarterly newsletter.

International Standard Book Number (ISBN): A system of ten-digit numbers used for identifying books and their publishers. This is a standardized system of identification used around the world.

internegative: A copy negative made from a slide, required when a print from a slide is to be made on photographic paper intended for use with color negatives.

internet: See **World Wide Web**.

Intimate Gallery: A photo gallery directed by **Alfred Stieglitz,** located at 489 Park Avenue in New York City from 1925 to 1929.

ISO (International Standards Organization) rating, or speed: The rating is applied to photographic **emulsions** to denote their relative sensitivity to light.

Iturbide, Graciela (1942–)
Mexican art photographer
Iturbide conveys her personal vision with black-and-white scenes of Mexican life that are subtly poetic, sometimes surreal, or dreamlike in their portrayal of native cultures.

Born in Mexico City, she turned to photography after the loss of a daughter led her to reevaluate her life. She studied filmmaking at the Centro Universitario de Estudios Cinematográficos and began taking photographs when she was assistant to **Manuel Alvarez Bravo** in the early 1970s. She met **Henri Cartier-Bresson** on a trip to Europe, and his work has been a major influence on her style. In 1978 she was a founding member of the Mexican Council of Photography. In 1987 she won the W. Eugene Smith Award for her "Juchitan" project, for which she photographed the traditional matriarchal society of that region of Oaxaca. In 1988 she won a **Guggenheim fellowship**. In 1996 her work was exhibited in a traveling solo show organized by the Philadelphia Museum of Art, and a monograph titled *Images of the Spirit* was published in conjunction with the exhibition.

Ives, Frederic Eugene (1856–1937)

American photographer and inventor

Ives was a pioneer in the world of color photography and obtained more than 70 patents, many directly related to improvements in the **halftone** process, which revolutionized the field of printing newspaper and magazine illustrations. His work in the field of subtractive color was essential to the development of **Kodachrome** film. He received awards and honors from numerous organizations, including the Franklin Institute and the American Academy of Arts and Sciences.

At the age of 13, Ives was apprenticed as a printer at his hometown newspaper, the Litchfield, Connecticut, *Enquirer.* He started studying photography and how it could be better integrated into the newspaper. In 1874 he was appointed official photographer of Cornell University. He established a photo department and began his lifelong work in improving color and photomechanical reproduction processes. In 1886 he created the cross line screen, still in use today.

In 1892 he patented the first practical color camera, the Photo-chromoscope. In 1894 he patented an advanced, **stereoscopic** version he called the Kromscop, then improved on that, in 1895, with a three-color magic lantern called Projection Kromscop.

His son, Herbert Eugene Ives (1882–1953), was an award-winning physicist and pioneer in the field of color photograph transmission.

Jackson, William Henry (1843–1942)

Pioneering American landscape photographer, writer, and artist

One of America's greatest photographers, Jackson was *the* pioneering photographer of the American West, recording during his long and productive career the natural wonders and pristine landscapes of the United States and the world. Working with great energy and vision, he took thousands of negatives that were seen in stereo cards, lantern slides, original prints, and murals and reproduced in newspapers, magazines, and books. Among the landmark works that established Jackson's reputation are his surveys of Indian tribes of the West, panoramic views of the Rockies, documentation of the lost cities of Indian tribes, the first views ever of Yellowstone, a survey of transportation around the world, albums of natural beauties, and archaeological and geological surveys of wide scope.

Born in Keesville, New York, he remembered playing as a child with the parts of a camera discarded by his father, a failed **daguerreotypist**. His mother encouraged him to learn painting and drawing, and Jackson became both an artist and later a photographer. He got his first job in photography at the age of 15, retouching and coloring photos in a portrait studio in Troy. As a Union soldier in the Civil War, he was appointed staff artist for the 12th Vermont Infantry. He sent home some of the sketches he made of camp life and the countryside.

After the war he traveled west to seek his fortune as a silver miner. Giving up that notion, he traveled on wagon trains and later as a driver in Wyoming, Montana, California, and Utah. He finally settled in Omaha, Nebraska, in 1867 and worked as a colorist in Hamilton's photo gallery, which he and his younger brother, Edward, bought the following year. Jackson Brothers, Photographers, became the most successful portrait studio in town. Jackson left the daily work of the studio to his brother and went out photographing the countryside.

His first major effort was a series of photographs he took along the line of the Union Pacific Railroad, moving around with his traveling darkroom. He covered the territory within a 100-mile radius of Omaha and photographed Indian tribes, many for the first time ever. Traveling farther afield to Wyoming, he captured the magnificent scenery of its picturesque canyons and landscapes. Ferdinand Vandiveer Hayden, head of a federal survey of the territories, had seen Jackson's work and in 1870 invited him to be official photographer of the next summer's survey, along the Old Oregon Trail. Under the terms of Jackson's agreement, he was paid only for his expenses and the right to ownership of his negatives. Jackson accompanied Hayden on survey trips for the rest of the decade. Thomas Moran was the official artist for the survey, and Jackson acknowledged Moran's aid in composing his pictures.

They documented the Yellowstone region, the Tetons, Pawnee and Omaha villages in Nebraska, the Colorado Rockies, Mesa Verde, and ancient ruins in Arizona and Utah. Jackson not only took pictures but also wrote extensively about his travels. In 1876 his work was exhibited at the Philadelphia Exposition.

By 1878 appropriations for the surveys had become increasingly difficult to get. Jackson left government employ and opened a studio in Denver, but he continued to travel, with expeditions to the Southwest and Mexico. He sold **stereoscopic** views of his pictures until the turn of the century, when he closed the Denver studio to join a group of businessmen in Detroit in a new venture. The firm had bought the rights to the new Photochrom process for printing photographs in color, and Jackson contributed his huge collection of plate-glass negatives to be colored and sold. Jackson was associated with the Detroit Publishing Company from 1898 until 1924. He

continued to photograph landscapes and monuments until 1903, when he stopped work as an active photographer to take over management of the company. Its bankruptcy led Jackson to transfer his 40,000 negatives to the Edison Institute of the Ford Motor Company, which later divided the archive between the **Library of Congress** and the Colorado Historical Society.

In the 1930s Jackson painted murals of the Old West for the Department of the Interior. His work earned him international fame, and he was buried in Arlington National Cemetery in honor of his work, which was instrumental in inspiring Congress to establish Grand Teton, Yellowstone, and Mesa Verde national parks.

Jacobi, Lotte (1896–1990)

German-born, American portrait photographer

A noted portrait photographer, Jacobi was the fourth generation of her family to be a photographer; her great-

grandfather learned from **Daguerre** himself.

She was born in Thorn, Germany, and took her first photograph with a pinhole camera in 1908. After studying photography at the Bavarian State Academy and art history at the University of Munich, she took over her father's Berlin studio in 1927. She specialized in portraits of German artists, theater people, musicians, dancers, and film stars. Among her sitters were Bertholt Brecht, Kurt Weill, and Lotte Lenya.

She fled Nazi Germany and in 1935 moved to New York, where she continued to do portrait work, photographing many authors and German immigrants. Her subjects included Albert Einstein, Marc Chagall, **Alfred Stieglitz**, Thomas Mann, J. D. Salinger, Theodore Dreiser, and Eleanor Roosevelt. She also began to experiment with photogenics, abstract photographic prints made without a camera but directly printed on paper, using a miniature flashlight. In 1955, she moved to New

William Henry Jackson. *Hot Springs on Gardiner's River, Upper Basins, Yellowstone, Wyoming Territory.* 1873. The Academy of Natural Sciences of Philadelphia.

Hampshire, where she lived for the rest of her life. In addition to extensive traveling, she opened an art gallery in the town of Deering, where she lived, and her portraits and landscapes are still widely exhibited there. In 1977 she won a **National Endowment for the Arts** grant to photograph other photographers.

Jenshel, Len (1949–)
American photographer and teacher

Jenshel is a leading figure in new color photography. A Brooklyn native who earned his master of fine arts degree from Cooper Union, he studied with and was influenced by two of his teachers, **Joel Meyerowitz** and **Garry Winogrand**. After being trained as a black-and-white street photographer, he decided to pursue color work and picturesque subject matter. He was quickly recognized, both critically and commercially. He won a Creative Artists Public Service grant and a **National Endowment for the Arts** award in 1978.

He won a **Guggenheim fellowship** in 1980 and with it produced a series on Gilded Age mansions in Newport, Rhode Island, Old Westbury, New York, and landscapes that were featured in *The New Color Photography* (1981). In 1984 he published *Pictures at an Arboretum* (1984), landscapes that flow with energy and visual surprise.

In addition to his own work, he has given many master's workshops and taught classes at the **International Center of Photography**, Cooper Union, and New York University. He shoots with a hand-made, handheld 6 x 9-centimeter camera that takes both 120 and 220 film and houses a 65mm wide-angle lens. It enables him to move around easily, reacting more quickly than would be possible with large-format equipment.

Johnston, Frances Benjamin (1864–1952)
Early American female photojournalist

Vastly underappreciated and not very well known, Johnston is a significant figure in the history of photogra-

Frances Benjamin Johnston. *The Isadora Duncan Dancers,* ca. 1910. Library of Congress/Corbis.

phy. She was one of the first female photojournalists, was among the first photographers to make a business of supplying pictures to magazines, and was the unofficial White House photographer for five administrations.

Originally an art student and a writer, she took up photography only as a way to illustrate some of her articles. She studied at the Academie Julien in Paris for two years starting in 1883, then at the Art Students League in Washington, D.C., in 1885, the same time she began to study photography at the **Smithsonian Institution**. In 1890 she opened a studio in Washington. She received

many commissions from schools, magazines, and the government, which led to a friendship with Mrs. Theodore Roosevelt before her husband became president. Her images of the administrations of Benjamin Harrison, Grover Cleveland, William McKinley, Roosevelt and William Howard Taft were widely reprinted at the time. She snapped the last photo of President McKinley before he was assassinated in 1901.

Her major journalistic work was accomplished between 1889 and 1910, and thereafter she specialized in architectural photography. She is noted for documentary

Theo Jung. *Younger Part of a Family of Ten to be Resettled on Ross-Hocking Land Project, Chillicothe, Ohio.* April 1936. Library of Congress.

series on iron ore mining, the women workers of Lynn, Massachusetts, and the District of Columbia public schools.

In 1897, she published "What a Woman Can Do with a Camera" in the *Ladies' Home Journal.* She also championed female photographers by organizing a 142-print exhibition of 28 female colleagues. The touring show opened in Paris and went on to Moscow and St. Petersburg. Johnson also produced a noteworthy series on black institutions, especially the Tuskegee and Hampton institutes, a near-revolutionary move for the era.

She undertook her first architectural commission in 1909: photographing historic buildings and gardens in the South. In 1913 she opened a studio in New York City and after 1917 specialized in architectural and horticultural work. Her pictures caught the attention of the Carnegie Foundation, which awarded her a grant to continue her photodocumentation in the South. From 1933 to 1940 she traveled the Atlantic and Gulf Coast states. Several books resulted from that period, including *Plantations of the Carolina Low Country* and *The Early Architecture of North Carolina.* Her work earned her an honorary membership in the American Institute of Architects. She spent her last years in New Orleans.

jukebox: A device for holding a large number of **photo CD**s, any one of which can be readily accessed, thus forming the basis for an image library system.

Jung, Theo (1906–)

Austrian-born, American documentary photographer

Jung was one of the few non-native-born people to work for the federal **Farm Security Administration** (FSA), which he did as a photographer for the Historical Section, creating many memorable images of Depression-era America.

Born in Vienna, Jung came to the United States at age six, his family settling in Chicago. He got his first camera, a Box Brownie, for his tenth birthday and took pictures of friends and family, but he had no inkling that he would become a photographer. When a cousin he considered a hard worker got laid off and went on relief, he started taking pictures, on his own initiative, of the empty stores, slums, and other signs of hard times. In 1934, he got a job with the Federal Relief Emergency Administration; when he heard that **Roy Stryker** and the FSA were hiring photographers, he put his portfolio together and was hired.

His series of pictures taken in Jackson County, Ohio; Garrett County, Maryland; and Brown County, Indiana, of poor people and squalid living conditions are still striking reminders of that period. He stayed only one year at the FSA, leaving after a disagreement with Stryker.

He later worked in advertising as an art director and photographer. He became interested in book design and calligraphy and won several awards for design. His last job before retirement was with the News and Publications Section at Stanford University. Jung continued to take photographs on his own; a major personal photo project was a series on Harpers Ferry. He eventually donated his life's work to the San Francisco Museum of Art and left a major bequest to that museum to purchase the work of young photographers.

Alter Kacyzne. *At the Information Desk of the HIAS (Hebrew Immigration Aid Society), Warsaw.* 1921.
Courtesy Yivo Institute for Jewish Research, New York

Kacyzne, Alter (1885–1941)
Yiddish writer and photographer

Beaten to death by Nazi sympathizers in 1941, he was a commercial photographer by profession and left an impressive body of work documenting the lives of Polish Jews. Kacyzne also wrote poetry, fiction, drama, and essays.

Born in Vilnius (Vilna), he wrote his earliest short stories in Russian. His play *The Duke* (1926) was first staged in Warsaw, and then in Yiddish theaters around the world. He also wrote a historical drama, *Herod* (1926), that was well regarded, as was his two-volume novel *Strong and Weak*, about Polish-Jewish intellectuals during World War I, which was published posthumously in Argentina in 1954. Fleeing the Germans, he tried to escape to Tarnopol but was seized by Ukrainian collaborators.

Kacyzne's photos were included in the 1976 Jewish Museum show of Jewish life in Poland before 1939. An archive of his work is held by YIVO (Institute for Jewish Research) in New York City.

Kai's Super Goo: A popular photo-editing **software** used primarily to distort and manipulate images that have already been downloaded into a **computer**.

Kanaga, Consuelo (1894–1978)
Pioneering American female photographer

Kanaga was a wide-ranging photographer whose work reflected her eclectic interests, ranging from social documentation to near-abstraction, Precisionism, and commercial photography. Her portraits, particularly of African Americans, are powerful in their sculptural emphasis.

Born in Astoria, Oregon, she got a job as a reporter at the *San Francisco Chronicle* in 1915 but was encouraged to become a photographer. She joined the California Camera Club, where she met **Dorothea Lange,** who would become her lifelong friend. In 1922, she left her husband behind and moved to New York to work for *The New York American.* She met **Louise Dahl-Wolfe,** divorced her husband, and traveled to Italy with her for two years. Back in New York, she learned of the **f/64** group and became friendly with members **Edward Weston, Imogen Cunningham,** and others, and she was in their first show in San Francisco in 1932.

She then started working for leftist publications like *New Masses*, *Labor Defender*, and *Sunday Worker*. In 1936 she married the painter Wallace Putnam and found a new circle of friends including the painters Adolph Gottlieb, Mark Rothko, and Sally and Milton Avery. Known for her subtlety of tones, she was included by **Edward Steichen** in his **"Family of Man"** exhibit at New York's Museum of Modern Art. Her shot of a tubercular woman, aged by her illness, and her 12-year-old son, "The Widow Watson," is her most famous image. Kanaga had two major retrospectives at the Brooklyn Museum, in 1976 and again in 1993. Her work is included in the permanent collections of the Metropolitan Museum of Art and the Museum of Modern Art.

Kane, Art (1925–1995)
American photojournalist

Kane was a much-honored freelance photographer as well as the longtime design director of Penthouse International.

Born in the Bronx, he recalled taking his first picture at the Bronx Zoo at age 12, but after he saw the developed print, he ripped it up and did not pick up a camera for another 15 years.

After World War II, he studied graphic arts at Cooper Union and was graduated in 1950. He got a job

as a designer with *Esquire*, leaving to become art director of *Seventeen* magazine until 1957. During his work at *Seventeen* he studied with the legendary **Alexey Brodovitch**. He started out on his own as a freelance photographer in 1959. His subjects included everything from musicians and babies to fashions, portraiture and travel scenes, and his work appeared in *Vogue* and other major periodicals.

He won a prestigious Page One Award from the Newspaper Guild of America (1966) as well as accolades from Syracuse University's Newhouse School and Cooper Union. His work is in the collections of the Metropolitan Museum of Art and New York's Museum of Modern Art.

Kaplan, Daile (1950–)

American curator, author, and teacher

Kaplan is vice president and director of photographs at Swann Galleries, New York's oldest auction house and one of the three significant galleries in the city that regularly hold photography auctions (with Sotheby's and Christie's).

The Brooklyn-born Kaplan joined Swann in 1990 after many years of work as an independent curator, putting together shows on **Lewis W. Hine, Alice Austen,** and vernacular photography for such places as the **Library of Congress** and in Geneva's Musée Internationale de la Croix Rouge. Kaplan is an eminent authority on the work of Hine and was editor of *Photo Story: Selected Letters and Photographs of Lewis W. Hine* in 1992 and author of *Lewis Hine in Europe: The "Lost" Photographs* (1988).

After a stint as an adjunct professor of history at New York University's graduate program from 1990 to 1991, Kaplan became an instructor of creative writing in New York City's public school system, where she is able to use photographs to inspire young students.

An accomplished photographer in her own right, Kaplan is a member of the National Arts Club, and her work is included in many public and private collections.

Karsh, Yousuf (1908–)

Celebrated Armenian-born, Canadian portrait photographer

Karsh's black-and-white portraits of celebrated personalities have been a prominent feature of the contemporary photography scene since his famous portrait of the imposing Winston Churchill appeared on the cover of *Life* magazine in 1941.

Born in Armenia, he emigrated to Canada in 1924 to escape persecution by Turkish invaders. He was aided by his uncle, a photographer in Sherbrooke, Quebec. Karsh was apprenticed to John Garo, a painter and photographer in Boston, for several years before returning to Canada in 1932 and opening a studio in Ottawa. In 1935 he was appointed by the Canadian government as official photographer, and he has become known for his portraits of Ernest Hemingway, Pablo Picasso, Norman Mailer, Jacques Cousteau, and scores of other personalities. His Churchill portrait was used as the basis for commemorative stamps in six countries, as have 11 other of his portraits. His familiar "Karsh of Ottawa" credit has appeared in publications all over the world, and he has published several books, including a monograph, *Karsh Portraits*, in 1976 and *Karsh, A 50 Year Retrospective* in 1986.

He has received honorary degrees from seven universities and was visiting professor of fine arts at Ohio University. The first photographer to receive the Medal of the Royal Canadian Academy of Arts, he also was awarded a U.S. Presidential Citation. Karsh's work is represented in the permanent collections of the Museum of Modern Art, the Metropolitan Museum of Art, the National Gallery of Canada, and other leading museums.

Kasebier, Gertrude (1852–1934)

Influential early American photographer

Kasebier was one of American photography's true pioneers. She was the first woman elected to **The Linked Ring** (1900), a founding member of the **Photo-Secession** (1902), and a cofounder of the **Pictorial Photographers of America** (PPA) (1916).

After raising her family, she started to study art at Brooklyn's Pratt Institute when she was 36. She found that her major interest was in photography, and she opened her own studio in 1897. Best known for her romantic scenes on the subject of motherhood, she liked to dwell on emotional content and employed dramatic

Gertrude Kasebier. *Willie—Spotted Horse,* ca. 1904.
Collection of the authors.

lighting effects and compositions reminiscent of those of old master painters to achieve the picturesque atmosphere she sought. She also took artistic portraits of eminent personalities of the era.

For the first two decades of the century, she was part of a small group—along with **Alvin Langdon Coburn, Alfred Stieglitz, Edward Steichen,** and **Minor White**—that dominated art photography. Her work was featured in the first issue of **Camera Work** in 1903, and she got assignments from *The Photographic Times, McClure's, Scribner's,* and other major illustrated periodicals of the period.

She had a falling out with Stieglitz over his advocacy of straight photography, and with Coburn and White she founded the PPA. She continued to shoot for ten more years, showing extensively on both sides of the Atlantic, before closing her studio in 1927.

Keegan, Marcia (1942–)

American documentary photographer

Keegan was born in New Mexico, and the subject of much of her work has been the Navajos and other Native American groups and landscapes of the Southwest.

After graduation from the University of New Mexico, Albuquerque, she got a job at the *Albuquerque Journal* before moving to New York City to work with **Alexey Brodovitch**. Other than a two-year stint starting in 1974 with the **Associated Press,** she has been a successful freelancer. She won a New Mexico Press award in 1967 and a Creative Artists Public Service (CAPS) grant in 1971. Her books include *Oklahoma, Mother Earth, Father Sky,* and *The Taos Indians and Their Sacred Blue Lake.*

Ken: A short-lived picture magazine that was published biweekly from 1938 to 1939. *Ken* was established as an anti-fascist publication, claiming its mission to tell the unvarnished insider's truth about the world: "Equally opposed to the development of dictatorship from either Left or Right." Known as the magazine that everyone hated, it ran unflattering photographs of celebrities and articles that were considered offensive and in poor taste, but also some pieces of very hard-hitting investigative

journalism. Ernest Hemingway wrote briefly for the magazine. Because of a boycott from both the left and right, the magazine folded in 1939. It was published by Esquire, Inc. (of *Esquire* magazine).

Kennerly, David Hume (1947–)

American photojournalist

Kennerly won a **Pulitzer Prize** in 1972 for his Vietnam coverage and was the official White House photographer for President Gerald Ford.

A professional photographer since his teen years at several papers in his native Oregon, Kennerly joined United Press International in 1967 and served in Los Angeles, New York, Washington, and Saigon. In 1973 he moved over to Time-Life, covering southeast Asia. From 1974 to 1977 he was stationed at President Ford's side before becoming a freelancer. He has worked extensively for *Time* magazine in the ensuing decades.

Kepes, Gyorgy (1906–)

Hungarian-born, American surrealist artist and photographer

Kepes was a leading **surrealist** and maker of **photograms**—images made without a camera simply by putting objects on photographic paper, then exposing the object to a light source and developing and fixing the paper.

Born in Hungary and a student at the Academy of Fine Arts in Budapest, Kepes turned to work in motion pictures in 1929. In 1930 he moved to Berlin and started to collaborate with **Laszlo Moholy-Nagy** on light and design experiments. In 1937 he moved to Chicago, where he became head of the light department of the New **Bauhaus**. His 1944 *Language in Vision* was a landmark in photography and art.

In 1945 he went to the Massachusetts Institute of Technology, where he taught visual design and related classes for the next three decades while also taking pictures and painting.

Kertész, André (1894–1985)

Hungarian-born, influential American photojournalist

Kertész was one of the most influential, celebrated, and accomplished photographers of the twentieth century. In

André Kertész. *The Stairs of Montmartre,* 1926. ©Estate of André Kertész

a career that spanned 70 years he created images of ordinary life in a style without pretension. He changed the way photographers and picture magazines looked at the world and defined the use of the handheld camera.

Like many of the successful immigrant visual artists who came to the United States (Kertész was born in Hungary)—such as Willem de Kooning, Arshile Gorky, **Alfred Eisenstadt,** and **Andreas Feininger**—Kertész enriched twentieth-century art by bringing his European sensibilities to the American experience, making art out of the mundane and enlarging our understanding and appreciation of photography.

Trained to be a banker, he worked in the Budapest stock exchange and at the same time took his first pictures in 1912. As an officer in the Austro-Hungarian Army during World War I, he took pictures of the soldiers and wartime activities. Severely wounded, he returned to Budapest and the stock exchange, where he stayed until moving to Paris in 1925 to work as a photographer.

He became friends with Fernand Leger, Marc Chagall, and Piet Modrian, and in 1928 exhibited with **Man Ray, Eugène Atget,** and **Nadar**. He started contributing to major French and German photo magazines like *Vu, Muncher Illustrierte, The Berliner,* and *Frankfurter.* Museums started collecting his work the next year. In 1936, he came to the United States under a one-year contract with the Keystone Agency; he would remain in New York for the rest of his life. From 1936 to 1949 he freelanced for ***Look,*** *Collier's, Vogue, Harper's Bazaar,* and others. He became a U.S. citizen in 1944. From 1949 to 1962 he was under contract to **Alexander Liberman** at Condé Nast; from 1962 until his death he accepted no commercial assignments but continued to shoot for his own enjoyment. His witty monographs *On Reading* and *Washington Square* convey his delight in everyday occurrences such as taking a walk in the park or sitting on the grass and reading a newspaper.

He is said to have taught photography to **Brassai**; he befriended a young compatriot, **Robert Capa**; and strongly influenced **Henri Cartier-Bresson**.

Among the many honors he received are a **Guggenheim fellowship**; a Venice Biennale Gold Medal; a Paris Exposition Silver Medal; Commander, Order of Arts and Letters from the French government; and numerous others. The **American Society of Media Photographers** made him an honorary member, saying that all photographers were indebted to him. Dozens of books by him or including his work have been published, and he had one-man shows at the Museum of Modern Art, the **International Center of Photography,** and major museums and galleries the world over.

Kessel, Dmitri (1902–1995)
Ukranian-born, American photojournliast
For much of his career, Kessel traveled around the world taking photographs for *Life* magazine. As a war correspondent for the magazine he photographed scenes of battle and horror; later, he turned his camera to the works of art and architecture that were more in keeping with his personal interests.

Born in the Ukraine, he emigrated to the United States in 1923. He worked for some Russian newspapers based in New York City and enrolled at City College. He took a photography course and drifted into industrial photography, essentially because it paid well. He started getting assignments from *Fortune, Collier's*, the *Saturday Evening Post*, and, in 1936, *Life*. He was made a *Life* staffer during World War II and stayed there until the magazine ceased publication in 1972.

His sweeping reportages on the Greek Islands, China, Rome, the Vatican, and the Hermitage, as well as his sensitive portraits of famous people in the arts and politics, all appeared in the pages of the magazine and Time-Life books as well.

Ketchum, Robert Glenn (1947–)
American nature photographer and curator
Ketchum is a leading California naturalist photographer and a well-regarded teacher and curator.

He earned a bachelor of arts degree in design from UCLA and a master of fine arts degree from the California Istitute for the Arts (CIA). Working in both 35mm and 4 x 5, Ketchum produces black-and-white and Cibachrome color prints of quasi-abstract photographs of the natural environment. In 1994 he made an Arctic voyage across the Northwest Passage, producing a series of stunning color photographs documenting the harsh environment of the Arctic winter.

In addition to his own work, he has served as a curator for the Security Pacific Bank and the National Park Foundation in Washington, D.C., and taught at his alma mater CIA and in workshops that he started at the Sun Valley Center for the Arts and Humanities in Sun Valley, Idaho.

His work is in the collection of major museums, including those of the Museum of Modern Art, the Metropolitan Museum of Art, and the Los Angles County Museum of Art, and has been widely exhibited in one-man and group shows.

Kinney, Dallas (1939–)
American photojournalist
As a *Palm Beach Post* staffer, Kinney won the 1970 **Pulitzer Prize** for feature photography for his series on Florida migrant workers.

Kinney, who studied dramatic arts at the University of Iowa for three years, entered photography as a profession in a roundabout way. He was a professional dancer and did a song-and-dance routine in Chicago for two years before moving to New York to try his luck in the big time. He became friendly with a freelancer who was taking publicity shots. He started hanging out in the friend's darkroom, learning about processing, shooting techniques, and photography in general. He quit the theater and moved to Carmel, California, where he worked as a public relations photographer for nearly two years. His first stab at photojournalism came in 1965 when he became something of a utility man for the *Washington* (Iowa) *Evening Journal*. He was Iowa's Press Photographer of the Year in 1968 and was also cited for moving pictures he took at Dr. Martin Luther King Jr.'s funeral. He joined the

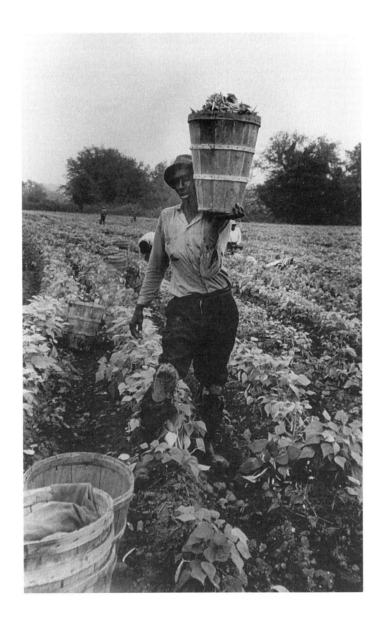

Dallas Kinney. *Florida Migrants*. Kinney won the 1970 Pulitzer Prize for feature photography for the *Palm Beach Post*,
showing the squalid living and working conditions of migrant workers in Florida.
© *The Palm Beach Post*. Courtesy *The Palm Beach Post*.

Darius Kinsey. *Crescent Camp No. 1*. 1936. Collection of the authors.

Miami Herald in 1969 and the *Palm Beach Post* a few months later.

Kinsey, Darius Reynold (1869–1945)

American documentary photographer

Kinsey, Tabitha (1875–1963)

American darkroom printer and studio manager

The 50-year partnership of husband and wife Darius and Tabitha Kinsey produced an archive of historic and artistic value documenting the logging industry of the Pacific Northwest. Darius was the photographer, Tabitha the photoprinter, and between them they accumulated a body of work that was a social history of the Northwest distinguished by its technical brilliance.

Darius was born in Maryville, Missouri, and moved with his family to Snoqualmie, Washington, in 1889. There he was lent a camera and began taking photographs. He traveled around the region as an itinerant photographer, taking portraits of homesteaders and making his first visits to logging camps. On one such trip he met Tabitha. They opened a photo studio in Sedro Wooley, where he honed his photographic skills and taught his wife darkroom technique. From that home base Darius traveled throughout the Northwest, including trips to Mount Baker and Mount Rainier.

They moved to Seattle in 1906 and established the Timber Views Company, with Darius on the road, shipping back to his wife his **glass plate** negatives that she developed and made prints of. The pictures were then

sent back to the logging camps to be sold. They worked continuously until 1940, when an accident put an end to Darius's traveling days. He spent his last years sorting his large inventory of negatives.

After their deaths, their work was rediscovered by the Museum of Modern Art photo curator **John Szarkowski,** who included them alongside works by **Alfred Stieglitz** and **Edward Steichen** in *The Photographer and the American Landscape.* In 1971 two photographers, Dave Bohn and Rodolfo Petschek, purchased the surviving 5,000 Kinsey negatives and published a collection of their photographs.

Kirlian, Semyon D. and Valentina C.

(dates unknown)

Russian inventors

This husband-and-wife team, in the process of investigating energy fields surrounding living organisms, inadvertently discovered corona-discharge photography, now commonly known as **Kirlian photography**.

Using himself as the initial guinea pig, Semyon Kirlian placed a photographic plate between the skin of his hand and a metal electrode and used a high-frequency instrument employed in electrotherapy. After ten years of work, in 1949 they had perfected this entirely new method of photography that did not require a camera but used a high-frequency spark generator or oscillator.

Their images show brilliant colors and patterns of light radiating from living organisms. Their work has made it possible to diagnose diseased plants and was the precursor to the MRI (magnetic resonance imaging) process used to diagnose human diseases.

Kirlian photography: A method of photography that some believe captures the human aura. Through the use of a high-frequency voltage, an image is made of the electrical discharges in the air around an object as well as of the flow of charged particles from the object to the film. All objects photographed by this means leave an image from the discharges in the air around the object, but only biological objects produce an image of the charged particles flowing through it. These flowing charges seem to be affected by the mental, emotional, and physical health of the person and are therefore claimed to be helpful in detecting illness before physical symptoms are present. The process was discovered by the Russian team of **Semyon and Valentina Kirlian** in 1939.

Klein, William (1928–)

American photographer, painter, and filmmaker

Better known in Europe and his adopted home town of Paris than in his native United States, Klein is accomplished in three distinctly different media. Born in New York, he served in the military with the U.S. Army. He was discharged from the service in Paris and remained there to study painting with Fernand Leger. He had his first exhibition at the age of 23. His work, though, retains a keen American sensibility.

While photographing art work in Milan, he became interested in the possibilities of **abstract photography** and published a book of abstract photos. He achieved recognition on the photography scene with the publication of *New York*, a photographic journal of his impressions there in the mid-1950s. The book won the Prix Nadar and provoked intense reaction, both pro and con. He spent the next ten years under contract to *Vogue*, establishing a reputation as a revolutionary and talented fashion lensman. In 1965, he moved to films, directing and often producing and writing them. Most received more attention overseas than in the United States, particularly *Muhammad Ali: The Greatest*, *The Little Richard Story*, and *Who Are You, Polly Magoo?*

Since 1972, Klein has produced more than 250 TV commercials—mainly aired in Europe—for such clients as Citroen and Fiat, and he has continued to produce photo books. *Close Up* and *In and Out of Focus* secured his reputation, as did a 1981 Museum of Modern Art retrospective of his 1950s work. Klein was named one of the 30 most important photographers in the history of the medium by the International Jury at Photokina in 1963. He has produced several books of his photographs and has exhibited in one-man shows in London, Paris, and New York. His work is owned by the Museum of Modern Art in New York, the Pompidou Centre in Paris, and the Victoria and Albert Museum in London.

Klett, Mark (1952–)

American landscape photographer and teacher

Klett is a much-honored and -exhibited Western landscape photographer. For the Rephotographic Survey Project of the Sun Valley Center for the Arts—of which he has been a photography director—Klett has photographed many sites of nineteenth-century Western landscapes.

After earning a bachelor of science degree in geology from St. Lawrence University in Canton, New York, and a master of fine arts degree in photography from the **Visual Studies Workshop** in Rochester, New York, he settled in Idaho and was hired by Sun Valley.

In 1979, he won an Emerging Artist fellowship from the **National Endowment for the Arts.** Working in small and large format, and both in black and white and color, Klett is especially interested in color and formal relationships. His work is held by major collections, including those of the Museum of Modern Art and the Whitney in New York, the Los Angeles County Museum of Modern Art, and the High Museum in Atlanta. He has had one-man shows of his work at major museums in the United States and has published several books of his photographs.

Klotz, Alan (1948–)

American gallery director and educator

Owner and director of Alan Klotz/Photocollect Gallery in New York City since 1977, Klotz came to photography from academia.

He earned a master of fine arts degree in photography from the **Visual Studies Workshop** in Rochester, New York, where he studied primarily with Nathan Lyons, the workshop's director, and **Beaumont Newhall,** the preeminent photohistorian and then director of the International Museum of Photography at the **George Eastman House**. Klotz was an intern at Eastman House, where he worked with the **Alvin Langdon Coburn** estate.

Klotz has had a long career as a teacher, beginning at the Rochester Institute of Photography, where he supervised the graduate program. While in Rochester he produced a documentary film on dissent in the Soviet Union. He later taught at the Rhode Island School of Design, the **International Center of Photography** program at New York University, and at Pratt Institute in Brooklyn, where he is visiting associate professor of art. He has lectured extensively and written numerous articles and reviews on photography.

The gallery specializes in vintage photographs, offering work by twentieth-century masters ranging from **Berenice Abbott** to **Minor White** and nineteenth-century greats from **Edouard-Denis Baldus** to **Carleton Watkins**.

Kodachrome: A **Kodak** brand of color **slide** film first marketed in 1935 and still considered one the finest. It is distinguished by a very complex development method that requires sending the film to specialized labs for processing.

Kodacolor: A **Kodak** brand of color negative film for making color prints and widely used today.

Kodak: See **Eastman Kodak**.

Koudelka, Josef (1938–)

Czech documentary photographer

Koudelka is well known for his work documenting Gypsy life in his native Czechoslovakia (now the Czech Republic).

Born in Moravia, he studied aeronautics at the University of Prague, but after a series of jobs he devoted himself to photography in 1967. He photographed the invasion of Prague in 1968 and was anonymously awarded the **Robert Capa** gold medal of the Overseas Press Club for those pictures. In 1970 he was granted asylum in England. His early work shows an interest in the theater—he was the official photographer for a Prague troupe—but it is the studies of the nomadic Gypsies where he has done his best work. From the former Czechoslovakia to Romania, Spain, and Portugal he has followed their routes and produced the 1975 book *Gypsies*, reprinted in 1986.

A member of **Magnum** since 1971, he has done extensive freelance work for that agency. He had a

retrospective one-man show at the Museum of Modern Art in 1975 and had major exhibitions at London's Hayward Gallery in 1984 and the **International Center of Photography** in 1988. He won a Prix **Nadar** for *Gitans: La Fin du Voyage* in 1978, and he became a French citizen in 1987.

Kozloff, Max (1933–)
American documentary photographer and writer
Kozloff has achieved recognition both as a **Pulitzer Prize**–winning critic and color photographer, working in the street tradition of **Eugène Atget**.

After earning undergraduate and master's degrees from the University of Chicago, he had long stints as art critic for *The Nation* (1961–69), a contributor to *Artforum* (1963–74), and then its executive editor for two years. He won a **National Endowment for the Arts** fellowship for criticism in 1972, as well as a **Guggenheim fellowship** (1969), a Pulitzer Prize for criticism (1962), and a 1962 Fulbright Scholarship.

His teaching assignments have included the California Institute of the Arts, Yale University, and the School for the Visual Arts. His own work has been exhibited in solo shows in New York City.

Kraus, Hans P., Jr. (1958–)
American dealer
Kraus is an expert on photography from the paper negative era, which flourished before 1860. His expertise has made him a sought-after consultant on photography sales; among the famous ones he engineered was the Metropolitan Museum of Art's 1994 acquisition of the multimillion-dollar William Rubel collection.

In 1980, after graduation from Tufts University with a degree in art history, Kraus worked as cataloguer for Christie's auction house in New York and London. In 1983, he established himself as a private dealer out of Manhattan's Mark Hotel. He organizes exhibitions, meets with curators and collectors, and advises clients on acquisitions and deaccessions.

He is an honorary fellow of the **Royal Photographic Society,** serves on the Board of Directors of the Association of International Photography Art Dealers, and is a member of the Private Art Dealers Association. His eponymous company produces monographs on early photographers and catalogues under the series title "Sun Pictures."

Krementz, Jill (1940–)
American photojournalist and writer
Krementz carved out a successful career as a **photojournalist** at a time when women were not accepted as news photographers, and later as a portrait photographer of writers and author of the "Very Young" series of books for children.

Born in New York, she attended Drew University in New Jersey and the Art Students League in New York. She started photographing as a freelancer, and at the age of 21, Krementz became the first female staff photographer at the *New York Herald Tribune*. After two years there she went to Vietnam and published her first book, *The Face of South Vietnam*, with text by Dean Brelis. Her next book was a project documenting *Sweet Pea—A Black Girl Growing Up in the Rural South* (1969). Always interested in reading, she embarked on a self-assigned series of photographs of writers. Her portraits of writers have appeared on numerous book jackets and periodicals. They also resulted in a book, *The Writers Image*, with text by her husband, Kurt Vonnegut. Later, she did *The Writer's Desk*, a collection portraying authors at their desks.

Her series of "Very Young" books focused on achieving children in skating, riding, dancing, and other activities. Since 1974 she has been a regular contributor to *People* and continues to photograph and exhibit her images of literary figures, including Norman Mailer, E. L. Doctorow, William Styron, and **Susan Sontag**.

Krims, Les (1944–)
American art photographer and teacher
Krims's work has been described as brilliant and horrifying, often in the same sentence. He emerged on the contemporary photography scene with images that showed people acting out a variety of psychodramas. There were images of his naked mother making chicken soup, and others that lived up to such titles as "Siamese Breast Twins," "Feeding Jesus Strawberry Ice Cream with

a Small Spoon," and "How Many Things Can You Find Wrong with This Picture?" which portrayed a nude woman with salt and pepper shakers hanging from her glasses, socks attached to an umbrella, and other equally bizarre elements.

After studying painting and printmaking and earning a bachelor of fine arts degree from Cooper Union and a master of fine arts degree from Pratt, Krims started making pictures that challenged sensibilities. He won **National Endowment for the Arts** awards in 1971, 1972, and 1976 and Creative Artist Public Service (CAPS) grants in 1973 and 1975; has had one-man shows at the **George Eastman House;** and is in the permanent collections of many museums, including those of the Museum of Modern Art, Boston's Museum of Fine Art, and the San Francisco Museum of Fine Art.

Now a professor at the State University of New York at Buffalo, Krims has alternately worked with Kodalith, a Polaroid SX-70 camera and 8 x 10 contact prints.

Kuhn, Heinrich (1866–1944)

Austrian impressionist photographer and inventor

An early **Pictorialist** known for his impressionistic prints, Kuhn was one of a triumvirate of photographers credited with founding the German-Austrian school of photography, as well as the inventor of several advances in photo technology.

Born in Dresden, Kuhn studied medicine in Leipzig before moving to Innsbruck, where he completed his studies. The scion of a wealthy family, he gave up medicine to devote himself to his hobby, taking photographs. In 1891 he saw an exhibit by members of **The Linked Ring** at the Vienna Camera Club. He joined the club and met there Hans Watzek, who, along with another Austrian photographer, Hugo Henneberg, formed the triumvirate known for their artistic work using the **gum-bichromate** technique to produce painterly effects. Kuhn became a member of The Linked Ring in 1895. His work was admired by **Alfred Stieglitz,** who had first seen it in 1894 at an exhibit in Milan and featured Kuhn's photographs in *Camera Work* in 1911.

Watzek died in 1903, and Henneberg returned to painting and etching, but Kuhn continued his experi-

ments with cameras and film materials and worked as a commercial photographer during the remainder of his life. In later years he moved away from the manipulated image to a more direct, simple style.

Kunhardt, Philip B., Jr. (1928–)

American writer and editor

Kunhardt has had a long and distinguished career with *Life* magazine and produced most of its famous photography books, such as *Life: The First 50 Years*, *The Joy of Life*, *Life's World War II*, and *Life in Camelot*.

A native New Yorker who was graduated from Princeton University in 1950, he joined *Life* as an editorial trainee immediately thereafter. Half a century later, he is still there.

He started as an entertainment and sports reporter but soon found his niche at the picture desk. He was made an assistant picture editor in 1959 and assistant managing editor in 1961. In 1965, in collaboration with his mother, Dorothy Meserve, he published *Twenty Days*, a groundbreaking interweaving of dramatic photos and moving text on the death of President Abraham Lincoln. In 1977 the same team produced *Mathew Brady and His World*, about the famous Civil War photographer.

Kunhardt also created the first test issue of *People* magazine, which essentially replaced *Life* as America's weekly picture magazine. As an executive in Time Inc.'s Magazine Development Department—where he worked when *Life* was not published between 1972 and 1978—he edited *Life*'s special "A Year in Pictures" annuals and large single-theme issues, like "A Day in the Life of America" and "One Hundred Great Events That Shaped America."

After retiring from the magazine world because of heart problems, he started to work as a writer and producer for his son Peter III's eponymous Kunhardt Productions. He has worked on programs that were aired about the New York Public Library (for PBS), P. T. Barnum (for the Discovery Channel), Abraham Lincoln (for ABC), and all the American presidents (for PBS).

On June 17, 2000, he and his wife, Katherine, celebrate their fiftieth wedding anniversary.

lamination: The process of sealing a photograph between layers of clear plastic to protect it from dirt, fingerprints, and tearing. Identification cards and driver's licenses are typically laminated.

Land, Edwin Herbert (1909–1991)

American inventor

Land's invention of the **Polaroid** process—a one-step technology for **developing** and printing photographs within the camera unit—is regarded as the single most important advance in photographic technology since **Eastman**'s flexible **roll film**. Only Thomas Edison has more patents than Land's 500-plus.

Born in Bridgeport, Connecticut, Land, while still an undergraduate at Harvard University, developed his first major discovery: a practical, synthetic, light-polarizing material in sheet form, in 1929. That process was successfully applied to sunglasses, camera filters, gun sights, dyes, and windows, making them glare-free. Six years later, in 1935, he founded the Polaroid Corporation in a Cambridge, Massachusetts, garage.

The first Polaroid camera was introduced in 1948. Within eight years, one million units had been sold. Some photographers denounced the Polaroid as a frivolous invention and an infringement on their aesthetic privilege. But it became a part of the American vernacular and opened new avenues for artistic photography. Land commissioned dozens of famous photographers to experiment with the camera and film, including **Walker Evans, Weegee, Art Kane, Bert Stern, Phillipe Halsman, Brett Weston,** and **Ansel Adams**—who remained a consultant to the company from the time the camera was introduced in 1948 until his death in 1984.

New Polaroid products appeared on shelves. Instant transparencies were introduced in 1957; large-format film packs came in 1958; Type 55 P/N film, which produced both a print and a finished negative, followed in 1961. In 1973, Land introduced the SX-70 camera, which produced dry color prints. Perhaps his only failure was his 1977 Polavision, instant silent movies, which was quickly eclipsed by the universal popularity of the VCR.

Also, Land taught for many years at Harvard and the Massachusetts Institute of Technology and served on numerous presidential advisory boards and top-level committees. He was appointed by President Dwight D. Eisenhower to develop a high-altitude surveillance system that was used by the U-2 spy plane and by satellites. His list of awards, honorary degrees, and inductions to various prestigious societies is great, including the Presidential Medal of Freedom.

When he retired in 1982, the company he started in his garage was a $1.4 billion business. He spent the rest of his life doing what he loved most, research, at the Rowland Institute for Science, which he had created in 1980.

A complete biography, *Insisting on the Impossible: The Life of Edwin Land*, by Victor McElheny, was published in 1998.

landscape photograph: Photography of the natural and human-made environment with an emphasis on the ground and its topography. Landscape photography is about as old as the medium itself and has been used for art, science, and documentation. In the United States, the first group of landscape photographers worked in the West after the Civil War. Much of their work was done under government auspices, on land surveys, or for the railroads. **Timothy O'Sullivan, A. J. Russell,** and **William Henry Jackson** worked under institutional patronage, while **Carleton E. Watkins** and **Eadweard Muybridge** took landscapes on their own. The early landscape photography by William Henry Jackson of

Yellowstone influenced Congress to designate it as the country's first protected National Park in 1872.

View of the Rocky Mountain National Park is an example of landscape photography. © Fred W. McDarrah.

Landy, Elliott (1942–)

American documentary photographer

Landy began photographing the anti-Vietnam war movement and underground music culture in New York City in 1967. He photographed many of the underground superstars of that period, both backstage and onstage between '67 and '69. His images of Bob Dylan and the Band, Janis Joplin, Jimi Hendrix, Jim Morrison, Joan Baez, Van Morrison, Richie Havens, and many others documented the music scene in that era through the 1969 Woodstock, of which he was the official photographer.

His photographs have appeared on the covers of *Rolling Stone*, **Life,** and the *Saturday Evening Post* and on numerous album covers, calendars, and collections focusing on Woodstock. Landy continues to photograph musicians occasionally, but has moved on to other imagery—his own children and travels, impressionist flower photography, motion and kaleidoscopic photography.

In 1994 a collection of his '60s photographs was published, *Woodstock Vision: The Spirit of a Generation*. A **CD-ROM,** *Elliott Landy's Woodstock Vision,* was published in 1997.

Lange, Dorothea (1895–1965)

Renowned American documentary photographer

Lange was one of the most celebrated American photographers of the twentieth century, who did some of her best, and best-known, work for the **Farm Security Administration** (FSA) in the 1930s. Her archetypal and timeless images of migratory workers in California, uprooted Dust Bowl families, cotton pickers, black tenant farmers, and drought refugees awakened the national consciousness to the plight of the dispossessed. Her "Migrant Mother," showing the careworn face of a 32-year-old pea-picker's wife, became a symbol of the Depression and is still one of its most often reproduced images.

Born in Hoboken, New Jersey, she was stricken at the age of seven with polio, which left her with a lifelong limp and heightened her sensitivity to other people's suffering. After graduation from high school in 1913, she worked as an assistant for various portrait studios. She learned camera technique from **Arnold Genthe** and later studied with **Clarence White** at Columbia University.

Lange moved to San Francisco in 1919, setting up a portrait studio and becoming the photographer of choice for the city's social and cultural elite. Concerned about

Elliott Landy. Bob Dylan in Woodstock, photographed for the *Nashville Skyline* album cover, April 1969. © Elliott Landy. Courtesy of the photographer.

the worsening social conditions of the early Depression years, she began to go outside her studio, capturing images that reflected her humanistic concerns. Her reputation was established in 1932, when she worked with her husband, the economist Paul Taylor, recording the living conditions of migrant farm workers for California's Division of Rural Rehabilitation.

Those images caught the eye of **Roy Stryker,** head of the FSA, and he hired Lange in 1935, just as the FSA's Historical Section was beginning its documentary work. Her first assignment was in the Southwest, and on that trip she stopped at the pea-pickers' camp in Nipoma, California, and took the photographs which

aroused such widespread concern that government aid was sent to help the workers.

From 1935 to 1939 Lange visited nearly every region of the United States, creating a compelling record of the times. She left the FSA in early 1940 and continued to produce photo essays that showed her keen and sympathetic interest in the human condition. From time to time she received assignments from various government agencies. After the United States entered World War II, she was assigned by the Office of War Information to photograph the internment camps where Americans of Japanese descent were forced to live.

Dorothea Lange. *Migrant Agricultural Worker's Family, with 7 Hungry Children, Mother Aged 32. Destitute Peapicking Camp, Nipomo, CA.* March 1936. Library of Congress.

The State Department asked her to photograph the 1945 San Francisco conference that led to the founding of the United Nations, but health problems that arose during that assignment severely curtailed her ability to work. In the mid-1950s she resumed work and undertook assignments from *Life* and *Look* magazines. In her last years she completed her books *The American Country Woman* and *To a Cabin*, the latter a photographic study of her family.

As she was preparing for a major retrospective of her work at New York's Museum of Modern Art, she died three months before the exhibit opened. A major biography, *Dorothea Lange: A Visual Life*, edited by Elizabeth Partridge, was published in 1994.

Langenheim, William (1807–1874)

Langenheim, Frederick (1809–1879)
Early American landscape photographers
Best known for their images of Niagara Falls, taken about 1845, the brothers also bought U.S. rights to **Fox Talbot**'s **calotype** process and established a company that became a major producer of stereo views.

Born in Germany, the Langenheim brothers emigrated to Philadelphia and opened a **daguerreotype** studio in the early 1840s. After enlisting and fighting in the Mexican-American War, they started serious work in photography. Among their portrait subjects were Andrew Jackson, Henry Clay, John Tyler, and John J. Audubon. On the technical front, they introduced the Petzval-Voigtlander lens to the United States and were the first to introduce glass transparencies for projection, usually known as **lantern slides**. Their attempt to sell individual licenses on Talbot's process—which they bought rights to for $6,000—was a failure, as American photographers used the paper negative process without concern for Talbot's patent and in 1851 turned to the superior **collodion** process.

The Langenheim brothers did, however, enjoy great success with the production of stereo paper prints mounted on cards and stereo glass slides. The company they founded, American **Stereoscopic**, was sold at a great profit to the E. & H. T. Anthony Co. in 1861.

Lanker, Brian (1947–)
American photojournalist
Lanker won the 1973 feature photography **Pulitzer Prize** for a photo essay on natural childbirth as a staffer at the *Topeka Capital Journal*. He later moved to the *Eugene* (Oregon) *Register-Guard* as chief photographer.

In the late 1990s he was featured in ads for **Canon,** the camera and photo-equipment manufacturer.

Brian Lanker. *Childbirth Sequence.* Pulitzer Prize in 1973 for feature photography. Courtesy *Topeka Capitol Journal.*

lantern slide: A positive photographic image on glass used to project images on screens for viewing by an audience. Lantern slide shows were very popular in the late

1800s, only to be replaced by movies. The slides measured 3 ¼ x 3¼ inches. Today, 35mm color slides have taken the place of lantern slides and are flashed on a screen through a projector.

laptop: A **computer** small enough to be used on a person's lap. Often used by photographers, along with powerful image-processing **software,** to edit their work in the field before sending the files electronically back to their offices.

large-format camera: Any **camera** that is intended for use with film 4 x 5 inches or larger.

Lartigue, Jacques-Henri (1894–1986)
French documentary photographer
Before he was 10 years old, Lartigue was fascinated by the world around him and recorded everything he saw—family, friends, strangers they encountered on outings—in his journal and with a clumsy wooden box camera given him by his father. Witty, charming, full of Gallic spirit, his candid pictures captured beach scenes, early racing cars, primitive flying machines, games, and elegant costumes with extraordinary artistry.

Born to a wealthy bourgeois family near Paris, he took his first photograph in 1901. Later he became famous for his humorous scenes of privileged life in France before and after World War I. He always considered himself a painter, having completed his studies at the Academie Julien in 1915. Lartigue became a painter, fashion illustrator, and filmmaker, photographing less and less as time went on. In the 1920s and 1930s his paintings were widely exhibited, and his interest in photography declined still further. Although his photographs appeared occasionally in magazines, it was not until 1963, when an exhibit of his photographs was held at the Museum of Modern Art, that his images reached an appreciative audience.

Over the years Lartigue compiled more than 120 albums of his photographs, forming a pictorial journal of his life. In 1979 he donated his albums and tens of thousands of negatives to the French government. Since then a number of books featuring his work have been published, and further exhibits have been held in Europe and the United States.

laser: An intense beam of coherent, monochromatic, electromagnetic light that may be focused very precisely and used for **holography** and numerous medical and scientific applications. The first working laser was introduced by Theodore Maiman in 1960. The name *laser* is an acronym for *l*ight *a*mplification by *s*timulated *e*mission of *r*adiation.

laser disc: A disc, usually 300mm (12 inches) in diameter and 1.2mm thick, used for storing video images and sound data in an analogue format. The data are recorded as stamped minute indentations, called pits, comparable to grooves on vinyl records. It is read by laser: as light is reflected off the surface, variations in the reflected light are interpreted.

laser printer: A printer that works via a rotating metal drum coated with a fine layer of photosensitive material. Unlike an **ink jet printer,** which literally shoots ink onto the page, a laser printer leaves an image of the original as an electrostatic charge on the drum. The drum rotates past a toner dispense; the ink has an electric charge and is attracted to the image on the drum. This toner image is then transmitted onto paper by giving the paper an opposite electric charge. Color laser printers use four drums with cyan, magenta, yellow, and black toners.

latent image: The term *latent* refers to something that is present but unseen. When photographic **film** and paper are exposed, there is an immediate change in its chemical makeup, forming the basis of the final photographic image. The chemical change that follows exposure is invisible until the film or paper is developed and therefore called a latent image, meaning that it is there but unseen.

latitude: The amount of variation in exposure that film can receive and still be useful. Some films have a wide latitude, meaning that they can receive more or less than the

Lantern slide projector made by Walter Tyler. A rare mahogany and brass bi-unial magic lantern with triple rack telescopic brassbound lenses, chimney and slide carriers and two brass limelight illuminants with adjustable controls.

optimum exposure and still be used; others have a narrow latitude and are useless if exposure is too much or too little. **Color negative film** typically has a wide latitude for exposure and slide film has a narrow latitude.

Laughlin, Clarence John (1905–1985)
American surrealist photographer

Laughlin was a prolific **surrealist** photographer who produced disturbing yet beautiful images taken in New Orleans. His work combines abstractions, still-life, multiple exposures, and architectural images in a mysterious, entirely original way.

Born in Louisiana, he spent most of his life in New Orleans, where he was a writer and poet before turning to photography in 1935. He was one of the original members of the **Julian Levy** gallery in 1940; his first show was of New Orleans architecture, and his work was exhibited with **Eugène Atget**'s images of Paris. The next year, he worked for *Vogue*, doing fashion photography. After spending World War II with the U.S. Army Signal Corps Photographic Unit in New York and the Office of Strategic Services, he returned to the South, where he produced his first book, *Ghosts along the Mississippi*, a collection of photographs of plantations. It has been reprinted more than 20 times.

A freelancer after 1948, specializing in contemporary architecture, he lectured and traveled widely and was published in *Life, Look, Harper's Bazaar*, and many other periodicals. He has had more than 200 one-man shows, and in 1973 a monograph of his work was published in conjunction with a major retrospective at the Philadelphia Museum of Art.

Laurent, Michel (1945–1975)
French photojournalist

Laurent was a cowinner (with **Horst Faas**) of the 1972 **Pulitzer Prize** for news photography and was the last journalist to be killed covering the Vietnam War.

While working for the **Associated Press,** he and Faas took photographs of soldiers bayoneting turncoats after the 1971 India-Pakistan war. He and Faas also did a widely exhibited photo essay called *Death in Dacca*, which won numerous awards. In 1973 he joined the **Gamma** agency, where he covered hunger in Biafra and the civil war in Jordan.

Lavenson, Alma (1897–1989)
American art and landscape photographer

From an accomplished amateur **Pictorialist** to an innovative fine-art photographer who embraced the modernist aesthetics of precisionism and constructivism, Lavenson worked independently in her chosen medium for more than 60 years. She photographed plants and flowers, the hilly countryside around San Francisco, scenes from the Gold Rush Country and from her travels in South America, and the American Southwest.

Born in San Francisco, she found that her interest in photography grew while she was a student at the University of California, Berkeley. By 1927 she was successfully submitting photographs in the then-popular soft-focus style to national and international salons. Instrumental in her development as a photographer was the influence of two key figures—**Imogen Cunningham** and **Edward Weston,** whom she met in 1930. At Cunningham's recommendation, Lavenson participated in **f/64**'s inaugural exhibit in California. In the early 1930s she was given solo exhibitions at the Brooklyn Museum and the M. H. DeYoung Museum in San Francisco.

Her work was included in major group exhibitions, including the "**Family of Man**" exhibit in 1955. She won the **Dorothea Lange** Award for an outstanding Woman Photographer, bestowed by the Oakland Museum, in 1979. A selection of her work was published in *Alma Lavenson: Photographs* in 1991.

layout: A plan of work, prepared in advance of assembly of copy from various sources, including rough copy, illustrations, and instructions for final makeup, or "layout."

LCD (liquid crystal display): A technology found on small preview screens on **digital cameras** and elsewhere. A liquid crystal is a semi-liquid, gelatin-like crystal of organic molecules, which change their configuration when they receive an electrical voltage.

Lee, Russell (1903–1986)

American documentary photographer

Lee was with the Historical Section of the **Farm Security Administration**'s photographic project longer than any other photographer (1936–1943), and his black-and-white images of life in rural and small-town America during the Great Depression captured the personality, mood, and spirit of his subjects with great distinction. Lee's outstanding contribution to the FSA was his documentation in 1940 of Pietown, New Mexico, where a group of Dust Bowl refugees had settled as homesteaders in a close-knit community reminiscent of nineteenth-century frontier life.

Born in Ottawa, Illinois, Lee lost his mother in an auto accident he witnessed at the age of ten. For the remainder of his childhood, he moved from relative to relative, learning to cope with change by being observant of those around him and developing a deep interest in things that made up others' places—their home. He was graduated from Lehigh University in 1925 with a degree in engineering and took a construction job in the Midwest. His wife, Doris Emrick, was a painter, and they decided to move to California in 1929, where she studied painting and he began to pursue his own interest in art. A friend in the San Francisco art community, Arnold Blanch, told the Lees about the artists' colony of Woodstock, New York, and in 1931 they moved east.

For the next five years they spent summers in Woodstock and winters in New York City, where they both studied at the Art Students League. Intellectual discussions in the Woodstock community awakened Lee's social conscience, and he wanted to portray his concerns

Russell Lee. *A Model T Ford Used by Many Dust Bowl Refugees Is Being Repaired.* Pietown, New Mexico, 1940. Library of Congress.

about the nation's problems, particularly the worsening conditions of workers' lives. Dissatisfied with his inability to reproduce what he saw, he bought a 35mm Contax camera to use as a sketchbook.

What started as a simple means of taking notes became his life's work. As an artist, he was interested in the images; as an engineer he was fascinated by the technology of photography. By 1935 he had an agent in New York and was taking photo essays of workers for publication. In 1936 he applied for a job in the FSA under **Roy Stryker**. Coincidentally a photographer, **Carl Mydans,** had just left the project for a job with *Life* magazine, and Lee was hired. He worked first in the Midwest, and his pictures impressed Stryker with their intimate, almost family-album-like quality. On an FSA assignment in New Orleans he met Jean Smith, who would become his second wife and expert editor of his photographs.

By the early 1940s Lee's work was widely recognized and featured in national magazines. He worked with Richard Wright on the book *Twelve Million Black Voices*, an intensive investigation of urban ghetto misery. During World War II he joined the Air Transport Command's photographic unit, flying on missions all over the world.

After the war he participated in a government survey of mining conditions, and his photographs were instrumental in the fight to clean up the industry. For the next few years Lee did assignments for Standard Oil of New Jersey, under Roy Stryker, photographing farming operations as well as industrial scenes. He and his wife traveled considerably and also took part in a photographic workshop sponsored by the University of Missouri.

The Lees settled in Texas, and Lee continued photographing for the *Texas Observer* in Austin, where he

Gustave Le Gray. *Brig on the Water.* Albumen print from wet collodion on glass negative, 1856.
Courtesy The Board of Trustees of the Victoria & Albert Museum.

began teaching at the University of Texas. From 1965 to his retirement in 1973, teaching was his major occupation.

His work is owned by numerous museums, including the University of Texas, Austin; New York's Museum of Modern Art; and the **Center for Creative Photography** in Tucson.

Le Gray, Gustave (1820–1882)

French photographer, inventor, and teacher

Le Gray is noted both for his technical achievements and for his artistic photography.

An art student of the painter Paul Delaroche, he became interested in the **daguerreotype** process and turned to photography. After experimenting with the daguerreotype, he became a strong advocate of **Fox Talbot**'s **calotype** process in France. Working to improve it, he invented the Le Gray waxed paper process, which provided the photographer with a dry, pre-sensitized paper negative of increased transparency. With his invention, photographers could store sensitized paper for at least two weeks, instead of having to use the paper within 24 hours.

A landscape and seascape photographer who also did some portraiture, he initiated combination printing, combining two different negatives to achieve a single image. The spectacular cloud effects he achieved with his waxed paper negative and wet-**collodion** negatives were greatly admired in their day.

Along with **Henri Le Secq** and **Charles Negre**, he founded the Société Héliographique in 1851, the first group of its kind devoted to photography. Le Gray failed to achieve commercial success as a photographer and moved to Cairo, Egypt, to escape his creditors. He remained there, working as a drawing instructor, until his death.

Lehr, Janet (1937–)

American dealer, writer, and lawyer

Lehr is a partner in the Vered Gallery, East Hampton, New York, which exhibits the works of many photographers. She is also a collector herself and has written for several photography and art publications.

A 1959 Brooklyn Law School graduate, Lehr worked from 1962 to 1972 as co-director of Gallery 6M in New York. She ran her own business for much of the 1970s and 1980s before joining up with Ruth Vered in 1988 to open their East Hampton space.

She has also written for *Photographica* and *Maine Antiques Digest* and in 1979 was a founding member of the International Association of Photographic Art Dealers. In 1978 she wrote *William Henry Jackson, Picture Maker of the American West, William Henry Fox Talbot, and the Art of Photo Mechanical Illustration*. She has curated shows in Munich, in Sydney, and at Yale University's British Center for the Arts.

Leibovitz, Annie (1950–)

Noted American portrait photographer

Leibovitz is one of the most famous of contemporary portrait photographers by virtue of her long tenures at *Rolling Stone* and then *Vanity Fair* magazine, where she has captured numerous political and entertainment personalities in striking fashion.

The daughter of an Air Force colonel, she grew up around the country. She started shooting for *Rolling Stone* while a student at the San Francisco Art Institute in 1970. She was the magazine's chief photographer three years later and stayed until the reincarnation of *Vanity Fair* in 1983.

Her images of everyone from John Lennon to John Belushi are carefully planned, dramatic, colorful setups that have made her a portrait artist of distinction and earned her the 1984 Photographer of the Year Award. Her commercial work has also won her awards, including a Clio for her 1987 American Express campaign, among many other honors. After her Gap campaign in 1988, she became as famous as the subjects she photographs.

Liebovitz's books include a Pantheon companion to a big 1983 show at the Sidney Janis Gallery and *Photographs 1970–1990*. In 1991 she had a major retrospective at the **International Center of Photography** and was the second living photographer and first woman to have a retrospective at the **National Portrait Gallery**. The book *Olympic Portraits*

Annie Leibovitz. *John Lennon & Yoko Ono, 1980.* © Annie Leibovitz. Courtesy Contact Press Images.

was published in conjunction with the 1996 Atlanta summer Olympics. For portfolios done in Rwanda and Sarajevo for *Vanity Fair*, Liebovitz returned to her original photo-reportage style. She continues to be widely published—she is a contributing photographer for *Vogue*, *Vanity Fair*, and *The New Yorker*—and widely collected and exhibited.

Leica: One of the first handheld **35mm** cameras, introduced in the spring of 1925 at the Leipzig Fair and

manufactured by the Leitz/Wetzlar Company of Germany. The Leitz Company was a well-known maker of precision optical equipment and the Leica camera was, and continues to be, one of the finest precision cameras made.

Designed by **Oskar Barnack,** who had joined the Leitz company in 1911, the Leica was originally conceived as a pocket camera much reduced in size and weight from then current, bulky picture-making equipment. Barnack was a photo hobbyist who wanted to

Leica advertising poster with cutaway view, ca. 1930s.
Collection of the authors.

improve upon the 5 x 7 camera, **tripod,** plate holder, and accompanying equipment that he had to carry around on a Sunday picture-taking outing. His miniature design used inexpensive 35mm film and could hold up to 36 exposures. It offered convenient size and easy portability for tourists, sportsmen, and weekend photographers.

The introduction of the 35mm camera enabled **photojournalists** to take pictures unobtrusively, and the Leica has been the camera of choice for many **amateurs** and professionals, including such greats as **Henri Cartier-Bresson** and **Alfred Eisenstaedt**. The Leica has been used by explorers and scientists throughout the world, including those of the Byrd Antarctic expedition and of Sir Hubert Wilkins's submarine voyage to the North Pole.

Leifer, Neil (1942–)

American photojournalist and film director

Leifer has had a successful career as a freelance magazine photographer, specializing in sports assignments,

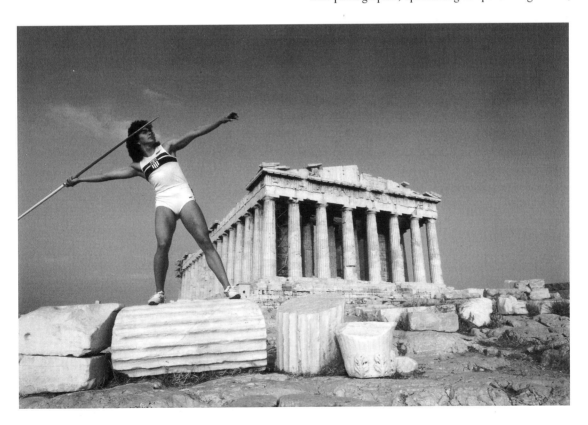

Neil Leifer. *Sophia Sakorafa of Greece at the Parthenon, Athens, Summer 1983.*
(Original in color). © Neil Leifer. Courtesy of the photographer.

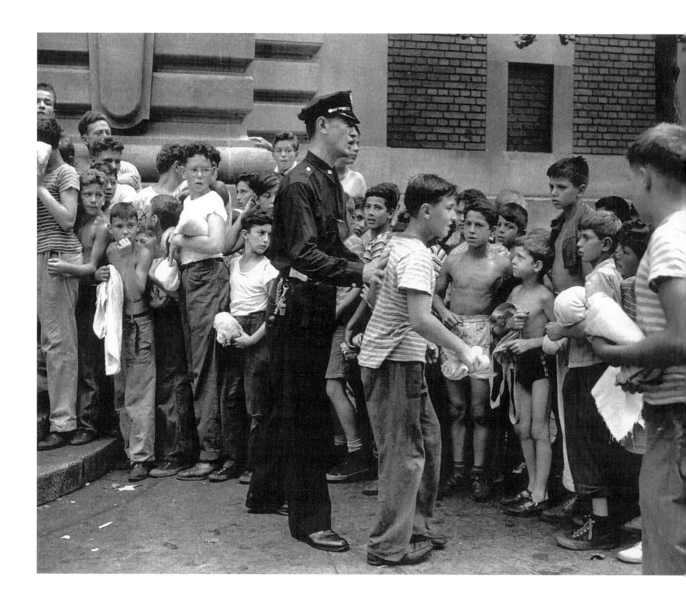

and has also been affiliated with *Sports Illustrated* and *Time*, where his assignments have covered events and figures as diverse as the space shuttle, Presidents Jimmy Carter and Ronald Reagan, and many sports figures.

Born and raised on New York's Lower East Side, Leifer became a professional photographer while still in his teens. After spending two years at Hofstra University, he withdrew to concentrate on his photographic work. He joined the staff of *Sports Illustrated* from 1972 to 1978 and photographed seven Olympic games for the magazine. His pictures have appeared on more than 200 covers of *Sports Illustrated*, *Time*, and *People*. His photograph of Muhammad Ali standing over Sonny Liston is considered one of the best sports pictures of all time.

He has worked as a film director and produced nine books, including *Sports,* which was published by Abrams in 1985. He has often been a lecturer at photography classes and seminars, and his work has been exhibited at galleries in the United States and abroad.

Leipzig, Arthur (1918–)
American documentary photographer
Leipzig is a quintessential New York City photographer,

Arthur Leipzig. *Pitt Street Pool.* 1947. From *Growing Up in New York* by Arthur Leipzig, David R. Godine, 1995. © Arthur Leipzig. Courtesy of the photographer.

having traveled the city by day and night, on assignment or on his own, taking pictures of its people, streets, and myriad activities. His 1995 book of black-and-white photographs taken since 1943, *Growing Up in New York*, is a nostalgic look back at an era long since gone.

Leipzig was born in Brooklyn. He left school at the age of 17 and had a variety of odd jobs. Working at a glass factory, he seriously injured his hand, and a friend suggested he study at the **Photo League** to get a job as a darkroom technician. After two weeks of classes he knew that photography would be his life's work.

From 1942 to 1946 he was a staffer at the newspaper *PM* and thereafter has worked as a freelancer. In addition to freelancing, he has been a professor of photography at C. W. Post College, Long Island University, New York. His work has been included in numerous group exhibitions, including "New Faces" and **Edward Steichen**'s "**Family of Man**" at the Museum of Modern Art, and the Metropolitan Museum's "Photography as a Fine Art." He has also had several one-man shows and received awards, including one from the National Urban League and the Long Island University Trustees Awards for Scholarly Achievements.

Leipzig's photographs are held by private and public collections, including those of the Museum of Modern Art in New York, the **George Eastman House,** and the Brooklyn Museum.

lens: The part of a camera that focuses on objects in front of it and projects the image into the camera and onto the film. Typically a lens is a tube with one or more pieces of glass, called elements. These elements are what **focus** the image projected onto the film and determine how sharp and what **focal length** (**wide-angle,** normal, or **telephoto**) the lens is. Lenses come in a wide variety for use with cameras, binoculars, microscopes, and telescopes and range from very simple, plastic lenses to highly sophisticated, high-powered ground-glass lenses for telescopes. On better cameras the lens is adjustable to allow for precise focusing and includes an adjustable **aperture** to control the amount of light allowed into the camera and to control **depth of field**.

lens shade: A device that is mounted on the front of a photographic lens in order to block any extraneous non-image-forming light from reaching the front surface of the **lens**.

Le Secq, Henri (1818–1882)
Leading early French photographer
Le Secq was one of the principal figures of early French photography.

Trained as a sculptor, he started his career instead as a painter, working at first with Paul Delaroche. He continued to paint throughout his life. Like many painters of his era, he was drawn to the new art of photography by its potential for quick sketches and study material. He was photographing much of the time by the late 1840s.

In 1851 he was one of the five photographers chosen by the Commission des monuments historiques to document ancient and medieval architecture in France. How the choices were made is unknown, but it means that the five (Le Secq, **Gustave Le Gray, Charles Bayard, Edouard Baldus,** and O. Mestral) were clearly the most respected and most technically able photographers in the French nation.

Interchangeable lenses made for the Nikon F camera.
© Fred W. McDarrah.

Pages 280 – 281: Henry Le Secq. *Eglise Metropolitaine de Notre-Dame.* Early 1850s. Blanquart-Evrard process salt print from a calotype negative. Courtesy Hans P. Kraus, Jr. Inc., New York.

Through the 1850s Le Secq photographed landscapes, still-lifes, and architecture in Paris and the provinces. He printed in various processes of the day, including **calotype, cyanotype,** and panotype. Le Secq seems to have made his last photo in 1856.

Lesy, Michael (1945–)
American photohistorian and writer

Lesy has produced several photo books filled with rare and captivating images of both urban and rural America from the earliest days of photography.

His doctoral thesis from Rutgers University became the book *Wisconsin Death Trip*; he then went on to teach American Studies at Yale and then Emory universities. Moving to the Art Institute of Chicago, he taught classes in documentary photography. He now teaches narrative nonfiction writing at Hampshire College in Amherst, Massachussettes.

Other works include *The Forbidden Zone*, *Rescues*, *Visible Light*, and *Dreamland*, all focusing on different segments of history and photography.

Levitt, Helen (1918–)
American documentary photographer

A native New Yorker, Levitt is known primarily for her documentation of the city's street life, notably in images of children.

She left high school before graduation and took some classes at the **Photo League** and went to work for a Bronx studio. Inspired by the work of **Henri Cartier-Bresson,** Levitt began photographing New York City scenes in the 1930s; her first images were of children in the streets of Harlem. As a young photographer she was also influenced by the work of **Walker Evans,** with whom she collaborated from 1938 to 1941. In 1941 she went to Mexico City, where she photographed the street life of that city and its suburbs. That work led to her first show, "Photographs of Children," held at the Museum of Modern Art in 1943. It was a body of work that demonstrated her ability to merge strong empathy for her subjects with a sense of moment and formal order.

In the late 1940s she collaborated with James Agee, whom she had met at Walker Evans's studio, and Janice

Loeb on two films: 1949's *The Quiet One* (which was nominated for an Oscar) and *On the Street*. Throughout the 1950s she concentrated on film as a director and editor.

In 1959 and 1960 she won **Guggenheim fellowships** to investigate the techniques of color photography. Her resulting work was exhibited at the Museum of Modern Art in 1963. After another hiatus, she resumed her street work and had a major MOMA retrospective in 1974. In 1976 she received a **National Endowment for the Arts** award and throughout the 1980s had a series of exhibitions at the Corcoran Gallery, Boston's Museum of Fine Arts, and in Sweden. In 1992, a retrospective of her work was organized by the San Francisco Museum of Modern Art.

Levy, Julian (1906–1981)
American gallery owner and dealer

In 1930, Levy opened his own New York gallery and was among the first dealers to treat photography as art, buying, selling, and exhibiting the work of **Walker Evans, Henri Cartier-Bresson,** and others.

Levy started collecting in 1927, when he was working for Weyhe Bookstore and Gallery, where he curated America's first **Eugène Atget** show. Striking out on his own, he decided "to experiment, to pioneer in photography and see if I could put it across as an art form. And make it perhaps pay enough to support the gallery!" It worked.

Levy also exhibited and sold works by **Laszlo Moholy-Nagy, Nadar, Man Ray,** Max Ernst, Herbert Bayer, **Manuel Alvarez Bravo, Ilse Bing, Anton Bruehl, Brassai, Imogen Cunningham, Gertrude Kasebier, André Kertész, Paul Outerbridge,** and **Berenice Abbott.**

Much of the collection Levy amassed was exhibited at a landmark show at the Witkin Gallery in 1977.

Liberman, Alexander (1912–)
American editorial director and photographer

Better known as the longtime editorial director of Condé Nast Publications, Liberman is also an accomplished designer, artist, and photographer. As an art

director and editor working with the world's top fashion and commercial photographers, he has shaped the practice of photography around the world. His own work includes portraits of artists, such as Picasso, Matisse, Ernst, Dali, and Giacometti, that he shot in their studios.

Born in Kiev, Russia, and educated in Paris and London, he found his first job as a design assistant to A. M. Cassandre in Paris in 1931. After stints as art director of *VU* in Paris and in the French army, he came to New York in 1941, fleeing the Nazis, and he began work as *Vogue*'s art director. From 1944 to 1961 he was art director for all Condé Nast publications, and from 1962 through his "retirement" in 1994, he was editorial director of the company. Throughout his tenure with Condé Nast he continued painting and photographing on his own. A 1995 book, *Then: Alexander Liberman, Photographs 1924–1995*, and show contained a selection of his 70 years as a photographer.

His paintings, photos, and sculptures continue to be widely exhibited at such venues as the Museum of Modern Art in New York City, the Corcoran Gallery, and Storm King Art Center in Mountainville, New York.

Library of Congress: The national library of the United States, established in 1800. Thomas Jefferson was a strong supporter of the Library, and after much of the collection was destroyed in 1814, he donated his own library to Congress. This is the largest collection of books in the United States and is operated and funded by the federal government. A copy of every book published in the United States is sent to the Library of Congress and receives a Library of Congress Catalog Card Number. The Library's collection also includes manuscripts, maps, rare books, prints and photographs, music, and historically important documents. The collection is located in Washington, D.C.

Life: A popular picture magazine founded by Henry Luce of *Time* magazine in 1936. *Life* attempted to humanize the complex social and political events of its day through photography and the picture story and employed an array of photographers to dramatize and record stories around the world. It quickly became a huge success with a readership of more than 3 million by its third year, in large part because of its innovative use of well-reproduced photographs and the magazine's large format. A tribute to its success was the quick proliferation of other picture magazines that imitated *Life*'s format and contents. *Life*'s success ushered in a new era in photography—**photojournalism**. The magazine was the first to take advantage of the new camera techniques that were just coming into vogue—the light, handheld **candid** camera, which produced pictures in available light with fast **lenses** and 35mm film, giving photographers mobility and freedom from cumbersome equipment. *Life* was the first magazine to reproduce photographs on coated paper that very nearly duplicated the quality of the original photograph.

light: Light is the essential component of photography, which literally means drawing with light (*photo* means light; *graphic* means drawing). Technically, light is electromagnetic radiation that we perceive and upon which we are dependent for sight. Light is what exposes **film** and paper and creates an image in photography, and the observation of how light affects the way things look is the most basic aspect of making an interesting photograph.

lightbox: A boxlike device with a light and translucent surface made for looking at slides, negatives, and other transparent materials. Also, a diffuse lighting fixture for studio use that produces a soft, shadowless light for portraiture and scientific photography.

light meter: A device that measures the brightness of **light** for the purpose of determining the correct exposure for photographic film. For proper usage, a light meter needs to be set for the film speed (**ASA**), and then a reading is made of the light illuminating the scene to be photographed (which can be natural, artificial, or a mixture of both). Once a measurement is made, the light meter provides the photographer with a basis for determining the proper settings of the camera's **apertures** and **shutter** speeds. "Exposuremeter" is another name for a light meter.

light sources: The types of light available to a photographer, including natural and artificial types. Natural light is that which is produced by the sun, including direct sunlight, the soft light in a shadow, and/or light bounced off a reflective surface. Moonlight, which is light reflected from the sun, and starlight are also sources of natural light. Artificial light includes all non-natural sources, such as continuous light from incandescent and fluorescent light bulbs, **electronic flashes,** and studio strobes.

limelight: A brilliant light that focuses public attention. The term originates from lighting for stage productions that early on used lime (calcium oxide), which was heated until it glowed, producing a bright lime-colored light.

Limelight Gallery: In 1954 **Helen Gee**, a young woman interested in photography, opened a European-style coffeehouse and photo gallery in New York's Greenwich Village. Over the course of the gallery's seven-year existence, some 70 exhibits were on view, including the work of such then unknowns as **Robert Frank, Dan Weiner, Edward Steichen, Berenice Abbott,** and **W. Eugene Smith.** The Limelight Gallery was a pivotal meeting place for the actors, writers, and photographers who were active in the Village in the 1950s. In 1931, the **Julian Levy** Gallery was the first in the United States to exhibit photography.

Link, Winston O. (1914–)
American documentary photographer
A train buff since childhood, when he received his first Lionel from his father, Link documented the last years of steam railroading in the United States—1955 to 1960—with a series of superb black-and-white photographs.

Born in Brooklyn, Link grew up in the Park Slope area and earned a bachelor's degree in civil engineering at the Brooklyn Polytechnic Institute in 1937. He was a skilled amateur photographer and during World War II worked as a researcher and photographer for the Columbia University Division of War Research. Here he first learned how to use strobe lights and adapt them for synchronized flash lighting, thus providing him with the experience he would later use to set up

the flash systems for his night photographs of trains.

After World War II he opened his own commercial studio in Manhattan, working for major American corporations. In 1955, while on an assignment in West Virginia, Link saw the great steam locomotives of the Norfolk and Western Railroad and discovered the subject with which he has become identified. The majority of his Norfolk and Western photographs show trains at night; he set up elaborate lighting systems to portray the trains' majestic presence. Between commercial assignments he traveled to the small towns of Virginia, West Virginia, Maryland, and North Carolina, where the Norfolk and Western operated. He photographed the engines, stationmasters and rural switchmen, train cleaners and conductors, the small stations and the men who worked there. During the course of the five years he worked on his project he also photographed the people of the backcountry areas—drive-in movies, small-town main streets, and swimming holes, capturing the look and feel of the era.

His photographs have been the subject of several museum and gallery exhibitions and are also held in private and museum collections. Several books, including *Ghost Trains* (1983), *Night Trick* (1983), and *Steam, Steel, and Stars* (1987), feature Link's train photos.

Linked Ring, The: Founded in 1892 by a group of 15 British photographers, the Brotherhood of the Linked Ring was quickly international in its membership, inviting both foreign and domestic photographers to join, based on their achievement in the field. Both straight photographers (purists) and those who advocated manipulating the image were welcome, and it was considered a great honor to be invited to join. The group's annual Photographic Salons, organized in London from 1893 to 1909, exhibited the finest work of members and other photographers. Portfolios of **photogravures** were published in conjunction with the salons. **Alfred Steiglitz, Gertrude Kasebier, Clarence H. White,** and **Frank Eugene** were all members of The Linked Ring.

Lippmann, Gabriel (1845–1921)
French physicist
Lippmann was a Nobel Prize-winning physics professor

at the Sorbonne in Paris who developed a process that marked the beginning of direct color photography.

In 1891 he announced his interference method of color photography, which consisted of putting a reflecting coat of mercury behind the emulsion of a photographic plate. His discovery was not commercially successful, because it necessitated long exposures and there were difficulties in viewing the image. However, it marked the first color work of its kind. A year later, he made color photographs of the French countryside.

He won the physics Nobel in 1908 for producing the first color photographic plate. He also did important work in optics, electricity, and acoustics.

List, Herbert (1907–1975)

German fashion photographer

Inspired and influenced by the **surrealists,** List began his career as a fashion photographer, staging tableaux of models with mysterious props; he later traveled through Greece taking photographs that showed his interest in classical antiquities and sculptural portraits of young men.

Born in Hamburg, he worked in his family's coffee business. A talented amateur, he received technical instruction from **Andreas Feininger,** and when List, a Jew, was forced to leave Germany in 1936, he moved briefly to London, and then Paris, where he found work as a fashion photographer. His work appeared in such magazines as *Vogue*, *Harper's Bazaar*, and *Life*. On his travels to Greece with **George Hoyningen-Huene,** he photographed numerous studies of young men whose figures seem to echo the Greek statues List also photographed. List also photographed his friends, among them such cultural icons as Pablo Picasso, George Braque, and Jean Cocteau.

After World War II List returned to Germany and worked for the German magazine *Du* until his retirement in 1960. He published several books with his photographs, and his work is owned by several museums, including New York's Museum of Modern Art, the San Francisco Museum of Modern Art, and the New Orleans Museum of Art.

lithography: Printing from a flat-surfaced material such as metal, stone, or plastic, using a technique that relies on the principle that water and oil do not mix. Where the image is to appear, the printing plate is ink receptive (grease) and water repellent; where the negative space is to be, the plate is water receptive and ink repellent. When the plate is pressed against paper, the ink is transferred to the paper (with the water-receptive areas remaining black), creating the final print. Lithography, also known as offset printing, was invented in Germany in 1796.

little magazine: A small-circulation magazine of fiction, photography, poetry, or other content, and commonly called a literary magazine.

Look: A large-format picture magazine founded by Gardner Cowles in January 1937, two months after *Life* magazine began. Oriented toward feature stories of general interest on celebrities, international and

Second only to *Life* magazine, *Look* was a major photo weekly. The June 7, 1938 issue featured the Dionne quintuplets on its cover. Collection of the authors.

national concerns, and human interest, the magazine was an immediate success (as was *Life*) and after the first year had a circulation of 2 million. *Look* was considered the magazine of the common man, was printed on cheap paper, and at first was rather amateurishly put together. After its initial success, it fell on hard times but was eventually saved and lasted until the end of the picture-magazine era, closing in September 1971. Its first copy had a photograph of Greta Garbo on the back cover. Although the magazine was long characterized as sensational, it covered world affairs, national politics, advances in medicine and education, religion and science, and the arts.

loupe: A small magnifying device for viewing minute detail, typically in slides, transparencies, and negatives. Jewelers use loupes for viewing precious stones for flaws.

Loupe. © Fred W. McDarrah.

Lowry, Bates (1923–)

American art historian, author, and museum director

An influential figure in contemporary art and photography, Lowry has served as director of the Museum of Modern Art in New York, university professor, and in 1998 co-author with Isabel Barrett Lowry of *The Silver Canvas: Daguerreotype Masterpieces from the J. Paul Getty Museum*, a historical and artistic study of the process that also chronicles more than two decades of European and American history and culture.

Born in Cincinnati, Lowry pursued studies at the University of Chicago (bachelor of philosophy degree, 1944; master of arts degree, 1953; doctor of philosophy degree, 1956). He has taught at a number of institutions, including Brown University, Pomona College, and New York University's Institute of Fine Arts. His published works include *Renaissance Architecture* (1962), *Architecture of Washington, D.C.* (1977–79), and *Building a National Image* (1985).

He served as chairman of the successful 1966–1967 campaign to rescue flood-damaged works of art in Florence and as founding director of Washington's National Building Museum.

Lumière, Auguste (1862–1954)
Lumière, Louis (1864–1948)
French inventors

The Lumière brothers are credited with the invention of the first motion picture camera and projector, which they patented as the cinematographe in 1895. They collaborated on the first movie ever shown to the public; it was a short feature called *La Sortie des Usines Lumière* and depicted employees leaving the Lumières' photographic-plate factory. Their movies used 35mm perforated, celluloid film, which is still employed in modern-day filmmaking.

The factory had been founded in Lyon by their father, Antoine, a painter and early photographer himself, in 1882. The brothers both attended Martiniere industrial school in Lyon and worked together in their father's laboratory. The factory was a great success and branched out to manufacture paper products. In 1904 Auguste and Louis invented autochrome, the first widely used color photographic process, which remained popular until the 1930s. Autochromes were employed by some of the **Pictorialists,** as well as by photographers of the **Photo-Secessionist** movement, including **Alfred Stieglitz.**

Prolific scientists, the Lumière brothers introduced other notable photographic inventions, including a 360-degree film projector that produced panoramas and a stereoscopic system for projecting motion pictures.

Lunn, Harry L. (1933–1998)
American art dealer

Lunn was a prominent photography dealer who operated his eponymous Washington, D.C., gallery from 1968 to 1983 and after that time acted as a private dealer of photography in Paris and New York. He acquired numerous works and collections of important photography and other works of art, both privately and at auctions, and marketed them to museums, to private collections, and at retail.

A 1954 graduate of the University of Michigan, he was in public service for ten years after leaving college. He was involved in foundation work until opening his gallery. He began making photo acquisitions in 1971 when he exhibited **Ansel Adams** for the first time in Washington and mounted a major **Man Ray** show the same year. In 1972, at Sotheby's first major photo sale, he bought one-quarter of the offerings.

His notable holdings included 5,000 **Lewis Hine** images and the **Walker Evans** archives, a 5,500-print survey. He also was an exclusive representative for **Brassaï**. He was known for his sales and holdings in nineteenth-century French artistic photography, including work by **Nadar, Gustave Le Gray,** and **Charles Negre**.

He acted as a consultant for major collections, such as the **Howard Gilman** collection and the Canadian Centre for Architecture. In 1981 he organized a retrospective for **Robert Mapplethorpe,** which included an installation of the three portfolios Lunn published with the Robert Miller Gallery.

Lynes, George Platt (1907–1955)
American fashion photographer, artist, and publisher

Famous during his lifetime for his technically superior fashion and commercial work for leading magazines, he is now highly regarded for his artistic male nudes and mythological studies. He also started his own publishing house, which produced works by writers ranging from Ernest Hemingway to Gertrude Stein.

He grew up in New Jersey, the son of a clergyman, and numbered among his friends Lincoln Kirstein. The two of them developed a strong interest in art; Kirstein became a leading art patron and dance entrepreneur. Lynes studied briefly at Yale University, then left to open a bookstore. He also started taking pictures and publishing the works of people he admired—like Hemingway—and asked artists like Jean Cocteau and Pavel Tchelitchew to illustrate the works.

In 1931, he met and was inspired by gallery owner **Julian Levy**. They collaborated on a series of **surrealist** still-lifes. In 1933, he opened a studio in New York and became well known for his portraits and fashion work.

Tchelitchew and Lynes continued to work together, often on homoerotic studies and dance and surrealistic images. Kirstein, head of the American Ballet Company, invited Lynes to photograph the ballets of the choreographer George Balanchine. In 1945 Lynes went to Hollywood, doing fashion work for *Vogue*, *Town & Country*, *Harper's Bazaar*, and other periodicals.

His work fell out of favor and was not exhibited in New York between 1941 and 1977. Alfred Kinsey, the noted sex researcher, collected more than 600 of Lynes's prints, which became part of the Kinsey Institute's archives. In 1981 a monograph of his work, *George Platt Lynes: Photographs 1931–1955*, was published. Other collections of his photographs include *George Platt Lynes Ballet* (1973) and *George Platt Lynes, Photographs from the Kinsey Collection* (1993).

His work is held by numerous collections, including those of the Metropolitan Museum of Art, the Museum of Modern Art, and the **Smithsonian Institution**.

Lyons, Danny (1942–)
American photojournalist and filmmaker

Lyons is known for his searing images of the 1960s, many taken in his official role as photographer of the Student Non-Violent Coordinating Committee in Chicago, the leading youth activist group of the Vietnam era. Later, he became an award-winning filmmaker.

As a student at the University of Chicago, he won a photo contest for his work documenting the nascent civil rights movement. His images, especially those taken during his stint traveling with a motorcycle gang, reverberate with the spirit, yearnings, and anxieties of that turbulent era. Later, he won acclaim for his book *Conversations with the Dead* (1971), a collection of photos of life in six Texas prisons.

He won **Guggenheim** awards for photography (1969) and filmmaking (1978) as well as **National Endowment for the Arts** awards for both photography (1972, 1974) and film (1976). Since then, he has traveled the North and South American continents, making photos of economically and often socially challenged people with a commitment to portray contemporary life in a truthful, sympathetic, and understanding manner.

Lyons, Nathan (1930–)

American curator, teacher, writer, and photographer
Founder and director of the **Visual Studies Workshop**

and former associate director and curator of the **George Eastman House** in Rochester, New York, Lyons has also been active as a photographer.

The Queens, New York, native took up photography in high school and has been involved in the field ever since. He enlisted in the Air Force after World War II and served in photo intelligence and as a public relations photographer. He received his bachelor of arts degree from Alfred University in 1957 and then began his long association with the George Eastman House. He has organized shows and published catalogue essays for hundreds of significant shows involving virtually every important photographer.

In 1963 he was a founding member and first chairman of the **Society for Photographic Education,** and he has also served as chairman of the New York State Foundation for the Arts and the **National Endowment for the Arts** Visual Arts Policy Committee. Lyons also has served as a professor at the State University of New York. A selection of his photographs, *Notations in Passing*, was published in 1974.

Maar, Dora (1909–1997)

French artist and photographer

Well known as a companion of Pablo Picasso and a model for his *Guernica* and *La Femme qui pleure*, Maar was a skilled photographer and painter in her own right and is said to have influenced Picasso himself in the field of photography.

The daughter of a French mother and Yugoslavian father, she was born in France and raised in Argentina. Maar returned to Paris to study painting and photography; it was during this time that she was introduced to the **surrealist** circle by Georges Bataille and became friendly with **Man Ray, André Breton,** Paul Eluard, and **Brassai**. Sharing a darkroom with Brassai, she worked for several years as an advertising and fashion photographer and did her own photo reportage. Many of her photos show the influence of the surrealists, particularly her photo montages. She contributed one of her most striking surrealistic images, *29 rue d'Astorg*, to a surrealist postcard project in 1937.

In 1935, at the Left Bank café Les Deux Magots, Eluard introduced her to Picasso. They collaborated personally and professionally; one notable series of photoetchings was published in *Cahiers d'art* in 1937. She sat for Man Ray for a portrait in 1936 and worked with him on photographs for a book of poetry by Eluard (*Le Temps Deborde*, 1947).

In addition to being a model for *Guernica* (and many other Picasso portraits in the 1930s), she photographed the painting at every stage of the work's evolution. She gradually gave up her photography for painting and had several exhibits of portraits and landscapes. Her last show was in London in 1958, and she lived in seclusion in the south of France for the remainder of her life.

MacGill, Peter (1952–)

American art dealer

The PaceWildensteinMacGill gallery in New York City is preeminent in the field of twentieth-century photography under the leadership of president Peter MacGill, who began working in the field in 1973 at Light Gallery.

MacGill received a bachelor of fine arts degree in 1974 from Ohio Wesleyan University and a master of fine arts degree from the University of Arizona in 1977. From 1974 to 1976 he was director of the Halsted Gallery in Birmingham, Michigan. In 1976 he became curator of exhibitions at the **Center for Creative Photography** in Tucson, Arizona, where he mounted exhibits by **Edward Weston, Ansel Adams,** and **Todd Walker** and a comprehensive survey of the center's collection, among others.

In 1978 MacGill returned to Light Gallery, becoming director in 1979. At Light he curated the first exhibitions of NASA space photographs, **Weegee**'s book dummies, and an exhibition of **André Kertész**'s late work. In 1983 he entered into partnership with the Pace Gallery to form PaceWildensteinMacGill. Among the shows he has put together are "**Paul Strand**: Exhibition Prints from '**291**'"; "Photographs of and by Picasso"; "**Andy Warhol**: Polaroids 1971–1986"; and "**Laszlo Moholy-Nagy**: Early Experiments." Among the artists the gallery represents are **Robert Frank, Harry Callahan,** and **Frederick Sommer**.

MacRae, Wendell (1896–1980)

American documentary photographer

MacRae enjoyed a renewed interest late in his career for his images of New York in the 1930s. His first exhibit was at the famous **Julian Levy** gallery in 1932; and in 1975 his images of art deco Zephyr streamliner trains,

Wendell MacRae. *Anita Foley MacRae on the Burlington Zephyr, 1936.*
© 1980 The Wendell MacRae Trust; courtesy Scotia MacRae.

steamships, and Rockefeller Center under construction were lauded as rediscovered treasures.

After graduation from the University of Minnesota, MacRae worked in the film industry in the research department of Paramount Studios in Astoria, New York City. He went west in 1927 to seek his fortune in Hollywood, but by 1928 he had returned to New York. He worked for Ewing Galloway photo agency until he started his own business in 1930, and he ran it until 1949. From then through 1965 he worked in University Park, Pennsylvania, as publications coordinator and later historical collection curator for Penn State.

His work is held by several collections, including those of the **Center for Creative Photography** in Tucson and the Metropolitan Museum of Art in New York. Selections of his photographs have been published, including a catalogue to accompany a 1980 exhibit in New York City at the Witkin Gallery.

macro photography: The term for **close-up photography** of small objects, such as coins and stamps. Most lenses will not **focus** to a close distance, so macro lenses are specially designed to allow up to a 1:1 focus ratio—that is, for a small object to be recorded on film at the same size it is in reality. A 1:1 focus of a coin would produce a negative with an image of a coin the same size as the coin itself. Macro photography allows for great detail in very small objects that may not be apparent to the naked eye.

MacWeeney, Alen Brasil (1939–)

Irish commercial photographer

MacWeeney has specialized in portraiture, fashion, and travel throughout his career as a photographer. In addition to his commercial work, his portrayals of the Irish landscape and scenes of Dublin have gained him recognition.

He was an intern at an Irish newspaper as a teenager and came to New York in 1961 as assistant to **Richard Avedon** and studied at **Alexey Brodovitch**'s Design Lab. He has been working steadily since 1964 for *Esquire*, *Life,* the *New York Times*, and other leading periodicals on both sides of the Atlantic.

In addition to photography, he has done fieldwork with Artelia Court in Ireland, collecting and recording Irish folklore, traditional literature, and music.

Selections of his photographs have been published in *Irish Walls* (1979) and *Bloomsbury Reflections* (1991). His work is represented in many collections, including those of the Museum of Modern Art, the Philadelphia Museum of Art, and the Virginia Museum of Fine Art in Richmond.

magic lantern: The projector used for viewing **lantern slides**, basically an old-fashioned slide projector. Prior to the invention of movies, magic lantern slide shows were a popular form of entertainment.

Magnum Photos: A cooperative photography agency founded in 1947 by **Robert Capa, Henri Cartier-Bresson, David Seymour, George Rodger,** and William and Rita Vandivert. Conceived as a cooperative of independent photographers who wanted to exert some control over their assignments and also to protect their **copyright** ownership, Magnum is considered one of the premier photography agencies and has a roster of some of the most respected names in the field. With bureaus in Paris, London, New York, and Tokyo, Magnum offers editorial, corporate, and advertising clients a stock photo source of some 3 million images.

Magubane, Peter (1932–)

South African photojournalist

As a black press photographer in an *apartheid* South Africa, Magubane endured severe penalties in bringing his nation's story to an international audience. He suffered nearly two years in solitary confinement, beatings, a ban on working, and long periods of house arrest. Throughout his career he has published many books of his photography and received numerous awards, including the **Robert Capa** Award in 1986.

Born in Vrededorp (now Pageview), a suburb of Johannesburg, he grew up in Sophiatown. He started his professional career as a "tea boy"—literally fetching beverages for others—at South Africa's *Drum* magazine, the *Life*-sized picture monthly that gave a voice to black

Africa, in 1954. His first real assignment came in 1955 when he covered an African National Congress meeting. He also covered the Sharpeville massacre funeral services and the subsequent Zeerust trials for *Drum*. Because no photographers were permitted inside the courtroom, he slipped in disguised as a farm worker with a camera hidden in a loaf of bread. He also used an empty milk carton with a cable release going through a straw. He got the pictures—*Drum* was the only publication in the world that did—but also was jailed, although he was not convicted of any crime.

From 1963 to 1965 he worked as a freelancer in the United States, but his desire to return to his homeland brought him back. After two years at the *Rand Daily Mail*, the government curtailed his ability to work, sentencing him to house arrest. From 1969 to 1974, a series of soldiers were assigned to make sure he did not work, or leave his house for any extended period of time beyond a short shopping or medical trip.

In 1976 he won a human rights press award from the *London Sunday Times* and since then has been shooting, exhibiting, and traveling between New York and South Africa freely. In 1978 he had a major exhibition at the **International Center of Photography** in New York and subsequently has been widely exhibited. In 1992 the Missouri School of Journalism presented Magubane with its Honorary Medal for Distinguished Service in Photojournalism for his lifelong coverage of *apartheid*. His work continues to document the evolution of his homeland to a free society. He has published several collections of his photographs, most recently *Vanishing Cultures of South Africa*.

Mahoney, Christopher (1966–)

American photographer and administrator

Now an assistant vice president at the prestigious Sotheby's auction house, Mahoney is a well known and increasingly influential figure on the photographic auction scene.

Mahoney earned a bachelor of fine arts degree in photography from New York University and a master of arts and humanities degree from the University of Buffalo. In 1991, he started working as a specialist in the photographs department at New York's Swann Galleries. He joined Sotheby's in 1995 as a senior cataloguer.

His own work as a photographer has led him to experiment with both conventional and alternative photographic processes. Also, he has written articles on various photographic subjects for the *Daguerreian Society Annual* and the PhotoArts site on the **World Wide Web**.

Maisel, Jay (1931–)

American commercial photographer

A freelance photographer since 1954, Maisel is known for his vibrant color images made for advertising, editorial, and corporate communications assignments. His photographs have been collected in Time-Life's "Great Cities" series, in books on Jerusalem, New York, and San Francisco.

Born in Brooklyn, he studied painting at Cooper Union (1952) and was graduated from Yale University (bachelor of fine arts, 1953), where he studied color with Joseph Albers. In addition to his freelance work, he lectures extensively at workshops in the United States and abroad and has taught color photography at Cooper Union and the School of Visual Arts.

His work has been exhibited in the Metropolitan Museum of Art, the **Smithsonian Institution,** and the Baltimore Museum of Art, among other venues. In 1996, he won the Lifetime Achievement Award of the **American Society of Media Photographers**. He also received the Infinity Award for Applied Photography from the **International Center of Photography** (1987) and, in 1977, Cooper Union's St. Gaudens medal.

Makos, Christopher (1948–)

American portrait photographer

Makos is known for his boldly graphic images of such icons of alternative culture as Patti Smith, William Burroughs, and Alice Cooper. Working as photographer for **Andy Warhol**'s *Interview* magazine, he photographed punk rock fans, the artist **Man Ray,** Mick Jagger, and the fashion designer Zandra Rhodes.

Born in Massachusetts, Makos grew up in California. He studied architecture in Paris and later served as apprentice to Man Ray. Since 1966 he has

Gerard Malanga. *Ira Cohen, Vondel Park, Amsterdam.* 1979.
© Gerard Malanga. Courtesy the photographer.

been developing his unique style of **photojournalism**. His photographs have appeared in such magazines as *Esquire*, *Viva*, and *Rolling Stone*. His book *White Trash* appeared in 1977; a second book, *Terrorist Chic*, was published in 1979.

Malanga, Gerard (1943–)

American photographer, poet, artist, and filmmaker

With his friend and mentor, **Andy Warhol,** Malanga worked in the Factory, spreading paint on silkscreens and assisting in making films; he was a cofounder of *Interview* magazine, wrote and published his poetry, and produced with Warhol the film portrait series entitled "Screen Tests" (1964–1966), which numbers in the hundreds. He also took portraits through the years of the artistic milieu of which he was an integral part.

Malanga was born in New York City and studied at the College of Applied Arts of the University of Cincinnati, The New School in New York, and Wagner College, where he earned a bachelor of arts degree. He pursued Tibetan studies with a *lama* teacher in Dharmsala, India.

His activities in the avant garde cultural scene since the late 1960s include poetry readings, collecting manuscripts of Beat poets for a private collection, being choreographer and dancer in the Velvet Underground's Exploding Plastic Inevitable multimedia show, and writing numerous books. His portrait of the 1970s, *Resistance to Memory*, was published in 1998. Other published works include *Autobiography of a Sex Thief* (1984) and *Scopophilia: The Love of Looking* (1985), *Good Girls* (1994), *Seizing the Moment* (1996), and *Screen Tests, Portraits, Nudes 1964–1996* (1998). He is the English translator for the poems of Cesar Vallejo and editor of several literary anthologies.

His photographs have been exhibited at the **George Eastman House** in Rochester, New York; the Special Collections Library at the University of Texas; and Galerie FNAC in Paris. He was a recipient of the Avant Garde Poetry prize of the Gotham Book Mart and won grants from the National Institute of Arts and Letters and the American Film Institute.

Mamiyaflex: A **twin-lens reflex camera** system made by the Mamiya Camera Company.

Man, Felix H. (1893–1985)

German / British photojournalist

A pioneer photojournalist who lived in Berlin until 1934 and then emigrated to England after the Nazis seized power, Man is noted for his picture essays, notably his *A Day with Mussolini* (1931). His dramatic photographs appeared in Munich and Berlin illustrated magazines, and later in *Picture Post* and *Life* magazine, bringing readers the same sort of visual immediacy viewers found later in television news coverage.

Man was noted for two innovations—he could tell the story with a sequence of pictures so that text was almost unnecessary, and he introduced the reportage portrait, showing the subject going about his or her daily activities and preserving the appearance and reality of everyday life. He worked with a small handheld camera, recording what was taking place and trying to avoid notice.

Born Hans Felix Sigismund Baumann in Freiburg, he shortened his name in later life. He took pictures as a child of ten with a Kodak box camera given by his father. He studied art and hoped to become a painter before serving in the German army in World War I. In 1926 he moved to Berlin and found a growing market for his photographs that led to his abandoning painting.

He found work at Dephot, a news agency, where a 16-year-old Hungarian boy, André Friedman (later, **Robert Capa**), worked in the darkroom. In the early 1930s Man was a freelancer, working closely with the editor Stefan Lorant, who started *Picture Post* magazine. Man was chief photographer at the magazine from 1938 to 1945.

After 1945 Man turned with renewed interest to art and published a book on lithography. In 1972 he moved to Rome, where he continued to write and publish articles on cultural affairs. His work is owned by major collections, including those of the **George Eastman House** in Rochester, New York, and the National Portrait Gallery in London.

Man Ray (1890–1976)

American surrealist photographer, artist, and filmmaker

Called the poet of the darkroom by the French writer Jean Cocteau, Man Ray had a brilliant career pioneering in all the media of the twentieth century—painting, sculpture, found objects, collage, film, and photography. He worked as a Cubist, a Dadaist, and **Surrealist,** contributing works of striking innovation. Although he took up photography in 1915 simply to reproduce his paintings, Man Ray went on to become an extraordinarily creative and inventive master of the medium.

Born Emmanuel Rudnitsky in Philadelphia, Pennsylvania, he moved with his family to New York City, where he worked as a commercial artist for a map publisher. At night he studied art at the National Academy of Design and the Ferrer School. He met **Alfred Stieglitz** at **291 Gallery,** and they became close friends. Through Stieglitz he met a circle of avant garde photographers and artists.

In 1914 he moved to Ridgefield, New Jersey, devoting much of his time to his painting. In 1915 he had a one-man show of paintings in New York and met Marcel Duchamp, who was on his first trip to New York. At that time Duchamp had already contributed to the founding of the Dada movement in Europe, and his *Nude Descending a Staircase* had caused a sensation at the 1913 Armory show. It was the start of a 53-year friendship between the two artists, with Duchamp as the revolutionary artist and Man Ray documenting his work.

Having decided to abandon commercial artwork, Ray opened a portrait studio, and his subjects were his friends—the actress Myrna Loy, the writer Djuna Barnes, and the designer Elsa Schiaparelli. He also began experimenting with photographic processes—in 1917 he revived the cliché-verre, a process for making a drawing on a glass negative with a needle point; the drawing is then printed on sensitized paper. With Duchamp he helped found Societe Anonyme, the first modern museum in America, where the work of Wassily Kandinsky, Fernand Leger, and Joseph Stella was introduced to New York.

After Duchamp returned to Paris, Ray followed in 1921. Quickly accepted by the avant garde, he turned to fashion photography for his livelihood. In 1922 he discovered by chance that if he put a few objects on a sensitized sheet of paper under light, he could produce not only an image of their shadows but also an additional three-dimensional quality with tone gradation. He called the resulting print a Rayograph. With his friend the Dadaist Tristan Tzara he produced a book of Rayographs called *Les Champs Délicieux* (1922) and a film using the same technique. He exhibited at the first surrealist show in Paris in 1925 and at the surrealist exhibition in New York at the **Julian Levy** gallery in 1932.

In his Paris studio Man Ray photographed many artists, poets, and musicians, such as Picasso, Matisse, Brancusi, James Joyce, Gertrude Stein, and Igor Stravinsky. Some of his assistants would later achieve recognition themselves, among them **Berenice Abbott** and **Lee Miller**. A **darkroom** error by Miller led to Ray's discovery of **solarization,** or exposing a developing negative to light to produce a painterly effect that accentuated the clarity of the image.

In the 1930s he traveled extensively, visiting Dali in Spain and Picasso in the south of France. With the coming of World War II, Man Ray returned to the United States, settling in Hollywood until 1951, when he returned to Paris. For the rest of his career photography took second place to his painting.

At the 1961 Venice Photography Biennale he received the Gold Medal. He had major retrospective exhibits at the Bibliothèque Nationale in Paris (1962), the Los Angeles County Museum (1966), and the Pompidou Center in Paris (1982). His autobiography, *Self Portrait*, was published in 1963, and several volumes of his photographs and books about him have appeared, including Roland Penrose's *Man Ray* (1975). His work is owned by numerous private collections and museums worldwide.

Mann, Sally (1951–)

American art photographer

Mann achieved recognition and some notoriety for her intimate photographs of her children growing up in Virginia. The honesty and intensity of those black-and-white images, collected in her first book, *Immediate*

Pages 296 – 297: Man Ray. *Profile and Hands.* 1932.
© Man Ray Trust, ADAGP 1998..

Sally Mann. *Emmett, Jessie and Virginia,* 1989. © Sally Mann. Courtesy Edwynn Houk Gallery, New York.

Family, showing the children in various poses and states of dress and undress, aroused controversy among those who considered the photos exploitative or pornographic.

Born in Lexington, Virginia, Mann studied at Bennington College and earned a bachelor of arts degree (1974) and master of arts degree (1975) at Hollins College. A series of family portraits resulted in publication of her first book in 1992 and exhibitions at the Institute of Contemporary Art in Philadelphia and a New York gallery. She has published five books, most recently *Mother Land* (1998), with photographs of the southern landscape. Her work has been exhibited in numerous museums, including London's Barbican; the Whitney Museum of American Art Biennial, 1991; Photo Gallery International, Tokyo; and the Museum of Modern Art in New York; and is in the collection of the **Smithsonian Institution,** the Metropolitan Museum of Art, and

other major institutions. Mann won a **National Endowment for the Arts** fellowship and Photographer of the Year award from the **Friends of Photography**. She has taught at several photo workshops and lectured at conferences.

Mapplethorpe, Robert (1946–1989)

Controversial American portrait and art photographer
Mapplethorpe's photos, which were widely exhibited, ranged from sexually explicit to sublimely beautiful. He gained recognition in the 1970s with elegantly composed, sometimes shocking male nudes. Throughout his career he also made portraits of his friends and celebrities in the fields of music, art, literature, and entertainment and took still-lifes of flowers that were simple in concept but exquisitely detailed.

Born in New York, he studied at Pratt Institute in

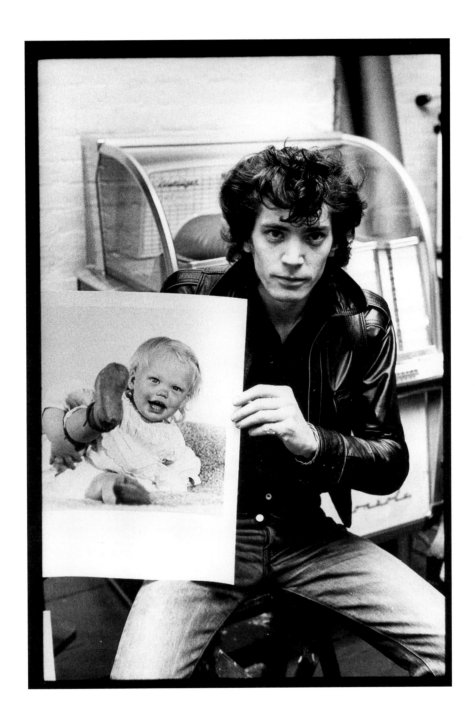

Robert Mapplethorpe holding one of his photographs. December 22, 1979.
© Fred W. McDarrah.

Brooklyn from 1963 to 1970. He began his career as an independent filmmaker and artist using photographs in collages. He began taking photographs with a **Polaroid** given him by a friend.

Besides being influential as a photographer, Mapplethorpe inspired his friend **Sam Wagstaff** to collect photography. Wagstaff's collection later was sold to the Getty Museum in Los Angeles. Even after he became known as a photographer, Mapplethorpe remained interested in art constructions and in 1988 had a show featuring photographic images imprinted on fabric. He was also a collector of photographs as well as of furniture, fabric, and other art objects. He was in demand as an editorial photographer, making celebrity portraits for magazines such as *Vogue* and *Vanity Fair*.

Himself a victim of AIDS, he established a foundation to focus on medical research for the disease. His photographs are in the collections of numerous museums, including those of the Metropolitan Museum of Art and the Museum of Modern Art. He had many solo exhibitions in the United States and Europe, including a major retrospective at the Whitney. Selections of his photographs are collected in several books, including *Robert Mapplethorpe* (1988), published in conjunction with the Whitney exhibit.

Marey, Etienne-Jules (1830–1904)
French scientist, inventor, and photographer

Interested in capturing movement in humans, birds, and animals, Marey, who had trained as a physiologist, invented a number of repeating-shutter cameras that permitted him to analyze the way movement flowed. He had met **Eadweard Muybridge** in 1881 and saw his motion studies, which inspired Marey to continue his own research. Marey produced slow-motion, motion picture, and high-speed cameras but was not interested in the commercial exploitation of these devices. Some authorities consider Marey, rather than the **Lumière** brothers, the inventor of moving pictures.

Born in Beaune, France, Marey earned his medical degree in Paris in 1859. Among his other inventions were instruments for recording blood pressure, the pulse, and other fleeting physiological functions. With his photographic gun, produced in 1881, he was able to photograph birds in flight. He founded the Marey Institute, which continued his work in **high-speed photography** after his death.

Mark, Mary Ellen (1941–)
American photojournalist

One of the most important contemporary photojournalists, Mark has produced photographs that often focus on people outside conventional society's bounds, whether there by choice or chance. Her projects have covered women in the maximum security section of an Oregon mental hospital (*Ward 81*, published in 1979), Mother Theresa's missions in India, and homeless families in America.

Born in Philadelphia, Mark earned both her bachelor of fine arts and master of arts degrees at the University of Pennsylvania. A freelance photographer, she achieved her first success with photographs taken in Turkey and throughout Europe, in 1965 and 1966, under a Fulbright scholarship. When she returned to the United States, she began to do assignments for magazines and has continued to do so.

Her best-known photo essay, a story of teenage runaways in Seattle, appeared in *Life* magazine in July 1983. With her husband, Martin Bell, she made a documentary about that project called *Streetwise*, which was nominated for an Academy Award in 1984. She has worked as a still photographer on movies and has done portraits of film stars.

Mark has taught at several photo workshops. A member of the **Magnum Photos** agency (1976–1981), she joined **Archives Photos** in 1981. She has been the recipient of three **National Endowment for the Arts** awards (1977, 1980, 1990) and many **photojournalism** awards, including the Photographer of the Year Award from the **Friends of Photography** (1987) and the **George W. Polk Award** (1988). A 25-year retrospective of her work was organized by the **International Museum for Photography** at the **George Eastman House** in Rochester, New York, and opened at the **International Center of Photography** in 1991. Several collections

Jim Marshall. *Janis Joplin Backstage at San Francisco's Winterland.* 1968. From *Not Fade Away* by Jim Marshall, Bulfinch/Little Brown, 1997. © Jim Marshall. Courtesy the photographer.

of her photographs have been published, including *Passport* (1974) and *Falkland Road* (1981), and her work has been exhibited in major museums worldwide.

Marshall, Jim (1936–)

American portrait photographer

Called "*the* rock and roll photographer" by fellow photographer **Annie Leibovitz,** Marshall has worked most of his career in the music business, doing magazine and editorial work, publicity, documentary photography, and album and CD covers.

After serving in the U.S. Air Force, Marshall started taking pictures in the 1960s in the clubs of North Beach, San Francisco, with his Leica M2. The first image he sold was of the comedian Lord Buckley. Since then he photographed at the Monterey Pop Festival (1967) and Woodstock (1969). He has photographed virtually every artist in the rock pantheon, from Muddy Waters to Janis Joplin, the Rolling Stones to the Red Hot Chili Peppers. A selection of his photographs was published in *Not Fade*

Away (1997), and an exhibit was organized by the Hard Rock Café in conjunction with that publication. His work has been published worldwide and is included in the permanent collection of the **Smithsonian Institution**.

Marville, Charles (1816–c. 1879)

French architectural photographer

Marville's methodical documentation of Parisian architecture resulted in an invaluable collection of photographs taken at the time of the Second Empire, 1858–1878. Working for the city government at a time when the city was undergoing a great transformation under the direction of Baron Georges-Eugène Haussman, Marville photographed first the narrow cobbled streets and small medieval structures of old Paris. He then photographed the same sites, with work in progress, showing demolition, constructions, installations of trees and statues, and landscaping of parks.

Born in Paris, Marville worked as an engraver and painter before he began a career as a photographer at the

age of 35. His first photographs were **calotypes** and were published in albums by **Blanquart-Evrard,** for whom he traveled to Algiers, to Germany, and throughout France. He photographed cathedrals, churches, and castles, as well as landscapes and some individuals. From 1856 on he used the new, much faster **collodion** technique. By 1862 he had become the official photographer for the city of Paris.

His work was highly praised for its precision and balance, and his photographs were exhibited at the Paris Universal Expositions of 1867 and 1878. His work is in the collections of the Musée Carnavalet, the Bibliothèque Historique, and other Parisian libraries.

masking: An overlay of either neutral density or colored material added to alter the final result of an image. Typically masking is used in the **darkroom** while printing a photograph and can be used to enhance local areas of a photograph, such as to make a sky darker, alter the color of an area, or reduce or obscure an area in the print. Masking is also used in electronic imaging to block areas from being affected by manipulation and alteration.

masthead: The listing in a publication of the publisher, editors, writers, photographers, and other relevant information such as address and phone number, fax, and e-mail.

matboard: A stiff cardboard material used for making mats, presentation surfaces with an opening through which a picture is viewed, creating a framelike effect that enhances the artistic effect of an image. Matboard comes in many qualities and colors; the finest is called museum board, which is acid-free and excellent for the long-term storage and presentation of fine art.

matte finish: A surface that is not **glossy** and does not create glare, making it a good surface for viewing an image, especially large, fiber-based exhibition prints.

Matter, Herbert (1907–79)
American abstract photographer and graphics designer

A prolific and accomplished photographer, as well as designer for such clients as Knoll International and the New Haven Railroad, Matter took pictures of quiet beauty, sometimes working with manipulated images. He took abstract photos, and some of his pictures had a **surrealist** edge.

Born in Switzerland, he studied painting at the Ecole des Beaux-Arts in Geneva and with Fernand Leger in Paris, where he also worked with Le Corbusier. On his return to Switzerland he designed a seminal group of photomontage posters for the tourist office. In 1936 he left for New York, where he began photographing as a freelancer for *Vogue* and *Harper's Bazaar* for the legendary **Alexey Brodovitch,** and in the 1950s became friends with artists of the Abstract Expressionist movement.

Matter was a photographer who evolved much of his work in the darkroom. Whatever the subject, his work was purely visual in approach. A master technician, he used every method available to achieve his vision of light, form, and texture. Manipulation of the negative, retouching, cropping, enlarging, and light drawing are some of the techniques he used to achieve the fresh, enigmatic form he sought in his still-lifes, landscapes, nudes, and portraits.

He was a professor of photography at Yale University from 1952 to 1976 and also was a design consultant for the Guggenheim Museum in New York and Houston's Museum of Fine Arts.

McBean, Angus (1904–1990)
British documentary photographer

A noted photographer of British theatre from 1930 to 1970, McBean became the official photographer for such important cultural institutions as Sadler's Wells ballet company, the Old Vic theatrical company, Stratford-on-Avon, Glyndebourne, and the H. M. Tennant theatre. Recognizing the historical value of his unique images, Harvard University bought 48,000 of his negatives, 4 ½ tons of glass, for their library

Born in South Wales, McBean worked briefly as a bank clerk before joining the antiques and decorating departments of Liberty & Co. He said he didn't learn about art at Liberty, but he did learn about people, an important skill for a portrait photographer. He opened

Charles Marville. *Rue du Platre,* ca. 1870.
Musée Carnavalet, Paris. Collection of the author.

his own studio in 1935 and earned his living making masks and theatrical scenery and taking society portraits. On his own he started photographing theater shows for no payments, selling portraits to the *Sketch* and other magazines. He met such stars as Ralph Richardson, Vivien Leigh, and Laurence Olivier, amassing an important pictorial record of their historic performances.

In addition to his documentary theatrical work, which included striking images of the Beatles, McBean produced a series of **surrealist** photographs of stage and other personalities. He also manipulated images for his annual Christmas cards, which have become sought-after collector's items.

McBean's photographs are held by such public collections as the Victoria and Albert Museum and **Royal Photographic Society** in London and the National Gallery in Canberra, Australia.

McCartney, Linda (1942–1998)

American portrait photographer

During the 1960s McCartney achieved recognition for her unique photographs of the fascinating milieu of the rock musicians and groups that would become legendary—Jimi Hendrix, Janis Joplin, the Beatles, the Rolling Stones, the Doors, and Cream, among them.

Born in New York, she remembered hearing rock and roll on the radio as a teenager. She developed a great love of the music and went to the seminal rock and roll concerts staged by disc jockey Alan Freed at the Brooklyn Paramount. She majored in art history in college but did not develop an interest in photography until she was living in Arizona, where she began studying at the Arts Center of Tucson. Inspired by the work of **Dorothea Lange** and **Walker Evans,** she began taking pictures.

McCartney moved to New York City in 1965. Her career as a photographer was assured after she took a set of photos of the Rolling Stones at a reception where she was the sole photographer. She soon was able to give up her office job at *Town & Country* magazine and work as a freelancer. She became the main photographer at Manhattan's Fillmore East and traveled on the road with major groups. She met her husband, Beatle Paul McCartney, in London where the album *Sergeant Pepper* was being launched.

After their marriage she moved to England, making it her principal residence until her death. Besides her work as a photographer she performed with her husband in two of his post-Beatle bands. A dedicated vegetarian, McCartney campaigned for animal rights and published two cookbooks for meatless meals.

A selection of her photographs of the 1960s was published in *Linda McCartney's Sixties* (1992). *Linda's Pictures* was published in 1976, and in 1996 she published *Roadworks*. She had just finished work on *Linda McCartney on Tour* (1998) when she died. Her work has been exhibited in London's Victoria and Albert Museum, the **Royal Photographic Society** in Bath, England, and galleries around the world.

McCullin, Donald (1935–)

British photojournalist

During the 1960s and early 1970s McCullin documented in powerful black-and-white images the conflicts in Cyprus, Biafra, Bangladesh, and Vietnam, mostly on assignment from the *London Sunday Times* magazine.

McCullin himself was as a child a casualty of war, in spirit if not in body, as he was five years old during the London blitz. With thousands of other children he was evacuated to the countryside. The son of working-class parents, he won a Trade Arts Scholarship for his painting but had to drop out of school when his father died. He was introduced to photography when he was in the Royal Air Force and was assigned to undergo training as a photographer's assistant. When he was demobilized McCullin shot a photo essay on members of his old street gang. He sold the pictures to the *Observer* and was on his way.

He has worked in the Congo, Cambodia, India, Northern Ireland, and the Sahara—wherever people were suffering, whether from war or famine.

His work has been exhibited in London at the Victoria and Albert Museum in a retrospective that later traveled to the **International Center of Photography** in New York. Books of McCullin's

work include *Is Anyone Taking Any Notice?* (1971), *Hearts of Darkness* (1980), and *Sleeping with Ghosts* (1996).

On his first war assignment in 1964, in Cyprus, his pictures won him the World Press Photo award and the Warsaw Gold Medal. Other honors and awards include a fellowship from the **Royal Photographic Society,** an honorary doctorate from the University of Bradford, and a Dr. Erich Salomon Award. In 1993 he was named a Commander of the British Empire.

McKenna, Rollie (1918–)

American portrait photographer

Known for her portraits of great poets and other creators, McKenna has been photographing major figures of the American arts community for more than 40 years.

Born in Houston, Texas, where her father was an Air Force pilot, she was named Rosalie; her last name was Thorne. She was called "Rollie" to avoid "Rose" or "Rosie." After she became a photographer, people thought her first name was spelled "Rollei," short for the popular camera she used.

She studied fine arts at Vassar College and in Paris in 1948 bought her first camera. She photographed many of the great architectural monuments in Italy and traveled to Kuwait in 1950. She sold her architectural studies to colleges in the United States and assembled an exhibition called "Three Renaissance Architects" that brought her some recognition. She also began taking her portraits in the early 1950s, among them the poets Philip Larkin in London, Bob Kaufman in San Francisco, and Seamus Haney near Belfast. Her pictures of Dylan Thomas and Edith Sitwell have become the definitive images of those artists.

She had numerous solo and group shows at such institutions as the Metropolitan Museum of Art, the IBM Gallery, and the Museum of Modern Art in New York. Her work is held by collections at the Vassar Art Gallery, Yale University Art Gallery, and San Francisco Museum of Modern Art. McKenna has done several films, two on Dylan Thomas (1965, 1968) and *A Kid Like You* (1969).

Among her published books are her pictorial autobiography, *A Life in Photography* (1991), *Portrait of Dylan* (1982), and *The Modern Poets: An American-British*

Anthology (1963, reprinted 1970) edited by John Malcolm Brinnin and Bill Read.

McNally, Joe (1952–)

American photojournalist

McNally achieved recognition as a feature photographer doing covers and spreads for *Newsweek*, **National Geographic,** *Sports Illustrated*, *Fortune*, *New York* magazine, *Time*, and **Life**. In the early 1990s McNally became *Life* magazine's first staff photographer in 23 years. His assignments included work in strife-torn nations such as Zaire, Somalia, Afghanistan, and Chechniya. One of his most haunting photos shows 500 or 600 human skulls displayed in rows on a large table at an abandoned church in Rwanda.

A communications major at Syracuse University, he began photographing in his junior year, when he took a photography class. After graduation he worked as a copy boy at the *New York Daily News* and took pictures freelance for United Press International, among them the World Series in 1978. He worked as a news feature photographer for the **Associated Press** and the *New York Times* before moving to ABC Television, taking promotional pictures of network stars and upcoming scenes from weekly shows. He left ABC to concentrate on color feature work. In his most recent work, McNally has become an accomplished storyteller through his photographs, with a particular interest in features about children in danger or distress.

McNally's work has earned him numerous awards, including a 1997 first prize in portraits from the World Press Photo Foundation and a 1988 first place in magazine illustration from the **National Press Photographers Association**.

Meatyard, Ralph Eugene (1925–1972)

American art photographer

One of the most imaginative and enigmatic photographers of the twentieth century, Meatyard produced diverse bodies of photographs: figurative scenes, portraits, and landscape studies; abstract photography, and "no-focus" pictures. For his portraits and staged tableaux he often put grotesque masks on members of his family and friends, suggesting psychological and spiritual realms

beyond the physical world. He used several techniques to achieve his mysterious effects, including multiple exposure, camera movement, and selective focus.

After graduation from high school in 1943 in Normal, Illinois, Meatyard joined the Navy. He studied at Williams College for one year as part of his naval training. In 1946 he apprenticed as an optician in Chicago. He eventually took a position as an optician in Lexington, Kentucky, where he opened his own shop, Eyeglasses of Kentucky, in 1967.

He bought his first camera in 1950 to photograph his newborn son. He progressed quickly to become a serious artist. He studied art photography with **Van Deren Coke,** who encouraged his work, and in 1956 took courses with **Minor White** at Indiana University.

His work has been published in *Ralph Eugene Meatyard* (1974), *The Family Album of Lucybelle Crater* (1974), and *Ralph Eugene Meatyard: An American Visionary* (1991). His photographs are held by such collections as those of the **George Eastman House,** the Massachusetts Institute of Technology, and the Metropolitan Museum of Art. Meatyard's work has been exhibited in numerous one-man and group shows since 1954.

medical photography: The specialized field of making photographs of human, animal, and scientific subjects for use by the medical profession.

Meiselas, Susan (1948–)

American photojournalist

When Meiselas first went to Nicaragua in 1978, she was a seasoned photographer but relatively inexperienced in news coverage. She acquired her credentials as an exceptionally able war correspondent with color photos of the country's revolution that appeared in such publications as *Paris Match*, *Time*, *Geo*, and the *New York Times Sunday Magazine*.

Meiselas was graduated from Sarah Lawrence College in 1970. After working on a documentary film, *Basic Training*, she earned a master of visual education degree at Harvard University. She went on to work as a photography consultant for the New York City schools

and the **Polaroid** Corporation. Her first major photo essay, *Carnival Strippers*, was published in 1976. The following year she joined the **Magnum Photos** agency.

She lived and worked in Nicaragua for ten years, covering much of Latin America as well. In 1981 her book *Nicaragua June 1978–July 1979* was published. She returned to Nicaragua to film *Pictures from a Revolution* (1991). A selection of her photographs of the Kurdish people, *In the Shadow of History: Kurdistan*, appeared in 1997.

Among her awards are the **Hasselblad** Foundation Prize (1994), a MacArthur fellowship (1992), and a **Robert Capa** Gold Medal (1979).

Metzker, Ray K. (1931–)

American art photographer and teacher

Metzker's work explores the possibilities of photography, particularly in composite photographs, employing methods of combination, repetition, and superimposition to challenge viewers with a sense of fragmentation that can give way to synthesis.

Born in Milwaukee, Wisconsin, Metzker was graduated from Beloit College in 1953, earning a master of science degree in photography in 1959 at the Chicago Institute of Design. While there he studied with **Harry Callahan** and **Aaron Siskind**. After serving in the military in Korea, Metzker worked as a freelance photographer and educator. Since 1962 he has been with the Philadelphia College of Art, as professor since 1978.

Metzker has received two **Guggenheim fellowships** (1966, 1979) and a **National Endowment for the Arts** grant. His work has been exhibited in one-man shows at the Art Institute of Chicago, the Museum of Modern Art, and the **International Center of Photography**. Among the collections holding his photographs are those of the Fogg Art Museum, Harvard University; the **George Eastman House**; and the **Smithsonian Institution**.

Meyerowitz, Joel (1938–)

American art photographer

Since the late 1970s Meyerowitz has been known for his artistic color photographs that characteristically observe

the effects of light and shadow, often on a place photographed from exactly the same spot.

Born in New York City, he earned a bachelor of fine arts degree from Ohio State University, where he studied painting and medical illustration. He worked as a graphic designer and art director until he took up photography, having been inspired after working with **Robert Frank** on a photo assignment. Meyerowitz has used an 8 x10-inch **view camera** for his color work and has produced several noteworthy books, including *Cape Light* (1978), *St. Louis and the Arch* (1981), and *A Summer's Day* (1985). He works as a freelance commercial photographer and pursues his own interest in color photography as an art form.

Meyerowitz has received two **Guggenheim fellowships** (1970, 1978) and a **National Endowment for the Arts** grant (1978). His work has been exhibited in one-man shows at Boston's Museum of Fine Art, the **George Eastman House,** and the Museum of Modern Art in New York City, all of which have acquired photographs by Meyerowitz for their permanent collections.

His film *Pop*—about a road trip with his father, who is in the early stages of Alzheimer's disease—debuted at the East Hampton Film Festival in 1998.

mezzotint: A printing technique which uses a copper or steel plate that is scraped and burnished and is then inked and pressed to paper to create the

Joel Meyerowitz. *Boy on a Bed of Nails, Cape Cod, 1977.* © Joel Meyerowitz; Courtesy Bonni Benrubi Gallery, Inc., New York.

image. Mezzotints are characterized by a velvety, stipple effect.

Michals, Duane (1932–)

American art and portrait photographer

Playful, conceptual, and deeply personal, Michals's work includes narrative sequences that have been carefully staged as well as pictures that he writes or draws on after developing. He has also done commercial work and portraits of such personalities as **Andy Warhol,** Marcel Duchamp, and Warren Beatty.

Born in McKeesport, Pennsylvania, Michals showed early artistic talent. He earned a bachelor of arts degree at the University of Denver. He took a job as a graphic designer in 1958, the same year he traveled to Russia, where he took many candid shots of people on the streets. That work was exhibited in 1959 in New York and set him on his dual-career path, as both a commercial photographer and an artist with a strong personal vision.

His work has been represented in major exhibitions since 1964, including those sponsored by the Museum of Modern Art and the Chicago Art Institute. Among the more than 60 public collections in which his work is represented are those of the **George Eastman House** and the Museum of Modern Art. Michals has published numerous books, including *Sequences* (1970), *Homage to Cavafy* (1978), *Take One and See Mt. Fujiyama* (1976), and *Now Becoming Then* (1991).

microfiche: A 4 x 6-inch sheet of film that contains very small images or informative text blocks and is used with a viewer to enlarge the information so it can be read. Libraries use microfiches to store book and picture index information; this allows them to reduce a large amount of information to a compact size.

microfilm: A roll of photographic film that contains very small images or informative text blocks and is used with a viewer to enlarge the information so it can be read. For both microfilm and **microfiche,** the idea is that large amounts of information can be stored in a small area and retrieved easily. Thousands of newspaper pages can be stored on a single roll of microfilm.

Microsoft: Software company founded by **William Gates.** Worldwide organization that supplies the majority of software in use, such as Microsoft Word. In 1997, Microsoft acquired the famous **Bettmann** Archive of 16 million images that it plans to digitize and offer through the **internet** via its **Corbis** photo agency.

Microsoft Picture It: Photo-editing **software** that can be used to get images into your **computer** from a **digital camera** or other outside source. It is generally regarded as the easiest-to-use photomanagement software.

Mili, Gjon (1904–1984)

American photographer and inventor

Mili's photographs appeared constantly in *Life* magazine for more than four decades and ranged from spectacular action shots of athletics and dance and theatrical performances to portraits of celebrities in entertainment and politics.

Born in Albania, he spent his boyhood in Romania. He emigrated to the United States in 1923 and was graduated from the Massachusetts Institute of Technology with a bachelor of science degree in electrical engineering. He worked as a research engineer, writing numerous technical papers on light projection, optics, and photography. He worked closely with Dr. **Harold Edgerton** at MIT on experiments with high-speed flash photography.

His career as a professional photographer began in 1938 with publication in *Life* of his action photographs of the tennis player Bobby Riggs. Late in his career Mili turned to filmmaking and made several documentary films on other photographers, artists, and musicians. He lectured at Yale University, Sarah Lawrence College, and Hunter College. A major retrospective of his photographs was held at the **International Center of Photography** in 1980, and a collection of his work, *Photographs and Recollections*, was published the same year.

Miller, Laurence G. (1948–)

American photography art dealer

Owner of the Laurence Miller Gallery in New York's Soho, Miller specializes in the exhibition and sale of

important nineteenth- and twentieth-century photography, with emphasis on Asian postwar photography. The gallery's extensive list of one-person shows includes those by **Helen Levitt, Alfred Stieglitz, Ray K. Metzker, Julia Margaret Cameron, Larry Burrows, Timothy O'Sullivan, Walker Evans, Robert Frank,** and **Eadweard Muybridge**.

A native New Yorker, Miller received a bachelor of arts degree and a master of arts degree (1973) from the University of Wisconsin. He continued graduate studies in art and photography at the University of New Mexico with **Beaumont Newhall** and **Van Deren Coke**. At UNM he organized exhibitions of photographs and handmade books.

From 1974 to 1980 Miller was associate director of Light Gallery in New York, the premier gallery for contemporary photography in the city at that time. He also taught history of photography at The New School and Parsons School of Design. In 1981 Miller began his own business, selling fine-art photography, and in 1984 he opened his first gallery, on 57th Street. The gallery moved to its present Soho location in 1986.

Miller, Lee (1906–1977)

American art photographer and war correspondent

In her twenties she was an international model renowned for her beauty; in her thirties she realized her ambition to become a photographer and went on to become a central figure in the **surrealist** movement, a landscape and portrait photographer, and an accredited World War II photographer. Lee Miller had a remarkable and varied career.

Born on a farm in Poughkeepsie, New York, the 22-year-old beauty was pulled from the path of an oncoming car by the publishing magnate Condé Nast, who promptly offered her a modeling job. She was on the front cover of *Vogue* and was photographed by **Edward Steichen, George Hoyningen-Huene, Horst,** and other famous photographers.

She set off for Paris to pursue her growing interest in working behind the camera. Steichen provided her with an introduction to **Man Ray,** and she worked with him as his protégé and lover. In his studio she accidental-

ly discovered the **solarization** technique that they developed together. She became a central figure in the surrealist movement and numbered among her friends such artists as Max Ernst, Paul Eluard, and **André Breton**. She played the statue in Jean Cocteau's classic film *Blood of a Poet*.

After quarreling with Man Ray, she returned to New York and set up a studio doing advertising work and portraits. Her photographs were exhibited in the **Julian Levy** Gallery's "Modern European Photographers" show in 1932. In 1934 she married an Egyptian businessman and moved to Cairo, where she photographed the desert landscape and the people who lived there. She traveled to Europe often and met there **Roland Penrose,** whom she would marry in 1947.

With the outbreak of World War II she left Egypt to live with Penrose in London. She was appointed staff photographer for *Vogue* but decided to become a war correspondent for the U.S. Army. Her reportage took her throughout Europe; she was present at Germany's surrender and among the first photographers to enter the concentration camps at Dachau and Buchenwald.

After the war Miller moved to Sussex, England, with her second husband and continued to make informal portraits of the many artists who visited them. In 1990 a major retrospective of her work was held at the **International Center of Photography**. Several books featuring her work have been published, including *The Lives of Lee Miller* (1985) by her son Antony Penrose and *Lee Miller's War* (1992), edited by him.

Miller, Wayne F. (1918–)

American documentary photographer

A member of **Edward Steichen**'s photo unit in the U.S. Navy during World War II, Miller has had a long and productive career as a freelance photographer.

Born in Chicago, he earned a bachelor of arts degree at the University of Illinois, Urbana, in 1940 and studied at the Art Center School in Los Angeles. After his wartime service, he won a **Guggenheim fellowship** in 1946–48 that permitted him to complete a project called "To Photograph the Way of Life of the Northern Negro," a study of the culture and lives in the

black community on the south side of Chicago. Working as a freelance photographer based in Chicago, Miller published work in *Life, Collier's, Ebony, Fortune,* and other magazines. From 1953 to 1955 he helped Steichen organize the "**Family of Man**" exhibit. Miller's photos were published in Dr. Benjamin Spock's *A Baby's First Year* in 1955, when he became chairman of the **American Society of Media Photographers**.

He joined **Magnum Photos** in 1958, the same year he published *The World Is Young,* a three-year study of his family and community, Orinda, California, where he established a redwood tree farm. He served as president of Magnum from 1962 to 1966 and then joined the National Park Service, working in environmental education. In 1975 he and his wife, Joan, were named California Tree Farmers of the Year. Since then he has operated a vineyard and been active in redwood preservation activities. He plans to donate his archives and papers to the **Center for Creative Photography** at the University of Arizona in Tucson.

Minkkinen, Arno Rafael (1945–)

Finnish-born, American art photographer and teacher
Self-portraiture is the hallmark of Minkkinen's work, with the focus often on a juxtaposition of physical fragments with the natural landscape.

Born in Helsinki, Finland, he emigrated to the United States, graduating with a bachelor of arts degree from Wagner College in New York and a master of fine arts degree in photography from the Rhode Island School of Design. He has taught photography as assistant professor at Massachusetts Institute of Technology since 1977. A selection of his photographs, *Frostbite,* was published in 1978. His work is represented in major collections such as those of the **Center for Creative Photography** in Tucson; the Addison Gallery in Andover, Massachusetts; and the Wamo Aaltosen Museo in Turku, Finland.

minicam:
A very small, portable video camera. Minicams have transformed television news programs because of their ability to go wherever a person can go, with very little equipment, and their ability to be concealed for surveillance use.

Misrach, Richard L. (1949–)

American documentary photographer
After working briefly as a documentary photographer using black and white in the 1970s, Misrach turned to color photography, producing two major studies of the American desert, *Violent Legacies,* with text by **Susan Sontag** (1992), and *Desert Cantos* (1987).

Born in Los Angeles, he received a bachelor of arts degree from the University of California at Berkeley. His photographs of Berkeley's youth culture at night were published in *Telegraph 3 A.M.* (1974). His photographs of the desert are spectacular landscape views, showing the beauty of the colors as well as the effects of the human presence.

He has taught at several workshops and has been visiting lecturer at the University of California. He has received four **National Endowment for the Arts** awards and a **Guggenheim fellowship,** as well as a **Friends of Photography** Ferguson Award. His photographs have been exhibited worldwide at such institutions as the Australian Center for Photography in Sydney, the Pompidou Center in Paris, and the Houston Museum of Fine Arts. His work is held by major collections, including those of the Victoria and Albert Museum in London, the Los Angeles County Museum of Art, and the Metropolitan Museum of Art.

Model, Lisette (1906–1983)

Austrian-born, American portrait photographer and teacher
Inspirational teacher for a whole generation of young photographers, most notably **Diane Arbus,** at The New School, Model produced many noteworthy series of photographs. Her candid portraits of people on the fringes of society secured her reputation, and she went on to produce portfolios such as *Reflections,* portraying those mysterious images in store windows along Fifth Avenue.

Born in Vienna, she studied music with Arnold Schonberg there before moving to Paris, where she continued her musical training. Around 1933 she turned from a musical career to pursue her interest in painting and photography. She quickly focused on subjects that would be her major interest—ironic studies

Wayne F. Miller. From his Guggenheim project "Way of Life of the Northern Negro in the United States, Chicago 1946–47." Courtesy Keith de Lellis Gallery, New York.

of the well-to-do and sympathetic portraits of the blind and homeless.

Seeking to escape the political unrest of 1938 Europe, she emigrated with her husband, Evsa Model, to New York City. She worked in the photo lab of the newspaper *PM* until her photos of wealthy vacationers in the south of France appeared in the newspaper and established her reputation. By 1940 the Museum of Modern Art had acquired two of her prints and she was working for *Harper's Bazaar*. With the guidance of the magazine's art director, **Alexey Brodovitch,** she took pictures of unconventional nightclub performers as well as more experimental images.

From 1951 to 1954 and from 1958 to her death she was an instructor of photography at The New School. She was awarded a **Guggenheim fellowship** in 1965 and a Creative Artists Public Service (CAPS) grant in 1967. A selection of her photos, *Lisette Model*, was published in 1979, and her work is held by major institutions, including the **George Eastman House** in Rochester and the **Smithsonian Institution**.

modeling: Tonal variations on a three-dimensional subject due to a light source. Modeling allows the two-dimensional photograph to convey a sense of depth and surface variation in an object, because of the way light falls onto it. The effect of light and shadow on an object is called modeling. *Modeling* is also the term for the act of posing for an artist.

modem: An acronyn for *modulator/demodulator*, an electronic device that converts a digital signal to an analog signal, and vice versa. In lay terms, a modem deciphers the hums and buzzes on a phone line into conventional text. The modem is connected via a traditional phone cord from a personal **computer** or computer system to a phone line. A **fax** modem is a similar device connecting a fax machine to a phone line. A modem is mandatory to connect a computer to an online system and for the transmitting of text, images, and sound. A more advanced or more powerful modem will result in a clearer image on the computer screen and better print quality on photographs.

Modotti, Tina (1896–1942)
Italian-born American photographer, model, and political activist

Modotti was a pioneering female photographer whose beauty and relationships with famous men sometimes obscure her artistic and political accomplishments.

Born in Udine, Italy, she left her native land in 1913, moving to San Francisco, where she became a star of the local Italian theater. After she married a poet and painter, Roubaix de l'Abrie Richey, they moved to Hollywood in 1918, where she had a brief career as a starlet. An avid reader, she was also interested in the radical political ideas of the era. She met **Edward Weston** in 1921 and they became lovers. She left her husband and moved with Weston to Mexico, becoming his model and also learning from him the art of photography.

She modeled also for her friends, the great muralists Diego Rivera and David Alafaro Siquieros. She contributed photographs to *Mexican Folkways* magazine and *El Machete* newspaper. Her contact with Mexican artists led to her involvement in leftist politics, and she became the lover of Julio Mella, a young Cuban revolutionary who was killed at her side in 1929.

A year later the Mexican government deported her as a communist. After she left Mexico she lived briefly in Berlin. All of her photographs were taken during her time in Mexico and during the Berlin stay. When she moved to Moscow she abandoned photography and worked for the Soviet government, first in Moscow and, during the Spanish Civil War, in Spain.

When the fascist cause triumphed in Spain, Modotti sought asylum in the United States but was refused entry. She returned to Mexico, where she died under mysterious circumstances at the age of 45. Officially the cause of her death was a heart attack, but it has been suggested that she was poisoned by one of Joseph Stalin's operatives.

Her photographs achieve a striking synthesis of artistic form and social content. They have a stately beauty reminiscent of Weston's work and portray the many facets of Mexican culture. Two biographies of Modotti have been published: *Tina Modotti: A Fragile Life*

(1975) and *Tina Modotti: Photographer and Revolutionary* (1993). A retrospective of her work was held at the Museum of Modern Art in 1977 and at the Philadelphia Museum of Art in 1995, and her work is held by numerous collections worldwide.

Moholy-Nagy, Laszlo (1895–1946)
Hungarian-born, American abstract photographer, painter, and graphic designer

Closely associated with the **Bauhaus** movement in Weimar, Germany, Moholy-Nagy was a multitalented artist, painter, thinker, teacher, and writer, as well as a talented inventor who carried out systematic investigations into the fields of painting, photography, and cinematography.

Born in Hungary, he enrolled as a law student in 1913 but was drafted into the Austro-Hungarian army in 1914. Always interested in avant garde art, he belonged to an artists' group, MA, and took his first **photograms** in 1920. He moved to Berlin in 1920 and shared a studio with the artist Kurt Schwitters. Invited by Walter Gropius, he joined the faculty of the Bauhaus school from 1923 to 1928. He planned, edited, and designed 14 works on the Bauhaus with Gropius and also was active doing light and color experiments in photography.

He made his first photogram, "Der Spiegel," in 1921, by placing circular and rectangular tissue papers directly upon light-sensitive paper and exposing the arrangement to light. The darkest areas were where the greatest thicknesses of the tissue layers were placed, the lightest areas where the least were placed. This medium was also explored by other photographers, who used different names for the same process—**Fox Talbot**'s photogenic drawings and **Man Ray**'s rayograms among them.

In 1928 he resigned from the Bauhaus and returned to Berlin. He was the stage designer for the State Opera and continued his photographic experiments. In 1935 he moved to London to work as a graphics consultant for major corporations before emigrating to the United States in 1937. He settled in Chicago and was a founder of the Chicago Institute of Design in 1938.

There he explored the use of photomontages, or photoplastiks, to reflect the suspended state of consciousness between sleeping and waking. He never called himself a photographer but rather a manipulator of light to create a new vision. One of the seminal figures in modern art, Moholy-Nagy produced many abstract photographs, arousing interest in new ways of manipulating the image for artistic effect.

Among the books written about Moholy-Nagy are Richard Kostelanetz's *Moholy-Nagy* (1970) and Krisztina Passuth's *Moholy-Nagy* (1985). His constructivist paintings and photographs are owned by major museums, including the Art Institute of Chicago, the **George Eastman House,** and the Museum of Modern Art in New York.

moiré: The effect of regularly spaced lines to create interference with one another in printing or video images, typically resulting in blurring or a shadow effect. A moiré appears when a photo is reproduced that has already been screened as a **halftone.**

monitor: A screen on which information is displayed, generally a **computer** or video monitor.

Monkmeyer: Photography agency located in New York with more than 50 years of experience and more than a million images in stock, specializing in people and travel.

mono-pod: A camera support that stabilizes a camera during exposure. Unlike a **tripod,** which has three legs, a mono-pod has only one leg. It is light and easy to carry and is used when extra stability is needed to make a sharp picture, such as in low-light conditions or at moderately slow shutter speeds.

montage: The combination of various photographs, clippings, or other two-dimensional images to create a new artwork. A composite image made by cutting and pasting different photographs together to form a new image, also called photomontage. Montage can also be made in the darkroom by exposing photographic paper to various negatives, creating a final image made up of many others.

Pages 314 – 315: Tina Modotti. *Hands of Puppeteer, Mexico.* 1929.
Collection of the authors.

Moore, Charles (1931–)

American documentary photographer

Moore has taken some of the most significant and poignant photographs of the U.S. civil rights movement in the South from 1958 to 1965.

The Alabama native studied in the Marines to be a combat photographer. After his time in the service, he studied photography at the Brooks Institute in California before returning home to shoot for the *Mongomery Advertiser* and the *Alabama Journal* (1957–1962). In 1962, he joined the **Black Star** agency and started freelancing, first covering the nascent civil rights movement.

From 1962 to 1972 he shot many diverse assignments for *Life* magazine, from unrest in Haiti and the Dominican Republic to jazz in New Orleans. Since 1972 he has freelanced from his home base in San Francisco, often working in southeast Asia. He has also done commercial work and taken portraits of subjects that included Presidents Dwight D. Eisenhower, John F. Kennedy, Lyndon B. Johnson, and Richard M. Nixon as well as Elizabeth Taylor, Richard Burton, and others.

Moore's 1991 book, *Powerful Days: The Civil Rights Photography of Charles Moore*, was well received. Other books include *The Mother Lode* (1983), about a gold rush in the California Sierras, and *King Remembered* (1986). Among the awards Moore has won for his photography was the first **Kodak** Crystal Eagle award for Impact on Photojournalism in 1989.

Moore, Peter (1932–1993)

American documentary photographer

Moore documented avant garde art of the 1960s and 1970s and amassed a unique archive with his photographs of performance art, happenings, and Fluxus events (Fluxus was a loosely associated group of avant garde performance and visual artists). His images of a naked, cello-playing Charlotte Moorman interacting with video artist Nam June Paik and **Robert Rauschenberg** roller skating with a parachute on his back are icons of that creative era.

Born in London, he attended the Massachusetts Institute of Technology before taking a job in the photography lab at *Life* magazine. His first exhibition, in 1961, was called "Kids!" and demonstrated a technical skill and feeling that would be evident throughout his career. From 1963 to 1966 he made 30 trips to document the destruction of New York's Pennsylvania Station; the resulting images now have much historical as well as artistic significance.

Moore's interest in the free-spirited 1960s art scene in New York became his principal concern. His "at work/at play" photos of Larry Rivers, Merce Cunningham, Meredith Monk, Yoko Ono, Philip Glass, George Brecht, **Andy Warhol,** Jim Dine, Allan Kaprow, and Claus Oldenberg and his documentation of the New York avant garde festivals in the 1960s constitute an important record of that era.

His work has been exhibited at the Venice Biennale (1990), at the Guggenheim Museum in New York (1997), and at Bound & Unbound, an exhibition space in New York City. Two books of his work were scheduled for publication in 1999, *The Destruction of Penn Station*, and a definitive volume on performance art with text by Barbara Moore.

Morath, Inge (1923–)

American photojournalist

Morath is a brilliant and technically proficient photographer who has traveled the world on assignment for **Magnum**; before making a series of trips to China, she learned Mandarin and speaks several other languages, including the German of her native Austria and Russian.

Born in Graz to research scientist parents, she was educated in Germany, France, and Romania and was graduated from the University of Berlin in 1944 with a degree in languages. She joined the United States Information Agency in Austria as a translator and interpreter in 1946. In 1950 she became a literary editor at *Der Optimist*, a well-regarded Austrian periodical; the next year she worked as the Austrian editor for the respected Munich newsweekly *Heute*. In postwar Vienna she started working with the photographer **Ernst Haas** on a project about returning prisoners of war, which inspired her interest in photography.

She apprenticed with a local photographer and did a story and pictures on a French workman-priest. **Robert**

Capa saw the story and invited Morath to join Magnum. She started as an assistant to and researcher for **Henri Cartier-Bresson** in 1953 and 1954. Her first Magnum assignment, in 1954, took her to Spain, and in 1955 she was made a full member of the agency.

In 1960, Morath was sent to Rome to shoot the filming of *The Misfits*, starring Clark Gable, Marilyn Monroe, and Montgomery Clift. Monroe's then-husband, Arthur Miller, wrote the screenplay and was present on the set. Miller and Morath later married and have collaborated on a number of books, including *In Russia* (1969) and *Chinese Encounters* (1979).

More than two dozen collections of Morath's photographs have been published, many of them focusing on the exotic locales she has been sent to cover. Her language skills have helped her explore and understand each culture she has photographed. In an interview in the *New York Times* in 1998, Morath said, "Before I tackle a project, I want to know its background, immerse myself in its civilization and learn at least the fundamentals of the language. Then I have more freedom to reach what Cartier-Bresson calls the decisive attitude of the photographer. He took his pictures with one eye open, observing the world through a viewfinder, and the other closed, looking into his own soul."

In addition to her books, her small-format travelogues and portraits have been exhibited in museums and galleries the world over. Her work is held by numerous public and private collections, including those of the Art Institute of Chicago, the **International Center of Photography,** and the Metropolitan Museum of Art in New York.

moray: Video disturbance caused by the reflection of light from bright object such as jewelry or glass, causing an unpleasant glare in the image.

Morgan, Barbara Brooks (1900–1992)

American art photographer

Morgan captured the genesis of what she called "the life force in action"—modern dance. She also was a pioneer in her use of photomontage, a founding member of the **Photo League** and *Aperture*, and she cofounded and ran for more than 35 years her own photography publishing house.

Born in Kansas, she remembers as her earliest influence her father's telling his five-year-old daughter to "think of everything in the world as dancing atoms." She studied art at the University of California at Los Angeles and while a teacher at San Fernando Valley High School in 1925 married Willard Morgan, a photographer and writer. The couple moved to New York in 1930.

She had started to take photographs, but photography did not become her career until after she saw Martha Graham's "Private Mysteries" modern dance performance in 1935. The two women began six years of intense collaboration on a book, *Martha Graham: 16 Dancers in Photographs* (1941). The book brought recognition for both women and is now considered the quintessential statement on dance and dance photography.

Morgan opened her own studio in Scarsdale, New York, in 1941 and then photographed such cultural icons as Merce Cunningham, José Limon, Erick Hawkins, Charles Weidman, Doris Humphrey, and many others. She also corresponded with many now-famous writers and artists, such as **Edward Weston,** William Carlos Williams, Margaret Mead, and others. Those letters are now an important reference for the cultural life of the period.

From 1935 to 1972 she and her husband operated Morgan and Morgan, a photographic publishing house. In addition to the Graham book, Morgan produced *Summer's Children* (1951), about a summer camp in Lake Placid and the children who she felt represented courage and hope in the aftermath of World War II, and *Barbara Morgan* (1988).

Morgan was the winner of a 1975 **National Endowment for the Arts** fellowship, and her work is today widely collected and exhibited. Among collections holding her work are those of the **George Eastman House,** the Addison Gallery of American Art in Andover, Massachusetts, and the Metropolitan Museum of Art in New York.

morphing: The process whereby one image is

transformed, through a series of steps, into another. The term was popularized in a Michael Jackson video, in which he morphed a series of human faces one into the next to show the similarities between seemingly disparate facial features. His own face began and finished the mesmerizing sequence.

Morris, John G. (1916–)

American photo editor, writer, and lecturer

In his long and productive career, Morris has assigned and edited the photos that have helped to provide the American public with a window onto the history of the 1940s to the 1980s. He worked closely with such famous photojournalists as **Robert Capa, Henri Cartier-Bresson,** and **W. Eugene Smith**.

Morris grew up in Chicago and was graduated from the University of Chicago in 1938. He joined Time Inc. as an office boy and rose rapidly, becoming a *Life* staff member on the first day of World War II. He worked for the magazine as Hollywood correspondent and was later sent to London to oversee *Life*'s coverage of D-Day. He followed the photographers to London and Paris, where he met Cartier-Bresson, who helped him gather pictures of France taken during the occupation.

In 1946 Morris became picture editor of the *Ladies' Home Journal* and was responsible for the inauguration of such important features as a candid look at the Soviet Union by John Steinbeck and a series on farm families called "People Are People the World Over." That series inspired **Edward Steichen** to mount his **"Family of Man"** exhibit at the Museum of Modern Art.

In 1958 Morris joined **Magnum Photos** as editorial director, and he helped guide the agency after the tragic deaths of Robert Capa and **Werner Bischof**. Morris went on to work as executive picture editor of the *Washington Post* before joining the *New York Times*, where he remained until retirement.

Morris has been a juror of the World Press Photo Competition four times. He lives in Paris and lectures widely on **photojournalism**. His memoir *Get the Picture* was published in 1998.

Morris, Wright (1910–1998)

American novelist, teacher, critic, and photographer

Known primarily as a novelist and critic, Morris was a photographer as well, publishing several photo-texts depicting rural scenes of the Midwest. There are no people visible in his photographs of structures, street or house furnishings, and street scenes. Morris first combined photos and text in 1939 and wanted readers to join the two elements in their mind's eye. Later he felt that the textual elements were a distraction, and he eliminated the words.

Born in Central City, Nebraska, Morris grew up in the Midwest, attending Crane College in Chicago and Pomona College in California. He dropped out of college to roam through Europe, where he began his lifelong interest in literature. On his return to the United States, he began photographing the landscape of a vanishing America, following in the footsteps of his idol, **Walker Evans**.

A professor of literature at San Francisco State University from 1962 to 1974, he worked as a writer and photographer since 1934. Among his many published works are his novels and the photo-texts, which include *The Inhabitants* and *The Home Place* (1948). A monograph without text, *Structures and Artifacts, Photographs 1933–1954*, was published in 1975. One of his most successful books was *Solo: An American Dreamer in Europe* (1983), about his prewar trip through Europe.

Morris exhibited his photos in numerous museums and received a National Book Award, a National Institute of Arts and Letters award, and three **Guggenheim fellowships** (1942, 1954, 1957). He was elected to membership in the American Academy of Arts and Sciences and the National Institute of Arts and Letters.

Morse, Samuel Finley Breese (1791–1872)

American inventor, photographer, and painter

While Morse is popularly remembered as inventor of the electric telegraph and the system of teletyping bearing his name (Morse code), he is also regarded by American photohistorians as the father of American photography.

Morse met **Louis-Jacques-Mande Daguerre** in France in 1839 and was one of the first to tinker with

Wright Morris. *Barber Pole, Weeping Water, Nebraska*. 1947. © Wright Morris.

Daguerre's new process in the United States. In New York City Morse shared a studio with a New York University professor at the school's main building, where Morse made **daguerreotype** images, including his famous group portrait of his class reunion in 1840. Morse instructed a number of his contemporaries in the daguerreotype process, among them **Mathew Brady, Albert Southworth,** and **Edward Anthony,** all of whom went on to produce noteworthy bodies of work themselves.

Born in Charlestown, Massachusetts, Morse was graduated from Yale University in 1810. He studied painting in London and on his return worked as an itinerant miniaturist. He became a professor of drawing at NYU, where he embarked on his experiments that resulted in the telegraph; he sent his first Morse code message from his university laboratory.

Morse was a founding member of the National Academy of Arts and won numerous awards for his inventions. His paintings of landscapes and portraits are held by several museums, including the Metropolitan Museum of Art.

mottling: Generally an undesirable texture pattern that may appear after sharpening an image. It is most obvious in areas of flat tone, such as a sky.

mounting photographs: The process of attaching a photograph to **matboard,** wood, metal, or other surface for display. Popular mounting techniques are **dry mounting,** spray adhesive, linen tape, and glue stick.

Moutoussamy-Ashe, Jeanne (1951–)
American photographer and author
A distinguished photographer whose work alone and with her late husband, the tennis star Arthur Ashe, reflects concern about human rights, Moutoussamy-Ashe published in 1986 a pioneering study on the contributions of black women photographers in the United States. The book, titled *Viewfinders*, fills a major gap in the history of photography and shows an important area of American minority culture in which black women played a significant part.

Born in Chicago, Moutoussamy-Ashe earned a bachelor of fine arts degree in photography from Cooper Union in 1975 and has done freelance editorial work for *Ebony*, *Jet*, and *World Tennis*, the **Associated Press,** and NBC television. She was a contributing editor for *Self* magazine and commented on photography on television. She has photographed the people of South Africa under *apartheid* and done a series on Dafuskie Island, South Carolina. Her photographs also appeared in *Getting Started in Tennis* (1977) with text by her husband.

Her work has been exhibited at museums and galleries in the United States and abroad and is represented in major collections, including those of the Schomburg Center for Research in Black Culture in New York and the Columbia, South Carolina, Museum of Art and Science.

Mulas, Ugo (1928–1973)
Italian art photographer
Mulas produced some of his best work with the New York pop artists **Andy Warhol,** Jasper Johns, Claes Oldenburg, George Segal, and **Robert Rauschenberg,** which appeared in his book *New York: The Art Scene* (1967). He also photographed in the fields of fashion, industry, and theater.

Born in Italy, he was a self-taught photographer. His first works were of Milan's intellectual café society in the mid-1950s. These moody photos had a style that was reminiscent of **Brassai**'s. After his work on the New York art scene, he followed his personal vision, seeking to explore conceptual theories of the role of the subject and camera in producing a work of art.

A selection of his photographs edited by **Germano Celant** was published in *Ugo Mulas* (1990).

multimedia: The combination of various media for a presentation, such as still photography used with sound and video images. Video and **computer** technology has advanced the idea of multimedia to include interactivity—viewer participation with the imagery and sound—making it a valuable tool for education and a source of entertainment.

multiple exposure: The act of making more than one exposure on a single piece of film or photographic paper, resulting in numerous otherwise unassociated images being present in the same photograph. This is commonly a mistake but can be used for creative purposes by a skilled photographer.

multiple flash: The use of more than one flash, either simultaneously or consecutively, for a photograph. This can be used to increase the intensity of the illumination, to light a large scene, to control lighting in a specific area of a photograph, or to create smooth, even illumination of a subject.

Munkacsi, Martin (1896–1963)

American fashion photographer

Munkacsi was for much of his career the world's highest-paid photographer, based on his groundbreaking work as a fashion photographer in the 1930s and 1940s. His light-hearted approach to his work resulted in pictures notable for their humor and charm. He sent his models jumping over puddles, striding through snowstorms, climbing sand dunes, or running through a park.

Born in Hungary, he started working as a sports reporter and photographer as a teenager. He achieved recognition when he took a photograph of a brawl through a train window. The image was later used to refute a murder charge because it clearly indicated that the defendant had acted in self-defense.

He used that fame to negotiate a contract at Ullstein, Berlin's leading publisher, in 1927. Covering an early zeppelin flight, he met William Randolph Hearst, who lured him to the United States in 1934 with a lucrative and exclusive contract to work for him. His work in *Harper's Bazaar*, *Ladies' Home Journal*, and *Life* earned him, at the height of his reputation, around 1940, more than $100,000 per year in earnings. In 1943 he suffered a heart attack and subsequently had to curtail his activities. He did produce some books, including *Fools Apprentice* in 1945 and *Nudes* in 1951.

Although he never had a one-man show during his lifetime, he was in a Museum of Modern Art group show in 1937, and a full retrospective was held at **the** **International Center of Photography** in 1978. A selection of his work, *Style in Motion*, with an introduction by the photographers **Richard Avedon** and **Henri Cartier-Bresson,** was published in 1979.

mural: A very large photograph, possibly mounted on a wall. Typically, photographs over 30 x 40 inches are called murals. Photographic-supply companies produce large rolls of photographic paper for making mural prints.

Muray, Nickolas (1892–1965)

Noted American portrait photographer

His skilled work and celebrity subjects—from Babe Ruth to Gloria Swanson, Franklin Roosevelt, and Claude Monet—made Muray as famous as the people whose portraits he took.

Muray studied photography, photoengraving, and lithography in his native Hungary and came to New York in 1913. He got a job as a darkroom technician for Condé Nast and took English classes at night school. In 1920, he opened a studio in Greenwich Village, and his work was soon appearing in the *Tribune* newspaper and *Harper's Bazaar* and *Vanity Fair* magazines. His subjects included Presidents Calvin Coolidge and Herbert Hoover; the screen stars Lillian Gish, Gloria Swanson, and Norma Talmadge; the writers Eugene O'Neill, F. Scott Fitzgerald, and D. H. Lawrence; the dancer Martha Graham; the attorney Clarence Darrow; and countless other icons of the 1920s and 1930s.

He later did color advertising and fashion work for *Ladies' Home Journal* and *McCall's* and worked in his own studio regularly until his death in 1965. Muray was also an accomplished fencer, competing in the 1928, 1932, and 1936 Olympics and as a judge in 1964.

Muray's work has been exhibited in group shows in the United States and abroad, and a selection of his witty portraits, *Celebrity Portraits of the Twenties and Thirties*, was reprinted in 1978.

Muybridge, Eadweard J. (1830–1904)

Ground-breaking English-born, American photographer and inventor

Muybridge is famous for his landmark "Animal Locomotion" series of photographs, which showed for the first time that a galloping horse at some time has all four feet off the ground. His photographic studies of animal movement radically altered both the scientific understanding of the subject and its depiction in pictorial art.

Born in England, he first worked in the family's stationery and papermaking business. At age 22 he emigrated to the United States and started experimenting with a camera. By 1856 he had set up a bookstore in San Francisco. In the 1860s he established himself as a photographer with spectacular Yosemite landscapes. He used 20 x 24 inch **collodion** mammoth glass plates to great effect.

He invented one of the first **shutters** for a camera in 1869 and in 1880 devised what he called a zoopraxiscope, or zoogyroscope. It projected pictures on a screen in a rapid, sequential order and is considered the first step in the development of motion pictures. He did not demonstrate the process until 1893, when it was viewed at the California School of Fine Arts in San Francisco and at the Chicago World's Fair.

In 1872, he was hired by former California governor (and university benefactor) Leland Stanford to use photos to prove that at one simultaneous point during a horse's gallop, all four legs leave the ground. His first attempts were unsuccessful because of a shutter that wasn't fast enough, but in 1877, using a string of cameras that made exposures at regular intervals, he proved Stanford's contention.

During this time his private life aroused controversy when he was accused of murdering his wife's lover, a crime of which he was eventually acquitted. He then traveled widely, documenting Panamanian ruins and Mexican Indian life, lecturing in Europe, and continuing his human and animal motion studies at the University of Pennsylvania. He retired to his native England in 1900.

Several books chronicle Muybridge's life story and illustrate his achievements, among them *Eadweard Muybridge, The Father of the Motion Picture* by Gordon Hendricks (1975), *Animals in Motion* (1957), and *The Human Figure in Motion* (1955).

Eadweard Muybridge. *Backtrain Camel in transverse gallop (.032 second).* 1887.
Collection of the authors.

Mydans, Carl (1907–)

American photojournalist

During a 35-year career as one of *Life*'s original staff photographers, Mydans covered scores of landmark events and personalities all over the world.

As a student at Boston University, he started writing for local newspapers as a freelancer, and after graduation in 1930 he moved to New York and got a job as a reporter with *The American Banker*. In 1935, he joined the **Farm Security Administration** to photograph rural life during the Depression. His evocative documentary work caught the eye of the editors of the fledgling magazine and Mydans was hired.

For the next four decades, he was everywhere. It was Mydans who covered Mussolini and fascism in Italy in 1940, watched Chiang Kai-shek's troops face the Japanese in Chunking in 1941, and was at Pearl Harbor before the Japanese attack. He was captured by the Japanese in China and imprisoned with his correspondent wife, Shelley, for two years. Mydans stepped ashore with General Douglas MacArthur in the Philippines in 1945 and was on the USS *Missouri* to capture the Japanese surrender on film. After World War II he became bureau chief for *Time* and *Life* in Tokyo.

After *Life* closed in 1972, he continued to shoot for *Time* and other magazines. His books include *More Than Meets The Eye* (1959) and a 1985 autobiography, *Carl Mydans, Photojournalist*.

Carl Mydans. *Roosevelt Banner, Harwick, Vermont.* September 1936. Library of Congress.

Nadar (Gaspard-Felix Tournachon). *Mlle. Grisl.* Salt print from a collodion negative, ca. 1855.
The Bokelberg Collection, courtesy Hans P. Kraus, Jr. Inc., New York.

Nachtwey, James Allen (1948–)

American photojournalist

Nachtwey's fearless work covering civil strife at global hot spots from Belfast to Sri Lanka has earned him three prestigious **Robert Capa** Gold Medals and made him the first photographer to win a Capa and a **National Press Photographers Association** Magazine Photographer of the Year Award in the same year (1984).

His first taste of photographing a crisis situation came while he was a student at Dartmouth College and he covered a Boston busing dispute. He moved to New York and joined the **Black Star** Agency in 1981. His first international assignment came in 1981 when he went to Belfast to cover the Irish Republican Army and the hunger strike involving Bobby Sands. Later assignments brought him to Lebanon, Afghanistan, El Salvador, the Sinai, and the Philippines.

Known for the sharp quality of his color images, he was invited to join **Magnum** in 1986. His photos have appeared in *Time* (where he is on contract), *Life, National Geographic, Stern, El Pais*, and the *New York Times Sunday Magazine*.

In 1989, his book *Deeds of War* was published, and in 1990 he won a **Leica** Medal and was honored with a show at the **International Center of Photography**. In 1993 he won the **W. Eugene Smith** Award, and in 1995 a selection of his work was published in *The Inferno*. During the winter of 1997–1998, he and screenwriter Denis O'Neill collaborated on a screenplay about the life of a documentary photographer.

Nadar (b. Gaspard-Felix Tournachon) (1820–1910)

Pioneering French photographer and balloonist

A most prolific man of diverse talents—cartoonist, writer, photographer, balloonist—Nadar was one of the great photographers of the nineteenth century. In his portrait studio in Paris he made many strong and distinguished portraits of the artistic and intellectual elite. An adventurer, he sought to explore the possibilities of photography and was the first to take aerial photographs from a balloon and to photograph the catacombs of Paris by artificial light.

Born Gaspard-Felix Tournachon in Paris, he was the son of a printer and shopkeeper. He may have studied medicine but, needing money, started work as a journalist, contributing drama criticism to three papers. His circle of friends consisted of the young musicians, artists, and writers of the bohemian community in Paris, and Nadar embarked on an ambitious publication project of literary albums.

Pseudonyms were very popular at this time, and he changed his name first to Tournadar, and then shortened that. In 1849 he joined the comic magazine *Le Journal Pour Rire* and contributed cartoons alongside artists such as Gustave Doré. He conceived the idea of compiling a pantheon or series of albums of drawings of a thousand celebrities. During the preparation of his pantheon he used photographs as reference sources for his drawings. Only one edition of the album ever appeared.

Fascinated by photography, he took lessons and by 1855 had set up a studio on the roof of his house. Business was good and the portraits he made, many of his good friends, concentrated on face and gesture and emphasized the psychological characteristics of his sitters. He used no props or backgrounds for his portraits of such luminaries as Manet, Corot, George Sand, Sarah Bernhardt, Hector Berlioz, and Alexandre Dumas.

Ballooning was all the rage at this time, and Nadar became involved in publicizing flights. He combined his two passions and, after several earlier failures, in 1858 set up a darkroom in the cab of a balloon and returned to earth with a clearly identifiable image. Soon Nadar was

active in promoting the use of aerial photography in land surveying and military reconnaissance. Nadar is also credited with the first use of a series of photos to accompany an interview, when he spoke with, and his son Paul took the photographs for a dialogue with, the famous chemist Cheveul in 1886.

Family dissension and his wife's illness led to his retirement from the Paris studio in 1894. At the age of 77 he opened a photo studio in Marseilles. His final moment of glory came at the Universal Exhibition in 1900, when a special section was devoted to his work and various activities.

Naef, Weston J. (1942–)

American curator and historian

As curator of photographs at the J. Paul Getty Museum in Los Angeles since 1984, Naef has been a major figure in the international photographic community.

Naef studied at Claremont Men's College (bachelor of arts degree, 1964), Ohio State University (master of arts degree, 1966), and Brown University (doctor of philosophy degree, 1969). He became interested in photography at Brown, where he worked with Henri Zerner, **Bates Lowry,** and William Jordy on nineteenth-century painting, prints, and architecture. He worked at the Boston Public Library in the Wiggin Print Collection in 1968, and at the Metropolitan Museum of Art from 1969 to 1984 in the Department of Prints, Photographs and Illustrated Books.

Among the exhibitions he has arranged are "Era of Exploration: The Rise of **Landscape Photography** in the American West" (1975), which led to the first modern publication of Carleton Watkins's work; "The Collection of **Alfred Stieglitz**" (1978); and "Georgia O'Keeffe: A Portrait by Alfred Stieglitz" (1978). His book *The Truthful Lens* (1980), done in collaboration with Lucien Goldschmidt, is the standard reference on the subject of books illustrated with photographs. He has also contributed to publications on such figures as **Julia Margaret Cameron, Laszlo Moholy-Nagy,** and **André Kertész.**

He was a board member (1971–1984) and continues to be an advisor of the Franklin Furnace archive in New York. He recently completed a survey of the Getty photo collection for publication.

Namuth, Hans (1915–1990)

German-born, American portrait photographer

Best known for his portraits of American artists, Namuth first achieved recognition for his work with the New York School in his film about the painter Jackson Pollock, shown at the Museum of Modern Art in 1951.

Born in Essen, Germany, Namuth studied acting but fled his native country as the Nazis rose to power in 1933. While living in Paris in the 1930s, he documented the Spanish Civil War. Some of those pictures appeared in *Life* magazine and were his first published work.

He moved to New York in 1941 and served in the military in World War II. After the war he studied at The New School with **Josef Breitenbach** and **Alexey Brodovitch** and began photographing artists at work, among them Pollock. His work was published in major periodicals.

During the next 25 years Namuth traveled often to Guatemala, where he took portraits of the residents of Todos Santos, a mountain village little changed since pre-Columbian times. He published a book with a selection of those photos in 1989. He also published several books of his artist portraits.

His photographs have been exhibited at the Corcoran Gallery, the Museum of Modern Art, and the Parrish Museum in Southampton. His films, all made in collaboration with Paul Falkenberg, include works on **Alfred Stieglitz,** Louis Kahn, Willem deKooning, and Josef Albers.

National Archives: The official repository for records of the U.S. government, established in 1934 by an act of Congress. Prior to its establishment, federal records were kept by the various agencies that accumulated them. This system produced much confusion, loss, and destruction of valuable documents. In 1926 Congress provided for the construction of the National Archives building and in 1934 the National Archives was organized to accept and preserve the records of the three branches of government. This

Installation of the statue of Abraham Lincoln at the Lincoln Memorial, Washington, DC. National Archives.

archive has proved invaluable in facilitating the research of scholars in American history.

National Endowment for the Arts (NEA): An agency of the federal government formed in 1965 to support the visual and performing arts. Money is awarded to nonprofit arts organizations, museums, galleries, and theaters to support the presentation and production of their work. Until 1992 individual artist were also able to receive awards. NEA grants are highly prestigious and considered an indication of quality and professionalism in the art world, having the effect of encouraging foundations and individuals to donate to those groups that receive them.

National Geographic: Award-winning monthly magazine that features in-depth stories about cultures, nature, and science and is well known for its high-quality photography. The publication is also the journal of the National Geographic Society in Washington, D.C.

National Museum of American Art: One of the art museums that make up the **Smithsonian Institution** in Washington, D.C.

National Portrait Gallery: One of the art museums that make up the **Smithsonian Institution** in Washington, D.C. The Portrait Gallery's permanent collection consists of paintings, watercolors, prints, and sculptures of persons who have made a significant contribution to the history of the United States, from presidents to the *Apollo 11* crew. The *Catalog of American Portraits* is a study collection of more than 25,000 photographs of portraits and more than 35,000 portrait engravings and lithographs chiefly from the nineteenth century.

National Press Photographers Association: Founded in 1946 and currently having more than 11,000 members, the association includes professional news photographers (both still and video) and others whose occupation has a direct relationship with photojournalism. The organization sponsors workshops and short courses as well as monthly and yearly competitions for the best images; helps members with professional advice, insurance, and ethical standards; and publishes a monthly magazine, *News Photographer*.

National Stereoscopic Association: Founded in 1974 with 3,500 members to promote the study and collection of stereo photography and **stereographs**; to encourage the appreciation of the stereograph as a visual record of more than 120 years of U.S. history; to foster the use of stereoscopy in the visual arts and technology; to provide a forum for collectors and students of stereoscopic history. It maintains the Oliver Wendell Holmes Library, which contains important early catalogues, trade lists of nineteenth-century stereo photographs and publishers, and a collection of sterographs and books on the subject.

nature photography: Photography that concerns itself with the natural environment, ranging from the planets to mountains to insects, though generally excluding humans and human-made objects. Nature photography is highly popular with amateurs and professionals, as evidenced by the large number of books, magazines, calendars, and camera societies devoted to the genre.

Navarro, Rafael (1940–)
Spanish art photographer
A creative fine-art photographer, Navarro is best known for his *Dipticos* (1986), a book of his superimposed photographs in vertical placement. The union of images, chosen with great care, presents the viewer with a number of possible impressions or interpretations, ranging from unity, complement, reversal, transference, and metamorphosis to division. A typical diptych might be two views of the sea at night, almost indistinguishable at first glance, or two abstract, geometric patterns.

Born in Zaragoza, Navarro began his career in 1968. After experimenting with various media, he chose to concentrate on fine-art photography. He has produced several portfolios of his work and works as a freelancer in Zaragoza, Spain. He is advisor to the Photography Department at the Fundación Joan Miró in

Mathew Brady. *Incidents of the War, no. 212. Mrs. Greenhow and Daughter, imprisoned in the Old Capitol, Washington, D.C.* 1862. Albumen silver print. National Portrait Gallery, Smithsonian Institution.

Square negative carrier used with a Rolleiflex, Hasselblad, or Mamiyaflex camera. © Fred W. McDarrah.

Barcelona and was a founder of the Aragon Center for Photography in 1979.

His work is held by numerous collections, including those of the Bibliothèque Nationale in Paris and the Centro Hidalgo in Mexico City.

negative: Commonly refers to developed photographic film that renders the light and dark areas of a scene in reverse (a white object appears as black in a negative). Negatives are printed onto photographic paper, which then reverses the tones again, creating a **positive** image. Color negatives reverse not only the tone but also the color of the scene photographed.

negative carrier: A metal frame for holding a negative in an **enlarger** during the printing process. A negative carrier typically consists of two metal plates with a hole in the center, usually intended to accommodate a 35mm negative or a 2¼ x 2¼-inch negative. The negative is placed between the plates, which hold it flat and steady while the enlargement is made.

Negre, Charles (1820–1880)
Early French documentary photographer, painter, and inventor
Negre applied his artistic skill to photography and is noted for his rich studies of the south of France, where he documented ancient and medieval monuments, landscapes, the local people, and the Mediterranean ports. As an inventor he perfected a combination of **lenses** that permitted him to take "instantaneous" pictures. He also patented techniques for transferring the photographic image onto an engraver's plate for relief printing.

Born in Grasse, Negre was a minor painter who worked in the studios of Paul Delaroche and Dominique Ingres. He took up photography in 1844, possibly as a reference source for painting. He took photographs of the Salon of 1850 and was awarded a medal by Napoleon III.

Among his best-known works are his photographs of the cathedral at Chartres (1851) and his documenta-

tion of the Vincennes Imperial Asylum for the disabled. He photographed in the streets of Paris, capturing the daily life of working people. Negre was a founder of the Société Héliographique, the first photo society. His early work used the **daguerreotype** process; later, he made wet waxed-paper negatives, **albumen,** and **collodion** negatives. He also made **stereographs** of his landscape views.

His work is held by museums and collections throughout the world, including those of such institutions as the Bibliothèque Nationale in Paris and the **George Eastman House** in Rochester, New York.

Nettles, Bea (1946–)

American art photographer and teacher

Nettles has incorporated photography with other media, including drawings, handstitching, mirrors, or whatever comes to mind in her fanciful depiction of her highly personal images. She does unique, nonsilver self-portraits and pictures of family and friends using unconventional processes to convey the experiences of her life and the environment in which she grew up.

Born in Florida, Nettles earned her bachelor of fine arts degree at the University of Florida in Gainesville and her master of fine arts degree at the University of Chicago. She has taught at the Rochester Institute of Technology, Tyler School of Art at Temple University, and Nazareth College in Rochester. She won a **National Endowment for the Arts** fellowship in 1979 and a Creative Artists Public Service grant in 1976. She has published several monographs of her work, including *Flamingo in the Dark* (1979) and *Breaking the Rules: A Photo Media Cookbook* (1977). Her work is held by numerous collections such as those of the **Center for Creative Photography** in Tucson, the Metropolitan Museum of Art, and Houston's Museum of Fine Arts.

Newhall, Beaumont (1908–1993)

American photohistorian, photographer, and teacher

A pioneering historian of the art of photography, Newhall was, in the course of his illustrious career, author of the definitive *History of Photography* (5th edition, 1982), the first curator of the Museum of Modern Art's Department of Photography, and later director of the **George Eastman House** in Rochester, New York.

Born in Lynn, Massachusetts, he studied art history at Harvard University and was graduated in 1930. The following year he earned his master of arts degree there and then studied at the University of Paris and the Courtauld Institute in London. He was hired by the Museum of Modern Art as a librarian in 1935. At the invitation of the museum's director, Alfred Barr, Newhall mounted a survey exhibition, "Photography 1839–1937." The catalogue he wrote for that show was expanded, with the help of a 1947 **Guggenheim fellowship,** into his landmark history of photography.

When he was called into service in World War II, Newhall's first wife, Nancy, took over his duties as curator until 1945. In 1947 he left MOMA and the following year joined the George Eastman House, first as curator, then as director in 1958. He retired to join the faculty of the University of New Mexico, Albuquerque. In his later years he was active as a photographer, taking black-and-white images of people and structures. A strong advocate of **straight photography,** he was critical of work that combined photographs with painting or other media. He championed the work of such modern masters as **Margaret Bourke-White, Henri Cartier-Bresson,** and **Paul Strand**.

His books include *The Daguerreotype in America* (1961), *Airborne Camera* (1969), and *Latent Image: The Discovery of Photography* (1961). In *Focus: Memoirs of a Life in Photography* (1993) Newhall recollects a rich and varied life, beginning with the day he was born and covering his education, travels, friendships, married life, military service, and illustrious career.

Newhall, Nancy (1908–1974)

American photohistorian, writer, and photographer

Nancy Newhall's distinguished work, on her own and with various collaborators, including her husband (the noted photohistorian **Beaumont Newhall**), **Paul Strand,** and **Ansel Adams,** covers a wide range of projects. She wrote a biography of Adams, *The Eloquent Light* (1963), and the text for a book of Strand's photographs, *Time in New England* (1950). Other writings

Pages 332 – 333: Charles Negre. *Arles, Porte des Châtaignes.* 1852. Salt print from a paper negative. Courtesy Hans P. Kraus, Jr. Inc., New York.

include *P. H. Emerson—The Fight for Photography as a Fine Art* (1975) and the two-volume notebooks of **Edward Weston** that she edited.

Born in Massachusetts, Newhall was graduated in 1930 from Smith College, where she studied painting. She shared her husband's interest in photography and took over his curatorial duties as head of the Museum of Modern Art's photography department when he was drafted. When they moved to Rochester, New York, she served as a consultant for publications at the **George Eastman House**. In 1967 she was a founding member of the **Friends of Photography** in Carmel, California.

From the late 1950s to early 1970s she was a prolific author, publishing numerous works about photography and photographers. She died in a boating accident on the Snake River near Jackson Hole, Wyoming.

Newman, Arnold (1918–)

American portrait photographer

A master of portraiture, Newman has produced indelible images of people from all walks of life. He is best known for his portraits of celebrities, particularly artists, whom he depicts in the contexts of their profession, identifying the sitter with his or her accomplishments. Among his subjects have been such figures as John F. Kennedy, Adlai Stevenson, Marilyn Monroe, Alexander Calder, Carl Sandburg, and Frank Lloyd Wright.

Born in New York City, Newman grew up in Atlantic City and Miami Beach. As a teenager he displayed a marked aptitude for art and pursued art studies at the University of Miami, where he met **David Douglas Duncan,** who would go on to become a renowned photojournalist. Financial problems led to Newman's leaving school and taking a job offered by a family friend in a Philadelphia photo studio.

As he learned the craft of photography, his interest in the medium replaced his ambition to become a painter. He was able to support himself as a portrait photographer while pursuing his personal vision, experimenting with cut-out images, assemblage, and other modernist design possibilities. On trips to New York he met **Alfred Stieglitz, Beaumont Newhall,**

and Dr. Robert Leslie of the A-D Gallery, who offered him his first exhibit.

Newman moved to New York at the opening of the exhibit in 1942 and at this time conceptualized the basic philosophy of his future work, "to take pictures of people in their natural surroundings with a little stronger feeling about not just setting it up." In 1946 he worked on assignments for **Alexey Brodovitch,** and *Harper's Bazaar* and *Life* were his major clients. He took some of his most famous portraits at this time, including one of Igor Stravinksy sitting at his piano, which ironically Brodovitch, in one of the most noted gaffes in photo history, rejected.

Newman's assignments from magazines have taken him around the world. He was commissioned by the National Portrait Gallery in London to photograph major British figures in the arts and politics. A film about him, *The Image Makers—The Environment of Arnold Newman*, was produced in 1977, and he has won numerous awards, including the **American Society of Media Photographers** Lifetime Achievement in Photography.

Newman's work has been exhibited in one-man and group shows worldwide, in museums that include the Metropolitan Museum of Art and the Israel Museum in Tel Aviv. Selections of his work have been published in *One Mind's Eye* (1974) and *Arnold Newman, Five Decades* (1986).

new journalism: A term coined in the 1960s to describe a form of personal writing that is subjective as opposed to the more traditional approach to journalism that advocates objective, impartial reporting.

new objectivity (*Neue Sachlichkeit***):** A term originating in the early 1920s and used to characterize the work of modernist German artists and photographers, **Albert Renger-Patzsch** and **August Sander** among them, noted for their technical expertise and realist aesthetic. Their subjects were taken from everyday life and their photographs were clinically objective, stressing the role of the camera in documenting the world with precision and clarity.

news photography: Photography taken in the course of reporting on news stories and the people involved in current events for newspapers, magazines, and television. This category can be divided into hard news (political, social, or economic events that will have a strong impact on the reader's life) and soft news (entertainment, domestic, or lifestyle stories that offer human-interest or cultural import).

Newton, Helmut (1920–)
German-born fashion photographer

One of the most famous of contemporary photographers who excel at fashion illustration, Newton is best known for his overtly erotic images of women in lavish settings that resonate with sexual tension. Some critics call his fashion pictures exploitative of women; others defend them as social commentary.

Born in Berlin, he acquired his first camera at the age of 12 and started taking pictures of his girlfriends in poses copied from magazines. At 16 he left school and apprenticed himself to Yva, a fashion photographer.

He escaped Nazi Germany in 1938, spent two years in Singapore trying to make a living as a photojournalist, and then moved to Australia, where he lived until 1956, establishing himself as a freelance fashion photographer. He later moved to Paris, where he became a contributor to such publications as *Elle*, *Vogue*, *Queen*, and *Stern*.

Several collections of his photos have been published, including *White Women* (1976), *Sleepless Nights* (1978), and *Portraits* (1987), which featured his celebrity portraiture. His work has been exhibited in both group and one-man shows worldwide, and his photographs are held by numerous collections, including those of the **George Eastman House** in Rochester; Bibliothèque Nationale, Paris; and the Museum of Modern Art in New York.

nicad batteries: Short for nickel-cadmium batteries, which are rechargeable.

Nicholls, Horace Walter (1867–1941)
British photojournalist

A pioneer **photojournalist,** Nicholls began his career as a professional photographer in South Africa, where he became a magazine correspondent during the Boer War. Among his best-known works are his pictures of women who took on men's jobs during World War I, taken while he was Official Photographer of Great Britain, a title he acquired in 1917 from the Department of War Information.

Born in England, Nicholls was the son of Arthur Nicholls, a watercolor painter and early photographer. He was apprenticed as a druggist/photographer in 1884 and worked abroad in Chile. In 1892 he went to Johannesburg, taking routine portraits until he began to photograph events leading up to the outbreak of the Boer War.

He returned to England in 1902, working as a freelancer for newspapers and magazines. Among his notable images were the major events of the social calendar, from the horse races at Ascot to the rowing events at Henley. During World War I he made propaganda pictures for the government, including his series "Women at War." He was put in charge of the Photography Department at the Imperial War Museum in 1919, remaining there until 1932. Throughout his life he was a successful freelancer, known for occasional use of montage techniques to heighten the effect of his photographs.

A biography of Nicholls, *The Golden Summer* by Gail Buckland, was published in 1989, the same year an exhibit of his work was held at the **Royal Photographic Society** in London.

Niepce, Joseph Nicéphore (1765–1833)
French inventor

Although **Daguerre** and **Fox Talbot** are usually credited with the invention of photography, it was Niepce, in the 1820s, who was actually the first to capture and reproduce lasting images. Trying to find a way to improve the way he prepared plates for printing by **lithography,** Niepce made his first photographic experiments, which he called **heliography** or sun drawings, in 1816. Working with his brother, Claude, he found that bitumen of Judea, a compound that hardens when exposed to light, could produce negatives. He made his first successful, lasting copy of an engraving of Pope Pius VII in 1822.

Brought up at Chalon-sur-Saone, Joseph and his brother were both interested in scientific pursuits. In 1793, when they were officers in the army stationed in Sardinia, they tried to record images with a **camera obscura**. In 1807 the brothers patented the Pyreolophore, an engine that could move a boat. For the next 20 years they sought to improve and market their invention.

Niepce continued his experiments with photography with advice from his brother, who moved to Paris. His first successful photograph taken from nature was in 1826 and showed the courtyard of Niepce's house. **Beaumont Newhall,** in his history of photography, relates how he saw that view in 1952, when he visited Niepce's house. That photograph, the oldest surviving picture known, is now owned by the University of Texas at Austin.

Niepce hoped to gain the patronage of the Royal Society in London for his work but was not successful in that endeavor. He returned to Paris, and after the death of his brother in 1829 he decided to collaborate with Daguerre to perfect his heliography process for practical use. But Neipce died in 1833, without having seen his process brought to world attention. His son, Isidore (1805–1868), continued the partnership with Daguerre briefly, receiving only token payment for his father's invaluable contributions to Daguerre's work.

night photography: Because **light** is essential to photography, night photography requires special considerations, such as the use of a long exposure and a **tripod**. Artificial lighting can often be used in night photography, whether it is from streetlights or from an **electronic flash**. Night photography often uses high-speed film or **infrared** film to capture scenes that would otherwise be unphotographable.

Nikon: Japanese camera company that produces a line of professional and amateur **cameras** and **lenses**. Well known for its durable, high-quality professional equipment.

Nikon Historical Society: Founded in 1983, it has 400 members. A for-profit, multinational organization for persons interested in Nikon cameras.

Nilsson, Lennart (1923–)

Swedish nature photographer

Nilsson has made a lifelong career of microphotography and won the **Leica** Medal of Excellence in 1990 for his classic series on the development of the fetus. A master of photo technology, he produced two landmark books, *A Child Is Born* (1965), showing the human embryo from fertilization to birth, and *Behold Man* (1973), revealing the inner workings of the human body.

Born near Stockholm, he was encouraged to become a photographer by his father and uncle, who owned a studio. He has become internationally recognized for his work in such diverse areas as insect and undersea photography, news photos and portraits, and the interior-of-body images produced with the aid of a scanning electron microscope.

Nilsson's photo essays appeared in *Life* magazine for many years, and he has published ten books of photographs. He was awarded an honorary degree in medicine by the Karolinska Institute in Stockholm. His work has been exhibited at Stockholm's Museum of Modern Art and in touring shows worldwide.

Nixon, Nicholas (1947–)

American architectural and portrait photographer

Using an 8 x 10 **view camera** for his medium of expression, Nixon is known for his clear, precise detail that defines unnoticed objects. His early work consisted of elevated views of Boston and New York before he moved to portraiture.

A graduate of the University of Michigan and the University of New Mexico, he has had one-man shows at many prestigious institutions from New York's Museum of Modern Art to London's Victoria and Albert Museum and is included in such collections as those of Seagram's, the **George Eastman House,** and the Fogg Art Museum.

He is a three-time **National Endowment for the Arts** winner (1976, 1980, 1987) and a double **Guggenheim** honoree (1977, 1986). His books include *Pictures of People* (1988) and *Family Pictures* (1991).

Noel, Frank E. (Pappy) (1905–1966)

American photojournalist

A longtime staffer for the **Associated Press,** Noel had a career that was marked by achievement and life-threatening peril; he won the 1943 **Pulitzer Prize** and while he was covering the Korean War he was captured and held as a prisoner of war for three years.

He joined the AP and was assigned to the Malayan jungle campaign after the bombing of Pearl Harbor. Then, he was assigned to cover Burma and India. He was on a boat that was torpedoed and sank in the Indian Ocean. From his lifeboat he snapped a prize-winning picture of a seaman in another vessel holding out his hand in silent supplication for water.

Later, he covered Berlin during the early Cold War, and when war broke out in Korea he volunteered to cover it. He was captured and held prisoner from 1950 to 1953. He was able to photograph other U.N. POWs, but when he tried to escape he was caught and thrown into solitary confinement for seven weeks. He finished his career working for the AP in Florida.

Noggle, Anne (1922–)

American landscape and documentary photographer

Noggle achieved recognition as a photographer in midlife, after an adventurous start in aviation. She earned her pilot's license at 18, was a longtime Air Force flyer and officer, and finally picked up a camera as a college undergraduate at age 38.

Always fascinated with aviation, she was a Women's Air Force Service pilot during World War II and from 1945 to 1953 was a cropduster and flight instructor. Then she joined the Air Force, where she rose to the rank of captain until leaving in 1960 to attend college. She got her bachelor of fine arts degree in art history (1970) and her master of fine arts degree in art (1976) from the University of New Mexico. In addition to her photography, she has taught at her alma mater since her graduation.

Her early works were long, narrow 140-degree images made with a 35mm Panon camera. Her later work documented the aging process; she focused on elderly women. In her book *The Silver Lining* (1978),

Noggles portrayed a series of middle-aged and elderly couples. In 1975 in *Face Lift* she recorded her own recovery from the surgical procedure.

She won **National Endowment for the Arts** awards in 1975, 1978, and 1988 and a **Guggenheim fellowship** in 1982. She has had numerous gallery exhibitions, many focusing on her portraits of seniors and female pilots, especially from World War II. Her work is held by such collections as those of the **George Eastman House,** the San Francisco Museum of Art, and the **Smithsonian Institution**.

Norman, Dorothy (1905–1997)

American writer, activist, and photographer

Norman is known for her long association with **Alfred Stieglitz,** her social conscience, and portraits of prominent artists and writers.

After attending Smith College and the University of Pennsylvania, Norman came to New York and in 1928 met Stieglitz. From 1930 to 1937 he made a series of photographs of Norman. She helped him open his famous gallery **An American Place,** began publishing the intellectual journal *Twice a Year*, and started taking her own pictures. Eventually, she would photograph Marc Chagall, Marcel Duchamp, Albert Einstein, and Mohandas Ghandi. Not primarily a photographer, she stopped taking pictures, with some few exceptions, in the late 1950s.

From 1942 to 1949 she wrote a column for the *New York Post* and also worked for a wide variety of civic and cultural organizations, from Planned Parenthood to the National Urban League. Her books include *Alfred Stieglitz, American Seer* (1978), *Civil Liberties and the Arts* (1964), and *Intimate Visions* (1993), which fully explores the Norman-Stieglitz relationship and includes many of her photographs of dramatic still-lifes, portraits, and New York City buildings.

Notman, William (1826–1891)

Scottish-born, Canadian portrait and documentary photographer

Notman, who was born in Scotland, became Canada's most famous photographer. His portraits,

tableaux, and montages of Canadian life earned him the title of Queen Victoria's Photographer to the Queen.

He emigrated to Montreal in 1856 and opened a small portrait studio. He prospered from the start—his work was of high quality and he charged reasonable prices. He achieved recognition after the Grand Trunk Railway hired him to document the building of the Victoria Bridge across the St. Lawrence River. His *cartes-de-visite* of the bridge were wildly popular and earned him the attention of the queen. Her interest in him led to his renown, and by the time he was 30, he had established studios in

Montreal, Ottawa, Toronto, and Nova Scotia, as well as U.S. branches in New York and Boston. In addition to portraits of the elite, he produced popular *cartes-de-visite* of hunters, trappers, Canadian Indians, and other subjects.

One of his innovations was the creation of hand-painted composite montages. His fame led to his being put in charge of all photography at the U.S. Centennial Exhibition in Philadelphia, a major honor that aroused some controversy because he was not a U.S. citizen. His sons continued his business for many years after his death until his archive was presented to McGill University in Montreal.

Ockenga, Starr (1938–)

American photographer, writer, and teacher

Ockenga is known for her insightful photo essays on the lives of women. The author John Updike in his introduction to her 1975 book *Mirror after Mirror: Reflections on Woman,* noted the formal beauty of her work and said her photographs hold a hidden mirror up the face of woman.

A graduate of Wheaton College, she became interested in photography and got work as a freelancer for some Boston-area newspapers. She enrolled at the Rhode Island School of Design and after studying with **Harry Callahan** and **Aaron Siskind** got her master of fine arts degree in photography in 1972.

She has taught at the Massachusetts Institute of Technology, where she ran the Creative Photography Laboratory (1977–1982), and Bennington College and won a **National Endowment for the Arts** award in 1981, which she used to travel the Northeast for two years, taking pictures of porches. Her photographs and articles have appeared in many publications, including *Life, Esquire, Victoria,* and *Horticulture.*

Her published works include *Women See Men* (1977), *Dressup* (1978), and *On Women and Friendship* (1993). In 1998 her book *Earth on Her Hands: The American Woman in Her Garden,* featuring 18 women gardeners, was published. Ockenga's photographs have been shown at numerous galleries and museums, including the Bibliothèque Nationale in Paris and the Fogg Museum in Boston. Among the private and public collections holding her work are those of the Addison Gallery of American Art, the Museum of Modern Art in New York, and the High Museum in Atlanta.

offset printing: A printing technique in which the ink is transferred from the roller to a soft rubber blanket and then transferred onto the paper. Commonly referred to as offset **lithography,** this technique is similar to lithography in that both are based on the principle that water and oil do not mix.

Okamoto, Yoichi Robert (1915–)

American documentary photographer

The post of personal photographer of the president of the United States was established by Lyndon Johnson in 1963, and Okamoto was the first to occupy the position.

A native of Bronxville, New York, Okamoto was graduated in 1938 from Colgate University with a major in international law and a minor in fine arts. With the Depression in full swing, he took the first job he was offered—photographer in a nightclub. He later became a photographer for the *Syracuse* (New York) *Post-Standard.*

After the outbreak of World War II he joined the army, although with his Japanese background he encountered much prejudice in the military. He served in Europe in the Quartermaster Corps until he persuaded then-General Dwight D. Eisenhower to transfer him to a job in photography. He was finally appointed a photo officer and spent the next nine years covering the occupation of Austria for the government.

LBJ became familiar with Okamoto's work when Okamoto was head of the U.S. Information Agency's pictorial branch and accompanied the then–vice president on overseas assignments. He appointed him presidential photographer after succeeding to the presidency upon the assassination of John F. Kennedy. Okamoto's approach to the job was not only to take the best pictures he could but to go beyond formal situations and photograph the president at various activities, to provide a unique document of history in the making. He was successful in his assignment and remained with Johnson until he left office in early 1969.

Starr Ockenga. *Dressup.* 1978. From *Dressup: Playacts and Fantasies of Children*, Addison House, 1978.
© Starr Ockenga. Courtesy of the photographer.

Okamoto has continued as a commercial photographer in the Washington area.

online: A personal **computer** or networked computer system that is connected via **modem** and telephone line to a computerized or digital source of information is said to be online. The most common use for online refers to connection to the **World Wide Web** or to private online services such as America Online, the **Microsoft** Network, or CompuServe. It is necessary to go online to send or receive electronic mail (e-mail), a growing form of communication. Photographs are often sent from the field to the newsroom online. The pictures are transferred digitally via phone lines directly into computers in the newsroom, where they are cropped, sized, edited, and put into layouts before publication. Text is also sent from the field to the newsroom in a similar manner.

open flash: A technique whereby the camera **shutter** is opened in a totally dark environment, and the exposure is made by firing one or more flashes. It is often used, for example, in **high-speed photography** when the time taken for the shutter to open would last longer than the event being photographed.

optical viewfinder: A device, usually built into a non-single **reflex camera,** consisting of a simple optical system used to give a close approximation of the field of view encompassed by a particular lens.

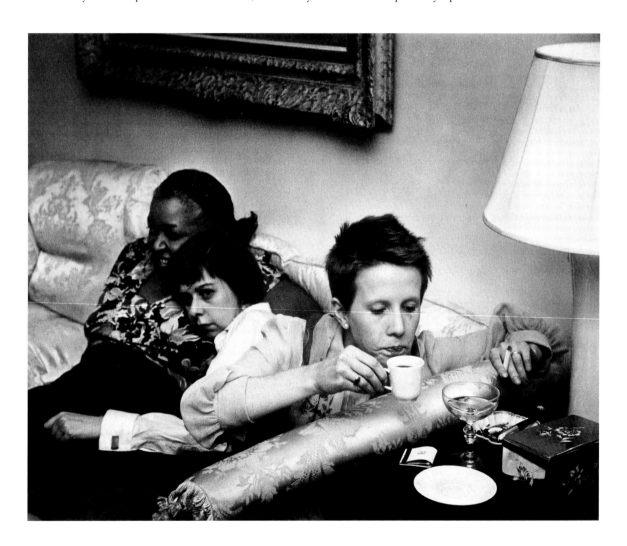

Ruth Orkin. *Opening Night Party of* Member of the Wedding: *(l to r) Ethel Waters, Carson McCullers, and Julie Harris, 1950.* © Ruth Orkin, courtesy Ruth Orkin Archive.

optics: The study of **light** and how we perceive it. Optics is a branch of physical science that deals with the properties of both visible and invisible light and how it travels, affects objects, is perceived, and has been instrumental in the development of lenses for photography and science.

Orkin, Ruth (1921–1985)

American photojournalist and filmmaker

A woman of wide-ranging talent and abilities, Orkin began her career as a photojournalist, with regular publication in *Life* and *Look* magazines and other leading publications. In 1953 she won third prize in *Life*'s first photography contest and in the same year received the Silver Lion of San Marco at the Venice Film Festival for co-directing, with her husband, **Morris Engel,** *Little Fugitive,* which was also nominated for an Academy Award. Her first book, *A World Through My Window* (1978), was a selection of color photos taken from her apartment window, facing Central Park, over a period of 25 years.

Born in Boston, Orkin grew up in Hollywood, where her mother, Mary Ruby, was a star of silent films. She became interested in movies and photography at an early age. With her first camera, a 39-cent plastic Univex, she took photos of her classmates in high school.

In 1944 she moved to New York to become a free-lance photojournalist. Her work was so well received that in 1959 she was voted one of the top ten women photographers in the United States, along with **Berenice Abbott, Dorothea Lange,** and others. Her magazine assignments were varied: She photographed celebrities like Leonard Bernstein and Marlon Brando and also did photo essays on Israeli immigrants and musicians in rehearsal.

Orkin's second book, *A Photo Journal* (1981), was a retrospective of her work including both her photojournalistic black-and-white and later color shots. She was represented in **Edward Steichen**'s "**Family of Man**" exhibit, and a major solo exhibit was held at the **International Center of Photography** in 1995. Her work is held in the collections of numerous museums, including those of the Metropolitan Museum of Art and the Museum of Modern Art in New York City.

O'Sullivan, Timothy (1840–1882)

Early American documentary photographer

O'Sullivan's brief but brilliant career began with the powerful Civil War photographs he took on the battlefields, both early in the war as an employee of **Mathew Brady** and later with **Alexander Gardner,** who published O'Sullivan's extraordinary pictures of the battle of Gettysburg in his Civil War *Sketchbook.* After the war O'Sullivan joined a series of western expeditions, photographing the remote mountain ranges, deserts, and canyons as well as the tropical jungles of Panama.

Born in New York to recently arrived Irish immigrants, O'Sullivan became an apprentice in Brady's New York studio before moving to the Washington branch managed by Gardner. O'Sullivan was a member of Brady's Camera Corps, chosen to photograph the war. When Gardner left Brady's employ to work on his own, O'Sullivan joined him and contributed almost half of the photographs that later appeared in Gardner's record of the war. O'Sullivan was present at major battlefields, from Bull Run to Appomattox.

O'Sullivan went on his first expedition west in 1867, with Clarence King's Fortieth Parallel Survey, which set out from Sacramento across the Sierra Nevada to western Nevada. On this trip he took the earliest-known photographs of a mine interior in Virginia City's Comstock Lode. The survey continued until 1869, working in Utah, southern Wyoming, and northern Colorado.

In 1870 O'Sullivan traveled to Panama as photographer for the Darien Expedition, which studied the practicality of building a canal across the isthmus. Sullivan returned several times to the West working for the U.S. Geological Survey. In 1873 he photographed Zuni and Magia pueblos; his photographs of the Indians are remarkable for the sincere interest and respect he conveyed in his natural, **candid** shots. O'Sullivan returned to Washington in 1880 and was appointed chief photographer for the U.S. Treasury Department. He was already ill with tuberculosis and served for only five months before returning to New York, where he died.

Outerbridge, Paul Jr. (1896–1958)

American fashion photographer

Best known for the avant garde fashion and still-life photography he created for *Vogue*, *Harper's Bazaar*, and *Vanity Fair*, Outerbridge also experimented with new techniques for making photographic images, perfecting an elaborate and costly **carbro** color-printing process. His published photos had abstract qualities that were heightened by their technical perfection. One aspect of his work, his female nude photographs, were considered shocking in their suggestiveness and remained virtually unknown to the general public until after his death.

Born in New York, he was interested in art as a youth and studied at the Art Students League. He designed theatrical posters and worked on stage design. In 1917 he joined the Canadian Air Force and later the Army, where he assisted in the photo documentation of a lumber camp. He entered the **Clarence White** School to study photography in 1921, and nine months later his first photo, a still-life of a milk bottle and some eggs, was published in *Vogue*.

A successful freelance photographer, he traveled to Paris, where he met and was strongly influenced by **Man Ray**. He worked in France, Germany, and London and returned to New York in 1929. His experiments with color processing led to publication of his book *Photographing in Color* (1940). He moved to Hollywood in 1943 and set up a small studio in Laguna Beach. He continued publishing picture stories in magazines and wrote a column for *U.S. Camera* magazine in 1954.

Outerbridge's work is held by major collections, including those of the Metropolitan Museum of Art, Boston's Museum of Fine Art, and the **George Eastman House**.

outtake: Any photograph or slide eliminated or discarded during the **editing** process.

overdevelopment: The chemical process that follows exposing photographic film and paper is called development. When this process is done excessively it is called overdevelopment, and may result in a negative that is very dense or a print with too much **contrast**. Sometimes overdevelopment can be corrected by the use of a **reducer,** which removes metallic silver from a negative. A commonly used reducer made by Kodak is called Farmer's Reducer.

overexposure: Exposure is the amount of **light** allowed to reach photographic film or paper. When too much light reaches the material, overexposure occurs. When film and paper become overexposed, the material becomes very dark and is often unusable. A **light meter** set for the film's **ASA** can help prevent overexposure.

overhead projector: A device for **enlarging** and projecting images from paper and **transparencies** onto a screen, so called because the paper lies horizontally and the image is projected up and then out toward the screen, over the heads of viewers.

Owens, Bill (1938–)

American documentary photographer

Owens's black-and-white photography documents the lives of ordinary people in American suburbia. A published selection of his photographs, *Suburbia* (1973), portrayed such homely events as a Tupperware party, a parent–child confrontation in an untidy bedroom, and a Fourth of July block party.

Born in San Jose, Owens earned a bachelor of arts degree from Chico State College in 1963. During the time he was collecting photos for his book on suburbia he worked for the *Livermore* (California) *Independent*.

His work is held by major collections, including those of the Museum of Modern Art in New York City, the San Francisco Museum of Art, and the Bibliothèque Nationale in Paris.

owned property: Property that, at the time it is offered for sale at auction, is owned solely or partially by the auction house.

Paul Outerbridge, Jr. *Piano.* 1924.
Courtesy G. Ray Hawkins Gallery, Santa Monica.

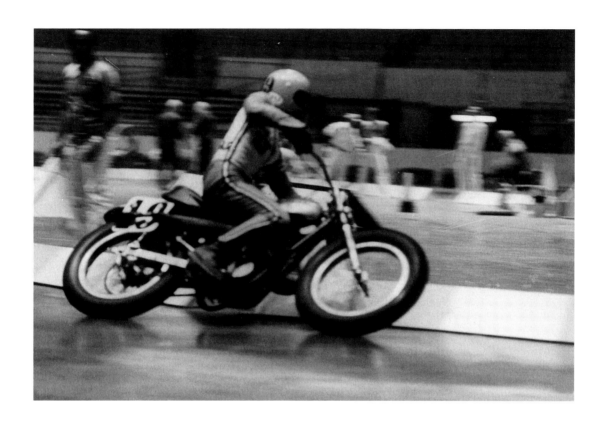

When the camera moves with the subject (panning), the background is blurred
while the subject is in focus. © Fred W. McDarrah.

Page, Tim (1944–)

British photojournalist

Only 20 years old when he arrived in Vietnam to start his photographic coverage of the conflict there, Page has become identified with his memorable images of the wars in southeast Asia, as well as his coverage of the Six-Day War in Israel and other assignments worldwide. In 1997 he and **Horst Faas**, two photographers who worked and were wounded in Vietnam, compiled *Requiem*, a brilliant selection of work by photographers who were killed in Vietnam and Cambodia between the mid-1950s and 1975. It is a touching legacy to the courage and talent of some of the greatest photojournalists of the century, among them **Robert Capa** and **Larry Burrows**.

Born in Tunbridge Wells, Page began his photo career in southeast Asia, where he covered the civil war in Laos for United Press International. His Vietnam pictures appeared in **Associated Press** and UPI dispatches and in *Paris Match*. He was wounded four times, the final time almost fatally.

In 1970 he moved to Rome on contract to Time-Life, and the following year he went to the United States, becoming a photographer on the west coast for the French photo agency SIPA.

In 1979 he returned to England and was the subject of a film, *Mentioned in Dispatches*. His return to Cambodia in 1994 inspired him to found the Indochina Media Memorial Foundation and to do *Requiem*. His work has been published in numerous books, including *Tim Page's Nam* (1983) and *Mid-Term Report* (1995). Page's photos have been exhibited at such venues as the Institute of Contemporary Arts and the Victoria and Albert Museum in London.

panchromatic: Sensitive to all colors of light, which most photographic **film** is.

panning: A technique for photographing moving objects in which the camera is moved in the same direction as the subject, creating a sharp-focused image with a blurred background. This technique gives the added impression of action and movement in the final photograph.

panoramic photography: Photography that has a very wide horizontal shape, at least twice the length of the height. Panoramic photography can be achieved in a number of ways: by using a panoramic camera, which is now widely available; by making consecutive photographs while panning across the horizon and then joining them together; or by **cropping** an image so that its width is at least twice its height.

Panzer, Mary Caroline (1955–)

American curator and scholar

Curator of photographs at the **National Portrait Gallery** in Washington, D.C., since 1992, Panzer is a noted scholar and writer in American art and photography in the nineteenth century, particularly in portraiture.

Born in Flint, Michigan, she completed her education at Yale University (bachelor of arts, 1976), Columbia University (master of arts, 1980), and Boston University (doctor of philosophy in American and New England Studies, 1990). From 1989 to 1991 she was assistant professor of art history and curator of photographs at the Spencer Museum of Art, University of Kansas. The following year (1992) she served as assistant director of the David and Alfred Smart Museum at the University of Chicago. Panzer has also been guest curator at the Hudson River Museum and Yale University Art Gallery.

Her publications include *Halsman: A Retrospective* (1998), *Mathew Brady and the Image of History* (1997), and "Thomas Eakins, Science and Photography" in *Eakins and the Photograph* (1994).

paparazzi: Street photographers who take **candid** shots of celebrities and sell them to celebrity and gossip magazines and newspapers. Some single paparazzi images have earned individual photographers over 6 figures. The term had its origin in the 1950s, when a central character named Paparazzo was featured in Federico Fellini's film *La Dolce Vita*. The movie was about Roman café society and the character of Paparazzo was inspired by real-life Italian freelancer **Tazio Secchiaroli**. There are a number of theories about the etymology of the name Paparazzo. Some claim it is a contraction of the Italian words *papagallo* (parrot) and *ragazzo* (guy). Fellini once said it was the name of a childhood friend "who liked to imitate the buzzing sounds of pesky insects." Perhaps the most famous *paparazzo* in the United States has been **Ron Galella**, who made a career out of photographing Jackie Kennedy-Onassis and her children. Annoyed by his constant presence, she eventually sued to keep Galella away from her. However, the court ruled that she was a public figure, and Galella could photograph, though he was ordered to stay 100 feet from her at all times. Paparazzi are noted for their aggressiveness, a necessary trait in competing with other photographers for a unique, saleable shot. In 1997, paparazzi were initially blamed for chasing the car in which Princess Diana was riding and causing the ensuing crash in which she and two other people were killed.

papers: Paper is made from thin sheets of cellulose pulp from wood, rags, cotton, and other fibrous materials. In photography, paper usually refers to light-sensitive photographic paper for making prints, which is available in a wide variety of sizes, surfaces, and contrast grades. Paper commonly has some **acid** in it that will cause it to become brittle, to discolor, and to crumble eventually. Photographic papers and other fine papers are acid free so as to last longer.

paper safe: A light-tight box for storing photographic paper while it is in use in the **darkroom**. A paper safe has a hinged door for quick and easy access.

parallax: The seeming change in position of objects when they are viewed from different viewpoints. For example, your right eye sees things from a slightly different position from your left eye, and that difference is parallax. In photography, parallax occurs in a camera that does not have through-the-**lens** viewing but rather a **viewfinder,** making what the photographer sees and the final photograph slightly different. This effect is more pronounced the closer you are to an object; distant objects are unaffected.

Pare, Richard (1948–)
British photographer, teacher, and curator
Pare is an architectural photographer, as well as a lecturer and editor. He was editor, one of the photographers, and one of the writers of *Court House* (1978), cited by **John Szarkowski,** former director of the Museum of Modern Art's photography department, as "one of the most original, intelligent, and useful architectural documentations of recent years. . . . exemplary of the social and artistic history of this country."

Born in Portsmouth, England, Pare received a bachelor of fine arts from the Ravenswood College of Art and Design in 1970 and a master of fine arts from the Art Institute of Chicago in 1973. His book on courthouses was also the basis for a traveling exhibit in major museums in the United States and England.

Pare's work has been exhibited in the Royal Academy, the Corcoran Gallery, and the Center for Architecture in Montreal. His work is held by such collections as those of the Museum of Modern Art in New York, Stedelijk Museum in Amsterdam, and the Victoria and Albert Museum in London.

He is currently curator at the Canadian Center for Architecture in Montreal and has been consulting curator for the Seagram Collection. Pare has taught photography in colleges in the United States and has received a Photokina Award.

Gordon Parks. *Women in Telephone Booths inside the Hurricane Ballroom, New York City. 1943* Library of Congress/Corbis.

Parker, Olivia (1941–)

American art photographer

Parker's photographs, reminiscent of early American rural scenes, consist of found objects that are arranged into a still-life composition and then photographed.

Born in Boston, she earned a bachelor of arts degree from Wellesley College in 1963. Her work is in the collection of the Victoria and Albert Museum in London, the Boston Museum of Fine Arts, and the Museum of Modern Art in New York. She has exhibited in museums and galleries throughout the United States, including one-person shows at the **Friends of Photography** in Carmel, California, and the **George Eastman House** in Rochester. Her published work includes *Under the Looking Glass* (1983) and *Darkroom Dynamics* (1979), to which she was a contributor.

Parks, Gordon (1912–)

American photographer, novelist, filmmaker, and composer

A versatile artist, Parks began his photographic career at the **Farm Security Administration** (FSA) and went on to become an important *Life* magazine staffer, where his work has been most affecting and heartfelt in his portrayal of black suffering and poverty.

Born in Fort Scott, Kansas, Parks writes in his 1975 book *Moments Without Names* that he endured a "black childhood of confusion and poverty. The memory of that beginning influences my work today." He never finished high school and worked at many jobs as a youth, among them dining car waiter, semi-professional ballplayer, and piano player. Self-taught as a photographer, he got his first job in the field with **Roy Stryker** in the FSA in 1942, just as the program was in its last years. A picture Parks took while at the FSA,

showing a cleaning woman with mop and broom in front of an American flag, became a symbol of the ironies of racism.

He followed Stryker to Standard Oil of New Jersey and remained there until he moved to *Life* in 1949, working there until 1972. His *Life* assignments were varied, ranging from gorgeous color spreads of fashionable scenes to memorable essays on Harlem street gangs. His photo essay about a slum boy in Rio de Janeiro brought in so much money in charitable donations that the boy was brought to the United States and treated for what had been considered a terminal illness.

His 1963 autobiographical novel, *The Learning Tree*, was an international bestseller, and Parks wrote, produced, directed and scored the music for the movie production. In 1971 he directed *Shaft*, followed by *Shaft's Big Score* (1972) and *Leadbelly* (1976). He was a founder of *Essence* magazine and was director of its editorial office from 1970 to 1973.

A retrospective exhibit of Parks's photos was organized in 1997 by the Corcoran Gallery in Washington and later traveled to nine cities; subsequently, Parks donated a large collection of his prints to the Corcoran. An earlier retrospective was held at the **International Center of Photography** in 1975. He has been the recipient of many honorary degrees and journalism awards, and his photographs are represented in major collections around the world.

Parry, Roger (1905–1977)

French surrealist photographer

An imaginative **surrealist** artist, Parry employed a variety of experimental techniques, including multiple exposures, photomontages, negative prints, and solarization, in his work. Introduced to photography by **Maurice Tabard**, Parry assisted his mentor in advertising and illustration work while following his avant garde spirit with his own dreamlike images.

Born in Paris, Parry was a student at the Ecole des Beaux Arts, where he concentrated on painting. He met Tabard in 1928 and learned photography from him. Parry's work was published in the leading French magazines of that era—*Photographie*, *Voila*, and *Vu*—and in

1929 he illustrated with his photographs a book of prose and poetry by the writer Léon-Paul Fargue. The book was published by Gallimard, a publisher with which he would remain associated. He eventually took over management of Tabard's studio and traveled to Africa and Tahiti in the early 1930s. Parry's photographs were exhibited at the **Julian Levy** Gallery in New York and in a group show of surrealists. After serving as a war correspondent for Agence France Presse in World War II, he went to work for Gallimard as head of photography and art director, a post he held for the remainder of his career.

passepartout: An adhesive tape for use in picture framing and/or a type of picture-**mounting** technique in which the glass, picture, and mat are all attached. From the French for "passes through."

paste-up: Artwork and text laid out on a board and ready for reproduction as a page in a newspaper, magazine, brochure, or other medium. Paste-up should be designed for maximum impact of the artwork and text and is usually done by a designer or art director. The term refers to the traditional method of cutting and pasting text and artwork directly onto a board, which was then photographed and made into a printing plate. **Computer software** now does this job without the use of paper, cutting, or pasting.

Penn, Irving (1917–)

American fashion and portrait photographer

In Penn's long and productive career he has achieved recognition for his creative fashion and advertising photography as well as for his independent art photographs of celebrity portraits, found objects, and disappearing aborigines in remote areas of the world. His substantial body of art photography uses paper hand-coated with a platinum solution to produce subtle nuances of texture and tone.

Born in New Jersey, Penn studied design with **Alexey Brodovitch** at the Philadelphia Museum of Art School of Industrial Art from 1934 to 1938. His first drawings were published in *Harper's Bazaar* while he was living in New York and working as a graphic artist. He

went to Mexico in 1942 to paint but was dissatisfied with his own work.

He was hired by **Alexander Liberman** to work at *Vogue* in 1943 and took up photography at Liberman's suggestion, when other photographers refused to follow his cover designs. In 1950 Penn married a model, Lisa Fonssagrives, whom he photographed for some of his best fashion work. Penn continues to photograph for Condé Nast Publications and also does his commercial and art work.

His 1991 monograph *Passage: A Work Record*, won the Prix Nadar in France for the best photographic book of the year. Other selections of his photographs have appeared in *Moments Preserved* (1960) and *Irving Penn* (1984), with text by **John Szarkowski**. His work has been exhibited at the Los Angeles County Museum of Art, the Art Institute of Chicago, and the Metropolitan Museum of Art and is held by numerous collections.

In 1996 he donated his archives, including 134 original prints, to the Art Institute of Chicago. The gift was the impetus for a retrospective that opened at the museum the next year and was set to travel through the year 2000.

Penrose, Roland (1900–1984)
British art patron, painter, and photographer
A member of international avant garde communities in London and Paris and close friend to **Man Ray** and **André Breton,** Penrose organized the International **Surrealist** Exhibition in London in 1936 and founded the London Gallery. He was a backer of Max Ernst's film *Une Semaine de Bonté* (1936) and author himself of a Picasso monograph, *Picasso: His Life and Work* (1958).

Born in London to a well-to-do banking family, Penrose was an ambulance driver in Italy during World War I. He completed his studies at Cambridge University, where he met the artist and critic Roger Fry, who encouraged him to pursue a career in the arts. He developed a great interest in surrealism and invested in films and books that explored the movement's themes of dreams and fantasy.

He met **Lee Miller** in 1937 and on a trip with her took the photographs and wrote the text for his *The Road Is Wider than Long*. After World War II he married Miller and was instrumental in the creation of the Institute of Contemporary Art. He won several awards, including a knighthood, and was made a trustee of the Tate Gallery.

Penrose's Pictorial Annual: The Process Yearbook: Edited by William Gamble and published in London from 1905 through 1940, *Penrose's Annual* was one of the most visually interesting art annuals of the day. It contained scholarly articles on topography, bookmaking, and illustration. Photographs were reproduced in various processes, and it was the first publication to feature color photographs, **photogravures, rotogravures, collotypes,** and **halftones**.

Peress, Gilles (1946–)
French photojournalist
Peress expresses with his documentary photo essays his interest in social conditions and news events worldwide.

Born in Neuilly-sur-Seine, Peress studied at the Institut d'Etudes Politiques in Paris from 1966 to 1968 and the Université de Vincennes from 1968 to 1971. He completed his first photo assignment about a coal mining village in the south of France in 1970. Two years later he joined the **Magnum Photos** agency and has served as vice president and president of the agency.

He has documented immigration in Europe, particularly Turkish immigrants in Germany, Belgium, and France. He made the first of many trips to northern Ireland in 1970, beginning a long-term effort to photograph the "troubles." He moved to New York in 1975 and has worked in the United States covering news events. In 1979 he went to Iran and photographed the hostage crisis. His photographs were published in the *New York Times* and later in book form as *Telex: Iran* (1983).

He has published several books, including *Power in the Blood: Photographs of the North of Ireland* (1996) and *Farewell to Bosnia* (1994). His many awards include the **W. Eugene Smith** Award (1984), **National Endowment for the Arts** fellowships (1992, 1984, 1979), and the Erich Salomon Prize (1995). His work has been in exhibitions at the Museum of Modern Art in New York, the

Art Institute of Chicago, and the Cranbrook Art Museum. Peress has also done videos and films on Bosnia, Peru, and New York street musicians.

He is the winner of the 1998 **Alfred Eisenstaedt** Award for Magazine Photography and a 1997 Art Directors Club Award for his 200-photo web site, "Bosnia: An Uncertain Path to Peace."

Perma Wash: A chemical made by the Heico Company that is used to remove residual fixer from fiber-based photographic prints for archival stability. The procedure is to wash the print for at least five minutes in running water (or three changes of fresh water) after fixing. Then the print is placed in a working solution of Perma Wash with intermittent **agitation** for five minutes, followed by a final **wash** of running fresh water for 20 minutes, then dried. This chemical is similar to Kodak's **Hypo Clearing Agent**.

perspective: The apparent depth of a three-dimensional scene when rendered in a two-dimensional medium such as photography, drawing, or painting. Ancient drawing did not take perspective into account, so objects in the foreground and background appeared the same size. In perspective drawing, objects in the foreground appear larger than those in the background and block the view of things behind them. Objects gradually become smaller until they reach the horizon line. The advent of perspective drawing is credited to an Italian architect named Brunelleschi in the 1420s.

Pfahl, John (1939–)

American photographer and teacher
Pfahl brings wit and technical expertise to new color photography. His altered images, ranging from landscapes to portraits, have been described as groundbreaking.

A New Yorker who studied at Syracuse University, Pfahl joined the Army after graduation and then worked with an advertising photographer in Manhattan. In 1966 he enrolled in the new graduate program in color photography at Syracuse. After graduation, he began teaching at the Rochester Institute of Technology, while

articulating his own vision in various bodies of work.

His first project, done between 1969 and 1973, was a series of sculptures in which photographic imagery was screen-printed with iridescent, transparent inks onto plastic sheets that were then vacuum formed. In 1974, he began photographing fabricated elements in the landscape as scores for "new music" in collaboration with the composer David Gibson.

In 1978 he began making images that only implied his participation; in 1979 he started shooting from the interiors of buildings, focusing on ready-made views through windows. The resulting book, *Picture Windows* (1987), he called "a step beyond landscape photography." Other publications with Pfahl's work include *A Distanced Land* (1990), *Arcadia Revisited* (1988), and *Altered Landscapes* (1982).

Pfahl was awarded **National Endowment for the Arts** fellowships in 1977 and 1990 and Creative Artists Public Service awards in 1975 and 1979. In addition to the five years he taught at Rochester, he was a visiting professor in 1983 and 1984 at the University of New Mexico and has been a guest lecturer at several other institutions. Pfahl's work is held by numerous public and private collections, including those of the Albright-Knox Art Gallery in Buffalo, the Chicago Art Institute, and the **George Eastman House** in Rochester. He has participated in group shows and had solo exhibits at such institutions as the High Museum in Atlanta, the Los Angeles County Museum, and the **Friends of Photography** in Carmel, California.

pH: The standard measurement of acidity and its opposite, alkalinity. Neutral is pH 7, compounds registering over 7 on the pH scale are **alkaline,** and compounds under 7 are **acid**.

Phillips, John (1914–1996)

English photojournalist
Phillips was the first *Life* photographer assigned overseas and had a 50-year career with the magazine. He has been described as "the grand-godfather of **photojournalism**, a master of lenses and multiple languages; elegant, exuberant and chrome-steel effec-

tual, who has recorded in his own peripatetic way some of the freshest footprints of history."

Born in Algeria, he moved with his family to France in 1925. His summer job from ages 13 to 20 (1927 to 1934) was as an apprentice to the municipal photographer of the city of Nice. His first assignment for *Life* came in 1936, when the magazine hired him to cover Edward VIII's opening of Parliament. He was included in the magazine's first issue and many more by virtue of having all of Europe as his territory during those tempestuous years.

He covered many events of World War II, including Hitler's invasion of Austria; Poland on the eve of the *Blitzkrieg*; the Tehran conference with Winston Churchill, Joseph Stalin, and Franklin Roosevelt; and the Yugoslav partisans' war against fascism. He also covered Israel's independence, the fall of Hungary to communism and a stunning array of royalty, rock and movie stars, industrialists, and political and military leaders.

His books include *It Happened in Our Lifetime* (1985), a masterful 400-picture collection of his life's work, and *A Will to Survive* (1977). His autobiography, *Free Spirit in a Troubled World* (1996), shows he was as skilled with words as with pictures.

Phillips, Sandra (1945–)

American curator and teacher

As the longtime curator of photography at the San Francisco Museum of Modern Art (SFMOMA), Phillips is one of the administrators helping to chart the course of photography into the new century.

Dr. Phillips earned an undergraduate degree from Bard (art history, 1967), received a master's degree from Bryn Mawr as a Woodrow Wilson Fellow (1969), and did her doctoral dissertation on "**André Kertész** in Paris, 1925–1936" at the City University of New York in 1985. She also studied with **Peter Bunnell** at Princeton, in the seminars on the history of photography 1840–1940.

Her professional career started when she taught art history and photography courses on the eastern seaboard at Bard (1971–1977), New Paltz (1977–1986), and The New School (1981–1986). In 1986 and 1987 she was curator of the Vassar College Art Gallery. Late in 1987

she went West, assuming the SFMOMA job and teaching at San Francisco State and the San Francisco Art Institute.

At SFMOMA she has curated shows on **Dorothea Lange**, **William Wegman**, **John Coplans**, **Sebastiao Salgado**, and others. She has written many catalogues and scores of magazine and journal articles, and she has delivered numerous public lectures nationally. The role of photography in criminality is the subject of a book she edited, *Police Pictures: The Photograph as Evidence* (1997), a compelling look at mug shots, crime scenes, and photographic evidence.

Philadelphia Photographer, The: Published in Philadelphia from 1864 through 1888, this art journal was edited by Edward L. Wilson. An ambitious and successful monthly, the journal's articles covered photographic experiments, inventors and inventions, processes, patents, societies, and aesthetics. Each issue featured a mounted photographic frontispiece. Numerous images of the Civil War and a group portrait of Civil War generals are among the notable photos published in the magazine.

photo agencies: Organizations that sell photographs to newspapers, magazines, advertising, and all others who request them. Photo agencies have large inventories of photographs on a wide variety of subjects that they supply for a fee. The fee is shared between the photographer who took the picture and the agency that sold the picture. The sale is for a one-time use of the image and the photograph must be returned, unless another agreement is made. Some photo agencies specialize in one category like sports photography or portraiture, while others have a large variety of subjects and styles. Some major news agencies are photo agencies as well, such as the **Associated Press,** Reuters, and Agence France Presse. Other prominent photo agencies are **Black Star, Contact Press, Gamma Liaison, Image Bank, Magnum Photos,** and **Sygma Photo News**.

photo album: A book with blank pages for mounting and preserving photographs in an orderly fashion. The photo album became widely popular in the 1860s to

Pges 352 – 353: Perspective refers to the appearance of depth when a 3-dimensional scene or object is represented in a 2-dimensional image. This railroad yard is in McCook, Nebraska. © Fred W. McDarrah.

store and view one's collection of *cartes de visite,* **tintypes,** and, later, **cabinet photographs.** The interest in keeping photographs in an album has continued ever since the development of the amateur snapshot. By the turn of the twentieth century, practically every home had an album of photographs of one's family and friends and, if the owner was wealthy, photographs of his or her travels abroad. Today we still keep our family photographs in albums, and they represent a unique and personal archive of our lives, travels, and loved ones. Wedding albums are one of the most popular keepsakes for family photos. Marketed by commercial wedding photographers as part of the photo package, they are usually elaborate presentations with handcrafted white leather covers.

photo awards: Awards for excellence in photography have grown considerably in recent years and apply to many areas of the field, ranging from commercial, fashion, editorial, and photojournalism to fine art. The first photo awards were administered by photography clubs in the mid-1800s. Now, most awards are provided by professional associations and private foundations. Some of the prominent photography awards are the **Pulitzer Prize,** the **Guggenheim fellowship,** the McArthur Foundation fellowship, the Fulbright Fellowship, the Alicia Patterson grant, the **W. Eugene Smith** grant, the **Aaron Siskind** grant, the Chapnick grant, the **Alfred Eisenstaedt** Award, the Press Photo of the Year Award, the Overseas Press Club Award, the Picture of the Year Award, the **Dorothea Lange**/Paul Taylor Prize, and the **Leica** Medal of Excellence, among others. In addition, state arts agencies often have grants for photographs, and the **National Endowment for the Arts,** until recently, had a grant program that included photographers.

photo booths: Unmanned automatic photography studios commonly found in drugstores, malls, and amusement arcades in which the subject inserts money, sits inside, and has his or her picture taken and developed in minutes. Typically, the photo booth takes four to six photographs that are presented in a small format (around 1 ½ x 2 inches) with the images printed on a continuous strip. In the 1960s, the pop artist **Andy Warhol** made use of the vernacular photo booth snapshot in his art. Digital photo machines, in use in Japan since 1995, were introduced in the United States in 1996. Unlike traditional photo booths, these kiosks produce sheets of tiny (½ x ¾ inch) sticky-backed **portraits** taken against a wide choice of digitally generated backgrounds.

Photo-booth portraits. © Fred W. McDarrah.

photo call: A request for newspapers, magazines, and other media outlets to send photographers to cover an event, also called a **photo opportunity** or photo op.

Photo CD: A process created by **Kodak** to store images originally taken with conventional film on a compact disc in digital form. The images are viewed on a **monitor** and can be manipulated with **computer software**.

photo education: Formal education in photography, whether as a commercial occupation or as a fine art, is available at practically every college and university today. Since the advent of photography in 1839, formal and informal information on the practice of photography has grown. By 1856 the University of London was offering a course in photographic chemistry, and in the 1860s courses were available in Germany. By 1900, photography instruction could be obtained in school or in less formal workshop settings by established photographers and through photography clubs. In 1907 **Clarence White,** a founding member of the **Photo-Secessionist** movement, began teaching photography at Columbia University in New York City. By 1914 White had established the now-famous Clarence White School of Photography. In Germany, the **Bauhaus** officially added photography to its curriculum in 1925. **Laszlo Moholy-Nagy,** one of the Bauhaus teachers, helped establish the New Bauhaus in Chicago (which later became the Institute of Design) in 1937. This private institution produced a new generation of photographer/teachers such as **Aaron Siskind, Harry Callahan,** and **Minor White,** all of whom became highly influential educators across the United States.

In 1962 the **George Eastman House** in Rochester, New York, held a conference on photography and education. From this conference the **Society for Photographic Education** was born, the largest association of college-level photography teachers, which promotes the history, aesthetics, practice, and theory of the medium.

Academic degrees in photography include the bachelor of arts, bachelor of fine arts, master of art, and the master of fine arts. The master of fine arts is the terminal

Photo Era. Collection of the authors.

degree in the field and is considered the necessary qualification to teach photography at the college level.

In pursuing a photographic education, it has become increasingly necessary for the student to define what type of photography he or she wishes to concentrate on, whether it be **photojournalism, commercial photography,** or fine art. For undergraduates, most colleges and universities can offer courses in one or all of these areas to help the student decide upon the preferred area. For graduates, it's important to be aware that each area of photography is very different and offers instruction and support that may or may not be applicable to the student's interest. All schools have catalogues and information on their programs and faculty, many available on the internet, that can help the student decide which school and program is best.

photoengraving: The photographic process for making a printing plate for letterpress printing.

Photo Era: An Illustrated Monthly: Published in Boston from 1898 through 1924, this periodical contained articles about war photography and nature

photography, technical and aesthetic essays, features on or about photographers, and information about competitions and associations. Illustrations were **halftones, heliographs** (sun writing), and **photogravures** and it had well-designed covers featuring leather-backed marble boards.

photo essay: A series of photographs that tell a story. This idea was made popular by the early weekly picture magazines such as *Life, Look,* and *Colliers.*

photofinish: When a photograph is used to determine the winner of a race or contest like the Kentucky Derby. The photograph provides proof of who crossed the finish line first.

photo flo: A chemical that is known as a "wetting agent" and in which fully washed photographic film is placed before drying. A wetting agent leaves a slight coating on the film that prevents water marks in drying.

photoflood: A bright light bulb with a wide angle of illumination for photographic lighting, usually 3400K or 3200K for use with tungsten-balanced color film or any black-and-white film.

photogelatin: A printing process that uses a **gelatin**-coated glass plate for high-quality reproductions of artwork and photographs. The print made from this process is a photogelatin or a **collotype**.

photogenic: A subject that is considered attractive in a photograph. For most amateur photography this means a subject that appears natural and pleasant. For professionals, this means something that adds impact or a compelling component to a photograph.

photogram: An image made on photographic **paper** without a **negative**. The image is made by placing objects directly on the paper and exposing it to light. Opaque objects lying flat against the paper produce a clearly defined silhouette. Objects that are partially translucent or do not lie flat produce less clearly defined

silhouettes and can produce a mysterious and sometimes beautiful image. Photograms as fine art were made popular in the 1920s by **Laszlo Moholy-Nagy** and **Man Ray**. The term *photogram* is the generally accepted name for this process, although other terms, including **Fox Talbot**'s *photogenic drawing* and Man Ray's *rayograms* have been used to refer to it.

photogrammetry: The method of determining the height and distance of topography from aerial photographs for the purpose of making maps.

Photograms of the Year: First issued in 1895, this British periodical was conceived as an ongoing project to publish the best photographic work of each year. The list of recognized photographers who were published in this annual is exhaustive, making it a valuable reference. There were halftone illustrations, some mounted in salon style. Articles of aesthetic, historical, and technical subjects appeared in each issue.

photograph: An **image** on light-sensitive material that is then printed onto light-sensitive **paper**. Usually the image is created on **film** in a **camera** that is then developed and printed onto photographic paper, making a photograph.

Photographic Arts Workshops: Founded in 1991 by Bruce Barnbaum of Granite Falls, Washington, the workshops are devoted to the study of photography as an expressive art form. They are held throughout the United States and abroad and may feature color photography, outdoor work, black-and-white darkroom printing demonstrations, archival processing, and print mounting.

Photographic Historical Society: Founded in 1965 and having 150 members, it works to bring together individuals interested in preserving the historical objects that depict the history of photography and to share knowledge and experience with its membership, which includes photographers, historians, and image collectors.

Naomi Savage. *Enmeshed Man.* 1978. Photoengraving, etched copper plate. © Naomi Savage. Courtesy of the photographer.

photographic history: The compilation of information on the history of photography began soon after the medium's introduction in 1839. Concerned with the technological development of the various photographic processes, the history of photography remained devoid of artistic discussions until the 1880s, when the **Pictorialist** movement began stressing and advocating for photography's artistic role. But it was not until the 1930s that a wide view of the technological and artistic history of the medium and its social influences began to be organized. Seminal accounts came from Robert Taft's 1938 *Photography and the American Scene*, **Beaumont Newhall**'s 1937 exhibition catalogue *The History of Photography, from 1839 to the Present* (rewritten in 1949), and *The History of Photography, from the Camera Obscura to the Beginning of the Modern Era*, by Alison and **Helmut Gernsheim** in 1955.

The current standard bearer for the field, in addition to the above-mentioned books and many others, is *A World History of Photography* by **Naomi Rosenblum,** a well-researched, illustrated volume that gives the most comprehensive account of the history of photography to date.

Photographic News Weekly Record of the Progress of Photography: Edited by William Crookes, this London-based journal began publishing in 1858; it merged with The Amateur Photographer in 1908. An important publication, it was noted for exhaustive reportage and for the influence its articles had on the further development of photography. The **Gersheims** used it often as a source in their History. Information about virtually all the early British photographers, discoveries, and societies was published. In the mid-1880s, The Photographic News became one of the first British journals to experiment with photographic **halftone** illustrations.

photographic processing: The chemical act of changing a **latent image** into a visible image on photographic **film** and/or **paper.** The process is done after the light-sensitive material is exposed to **light,** and the image is then made permanent and stable through a set series of chemical procedures. The three most basic pho-

tographic processes are (1) black-and-white processing for black-and-white negatives, (2) C-41 for color negatives from color negative film, and (3) E-6 for color slides from color slide film.

Black-and-white processing is relatively easy, and many photographers do this themselves for greater control over the finished negative and print. The two color processes are more complicated and very sensitive to temperature variations, and so they are usually done by a professional photography processor such as a photo lab.

Photographic Society of America: Founded in 1934, it has 11,000 members. For amateur, advanced amateur, and professional photographers, the society has eight special-interest divisions to administer its educational and program services—color slide, pictorial print, nature, video and motion picture, photojournalism, stereo, photo travel, and techniques. The society sponsors a journal, holds competitions, conducts slide and print contests, maintains a listing of photo exhibitions worldwide, and provides instructional slide sets, slide analysis, and other technical services.

photography: From the Greek term meaning "painting with light." From its "invention" in 1839 through the late part of the twentieth century, it has meant the recording of **images** onto a light-sensitive silver halide **emulsion** coated onto a glass, plastic, or paper base, which may then be chemically processed to produce a visible image. Increasingly, photography is an electronic process more than a chemical one.

photogravure: A photomechanical process, one of the finest ever developed, in which the finished prints are made in ink on a printing press. The image is transferred to a copper printing plate, which is then etched to retain ink in the areas corresponding to the blacks of the picture. The shadow areas of the image become etched recesses and hold the ink while the highlight areas of the image remain raised and are wiped clean. Photogravures are considered one of the highest forms of photographic reproduction, producing continuous tones as opposed to the dot pattern of **halftone** printing.

photojournalism: The visual reporting of news through photographs for magazines and newspapers. Unlike news photography, which results in a photograph of a news event, photojournalism implies a group of photographs that will tell a story of important news or an event. The skills of both photographer and reporter are combined to give an in-depth study of a situation in pictures.

photo junket: A trip for photographers arranged by a tourist board, manufacturer, or other group with the intention of gaining positive publicity for a tourist destination or product.

Photo League: Founded in 1936 by New Yorkers **Sid Grossman** and Sol Libsohn, it was a volunteer membership organization of professional and amateur photographers that ran a school, directed exhibits, published a monthly bulletin called *Photo Notes*, sponsored lectures and symposia, and produced documentary features. The League also was responsible for preserving the **Lewis W. Hine** Memorial Collection. Their members included almost every prominent photographer in the United States, among them **Paul Strand, Aaron Siskind, W. Eugene Smith, Weegee, Rudy Burckhardt, Eliot Elisofon, Arnold Newman,** and **Lisette Model**. The league was an outgrowth of the Worker's Film and Photo League, an organization founded in the late 1920s and modeled after the communist-inspired German photographers group Film und Foto. The Photo League was in existence until 1951, when it disbanded after being listed as a communist-front organization by the U.S. attorney general in 1947.

The members of the Photo League believed that photographers had an obligation to produce social documentary work that reflected the communities in which they lived. The League sought to encourage honest photography, taking as its standard the work of **Eugène Atget, David Octavius Hill, Alfred Stieglitz,** Lewis Hine, **Berenice Abbott, Edward Weston,** and the photographers of the **Farm Security Administration**. The League's meetings featured print competitions, lectures, and films. The school, under Grossman and Libsohn, had a program of three 15-week courses. Its graduates and members participated in group projects that included "Chelsea Document," **Walter Rosenblum**'s "Pitt Street," Aaron Siskind's "Harlem Document," and other New York City subjects that eventually created a photographic archive of neighborhoods, streets, and people, including landlords, political bosses, policemen, factory workers, immigrants, artists, street vendors, preachers, rabbis, and even members of their own families.

Because the League had supported some of the social reforms also supported by the Communist party in the 1930s, it was unfairly tarnished as a Communist organization, and as Cold War tensions increased, support for the organization weakened. Although it was unable to weather the political attacks orchestrated by Senator Joseph McCarthy, there can be no question of the League's importance as a training ground for young, poor, mostly second-generation immigrants who wanted to learn about the art and craft of photography.

photo opportunity: With an advance announcement to the working press, any group or individual invites press photographers for a brief photo session at a designated location and time. For example, when world leaders meet, photographers are not permitted to be present at their meetings. Instead, photo opportunities, or photo ops, are held before and after the meeting so that photos marking the event can be taken.

Photo Realism: A style of painting that closely resembles a photograph and may be mistaken for one because it is an accurate representation of the subject.

Photo-Secession: A breakaway movement of photographic **Pictorialism** led by **Alfred Stieglitz** in New York in 1902, advocating a straightforward style and the use of the urban scene for its subject. The Photo-Secessionist movement was modeled after the British secessionist group Brotherhood of **The Linked Ring,** which sought to have photography accepted as fine art. Stieglitz, who was the first American elected to The Linked Ring, admired the British Pictorialists. He had

been the vice president of the New York Camera Club but resigned after a new, conservative regime took it over. When Stieglitz was presented with the opportunity to stage a salon at New York's National Arts Club, he called it "An Exhibition of American Photography arranged by the Photo-Secession."

The Photo-Secessionist group took shape late in 1902, its founding aim "to advance photography as applied to pictorial expression." The journal of the movement, *Camera Work,* began publication in 1903. In 1905 a permanent exhibition space, called the Little Galleries of the Photo-Secession, located at 291 Fifth Avenue and best known as the **291 Gallery,** was founded. By 1917, Stieglitz had become less interested in Pictorialism as the new European modern movement took shape. By 1917 the Photo-Secessionist movement had ceased to exist, its demise marked by the closing of the 291 Gallery.

The group had more than 40 members, including **Edward Steichen, Alvin Langdon Coburn, Frederick H. Evans, Robert Demachy, Frank Eugene, Gertrude Kasebier, Consuela Kanaga, Clarence H. White, Anne W. Brigman, F. Holland Day,** and **Paul Strand,** among others.

Photoshop: The most popular and widely used **software** program for **computer** imaging, made by Adobe. Photoshop allows for the **scanning** of existing photographic prints, negatives, and slides into the program for unlimited manipulation either by itself or by combining them with other images. A scanned image becomes digitized and converted to bits of information. Each bit can be altered either individually or by group for unlimited effect. Photoshop is used by commercial and media organizations as well as consumers in the home—all one needs is a powerful computer and the Photoshop software. For those wishing to learn the program on their own, Adobe has an excellent book that includes an instructional **CD-ROM,** called "Classroom in a Book."

photostat: A copy of original artwork by the photostat process, often used for posters and other **enlargements**. Because of its high quality, the photocopy has replaced the photostat for most common uses.

Pictorialism: An artistic movement with the purpose of establishing photography as a fine art. Active in the late nineteenth century and early twentieth century in Europe (particularly Britain) and the United States, it was largely a reaction to the growing popularity of photography and the proliferation of commercial uses of the medium. In 1869, **Henry Peach Robinson,** a prominent British photographer, published *Pictorial Effects in Photography*, which emphasized photography's use as an art form and began the Pictorialist movement. Pictorialism advocated an expressive feeling in photography and the adaptation of the styles and subjects of traditional painting and was concerned with idealized and personal views and picturesque scenes that might include **allegorical** subjects, careful attention to the nuance of **light,** and evidence of the hand of the artist. In 1889, another prominent British photographer, **Peter Henry Emerson,** published his idea of naturalism, which advocated a **soft-focus** picture, which he considered similar to the way the eye sees (a theory he later rejected). All of these types of Pictorialism have a strong connection to, and often the "look" of, painting. In 1902 **Alfred Stieglitz** formed a breakaway form of Pictorialism called the **Photo-Secession**, which, while still advancing the notion of photography as a fine art, advocated a more modern approach that reflected the nature of the medium (sharp **focus** and detail) and the use of contemporary subject matter such as the city and urban life. By the end of World War I, European modernism was overtaking contemporary art, and the more romantic notions of art and pictorialism were set aside. Since the 1970s there has been a renewed interest in the style, and some contemporary photographers consider themselves working in its tradition.

Pictorial Photographers of America: Founded in 1916 and having 85 members, it aids members in perfecting their photographic techniques. It also sponsors individual print and slide analysis, exhibitions, and field trips.

picture: Any **image** of an object, scene, or abstraction, such as a photograph, drawing, or painting.

Sylvia Plachy. *Black Jacket*. 1982. © Sylvia Plachy. Courtesy of the photographer.

picture story: A group of photographs that tell a story and may include captions or text. Picture stories are popular with magazines such as *Life* and *National Geographic* and require considerable skill and planning on the part of the photographer for the picture story to be coherent and interesting.

pinhole camera: A camera that uses a tiny pinhole for its **lens**. In a darkened area, a tiny pinhole projects an image of what is in front of it. In a pinhole camera, the tiny hole projects an image onto photographic **film** or **paper** that is **developed** and/or printed. The effect can be dramatically **surreal,** often described as "dreamlike" with **soft focus,** distorted edges, and obscured detail. Some photographers find it an interesting style that enhances the expressive mood of their pictures.

pixel: Literally, picture elements, or the dots that make up a printed image. The more pixels the camera can capture in an image, the better the image quality. As a practical matter, the higher the pixel count, the larger the prints can be made. A wallet-sized color photograph would be described on a **computer** as having 640 x 480 pixels. Multiplying the two numbers yields the total pixel count of 307,200. While that sounds like a lot of dots, it is barely enough to make a decent wallet-sized color photograph.

Plachy, Sylvia (1943–)

Hungarian-born, American portrait and
journalistic photographer

Plachy, a longtime photographer for the *Village Voice*, is known for her portrait work and her "Unguided Tour" newspaper series and book, a quirky look at people in their own environments.

Born in Budapest, she moved to Vienna with her family after the 1956 uprising. She emigrated to the United States in 1958. After earning her bachelor of fine arts from Pratt Institute in 1964, she became a U.S. citizen and started taking pictures. She began working at the *Village Voice* in 1974.

In addition to her work at the *Voice*, where she remains a staff photographer, Plachy's work has appeared in the *New York Times Sunday Magazine*, *L.A. Style*, *Newsweek*, *Stern*, *Geo*, *Connoisseur*, *Vogue*, and elsewhere. Her book *Sylvia Plachy's Unguided Tour* won an **International Center of Photography** Infinity Award as the best photo book of 1990. In 1996, she and the writer James Ridgeway collaborated on *Red Light: Inside the Sex Industry*, a photodocumentary about which a reviewer wrote, "That is a tribute both to the photographer's keen sense of esthetic and the . . . decision to tell the story through the sex workers themselves."

Her subjects have ranged from Coney Island to Three Mile Island, and her assignments have taken her around the world. She won a **Guggenheim fellowship** in 1977, a Creative Artists Public Service grant in 1982, and a Page One award from the Newspaper Guild for a feature essay. Plachy has had gallery and museum exhibitions at such venues as the Minneapolis Institute of Arts and the Whitney Museum at Philip Morris in New York. Her work is held in private and public collections, including that of the Museum of Modern Art in New York.

platinum print: Also called platinotype, a platinum print is a photograph that uses light-sensitive platinum salts to form the photographic image instead of silver salts, which are used in almost every **black-and-white** photographic paper. The platinum printing process became available in the early 1880s and was favored by fine-art photographers of the **Pictorialist** movement until World War I, when platinum became very expensive. Platinum prints are made by placing a negative directly against the specially coated paper and then exposing it to sunlight. Sunlight or a very strong UV **(ultraviolet) light** is necessary for this process. The image appears on the paper, which is then put into a solution of potassium oxalate to develop it fully. A very long tonal range characterizes platinum prints—that is, there are many shades of gray and the black areas are not too deep. The image is permanent and, when done well, considered one the finest photographic prints. Though this is an obsolete process, some photographers buy the chemistry needed to coat their own paper and make platinum prints.

Plowden, David (1932–)

American documentary photographer

Plowden is known for his powerful images of human-made America, as he documents the transformation of the country from the nineteenth to the twentieth century. David McCullough, in his introduction to Plowden's *American Chronology* (1982), said, "He has photographed roadways and main streets and grain elevators, gas stations, ore docks, river steamers and lake steamers, docks, freighters, ferry boats, tugs, lighters, bridges, . . . coal mines, parking lots, skyscrapers . . . rails and crossings, railroad stations and locomotives."

Born in Boston, Plowden received a bachelor of arts degree from Yale University in 1955 and then studied photography with **Minor White**. He has produced more than a dozen books, including *The Hand of Man in America* (1971), *A Time of Trains* (1987), and *A Sense of Place* (1988). His work has also illustrated other writings. John Ashbery has called him "a poet with a true sympathy for the marvelous, awful American scene."

Winner of a **Guggenheim fellowship** in 1968, Plowden has also won awards not usually given for photography, including the 1977 Wilson Hicks Award, a research grant from the U.S. Department of Transportation and the **Smithsonian Institution**. Plowden taught at the Institute of Design at the Illinois Institute of Technology from 1978 to 1984 and has been visiting lecturer at several universities.

His work is held by collections such as those of the Smithsonian and the Museum of Modern Art in New York. He has been in group and solo exhibits at numerous venues, including the Walker Art Center in Minneapolis, the Davenport Museum of Art in Iowa, and the Kunst Museum in Lucerne, Switzerland.

point-and-shoot camera: Popular term for an **automatic camera** that has built-in focusing and lighting capability. All the photographer needs to do is point the camera at the subject and shoot the picture.

polarization: A process of modifying the orientation of the plane of vibration of **light** waves, a photographically significant property of light. Useful in controlling reflected light from certain surfaces without altering color.

polarized light: Light is made up of particles moving in all directions, and when those particles are made to move in only one direction, that is called polarized light. The use of a **polarizing filter** allows only light particles moving in the same direction to pass through, and the effect is that there is no glare off shiny objects like glass or water. In photography, polarizing screens or filters are often used to eliminate glare.

polarizing filter: A clear optical **lens** that causes light to be polarized. It allows the axis of **polarization** to be varied.

Polaroid photography: In 1947 Dr. **Edwin H. Land,** president of the Polaroid Corporation, announced his invention of an instant-picture process at a meeting of the Optical Society of America. One of the most exciting discoveries of the post–World War II era, the first Polaroid Land **camera,** which went on sale in 1948 in Boston, could produce made-in-a-minute sepia prints. The company concentrated its efforts on inventing, designing, and manufacturing new camera models and new **films,** refining the chemical processes, creating a color film and transparency and negative in black and white, and finally creating a whole new system involving an automatic electronic **shutter,** a new type of **flash bulb,** and a **battery** in the film pack instead of in the camera.

The company commissioned established photographers to experiment with the films and equipment and explore the possibilities. Today both professionals and amateurs can produce high-quality work with the Polaroid one-step system.

(George) Polk Awards: Annual journalism awards established in 1949 in honor of George W. Polk, a CBS News correspondent who was killed in 1948 while covering the civil war in Greece and given by Long Island University in Brooklyn, New York. Categories for newspaper awards include excellence in journalism and

reporting on business, national news, foreign news, sports, environmental, local, medical, and military affairs, plus individual awards for magazine, book, and network television reporting.

Polk, Prentice H. (1898–1984)

Pioneering American portrait photographer

Polk is one of America's foremost black portraitists and was the official photographer at the Tuskegee Institute.

Born in Bessemer, Alabama, Polk first aspired to be a painter. In 1916, the photography instructor at Tuskegee, C. M. Battey, encouraged Polk to master the relatively new art form. He left the Institute for Chicago, where he worked for several years before returning to the school as a teacher, advisor, administrator, and department head. At Tuskegee, he captured on film the school's famed scientist George Washington Carver, as well as many of the dignitaries and personalities who have graced the campus, from Eleanor Roosevelt to Dr. Martin Luther King Jr.

For many years he was not merely the only black photographer in Alabama's Black Belt Region but also the only photographer; he catered to a broad base of white and black patrons in his studio.

His work has been exhibited at the Corcoran Gallery of Art and the National Civil Rights Museum in Memphis, and he has won several photo awards. A collection of his photographs, *P.H. Polk*, was published in 1980. A critic wrote that his images "display an eerie tension between precise formality and x-ray vision. The result is a compelling style that stuns the viewer with an unexpected intimacy. The subject of Polk's pictures are looking at you."

Pollack, Peter (1909–1978)

American curator, historian, and teacher

At the Art Institute of Chicago, Pollack was one of the first museum curators to organize exhibitions of contemporary photography as a form of artistic expression.

Born in North Dakota, Pollack studied at the University of Illinois in Chicago and with **Laszlo Moholy-Nagy** at the Institute of Design in Chicago. He spent four years beginning in 1939 working for the Federal Arts project in Chicago. He served in the Middle East as a Red Cross field director during World War II and, after returning stateside, got a job at the Art Institute of Chicago. He worked to establish a strong photography department and was made curator of photography in 1945. Over the next 12 years he put together shows by **Aaron Siskind**, **Henri Cartier-Bresson,** and other important photographers.

He worked as a private consultant for a variety of institutions after leaving the Institute in 1957, including the Guggenheim, the Cincinnati Museum, and the Detroit Institute for the Arts. He contributed many articles on photography to various publications and was the author of *The Picture History of Photography* (1958, rev. 1977) and *Understanding Primitive Art* (1968). From 1962 until he died he was honorary curator of photography at the Worcester Art Museum.

His photographs have been exhibited at the Worcester Museum, the Overseas Press Club, and the University of Indiana at Evansville.

pool photographer: A photographer or small group of photographers who are allowed to cover a particular event or judicial proceeding with great public interest but limited press access.

Porter, Eliot (1901–1990)

American nature photographer

Porter was a nature photographer whose pictures showed a clear emphasis on birds, wild animals, insects, and landscapes. He also did extensive archaeological and architectural work in Greece, Egypt, and Mexico.

Born in Winnetka, Illinois, he earned a bachelor of science degree from Harvard University (1924) and a doctor of medicine from Harvard Medical School (1929). He worked as a tutor and instructor at Harvard from 1930 to 1939, when he decided to turn his hobby—photographing birds—into a career, with the encouragement of **Alfred Stieglitz**, who admired his work and exhibited it at **An American Place** gallery. He began to work in color in 1940.

In 1941 he was awarded a **Guggenheim fellowship** to photograph birds, and it was renewed in 1946.

A photographer at a street fair uses a Polaroid camera to make instant portraits. © Fred W. McDarrah.

His bird photographs were exhibited at the Museum of Modern Art in 1943. Porter's work has appeared in numerous periodicals and been widely exhibited at such institutions as the Metropolitan Museum of Art, where he had the first one-man show of color photography, the Museum of Modern Art, and the **George Eastman House**.

Porter had more than 20 books published, including *The Place No One Knew: Glen Canyon on the Colorado* (1963) and *Monuments of Egypt* (1990). He was named a Fellow of the American Academy of Arts and Science in 1971 and received numerous other honors and awards, including the Academy of Natural Science's Gold Medal of Distinction in 1983.

portfolio: A select group of photographs that demonstrate a photographer's skill and usually presented in a box, folder, or binder.

portrait: A picture of a person that attempts to show his or her personality or reveal some hidden quality.

positive image: An image that appears tonally correct—that is, the white areas represent highlights and the dark areas represent shadows. The term was coined in 1840 by **Sir John Herschel,** an English astronomer and photographic chemist.

postcard: A heavyweight card usually measuring 4 ¼ x 6 inches with an image on it that can be sent through the mail. Postcards are often characterized by the cheerful color photograph of a tourist destination and are often sent to friends from a vacation site. The format is also used for invitations, commercial announcements, and other mailings as well.

power pack: A high-powered battery unit used for photographic flashes and video equipment. Commonly attached to a belt, a power pack allows the photographer to carry electronic equipment anywhere.

Prakapas, Eugene J. (1932–)
American art dealer and publisher
The gallery that Prakapas opened under his name in New

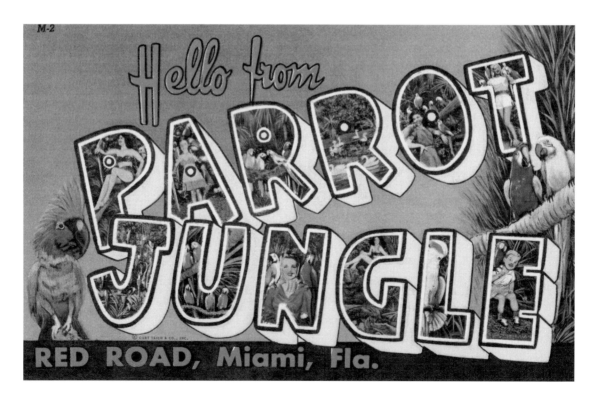

Postcard from Parrot Jungle, ca. 1951. Lake County Museum/Corbis.

York in 1976 has been a focal point of twentieth-century modernist art. While handling works of all media, Prakapas has paid special attention to photography. In well over 100 exhibitions he has demonstrated that photography is an integral part of the major art movements of the contemporary era, while introducing artists whose work has been neglected or overlooked. **Ben Shahn** and **Albert Renger-Patzsch** are among the artists first exhibited at a gallery in the United States.

A graduate of Yale and Oxford universities, Prakapas had a notable career in book publishing at Simon and Schuster before opening a gallery. His interest in photography goes back to a volume of **Wright Morris**'s text and photographs that he encountered as a publisher in the 1960s. While working in publishing he began creating a collection of his own, which eventually led to the career change. In 1987 Prakapas served as visiting professor at the San Francisco Museum of Modern Art. Since 1993 he has confined himself almost exclusively to photography, working as a private dealer.

press: 1) A general term denoting any media, and the employees of those media, that disseminate information to the public. 2) A press is also the equipment used for producing print media.

press alert: An advisory from a group or individual that an upcoming event is newsworthy and should be covered by the press. The events may include movie openings, political rallies, celebrity press conferences, or feature news stories. Press alerts can be in the form of mail, e-mail, telephone, or **fax**.

press camera: Traditionally, a 4 x 5 Graflex camera with a **bellows,** used from about 1910 to the 1960s. Today most **photojournalists** use **35mm** cameras because they are smaller, faster, and easier to carry, and they can use film with 36 exposures. The Graflex can take only one photograph at a time, and a cumbersome plate, called a **film holder,** must be inserted for each image. As an example, when the *Hindenberg* zeppelin exploded on May 6, 1937, a photographer on the scene, Murray Becker, was able to take only three photographs of the disaster. If he had been using 35mm equipment with a motor drive (a device that automatically advances the film between exposures), he would have been able to capture the entire sequence of the explosion, which lasted less than three minutes.

press card: Identification issued by a police department or other government agency on a card which verifies that the holder is a member of the press and for what organization he or she works.

press conference: A meeting organized to present newsworthy or important information to news organizations, commonly referred to as the press.

press gallery: The press section of a legislative chamber, such as those of the U.S. Congress or state legislatures. This is the area where reporters and photographs sit while covering the proceedings. Photographers and TV cameramen are usually confined to a different press area.

press party: A gathering given for reporters and photographers to introduce and publicize a new product, which could include anything from a new model car to a new movie. In the convivial atmosphere of the press party, the host organization aims to generate word-of-mouth publicity as well as favorable press to arouse public interest. While the party's sponsor may also pay for advertising the new product, an editorial photograph or article is the equivalent of free advertising with the implicit, or stated, endorsement by the news organization.

press photography: Pictures taken for newspapers or magazines of news events or personalities or to explore a newsworthy theme with a series of pictures called a **photo essay**. Press photography includes pictures of breaking events as they occur and feature pictures to illustrate articles on anything from sports to food. Oftentimes photographs of fires or natural disasters are taken by amateur photographers who just happened to be on the scene when the event occurred.

press release: A written statement prepared by a public or private agency containing news about an event, product, or person the sender wants publicized and intended for publication and/or broadcast. A press photo accompanying the release is available free for such publication or broadcast.

press room: A room provided with facilities for members of the press to write and transmit their stories to their offices. Government buildings have press rooms, as do sports arenas, political convention halls, and other centers of newsworthy public interest.

Prevost, Victor (1820–1881)

Early French documentary photographer

Prevost is known for his images documenting the building of New York's Central Park.

Like many of his contemporaries, he started as a painter, studying under Paul Delaroche and exhibiting in the salons of the 1840s. He came to the United States for the 1849 California Gold Rush, setting up shop in San

Fully equipped press photographer with six 35-mm cameras, flash and battery, exposure meter, mono-pod, gas mask, helmet, and at least 4 press cards to achieve complete access to almost anything.
© Abner Symons. Courtesy of the photographer.

Francisco as a painter. In 1851 he was in New York learning the **calotype** process, and by 1853 he was back in France, learning photography from **Gustave LeGray**.

He returned stateside three years later, having been chosen to photograph the creation of Frederick Law Olmstead's new urban oasis. He also took street and building scenes of New York in the mid-1850s and 1860s.

Price, Larry (1954–)

American photojournalist

Price is the winner of two **Pulitzer Prizes,** one for spot news and one for features.

A 1977 graduate of the University of Texas, Price got a job at the *El Paso Times* right out of school. In 1979, he joined the *Fort Worth Star-Telegram.* On assignment for the paper in Africa in 1980, he caught on film the execution of 13 Liberian political figures. He took home the

Victor Prevost. *Central Park in 1862, No. 17, Bird's Nest, Bethesda Fountain Stairway.* 1862.
From Presentation Portfolios made for A.H. Green Esq.
Collection of the authors.

prize the next year. He joined the *Philadelphia Inquirer* as a photographer in 1983 and remained overseas. In 1985, he won the features award for a series on life in war-torn El Salvador and Angola.

He returned stateside in 1986 to become photography director for the paper's Sunday magazine. In 1987 he was made director of photography for the entire *Inquirer*.

print finishing: The final steps that are taken to complete a photographic print. These are non-photographic applications designed to enhance the appearance or presentation of the photograph that may include:

- **Drying**. Fiber-based photographic **paper** is either air dried, which produces a low-gloss surface on **glossy** papers, or treated in a heated drying unit. A high-gloss surface can be obtained by placing the surface of the wet print in an electric dryer against a ferrotyping plate (a very smooth plate). Resin-coated papers are usually air dried, or a low-temperature electric dryer can be used.

- **Spotting**. Pigments are applied to the surface of the print with a brush to hide small white dots caused by dust or white lines caused by scratches.

- **Etching.** A sharp knife is used to gently remove black specks from the **emulsion,** which are caused by pinholes or deep scratches in the negative emulsion.

- **Retouching**. One paints on the negative or print to remove or alter existing imagery.

- **Hand coloring.** One uses a paint and brush to add color to black-and-white photographs.

- **Trimming.** One removes unwanted edges from the print.

- **Mounting**. One adheres the print to a board for display purposes by any number of methods, such as dry mounting, glue, spray adhesive, or tape.

- **Framing**. One places the print in a window overmat and then in a frame for presentation.

prism: Transparent optical material such as glass or plastic that splits a ray of white light into its color spectrum and can also be used to reflect and invert images of light.

process photography: A technique using a rear-**projection** image behind an object or scene, creating the illusion that they form a seamless scene. This is a commonly used device in film production where a character appears to be outdoors but is in fact in a **studio** with a rear projection of an outdoor scene behind.

processing: The general terminology for the **development** and **finishing** of photographic film and prints. This begins with developing the **film, fixing** and **drying** it, and then making a print from the negative. The print is **enlarged** and then **developed,** fixed and dried, and then is ready for use.

product photography: Taking photographs of manufactured products that will be used on packages, in brochures, or for advertisements or posters displaying the item. Product photos are taken in the **studio,** in a controlled environment, where every aspect of the shot can be manipulated to show the product to its best advantage.

projection: The act of casting an **image** onto a screen, wall, or other surface. Usually this entails using a **slide** or movie that is enlarged by a **lens** on a slide or movie projector. A light behind the slide or movie projects the image through the lens and onto the surface.

professional photographer: A professional photographer is one who earns his or her living by taking pictures, whether for several different clients as a **freelancer** or as a staff person whose work appears in just one publication or group of publications. Self-employed photographers range from commercial studio owners specializing in portraiture or weddings to pure-art photographers who may teach photography while pursuing their personal artistic vision.

proof prints: Photographic prints, usually small and of low quality, that are used by the photographer to determine the best shots. Intended for inspection only, the chosen sample prints will be reprinted to the desired size and to a better quality.

public domain: After a **copyright** expires the once privately owned image, section of text, or software becomes available for dissemination by the general public. In some cases the copyrighted item is considered to be in the public domain if it has become so much a part of the fabric of the culture that exercising rights or claims on it becomes impossible. For example, the song "Happy Birthday," a film clip of Martin Luther King's famous "I Have a Dream" speech, works by Shakespeare, and a computer Solitaire program were all once copyrighted or privately owned. Now they are all in the public domain.

publicity photo: A photograph sent to news organizations, usually accompanied by a **press release,** to publicize a person, place, product, or event. A publicity photo, also called a press photo, is provided without charge and can be used without paying a fee for reproduction. Often, a publicity photo can be kept by the news organization and filed for later use. A sponsoring organization or a publicity agent or a public relations firm sends the photo out and hopes that it will be used by a large number of news organizations (newspapers, magazines, wire services, and television news) to generate favorable interest and therefore increase sales with positive publicity about the subject or event.

Pulitzer Prizes: Annual awards for excellence in American journalism, fiction, drama, history, biography, nonfiction, poetry, and music from a fund left by the newspaper publisher Joseph Pulitzer and administered by Columbia University in New York. They have been awarded each spring since 1917 and judged by an advisory board of journalists, the president of Columbia University, and the dean of the graduate school of journalism. The category of news photography was added in 1940, and feature photography added in 1967. **Amateurs** and **professionals** alike are eligible and may be nominated by newspapers, magazines, publishers, and the general public. Any work submitted must have been published in an American newspaper the previous year. One of the most famous Pulitzer Prize-winning photographs was **Joe Rosenthal**'s image of soldiers raising the U.S. flag on Mount Suribachi on Iwo Jima in 1945. That iconic image was used to create the Iwo Jima Memorial statue in Washington, D.C.

pulling: A **darkroom** technique for reducing film speed and/or reducing **contrast** by removing film from the developer before the normal processing time has elapsed.

Purcell, Rosamond (1942–)
American documentary photographer
Purcell is renowned for her images of medical and historical subjects.

Born in Boston, she received a bachelor of arts degree from Boston University in 1964. She began photographing in 1969. She started to take pictures with only Polaroid Land black-and-white film, using found glass plates and other Victorian ephemera. Her first monograph, *A Matter of Time*, was published in 1975.

She was given a major assignment from Polaroid to photograph children in 1976 and the next year started conducting workshops at Massachusetts Institute of Technology and the Delaware Art Museum. She uses only Polaroid material, she says, because "I am more interested in the esthetic than the mechanical aspects of the art. It did not matter . . . that I had only one of each good photograph," although she later used negative film so she could "manipulate effects in the final print."

Her images have appeared in seven books, as well as in magazines and catalogues. She made her debut as an author in her 1997 book, *Squeamish Cases*. The images in that book and the accompanying show at the Getty Museum in Santa Monica, California, include both historical photographs and Purcell's own pictures of two-headed conjoined twins, individuals with unusual appendages and rare skin conditions, giants, dwarfs, and other anomalous beings whose physical traits can be described as medical abnormalities.

Purcell's work is held by numerous collections, such as those of the Metropolitan Museum of Art, the Museum of Fine Arts in Boston, and London's Victoria and Albert Museum.

pushing: A **darkroom** technique for increasing film speed and/or increasing **contrast** by allowing the film to remain in the developer longer than the normal processing time. Pushing allows the film to gain more detail and density in low-light situations or when the film's normal speed (**ASA**) is being exceeded. Any time the film's ASA is being raised, it is called pushing; the opposite, when it's being lowered, is called pulling.

push-pull processing: When film is exposed at high-er or lower than recommended **ASA**s, the **development** needs to be adjusted accordingly. When film is rated at a higher than normal ASA, the development needs to be "**pushed,**" that is, increased. The opposite, when film is rated slower than normal, development is reduced, or "**pulled**."

quartz light: A high-powered **light** source that maintains its color balance over the life of the bulb, making it excellent for color photography. A quartz light is balanced for tungsten light, which is 3200K and for which tungsten-balanced films are used. Daylight-balanced color films (5000K) can be used with quartz lights, but the image will have a strong orangey cast unless a correction **filter** (80A) is used over the camera **lens**.

RAM: Random access memory. A **computer**'s RAM number denotes the amount of memory or information that can be stored. VRAM, commonly referred to as video memory, as compared with RAM, which is text memory, denotes the number of **pixels** that can be stored. Pixels are the dots that make up a picture.

rangefinder: An optical system for determining an object's distance from the camera for sharp **focus**. Cameras that use this system are called rangefinders and are distinct from the other camera system called **single lens reflex**. With a rangefinder, the photographer looks through a window on the camera and a superimposed, transparent "ghost" image appears along with the natural image. The photographer turns the focusing mechanism until the ghost image and natural image align for accurate focus.

Rauschenberg, Robert (1925–)

American artist

A leading figure in avant garde American art since the early 1950s, Rauschenberg first exhibited as a painter, and later became known for his combines, mixed media works using photographs, sculpture, found objects, and furniture. He has used photographs extensively in silk-screened paintings and as transfers from printed material.

Born in Port Arthur, Texas, he briefly attended the University of Texas, Austin. He was drafted in 1944 and served in the Navy. While he was stationed in San Diego, California, he visited the Huntington Library and Art Collections in San Marino. He had always enjoyed drawing and inspired by the original oil paintings he saw, he realized he could become an artist.

After leaving the service, Rauschenberg studied at the Kansas City Art Institute, the Academie Julien in Paris, and Black Mountain College, where painter Josef Albers was an important influence on his development as an artist. His interest in performance art dates back to 1952, at Black Mountain, where he met dancer Merce Cunningham and composer John Cage, with whom he collaborated on the first Happening—mixed media performance. His first solo exhibition of painting was at the Betty Parsons Gallery in 1951. The Museum of Modern Art bought two of Rauschenberg's photographs in 1952, both made at Black Mountain College. In 1981 Pantheon published his book, *Photographs.*

Since then Rauschenberg has achieved international renown and has been honored with a full-scale retrospective at the Guggenheim Museum in New York. The catalogue for that exhibit, "Robert Rauschenberg" (1997), chronicles the working process and achievements of this major artist's life and career. His work is held by numerous museums, including New York's Museum of Modern Art, the Tate Gallery in London, and the National Gallery of Art in Washington, D.C.

Ray-Jones, Tony (1941–1972)

English photographer and teacher

Ray-Jones's rising career as a freelancer was tragically cut short when he died of leukemia at age 31. Although he was trained as a photographer in the United States, his body of work focused on British life, sporting events, landscapes, and people. His photographs were not only indicative of the British lifestyle but also went beyond the surface to offer insights into the country's culture and tradition.

A native of Wells, Somerset, he studied graphic design at London's College of Printing. He studied photography in New York City with **Richard Avedon** and

Robert Rauschenberg. *New York City, 1981*. © Robert Rauschenberg. Courtesy of the photographer.

Alexey Brodovitch at the Design Laboratory in New York City in 1962–1963, and he earned a master of fine arts degree at Yale University in 1964.

He continued his association with Brodovitch at *Sky* magazine, where he worked as an associate art director before embarking on his freelance career in 1965. His photographs appeared in major publications on both sides of the Atlantic.

In 1971 he started lecturing at the San Francisco Art Institute's Department of Photography. A monograph of his work, *A Day Off*, was published in 1974, and he is included in many anthologies. His work is in many major collections and continues to be widely exhibited.

RC print: Common term for a photographic print made on resin-coated **paper** (RC paper). This type of photographic paper takes less time to develop and is coated with plastic to reduce washing time. RC paper is considered fine for commercial purposes but inadequate for fine-art printing.

rear projection: A system of projecting slides or movies in which the projector is behind the screen and unseen by the audience. This is commonly used to create backgrounds for photography or film, giving the illusion that the subject is on location, as in **process photography**.

red eye: A common effect in color photography when a flash is used that produces a subject with red eyes. This is caused by the flash's bouncing off the back of the eye and reflecting back into the camera lens. Techniques to avoid this are (1) having the flash away from the camera lens so when the light is reflected back, it doesn't go into the camera lens, (2) having the flash emit a short series of flashes before the camera exposure to close down the eye's pupil, making it harder for the light to reflect back into the camera lens, and (3) using a black marker to darken the red eye marks on the final photograph (such red eye pens are readily available at photo stores).

reducer: A chemical that removes metallic silver from negatives, commonly called Farmer's Reducer. There are three general types of reducers: cutting, proportional, and superproportional. Cutting reducers affect the thinnest areas of the **negative** first, reducing **fog** and enhancing **contrast**. Proportional reducers affect the whole negative simultaneously with the effect of a uniformly thinner negative (if a negative has been overexposed or **overdeveloped,** this is a good technique; Farmer's Reducer is a proportional reducer). Superproportional reducers affect the densest areas of the negative more than the thinner areas but are difficult to control.

Reed, Eli (1946–)
American photojournalist
Reed is one of America's leading photojournalists whose award-winning work in print and for broadcast has included reports on The Million Man March (1995), Central America (1982), Beirut (1983–1987), Haiti (1986), Panama (1989), and Zaire (1992). In 1988 he photographed the effects of poverty for an essay that became the core of a film documentary, *America's Children: Poorest in the Land of Plenty*, which was narrated by Maya Angelou and broadcast on NBC network television.

Born in Linden, New Jersey, Reed is a 1969 graduate of the Newark School of Fine and Industrial Arts. He began to take pictures in 1970 and started his first professional job in 1977 with the Middletown, New York, *Times Herald Record*. The next year he went to the *Detroit News* and then to the *San Francisco Examiner* in 1980. He was a Nieman Fellow at Harvard University in 1982 and the next year began his association with the **Magnum Photos** agency. Editorial assignments include those at *Life*, *Time*, *People*, *Newsweek*, and many others. He has worked as a still photographer for several films, including *Day of the Jackal* (1996), *Ghost of Mississippi* (1996), and *Clockers* (1995).

Reed has lectured and taught at the **International Center of Photography**, Columbia University, New York University, and Harvard University. He has also worked for a long list of corporate clients, including **Polaroid**, McDonald's and the Ford Foundation. Among his eight books are 1997's *Black in America*, *Magnum: In Our Time* (1989), and *Homeless in America* (1987). Among the

honors he has won are the **W. Eugene Smith** award (1992), World Press award (1988), and the **Leica** Medal of Excellence (1988).

Reed, Roland (1864–1934)

Early American documentary photographer

Reed's life ambition was to produce a definitive photo record of the North American Indian. He was partially successful in his endeavors, but his pictures, which offer an unmatched glimpse into a people and a culture long since vanished, have remained largely unpublished and little known.

Growing up in a log cabin along an old Wisconsin Indian trail, Reed watched the Native Americans who used the old trail and was fascinated by them. He started documenting them with crayon and pencil, and in 1893 he apprenticed himself to a Civil War veteran who knew something about the new medium of photography. In 1897, Reed signed on with the **Associated Press** to photograph the Klondike Gold Rush in Alaska; he caught a boat out of Seattle with Jack London, among others.

By 1900 he was in Minnesota, where he did the bulk of his work. His photos constitute a haunting record of Native American life not necessarily as he encountered it but as he envisioned it. Choosing not to depict the ragged reservation people, he instead evoked the proud people of an earlier era. He did not photograph for commercial purposes, refusing offers for calendars and **postcards** and a $15,000 offer for a one-time advertising job. His shots appeared only in *National Geographic* during his lifetime. It was not until the 1970s that they started to be more widely exhibited and published. His entire collection is now owned by the Kramer Gallery in St. Paul, Minnesota.

reflection densitometer: A densitometer that measures the **light** reflected from photographic print material.

reflectors: White or metallic surfaces used to bounce light from a source onto a subject. White reflectors produce an even, smooth illumination and metallic reflectors produce a harsher illumination with some shadows. Metallic reflectors come in silver, for a white-light effect, and gold, for a warm effect in color photography.

reflex camera: A camera system that uses a mirror placed at a 45 degree angle, to reflect upward into a **viewfinder** to a ground glass the image to be photographed. The image's sharpness is controlled by a focusing mechanism on the camera or **lens**.

refraction: The change of direction of a ray of **light** as it passes from one substance to another, as when light passes through water or curved glass and objects viewed through the substance appear distorted.

register marks: Small marks superimposed during printing, often in the shape of a target, that appear alongside photos and artwork to ensure that the different colored printing plates are lined up correctly to create a sharp image.

Rejlander, Oscar Gustav (1817–1875)

Swedish-born, British art photographer

Called the father of art photography, Rejlander adapted the earliest photographic techniques to the artistic forms of his time, with his portraits and tableaux much in keeping with the work of contemporary painters such as the pre-Raphaelites. He is best known for his **allegorical** photomontage "The Two Ways of Life," which he made in 1857 using a combination of more than 30 negatives. He discovered the technique while experimenting with the possibilities of **depth of field** in portraiture. The photograph was so famous that Queen Victoria is said to have purchased a print for Prince Albert.

Born in Sweden, Rejlander studied painting in Rome, where he earned his living by copying old masters. He married an Englishwoman and moved first to Lincoln, then to Wolverhampton, England, where he took up photography as a more lucrative career than painting. He became known for his theatrical tableaux, and by the time he moved to London in 1862 he was active as a portraitist.

In London his subjects included **Lewis Carroll** and

Gustave Doré, and he had a large studio with a monied clientele. Charles Darwin asked him to help illustrate his book *On the Expression of the Emotions in Man and Animals*, and Rejlander and his wife posed for some of the pictures. He completed the work for Darwin although he was already seriously ill with diabetes.

A biography of Rejlander, *Father of Art Photography* by Edgar Yoxall Jones, was published in 1973. His photographs are held by public and private collections, including those of the **George Eastman House**, the **Royal Photographic Society**, and the **Smithsonian Institution**.

release sticker: A notification affixed to the back of a photograph indicating what rights are included with the sale of the picture and what rights are retained by the photographer. Typical rights for the buyer are one-time reproduction, and typical rights of the photographer are that the photograph be credited to him or her and the print be returned in good condition.

relief images: Images in which the surface is slightly raised to correspond to areas of greater and less density. Typically relief images are used for reproduction with the ink printing darker where the image is raised and lighter where the image is recessed. Relief is the opposite of intaglio printing.

remote control: A device to activate something from afar. A remote control in photography is usually an electronic device that controls a camera's functions without the photographer's having to be near or actually make contact with it.

Renger-Patzsch, Albert (1897–1966)
German documentary photographer

One of the pioneering figures in twentieth-century German photography, Renger-Patzsch wanted to record the exact appearance of objects—their form, material, and surface—and rejected any kind of artistic claim for himself. A member of the movement that came to be called "Neue Sachlichkeit" (**New Objectivity**), he photographed still-lifes, industrial objects, landscapes, technical apparatus, architecture, and studies of trees and stones.

Born in Wurzburg, Germany, he was raised in Essen and the Thuringia region. His father's hobby was photography, and Renger-Patzsch began to use a camera in his teens. After serving in the army in World War I, he studied chemistry at the Dresden Technical College. In 1920 he became director of the Folkwang Archives Publishing House.

In 1925 he decided to make his career in photography and worked in the documentary vein while teaching photography in Essen. After 1934 he devoted all his time to his personal creative work. He worked as a war correspondent during World War II, then concentrated on landscape photography until his death.

His most famous work was a 1928 photo album, *Die Welt ist Schon* (The World Is Beautiful), a catalogue of objects photographed in his typically cool and clinical style. The book was one of the most influential photography books ever published. He received many prizes in his lifetime, including the **David Octavius Hill** award in 1957 and in 1965 an award for skilled craftsmanship from the North-Rhine Westphalian government.

replenisher: A solution that is added to photographic chemistry to maintain its consistency and potency. When a photographic chemical is used, it loses some of its strength, but by adding replenisher, one can maintain its strength at a constant level for further use.

reprints: Additional prints from the same **negative**.

reproduction rights: An agreement between the owner of an image and a publisher (newspaper, magazine, company, or other entity) as to how an image may be reproduced. While there are standards for reproduction set by organizations such as the **American Society of Media Photographers,** individual photographers and owners of **copyrighted** material are free to negotiate reproduction rights with publishers as they see fit. For example, Elvis Presley's estate has sold the rights to reproduce the rock star's likeness on souvenirs such as coffee mugs and key chains. Photographers sell specific

images they have shot for reuse on posters, postcards, and T-shirts or to be reprinted in books and magazines.

reserve: A term used in auction houses that refers to the minimum acceptable price for an item that is being sold. A reserve price is agreed upon in advance, in confidence, between the owner of the item and a representative of the auction company. If this agreed-upon price is not reached during the auction, the item will remain unsold.

resolution: The level of image detail that a photograph can capture. Resolution is measured in **pixels,** which stands for "picture elements." Pixels are always expressed in two numbers, measuring the horizontal and the vertical dimensions. The more pixels there are, the clearer the image and the higher the quality of the resolution.

restoring photographs: The act of bringing photographs back to their original state after they have been damaged. Museums regularly have professional restorers on staff to repair photographs that have been damaged because of exposure to water, smoke, chemical contamination, or dirt or that have faded or been physically damaged. While some damage is irreparable, much can be done to restore photographs to their original condition and prevent further deterioration.

retouching: To apply paint or ink in varying degrees to a negative, slide, or photograph to enhance its quality. When done well, retouching can add or subtract elements and be undetectable to the viewer. Poorly done, retouching can ruin an image and destroy any value it has.

reversal film: A photographic film (color or black and white) that records an image in which dark areas of the subject are rendered as dark on the film, and light areas of the subject are rendered as light on the film.

Rial, Martha (1962–)
American photojournalist
Rial won the 1998 **Pulitzer Prize** for spot news photography. Following harrowing accounts of the conflict in

Rwanda and Burundi told by her sister, a nurse at the Mtendeli Refugee Camp near Kibondo, Tanzania, Rial traveled alone on her first overseas assignment and took a series of life-affirming photographs of survivors. She worked in northern Tanzania for three weeks, documenting the stories of the refugees there.

A Pittsburgh-area native, Rial was graduated from the Art Institute of Chicago and Ohio University. Her first professional stop was at the Journal newspapers in Virginia and then south to the *Fort Pierce Tribune* in Florida. In 1994 she returned to her hometown paper, the *Pittsburgh Post-Gazette*, where she published her award-winning refugee camp series. The work also garnered her a National Headliners Award for News Photography, and she was named Pennsylvania News Photographer of the Year. She has also been honored by the national groups Women in Communication, the Society of Black Journalists, and the Scripps-Howard Foundation.

She has completed several award-winning photo essays for the *Post-Gazette*, including "Shalom Pittsburgh," a four-parter about the city's mushrooming Jewish population, and "Prisoners of the Mind," about mental illness.

Riboud, Marc (1923–)
French photojournalist
Noted especially for his classic images of France, China, and Vietnam, Riboud is a **Magnum** photographer who says his determination to photograph faraway places began through his friendships with **Henri Cartier-Bresson**, **Robert Capa**, and **George Rodger**.

Born in Lyons, Riboud started to take photographs with his father's Vest Pocket Kodak. He pursued engineering studies, but with the outbreak of World War II he joined the French Resistance and saw action in several fronts. After the war he worked as an engineer but left to pursue a career in photography.

He met Cartier-Bresson, Capa, and **David Seymour** in Paris in 1951 and joined Magnum in 1953; he later became one of its officers. His far-flung travels began in 1955, when he took off on a two-year stint in the Far East. Since then he has taken a road trip from Alaska to Mexico, visited the Soviet Union, and between

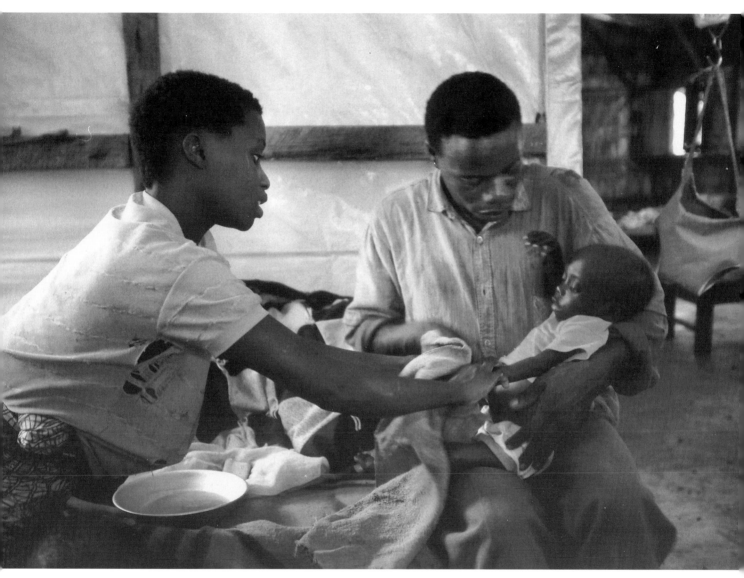

Martha Rial, Pulitzer Prize, 1998, *Pittsburgh Post-Gazette*. Rial's Spot News award photo showed a mother and father bathing their adopted son in the Mtendeli Refugee Camp near Kibondo, Tanzania. Courtesy *Pittsburgh Post-Gazette*.

1960 and 1970 worked in Africa, Algeria, China, North and South Vietnam, and Cambodia. He reported on the war in Vietnam and the Iranian revolution. He was the last Western journalist to interview Ho Chi Minh. In 1979 he left Magnum, although his archive is still held there. He continues to be active as a photographer in France.

His *Marc Riboud In China* (1997) is a massive volume with selected photographs from all of his visits over a 40-year period. His other books include *Photographs at Home* and *Abroad* (1986), *Ghana* (1964), and *Women of Japan* (1959). Riboud's work has been in numerous exhibitions, including solo shows at the **International Center of Photography**, the Art Institute of Chicago, and Musée de l'Art Moderne in Paris. His work is held by such collections as those of the Museum of Modern Art in New York and the Metropolitan Museum of Art.

Rice, Leland D. (1940–)

American photographer, curator, and teacher

In his black-and-white or color photographs Rice uses simple elements—an abstracted wall, a window, or sometimes a figurative portrait of a woman—in frontal views that achieve painterly effects exploring tonal patterns and the relationship between the subject and the space it occupies.

Born in Los Angeles, he earned a bachelor of science degree from Arizona State University, where he studied with **Van Deren Coke**, who encouraged him to pursue a career in photography. He received a master of arts from California State University, San Francisco, where he continued his photography studies with Jack Welpott and other practitioners.

He has taught at Pomona College in California, where he was also curator of photography, and been a visiting artist or lecturer at a number of universities in the United States. Rice was one of the founders of the Visual Dialogue Foundation, a discussion group that held exhibitions in San Francisco between 1968 and 1973. His work has been exhibited at the Whitney Museum, the Museum of Modern Art, and other venues. Rice's work is held by numerous private and public collections, including those of the **George Eastman House**, the San Francisco Museum of Modern Art, and the Museum of Modern Art in New York.

Rice, Shelley (1950–)

American critic and art and photo historian

Rice has published, taught, curated, and lectured widely in the United States and Europe. She is on the faculties of New York University and the School of Visual Arts, and her columns have appeared in the *Village Voice*, the *Soho Weekly News*, and *Artforum*.

Born in New York, Rice studied at Smith College, the State University of New York at Stony Brook (bachelor of arts), and New York University's Institute of Fine Arts (master of arts), and Princeton University. She has worked as a freelance curator and critic since 1978, organizing such shows as "The Male Nude" (Marcuse Pfeifer Gallery) and "Deconstruction/Reconstruction" (the New Museum). Her published works include *Parisian Views* (1997) and *Lartigue: Le Choix du Bonheur* (1993).

Among her many awards are a **Guggenheim fellowship,** a Fulbright research grant, **National Endowment for the Arts** Critics' fellowship, and two National Endowment for the Humanities grants.

Richards, Eugene (1944–)

American photojournalist

A committed photojournalist whose black-and-white photographs have documented the faces of poverty in America, the ravages of war in Beirut and El Salvador, and a courageous woman's struggle with cancer, Richards has been active also as a publisher, lecturer, and member of the **Magnum Photos** agency.

Born in Dorchester, Massachussetts, Richards earned his bachelor of arts degree at Northeastern University in Boston (1967) and studied photography with **Minor White** at the Massachusetts Institute of Technology. He went to southeastern Arkansas as a VISTA volunteer in 1968 and spent two years working to set up a day-care center and recreation programs. He and some of his fellow workers founded RESPECT, Inc., a private social agency to provide food and clothing and other services in the West Memphis black community.

A selection of the photographs he took in the Arkansas delta were published in *Few Comforts or Surprises* (1973). His other books include *Below the Line* (1987), published by his own Many Voices Press, and *Exploding into Life* (1986), documenting the ultimately unsuccessful battle against breast cancer by his longtime companion, Dorothea Lynch.

In 1990 Richards won the **Leica** Medal of Excellence for a series on drug abuse in Philadelphia. He has also won two **National Endowment for the Arts** awards (1974, 1983) and a **Guggenheim fellowship** (1980). His work is held by numerous private and public collections, including those of the Museum of Modern Art in New York, the Museum of Fine Arts in Boston, and the Addison Gallery of American Art in Andover, Massachusetts. His photographs have been exhibited at the National Museum of Art in Washington, the **International Center of Photography**, and the San Francisco Museum of Modern Art.

His first retrospective was held in the summer of 1997 at the photography festival in Arles, France, and,

with the book *Eugene Richards* that accompanied it—his ninth—was an important career milestone. The same year, he was the first photographer to receive a fellowship from the Henry J. Kaiser Family Foundation.

Richardson, Yancey Lynn (1956–)

American dealer and gallery owner

An active member of the photographic community, Richardson opened her own gallery in 1995. In addition to showing masters from **Brassai** to **Robert Mapplethorpe**, she is known for encouraging and showing new talent.

Richardson received both bachelor of arts and master of fine arts degrees from Southern Methodist University in Dallas. She won the prestigious Helena Rubenstein Fellowship in Museum Studies at the Whitney Museum; this award cemented her interest in working with, showing, and representing photographers.

She started as a private dealer in 1980; among her early jobs was curating several corporate collections, including those of London Fog and McCann Erickson. She serves on the board of directors of the Association of International Photography Dealers, holds a seat on the board of Photographers+Friends United Against AIDS and serves on the executive committee of the **International Center of Photography**'s Focus Group.

Riefenstahl, Leni (1902–)

German photographer and film director

Her reputation as Hitler's favorite moviemaker has dogged her career since she was personally commissioned by him to produce *Olympia*, a film about the 1936 Berlin Olympics, noted for Hitler's snubbing of the black American track star Jesse Owens. Her film *Triumph of the Will* has been termed the most notorious documentary ever filmed—it depicted the Nazi party rally that epitomized Hitler's dictatorship. After World War II she spent three years in American and French internment camps.

Born in Berlin, she studied painting before becoming a ballet dancer and then an actress. In 1931 her interest turned to film and she formed her own production company. Several of her films before *Olympia* suggested the superiority of the Aryan race, and Hitler sought her out.

After her rehabilitation, she distanced herself from her past political involvement. She made her way to Sudan and took pictures of the Nubian people, producing *The Last of the Nuba* (1973) and *People of Kau* (1976). Even these books have aroused controversy, bringing tourists and encroaching development into unspoiled regions. In 1974 she took up scuba diving and produced *Coral Gardens* (1978).

Her first solo gallery show was in Tokyo in 1980, and since then her reputation as a photographer has grown as her notoriety as a Nazi sympathizer has ebbed.

rights and permissions: An agreement between the **copyright** owner of an image and a client who purchases it as to the rights retained by each. Typical rights discussed are who may reproduce the image, how many times, and in what venue, language, and context. It's important that rights and permissions be made clear in advance of any final agreement.

Riis, Jacob August (1849–1914)

Danish-born, American social reformer, journalist, and photographer

A police reporter turned social reformer, Riis took up photography to illustrate his muckraking stories exposing conditions in the tenements and slum sections of New York City's Lower East Side. His pioneering work as a social reformer was directly responsible for a wide variety of societal changes for the American underclass. His classic book, *How the Other Half Lives* (1890), was far more effective than conventional reforms, and it forced wealthy New Yorkers to see the hellish environment that constituted daily life for the poor. He was the first photographer to use the power of the image as a tool for reform. In the original edition of the book, photoreproduction was very primitive, and the illustrations were actually drawings taken from his photos.

Born in Denmark, he learned about journalism as a child because his father helped prepare copy for a week-

Jacob Riis. *Bandits' Roost, 59-1/2 Mulberry Street,* ca. 1890s. Collection of the authors.

ly newspaper. Riis was an apprentice carpenter in Copenhagen before emigrating to New York in 1870. Economic times were on the downswing, and it took Riis nearly four years to find a regular job with a news association.

In 1877 he became a reporter for the *New York Tribune* and the **Associated Press** Bureau. He often went to police headquarters on Mulberry Street, where he saw the degradation and suffering of the neighborhood. He wrote stories daily about the misery and squalor he witnessed, and his articles led to the creation of the Tenement House Commission.

He moved from the *Tribune* to the *New York Sun* in 1888 and began work on *How the Other Half Lives.* At first he was accompanied on his investigation by a photographer, but, dissatisfied with the pictures, he taught himself how to use a camera and for about ten years documented his own writing. He stopped taking pictures after 1898

but continued his writing and lecturing until 1913, using slides of his photographs to accompany the lectures. His autobiography, *The Making of an American*, was published in 1901.

Although his writings were kept in various libraries and archives, the photographs disappeared from view until **Alexander Alland**, himself an immigrant photographer and writer, sought them out from Riis's family. His biography, *Jacob A. Riis: Photographer and Citizen* (1974), helped bring Riis's work to the public eye again.

Riis's original surviving negatives are now held by the Museum of the City of New York.

Rinehart, F. A. (1861–1928)

Early American documentary photographer

Rinehart was official photographer of the Trans-Mississippi and International Exposition of 1898 in Omaha, which included an Indian Congress attended by

500 Native Americans from 36 tribes. He made more than 1,200 platinum prints of his stunning portraits of American Indians, among them Geronimo, who was brought under guard from his prison at Fort Sill; Red Cloud; and White Star, who was Custer's last scout. They were formal portraits, with the Indians in full regalia, sitting, seemingly unposed, with character and dignity.

Born in Lodi, Illinois, Rinehart at the age of 17 headed to Denver, where he began taking pictures, possibly with **William Henry Jackson**. In 1885 he moved to Omaha, establishing his first portrait studio. It became so successful that he was named to photograph the exposition, where he recorded the dignitaries and structures, and took the Indian portraits.

Rinhart, George (1944–)

American collector

Rinhart is one of the world's preeminent photo collectors. *Oh Say Can You See*, a collection of his images taken between 1839 and 1939, is a handsome document with many one-of-a-kind and more familiar images of famous Americans like Harriet Beecher Stowe, taken by **Mathew Brady, Alexander Gardner,** and others. It was published by the MIT Press in conjunction with a 1989 show at the Berkshire Museum.

Ritts, Herb (1952–)

American fashion and portrait photographer

Best known for his vivid portraits of popular-culture celebrities of the 1980s and 1990s, such as Madonna, Tom Cruise, Magic Johnson, Denzel Washington, and many others that have appeared in the editorial pages of *Rolling Stone*, *Vanity Fair*, and *Vogue*, Ritts has also gained a reputation as a major photographer for advertising campaigns.

His advertising clients include such well-known corporate names as Giorgio Armani, Calvin Klein, and Honda. His elegant portraits for The Gap brought Ritts the Infinity Award for Applied Photography from the **International Center of Photography**. Ritts has directed music videos for Michael Jackson, Madonna, and Janet Jackson.

One-man exhibitions of his work have been held in the United States, Europe, and Japan. Several collections of his photographs have been published, including *Herb Ritts: Pictures* (1988), *Herb Ritts: Man Woman* (1989), *Herb Ritts: Notorious* (1992), and *Africa* (1994).

In 1996 he had a major 182-photo retrospective at the Museum of Fine Arts in Boston. More than 250,000 people attended the show, the first ever by a single photographer in the larger galleries at the museum.

(H. Armstrong) Roberts: An international **stock photography** agency with more than 75 years of experience.

Roberts, Richard Samuel (?–1936)

American documentary photographer

Working in Columbia, South Carolina, Roberts provided a unique documentation of middle-class black life in a southern city during the 1920s and the Depression era. He was a master photographer, self-taught and gifted in the uses of light and shadow for the purposes of photo composition.

A native of Florida, Roberts was employed as a custodian in the U.S. Post Office in then-segregated Columbia. He worked there from 4:00 A.M. to noon, then went over to his studio, where he conducted his business. Although the popular image of southern black life in that era is of the rural and working class, every southern community also had an active black middle class, made up of professional people—teachers, government employees, and merchants—and their families.

Roberts photographed in his studio but also traveled around the city, recording people at work and play, in their homes, and with automobiles and other possessions. After his death, his studio was closed and the glass plates that were his archive were stored in the crawlspace under the family home. A chance inquiry by a staff member of the University of South Carolina's library field archival program led to their discovery in 1977.

The glass plates were cleaned and restored, and a selection of the pictures was published in *A True Likeness: The Black South of Richard Samuel Roberts, 1920–1936* (1987), with text by Philip Dunn.

Richard Samuel Roberts. *Unidentified Portrait*. 1920s. Collection of the authors.

Robertson, James (active 1852–1865)

British travel photographer

Although little documentation survives about Robertson's life, he is known for his striking images of Constantinople (around 1854), Crimean War pictures taken in collaboration with **Felice Beato**, who would later be his brother-in-law (1855–1856), and views made on his trip to India via Egypt and Palestine, also taken with Beato.

Robertson was superintendent and chief engraver at the Imperial Mint in Constantinople. He went to the battlefield at Balaclava with Beato, who served as his assistant. They covered the same territory that **Roger Fenton** had photographed, and the approximately 60 photos they took, using the **albumen**-on-glass process, formed a continuation of Fenton's Crimean War pictures, completing the documentation of the war.

Robertson continued to work with Beato on a series of views of Mediterranean cities. Their views of Constantinople were published in the *London Illustrated News* in 1854 and were shown the following year at the London Photographic Society and at the Paris Exposition Universelle. The Crimean War pictures were exhibited in London along with Roger Fenton's photographs in 1855.

Robertson set off for India with Beato in 1857. He remained in India as official photographer for the British Army while Beato eventually continued on to Japan, becoming one of the first Western photographers in that country. The photos taken by both men were not clearly attributed, many having been signed by both Robertson and Beato. It is believed that Robertson later took up residence and remained in Constantinople.

Robinson, Henry Peach (1830–1901)

British art photographer and writer

An early advocate of **Pictorialist** photography and a founder of **The Linked Ring**, Robinson produced a diverse body of photographic work that evolved from fine, standard portraits to composite prints, for which he is best known, to picturesque landscapes. A prolific writer on the theory and aesthetics of photography, he published eleven books and numerous articles.

Born in Shropshire, he studied drawing and painting while employed in a bookshop in Leamingon Spa. He wrote copiously about art, and his articles were published in various journals. He exhibited his paintings one time, at the Royal Academy in 1852. His interest in photography was sparked in 1851, when he visited an exhibition in London and met a member of the Photographic Exchange Club.

He opened his own portrait studio in Leamingon in 1857, and he soon had a successful business in making portraits. On his own, he began to experiment with combination prints after he saw the work of **O. G. Rejlander**, especially his famous composite "Two Ways of Life." In 1858 Robinson made his most famous work, a print composed from five negatives, "Fading Away," which pictured a young girl's dying.

Robinson became the spokesman for Pictorialism, insisting that every picture should tell a story, and treated his own photographs as works of fine art, complete with gold frames. A member of the Photographic Society of Great Britain, he left that group as part of the **Photo-Secessionist** movement, which founded The Linked Ring, the exclusive society of Pictorialist photographers.

His pictures were widely exhibited and he won many awards for his work. His most influential books were *Pictorial Effect in Photography* (1869) and *Picture-Making by Photography* (1884). Robinson's work is held by major private and public collections, including those of the **George Eastman House**, the **Smithsonian Institution,** and the University of Texas at Austin.

Robinson, John R. (1907–1972)

American photojournalist

Along with **Don Ultang**, Robinson won the 1952 **Pulitzer Prize** for photography for their sequence of six pictures of the Drake–Oklahoma A & M football game of October 10, 1951, in which the black All-American fullback Johnny Bright's jaw was broken by a deliberate blow.

Robinson worked at the *Des Moines Register and Tribune* from 1927 to his retirement in 1972 and took the prize-winning sequence for the newspaper. He was a Des Moines native and served during World War II as a photographer for the Signal Corps. He was primarily

a sports photographer but covered other news events as well.

Rodchenko, Alexander (1891–1956)

Russian art photographer and painter

Rodchenko was one of the most productive artists of the post–Russian Revolutionary era. A versatile constructivist and productivist artist, he used all sorts of techniques—photomontage, double exposures, unusual angles, distortions, and unexpected close-ups—to compose his abstract photographs in the 1920s. In the 1930s his body of photographic work also included portraits and sports photography.

Born in St. Petersburg, he studied at the Kazan School of Art. He continued his studies in Moscow in 1914 and exhibited his first abstract drawings around 1916. He was active in many areas, doing costume design for a production of Oscar Wilde's *The Duchess of Padua*, turning out spatial constructions, and working for the government as a professor of art. His designs for work clothes and for a tea service date from this era.

He produced a series of advertising posters and worked with Vladimir Mayakovsky, illustrating poetry for him. In 1921 he joined the productivist group, which advocated that art be made a part of daily life.

From 1924 onward he devoted himself to photography, taking portraits of Mayakovsky, his mother, and others. He also worked for the film industry, designing furnishings, costumes, and sets. In the 1930s he followed Communist party guidelines and concentrated on sports and images of parades and other choreographed movements. He stopped taking pictures in 1942 but continued to organize photo exhibitions.

He also worked on photo books and, with his wife

Henry Peach Robinson. *The Day's Work Done.* 1877. Hulton-Deutsch/Corbis.

Varvara Stepanova, organized photo albums such as *The Soviet State Farm* (1940). He published his last two, *300 Years of the Reunification of the Ukraine to Russia* and *Belinsky*, in 1954–55.

Rodger, George (1908–1995)

British photojournalist

A committed photojournalist, Rodger was a co-founder of the **Magnum Photos** agency who worked as a war photographer in World War II on assignment from *Life* magazine. The concentration camp scenes he witnessed at Bergen-Belsen so moved him that he never again photographed violence but instead traveled widely, often in Africa, on assignment or speculation for various publications or industrial clients.

Born in Cheshire, he traveled twice around the world before he was 19, as a member of the British Merchant Navy. He settled in the Depression-era United States and held a variety of odd jobs from 1929 to 1936, when he returned to England and, without any background, was hired as a photographer by the British Broadcasting Corporation. In 1938 he acquired his first 35mm camera and freelanced in London through the **Black Star** agency.

His military service (1939–1947) as a war correspondent took him to North Africa, to Burma, and throughout Europe. He met **Robert Capa** in 1943 and they became lifelong friends. After the war, he photographed for *Life* and *Ladies' Home Journal* and, between 1947 and 1960, made 15 expeditions to Africa for *National Geographic, Holiday, Paris Match*, and other publications. In 1947, along with Capa, **Henri Cartier-Bresson**, and **David Seymour**, he was a founder of the photographers' cooperative Magnum agency.

A major retrospective of Rodger's photographs was held in 1987 at the Photographers Gallery in London. Although his work has not achieved the recognition afforded some of his contemporaries, such as Capa and Cartier-Bresson, he produced images of enormous power. His pictures of the London blitz are still in constant use as the defining portrait of the city under fire. Eleven books with his photographs were published; the most recent, *Humanity and Inhumanity: The Photographic*

Journey of George Rodger, appeared in 1994. His work has been exhibited widely and is held by collections such as those of the Museum of Modern Art in New York, the **International Center of Photography**, and Bibliothèque Nationale in Paris.

Rodriguez, Joseph (1951–)

American documentary photographer

Rodriguez has achieved recognition with his gritty black-and-white documentary photographs of urban life, with particular emphasis on the neighborhoods of the Hispanic communities of New York and Los Angeles.

After studying at the School of Visual Arts and the **International Center of Photography**, he started freelancing. His work has appeared in the *New York Times Sunday Magazine*, **National Geographic,** the *Village Voice*, and other periodicals. He has won several grants and awards to support his work, including a **National Endowment for the Arts** fellowship (1994), Mother Jones International Fund for Documentary Photography award (1993), and an Alicia Patterson fellowship (1993).

He has published several books, among them *Spanish Harlem* (1995) and *East Side Stories* (1997). In 1998 a selection of his photographs was published in *East Side Stories: Gang Life in East L.A.*

His work has been exhibited at the **International Center of Photography**, the California Museum of Photography in Riverside, and the Fort Worth Museum of Art in Texas.

Rogovin, Milton (1909–)

American documentary photographer

Rogovin has always been surrounded by lenses, but not always by cameras: He began his professional life as an optometrist before turning to photography. A major photo project of his has been to document life in his native Buffalo, New York, by going back once a decade to photograph the same working-class people.

After graduation from Columbia University in 1931, he started his first career. After getting a master of arts degree from the State University of New York at Buffalo in 1972, he started his second. His earliest photos were of friends and family; he finally closed his eye

Pages 388 – 389: Joseph Rodriguez. *Members of Florencia 13 Gang Outside High School Show off Their Tattoos, South Central.* 1992. © Joseph Rodriguez. Courtesy of the photographer.

practice and devoted himself to social documentary photography.

A winner of the **W. Eugene Smith** Award for Humanistic Photography, he has traveled as far as southern Chile in search of "the truth," as he puts it, about the human condition. After his last visit to Buffalo's Lower West Side in 1992, he published *Triptychs* (1994), about his three visits to photograph the neighborhood.

His work has been exhibited in solo shows at the Allbright Knox Art Gallery in Buffalo, the Brooklyn Museum, and the Art Institute of Chicago. Rogovin's photos are held by such collections as those of the Metropolitan Museum of Art, the Museum of Modern Art, and the San Francisco Museum of Art.

Rolleiflex: A high-quality twin lens **reflex camera** invented by Dr. Reinhold Heidicke in 1929 and still in production. It uses **roll film** of 12 exposures and produces a 2 ¼ x 2 ¼-inch image. Popular with news photographers in the 1950s and 1960s, it is still highly regarded and used today, though not generally for news events.

roll film: Photographic film that comes on a flexible base and is packaged in rolls. Various sizes of roll film are available from 35mm to 120 and 220 medium-format film. There are also specialty roll films for **spy cameras** and very long rolls for many exposures.

Ronis, Willy (1910–)
French photographer
Ever since taking over his father's photo studio in 1936, Ronis has been one of France's leading photographers and has been honored with some of that nation's major artistic awards.

He studied, variously, art, law, and music before the Depression led him to drop out of school and join his family's studio, taking wedding pictures, making postcards, and taking portraits for identity cards. After photographing his first picture story—of the actor Edward G. Robinson in Paris in 1937—he stayed with photography as a career for the rest of the century. After World War II, he left studio work to concentrate on

photo reportage for top French and many European magazines.

He won the 1979 Grand Prix Nationale des Arts et Lettres and the 1975 President d'Honneur of the Association Nationale des Reporters Photographes Illustrateurs.

Rosenblum, Naomi (1925–)
American author and historian
Rosenblum has made significant contributions to the study of photographic history. Her third edition of the *World History of Photography* was published in 1997. She also wrote *A History of Women Photographers* (1994), which brought to light many names and much work not previously known in the field—and became a major exhibition that traveled throughout the United States.

In 1977 she and her husband, Walter, were cocurators of a major **Lewis Hine** retrospective at the Brooklyn Museum, and in 1980 they were invited to install that exhibition in Beijing, the first official loan from an American museum to China.

Holder of a 1978 doctorate from the City University of New York (she did her thesis on **Paul Strand**), she went on to teach the history of photography at Parsons School of Design in New York and has

Rolleiflex manufactured in 1932. The focusing knob is on the left, and the crank to advance the 12-exposure-roll film is on the right.
© Fred W. McDarrah.

taught that subject and art history at Brooklyn College and York College of the City University of New York and abroad. Rosenblum has also presented numerous lectures and participated in several conferences on photographic history. She has written extensively on Hine, Paul Strand, modernism, and other aspects of twentieth-century photography.

Rosenblum, Walter (1919–)

American documentary photographer and teacher

Rosenblum achieved recognition as a social documentary photographer. As a youth he became involved with the **Photo League**, meeting such figures as **Paul Strand** and **Eliot Elisofon** at the legendary school. Strand's influence has been apparent in his career, whether he was photographing the D-Day landing, Mexican migrants, East 105th Street, Haiti, or the south Bronx. Rosenblum was the first photojournalist to enter the liberated Dachau concentration camp at the end of World War II.

Born on Manhattan's Lower East Side, he attended City College. Strongly influenced also by the work of **Lewis Hine**, he published his first photos in the newspaper *PM*. His work is noted for celebrating the profound and complex human experience of people who survive intact despite great odds.

He won a **Guggenheim fellowship** in 1979, a **National Endowment for the Arts** award in 1978, and numerous other awards. His work is held in private and public collections, including those of the Brooklyn Museum, the **International Center of Photography** (ICP), and the Museum of Modern Art.

From 1947 to 1986 he was a professor at Brooklyn College. He also has taught at Yale University (1952–1978) and Cooper Union (1949–1959). With his wife, the photohistorian **Naomi Rosenblum**, he has curated several major photo shows and lectures around the world, including the Lewis Hine exhibit at the Brooklyn Museum. A monograph of his work, *Walter Rosenblum*, was published in 1991, and a retrospective was held at Queens College in 1998. In 1998 he also received a lifetime achievement award from the ICP.

Rosenthal, Joe (1911–)

American photojournalist

Rosenthal took one of the most often reproduced and imitated photographs ever—the historic and, some observers have said, staged **Pulitzer Prize**–winning shot of American soldiers planting the Stars and Stripes on Mount Suribachi on Iwo Jima.

He was an **Associated Press** photographer when he snapped the picture that won the 1945 prize. From 1946 until 1981 he was a staffer at the *San Francisco Chronicle*. He started his career at the Newspaper Enterprise Association in 1932. He was at the *San Francisco News* from 1932 to 1935 and at the New York Times Wide World Photos from 1936 until joining the AP in 1941.

He was assigned to the Pacific theater from 1944 to 1945 when he took his famous picture. Nearly 4 million posters of the image were made for a war loan drive; 15,000 outdoor panels and 175,000 car cards were also made. A float based on it won a prize at a Rose Bowl parade, and the image was reenacted in the 1949 film *Sands of Iwo Jima*.

Ross, David (1949–)

American museum director and curator

After establishing New York's Whitney Museum as a major force in the world of photography, director Ross set out for San Francisco in 1998 to perform a similar function at the San Francisco Museum of Modern Art as head of that prestigious institution.

Born in Malvern, New York, he earned a bachelor of arts degree at Syracuse University and pursued further studies at the university's Graduate School of Fine Arts. His first job was at that university's Everson Museum as video curator from 1971 to 1974. He worked at California's Long Beach Museum for three years and at Berkeley's Art Museum for five; from 1982 to 1991 he was at Boston's Institute of Contemporary Art.

He joined the Whitney as director in 1991, when it had no photo department or collection, and launched a major acquisitions program, emphasizing the interrelationship of painting, sculpture, photography, and film. When he left in 1998, there were more than 1,400

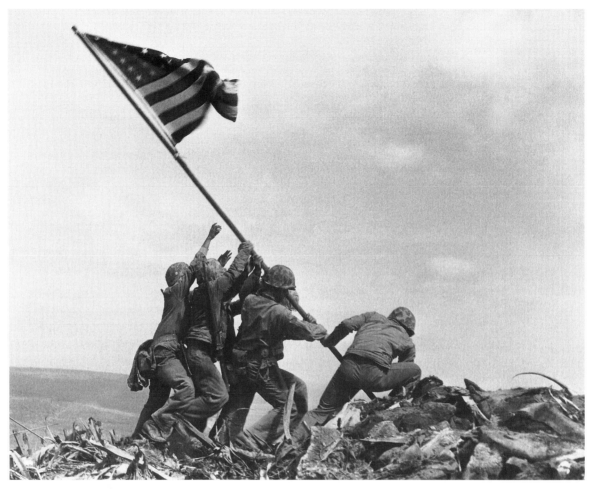

Joe Rosenthal. *Marines Raising the Flag on Mt. Mirabachi at Iwo Jima.* Pulitzer Prize 1945. *From* Flash! The Associated Press Covers the World.
Introduction by Peter Arnett, Edited by Vincent Albasio, Kelly Smith Tunney, and Chuck Zoeller. © *The Associated Press. Courtesy Harry N. Abrams, Inc.*

prints housed in a new, separate photo gallery. He also curated such important shows as **Richard Avedon**'s 1994 retrospective and the Whitney's star-making 1996 **Nan Goldin** show.

Rothstein, Arthur (1915–1985)

American documentary photographer

Rothstein made an important contribution to the archives of American photography with such memorable Depression-era images as his Oklahoma dust storm photo of 1936 and a bleached skull on the parched plains of South Dakota. He was the first person hired by **Roy Stryker** for the Historical Section of the **Farm Security Administration** (FSA) and later became photo editor of *Look* and then of *Parade* magazine.

Born in New York, Rothstein was Stryker's student at Columbia University and founder of the camera club

there. At age 21, he started a five-year stint at the FSA; his first assignment was to set up the photo lab. Before long he was going out on assignments. He learned much from his colleagues there, especially **Walker Evans** and **Ben Shahn**, both of whom considered photography a fine art as well as a medium of documentation.

His first major assignment was to photograph the mountaineers who were to be evacuated to make room for Shenandoah National Park. Rothstein used his small Leica camera unobtrusively, so he could observe and record the traditional life patterns of his subjects without drawing attention to himself. He spent time photographing in New England, in the Deep South, and on a Montana ranch. His trip to the Oklahoma-Kansas-Texas dust bowl was the most significant of his FSA years.

He left the FSA and moved to *Look* in 1940 as a photographer. During World War II he served in the army as

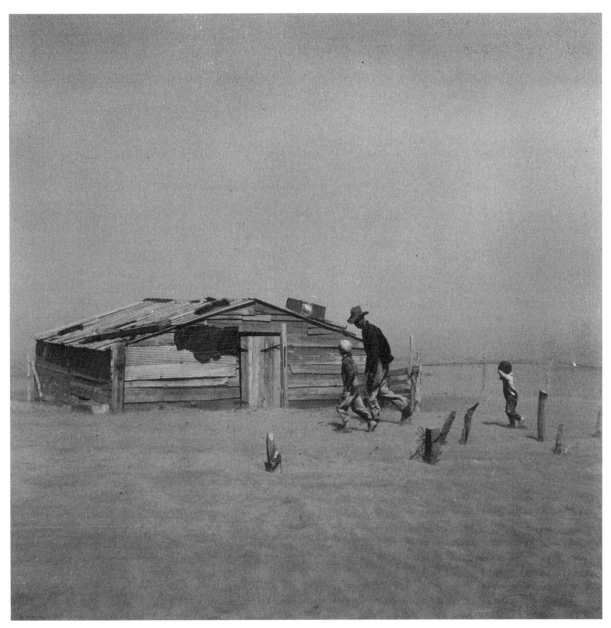

Arthur Rothstein. *Farmer and Sons Walking in the Face of a Dust Storm, Cimarron County, Oklahoma.* April 1936. Library of Congress.

a Signal Corps photographer. He returned to *Look*, became director of photography and stayed at the magazine until it closed in 1971. He then joined *Parade* as photo editor.

Also a tinkerer, he developed a three-dimensional photo and printing technique—Xograph—in 1963, for which he won numerous citations and awards.

He once said that he considered his FSA work not as art but as a tool of social change. Today his work is considered both, and many of his pictures can be seen hanging in museums, as well as illustrating histories of the Depression era. His pictures are held by such collections as those of the **George Eastman House**, the Museum of Modern Art in New York, and the **Smithsonian Institution**. Several books of his work have been published, including *Words and Pictures* (1979) and *The Depression Years as Photographed by Arthur Rothstein* (1978).

rotogravure: A printing technique using a rotary press and **intaglio process** in which the image is etched beneath the surface of the printing plate. The

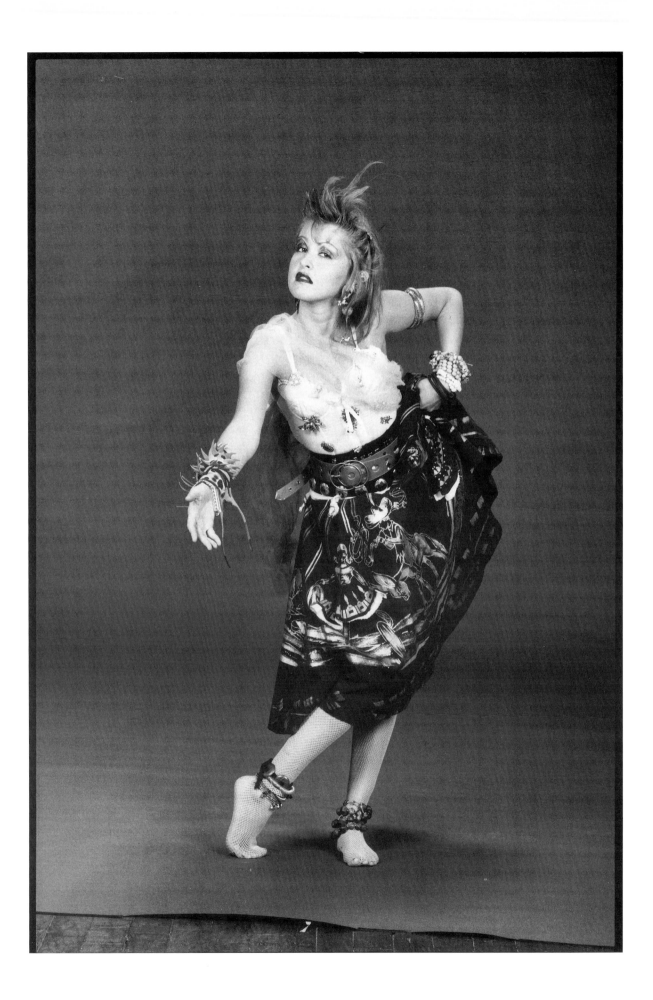

recessed areas hold ink and the surface areas are wiped clean.

Royal Photographic Society: A British organization founded in 1853 as the Photographic Society of London. Queen Victoria formally named the organization by an official decree in 1894. Its purpose is to encourage technological advances in the medium and support the documentary and creative uses of photography with exhibitions and awards.

royalty free images or photographic "clip art": Collections of images that are sold commercially and then used by the purchaser for a wide variety of publication purposes without any additional payment.

Rubenstein, Raeanne (1952–)

American portrait photographer

Rubenstein is a leading chronicler of the country music scene who has produced several books of celebrity photographs.

Born on New York's Staten Island, she majored in English literature at the University of Pennsylvania. She took her one and only photo class there, then took up photography as a hobby.

Returning to New York City after college, she started taking snapshots of some of her famous friends, like John Lennon and **Allen Ginsberg**, and soon found her work being published in *Rolling Stone*, *Time*, *People*, and then *Entertainment Weekly*, among others.

Her books include *The Fillmore East: Recollections of a Rock Theater* (1996), *Gone Country: Portraits of Country Music's Newest Stars* (1997), and *Honkytonk Heroes* (1975). Her work has been exhibited at numerous galleries and museums, from the Whitney in New York to the Country Music Hall of Fame in Nashville. Rubenstein has also shot numerous CD and record album covers and has contributed to several TV programs.

Rubinstein, Eva (1933–)

American art photographer

Rubinstein's varied body of work includes editorial, documentary, and portrait photographs done as a freelancer plus her own personal images that convey her artistic vision in portraits, nudes, and interiors.

Born in Buenos Aires, Argentina, where her mother was accompanying her husband (Arthur Rubinstein) on tour, Rubinstein lived in Paris as a child before emigrating with her family to the United States at the outbreak of World War II. She attended Scripps College and studied at the theater department of the University of California at Los Angeles. Trained in ballet from the age of five, she danced and acted both on and off Broadway, where she was in the original production of "The Diary of Anne Frank" (1955–1956).

She began photographing in 1967 with the help of Sean Kernan, and she also studied briefly with **Lisette Model**, **Jim Hughes**, **Ken Heyman**, and **Diane Arbus**. As a teacher she has participated in many workshops and lectured at universities and arts institutions worldwide.

Her work has been published in several monographs, including *Eva Rubinstein* (1974). Rubinstein has exhibited in many solo and group exhibitions, at such venues as the Arles Festival, the Bibliothèque Nationale in Paris, and the **Friends of Photography** in Carmel, California. Her work is held in numerous private and public collections, including those of the **International Center of Photography**, the Metropolitan Museum of Art, and the Library of the University of Lodz, Poland.

Ruscha, Ed (1937–)

American painter and photographer

Ruscha is an artist who first achieved notice in the 1960s with his pop art painting. He then became interested in signage and produced a series of word paintings using ordinary phrases that were a common feature of Los Angeles street life. One of his most often reproduced images is of the Hollywood sign billboard that is that city's most widely visible landmark. He moved into conceptual art with his photo books, the first of which, *Twenty-six Gasoline Stations*, was a series of pictures showing gas stations along Route 66 between Oklahoma City and Los Angeles.

Born in Omaha, Nebraska, Ruscha studied at the Chouinard Art Institute. His work has been widely exhib-

Raeanne Rubenstein. *Cindy Lauper.* 1984. © Raeanne Rubenstein. Courtesy of the photographer.

Eva Rubinstein. *Mas de la Barjolle.*1984.
© Eva Rubinstein. Courtesy the photographer.

ited in group and solo shows at such venues as the Museum of Contemporary Art in Los Angeles, the Whitney Museum, and the San Francisco Museum of Modern Art. Among the private and public collections holding his work are those of the Museum of Modern Art in New York, the Hirshhorn Collection, and the Pompidou Center in Paris.

In 1998 Ruscha completed a 23-foot-long painting of shafts of light in the lobby of the auditorium at the Getty Center in Los Angeles. The Getty painting uses Ruscha's "Miracle Drawings," a series completed in the 1960s, as its prototype.

His photo books include *Various Small Fires* (1964),

Every Building on the Sunset Strip (1966), and *A Few Palm Trees* (1971). He has been a visiting lecturer and the recipient of several awards, including two **National Endowment for the Arts** grants (1969, 1978) and a **Guggenheim fellowship** (1971).

Russell, Andrew J. (1830–1902)
Early American documentary photographer
Best known for his photographs of the construction of the Union Pacific Railroad, Russell earlier had been a notable Civil War photographer with a similar assignment, photographing construction and fortifications for the U.S. Military Railroad Construction Corps.

A talented painter who became interested in **wet plate** photography, Russell moved from Nunda, New York, where he taught penmanship, to New York City, where he opened a studio combining both his talents. This was not an uncommon practice in the early days of photography. He made numerous paintings from the photographs he took, including Civil War battlefield scenes.

After the war he traveled between the East and Omaha, Nebraska, headquarters for the Union Pacific. His railroad images provide an important record of the impact on the landscape of the construction. They show the camps of men who worked on the railroad and the various projects, such as the bridges and tunnels, undertaken in conjunction with the laying of rails. Russell took copious notes and sent back reports of his activities to the Nunda Press.

The Union Pacific published an album of Russell's **albumen** prints in 1869. His most famous photograph, of the joining of rails in Promontory, Utah, was wrongly attributed to another photographer, and many decades passed before he received proper credit.

After completing his work in the West, Russell returned to New York and established a studio where he did work for weekly magazines.

A. J. Russell. *Mormon Family, Great Salt Lake.* 1868–69. Western Americana Collection, Yale University.

PORTRAITS OF PHOTOGRAPHE

s

M – Z

Christopher Makos seen at Andy Warhol retrospective, Whitney Museum. November 20, 1979

Gerard Malanga at the Andy Warhol Factory. April 24, 1969

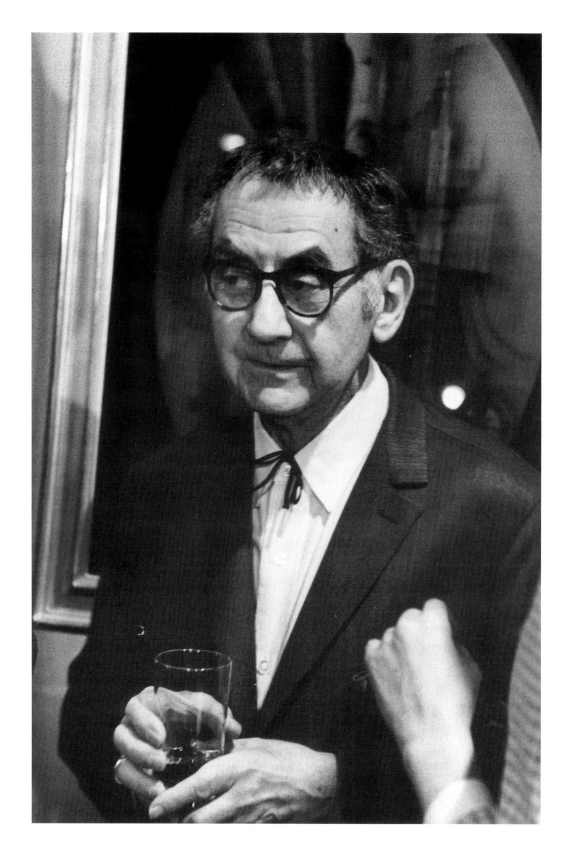

Man Ray attending his Cordier & Ekstrom Gallery show in New York. April 30, 1963

Mary Ellen Mark on LaGuardia Place, in Soho, New York. February 1, 1978

Herbert and Mercedes Matter at Jasper Johns exhibit, Whitney Museum. November 21, 1978

Duane Michals at the International Center of Photography. November 14, 1974

Lisette Model at Richard Avedon show, Marlborough Gallery. September 9, 1975

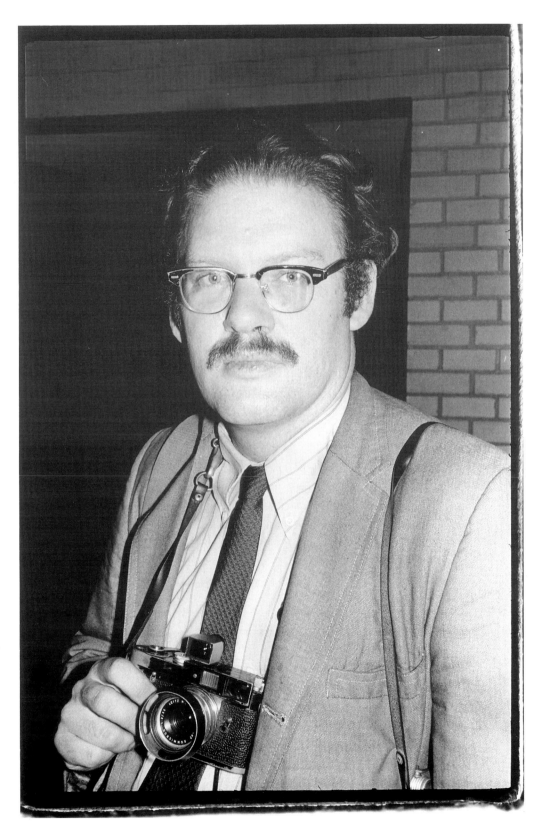

Peter Moore at the New School, West 12th Street. September 8, 1969

Inge Morath and Arthur Miller seen at an Amnesty International fund-raiser. November 20, 1977

Hans Namuth (right) and Jasper Johns at the Whitney Museum. October 14, 1977

Beaumont Newhall at the Museum of Modern Art. January 27, 1975

410

Arnold Newman seen at the French Cultural Center for a film party. October 8, 1981

Helmut Newton at his Marlborough gallery opening; behind him (right) is Bill Cunningham
of the *New York Times.* November 21, 1978

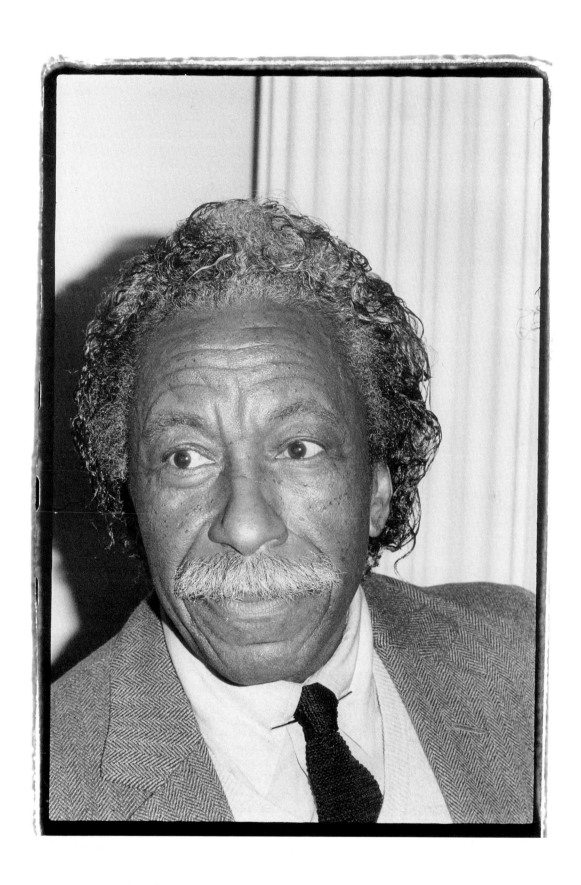

Gordon Parks receiving a mayor's award at Gracie Mansion, New York. February 10, 1982

413

Sylvia Plachy (holding cigarette) and André Kertész at a photo exhibit at the Overseas Press Club, New York. November 21, 1978

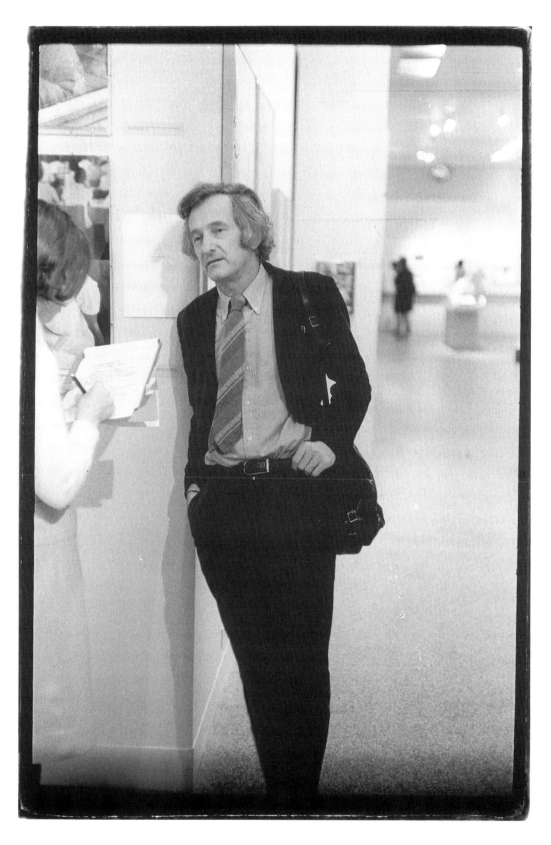

Marc Riboud being interviewed on his 20th anniversary with Magnum Photos. February 15, 1972

Critics Shelley Rice (right) and A. D. Coleman at a press luncheon. June 27, 1979

Arthur Rothstein at the inaugural exhibit of the Soho Photo Gallery, New York. October 23, 1975

417

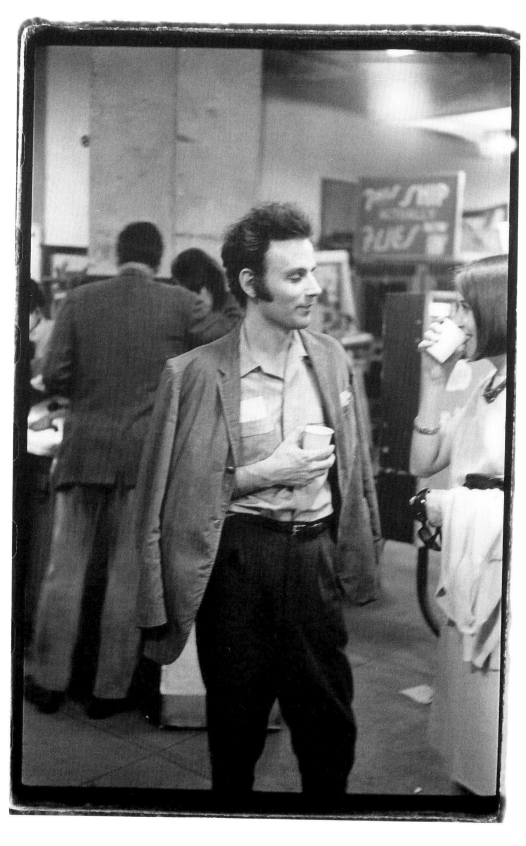

Lucas Samaras in a penny arcade on Times Square. May 19, 1964

Francesco Scavullo at Peter Beard's exhibit. November 10, 1975

Aaron Siskind attending a gallery opening. December 1, 1978

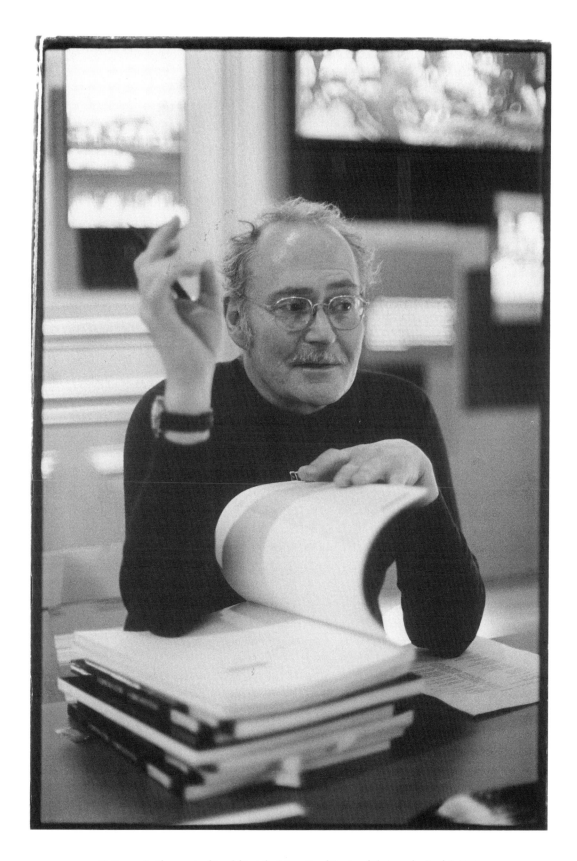

W. Eugene Smith preparing his exhibit at the International Center of Photography. April 8, 1975

Lord Snowden (Antony Armstrong-Jones) in New York to open the exhibit "The English Eye." November 20, 1965

John Szarkowski at the Museum of Modern Art. January 27, 1975

James Van Der Zee at a Gracie Mansion award ceremony. February 10, 1982

Willard Van Dyke at the Museum of Modern Art. January 27, 1975

Carl Van Vechten and Martha Graham at The New School, New York. September 20, 1962

426

Roman Vishniac at an International Center for Photography show. November 14, 1974

Sam Wagstaff in attendance at the Peter Beard exhibit. November 10, 1975

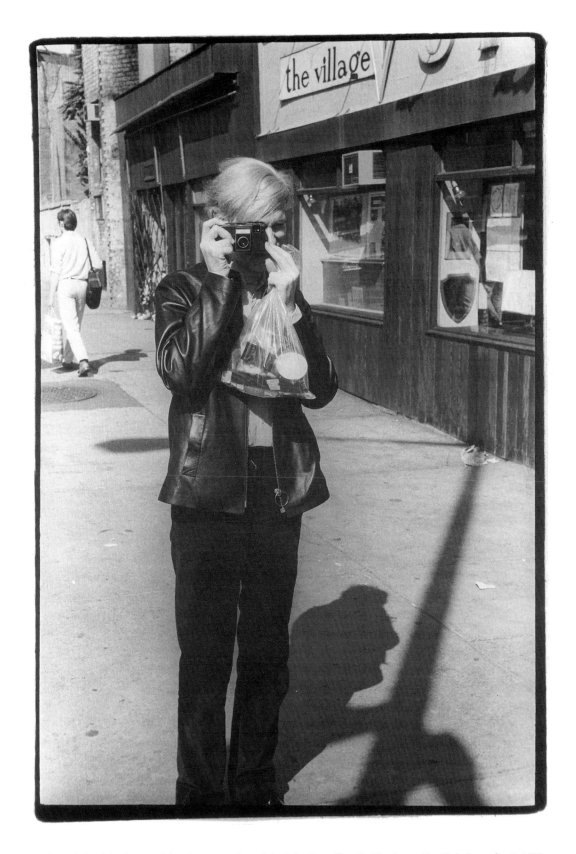

Andy Warhol with his "point and shoot" camera in front of the *Village Voice* office, Sheridan Square, New York. September 9, 1968

Minor White with Grace M. Mayer (back to camera) at the Museum of Modern Art. January 27, 1975

430

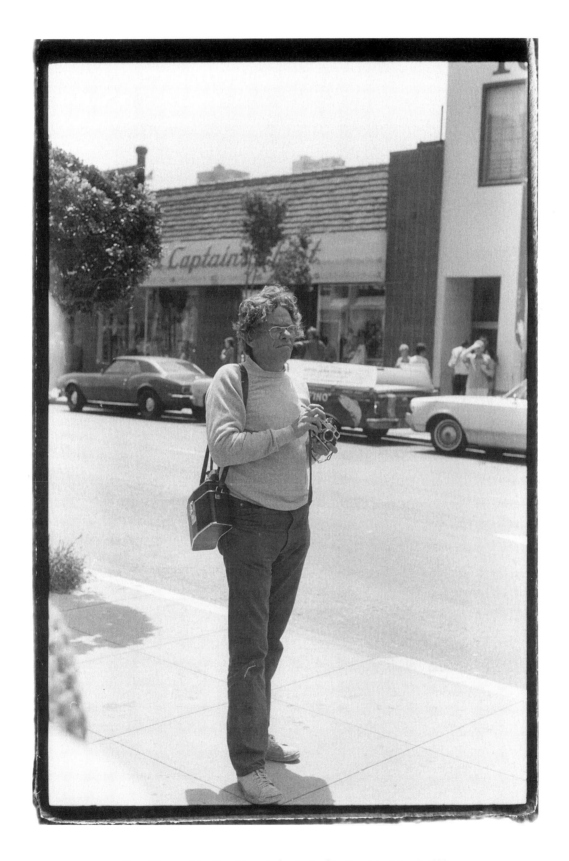

Garry Winogrand shooting pictures in the streets of San Francisco. August 7, 1972

August Sander. *Handlanger (Hod Carrier)*. 1929.
The Bokelberg Collection, courtesy Hans P. Kraus, Jr., Inc., New York.

Sabatier-Blot, Jean-Baptiste (1801–1881)

Early French portrait photographer

A miniaturist painter, Sabatier-Blot adapted the best qualities of his miniature portraits to the **daguerreotypes** he made. He was a student and close friend of **Daguerre**, and his daguerreotype of the inventor is considered the earliest portrait of the man; it was made in 1844. His daguerreotype portraits of his wife, Marie, and his mother-in-law are among the most highly regarded of his works.

Born in Lassur, Sabatier studied to be a painter and exhibited in the salons of 1831. His wife's last name was Blot, and he frequently signed his work with his name hyphenated with hers. His daguerreotypes were highly praised during his lifetime, and he exhibited in 1849 at the Exposition des Produits d'Industrie in Paris. In 1851 he was a founding member of the Société Héliographique. His later work, using the wet-**collodion** process for *cartes de visite* did not achieve the high quality of his daguerreotypes.

safelight: A light with a dark, reddish-brown color used in a photographic **darkroom**. While most film is sensitive to all colors of light, most **black-and-white** photographic **paper** is not sensitive to the reddish brown of the safelight, so it can be used for illumination when printing black-and-white photographs in the darkroom.

safety film: Photographic film that is not flammable. Until 1950 some films used nitrate in their base and were highly flammable. All photographic films used today are safety film.

Sakai, Toshio (1940–)

Japanese photojournalist

Sakai was the 1968 **Pulitzer Prize** winner for his shot of an Amercian GI wrapped in a poncho trying to get some sleep during a Vietnam monsoon.

After getting a degree in economics, he joined United Press International in 1965 as a photographer in the Tokyo bureau. He moved to UPI's bureau in South Korea in 1975 and two years later started a freelance career.

His work has been included in *Moments* (1978) with a foreword by Dan Rather, and *The Photo Book on Vietnam* (1979).

Salgado, Sebastião (1944–)

Brazilian photojournalist

A committed photojournalist, Salgado is one of the most outstanding and versatile of contemporary photographers. A humanist who conveys his feelings with powerful, beautiful photographs, he has revealed a world of human despair from the miserable conditions endured by Brazilian coal miners to African famine victims to oil well firefighters in Kuwaiti oil fields.

A trained economist with advanced degrees in the field, he first became interested in photography while touring Africa as an economic advisor in 1970. In 1973 he quit his job to travel to Africa with his wife to document famine there. In 1974 he joined the **Sygma** agency, and then the **Gamma** agency (1975–1979). In 1979 he was invited to join **Magnum**. Two years later he was in the doorway of the Washington Hilton taking pictures when President Ronald Reagan was shot by John Hinckley.

His images of Latin American peasants from six different countries were compiled in the 1984 book *Other Americas*. His 1993 book *Workers: An Archeology of the Industrial Age* is an homage to manual labor. In 1997 he published *Terra: Struggle of the Landless*, about the hard life of Brazilian peasants.

Salgado, who lives in Paris, has won various awards, including the **W. Eugene Smith** Award in 1982 for his essay and series *Ethiopian Famine*. In 1985 he won the **Oskar Barnack** Award. He was named Photographic Journalist of the Year by the **International Center of Photography** in 1986 and received the **Hasselblad** Award in 1989.

His work has been exhibited internationally at such venues as the Philadelphia Museum of Art, the San Francisco Museum of Art, and the Corcoran Gallery. In 1993 he received the ultimate American cultural accolade, a feature in *People* magazine. His work has been published in magazines and newspapers worldwide.

Salomon, Erich (1886–1944)

German documentary photographer

Salomon is known as the "father of **candid photography**" for his pioneering use of 35mm cameras. Early in his career he became world famous after he smuggled a camera into a murder trial and took unique pictures inside the courtroom. He documented many political and cultural events, always using an informal, low-key style that became the preferred approach of photojournalists photographing celebrities.

Born in Berlin, he studied engineering and then earned a law degree at the University of Munich in 1913 and opened a practice just before the outbreak of World War I. He was a prisoner of war for four years. He turned to photography as a profession in 1927 when he was unable to maintain his law practice during Germany's hard economic times.

When the sensational murder-trial pictures appeared, his work was in demand and he published in the leading mass market periodicals. In 1930 he came to the United States, where his subjects included President Herbert Hoover in the White House, the actress Marlene Dietrich, and a host of others. His book *Famous Contemporaries in Off-Guard Moments* appeared in 1932. He usually kept his camera hidden in his briefcase, and French Prime Minister Aristide Briand called Salomon "Le roi des indiscrets"—or, "the king of prying."

He and his family fled Germany when the Nazis' persecution of the Jewish people threatened their freedom, but Salomon, his wife, and a son were imprisoned when the Nazis invaded Holland, where they had taken refuge. They were put to death in 1944 at Auschwitz.

His work has been exhibited internationally at such venues as the **George Eastman House**, the **International Center of Photography**, and the **Royal Photographic Society** and is held by major collections including those of the Museum of Modern Art in New York, the University of Texas at Austin, and the Life Picture Collection in New York.

salon photography: Photography for salon exhibitions. Before the advent of art galleries for photography, exhibitions were shown in salons or rooms rented specifically for the **exhibition** purpose. Salons were juried shows of work in the United States and Europe in the nineteenth and early twentieth centuries.

salt paper process: The earliest paper photograph process, invented by **Fox Talbot,** in which paper is soaked in salt, dried, and then floated in a solution of silver nitrate under dim candlelight and dried in the dark. The paper is then used to make **contact prints** from paper negatives (see **calotype**; Talbotype) by exposing it to sunlight and then toning it in gold or platinum and fixing it in **hypo** and **washing** it.

salt print: A photograph made by the **salt paper process**.

Samaras, Lucas (1936–)

Greek-born, American sculptor and photographer

Born in Greece and educated at Rutgers University in New Jersey, Samaras was an early participant in the 1960s' performance art happenings and achieved considerable success as a sculptor in addition to his art photography.

By 1963, he was incorporating photos in his box sculptures. In 1969 he bought a **Polaroid** SX-70 camera and began a series of self-portraits that culminated in the book *Samaras Album: Autobiography* (1971). His "Transformations" series (1973) was among the first to

use manipulated Polaroid images. His technique is to manipulate with light or his body or the process itself. The art critic Peter Schjeldahl has called Samaras the artist laureate of narcissism, because he has taken thousands of self-portraits in scores of mediums.

His photo portrait work can be seen in *Sittings 8 x 10* (1978–1980) and *Panoramas* (started in 1983), in which he cut and reassembled Polaroid prints and still-lifes to create horizontally extended life-sized images.

His work has been exhibited internationally and is held by such collections as those of the Museum of Modern Art in New York, the Hirshhorn Museum in Washington, D.C., and the Walker Art Center in Minneapolis.

Sander, August (1876–1964)

German documentary photographer

Sander is best known for his self-conceived archival project of assembling a portrait collection of the people of Germany from the years of the kaisers to the Weimar Republic, the Nazi regime, and the early Federal Republic. He planned to reveal the social and cultural levels of German life by creating simple, natural, narrative scenes showing the subjects—from bricklayers and peasant girls to generals and corporation presidents—straight on, in natural light.

Born in Herdorf an der Seig, the son of a miner, he completed an apprenticeship in mine work. His introduction to photography came in 1892, when he was called on to assist a photographer commissioned to take pictures of the mine. After he was allowed to look through the ground glass focusing screen, he said, he decided then and there to become a photographer.

He bought himself a camera and set up a rudimentary darkroom in a shed. After his military service he left the mines and worked in Berlin, Chemnitz, and Dresden, gaining experience in his craft. In Dresden he also attended the Academy of Painting. In 1902 he and a partner took over a studio in Linz. His professional success was quick, and he won various state and local awards for his work. He sold his Linz studio in 1904 and moved to Cologne, where he remained until the outbreak of World War I. While in Cologne he started to photograph the

local peasants, which was the genesis of his massive project.

He had a major exhibit entitled "People of the Twentieth Century" in Cologne in 1927. The Munich publisher Kurt Wolff came up with the idea of bringing out a work with 5,000 to 6,000 pictures. The first section, *The Face of Our Time*, was published in 1929.

But the Nazi imprisonment and subsequent death of Sander's son Erich, a talented photographer, affected Sander deeply. The Gestapo hounded the family incessantly, because Sander's pictures of the German people showed them not as the master race of Nazi propaganda but as perfectly ordinary people in the circumstances of their time and place. In 1936 the Nazis confiscated and destroyed the printing plates of the first section, and at the end of the war Sander's studio in Cologne was hit by bombs.

After World War II little was heard of Sander until an exhibit of his work was held in Cologne, and **Edward Steichen** invited him to contribute to the **"Family of Man"** exhibit. He was awarded honors by his country, but he led a retiring life until his death in a Cologne hospital.

In 1986 Sander's son Gunther edited *August Sander: Citizens of the Twentieth Century*, which follows in a general way Sander's 1924 outline for his project.

His work is held by such collections as those of the **George Eastman House**, the Museum of Modern Art in New York, and the Cologne Museum in Germany.

Sarony, Napoleon (1821–1896)

American portrait photographer

Theatrical portraits were Sarony's specialty throughout his life, and his dramatically posed and costumed **cabinet photos** of the leading actors and actresses of the late nineteenth century were eagerly puchased by an adoring public. He started his career as a lithographer but found full expression for his own flamboyant style in his distinctive portraits of such glamorous figures as Buffalo Bill (William Frederick Cody), Lillian Russell, Joseph Jefferson, Edwin Booth, Sarah Bernhardt, and Oscar Wilde.

Born in Quebec, Sarony came to New York City in

Napoleon Sarony. *Theatrical Portrait,* ca. 1880s.
Collection of the authors.

the mid-1830s. He worked as a liithographer for, among others, Nathaniel Currier, for whom he made a print of the sinking of a steamship in Long Island Sound. The print was a great success, bringing recognition to Sarony and Currier. He started his own lithography shop in 1846, and it prospered, producing, among other subjects, scenes of Commodore Matthew Perry's visit to Japan, the war with Mexico, illustrations for books and government publications, and theatrical posters, for which he drew portraits of the actors and scenes from the plays.

In 1858 Sarony sold his interest in his business and took his family to Europe, where he sought to develop his artistic talent. However, he was unable to establish himself as a painter, and, after visiting his brother Oliver, a commercial photographer who lived in northern England, he opened a studio in Birmingham, where his most famous customer was an American actress on tour, Adah Isaacs Menken.

In 1866 Sarony returned to New York City and

opened a photo studio in the theater district, then centered in Union Square. Theatergoers could see photos of their idols in his window and go upstairs to his extravagantly furnished studio to buy the photographs. He is said to have amassed some 40,000 negatives of theatrical personalities. His subjects also included other famous people of the day, who were attracted to his studio by his theatrical work.

A selection of Sarony's best work, *The Theatrical Photographs of Napoleon Sarony* by Ben L. Bassham, was published in 1978.

Savage, Naomi (1927–)
American abstract photographer
Known for her commission to make a photoengraving of a mural wall for the Lyndon Baines Johnson Library in Austin, Texas (1971), Savage has a body of work that encompasses portraiture, abstraction, and the use of such techniques as collage, photogram, and solarization to produce unique images.

Born in New Jersey, she was class photographer in high school. She studied photography with **Berenice Abbott** at The New School in 1943 and later attended Bennington College. From 1947 to 1948 she assisted her uncle **Man Ray**, then living in Hollywood, who encouraged Savage to maintain an attitude of exploration.

In 1949, after her return from California, Savage took several photographs of her sister Elaine. One of the portraits, called "Mask" inspired Savage to make a new print from the original negative over a 50-year period with each new process that she learned. The LBJ Library mural is probably her most widely known work; it consists of five 8 x 10-foot photoetchings showing Johnson as president and with John F. Kennedy, Dwight D. Eisenhower, Harry S. Truman, and Franklin D. Roosevelt, the four preceding presidents.

She received a **National Endowment for the Arts** grant in 1971 and a Cassandra Foundation Award in 1970. Savage's work is held by such collections as those of the Museum of Modern Art in New York, the Fogg Museum in Boston, and the New Jersey State Museum. Her work has been widely exhibited at such venues as the Museum of Modern Art, the Hudson River Museum, and

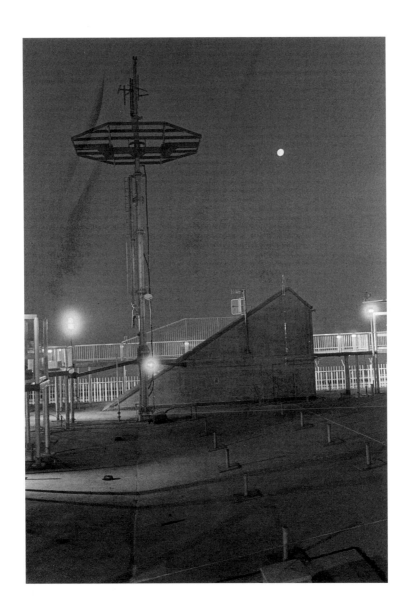

Lynn Saville. *Whispers from the Sky.* 1989.
© Lynn Saville. Courtesy of the photographer.

the San Francisco Museum of Art. A monograph of her work, *Everchanging Faces of Naomi Savage* by Julia Scully, was published in 1968.

Saville, Lynn (1950–)

American architectural and landscape photographer

Saville has achieved recognition for her haunting and artistic black-and-white photos of places and buildings taken at night.

A graduate of Duke University (bachelor of arts, 1971) and the Pratt Institute (master of fine arts, 1976), she studied with **Philippe Halsman** in New York in 1979 before striking out on her own. Her freelance career has been successful, and her work has systematically been acquired by such places as the **George Eastman House** and the New York Public Library. A critic has said of her work, "By braving the hours between dusk and dawn, Saville demonstrates an ample understanding of the psychological perception of light."

Her most recent book is the Rizzoli monograph, *Acquainted with the Night, Photographs by Lynn Saville* (1997). She is represented by the Photographers Gallery in London as well as by dealers in Los Angeles and New York and has been in many solo and group gallery and museum shows.

Sawada, Kyoichi (1936–1970)

Japanese photojournalist

His **Pulitzer Prize**-winning photographs taken in Vietnam in 1965, particularly the searing image of a mother swimming with her children across a river to safety, were only the first of the many awards Sawada earned as a combat photographer in southeast Asia. After the war expanded into Cambodia he worked there and was killed along with the new United Press International bureau chief, Frank Frosch, whom he had volunteered to take on a tour of the area near Phnom Penh to assess the conflict.

Born in northern Japan, Sawada worked in the camera shop of a U.S. military base in Misawa. He went to work in Tokyo for UPI in 1961 and became bureau chief. Unsuccessful in his request to be sent to Saigon, he used his vacation time in February 1965 to begin his coverage of the war.

He won grand prize in the Ninth Annual World Press Photo contest, an Overseas Press Club award, and the U.S. Camera Achievement award in 1965. In 1966 he won first and second place in the World Press contest and in 1967 another Overseas Press Club award. In 1968 UPI named him Hong Kong bureau chief, but he chose to go back to Vietnam. After his death the Overseas Press Club honored him with its **Robert Capa** Award.

scanner: A device that converts artwork, photographs, or text into digital data.

scanning: The transformation of an image to digital form. An image is placed on a scanning bed and is copied and converted to digital information for use in the **computer**.

Scavullo, Francesco (1929–)

American fashion and portrait photographer and director

A career that has spanned more than five decades has made the name Scavullo synonymous with fashion and beauty. His pictures in the world's top magazines of supermodels, rock stars, and other pop culture celebrities helped redefine the word *glamorous*.

Born in Staten Island, New York, Scavullo first became interested in fashion, beauty, and film when his grandfather took him to see Greta Garbo in *Queen Christina* when he was five years old. As a young teen he started taking photos of his sister and her friends, dressing them up and applying their makeup to make them as glamorous as possible. He dropped out of high school to take a series of jobs cleaning up photo studios and at 16 got a job as a studio assistant to the legendary fashion photographer **Horst P. Horst**.

In 1948, at age 19, he embarked on his professional career when he was signed by *Seventeen* and shot his first cover. Assignments quickly followed from *Town & Country*, *Good Housekeeping*, and *Ladies' Home Journal*. In 1955 he began working with **Alexey Brodovitch** at *Harper's Bazaar* and ten years later started shooting for *Cosmopolitan*. The list of his portrait subjects is a who's who of celebrity, from Verushka to Cindy Crawford,

Naomi Savage. *Mask*. 1965. Linecut photoengraving on silver-plated copper. © Naomi Savage. Courtesy the photographer.

Edward Albee to Barbra Streisand, **Andy Warhol** to Truman Capote. He was the first person to photograph Brooke Shields—when she was seven months old, for an Ivory Soap commercial.

He directed his first TV commercial in 1974, an ad for Memorex tape with Ella Fitzgerald. The next year he screen-tested Margaux Hemingway for the film *Lipstick*. He played himself in that film. Other film credits include a 1979 CBS special on the singer Crystal Gayle.

His books include *Scavullo on Beauty* (1976), *Scavullo on Men* (1977), *Scavullo Women* (1982), *Scavullo Photographs 1948–1984* (1985), and *Scavullo: Photographs 50 Years* (1997), and he has also done numerous record album covers for friends like Mick Jagger and David Bowie.

Schmidt, Bastienne (1961–)
German documentary photographer

Schmidt's seminal work *American Dreams*—a selection of photographs taken during a trip across America from the perspective of a person born elsewhere—has earned her favorable comparisons to **Robert Frank**, who completed a similar book project, *The Americans*, 30 years earlier.

Born in Munich and educated in Athens and then Italy for her college years, Schmidt moved to New York City in 1987. She worked for **Ralph Gibson** and the **International Center of Photography**. In the early 1990s she traveled in Central and South America, documenting death rituals and memorial services for a book, *Vivir La Muerte* (1996). After that, she spent time crisscrossing the United States for *American Dreams* (1997). "Schmidt has a sharp sense of the times," wrote the critic **Vicki Goldberg** of *Dreams*.

Her work has also appeared in the *New York Times Sunday Magazine*, *The New Yorker*, and German publications. Her work has been featured in several group shows and solo exhibitions and is held by such collections as those of the Brooklyn Museum, the Museum of Modern Art in New York, and the Bibliothèque Nationale in Paris.

Schulze, Johann Heinrich (1687–1744)
German chemist

Schulze made the key discovery that eventually led to the invention of photography: that light darkens **silver**

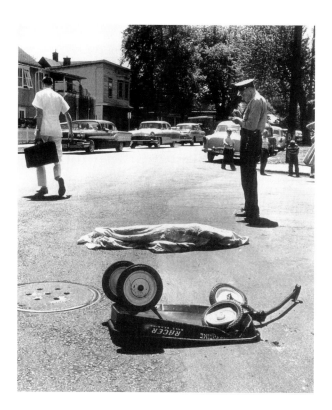

nitrate, whereas heat does not.

In 1725, he mixed nitric **acid** with a solution of chalk precipitate in water. The solution also contained a small amount of silver, which reacted with the acid to form silver nitrate. Schulze was surprised to see that the side of the bottle that was facing the window—and thus exposed to sunlight—darkened, while the shadowed side did not. He did additional experiments, which included letters and designs cut out of paper and pasted on a bottle of the solution—they left silhouettes of themselves when peeled away after exposure. This was a kind of photograph in liquid.

He recorded and published the results of these experiments, but it was not until 11 decades later that others put the information to a more practical use.

screen process: Printing a tiny grid pattern across a photographic image to translate it from a continuous-tone image to a **halftone** image for reproduction. The number of lines in a screen determines how sharp the image is reproduced and is indicated by lines per inch.

William Seaman. *All the Bright Shiny Dreams.*
Pulitzer Prize winner 1959 for Spot News.
© *Minneapolis Star Tribune.*

A 175-lines-per-inch screen gives the appearance of a continuous-tone photograph even though it is actually made up of tiny dots from a screen.

Seaman, William C. (1925–)

American photojournalist

During his 50-year career with the *Minneapolis Star*, Seaman won the **Pulitzer Prize** for spot news photography in 1959 for his searing image of a child who had moments before been shot to death in the street. He won a National Headliners Award in 1956.

Completely self-taught, he moved to Minneapolis from his native Nebraska as a teenager and got a job with the *Star* in 1945. He remained there for the rest of his career. In 1975 he won Honeywell's 25th Anniversary Photographic Award. His work has been included in *The Instant It Happened* (1972) and in *Moments* (1978), with a foreword by Dan Rather, a collection of some of the most memorable news photos of all time.

Secchiaroli, Tazio (1925–1998)

Italian celebrity photographer

The model for the famed paparazzo charcter in Fellini's *La Dolce Vita*, the celebrity-hounding Secchiaroli is generally regarded as the original ***paparazzo***.

As a young freelancer for Italian magazines in the early 1950s, he found that editors were bored with staged portraits and would pay handsomely for what he called "surprise" pictures of stars, all the better if they were caught where they were not supposed to be, with people other than their spouses. So he started to stake out locations like restaurants, hotels, and movie sets where he could catch celebrities off guard.

His reputation was made on August 14, 1958, during the Feast of the Assumption holiday in Rome. He caught the deposed King Farouk of Egypt in a café with two comely young ladies, neither of whom was his wife. When another photographer made a picture of the king attacking Secchiaroli in a mad grab to get his film and camera, his name was forever synonymous with celebrities. His photos sparked two other major global brouhahas. The first was when he took a photograph of Ava Gardner kissing Tony Franciosa—when he was mar-

ried to Shelly Winters. The other was of Anita Ekberg and her apparently inebriated spouse, British actor Anthony Steele. Today such images seem tame, but in their day they caused a tremendous uproar

After *La Dolce Vita* came out in 1960, Secchiaroli's fame soared and he became the personal photographer for such stars as Sophia Loren and Marcello Mastroianni. Fellini came upon him totally by accident when looking at pictures—some of them by Secchiaroli—to inspire him for a film about café society.

Although *paparazzi* developed a bad reputation with the public—especially after Princess Diana died in 1997—Secchiaroli remained proud and defiant. "We photographers were all poor starving devils and they had it all—money, fame, posh hotels," he said after Diana died. "The doormen and the porters in the grand hotels gave us information tips—you could call it the fellowship of the proletariat." Shortly after Diana's death his work was featured in a paparazzi retrospective at the Robert Miller Gallery in New York. He was featured in many shows in his native Rome. The Italian publisher Motta was expected to publish posthumously a collection of Secchiaroli's celebrity photos that he had selected just before his death.

second generation: A copy made from an original, such as a print made from a photograph and not from the original negative. In technology, second generation refers to a more advanced system than previously used.

Seed, Brian (1929–)

British photojournalist

Seed's body of work includes photoreportage, much of it taken between 1951 and 1966, when he worked under contract for *Time*, ***Life***, and *Sports Illustrated* magazines, books, audiovisual programs, and corporate accounts. He was also a founding partner of Click/Chicago Ltd., a stock and assignment photo agency.

Born in London, Seed worked in the London Bureau of Time, Inc. He learned photography while working as assistant to a variety of *Life* photographers, including **Cornell Capa**, from 1950 to 1954. His photographs have appeared in major periodicals, including *Paris Match*,

Brian Seed. *Labor Party Procession.* 1959. © Brian Seed. Courtesy the photographer.

Smithsonian, and the *London Illustrated News.*

He was principal photographer for "The London Experience," a multimedia program that was shown for many years in London. He also was a contributing photographer to the "Here's Chicago" program, shown at a specially constructed theater in the city.

From 1981 to 1988 he managed the Click/Chicago agency. In 1990 he launched *Stock Photo Report*, a monthly publication for stock photo professionals. As of 1998, he has written by his own estimate more than 300,000 words on the subject of stock. Along with the stock work, he has been a visiting lecturer in photojournalism at Guildford School of Art in England and a part-time instructor at Chicago's Columbia College.

He was named 1966 Photojournalist of the Year in the United Kingdom. His insightful photographs have appeared in several Time-Life books, including *London* (1976), *Africa* (1970), and *Spain-Portugal* (1969). He also did a film, *River Shannon,* in 1971.

Seeley, George H. (1880–1955)
American photographer and painter

Invited by **Alfred Stieglitz** himself to join the **Photo-Secessionist** movement, Seeley was known for the lyric quality of his outstanding **pictorial** photographs.

Born in Massachusettes, he studied art at the Normal Art School in Boston. During this period, he met **F. Holland Day**, who encouraged him to work in photography as a fine art. He exhibited at the First American Photographic Salon in New York in 1904, where his talent caught Stieglitz' eye. From 1906 to 1910 he was an active if isolated member of Stieglitz's group, living with his family in the Berkshires. He was regularly featured in the journal **Camera Work**.

Seeley was the supervisor of art for the Stockbridge schools for many years; he was also associated with the Springfield *Republican* for a time. His passion was birds, and he was a member of the Biological Survey of Washington, maintaining a landing station and reporting migratory patterns.

George H. Seeley. *The Firefly,* ca. 1907. From *Camera Work,* no. 20, October 1907. Collection of the authors.

selenium treatment: After a photograph is made, it can be treated with various substances to change its image color and to preserve its image stability. Selenium is an element that converts the silver image in a **black-and-white** photograph to silver selenide, which has a reddish-brown color and is more resistant to fading than regular metallic silver. Selenium toner comes in pre-mixed packages and is easy to use, but it is quite toxic and should be avoided if possible or used only with great care. Some commercially available photographic **papers** react dramatically to selenium, changing color significantly, and others resist it, changing little or not at all. Whether a tonal change is evident or not, the permanent quality of selenium is produced.

self-timer: A device on some cameras that delays the film exposure so that the photographer can position him- or herself in the picture. Usually the procedure is to set the camera on a **tripod** or other surface and **focus**. The film is advanced and/or **shutter** cocked, then the timer set. When the shutter release button is pressed, the timer is activated and the picture is taken a few seconds later, giving the photographer enough time to get into the picture. On some cameras the self timer is activated by remote control.

separation negatives: Three separate negatives of color photographs, negatives, or artwork for reproduction that correspond to magenta, yellow, and cyan in the original. Separation negatives are used mostly by the graphic reproduction industry, but they are also used to make **dye transfer** photographic color prints.

sequence camera: A camera that makes a number of exposures automatically over a short period of time. The results can be pieced together to illustrate a sequence of events or movements, used mostly in sports and **surveillance photography**.

sequential photography: Photography that represents a series of actions, events, or movements. The sequence can be of long duration, as in grass growing, or of short duration, as in a horse running. In the 1870s,

Eadweard Muybridge devised a series of cameras to record a horse in motion in order to determine if all four hooves left the ground simultaneously; they did. This was the first example of sequential photography. Today nature programs routinely show a flower opening or other natural events that occur very slowly over time by means of sequential photography.

series print: After **vintage prints** are made from the original negative, it is not uncommon for several years to pass before the photographer prints again from the negative. Owing to changes in the negative or the printing paper or the chemicals used to make the positive, the final surface quality of the image may differ from that of the vintage print. These series prints may be made over the course of several years.

Serrano, Andres (1950–)
American artist

Serrano made a photo that achieved international notoriety and placed the issue of government funding and artistic freedom smack dab on the front burner of the American cultural and political agenda. The debate that "Piss Christ"—a photograph of a beaker of urine containing a model of Jesus on the crucifix—ignited still rages.

A largely self-taught artist and photographer, Serrano studied for two years at the Brooklyn Museum Art School. His work is generally political in nature and has been since the outset of his career; he first exhibited publicly in 1983 at the activist-oriented Judson Church in Greenwich Village in a show called "Artists Call Against U.S. Intervention in Central America."

He has been in numerous group and solo shows since then, creating thought-provoking, esoteric, often **surreal** and **abstract** art all along the way. In 1986, he was the recipient of a **National Endowment for the Arts** photography grant. His controversial Christ image, and other Serrano images of Jesus, appeared soon thereafter in a show called "The Unknown Christ" at the Museum of Contemporary Hispanic Art in New York City. Some conservative religious and political leaders were outraged that government money had been given to Serrano to

Andres Serrano. *The Morgue—Fatal Meningitis.* 1992. (Original in color.) © Andres Serrano. Courtesy Paula Cooper Gallery, New York.

create what they regarded as blasphemous work.

An international controversy exploded on op-ed pages, on college campuses, in the halls of goverment, on gallery floors and elsewhere. It intensified when the Cincinnati Museum refused to show the work with some homoerotic **Robert Mapplethorpe** images as part of a show on new photography. As a result, Serrano rocketed to fame.

His work has been exhibited around the world, in such venues as the **Smithsonian Institution,** the Whitney Museum, and the Aldrich Museum of Contemporary Art in Ridgefield, Connecticut, and it is held by such collections as those of the New Museum for Contemporary Art and the Brooklyn Museum. He continues to live and work in New York.

sequence photography. A series of photographs often taken to illustrate movement over time.

Sometimes a sequence will have an implied narrative, or be used to illustrate a series of events. The first great master of sequence photography was **Eadweard Muybridge**, in his famous studies of human and animal locomotion.

Seymour, David "Chim" (1911–1956)
American photojournalist
Seymour, a committed photojournalist and a cofounder of **Magnum Photos,** was tragically killed by sniper fire while on assignment near the Suez Canal.

Born in Warsaw, as a youth he experienced the hardships of World War I, the upheaveals of the Russian revolution, and the rise of the Polish Republic before he reached puberty. (His nickname is a derivative pronounciation of his original family name, Szymin. His father, Benjamin Szymin, was a renowned Hebrew and Yiddish publisher.) He studied photography at the Leipzig

Pages 446 – 447: Eadweard Muybridge. *Woman with Fan.*
Associated American Artists, New York.

Academy and then at the Sorbonne. His first serious pictures documented left-wing political movements in Paris in the 1930s.

Sharing a darkroom with **Robert Capa** and **Henri Cartier-Bresson**, he started his freelance career in 1933 and soon was covering the Spanish Civil War and other important events throughout Europe. In 1939, he was in New York when war broke out and he was unable to return to Europe. In 1942 he became an American citizen and joined the Army, earning a Bronze Star during his three years of service.

In 1947 he was part of the group that founded Magnum. The next year, on assignment from UNESCO, he documented with great empathy the plight of refugee children in postwar Europe. The project, called "Chim's Children," later made into a book named *Children of Europe* (1949), earned him international acclaim. From 1949 to 1956 he worked on assignment for major magazines, covering such milestone events as the birth of Israel. Chim's many books include *Little Ones* (1957) and *Chim: The Photographs of David Seymour* (1996).

Two years after his death, a photographic foundation in Israel was named for him and for Robert Capa, who had also died on assignment. In 1966, the Fund for Concerned Photography was established "to foster the ideals and professional standards of these three men (Seymour, Capa, and **Werner Bischof**, who died on assignment in Peru in 1954) who died . . . while on photographic missions."

His photos are still widely exhibited; a major traveling show began at the **International Center of Photography** in 1996, marking the 40th anniversary of his death. His work is held by such collections as the ICP, the Metropolitan Museum of Art, and the Museum of Modern Art in New York.

Shahn, Ben (1898–1969)

American artist, social-documentary photographer, and teacher
Well known during his lifetime as an artist and muralist, Shahn has received increased attention for his humanistic **Farm Security Administration** (FSA) photos in the years after his death.

Born in Kovno, Russia (now Lithuania), he emigrated with his family to the United States when he was eight. After graduation from the City College of New York, he worked as a lithographer's apprentice and then traveled to Europe and North Africa to study art. Returning to New York in 1930, he shared an apartment with **Walker Evans**, a friend who had been the subject of some of Shahn's paintings. Evans inspired Shahn's growing interest in photography. He bought a used Leica for $25 and started to accompany Evans when he went out to shoot. Shahn also met **Henri Cartier-Bresson**, and his exhibition at the **Julian Levy** Gallery made a strong impression.

In the 1930s Shahn assisted Diego Rivera on the Rockefeller Center frescos and other public murals. From 1935 to 1938 he worked for **Roy Stryker** and the FSA as an artist, designer, and photographer. He often traveled with his wife, Bernarda, and photographed government homestead projects and American small-town life, amassing more than 6,000 photographs of the South and Middle West, an archive that would be his most famous photographic work. After he left the FSA, Shahn virtually ended his work in photography, using his camera principally in conjunction with his graphic design and painting.

During World War II he designed posters for the Office of War Information and after that began a career as a professor at Harvard University.

Shahn's photography is notable for its compassionate concern for humanity—a concern evident in all his work.

Sheeler, Charles (1883–1965)

American artist and architectural photographer
Known primarily as a precisionist painter of urban and industrial scenes, Sheeler also was a significant figure in architectural photography, notably his series on the Chartres cathedral, Shaker architecture, and Ford's River Rouge factory.

Born in Philadelphia, he studied painting with William Merritt Chase at the Pennsylvania Academy of Fine Arts from 1903 to 1906 and started taking architectural pictures to support himself while he pursued his painting. **Alfred Stieglitz** and **Edward Steichen** saw

Ben Shahn. *Unemployed Miner, Purseglove Mine, Scot's Run, West Virginia*, 1935. Library of Congress.

his early work and encouraged him to continue in photography. In 1918, he exhibited with **Paul Strand** and won two medals at the prestigious John Wanamaker Photography Exhibition.

In 1923 he was hired by Condé Nast to do fashion and beauty photography for *Vanity Fair* and *Vogue*. He photographed the Ford plant in 1927; those industrial images became his most famous work, as well as a major influence on his painting in the following years. He left Condé Nast in 1929 and traveled to Europe, when he took his series in Chartres. On his return he concentrated on painting, although he remained active as a photographer. From 1942 to 1945 he was staff photographer of the art works at the Metropolitan Museum of Art. A stroke in 1959 prevented him from continuing his art and photography.

Retrospectives of his work were held at the Museum of Modern Art in 1939, the Walker Arts Center in Minnesota in 1952, and at the **Smithsonian**'s National Collection of Fine Arts in 1989; he has also had numerous gallery and other museum shows. The major book of his work is *Charles Sheeler: The Photographs* (1987).

sheet film: Film in 4 x 5 or 8 x 10-inch size, used in **large-format cameras** in professional studios or advertising work. The sheet film is placed in a light-proof **film holder** that is then inserted into the back of the camera. The film holder generally accommodates two sheets of film.

Sherman, Cindy (1954–)

Famed American art photographer

In Sherman's distinctive self-portraits she is dressed up and made up to portray hundreds of different women and occasionally men, but never herself. She says her art deals with female stereotypes, and they are portraits not of

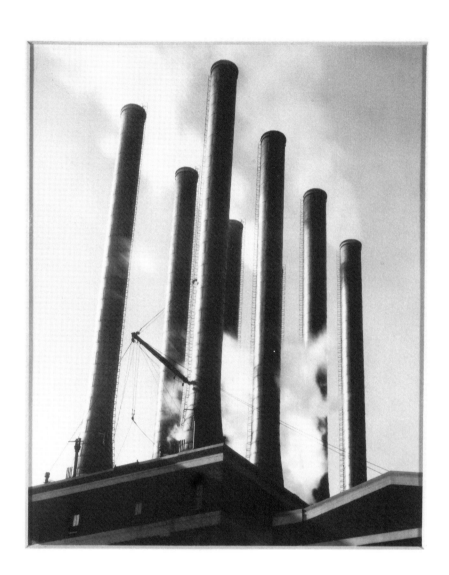

Charles Sheeler. *Power House No. 1—Ford Plant,* 1927. Courtesy the Museum of Fine Arts, Boston.

how she sees herself but how she sees men seeing women.

Born in Glen Ridge, New Jersey, she studied at the State University of New York at Buffalo (bachelor of arts, 1976). As a teenager she began to wear makeup to look more glamorous and found that she could turn herself into a different person by changing her appearance. In college she started making photo narratives starring herself.

included movie stars, centerfold nudes, fairytale characters, victims of disasters, and historical figures. Some of her portraits have produced comic or grotesque effects with plastic body parts, dolls, and her own made-up body. Her work has been exhibited worldwide in numerous group and one-person shows at such venues as the Los Angeles Museum of Contemporary Art, the Museum of Modern Art in New York, and the Pompidou Center in Paris. Among the collections holding her work are those

Cindy Sherman. *Untitled,* 1981. (Original in color.) © Cindy Sherman. Courtesy Metro Pictures, New York.

She moved to New York in 1977, when she was awarded a **National Endowment for the Arts** grant. Early recognition came in the late 1970s with a series of black-and-white photographs called "Untitled Film Stills," showing Sherman as a B-movie actress in various poses. She continued pursuing her art and earned her living at the Artists Space gallery. When the Metro Pictures Gallery opened in 1980, Sherman had one of the first shows, of her early color photos. It was the beginning of her success, and today Sherman is one of the highest-earning female artists.

Over the years her repertoire of images has

of the Metropolitan and Brooklyn museums in New York and the Tate Gallery in London. A selection of her photographs, *Cindy Sherman Retrospective* (1997), was published in conjunction with a major traveling exhibit.

Shore, Stephen (1947–)

American art photographer

Shore has achieved recognition as a key figure in new color photography, a loosely defined movement whose practitioners have brought serious aesthetic considerations to color photography as an art form. Shore's body of work includes banal images of everyday subject

matter—the back wall of a parking lot, yellow traffic stripes, a tabletop place setting in a restaurant—in sparsely populated areas that convey his formalistic vision of balance and serenity.

Born in New York City, he began photographing at the age of nine. A self-taught photographer, he began working with **Andy Warhol** at his Factory when he was 15. His black-and-white photographs of Warhol's milieu were published in *The Velvet Years: Warhol's Factory 1965–67* (1995).

Shore had his first major solo exhibit at the age of 24, at the Metropolitan Museum of Art. He began concentrating on color work, which was exhibited first at the Museum of Modern Art in New York. He has worked on assignments for magazines and other clients, including the Metropolitan Museum, for which he photographed Monet's *Giverny Garden*.

He has been in solo and group exhibitions in the United States and abroad. His work is held by private and public collections that include those of the **George Eastman House**, the Art Institute of Chicago, and the **Center for Creative Photography** in Tucson. His awards include two **National Endowment for the Arts** grants (1974, 1979), a **Guggenheim fellowship** (1976), and an American Academy in Rome Special Fellowship.

shutter: One of the two mechanisms that determine how much **light** reaches the **film** and the one that determines the length of time the exposure is for. Shutter speeds typically range from B (bulb, which means that the shutter stays open as long as you want) to 1/1000 of a second or less. A fast shutter speed can freeze a moving object and a slow shutter speed can create a blurring effect.

shutterbug: Slang for a photographer. Also, the name of a photography magazine that has ads of used equipment for sale.

sidebar: This term may have originated as a legal expression when conversations between a judge and a lawyer are held at the "side of the bar." In photography

and journalism it is generally a related news item or photo set off (sometimes in a box) from the main picture feature or article.

Sieff, Jeanloup (1933–)
French fashion and portrait photographer
A prolific photographer in the fields of fashion, advertising, and portraiture, Sieff brings his Gallic wit, technical expertise, and intuitive sympathy into full play in his memorable black-and-white images. He regards photography as work undertaken for his own pleasure, a means of briefly restraining the inevitable passage of time.

Born in Paris of Polish parents, he became interested in photography as a teenager, although his earlier ambition was to become a film director. After studying for seven months at the Ecole de Vevey in Switzerland, he began working as a freelance reporter in 1954. He joined *Elle* magazine the following year as a reporter and as a fashion photographer in 1956. He left *Elle* and was briefly associated with the **Magnum Photos** agency (1958–1959). He moved to New York and remained there from 1961 to 1966.

He has lived in Paris since 1966, working on assignment for *Vogue*, *Harper's Bazaar*, *Paris Match*, and other publications. A retrospective collection of his images, *Jeanloup Sieff: 40 Years of Photography* (1996), is the most recent of several monographs. His work has been exhibited at group and solo shows at such venues as the Victoria and Albert Museum in London, the Musée de l'Art Moderne de la Ville de Paris, and the Arles Festival. He was awarded the Prix **Niepce** (Paris, 1959), the Chevalier de la Legion d'Honneur (1990), and the Grand Prix de la Biennale de Nancy (1994).

silhouette: An image that is rendered completely black on a light background, showing only the outline of the subject.

Silk, George (1916–)
New Zealand-born, American photojournalist
After a 30-year career at *Life* magazine, Silk became a successful freelancer, and he is well known for both his sports pictures and his World War II photos, from

Rommel in the Middle East to fighting in New Guinea.

Born in New Zealand, he left the Auckland Grammar School (Sir Edmund Hillary's alma mater) at 14 and worked at a variety of jobs—from ranch hand on a cattle farm to salesman in a photo store. Silk had already started taking his own pictures, mainly of people skiing and sailing, when he joined the Australian Ministry of War Information in 1939. He came to the United States in 1943 to work for *Life* and remained until the original magazine closed in 1972. He traveled widely for the magazine, visiting locations like a North Pole weather station and the site of Olympic tryouts in Palo Alto. His images of track and field participants in the 1960 trials are renowned for their celebration of athletics and the human body.

He won many major awards during his time at *Life*, including four Magazine Photographer of the Year prizes (1960, 1962–1963–1964), a New York Art Directors Gold Medal (1961), and **American Society of Media Photographers** (ASMP)'s 1964 Photographer of the Year award.

In 1969 he made a film about one of his passions, sailing, *The Many Moods of a Thistle*.

Silk, who retired to Westport, Connecticut, continues to exhibit his work internationally. He was featured at a major show in Perpignan, France, in 1992 and in two important 1998 exhibits, one in New York showcasing seven photographers from *Life*'s heyday and another in Sydney, Australia, featuring Silk's pictures of the Australians at war in New Guinea.

silkscreen printing: A printing technique in which paint is forced through a fine screen onto the printing surface. Where there are to be negative areas of the image, the screen is blocked.

silver nitrate: A poisonous and corrosive substance made from dissolving metallic silver in nitric acid and then recrystallizing it (removing the liquid so that only a powder remains). Silver nitrate was used in early photographic processes to make **paper** and **film** sensitive to **light**.

silver print: Common name for a **gelatin** silver print or **black-and-white photograph**. Also, a photocopy that is used as a printing proof to make line-cut representations.

Simmons, Laurie (1949–)
American art photographer
Simmons has said that her work is about memory–not necessarily about her own experiences but an exploration of memory and history over the past 50 years in the United States, in relation to social identity and gender representation. Her body of images includes dolls, ventriloquists' dummies, and other toys that she carefully stages in tableaux to convey concepts that can be disturbing or charming, humorous or depressing.

Born on Long Island, she studied at the Tyler School of Art at Temple University (bachelor of fine arts, 1971). Her work is held by private and public collections, including those of the High Museum in Atlanta, the Walker Art Center in Minneapolis, and the Museum of Modern Art in New York. Simmons won a **National Endowment for the Arts** grant in 1984.

Her work has been exhibited in solo and groups shows at such venues as the Whitney Museum, the Museum of Modern Art in New York, and the Baltimore Museum of Art. *Laurie Simmons: The Music of Regret* (1997) was published in conjunction with the first major retrospective of her work, organized by the Baltimore Museum.

single lens reflex (SLR) camera: A camera that uses a mirror to project the image from the **lens** into a **viewfinder**. When the **shutter** is released, the mirror is lifted and the **focal-plane shutter** is activated, exposing the film. With this system when you look in the camera you are seeing exactly what the film will record.

single-use camera: Another term for **disposable camera,** that is, one that comes with film already loaded. When the film

Seattle Filmworks 35-mm single use (disposable) camera. © Fred W. McDarrah.

has been exposed, the entire camera is sent off to the manufacturer and developed prints are returned.

Siskind, Aaron (1903–1991)

American documentary and abstract-art photographer

Siskind began his photograpic career as a documentary photographer, who became known in the Depression era for his social documentation, particularly his *Harlem Document: Photographs 1932–1940*, *Dead End: The Bowery*, and *Portrait of a Tenement*. After 1940 he turned to a personal, semi-abstract form of photography, making painterly images of rocks, walls, graffiti, and plants that paralleled the work of the abstract expressionist painters of the late 1940s and 1950s.

Born in New York City, Siskind earned a bachelor of social science degree at the College of the City of New York in 1926 and taught English in the city's elementary and junior high schools until 1949. He was given a camera in 1930 on a trip to Bermuda and found photography a satisfying means of self-expression. He joined the **Photo League** in 1932 and was active in several of the group's projects.

Having established himself in photography with several exhibits of his work, Siskind left teaching after

23 years. At the recommendation of **Harry Callahan** he was hired by the Institute of Design in Chicago, where he became head of photography in 1959, the year his first book, *Aaron Siskind: Photographs*, was published.

He was a founding member of the **Society for Photographic Education** in 1963. He left Chicago in 1970 to become an adjunct professor at the Rhode Island School of Design in Providence. He won a **National Endowment for the Arts** grant in 1976 and was a **Guggenheim fellow** in 1966 and an Honored Artist at the Arles Festival in France in 1979.

Siskind's photographs are held by private and public collections, including those of the **George Eastman House**, the Metropolitan Museum of Art, and the Museum of Modern Art in New York. He has exhibited in group and solo shows at such venues as the Oxford Museum of Modern Art, San Francisco Art Institute, and the Art Institute of Chicago.

Skoglund, Sandy (1945–)

American art photographer

Bridging the boundaries of sculpture, installation art, and photography, Skoglund constructs witty, puzzling room environments often peopled with models, mannequins,

or animal sculptures, which she then photographs. One typically thought-provoking photograph showed an all-pink suburban patio inhabited by a swarm of pink and black squirrels. Another installation she photographed and exhibited showed an unhappy-looking bride and groom with a huge, elaborately decorated red wedding cake that filled a bright red room coated with jam.

Born in Quincy, Massachusetts, Skoglund studied at Smith College (bachelor of arts, 1968) and the University of Iowa (master of fine arts, 1972). She has taught at the University of Hartford in Connecticut and is currently a professor at Rutgers University in Newark, New Jersey. Her work has been exhibited in group and solo shows at the **George Eastman House**, the Mississippi Museum of Art, and the Aspen Art Museum. Skoglund's photographs are held by private and public collections, including those of the Metropolitan Museum of Art, the Los Angeles County Museum of Art, and the **Center for Creative Photography** in Tucson.

slave unit: A device that will activate a camera flash when another one in the area goes off. The slave is a small unit that is either built into a flash or attached to it. It has an electronic sensor that can tell when a nearby flash goes off and automatically fires the one to which it is attached.

Slavin, Neal (1941–)
American photojournalist

A successful freelance photographer whose assignments have included the official cabinet portraits of the Carter administration and the official White House portrait of President and Mrs. Bill Clinton for their first White House Christmas card, Slavin has also achieved recognition for his own personal work. He documented the lives of the black poor in rural areas of the South (1964) and in 1968 was awarded a Fulbright fellowship for a trip that resulted in his first book, with black-and-white photographs, called *Portugal* (1971). He has also produced two books of selected color photographs, *When Two or More Are Gathered Together* (1976) and *Britons* (1986), both collections of group portraits of clubs, societies, and organizations that offer witty, insightful views of contemporary society in the United States and Great Britain.

Born in New York City, Slavin was a scholar at Lincoln College, Oxford University, England, in 1961 while studying painting at Cooper Union (bachelor of fine arts, 1963). Before graduation he began work as a photographer's assistant at the Guggenheim Museum, photographing works of art, a job that provided him with the technical expertise of his craft. He worked as a free-lance designer and photographer and spent a year traveling throughout the United States for a postcard company. While traveling he also pursued his own photographic interests.

Slavin has taught at various schools, including Cooper Union, the School of the Visual Arts, and Queens College. His awards include two **National Endowment for the Arts** grants (1972, 1976) and the Augustus St. Gaudens Medal from Cooper Union (1988). His work has been exhibited in solo and group shows at such venues as the **International Center of Photography**, the Museum of Modern Art in New York, and the Arles Festival. Slavin's photographs are held by such collections as those of the Metropolitan Museum of Art, the **George Eastman House**, and the Akron Art Institute.

Sleet, Moneta Jr. (1926–1996)
American photojournalist

The first African American to win a **Pulitzer Prize** for photography, Sleet is known for his portraiture and reportage, particularly of the civil rights movement. His compassion for and empathy with his subjects are evident in the 1969 prize-winning shot of the widowed Coretta Scott King comforting her daughter Bernice at the funeral of the Rev. Martin Luther King, Jr.

Born in Owensboro, Kentucky, Sleet was introduced to photography by his parents, who gave him a box camera when he was a child. He studied business at Kentucky State College (bachelor of science, 1947) and after graduation taught at Maryland State College, where he set up the photography department. He studied journalism at New York University (master of arts, 1950), and worked in New York at the *Amsterdam News* before joining *Ebony* magazine, where he photographed for the magazine and other Johnson Publishing Company

Sandy Skoglund. *Radioactive Cats.* 1980. (Original in color.)
© Sandy Skoglund. Courtesy Janet Borden Gallery, New York.

publications. He has traveled on assignment throughout the United States, South America, Europe, and Africa.

In 1987 a major retrospective of his work was organized by the New York Public Library's Schomburg Center for Research in Black Culture.

slide: A **transparency** that has been mounted for use in a projector. Slides are made by using **reversal film,** which instead of producing a **negative** image, produces a **positive** image. Slide films often have the suffix "chrome" in their name, such as **Kodachrome,** Fujichrome, and **Ektachrome.**

small-format camera: Any camera that uses **35mm** film.

Smith, Marvin (1910–)
Smith, Morgan (1910–1993)
Pioneering American portrait photographers
For three decades, operating out of their studio on 125th Street, these twin brothers photographed noted black Americans, from Fats Waller to Jackie Robinson, Paul Robeson to Zora Neal Hurston.

Born in Nicholsville, Kentucky, the brothers moved with their family to Louisville when they were 12, and set up a photo studio in the basement of their house. They left their native state for New York in 1933. They enrolled in a free art school run by the sculptor Augusta Savage and through her met such notable literary figures as Countee Cullen and Langston Hughes. They experimented with street photography and contributed photos of Harlem social and political events to African-American newspapers.

By 1939 the brothers had opened their own studio, which became a popular meeting place for artists, writers, performers, and prominent community members. After World War II, Marvin studied painting in Paris with Fernand Leger; in 1954 the brothers abandoned photography for television. Morgan became a sound engineer and Marvin a set decorator. In 1967 they closed their photo studio, but both continued to dabble in the creative arts, from painting and sculpture to macramé and crocheted vests.

The pair were again "discovered" in 1992, when they were honored in their home town and a PBS documentary about them, broadcast in 1995, was begun. They were honored with a retrospective of their photography called "Harlem: The Vision of Morgan and Marvin Smith," held at the Schomberg Center in 1997.

Smith, W. Eugene (1918–1978)
Noted American journalistic and art photographer
A heroic figure in American photography, Smith created **photo essays** so compelling in their power that it can be said his work changed, as well as documented, history. The dramatic composition, mastery of lighting, and hard-edged brilliance of his photographs are evident throughout his career, from his World War II battle scenes, to his photo essays for *Life* magazine (beginning in 1939), to his final, memorable *Minamata* (1975), documenting the effects of the disastrous mercury contamination caused by industrial wastes that brought death and permanent damage to the inhabitants of the fishing village on the southern coast of the Japanese island of Kyushu.

Born in Wichita, Kansas, Smith began taking pictures with his mother's camera while still a boy. Encouraged by **Frank Noel**, a Wichita press photographer, he submitted work for local publication. He studied photography at the University of Notre Dame for a year, then in 1937 moved to New York City. He worked for *Newsweek* magazine as staff photographer in 1938, then worked as a freelancer for the **Black Star** agency, publishing photos in the major magazines of the day.

He was a war correspondent during World War II, for *Life* and also for *Popular Photography* and other Ziff-Davis publications. The pictures he took when he went ashore with the Marines at Saipan, Guam, and Iwo Jima were the first to bring together his sense of moral responsibility and his photographic genius. He was seriously wounded in 1945 in Okinawa and after his recuperation became a staff photographer for *Life*, from 1947 to 1954.

He published some of his most famous photo essays in *Life*—"Folk Singers" (1947), "Trial by Jury" (1948), "Country Doctor" (1948), "Spanish Village" (1951) and

Morgan Smith and Marvin Smith. *Easter Sunday in Harlem,* ca.1938. Morgan and Marvin Smith Collection. Courtesy Schomburg Center for Research in Black Culture.

W. Eugene Smith. *Marines Blow Up a Cave Connected to a Japanese Block House on Iwo Jima.* April 9, 1945. *Life* magazine; © Time, Inc.

"A Man of Mercy" (1954) among them. Unable to reconcile his own high sense of moral purpose and integrity with the commercial needs of a mass market magazine, he left *Life* and devoted the rest of his life to his own projects. He joined **Magnum Photos** in 1955 and did a number of photo essays, including a lengthy documentation of the city of Pittsburgh that became an emotional and financial drain on his resources. It was never completed in the form he envisioned and left him with the reputation of being eccentric and difficult to work with.

Minamata was his last great essay; it helped put an end to the mercury poisoning in that port, but a severe beating by factory thugs aggravated his failing health. He moved to Tucson in 1976 to teach at the University of Arizona and organize his archive for the university's **Center for Creative Photography.**

Smith won three **Guggenheim** awards (1956, 1957, 1968) and a **National Endowment for the**

Arts grant in 1971. His work has been exhibited in numerous one-man shows, at such venues as the **International Center of Photography**, the Museum of Modern Art, and the **George Eastman House**. His work is held by many private and public collections worldwide. *W. Eugene Smith: Shadow and Substance; The Life and Work of an American Photographer*(1990) by the noted photo editor **Jim Hughes** is the definitive biography of Smith. *W. Eugene Smith: Let Truth Be the Prejudice* (1986) by Ben Maddow is also a fine tribute to this great master of photojournalism, published in conjunction with an ICP exhibit.

Smithsonian Institution: An educational and research complex based in Washington, D.C., and founded in 1846 with funds from the will of James Smithson of London. In 1829 Smithson bequeathed his fortune to the United States to establish a center for the "increase and

diffusion of knowledge among men." Today the Smithsonian Institution is a massive complex of museums of art, history, and technology, housed in numerous buildings mostly along the Mall in Washington. At one end of the Mall is the Washington Memorial and at the other end is the U.S. Capitol. Some of the centers of this organization are the National Museum of the American Indian, National Museum of Natural History, the National Museum of History and Technology, the National Air and Space Museum, the National Zoological Park, and the Kennedy Center for the Performing Arts. The Smithsonian includes six art museums, five of them in Washington: the Freer Gallery of Art, Arthur M. Sackler Gallery, the **National Museum of American Art,** the **National Portrait Gallery,** the National Museum of African Art, and the Hirschhorn Museum and Sculpture Garden. One, the Cooper-Hewitt National Design Museum, is located in New York City.

For photographers, the National Museum of History and Technology has a History of Photography Collection with more than 500,000 pictorial items that reflect both the technical and artistic achievements of the medium from its inception to the present.

Smolan, Rick (1949–)

American documentary photographer

Smolan is well known as the creator of the top-selling *Day in the Life* photography book series.

A 1972 graduate of Dickinson College in Carlisle, Pennsylvania, he was hired by *Time* magazine the next year, when he was just 24. His first **Life** assignment came at age 25, his first for **National Georgraphic** three years later.

In 1981 he created the *Day in the Life* series. To date, more than three million copies of the books have been sold. *A Day in the Life of America* spent over one year on the *New York Times* bestseller list, a unique achievement for a photo book. In 1983 the *Washington Post* backed his formation of the world's first **online** network specializing in photography and publishing. Five years later he teamed with Apple Computer and *Newsweek* for an early **laser disk** project.

His Against All Odds Productions, a book and multimedia publisher, was formed in 1991. The company's goal is to place it—and himself—"directly in the path of the converging worlds of photography, design, publishing, and technology." On February 26, 1996, the company produced *24 Hours in Cyberspace*, the largest online one-day event to date. Random House and the company published a book version, *One Digital Day: How the Microchip Is Changing Our World* in June 1998.

Snowdon, Lord (Antony Charles Robert Armstrong-Jones) (1930–)

British celebrity portrait photographer

As brother-in-law of Britain's Queen Elizabeth, Snowdon is a leading celebrity photographer and official chronicler of the royal family.

An Eton College graduate, he worked in the theater as a photographer and designer in the 1950s. In 1960 he married Princess Margaret; they divorced in 1978. A freelance photographer since the early 1960s, Snowdon has been artistic advisor to the British *Sunday Times* since 1962. He has worked regularly for such major magazines as *Vogue*, *Vanity Fair*, *House and Garden*, **Life,** and the top British periodicals. His many honors include the **Royal Photographic Society**'s Hood Award.

His books include *London* (1958), *A View of Venice* (1972), *Assignments* (1972), *Personal View* (1979), *Sittings, 1979–1983* (1984), *Israel, A First View* (1986), and *Public Appearances, 1987–1991* (1991). In addition to still work, he has made several TV films, including *Don't Count the Candles*, which won two 1968 Emmy Awards.

His professional associations include the Civic Trust for Wales, the Greater London Arts Association, the Contemporary Art Society for Wales, the Design Council of London, and the Royal Society of Arts.

snapshot: Casual photographs taken by amateurs are called snapshots. The term was coined by **Sir John Herschel** in 1860, 28 years before the first handheld amateur camera became available (the Kodak #1 in 1888). Snapshot has also become known as a style in professional and fine-art photography that is characterized by seemingly careless composition, harsh lighting, and poor focus.

Snapshot portrait taken at an amusement park. © Fred W. McDarrah.

Sobieszek, Robert A. (1943–)

American curator and historian

As curator of photography at the Los Angeles County Museum of Art (LACMA), Sobieszek has helped to build the museum's photo collection as well as broaden the audience for photography as art.

Sobieszek is a trained art historian with degrees from the University of Illinois, Stanford, and Columbia University. The first 20 years of his career were spent at the **George Eastman House,** which he left as curator and director of photographic collections. He wrote scores of publications there and organized many important exhibitions, including "British Masters of the **Albumen** Print," "The Spirit of Fact: The **Daguerreotypes** of **Southworth** and **Hawes**," and "New American Pastoral: **Landscape Photography** in the Age of Questioning."

He came to Los Angeles in 1990 and has been instrumental in increasing the permanent collection from 2,500 pieces to more than 6,000—and in helping to develop a new physical expansion of the department.

At LACMA, he inaugurated in 1992 a series of permanent collection exhibitions, "New Acquisitions/New Work/New Directions." In 1995 he organized P.L.A.N. (Photography Los Angeles Now), LACMA's first complete **internet** catalogue.

His largest project was scheduled to open in 1999; he will curate and create the illustrated catalogue for "Ghost in the Shell: Photography and the Human Soul, 1850–2000."

Sochurek, Howard J. (1924–1994)

American photojournalist

In his twenty years with *Life* magazine, from 1950 to 1970, Sochurek was an accomplished photojournalist winning major awards, including both the Overseas Press Club **Robert Capa** Award for exceptional courage and enterprise in reporting from abroad in 1956 and the

Howard Sochurek. *Hand, Thermography.* (Original in color.)
© Howard Sochurek, Inc.
Courtesy the photographer's estate.

University of Missouri Magazine Photographer of the Year Award in 1955 for his coverage of the Korean War. Sochurek was a pioneer in the use of **electronic flash** photography in photojournalism and later in electronic imaging, including thermography, **digital photography,** and **computer**-enhanced imaging.

Born in Milwaukee, Sochurek was graduated from Princeton University in 1942 and commanded a U.S. Army photo unit in the Pacific during World War II. In 1946 he left the service and joined the photography department of the *Milwaukee Journal*, where he was the first to use **stroboscopic lighting** at sporting events.

He moved on to *Life* magazine, where he covered a wide range of stories both in the United States and abroad. During the Korean War he parachuted behind enemy lines to photograph the cutting off of the communists from their supplies from the north. He opened the Time-Life Moscow bureau in 1958 and did many exclusive stories about life in the Soviet Union. During the Vietnam War he photographed the fall of Dien Bien Phu and, posing as a Polish diplomat, remained in Hanoi after the French left in defeat.

In 1965 he became interested in the use of computer-generated images when Time-Life editors assigned him to work on a report on the future of image gathering. After leaving *Life*, he produced computer-colorized X-rays and CAT scans that led to his pioneering work in the medical field. As a freelancer he photographed major essays for *National Geographic*, and one of his articles became the basis for his book *Medicine's New Vision* (1987). An exhibition of his medical images was shown at the National Academy of Sciences in Washington.

His work is held by private and public collections, including those of the **International Center of Photography** and the Metropolitan Museum of Art.

Society for Photographic Education: Founded in 1962, this group is composed of college-level teachers of photography.

soft focus: When an object in a photograph or the whole image appears fuzzy, the effect is called soft focus. While the result may be achieved by accident or by the use of a poor-quality **lens,** soft focus is usually a consciously employed device used for an effect such as creating a dreamlike atmosphere. Soft focus is associated with the **Pictorialism** of the 1880s.

software: The programmed information that is used to make **computers** operate. Software comes in a huge variety for every purpose from video games to financial spreadsheets to **digital imaging** to word processing. *Hardware* is the term that refers to the actual computer components that enable the software to function.

solarization: Also known as the **Sabattier** effect, it is a process that creates an image with some tones being seen in reverse—that is, a normal photograph in which some of the tones are seen in negative, while most are seen as positive. Solarization is done by exposing a print (or negative) to light, partially developing it, and then re-exposing it to some white light and then finishing the development process. The result, when done well, gives an image with both negative and positive tones, creating a rather **surreal** picture. This procedure seems to work best with a high-**contrast** image and paper and partially exhausted developer.

Sommer, Frederick (1905–)

American landscape and art photographer

Shifting focus from his training as a landscape architect, Sommer has produced over his lifetime a body of work that began with Arizona landscapes and moved on to increasingly **surrealist** images of found objects and a number of experimental techniques that involve superimposed images, distortion, cameraless pictures, and manipulated negatives.

Born in Italy and raised in Brazil, he came to the United Stated to study and received a master of arts degree in landscape architecture from Cornell University in 1927. He then returned to Brazil, but after contracting tuberculosis he went to Switzerland to convalesce. It was there that he became interested in photography. He continued his recovery in Arizona, where he has lived since the early 1930s.

In 1935 on a trip to New York he met **Alfred**

Eve Sonneman. *Water Vision, Paris.* 1977. (Original in color.) © Eve Sonneman. Courtesy of the photographer.

Stieglitz at his **An American Place** gallery. He later met **Paul Strand** and **Edward Weston**. They all encouraged his work, but the results could not have been more different from their own vision. Many of his photographs are carefully constructed creations, painstakingly arranged for his camera, surrealistic compositions of found, discarded objects, from dead animals to bits of torn paper and broken toys.

He had his first one-person show in 1946 in Santa Barbara, California, and has been exhibited consistently ever since. He won a 1974 **Guggenheim** award, and a **National Endowment for the Arts** fellowship in 1973. There was a major retrospective of his work at the **International Center of Photography** in 1981. His photographs are held by private and public collections, including those of the Art Institute of Chicago, the Museum of Modern Art in New York, and the **George Eastman House**. His books include *Frederick Sommer at Seventy-Five* (1980).

Sonneman, Eve (1946–)

American photographer, teacher, and filmmaker

Sonneman is well known for her paired color photographs—two images of the same site, taken from slightly different angles, at different times, and displayed side by side.

Born in Chicago, she studied at the University of Illinois, Urbana (bachelor of fine arts, 1967), and the University of New Mexico (master of arts in photogra-

phy, 1969). Her work evolved from black-and-white diptychs to quadrants and finally color diptychs.

She has also made several 16mm films and appeared on cable television in programs about her work. Her work has been published in *Esquire*, **Life,** the *New York Times Sunday Magazine*, and other major magazines.

Her teaching stints since 1970 have been at Cooper Union, Rice University, the City University of New York, the Institute for Art and Urban Resources, and the School of Visual Arts. She is the author of *Real Time* (1976), co-author with Klaus Kertess of *Roses Are Read* (1982), and co-author with Patricia Thorpe of *America's Cottage Gardens* (1990).

She has received two Boskop Foundation grants (1969, 1970), two **National Endowment for the Arts** grants (1972, 1978), three **Polaroid** grants (1978, 1988, 1989), and a Cartier Foundation award (1989). Her work is held by numerous private and public collections, including those of the Museum of Modern Art in New York, the Art Institute of Chicago, and the **George Eastman House**. Her work has been included in group exhibitions at such venues as P.S. 1 in New York, Cooper Hewitt Museum, and the **International Center of Photography**.

Sontag, Susan (1933–)

American writer and film director

Sontag is one of the leading critical voices of her generation. Her scholarly 1977 essay collection *On Photography*

validated the field as an academic discipline and cemented her personal reputation when it won the National Book Critics Circle Award for criticism in 1978.

Born in New York City, Sontag earned a bachelor of arts degree (1951) at the University of Chicago, master of arts degree in English at Harvard University (1954), and master of arts degree in philosophy (1955). She taught at several colleges, including Columbia University and City College in New York City, and was writer-in-residence at Rutgers University in the 1960s.

A familiar figure at cultural and intellectual events in New York City and elsewhere since the 1960s, she published her first novel, *The Benefactor*, in 1963. Other novels include *The Volcano Lover* (1992) and *Death Kit* (1967). Her byline has appeared in such publications as the *New Yorker*, the *New York Review of Books*, *Film Quarterly*, *Vogue*, *Harper's*, *Harper's Bazaar*, the *Atlantic*, *Sight and Sound*, and the *New York Times*. Her book *Illness as Metaphor* (1978) was inspired by her personal experience with cancer.

Sontag has been screenwriter and director of several films, including *Duet for Cannibals* (1969), and director for *Promised Lands* (1974) and 1983's *Unguided Tour*.

She has won a pair of **Guggenheim** awards (1966, 1975) as well as two Rockefeller Foundation grants (1965, 1974), which she used to continue her writing on art and photography. She has also been honored by the American Institute of Arts and Letters and received Brandeis University's Creative Arts award. Sontag was a MacArthur Fellow from 1990 to 1995.

Soule, William Stinson (1836–1908)

Early American documentary-portrait photographer
Soule is best known for his portrait work of American Indians that has proved to be an invaluable documentation of many now virtually extinct tribes.

After being wounded while serving in the Union Army during the Civil War, Soule worked in a photo studio in Chambersburg, Pennsylvania. In 1867 he moved to Fort Dodge, Kansas, and supplemented his income as an employee at Tappin's Trading Post by taking pictures with equipment he brought from back East. Two years later he moved to Kansas's Fort Sill, which was the Indian Agency and Military Control Headquarters for the Comanche and other tribes. The U.S. Army had him create a photographic log of the new fort's construction, and he ran a photo gallery there as well.

In Kansas, he took formal portraits of members of the Kiowa, Apache, Wichita, Caddo, and other tribes. His work "deserves very serious attention by photographers, historians and ethnologists," said a biographer of Soule.

Records show that he apparently left the area in 1875 for Boston, where he ran a photo studio until he retired in 1902.

His work was collected in a 1968 photo volume, *Plains Indian Raiders*, and a 1969 biography, *Will Soule*, by Russell E. Belous and Robert Weinstein.

Southworth, Albert Sands (1811–1894)

American daguerreotypist
Southworth and his partner **Josiah Hawes** left their careers as a druggist and a painter, respectively, to open a business that became one of the most accomplished of early American **daguerreotypy**.

From 1843 to 1862 they ran a successful Boston studio, making images of some of the most prominent people of the day, from Daniel Webster to Horace Mann. They were acclaimed for their aesthetic accomplishments as they consistently produced unusually beautiful and sensitive portraits. They were also admired and imitated for their use of dramatic lighting, rather than the flat, unflattering bright light favored by other daguerreotypists. They also took pictures outside the studio that had never before been photographed, such as those of ships idle at dock and children in a classroom.

They experimented with early paper prints and had some work exhibited at the Massachusettes Mechanics' Fair in 1856. The pair also taught photo courses and dealt in photo supplies. Little is known about what they did professionally after their partnership dissolved. One theory is that they joined **Mathew Brady**'s Civil War team of photographers.

space photography: Photographs taken in space, whether from an automated camera on a satellite or by an astronaut. Lt. Col. John H. Glenn was the first astronaut

to make pictures while in space in the early 1960s. He used a 35mm ANSCO AUTOSET camera that he bought in Florida for $20. M. Scott Carpenter used a spring-wound 35mm ROBOT, and on a *Mercury* flight Walter M. Schirra used his own **Hasselblad** 500.

special effects: Photographic effects that may or may not resemble reality in the final image but are done to enhance an image's impact or to make a statement. The result is an image that would not exist without the use of special effects. Special effects can be as simple as a **filter** over a **lens** (changing a color or making lights appear starlike) to digitally altering an image (putting yourself on the moon or a spaceship landing on the White House lawn).

Speed Graphic: A brand of camera that uses 4 x 5-inch sheet film that was highly popular with press photographers from the late 1930s to the early 1950s. It is a large, handheld, folding camera that can be used with a flash gun and **flash bulbs**. The most famous of the **press photographers** who used a Speed Graphic was **Weegee**, and a well-known picture shows him, cigar in mouth, holding one.

sports photography: Photography of a sport in action, usually freezing the movement so as to view the determination, effort, and accomplishment of the athletes. Sports photography is a specialized form of **commercial photography** requiring a keen eye for detail, quick reflexes, and a knowledge of the sport being photographed. Newspapers and magazines around the world use sports photography, and many specialized publications cover sports exclusively, making it a highly competitive and profitable field.

spotlight: A light with a focused beam that can be directed at a subject or spot. This is the opposite of a **floodlight,** which covers a wide area.

spotting: In photography, spotting refers to using a small paintbrush and specially made ink to cover white spots on a photographic print caused by dust on the negative. The ink is diluted to match the tone and/or color of the area affected and is then gently dabbed onto the white spot, making it undetectable on the print. Spotting is done on both black-and-white and color photographs.

spy camera: Usually refers to a camera disguised as a matchbox, card case, pocket watch, or other small item and used surreptitiously.

Squiers, Carol (1950–)
American writer and curator
Squiers, a senior editor of *American Photo* magazine, is an influential figure in contemporary photography.

Born in Oak Park, Illinois, she was graduated from the University of Illinois, Chicago (bachelor of arts, 1971), and went on to study at Hunter College in New York City. Squiers first worked as a photography curator at PS 1, the avant garde art and performance space in Long Island City. She later worked for the *Village Voice* and *Vanity Fair* before joining AmPhoto in 1986.

Her work has also been seen in the *New York Times*, *Art in America*, *Artforum*, *Vogue*, and elsewhere. She has contributed to numerous catalogues, including *Police Pictures: Photographs as Evidence* in 1997 for the San Francisco Museum of Modern Art.

A 1981 **National Endowment for the Arts** award winner, she also wrote the script for *The Image Makers,* the 1997 VH1 show on the history of rock and roll photography.

Staller, Jan Evan (1952–)
American architecture and portrait photographer
Staller's striking color photos of New York, architecture, and people have earned him international acclaim.

Born on Long Island, Staller earned a bachelor of fine arts from the Maryland Institute in 1975 and immediately launched his freelance career. In 1978 he won a grant from the **Polaroid** Corporation. He received a **National Endowment for the Arts** grant in 1980 which in part funded a project that would become *Frontier New York* (1988), a book featuring unique views of New York that make the city appear almost organic in

Pages 466 – 467: Jan Staller. *Frenchman Flat, Nevada Test Site.* n.d. (Original in color.)
From *On Planet Earth: Travels in an Unfamiliar Land,*
Aperture Foundation, Inc., 1997. © Jan Staller.
Courtesy the photographer.

nature, with an introduction by the Pulitzer Prize-winning architecture critic Paul Goldberger. Staller's monograph *On Planet Earth: Travels in an Unfamiliar Land* was published in 1997.

In most of his images the foreground of the landscape is illuminated with artificial light, and this can account for the otherworldly quality in many of the images. He always uses a tripod, to "achieve maximum sharpness and depth of field," and his exposure times can range from fractions of a second to seven hours.

Using medium format, the photographer works in color, his other subjects being cityscapes and constructed objects. Staller's work has been widely published in the *New York Times Sunday Magazine*, *Der Spiegel*, *New York*, and other major periodicals. He has done film stills for *Fargo*, *Twelve Monkeys*, and *Amazing Story of Two Girls in Love*. His commercial clients include General Electric, Owens Corning, and Arista Records.

His work is held by such collections as those of the Museum of Modern Art, the Corcoran, and Seagram's. He has had shows at Houston's Museum of Fine Arts, the Fogg Art Museum, the **International Center of Photography**, the Basel Art Fair, and many other settings.

stabilization process: A black-and-white printing system that produces prints in a shorter period of time than the usual develop-stop-fix-wash-dry process. The system works well when a quick print is needed, such as for a publication under deadline, but the resulting prints are not permanent and will discolor over a short period of time.

standard: A standard is a board that holds either a lens or a piece of ground glass on a **view camera**. A view camera has three distinct elements: the front standard, with a **lens;** the back standard, with a piece of ground glass for focusing and image; and a flexible, light-tight **bellows** attaching the front and back standards.

Starn, Mike (1961–)
Starn, Doug (1961–)
American art photographers
Contemporary artists of prominence and renown, the

Starn twins use scientific and cultural references as they investigate the source of light and, therefore, the source of life. In much of their work, the focus is the sun, as image and symbol. They use photography as the starting point for their various works, which involve a variety of media. One installation consisted of a plastic book, with lights built into the pages that go on and off as the pages are turned. Another installation presents layers of transparent film, lit from behind with fluorescent bulbs.

Born in Absecon, New Jersey, the brothers studied at the School of the Boston Museum of Fine Arts. Their work has been exhibited in solo and group shows at the Friends of Photography/**Ansel Adams** Center in San Francisco, the Museum of Modern Art in New York, and the Whitney Museum. Among the private and public collections holding their work are those of the Metropolitan Museum of Art, the Los Angeles County Museum of Art, and the Chicago Art Institute.

Steichen, Edward (1879–1973)
Acclaimed American photographer
In a career that spanned 77 years, Steichen became the country's most celebrated and highest-priced photographer, a craftsman of genius who was able to transform his medium into a legitimate art form. From his personal body of work, to his being curator of the most famous photo show ever—the Museum of Modern Art's 1955 **"Family of Man"**—Steichen more than any other individual is responsible for the public acceptance and high standing photography has in American culture.

Born in Luxembourg, he moved to Michigan with his family when he was three. At 15, he was apprenticed to a lithographer. At 16, he took his first pictures—50 shots of family, of which 49 were horrible. "My mother said the one picture [of his sister] was worth the 49 failures." Encouraged by his mother, he continued to tinker with photography. The 1 in 50 established a lifelong pattern of seeking perfection. He once took 1,000 shots of a single cup and saucer as he experimented with **light**. For an early show he curated, he whittled down some 10,000 selections for the 150 he eventually exhibited.

He exhibited at the Second Philadelphia Salon in

Edward Steichen. *The Flatiron Building—Evening New York*. 1905. Alfred Stieglitz Collection, 1933. Metropolitan Museum of Art, New York.

1899 and achieved recognition for his portraits of notables such as Auguste Rodin and Maurice Maeterlinck. A member of **The Linked Ring**, he was strongly influenced by the work of **Alfred Stieglitz**. His photographs showed the misty, soft-focus effects favored by the **Pictorialists**. He alternated between painting and photography, pursuing both first in Milwuakee and then in Paris in 1910. An early member of the **Photo-Secessionist** movement, he worked with Stieglitz to open **291**, the Photo-Secession gallery, which showed works in all media. He designed the covers and logo for *Camera Work*, the Photo-Secessionist magazine.

When the United States entered World War I in 1917, he commanded the Photographic Division of **Aerial Photography**. He abandoned painting for photography after the war and spent three years experimenting with various techniques to achieve the precise light and shadow effects he wanted.

In 1923, he opened his first New York studio and started shooting for Condé Nast for a then-princely sum of $35,000 per year. Among his subjects would be Charlie Chaplin, Greta Garbo, Mary Pickford, Martha Graham, and Lillian Gish. In 1938, bored, he closed his studio and first traveled to Mexico. Then, at a farm he had bought in Connecticut in 1929, he worked with plants, specifically delphiniums, which he worked to cross breed, for which he achieved renown in botany circles. He also created a new type of Oriental poppy, more delicate and smaller than what had been the norm until then.

In 1943, he was commissioned as a lieutenant commander in the Navy to photograph the war at sea. He curated the photo shows "Road to Victory" and "Power in the Pacific" and supervised the film *The Fighting Lady*. He returned to New York in 1946 and the next year was hired as director of photography at the Museum of Modern Art. He remained there for the next 15 years.

He stopped taking pictures while he was at MOMA to stay objective, he said. He considered the 1955 "Family of Man" show the culmination of his career. It included every important photographer of the midcentury and is still discussed more than 40 years later. In 1961, MOMA honored Steichen with a 300-print one-man show, selected from more than 30,000 negatives. In 1962 he retired, but he never stopped working.

At his ninetieth birthday at the Plaza Hotel in 1969, he said, "When I became interested in photography I thought it was the whole cheese. My idea was to have it recognized as one of the arts. Today I don't give a hoot in hell about that. The mission of photography is to explain man to man and each man to himself. And that is no mean function. Man is the most complicated thing on earth and also as naive as a tender plant."

Steichen won many awards, including the Presidential Medal of Freedom, presented by John F. Kennedy in 1963, and the Distinguished Service Medal; he was the first foreigner inducted into the Photographic Society of Japan. His work has been exhibited in museums worldwide and is held by major private and public collections. The 1997 book *Steichen: A Biography* by Penelope Niven tells the full story of his life and work.

Steiner, Ralph (1899–1986)

American photographer and filmmaker

Steiner's body of work is composed of his assigned advertising and editorial work, done to earn his livelihood; his personal photography, which was strongly influenced by **Paul Strand**; and his films, which were also personal expessions of his own creativity.

Born in Cleveland, Ohio, Steiner was graduated from Dartmouth (bachelor of arts, 1921) and studied photography at the **Clarence White** School from 1921 to 1922. He then worked as a photo technician, making plates for the company that produced the photogravure reproductions for **Alfred Stieglitz**'s *Camera Work*.

Steiner pursued a career in advertising photography in New York until the late 1920s, when he met Paul Strand. He was so impressed with his work that he decided to continue his studies of his craft at Yaddo, an artist's colony near Saratoga Springs, New York.

On his return to the city he continued alternating his commercial and private work but also embarked on his first film *H20*, an abstract art film of moving water. He worked as a cameraman on a series of films called *The Joy of Seeing*, and with his friend Strand on Pare Lorenz's 1935 *Plow That Broke the Plains*. From 1939 to 1941 he was

Ralph Steiner. *Typewriter Keys*. 1921. Courtesy Witkin Gallery, New York.

the photo editor of the Sunday magazine of *PM* newspaper, where he published young photographers like **Walter Rosenblum** and **Weegee**. He moved to Vermont in 1963 and continued taking photographs of the New England landscape.

He was awarded grants by the **National Endowment for the Arts**, the Carnegie Corporation, and the **Guggenheim** foundation. His work is held by private and public collections, including those of the Metropolitan Museum of Art, the Museum of Modern Art, and the Milwaukee Art Center. Steiner's autobiography, *Point of View*, was published in 1978. Ralph and Caroline Steiner published *In Spite of Everything, Yes* (1986), a collection of life-affirming photographs by many different photographers, including **Minor White**, **Eliot Porter**, and **Walker Evans**.

Stellman, Louis J. (1877–1961)

American photographer, writer and historian

Stellman had a long career as a California newspaperman but is best known for his short time as a photographer, when he documented his adopted state's Asian community.

Born in Baltimore and educated there and in Pittsburgh, he was an acquaintance of **Arnold Genthe**, the great San Francisco Chinatown photographer, who took Stellman's wedding pictures in 1904, six years after he moved to California.

He worked variously for the *Herald*, *Times*, and *Examiner* in Los Angeles, and the *Post*, *Globe* and *News* in San Francisco. He mainly took pictures to illustrate his varied writings. His specialty was San Francisco and its Chinatown. He also took candid pictures of the waterfront, the hills, and the hidden streets and alleys that only an intimate of the place would know.

His photos were collected in many books, from *Said the Observer* (1903) to *Images of Chinatown* (1976). The book that he said was his favorite, a small Baedeker, *Chinatown, A Pictorial Souvenir and Guide*, was ready to be published in 1917, but World War I made him shelve the project indefinitely. Much of it finally appeared in the 1976 book.

Stellman always referred to himself not as a historian but as an interpretor of Chinese-American culture to Caucasian Americans.

stereoscopic photography:

The simulation of a three-dimensional scene by photographing from two slightly different angles (reflecting the distance between the eyes) and then presenting the images mounted side by side on a card so that each eye sees it own, slightly different image. This entails the use of a viewing device, a stereoscope, so that each eye sees only one image, each taken from a slightly different point of view, creating the illusion of depth.

The stereo image and the industry that resulted from the millions of stereographs that were produced between 1850 and 1920 flourished in Europe and the United States. The images covered every possible theme, from travel, religion, and news events to scenic features, historic sites, and hometown celebrations. **Underwood** and Underwood, the major firm manufacturing stereo views, produced some 25,000 cards a day by 1901. They also introduced a related item, a descriptive guidebook that helped armchair travelers understand exactly where the camera was when the pictures were taken and the location of nearby points of interest.

Stereoscopic Society of America:

Founded in 1893 and having 143 members, it furthers the art of **stereoscopic photography**. The organization encourages meetings and the sale or exchange of equipment and images among its members, who present their work for comment and criticism.

Stern, Bert (1929–)

American fashion photographer

From the 1950s to the 1970s Stern was an advertising and fashion photographer of international renown, producing a large body of impressive work, including a famous portfolio of Marilyn Monroe.

Born in Depression-era Brooklyn, Stern spent much of his childhood copying comic strips and being fascinated by commercial signage. After dropping out of high school, her worked as a mail room clerk at *Look* magazine in 1947. His interest in graphic design was

George S. Cook. *A Confederate Camp Near Charleston, S.C.* 1861. Stereoscopic view.
Courtesy the Cook Collection, Valentine Museum, Richmond, VA.

encouraged by art director Herschel Bramson, his life-long mentor. In 1949 Stern left *Look* for *Mayfair*, where as art director he met a commercial photographer named Ed Brown, who helped Stern buy his first camera, a 35mm Contac with a 50mm uncoated lens. Stern had his camera with him when he was drafted into the Korean War, where he was trained in cinematography and stationed in Tokyo. His first published photos were of troopships, which appeared in the Seattle *Post*.

His 1953 advertising campaign for Smirnoff vodka established him as a star. Editorially, he was regularly shooting for *Life,* *Vogue*, and other publications. His 1962 session with Monroe is now legendary; he also shot everyone from Twiggy (about whom he made three ABC television shows for the then staggering sum of $600,000) to Elizabeth Taylor and Audrey Hepburn. He was based in a four-story former school building on Manhattan's East Side that was run like a photo factory. The space, which cost more than $10,000 a week to staff and support, was described as a paradigm for the Swinging Sixties. Stern was the prototype of the fashion photographer as the embodiment of glamour.

In 1971 Stern withdrew from the spotlight, closed his studio, and went into seclusion. It was another ten years before he returned to photography, rebuilding his career with fashion spreads regularly appearing again in *New York, Vogue, Condé Nast Traveler*, and others. He also reentered advertsing work, doing campaigns for cigarettes and Levi's.

He is now a respected icon, with regular shows at prestigious museums and galleries; his books include a collection of black-and-white and color pictures called *Marilyn Monroe: The Last Complete Sitting* (1982).

Sternfeld, Joel (1944–)

American photographer and teacher

Sternfeld is a leading new color photographer who has achieved recognition with a project for which he crisscrossed the United States taking pictures from a Volkswagen.

A 1965 graduate of Dartmouth College, he first explored Josef Albers's color theories by taking pictures in the Deep South and in Nag's Head, North Carolina. In 1978 he won a **Guggenheim fellowship** and started on his America project with his wooden Wista 8 x 10 camera. He continued working on it with the support of a 1980 **National Endowment for the Arts** grant, another

Guggenheim fellowship (1982), and an American Council on the Arts Emerging Artist Award (1983).

He has photographed people at suburban shopping malls and theme parks. Sternfeld has taught at Stockton (N.J.) State College (1971–1984), Yale University (1984–1985), and Sarah Lawrence College (1985–present). His work has been exhibited in solo and group shows at the California Museum of Photography in Riverside, the Barbican Art Gallery in London, and the Museum of Modern Art in New York. Among the private and public collections holding his photographs are those of the High Museum in Atlanta, the Museum of Modern Art in New York, and the Houston Museum of Fine Arts.

Stettner, Louis J. (1922–)

American architectural and documentary photographer

Stettner's black-and-white images offer windows onto reality, inviting the viewer to share his vision of the surface and inner meaning of the scenes he portrays, whether they be New York City street life, subway stations, or architectural studies.

Born in Brooklyn, Stettner began taking pictures when he was 13, using a Hawk Eye Folding Camera given him by his parents. He became interested in photography in a short time and was influenced by the images he saw at the Metropolitan Museum of Art, notably the work of **Alfred Stieglitz**, **Paul Strand**, **Clarence White**, and **Alvin Langdon Coburn**. He studied basic photography at the **Photo League**.

He enlisted in the U.S. Army in 1940 and was sent to study engineering at Princeton University (1942–1944). After World War II he traveled in Europe, settling in Paris where he remained until 1952. In France he became friends with **Brassai**, who aided Stettner in publishing his work. He studied film at the Institute for Cinematic Studies in Paris (bachelor of arts, 1949) and continued to publish in major magazines (*National Geographic*, *Time*, *Fortune*) as well as work on personal projects. He organized an exhibition of French photography in the United States in 1947.

From the 1950s to the 1990s Stettner lived in New York, although he continued to travel widely. He taught photography at C. W. Post Center, Long Island

University, and also undertook a project, inspired by **Lewis Hine**, photographing factory workers. He returned to France permanently in 1990 to live and work.

His books include *Paris Streets* (1949), *Weegee the Famous* (1978), and *Louis Stettner's New York: 1950s–1990s* (1997). He was awarded a **National Endowment for the Arts** grant in 1974. His work is held by collections, including the Victoria and Albert Museum, the Metropolitan Museum of Art, and the Museum of Modern Art. He has exhibited at such venues as the **International Center of Photography**, the San Francisco Museum of Modern Art, and the **Smithsonian Institution**.

Stieglitz, Alfred (1864–1946)

Seminal American photographer and publisher

Stieglitz is a towering figure in twentieth-century photography. Through his **291** Gallery and writings in his influential magazine **Camera Work**, he was the driving force for the **Photo-Secessionist** movement and a champion of photography as an art form. He discovered and encouraged young talent with exhibitions and publications, nurturing, among others **Paul Strand**, **Minor White**, and **Gertrude Kasebier**. Many of his own photographs, beginning with his series of images of New York City taken in mist, snow, or rain, have become icons, instantly recognizable as modern masterpieces.

Born in Hoboken, New Jersey, he moved with his family to New York in 1871. He studied mechanical engineering in Berlin, Germany, and at the same time developed an interest in photography, studying under Dr. H. W. Vogel. He dropped his engineering studies and traveled in Germany and Italy, becoming interested in the artistic movement called the German Secession. His travel pictures resulted in his winning first prize awarded by **P. H. Emerson** in a photo competition for *Amateur Photographer* magazine in 1887.

He returned to the United States in 1890. He joined the Society of Amateur Photographers in New York and became editor of *American Amateur Photographer*. When the society evolved into the New York Camera Club, he became the founding editor of its magazine,

Louis Stettner. *Tuileries, 1997*. © Louis Stettner. Courtesy Bonni Benrubi Gallery, Inc., New York.

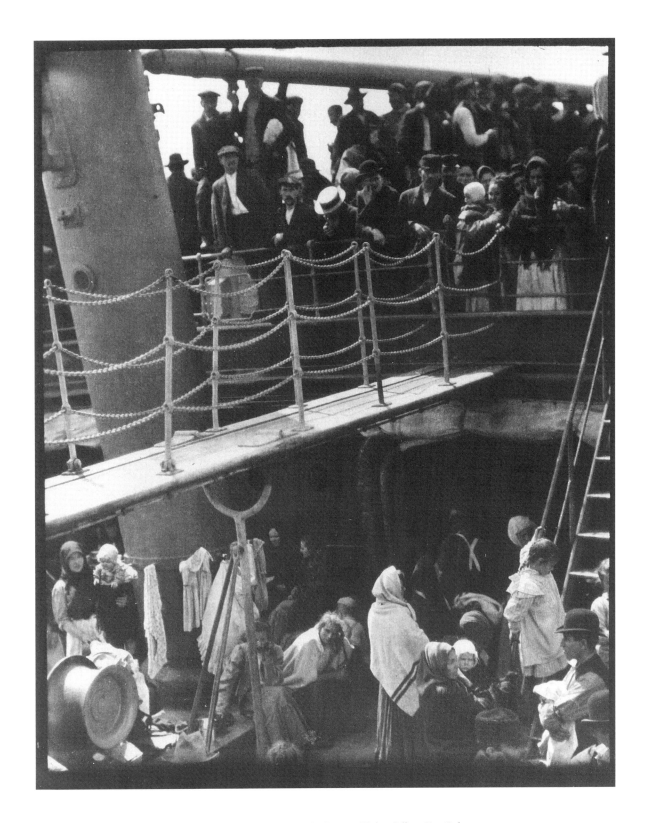

Alfred Stieglitz. *The Steerage*. 1907. Courtesy Witkin Gallery, New York.

Camera Notes. He used hand-pulled gravure illustrations and sought out the finest writers and photographers to contribute.

In 1902 he organized a major exhibition at the National Arts Club, "American Pictorial Photography arranged by the Photo-Secession." It included work by Kasebier, **Clarence White,** and **Edward Steichen**. Under the Photo-Secession aesthetic, he founded a new photographic quarterly, *Camera Work*, which first appeared in 1903. *Camera Work*'s success was instantaneous, and it aroused so much public interest that Stieglitz, at Edward Steichen's urging, opened the Little Galleries of the Photo-Secession, or 291 as it came to be called.

Stieglitz was also a collector of photographs who acquired some 650 prints between 1894 and 1910. Among the highlights of his collection was work by **Robert Demachy, Ansel Adams,** and **Eliot Porter**. He eventually bequeathed the entire collection to the Metropolitan Museum of Art.

Between 1905 and 1917 there were 22 exhibitions at 291, showcasing the work of European and American photographers, including **Baron de Meyer, Annie Brigman,** and **Frank Eugene**. Photo-Secession achieved its goal—acceptance of photography as a fine art—when the Albright Art Gallery in Buffalo, New York, invited Stieglitz to install a major exhibit in 1910. After that landmark show, the movement seemed to lose its freshness, as new styles became popular. In 1917 the 291 gallery closed, and *Camera Work* ceased publication.

Stieglitz opened the **Intimate Gallery** in 1925 and in 1929 formed **An American Place,** which he ran until his death in 1946. He showed his studies of the painter Georgia O'Keeffe, his photographs of Lake George, where he and O'Keeffe spent summers (they married in 1924), his cloud series, and views of New York City. After 1937 his career as a photographer was over.

His photographs are held by major private and public collections, including those of the Metropolitan Museum of Art and the Museum of Modern Art in New York and the **Royal Photographic Society** in London. Stieglitz's work has been exhibited in museums worldwide. *Camera Work: A Critical Anthology* (1973) by Jonathan Green and *Alfred Stieglitz: An American Seer* (1973) by Dorothy Norman are two of the many books published about the father of modern photography.

still life: The general term for photos of inanimate objects, products, and merchandise—often for use in advertising, promotion, or publicity and executed in a photo studio. Still-life is sometimes called "table top" photography when objects are very small and arranged on top of a table.

still photo: A single two-dimensional photograph, as opposed to a motion picture. A single frame of a motion picture can be printed as a still.

Stock, Dennis (1928–)
American nature and landscape photographer
Stock has shot many color stories on nature and landscape and has also produced several documentary films.

Born in New York City, he apprenticed with **Gjon Mili** from 1947 to 1951. In 1951, the same year he joined **Magnum Photos,** he won first prize in *Life* magazine's Young Photographers contest. He photographed the actor James Dean, whom he met in Hollywood in 1955, and the photos were published in *Portrait of a Young Man: James Dean* (1956). His pictures of jazz musicians, taken between 1957 and 1960, were published in *Jazz Street* (1960).

In 1968 Stock took a leave of absence from Magnum and set up a film production company, Visual Objective, Inc. His work has been published in more than 20 books, including *New England Memories* (1989) and *Provence Memories* (1988).

His work was honored with a major retrospective at the **International Center of Photography** in 1977.

stock photograph: A previously taken picture, as opposed to an assigned photo, that is kept on file to be sold or distributed when needed, either by a photographer or by his agency. Some photographers shoot stock with the intention of keeping it on file for future sale.

stock solution: A concentrated photographic solution that is diluted into a working solution before it is used.

A stock solution will maintain its strength longer than a working solution but needs to be diluted before use.

Stoddard, Seneca Ray (1844–1917)

American documentary-landscape photographer

Stoddard explored and documented the pristine lakes and primeval forests of the Adirondack Mountains of New York state in a series of black-and-white photographs notable for their poetic effects of light and atmosphere.

Born in Wilton, Saratoga County, New York, Stoddard grew up on the outskirts of the Adirondack region. Educated in rural schools, he served an apprenticeship as a decorative painter of railway carriages. A self-taught photographer, he took his first significant pictures, of Ausuble Chasm, in the 1860s.

In the next decade he produced guidebooks to Lake George, Lake Champlain, and Saratoga Springs. His first portfolio was published in *The Adirondacks Illustrated*. In the 1880s he set out on an ambitious canoe trip over a few summers, photographing along the eastern coast from Long Island to Nova Scotia. He later traveled west, going as far as Alaska, and to the Mediterranean basin.

In addition to his landscape photography, Stoddard also portrayed the leisure life of the Adirondacks—the big resort hotels, the local guides, and the vacationers who came to experience the wild and beautiful natural setting.

Stoddard's photographs and papers are held by the Adirondack Museum in Blue Mountain Lake, New York. *Early Days in the Adirondacks: The Photographs of Seneca Ray Stoddard* by Jeanne Winston Adler was published in 1997.

stop bath: An **acid** bath that is used to stop the development process with photographic film and paper. Stop bath doesn't affect the **image** but only stops further **development** and neutralizes the developer solution. A popular stop bath is indicator stop bath, which has a deep orange color and turns blue/purple when it needs to be replaced. Another common stop bath is diluted acetic acid.

Stoumen, Lou (1917–1991)

American photojournalist and filmmaker

In his more than 50 years as a photojournalist, Stoumen photographed a wide assortment of people—world leaders like Winston Churchill and General Claire Chennault, and fellow photographer **Edward Weston**, as well as ordinary people like a World War II war widow, a New York City street artist, and mothers and children on a California beach.

Born in Springtown, Pennsylvania, he was graduated from Lehigh University (bachelor of arts, 1939). During World War II he served as a war correspondent for the Army newspaper, *Yank*, and also published work in *PM*. After the war he continued working as a freelance photojournalist. He became interested in filmmaking and shot a film on Edward Weston. Stoumen taught film production at the University of California at Los Angeles. His film work was honored with two Academy Awards, in 1957 for the best short documentary, *The True Story of the Civil War* and in 1964 for *Black Fox*.

Stoumen's still photographs were exhibited at **Friends of Photography,** Carmel, California, and are held by private and public collections, including those of the **International Center of Photography**, the **Center for Creative Photography** in Tucson, and the Jerusalem Museum.

In 1990 Stoumen published *Ablaze with Light and Life: A Few Personal Histories*, with 85 images taken over his long career and brief essays about his experiences taking the pictures. Several monographs of his work have been published, including *Times Square* (1984).

straight photography: Using the most obvious attributes of photography—the reproduction of a real subject, clearly rendered with fine detail—photographers from **Alfred Stieglitz** to **Ansel Adams** have produced a broad range of images that are characterized as straight photography. It has been called a purist aesthetic because the finished print may not be cropped or manipulated in any way, either as a negative or during the processing stages. The San Francisco group led by **Edward Weston** and Ansel Adams, **f/64,** favored the straight aesthetic and advocated the use of large-format cameras.

Strand, Paul (1890–1976)

Influential American photographer and filmmaker

A legendary figure in twentieth-century American photography, Strand was a practitioner of pure fine-art photography who later expressed in filmmaking his humanitarian concerns for social progress. Strand's body of work evolved from the heyday of **Pictorialism**, to his abstract shots of machines, rocks, and landscapes, to the socially aware content of his pictures of community life. An artist of the camera, he believed in the virtue of craftsmanship, sometimes spending days in the darkroom to assure the quality of his prints.

Born in New York City, he received a camera as a twelfth-birthday gift from his parents. At great financial hardship he was sent to the Ethical Culture School in Manhattan, where he took **Lewis Hine**'s extracurricular course in photography. The school's camera club visited **Alfred Stieglitz**'s **291 Gallery**, and Strand returned there often, making friends with Stieglitz. By the age of 17 Strand knew he wanted to a photographer.

After graduation he worked briefly as an office boy, then spent his savings on a European tour. On his return, he opened a commercial studio, where he experimented with hand-tinted platinum plates, soft-focus lenses, and various other techniques. He spent more and more time on his own project—taking cityscapes, which Stieglitz exhibited at 291 in 1916, Strand's first solo show. The following year Stieglitz devoted an entire issue of **Camera Work** to Strand.

In the years after World War I, Strand, following Stieglitz's advice to focus more sharply and move away from the Pictorialist aesthetic, turned to abstract photography. Although he produced many memorable images, they were not salable at that time, and Strand found he could earn a living as a freelance cinematographer, making newsreels for Fox and Pathé Films. His first documentary, *Mannahatta*, done in collaboration with **Charles Sheeler**, was completed in 1920.

In the late 1920s and 1930s Strand's interest in the social content of his work resulted in the pictures he took in the Gaspé Peninsula in Quebec, New Mexico, and Mexico. His work in Mexico was so highly regarded that he was named to head the Education Department's photo and film section; that work also inspired his 1935 film *The Wave*, about a strike of fishermen in Veracruz. In 1936 Strand collaborated with **Ralph Steiner** on another important film, *The Plow That Broke the Plains*, directed by Pare Lorenz.

Strand continued as a cinematographer after 1937, when he was a cofounder of Frontier Films, a nonprofit company that made seven films. In 1945 the Museum of Modern Art in New York had its first photography show, featuring Strand's work. He subsequently collaborated with **Nancy Newhall** on *Time in New England* (1950), his first photography book.

Unhappy with the political climate of the United States, Strand moved to Oregeval, France, in 1951. He traveled extensively in Africa, Egypt, and Europe, taking social documentary pictures that were later collected into books.

Strand was awarded the **David Octavius Hill** Medal by the Gesellschaft Deutscher Lichtbildner in Mannheim, Germany. Major retrospectives of

Paul Strand. *Blind,* 1916. The Metropolitan Museum of Art, New York, Alfred Stieglitz Collection, 1933.
© Paul Strand Archive, Aperture Foundation, Inc.

A street photographer in New York who used a pony as a prop to attract customers. © Fred W. McDarrah.

Strand's work have been held at the Metropolitan Museum of Art, the Los Angeles County Museum of Art, and the Philadelphia Museum, and his work is represented in public and private collections worldwide.

street photography: Since the early days of the twentieth century, itinerant photographers have taken pictures of passersby for a modest fee. In some city neighborhoods, it was the custom for a street photographer to have a pony and sell pictures of children sitting astride the animal. In resort cities like Miami or Atlantic City, vacationers could bring back personalized mementos of their visit with buttons, cards, or other souvenir items to which the photographer had affixed a snapshot. Today's street photographers usually use a **Polaroid** camera to produce instant souvenirs for tourists at sites around the world.

stringer: A photographer or writer who works under contract or agreement with a news agency, newspaper, magazine, or television network and is paid only for work used.

stroboscope (strobe): A device that produces a very short, bright light at regular intervals. When one views a moving object in a dark room with a stroboscope in operation, the object appears in a series of stationary poses, each a bit different from the one before, accounting for the movement.

Struss, Karl (1886–1981)
American photographer and filmmaker
Struss was a master of both still and motion picture photography: His **Pictorialist** images were exhibited by **Alfred Stieglitz** at **291** in a 1910 exhibition and a 1912 issue of ***Camera Work*** and he became the last member to

Karl Struss. *Queensborough Bridge.* 1911.
Courtesy James Danziger Gallery, New York.

join the **Photo-Secession** movement. After World War I he began a new career in film, and his artistry with a motion picture camera earned him the first Academy Award for cinematography for *Sunrise* (1927).

Born in New York City, Struss studied with **Clarence White**. In typical Pictorialist fashion he favored soft-focus lenses and various printing techniques to achieve poetically hazy images. Strong anti-German sentiment preceding and during World War I caused his work to slip into near-oblivion. He served in the U.S. Army from 1917 to 1919, and then moved to Los Angeles where he had a long career in film and television that lasted through the 1960s. His first assignment was shooting stills for Cecil B. DeMille. Later he worked as a cinematographer for *Ben Hur* (1924), *The Great Dictator* (1940), and *Limelight* (1952).

His still photographs were "rediscovered" in the late 1970s, and the majority of his estate was acquired by the Amon Carter Museum in 1983. Among the books featuring his work are *New York to Hollywood: The Photography of Karl Struss* (reprinted 1995) and the catalogue accompanying a major retrospective of his work called *Karl Struss: Man with a Camera*. The show was organized by the Cranbrook Academy of Art/Museum in 1976 and traveled to the **George Eastman House**, Los Angles County Museum of Art, and other major institutions. His photogravures in *Camera Work* are included in the collections of major museums in the United States.

Stryker, Roy Emerson (1893–1975)

American documentarian

As chief of the Historical Section of the **Farm Security Administration** (FSA) from 1935 to 1943, Stryker hired and directed the photographers who documented the United States during the Depression. Among his cadre of photographers who later won fame for their great work under him and in later careers were **Carl Mydans**, **Ben Shahn**, **Arthur Rothstein**, **Esther Bubley**, **Walker Evans**, and **Dorothea Lange**.

Born in Great Bend, Kansas, Stryker grew up in Montrose, Colorado. He served in the Army in World War I and studied economics at Columbia University (bachelor of arts, 1924), remaining at the school as an instructor. One of his professors, Rexford Tugwell, asked him to help collect photographs for an economics textbook, and Tugwell was impressed with the photos Stryker brought in, which helped make the textbook a great success.

Shortly thereafter Tugwell joined President Franklin D. Roosevelt's newly formed "brain trust" as head of the Resettlement Administration. He was inspired by the idea of again using photographs to present the American people with a dramatic picture of the economy's drastic effects on the nation and the need for reform. He called on his old student, Stryker, to recruit, organize, and manage a team of photographers commissioned to travel around the country and record the terrible effects of the Depression.

Stryker carried out his assignment until 1943, when his section was taken over by the Office of War Information. He left government service to perform similar work for Standard Oil of New Jersey, as head of its new photography department. When he left Standard Oil in 1950, its archive contained some 85,000 negatives. His next assignment was to assemble a photographic history for the Pittsburgh Photo Library; his final work was done for the steel manufacturer Jones and Laughlin.

In 1974 Stryker collaborated with Nancy Wood on the publication of *In This Proud Land*, illustrated with 200 of the FSA photographs. The FSA archive amassed under his direction is now held by the **Library of Congress**.

studio: A space designed specifically for making photographs. Typically a room with lighting equipment, backdrops, cameras, and props.

studio camera: A large camera for use in a studio. For television and film use, the camera is housed in a soundproof insulation to prevent the sound recording from being disturbed.

Suau, Anthony (1956–)

American photojournalist

Suau's searing images of famine in Ethopia won him the 1984 **Pulitzer Prize**.

After graduation from the Rochester Institute of

Technology in 1979, he was an intern at the *Chicago Sun-Times*, which later hired him as a staff photographer. He then moved to the *Denver Post* and embarked on a series of international assignments. He was in Ethopia early in that nation's years of mass starvation. He won the feature photography Pulitzer for a series depicting the tragic effects of starvation and a single image of a woman huddled over her husband's grave on Memorial Day.

After the prize he joined the **Black Star** agency as a globe-trotting freelancer, covering events in Afghanistan, South Korea, the Philippines, and Colombia. He has also won two World Hunger Foundation awards (1984, 1986) and was the subject of a one-hour 1986 TV documentary.

Sudek, Josef (1896–1976)
Czech art photographer

One of his nation's most honored and best-known photographers, he took lyrical still-lifes and poetic landscapes of his beloved Prague, often from the window of his studio.

Sudek thrived as a photographer despite a tremendous handicap; during World War I he was injured at the Italian front and lost his right arm. Unable to continue his career as a bookbinder, he turned to photography. He studied photography in the early 1920s at Prague's School of Graphic Art, and in 1924 he founded the Czech Photographic Society.

He had his first one-man show in 1933. In 1936 he participated in the International Photo Show in Manes with **Man Ray**, **Laszlo Moholy-Nagy**, and other avant garde photogaphers and was hitting his stride professionally. Then came World War II, and he stayed indoors much of the time, photographing at his window. He also made an important decision about his work. In 1940, viewing a large contact print made 40 years earlier, he saw that it had a remarkable quality that no enlargement could yield. From that day on, he never made another enlargement.

Sudek was a transitional photographer who moved from **Pictorialism** to modernism in the same manner as the rest of Europe, but unlike the rest of the modernist world, Sudek eschewed strict hard edges and maintained

a romance of place and a selectively soft look that is present throughout all his images.

In the 1950s he started using an early Kodak panoramic camera for his cityscapes. The collection *Prague Panoramas* was published in 1959. His first monograph had appeared three years earlier, when Sudek was 60. He was the first photographer to receive the title Artist of Merit, which the government awarded him in 1961. His last book appeared when he was 75–*Sudek* (1978), an appreciation and collection of his photos by his one-time assistant Sonja Bullaty.

sun photography: Photographic printing techniques that use the sun to develop the image on the paper. Examples are **platinum printing, cyanotypes,** Talbotypes, **salt prints,** and **Van Dyke prints**. While almost every type of photographic printing done today uses artificial light sources in the darkroom, some photographers who are interested in the old-fashioned processes still use sun photography.

surrealism: An artistic movement begun in Europe after World War I and in reaction to the insanity and brutality of that conflict. Surreal means "above real," and the surrealists sought to make art that was shocking and unorthodox and that usurped the traditional notions of artistic representation. Surrealist imagery employed found symbols, tribal art, dreams, intuitive ideas, and psychoanalytical theory, all of which contradicted the normally held ideas and traditions of society and art. Surrealism was an important force in modern art between the world wars and is a major historical art movement, with followers to this day. Major practitioners of surreal photography are **Man Ray, Roger Parry, Brassai, Bill Brandt, Jerry Uelsman, Fredrick Sommer, Arthur Tress,** and **Joel-Peter Witkin,** among others.

surveillance photography: Photography that is used to spy, track movements, and observe the activity of the subject without his or her knowledge. Surveillance photography is used by law-enforcement agencies in their investigations of crime and criminals

and by news media in their investigation of corruption to identify people and produce evidence of their whereabouts and associates.

Sutcliffe, Frank Meadow (1853–1941)
Early British nature photographer

One of the first men to devote his career to photography, Sutcliffe was a founder of **The Linked Ring** photographic society who set himself the task of photographing scenes of nature and Yorkshire life in as truthful and straightforward a way as possible.

Born in Headingly, Leeds, England, he was introduced to photography by his father, an amateur hobbyist. He opened a studio in 1875 and achieved great commercial and critical succcess with his work. His *cartes de visite* were bestsellers, and he did a thriving portrait business. But it was his personal work—images of small-town farmers and fishermen and their families at work and at play—for which he is remembered. His naturalistic and candid style was unusual for the era.

Starting with an 1888 Camera Club show, he was widely exhibited. In 1941 he was made an honorary member of the **Royal Photographic Society**. Later in his life he photographed with the new Kodak hand-held cameras, enjoying the increased freedom the snapshot camera gave him—a vast improvement over the bulky equipment he had used earlier.

Sutcliffe also wrote a photo column from 1908 to 1930 in the *Yorkshire Weekly Post* and was curator of the Whitby Literary and Philosophical Society from 1923 to 1940. Sutcliffe's work is held by major collections, including those of the **George Eastman House**, the Philadelphia Museum of Art, and the **Royal Photographic Society**. *Frank Sutcliffe: Photographer of Whitby* (1974) by Michael Hiley gives an overview of Sutcliffe's life and works.

Sygma Photo News:
Established in 1970, Sygma has become one of the largest agencies, with offices in major cities worldwide. The agency specializes in photojournalism, human interest, films, personalities, politics, and feature stories.

synchronization:
The coordination of two distinct things to operate simultaneously for a desired end. A synchronized camera flash is one in which the flash goes off at the precise moment that the **shutter** opens.

Szarkowski, John Thaddeus (1925–)
American curator, photogapher and writer

During his three-decade stint as director of the photography department at the Museum of Modern Art, Szarkowski had a profound and lasting impact on the development of the museum's photography collection and the public appreciation of photography.

Born in Ashland, Wisconsin, he had his studies at the University of Wisconsin interrupted by military service in 1945–1946. He was graduated in 1948, having majored in art history. He worked as a photographer at the Walker Art Center in Minneapolis until 1951, when he moved to teach at the Albright Art School in Buffalo. He stayed there until winning a 1954 **Guggenheim fellowship**. The award supported a project that became a book called *The Idea of Louis Sullivan* (1960); his 1961 Guggenheim award supported a photographc project in the Canadian wilderness.

In 1962, he was appointed to succeed **Edward Steichen** as director of photography at the Museum of Modern Art. He would go on to curate and contribute to the catalogues of more than 100 major shows. In 1966 he published *The Photographer's Eye*, in 1973 *Looking at Photographs*, and in 1978 *Mirrors and Windows, American Photography since 1960*.

Perhaps his most influential show was the 1967 "New Documents," which established snapshot photography and included such legends-to-be as **Diane Arbus**, **Lee Friedlander**, and **Garry Winogrand**. He also did major shows of the work of **Irving Penn**, **Brassai**, **Henri Cartier-Bresson**, **Dorothea Lange**, **Ansel Adams**, and **Eugène Atget**.

After 30 years of displaying the work of others, he returned to his own photography. He did a show and book of photos about a barn he owns and *A Maritime Album* (1997), photos of ships, shipwrecks, ship life, and ship people over the past century.

He has been cited numerous times by a variety of public and private institutions, has been on the Guggenheim Advisory Board, and has received many honorary degrees. He has been a professor and lecturer at New York University, Harvard University, Cornell University, and won a prestigious **International Center of Photography** award for writing. He continues to write, edit books, and create his own work.

Frank Meadow Sutcliffe. *Give Us a Lift,* ca. 1890s. The New York Public Library.

William Henry Fox Talbot. *Ships in Harbour at Rouen on the Seine,* May 1843. Salted paper print from a calotype negative.
Part of the Rubel Collection. Courtesy Hans P. Kraus, Jr., Inc., New York.

Tabard, Maurice (1897–1984)

French surrealist photographer

Strongly influenced by the avant garde artists working in Europe in the 1920s and 1930s, such as Rene Magritte, **Man Ray**, and **André Breton,** Tabard started his own experiments with various techniques—solarization, photomontage, double exposure, and negative printing. His work was well received, published widely, and exhibited in the New York **Julian Levy** Gallery's show of modern European photographers. Tabard was also a productive portrait photographer in the early years of his career, and after World War II he became known for his fashion work.

Born in Lyon, France, Tabard moved to Paterson, New Jersey, with his family in 1914. He father was a silk manufacturer, and Tabard worked as a fabric designer and studied painting before his interest turned to photography. He studied at the New York Institute of Photography before moving to Baltimore, where he worked for the noted Bachrach firm doing portraits, among them those of many government officials, including President Calvin Coolidge and his family.

In 1928 Tabard returned to France, where he became part of the avant garde circle centered on Man Ray. During World War II he lived and worked as a freelance photographer in the south of France. He earned his living as a fashion photographer after the war, and his work appeared in *Elle, Paris Match*, and other major periodicals. He also continued his experiments into the nature of his medium and his own personal work.

Tabard's work has been exhibited at the Pompidou Center in Paris.

tabletop photography: Photographing small objects and miniature sets on the top of a table, often giving the effect that the objects are much larger than they are. This is a specialized form of photography used for commercial purposes and in motion pictures.

tabloid journalism: Reporting via writing and photography for the tabloid press. Tabloids are newspapers that are about half the size of traditional newspapers and became known for their populist coverage of lurid, seamy subjects and sensational headlines. Photography has always been an important element in tabloid journalism, adding to its popular appeal and enabling those with limited reading skills to understand a news story. Traditionally *tabloid press* was another term for "supermarket scandal sheet," but many modern-day papers are of the tabloid format and are somewhat more highbrow than the papers found at the checkout counter. In the past, stories on the Loch Ness monster mating with two-headed extraterrestrials and invading the U.S. Senate were standard fare. Now, though, some highly respected newspapers use the tabloid format and such traditional staples of the tabloid press, such as the *National Enquirer* and *The Star*, now focus on celebrity journalism more than the world of the bizarre, like Elvis Presley's coming back from the dead. The *Chicago Sun Times*, the *New York Post*, the *New York Daily News*, and the *Boston Herald* are all published in tabloid format but are also read by white-collar movers and shakers from the president of the United States on down. Because the format is so popular, traditional broadsheets, like the *New York Times*, are adopting tabloid features. The *Times* has run front-page stories on gossipy celebrity bios like Kitty Kelley's Nancy Reagan tome and features a daily half-page gossip column, complete with boldfaced names, unattributed sources, and celebrity doings.

Talbot, William Henry Fox (1800–1877)

Landmark British inventor and photographer

Talbot is generally regarded as the father of photography.

He invented the negative-positive process that enabled the production of multiple prints on paper from a single negative, which continues to be the basis for photography today.

A brilliant student at Harrow and Trinity College in Cambridge, he was graduated in 1825. A scientist at heart, he was elected to the Royal Society in 1831. Like earlier inventors, he experimented with salt and **silver nitrate** and the **camera obscura** (Latin for dark chamber) and the possibilities of fixing the reverse image it projected. In August 1835 he produced what has become the first surviving **negative,** a one-square-inch image of a latticed window, taken with an exposure time of about 30 minutes.

A scholar of many pursuits, Talbot left photography after those experiments, but in early January 1839, when he heard of **Daguerre**'s work, he became disturbed that he would not receive credit for his findings, so he presented his "photogenic drawings" on January 25 and described his experiments in a paper presented to the Royal Society on January 31.

In 1843 he produced a book, *The Pencil of Nature,* with 24 photographs and text detailing the scope and potential of his **calotype** process. He would go on to take many images of insects, leaves, and other botanical specimens.

In June 1844 he made a walking tour of Scotland and published a portfolio—the world's first photo book without text—*Sun Pictures of Scotland.* Talbot went on to discover in 1851 a method for taking instantaneous pictures, invented a new photoengraving process the next year, and in 1854 created a traveler's camera. It combined a camera and two **tanks,** one for sensitizing wet plates and one for developing prints.

Much of his work was of scenes in and around his home, Lacock Abbey (now a photography museum) and its environs. He usually created simple documents of nineteenth-century life. Other especially notable photos are his chess players and the construction of Nelson's Column in Trafalgar Square.

In 1855 he won the Grand Medal of Honor in the Paris Exposition for his contributions to photography and another major prize in Berlin in 1865. By then, however, he had essentially retired from photography to concentrate on mathematical theory. He was made an honorary member of the **Royal Photographic Society** in 1873.

Many books and articles have been written about Talbot, including **Beaumont Newhall**'s *Latent Image: The Discovery of Photography* (1967). His personal photography is highly prized and collected and is in every major museum and private collection in the world.

tanks: Containers used to hold photographic **film** and chemicals for **development**. Tanks come in many sizes ranging from very small light-tight ones for developing a single reel of 35mm film to large, open tanks for developing 8 x 10-inch sheet film. All tanks are made of metal or special plastic or rubber that resists the corrosive nature of photographic chemicals.

tearsheet: A page from a publication with photography and/or text. Tearsheets are used by photographers, graphic designers, and writers to demonstrate the quality of their work in a published format. A photographer will typically have a book of tearsheets to show prospective clients the range and quality of his or her work. Having tearsheets demonstrates that one is a working professional.

Technicolor: A color motion picture process that uses the **dye transfer** system for its final **positive** print. **Color separations** from the negative are made corresponding to yellow, magenta, and cyan (and a fourth silver image for added sharpness and contrast) and are then printed together to form the positive image for viewing. Technicolor is the premier printing process because of its rich, vibrant color and ability to resist fading.

telephoto lens: A **lens** that increases the relative size of objects and scenes to be photographed. Distant objects appear near, as with a telescope, giving the photographer a close view of far objects without having to enlarge the photograph. Telephoto lenses also produce the visual effect of appearing to "flatten" the scene, minimizing the distance between faraway objects.

temperature control: When **film** is **developed,** the temperature of the chemistry affects the results, so it is important to maintain control of it. Developer that is too warm causes **overdevelopment**, higher **contrast,** and large film grain. Developer that is too cool causes **underdevelopment,** low contrast, and thin negatives. Optimum temperatures for film developing are from 68 to 75 degrees. The development time for film is lower at higher temperatures and greater at cooler temperatures, but most important is that temperature remain consistent throughout the development time and that the **stop bath** and **fixer** are at about the same temperature.

template: A guide, usually made of thin plastic or metal, that is used to aid in the drawing of shapes and letters. A template can also have an abstract design cut out and used to create lighting background patterns for photography and film, called a cookie.

tessar lens: Designed by Paul Rudolph in 1902, it was a simplified version of the best lens design, allowing for greater **apertures**. It continues to be produced today.

test strip: A piece of photographic paper that is cut into strips and used to test for the best print exposure, thereby saving time and money. Once the best exposure on the strip is found, a whole sheet of paper is used for the final print.

thermometer: An instrument that indicates temperature. In photography it is necessary to control the temperature of the water and chemicals used in the **darkroom** for processing **film** and **developing** prints. A professional darkroom thermometer with great precision and accuracy is vital for maximum quality of negatives and finished prints.

35mm photography: Photography done with a camera designed to use rolls of 35mm film. With the 1925 introduction of the **Leica** camera, designed by **Oskar Barnack** and manufactured by the German firm of Ernest Leitz, 35mm photography came into wide use. Such pioneering photojournalists as **Erich Salomon, Henri Cartier-Bresson,** and **Alfred Eisenstaedt** immediately saw the great potential of being able to shoot more pictures, faster, and be less obtrusive by using the small-size camera that employed 35mm film. The format became fully established during World War II when the 35mm camera was used by **Robert Capa, W. Eugene Smith, David Douglas Duncan,** and a number of other combat photographers and photojournalists. The 35mm camera was not only more portable, but the format led to better-quality **lenses,** automatic exposure control, automatic focusing, better flash efficiency, and **films** that had more speed and greater grain characteristics. In addition to Leica, Contac, **Nikon,** and Pentax are among the leading present-day manufacturers of 35mm cameras.

Thomson, John (1837–1921)
Early British photojournalist
A pioneer **photojournalist** and **travel photographer,** Thomson was a significant figure who produced early social documentary views of the Far East and London. His best-remembered achievement is his book in collaboration with the writer Adolphe Smith, *Street Life in London* (1877), which gave an accurate and evocative portrait of working-class life. The pictures were photomechanically reproduced in exquisite detail.

Born in Edinburgh, he studied chemistry, although his real love was geography. He was a fellow of the Royal Geographic Society and from 1862 to 1870 was traveling in the Far East–first to Ceylon, and then on a second trip to China, stopping along the way in Thailand, Cambodia, and Hong Kong. Interested in photography since the late 1850s, he planned to open a studio in London after documenting his travels. The photographs he took on his travels were published in *The Antiquities of Cambodia* (1867), *Illustrations of China and Its People* (1873–1874), and *The Straits of Malacca, Indochina and China* (1875).

After his return to London he began his most famous project, which was published in twelve monthly installments and then in book format. His final

work, *Through Cyprus with a Camera* (1879), was an illustrated account of a three-month visit there.

3-D photography: Photography that simulates the three-dimensional aspect of real life on the two-dimensional plane of the photograph. 3-D photography is done using a **stereoscopic** camera, which has two lenses that take two pictures simultaneously from a slightly different perspective. The distance between the two lenses is similar to the distance between the eyes— our perception of depth and three-dimensionality is due to our eyes seeing the same scene from two different vantage points. When the two pictures taken with a stereoscopic camera are viewed simultaneously, the effect is one of three-dimensionality.

Tice, George A. (1938–)

American art photographer

Tice has photographed such diverse subject matter as the cityscape of Paterson, New Jersey; the Amish people in Pennsylvania; a California ghost town; and the natural beauty of trees, plants, and ice forms. His work has been compared to that of the painter Edward Hopper, offering spare, romantic views and portraits that reveal the essence of the subject and its deeper implications.

Born in Newark, New Jersey, Tice became interested in photography as a teenager and studied the medium at the Technical High School. After a naval tour of duty as a photographer, he established himself as a portrait photographer. He works as a freelance photographer, has been instructor for a master class in photography at The New School since 1970, and has also given numerous workshops. His work has been published in various periodicals, including **Life,** *Art International*, and *Du*.

Tice's work has been featured in several books, including *Fields of Peace* (1997), *Hometowns* (1988), and *Urban Romantic: The Photographs of George Tice* (1982). He was honored with the Grand Prix of the Arles Festival and **National Endowment for the Arts** and **Guggenheim fellowships**.

He has had one-man shows at the Metropolitan Museum of Art, the New Jersey State Museum, and other venues. His work is included in such collections as the Museum of Modern Art, the Art Institute of Chicago, and the Victoria and Albert Museum.

time exposure: A camera exposure of more than one second using the "T" (time) **shutter** speed. When the shutter is opened on T, it stays open until the shutter release button is pushed again, thereby allowing exposures of any length. This is different from the B (bulb) setting, which opens the shutter for only as long as the shutter release is held down.

time-lapse photography: The recording of a slowly moving object over a long period of time, usually with a video or a movie camera, such as grass growing or a flower blossom opening. Single exposures are done at regular intervals over a long period of time and, when viewed together at normal speed, present the event happening at a greatly exaggerated speed.

Time-Life Syndication: The *Time* archive consists of pictures by many of the photographers whose work has appeared in *Time* magazine. The **Life** archive is made up of published and unpublished photographs take by *Life* magazine staff and contract photographers from 1936 to the present.

timer: A clocklike device that can be set for a desired amount of time. Timers are used to control how long an enlarger is allowed to expose photographic material and to keep track of how long to develop film, among other photographic uses.

tintype: A photographic image on a sheet of metal, typically iron. Tintypes were a cheap form of photography invented in 1856 by Hamilton Smith and continuing into the 1880s. Early photographic processes (the **daguerreotype** and later the **ambrotype**) were expensive, and so inventors had been seeking a cheaper means of photography that could be marketed to a larger audience. Tintypes are similar to ambrotypes in that they are made using the wet-**collodion** process, but instead of being on glass, they are on metal. Some tintypes were placed in ornate cases, called union cases, to resemble

John Thomson. *Ted Coally, aka "Hookey Alf" of Whitechapel,* ca. 1876–77. From *Street Life in London*, Chapter VI. Courtesy the Witkin Gallery, New York.

daguerreotypes and ambrotypes, but close inspection shows them to have less detail and tonality. Tintypes were enormously popular and became the first widely available photograph for the masses. Traveling photographers typically made tintypes and set up their studios around the camps of Civil War soldiers to make **portraits** that could be sent home through the mail without being damaged. Some old-fashioned photo studios still make photographs on tin, but with a process different from that used for the original tintype.

Tintype taken in Weimar, Germany, ca. 1880.
Collection of the authors.

toning: Because **black-and-white** photographs have a basically neutral color, toning is done to add an overall color for creative effect. Toning is done through a chemical process, and many different processes are commercially available. Most popular and recognizable is sepia toner, which gives the photograph a reddish-brown cast, familiar in some old photographs. Selenium toner is popular with art photographers and can be controlled to change the color to varying degrees from reddish brown to unnoticeable.

Trager, Philip (1935–)
American architectural photographer
A practicing lawyer as well as a photographer, Trager has achieved recognition for his architectural photography, notably his book *Photographs of Architecture* (1977), which shows unusual and outstanding architecture in Connecticut. The critic Eliot Fremont-Smith, writing in the *Village Voice*, called Trager's pictures "commanding in their clarity and reserve."

Born in Bridgeport, Connecticut, Trager was graduated from Wesleyan University (bachelor of arts, 1956) and Columbia University Law School (doctor of law, 1960). His work has been published in *Flatiron: A Photographic History of the World's First Steel Frame Skyscraper* (1990) and *Dancers* (1992).

He has exhibited in solo and group shows at such venues as the **International Center for Photography** and the Brooklyn Museum, and his work is held in the collections of the Museum of Modern Art, the Metropolitan Museum of Art, and the Corcoran Gallery, among others.

transfer processes: A variety of photographic printing processes that use a transfer of an image from one material to another and can be done through chemical or physical means. Chemicals can transfer an image from one material to another, and physical transfers involve a movement of ink or other material from the original directly to another material.

transparency: An image, usually a positive, made on a clear or translucent base to be viewed directly with transmitted light (on a **lightbox**) or with a projector. Commonly called **slides** (35mm mounted transparencies), transparencies range from 35mm to 8 x 10 inch and larger. Bus shelters and other advertising displays use very large transparencies for their displays.

Uniformed American baseball players—from Chicago, Kansas City, and Pittsburgh—on an 1890s promotional swing through the Middle East posed for this carefully arranged group portrait at the Sphinx on the Giza Plateau, near Cairo, Egypt. Collection of the authors.

travel photography: Photography done while on a trip and/or vacation. Typically, the result is a beautiful color photograph of a famous, interesting, or exotic place, taken to remember the place and its appearance. For amateurs, this is an indispensable way of recording the sights of the trip, and traveling with a camera is the norm. Professionally, it's a highly popular field, with practically every newspaper, magazine, and countless books using these images. Travel photography is a popular beginning point for many photographers that has led to a professional career.

Arthur Tress. *Bride and Groom*, 1970. From the series, *The Dream Collector.*
Courtesy Stephen Cohen Gallery, Los Angeles.

Tress, Arthur (1940–)

American documentary, later surrealist, photographer

In Tress's early work as an ethnographic photographer he recorded several primitive tribal groups, including Eskimos, Lapps, and Mayans. Since the early 1970s he has produced a series of books that explore the unconscious mind in surrealist photography with themes such as the dreams of children, shadows, anxieties, violence and danger, death, and erotic fantasies. Tress was one of the early creators of staged photography, in which the subject is manipulated to emphasize the photographer's point of view.

Born in Brooklyn, Tress earned a bachelor of arts degree (1962) from Bard College. From 1963 to 1966 he traveled in Central America, the Far East, and Europe, studying art history and ancient cultures. He worked for the U.S. government preparing studies of ethnic groups from 1969 to 1970 before pursuing his interest in "the hidden sphere of the Irrational." Winner of a **National Endowment for the Arts** grant, Tress has taught at The New School.

Among his books are *The Dream Collector* (1972), *Shadow* (1975), and *Theater of the Mind* (1976). His work has been exhibited in numerous one-man shows at such venues as the **Smithsonian Institution** and Arles Festival and is held by such collections as the **George Eastman House**, the Museum of Modern Art, and the Bibliothèque Nationale, Paris.

trick photography: Special effects are sometimes called trick photography. Photographic effects may or may not resemble reality in the final image but are added to enhance an image's impact or to make a statement. The result is an image that would not exist without their use. Special effects can be as simple as a **filter** over a **lens** (changing a color or making lights appear starlike) to digitally altering an image (putting yourself on the moon or a spaceship landing on the White House lawn).

tripod: A three-legged device for holding a camera steady during exposure. A wide variety of tripods is available, ranging from very small tabletop models to very large, heavy-duty ones for large cameras. Choosing the right tripod is important for camera safety, image quality, and portability.

tripod head: A device for securing a camera to a **tripod**. It allows control of the horizontal and vertical orientation of the camera.

Tucker, Anne Wilkes (1946 –)

American curator and teacher

Since 1976 head of the Department of Photography at Houston's Museum of Fine Arts, Tucker founded the photography department and has guided its growth to a respected national institution, with a collection of more than 10,000 images that range from historical landmarks to avant garde modern work.

Born in Baton Rouge, Louisiana, she received undergraduate degrees from Randolph Macon Women's College and Rochester Institute of Technology and a graduate degree from the Visual Studies Workshop of the State University of New York. She started her professional career as a curator at the Philadelphia College of Art and then worked, in succession, as a teacher in New York at Cooper Union and then The New School, as a curator at the Gernsheim Collection at the University of Texas at Austin, and at the **George Eastman House** in Rochester before assuming her position in Houston.

Tucker has mounted exhibitions, with accompanying catalogues, by such important photographers as **Robert Frank** and **Ray K. Metzker**. She spent more than 16 years researching **Brassaï**, in preparation for a 1999 show, acquiring a previously unknown cache of his work for Houston's permanent collection.

She has published many articles and lectured throughout the United States and Europe. She has been awarded fellowships by the **National Endowment for the Arts**, the **Guggenheim** Foundation, and the Getty Center.

tungsten bulb: A light bulb that uses a filament made of tungsten, which creates a bright light with a consistent color balance over its life, making it excellent for photography and balanced to 3200K. Any light bulb

that produces a light of 3200K is tungsten balanced but not necessarily a tungsten bulb.

Turbeville, Deborah (1938 –)

American fashion photographer

Turbeville worked first in front of the camera, as a model, and later as a fashion editor, before taking camera in hand to produce the kind of fashion layouts she wanted to publish. She has gone on to a successful career as a fashion and artistic photographer.

After attending finishing school in Boston, she came to New York at age 18 to study at Parsons School of Design and work as a model and design assistant. From 1956 to 1971 she served in editorial positions at *Ladies' Home Journal*, *Harper's Bazaar*, and *Mademoiselle* before starting her photo career in 1972. She started taking color pictures rather than black-and-white because she did not know how to print and could send the color film to a drugstore for processing.

From 1972 to 1974 she lived in Europe and produced a series called "Travel Through Europe as a Single Woman" that provided the direction for her future fashion work. She gained notoriety for fashion photos done in deserted public bathhouses and published in *Vogue* in 1975. Her work has a romantic atmosphere, often enhanced by soft-focus shots with mysterious settings. She has been widely exhibited and published in *Esquire*, *New York*, *Artforum*, and the major fashion magazines.

Turbeville moved in 1977 to Paris, where she continues to live and work. She had a major show at the Pompidou Center in 1986, and her books include the monograph *Wallflower* and *Women on Women*.

Turner, Benjamin Brecknell (1815–1894)

Early British landscape photographer

After he mastered **Fox Talbot**'s **calotype** process in 1849, Turner photographed the English countryside throughout the 1850s. This talented amateur photographer's first major exhibition at the Society of Arts in 1853 showed a number of pictures for use with a reflecting **stereoscope.**

From the age of 16 Turner was employed in his family's tallow-making business in London and managed the business after his father's death in 1841 until his own death. After he became interested in photography he erected a glassed-in studio on the roof of his shop in Haymarket, where he exhibited photos of his family and friends. In 1857 he traveled with his brother-in-law, Humphrey Chamberlain, of the Worcester china family, on a photographic tour of Holland. Nobody there had ever seen a camera, and an unruly crowd nearly pushed Turner into a canal. His box of equipment did fall into the water, ending the photography for that trip. However, some photos of Amsterdam survived and were auctioned at Christie's in 1980.

Turner, Pete (1934–)

American surreal photographer

Turner is recognized for his use of deep, saturated color and imaginative, often surreal photographs.

Born in Albany, New York, he started a freelance career immediately after his graduation from the Rochester Institute of Technology with a bachelor of arts degree in 1956. His first major published work, photographs of Barnum and Bailey's circus, appeared in *Look* magazine in 1961. His photographs have been featured in **Life**, *Esquire*, *Holiday*, *American Photographer*, and *Playboy*. Among his major projects have been views of the 1973 volcanic eruption on Heimaey, Iceland, and scenes of Masai tribesmen.

His work is held by private and public collections, including those of the Metropolitan Museum of Art, the **International Center of Photography**, and the Tokyo Metropolitan Museum of Photography. He has received numerous awards, including the 1981 Outstanding Achievement in Photography award from the **American Society of Media Photographers**.

Turnley, David (1955–)

American photojournalist

Separately, or together with his identical twin, Peter, David Turnley has photographed almost every international news event since 1981: the fall of communism in eastern Europe, the student uprising in Tiananmen Square, the return of Nelson Mandela and fall of *apartheid* in South Africa, the Desert Storm operation in the

Persian Gulf, and the separatists' rebellion in Chechnya in southern Russia. In 1990 he was awarded the **Pulitzer Prize** for his photographs of the political uprisings in China and eastern Europe.

Born in Fort Wayne, Indiana, David received a bachelor of arts degree in French literature from the University of Michigan in 1977 and also attended the Sorbonne. He worked for a chain of suburban Detroit newspapers before joining the *Detroit Free Press* as a staff photographer in 1980. On assignment for the *Free Press* David went to South Africa to report on *apartheid*; he remained for three years and produced a book, *Why Are They Weeping?: South Africans under Apartheid* (1988).

A selection of work by both Turnley brothers, *In Times of War and Peace*, was published in 1997. They also collaborated on *Moments of Revolution: Eastern Europe* (1991) and *Beijing Spring* (1989). David's work also was published in *The Russian Heart* (1992).

Among the honors David Turnley has received are the World Press Children's Jury Picture of the Year and Overseas Press Club Olivier Rebbot Award for best magazine photo reportage. He won the World Press Picture of the Year award in 1991 and 1989, and the **Robert Capa** Award by the Overseas Press Club. His work appears in major publications, including *Life, Stern, National Geographic, Time*, and *Paris Match*. A retrospective of the Turnleys' work was held at the **International Center for Photography** in 1996.

Still affiliated with the *Detroit Free Press*, David Turnley has been based in Paris since 1988.

Turnley, Peter (1955–)

American photojournalist

Peter Turnley, like his twin brother, David, is a well-known photojournalist who has covered most of the great world conflicts since 1981: the Gulf War, Bosnia, Somalia, Rwanda, South Africa, Chechnya, and the Israel–Arab conflicts in the Middle East. A contract photographer for *Newsweek* magazine since he did a cover story for the magazine on the 40th anniversary of D-Day, Peter continues also to work on a project documenting the plight of refugees worldwide.

Born in Fort Wayne, Indiana, Peter received a camera and a book of photographs by **Henri Cartier-Bresson** from his parents when he was 16 years old and recovering from a football injury. He has said he knew instantly he wanted to become a photographer. His brother, David, shared his enthusiasm, and they embarked on a project to document the lives of people living on a racially mixed block in Fort Wayne. David took the finished work, *McClellan Street*, to the **Magnum Photos** agency, and they were encouraged to continue in the medium.

Peter studied French literature at the Sorbonne and the University of Michigan (bachelor of arts, 1977), while also taking time off for various photo projects. He returned to Paris, where he still resides, and began a career as a freelance photographer. He worked in a photo lab and as assistant to **Robert Doisneau**. He also was graduated from the prestigious Institut d'Etudes Politiques in Paris, a feat few foreigners have ever achieved.

In addition to photographing international wars, Peter Turnley maintains his interest in photographing people's day-to-day lives, from Paris street scenes to his continuing interest in ballet. His photographs are frequently seen in such publications as *Paris Match*, **Life,** *Stern*, **National Geographic,** and the *London Sunday Times*. His work has been honored by many international awards, including the Overseas Press Club Award for Best Photographic Reporting from Abroad, and World Press Photo and Pictures of the Year competitions of the University of Missouri.

He has collaborated with his brother on several books: *In Times Of War and Peace* (1997), *Moments of Revolution: Eastern Europe* (1991), and *Beijing Spring* (1989). In 1996 a major retrospective of the Turnley brothers' work was mounted at the **International Center for Photography**.

twin lens reflex camera: A camera that uses two lenses of the same focal length—one to **focus** with and the other to expose the film. The top **lens** is used to focus the camera using a reflex mirror and ground glass viewing area. The lower lens contains the **shutter** and **aperture** control to expose the film. Twin lens

cameras use medium-format film and make 2 ¼ x 2 ¼-inch negatives, such as a **Rolleiflex**.

291 Gallery: Also called the Little Galleries of the Photo-Secession, 291 was a gallery established in 1902 by **Alfred Stieglitz** for the **Photo-Secessionist** movement, a breakaway group of **Pictorialists** in New York. There he showed the work of the photographers **Paul Strand, Adolf de Meyer,** himself, and many other Photo-Secession members, as well as that of a group of American and European modern artists such as Georgia O'Keeffe. 291 closed in 1917.

type C print: A color photographic print made from a **negative** using photographic **paper** that incorporates color couplers in the **emulsion**. The color couplers are reacted upon by the exposure to light and the **developer**. This is the most common type of color print for amateur and professional use and is also known as a chromogenic development print.

A 1915 advertisement for the Little Galleries of the Photo-Secession at 291 Fifth Avenue. Collection of the authors.

Ubac, Raoul (1910–1985)

Belgian painter and photographer

Ubac's association with photography is linked to his involvement in the **surrealist** movement in Paris in the 1930s and 1940s. He illustrated the works of surrealist poets and on his own experimented with such techniques as solarization, photomontage, burnt negatives, and petrification, a process of sandwiching images so as to give an appearance of dimension to the subject.

Born in Malmedy, Belgium, he wanted to develop his interest in drawing but was opposed by his family. He made a brief visit to Paris in 1928, where he soon became part of an artistic circle of friends. On his return home he read **André Breton**'s *Surrealist Manifesto*, and he was so moved by its philosophy that he returned to Paris. He painted surrealist images, often dreamlike in feeling, that showed the influence of his fellow Belgian René Magritte and Salvador Dali. He met **Man Ray** and, following his lead, turned to photography. In 1933 he visited the island of Hvar, in the Adriatic Sea, and photographed groups of stones similar to his painting images.

He was fascinated by the possiblities of the photographic medium and sought to express his artistic concerns with manipulated images. His photographs were published in the surrealist magazine *Minotaure* and in books with his friends' surrealist writings. After World War II, as interest in surrealism waned, he abandoned photography and concentrated on abstract painting.

Uelsmann, Jerry N. (1934–)

American surrealist photographer and teacher

Uelsmann's surrealistic body of work is distinguished by its complex and poetic multiple-image composition, revealing the extraordinary effects that the process of photography can accommodate. In a review of Uelsmann's 1975 monograph *Silver Meditations*, the critic Hilton Kramer said Uelsmann was abundantly endowed with "technical mastery and . . . flawless confidence in . . . the inspired energies of the imagination."

Born in Detroit, he was encouraged to take pictures by his father. He studied photography under **Minor White** and Ralph Hattersley at the Rochester Institute of Technology (bachelor of fine arts, 1957). His first published photos appeared in *Popular Photography* magazine's 1957 annual edition. Uelsmann earned a master of science degree at Indiana University in 1958 and a master of fine arts degree at the same institution, where he studied with Henry Holmes Smith. He became an instructor in

Jerry N. Uelsmann. *Untitled,* 1987. © Jerry N. Uelsmann. Courtesy of the photographer.

art at the University of Florida, Gainesville, where he has continued teaching as a tenured professor.

Multiple printing became his preferred technique early in his career. He received a **Guggenheim fellowship** in 1967 to further explore the possibilities of combining negatives, and a **National Endowment for the Arts** grant in 1972. His work has been exhibited in one-man and group shows in such venues as the **George Eastman House**, the National Museum of Modern Art in Kyoto, Japan, and the National Gallery of Australia. His work is held by numerous private and public collections, including the Museum of Modern Art, the Art Institute of Chicago, and the Philadelphia Museum of Art. His work has been published in several monographs, including *Uelsmann/Yosemite* (1996), *Photo Synthesis* (1992), and *Process and Perception* (1985).

Ulmann, Doris (1884–1934)

American documentary photographer

Although she was born to a privileged life, Ulmann made an early commitment to documenting the lives of the poor, specifically the blacks of Appalachia, among whom she spent much of her life taking memorable pictures.

Born in New York City, Ulmann studied with **Lewis Hine** at the Ethical Culture School and later met **Margaret Bourke-White**, **Ralph Steiner**, and **Laura Gilpin** while studying with **Clarence White** at Columbia University. In 1918 she became a professional photographer, joining the **Pictorial Photographers of America** and taking portraits of such distinguished figures of her day as Robert Frost, Thornton Wilder, and Sherwood Anderson. Several books resulted from that era, including *A Portrait Gallery of American Editors* (1925).

In 1925, she divorced her first husband, Dr. Charles Jaeger, and began to work in a new direction, photographing back-country rural people in the South. In the late 1920s she started her Appalachian expeditions with her companion, the folksinger John Jacob Niles. Seventy-two of her rural portraits were published in *Roll, Jordan, Roll* (1933), and other pictures were published in *Doris Ullmann: American Portraits* (1985). Late in her life she concentrated on photographing the rural handicrafts movement. That work was collected in *Handicrafts of the Southern Highlands* (1937).

Her photographs are held by private and public collections, including the **George Eastman House**, the University of Oregon Library, and the **Library of Congress**.

Ultang, Donald Theodore (1917–)

American photojournalist and aviator

A staff pilot and photographer for the *Des Moines Register*, Ultang won the 1952 **Pulitzer Prize**, along with his fellow staff photographer **John Robinson**, for their sequence of six pictures of the Drake-Oklahoma A & M football game of October 21, 1951, in which player Johnny Bright's jaw was intentionally broken.

Born in Fort Dodge, Iowa, Ultang earned a bachelor of arts degree in 1939 from the University of Iowa. He joined the *Des Moines Register* in 1946 and was promoted to manager of the news photo department in 1953. He won numerous other awards in the early 1950s, including the **National Press Photographers Association**'s Great Pictures contest in 1954. Since 1979 he has lectured in **photojournalism** at Drake University and continued working as a freelance photographer.

ultraviolet photography: The technique of recording images produced by ultraviolet radiation, which is undetectable to the human eye. Camera lenses and films typically filter out ultraviolet (UV) light, so it is necessary to use a special **filter** (exciter filter) to capture the image. This is a specialized form of photography used mostly for medical and forensic purposes.

umbrella lighting: A **reflector** that is shaped and folds like an umbrella. The surface is either white or silver, and a light is shone into it and reflected back onto the subject. Umbrella lighting gives a smooth overall effect that is flattering to subjects and provides even illumination for small objects and product photography. Mostly used in a **studio** setting.

Doris Ulmann. *Woman Leaning on Picket Fence.* 1920s. From *Roll, Jordon, Roll, Photographs by Doris Ulmann*, Robert O. Ballou Publishers, 1933. Courtesy the Witkin Gallery, New York.

underdevelopment: Underdevelopment occurs when an exposed photographic material is given less than the recommended development time or developed at too low a temperature or with exhausted chemicals. With **film,** if exposed at the suggested **ASA** speed, underdevelopment produces a thin negative that will not yield a good print. However, if the film has been overexposed, purposely or otherwise, underdevelopment may be necessary to prevent an overly dense negative (usually this entails reducing the development time). With prints, underdevelopment will produce a print that does not have a deep black or rich tonal representation. While film under some situations may benefit from underdevelopment, it is not recommended for paper.

underexposure: When a photographic material is given less than the recommended exposure to **light.** For **film** there are certain situations that may call for underexposure, such as a high-contrast light source or film that is too fast for the subject (see **pushing** and **pulling**), but otherwise underexposure produces thin negatives on film and weak images that are too light on photographic paper. With **reversal film** (slide film, transparency film), the image appears too dark. When in doubt, follow the film's recommended **ASA** and your **light meter** reading.

underwater photography: Photography that is made under water using a special watertight camera. Underwater photography was attempted from the 1850s with little success until a French scientist, Louis Boutran, succeeded in 1893. *National Geographic* magazine published the first color underwater still photography in 1927. Professional underwater photography is a highly specialized field. The photographs are taken by divers for scientific, artistic, and editorial uses with equipment that is made for underwater use or with regular equipment in watertight housings. The French oceanographer Jacques Yves Cousteau went on annual expeditions for many years, beginning in 1951, photographing with both still and motion picture cameras. He produced numerous books, including *The Silent World* (1953) and *The Living Sea* (1963), and movies featuring underwater photography.

In the 1997 movie *Titanic*, the spectacular underwater shots of the actual sunken ship were made possible by advances in the technology of undersea photography. The most popular underwater camera used by amateurs is the Minolta Weathermatic, which is a full 35mm instrument. Amateurs can now also take underwater photographs with single-use waterproof cameras available at most camera stores.

The Minolta Weathermatic underwater camera.
© Fred W. McDarrah.

Underwood, Bert (1862–1943)
Underwood, Elmer (1860–1947)
Early American commercial photographers
and agency co-owners
The Underwood brothers were photographers who were partners in founding a business that sold **stereoscopic** slides and equipment in 1882. The business grew into a major stock photo agency, with bureaus in several U.S. cities and abroad.

Born in Oxford, Illinois, Bert was a self-taught photographer. He covered news events worldwide. During World War I he was commissioned as a major and commanded the Signal Corps photographic unit.

Elmer, apprenticed to a printing firm, later established his own shop in Ottawa, Kansas. Also self-taught, he joined his brother in forming the photographic firm of Underwood and Underwood. Elmer was a pioneering advocate of using photos to cover news events, and he was personally active in taking news pictures and celebrity portraits, including those of several U.S. presidents.

U.S. Camera: One of the finest American photography magazines, first published in the fall of 1938. The first issue had contributions by **Edward Steichen, Arnold Genthe, Anton Bruehl, Beaumont Newhall,** and a young **Eliot Porter**.

Ut, Cong Huynh (Nick) (1951–)

Vietnamese photojournalist

In 1972, Nick Ut took one of the most searing and memorable war photos ever—that of a naked young girl and other children running away from their burn-ing, napalmed village near Saigon during the Vietnam War. It won him a **Pulitzer Prize**, as well as honors from the Overseas Press Club, Long Island University's **George Polk Award**, a National Press Club prize, and a World Press Photo Award.

Ut was an amateur photographer who turned pro-fessional after his brother was killed while on assignment for the **Associated Press** in 1965. Ut joined the AP in 1966 and has worked for it ever since. He was wounded three times during the war in Indochina. After the Americans withdrew from

Bert Underwood, Underwood & Underwood.
Steerage Passengers Waiting for Boat to Land, ca. 1910.
Prakapas Gallery, Bronxville, New York.

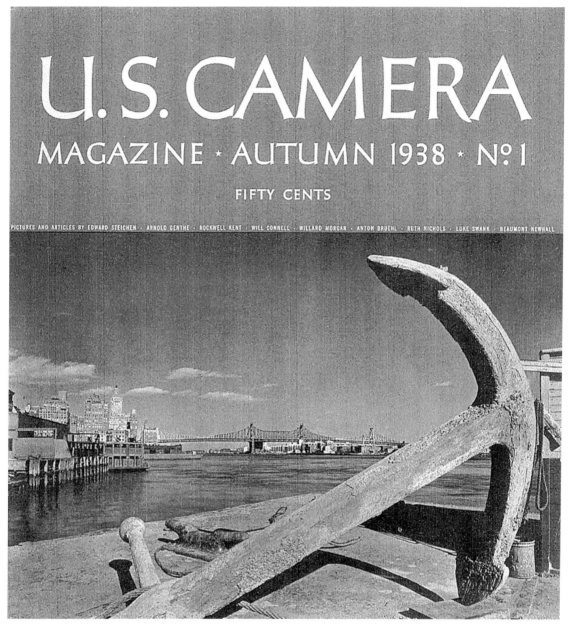

This is the first issue of *U.S. Camera*, the first serious consumer photography publication in the United States. Collection of the authors.

Vietnam, he transferred to Tokyo, where he covered Asia and occasional assignments in Europe.

In 1977 he joined the AP photo staff in Los Angeles, where he covers sports, politics, Hollywood, celebrity trials, earthquakes, and other breaking news.

Uzzle, Burk (1938–)
American photojournalist

Uzzle refers to his images of contemporary life as "visual music celebrating American life." A motorcycle enthusiast, he has photographed, participated in, and enjoyed Daytona, Florida, Bike Week since 1963.

Born in Raleigh, North Carolina, Uzzle began photographing when he was 12 years old and has supported himself in photography since he was a teenager. He worked as a contract photographer for the **Black**

Star agency and for *Life* magazine in the 1960s. He joined **Magnum Photos** in 1967 and has twice served as president of the agency.

Uzzle has been honored with the Page One Award of the Newspaper Guild of New York and has had many major solo exhibits, including shows at the **International Center of Photography**, the Philadelphia Museum of Art, and the Chrysler Museum in Norfolk, Virginia. His photographs are in major private and public collections, including those of the Museum of Modern Art in New York, the Chicago Art Institute, and the Metropolitan Museum of Art.

His work appears in two published collections, *Landscapes* (1973) and *All American* (1984).

Huynh Cong "Nick" Ut. Associated Press Pulitzer Prize 1973. Ut's memorable Spot News award picture shows terrified and screaming children in flight from napalm bombing. Phan Thai Kim Phuc, center, her burning clothes torn off, flees with other children after U.S. planes mistakenly dropped napalm on South Vietnamese troops and civilians. Phan became a symbol of civilian suffering in the Vietnam War. From *Flash! The Associated Press Covers the World*, Introduction by Peter Arnett, Edited by Vincent Albasio, Kelly Smith Tunney, and Chuck Zoeller. © The Associated Press. Courtesy Harry N. Abrams, Inc.

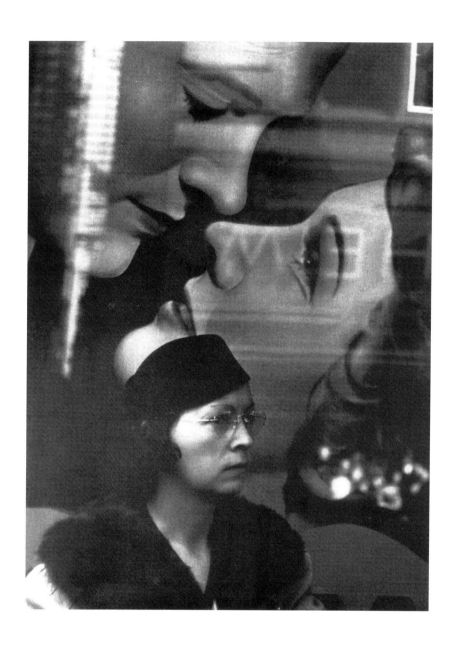

John Vachon. *Girl and Movie Poster, Cincinnati, Ohio.* October 1938.
Library of Congress.

Vachon, John (1904–1975)

American documentary photographer

Vachon was with the Historical Section of the **Farm Security Administration** (FSA) longer than any other photographer, contributing significantly to its documentation of the effects of the Depression with his pictures of the Great Plains as well as those of Illinois, Missouri, Wisconsin, and Minnesota in winter. He spent the remainder of his career at *Look* magazine and also taught a master class in photography.

Born in St. Paul, Minnesota, Vachon was graduated from the College of St. Thomas in 1935. He was an unemployed graduate student at the Catholic University of America in Washington, D.C., when he was hired by **Roy Stryker** as a messenger and clerk for the FSA. He had no interest in photography nor any knowledge of the medium.

Working with the FSA files, cataloguing and writing captions for the photographs, and meeting the photographers made him aware of the possibilities of photography. He approached Stryker and offered to take at his own expense some photographs of scenes not in the file on Washington, D.C. The idea of adding to the file at no expense appealed to Stryker, and soon Vachon was spending time on the streets of the capital. **Ben Shahn** showed him how to use a **Leica**, and later **Walker Evans** helped him use a **view camera.**

In 1937 Vachon began going outside the District, photographing in nearby Maryland, North Carolina, Georgia, and Delaware, all at his own expense. In 1938 the former file clerk, now a junior photographer, was sent to Omaha. From then on he worked as a photographer, staying with the FSA until 1942, and then going on to active military service. He worked for Stryker for another year at Standard Oil before going to *Look* for a 25-year stint, until the magazine closed in 1971.

Vachon won a **Guggenheim fellowship** in 1973–1974 for a study of North Dakota in winter. His work has been published in the many volumes about the FSA years, including *In This Proud Land* (1973) and *A Vision Shared* (1976), and exhibited in shows of FSA work.

Van Der Zee, James Augustus Joseph (1886–1983)

American documentary photographer

Van Der Zee's documentation of life in Harlem at the height of its social and cultural glory is not only of great historic significance but also important in terms of artistic merit and technical skill. For more than 50 years, "the picture taking man," as local children affectionately called him, was virtually unknown outside the African-American community. It was not until a 1969 Metropolitan Museum of Art show, "Harlem on My Mind," mounted when Van Der Zee was 82, that he received the international recognition that his work deserved.

Born in Lenox, Massachusetts, he grew up in a home where art and music were important; his parents had been butler and maid to General Ulysses S. Grant. A self-taught photographer, he began his work in the field as darkroom man for the Gertz Department Store in Newark around 1915. He opened his first studio in 1916 on West 135th Street, then the center of a thriving black community.

For the next six decades, at three different locations, he recorded just about every event in Harlem, as well as every personality. He was the official photographer for Marcus Garvey's back-to-Africa movement and took portraits of everyone, from clients who just walked in off the street to Bill "Mr. Bojangles" Robinson, Jack Johnson, Adam Clayton Powell, Muhammad Ali, Bill Cosby, and Eubie Blake.

In the 1960s Van Der Zee's business as a photographer declined, and he was close to poverty when his

James Van Der Zee. *A Couple Wearing Raccoon Coats with a Cadillac, Taken on West 127th Street, 1932.*
Consolidated Freightways Collection, Palo Alto, California.

work was discovered virtually by accident. In 1968, a consultant to the Metropolitan Museum of Art was walking through Harlem one day and stumbled upon Van Der Zee's G.G.G. Studio. He liked what he saw and arranged to acquire some photographs for the museum's collection. Thanks to his work's inclusion in the "Harlem on My Mind" show at the Metropolitan, his reputation began to grow. Shortly after the successful Met show, the James Van Der Zee Institute, with his collection of 125,000 prints, negatives, plates, and transparencies, was founded and housed in the Metropolitan. The Institute later became part of the Studio Museum in Harlem.

Van Der Zee was also noted for his funeral photographs, a genre that was fashionable in Harlem between the world wars. Many were collected in *The Harlem Book of the Dead* with a foreword by Toni Morrison (1978). Some of his other books include *Harlem on My Mind* (1969), *James Van Der Zee* (1973), and *James Van Der Zee, Photographer, 1886–1983* (1993).

In 1978, President Jimmy Carter bestowed a Living

Legacy Award on Van Der Zee; the photographer received scores of honorary degrees. His life was the subject of a 1975 film, *Uncommon Images*.

Van Der Zee's work has been exhibited at the **National Portrait Gallery** in Washington and is held by major collections including that of the High Museum in Atlanta.

Van Dyke, Willard (1906–1986)
American photographer, filmmaker, and educator
Having started a distinguished career in still photography, Van Dyke turned to documentary filmmaking in the 1930s as a cameraman on *The River* and coproducing with Ralph Steiner the classic *The City* (1939). He was appointed director of the film department of the Museum of Modern Art in New York in 1965 and remained there until 1972. He returned to his first love and produced still photographs and also taught at the State University of New York at Purchase until 1977.

Born in Denver, Colorado, Van Dyke began

photographing in 1928 in San Francisco, using an 8 x 10-inch **view camera**. He became apprentice to **Edward Weston** in 1929 and operated a small photo gallery in his home from 1930 to 1935. He was a founder, along with **Ansel Adams**, Weston, and **Imogen Cunningham**, of the **f/64 group**, which advocated straight photography. He left California for New York in the mid-1930s to begin a career in documentary film.

After World War II he made the official government film on the founding of the United Nations, *San Francisco* (1945). His film *Skyscraper*, made in collaboration with Shirley Clarke, won two prizes at the Venice Film Festival. After leaving SUNY Purchase he moved to Santa Fe, New Mexico, teaching at the University of New Mexico, Albuquerque, and continuing his still photography.

Van Dyke's photographs are held by private and public collections, including those of the Houston Museum of Fine Arts, the **George Eastman House**, and the Museum of Modern Art.

Van Dyke process: An early photography printing process that uses iron and silver salts to produce a brown print (also known as the brown print process), devised in 1889. Named after the Flemish painter Anthony Van Dyke because of the brownish tone of his paintings.

Van Vechten, Carl (1880–1964)

American portrait photographer, music critic, and author
Van Vechten was a respected music critic for the *New York Times* who had published nine volumes of music and literary criticism and more than 200 magazine articles when he turned to photography in 1932 as a champion of African American culture, setting out to compile a great visual record of the major black cultural figures of his time.

Born in Cedar Rapids, Iowa, Van Vechten studied at the University of Chicago. He pursued a career in journalism at the *Chicago American* before moving to the *New York Times*. He quit his job as music critic in 1920 and tried his hand at fiction writing for a decade.

During the Harlem Renaissance period of the 1920s, Van Vechten was a strong supporter of black artists

and began to feel that he had a mission to enlighten white America about the significance and contribution of African American artists. He concentrated on his ambitious project until shortly before his death, recording a host of renowned poets, writers, painters, and performers, including Marian Anderson, James Baldwin, Romare Bearden, Zora Neale Hurston, and Richard Wright.

Van Vechten's work is held by several important public collections, including those of the James Weldon Johnson Memorial Collection of Negro Arts and Letters at Yale University, the George Gershwin Memorial Collection of Music and Musical Literature, and the Florine Stettheimer Memorial Collection of Books about the Fine Arts at Fisk University. His photographs are also held by the Museum of the City of New York, the Museum of Modern Art in New York, and the University of New Mexico. Selections of his photographs have been published in *The Passionate Observer* (1993) and *Generations in Black and White* (1994).

Carl van Vechten. *Portrait of Canada Lee*, ca. 1940. Library of Congress/Corbis.

variable-contrast materials: Photographic printing **paper** that can be adjusted for **contrast** with **filters**. This material allows negatives that require a high-contrast paper and those needing a low-contrast paper to be printed on the same paper with only a filtration adjustment. This is due to the paper's having two **emulsions** that are sensitive to two different colors of light. The filters employed use a mixture of the two colors to gradually adjust from low contrast to high contrast, depending on what is needed. Filters range from 00 or 0 for low contrast to 5 for high contrast, with half-step increments. Prior to this advancement, paper contrast was controlled by different grades of paper, requiring that a larger inventory of paper be kept in the darkroom.

Vathis, Paul (1925–)

American photojournalist

Vathis has had a distinguished five-decade career with the **Associated Press**, including being awarded the 1962 **Pulitzer Prize**.

He served in the Marines in World War II, and joined the AP as a copy boy in Philadelphia in January 1946. A series of promotions put him in the Pennsylvania state capital, Harrisburg, as the bureau's photographer in 1949. He remained there for the rest of his career.

In April 1961, he was part of the press corps contingent covering President John F. Kennedy and his predecessor, former President Dwight Eisenhower, at a Camp David meeting regarding the Bay of Pigs fiasco. After the photo op of the two men smiling for cameras ended, the assembled press retired—all except for Vathis. He followed the two leaders up a narrow slate path through the woods. His shot of the two men walking away, heads bowed in somber discussion, Ike's hands clasped behind his back and holding in them his fedora, won several of that year's news picture prizes. In addition to the Pulitzer, it garnered Vathis Newspaper Guild honors and accolades from the Society of Professional Journalists.

In 1987 he photographed the press conference where the Pennsylvania state treasurer committed suicide by shooting himself in the mouth.

Veder, Sal (1926–)

American photojournalist

Veder won the 1974 **Pulitzer Prize** for feature photography for one of the few uplifting images to come from the era of the Vietnam War and its aftermath.

A veteran **Associated Press** photographer, Veder was on the tarmac at Travis Air Force Base near San Francisco when a plane touched down with two recently released prisoners of war aboard. Veder's shot of Lt. Col. Robert Strim running to meet his smiling family—running toward him, five happy people—reflected the nation's collective feelings of joy and relief that the long, bitterly controversial war had ended.

Veder, born in Berkeley, California, grew up in Martinez and attended Diablo Valley College in Pleasant Hill, California. After working as a fireman, sports writer, reporter-photographer, and copy editor, he joined the Associated Press in 1961 and was assigned to the San Francisco bureau.

Velox: A print made on photographic chloride paper from a **halftone** screen. **Retouching** may be done without marring the original, and the Velox itself can be used for reproduction.

video camera: Video is a system that converts light into an electronic image that can be viewed on a **monitor** or recorded on magnetic film by **scanning**. Television is mostly video that basically uses a record/playback system that is simultaneously transmitted via cable or through the airwaves.

view camera: A large camera that has a front **standard** (for the **lens**) connected to a rear standard (for the **film**) by an extendable **bellows**. The front and rear standards are adjustable for **focus** and can raise, lower, tilt, and swing for various optical effects. View cameras are classified by the maximum size of the **negative** they can produce, such as 4 x 5, 5 x 7, 8 x 10, 11 x 14, and rarely even larger sizes. The large negative size attracts photographers who want a great amount of detail as well as those using processes that require a **contact print** (when the negative is not enlarged but printed full size).

The front and rear standards can be adjusted to perform important optical effects, such as being able to correct for converging lines and perspective in **architectural photography** and extensive depth of field in **tabletop photography**. View cameras are large and bulky and require the use of a **tripod**. They are focused by looking at the image on the ground glass and adjusting the rear standard until the image appears sharp, which requires using a dark cloth draped over the rear standard and the photographer's head.

viewfinder: The camera device that is used to select the area to be photographed and to check the **focus** of the **lens**. The viewfinder has lines indicating a frame to show the photographer the perimeter of the viewing field. The photographer closely examines the edges of the viewfinder's frame to determine the best **composition** of the photograph before exposure. In an SLR (**single lens reflex**) camera, the viewfinder is a reflected scene of what the lens sees and as the lens focuses, the view becomes sharp. In a **rangefinder** camera, a semi-transparent image in the center of the viewfinder aligns when the lens is focused. For the photographer's convenience, most viewfinders have an internal display with the **light meter** readings of **aperture** and **shutter** speed, allowing the photograph to be focused and properly exposed without removing one's eye from the finder.

vignette: A darkening or lightening of an **image** around the edges is a vignette. A **lens** projects an image of a certain size; when that size is exceeded (usually with a **view camera** that can raise and lower the lens), the image falls away and the area where it falls away is black. Vignetting can also occur if a lens hood is too small, producing a circle of darkness around a picture, or it can occur in the darkroom as a device in portraiture. While the image is being printed, the edges can be covered intermittently, leaving a soft, undefined edge that fades away to white.

vintage print: A positive image developed from the original negative by the photographer or under his or her supervision at the time the image is made.

Vishniac, Roman (1897–1990)

Russian-born, American documentary photographer, microbiologist, inventor, and filmmaker

Vishniac was one of the world's foremost photomicrographers. His virtuosity and curiosity took him in many directions—from Jewish life in pre-Nazi Europe to life forms under a microscope—but always in an effort to record knowledge that could contribute to human awareness.

Vishniac was born to a wealthy Jewish family in Pavlovsk, in Czarist Russia. He took his first pictures at age seven, when he fitted the lens of a camera over the eyepiece of a small microscope and took a picture of a cockroach's leg. He studied at Shanyavsky University in Moscow from 1914 to 1920, earning a doctorate in zoology. In 1917 he enrolled in a three-year medical course sponsored by the Russian government amd received a medical degree. In 1918 he moved to Berlin and studied Oriental art at the university there. He was appointed an assistant professor of biology at Shanyavsky in 1920 and moved back home.

In the early 1930s his family emigrated to Berlin from what had become the Soviet Union, where the pressures of mounting anti-Semitism led them to leave what had been their home for generations. In Berlin a Jewish watchdog agency, the Joint Distribution Committee, asked Vishniac to travel back to eastern Europe and to document life in the *shtetls* (small towns). From 1932 to 1940 he traveled extensively through Jewish communities that would soon be destroyed by Hitler. His photographic record of these places and people remain of great interest on many levels half a century later. Because any Jew—especially one with a camera—was suspect, he often posed as a Nazi during his photographic excursions through Poland, Latvia, Lithuania, Hungary, Romania, and Czechoslovakia. Several books of this work have been published, including *Polish Jews: A Pictorial Record* (1942, reprint 1965), *Roman Vishniac* (1974), and *A Vanished World* (1983). After spending three months in a Vichy concentration camp, in 1940 he and his family fled to the United States.

He started working as a portrait photographer, but devoted a lot of time to his personal passion,

microphotography. He won best-in-show three years running (1952, 1953, 1954) at the annual exhibition of the New York chapter of the Biological Photographic Association. His subjects included dead leaves, slime mold, and the 42 blue eyes of the scallop. He won a Kodak Gold Medal at the same time and **American Society of Media Photographers**'s 1956 Memorial Award for "showing mankind the beauty of the world it cannot see."

He started teaching at the Pratt Institute and was appointed a research associate at the Einstein College of Medicine, where he pursued his micro work full time. In 1960 he was made project director for a film series called *Living Beings*. He made 40 educational films. He also produced several segments of a series, "The Vanquished World of Central European Jewry." He later taught at the Rhode Island School of Design and New York University. His professional associations were numerous, including the New York Academy of Sciences, the American Society of Protozoologists, the National Association of Biology Teachers, and the American Society of Limnology and Oceanography.

He was the subject of a film, *The Worlds of Dr. Vishniac*, which covered his research into the physiology of protozoa, employing his own cinematographic techniques. Using what he termed "colorization," Vishniac passed colors through devices that could speed up some wavelengths and slow down others, greatly sharpening detail and color. He insisted on preserving the natural colors of microscopic organisms, emphasizing the third dimension, and photographing only live subjects.

"Everything made by human hands looks terrible under magnification," he said. "But in nature every bit of life is lovely. The more magnification that we use, the more details are brought out, perfectly formed."

Vishniac's work has been widely exhibited, at such venues as the Jewish Museum in New York, the **International Center for Photography**, and the Louvre. His photographs are held by numerous private and public collections including those of the Museum of Modern Art in New York, the **Smithsonian Institution,** and the Victoria and Albert Museum in London.

Visual Studies Workshop: Founded in 1969 in Rochester, New York, this media arts center offers programs to those interested in the study and creation of visual media—illustrated books, films and videos, and photography. In addition to a master of fine arts degree program in conjunction with the State University of New York, the Workshop conducts community education series, sponsors lectures, and holds exhibitions. Its traveling exhibitions are available to colleges, universities, and museums throughout the United States and Canada. Its research center contains 100,000 photographic and photomechanical prints, books and periodicals, and independent films and videotapes, and the library is open to the public. The Visual Studies Workshop publishes *Afterimage*, a bimonthly journal covering the latest developments in the visual arts field, including computer and telecommunications technology, as well as job announcements, calls for work, exhibitions, and screenings.

Voightlander, Peter Friedrich (1812–1878)
Austrian manufacturer and inventor
Voightlander's family's optical equipment business was noted for being among the finest in Europe. His grandfather had founded the company in Vienna in the mid-1750s. Voightlander's father inherited the business and is said to have contributed to its wares with his invention of opera glasses.

Born in Vienna, Voightlander studied at the Polytechnic Institute of Vienna. He assumed control of the family business in 1837. He supervised the creation of the first **lens** used exclusively for a **camera**. It was calculated to be 16 times faster than the lens developed by **Daguerre** and was incorporated into the first all-metal **daguerreotype** camera, which he invented in 1841.

In the 1840s and 1850s the world's most popular cameras were those built by Voightlander. Business was so good that a second factory was opened in his wife's home town in Germany. His work was recognized with

Roman Vishniac. *Cracow, Poland, 1938.*
Courtesy YIVO Institute for Jewish Research.

many honors and awards during his lifetime, including a hereditary peerage from the emperor of Austria.

Von Gloeden, Baron Wilhelm (1856–1931)

German portrait photographer

Much of the life's work of this early homoerotic photographer was destroyed by Mussolini's fascist police. What remains is the work of an artist who did not mask his love for young men and was serious about his photography.

Born in Mecklenberg and a member of the German aristocracy, he originally studied to be a painter. Affluent and well educated, he went to Taormina for health reasons. His career as a photographer began when he took pictures of the landscape and the Greek and Roman ruins of Sicily and sold them as postcard views. He later switched to taking photographs of young male nudes, which he shot almost exclusively from 1889 to the start of the first World War.

His homosexuality was tolerated because he paid royalties to his models, whose images sold by the thousands. When Mussolini came to power, von Gloeden's 3,000 glass plates were at the top of the list of things to destroy. Much of the surviving work, a collection of 400 images that were the basis for his book *Taormina* (1986), was found in the collection of a Catholic priest. Other books with his work include *Photographs of the Classic Male Nude* (1975) and *Les Amours Singulières* (1975).

Vroman, Adam Clark (1856–1916)

Early American documentary photogrpaher

Vroman was an important chronicler of the Native Americans of the Southwest, photographing the Hopis, Navajos, and other tribal people between 1895 and 1904. He also gave his name to the well-known bookstore Glasscock and Vroman, which he founded in Pasadena, California.

Born in LaSalle, Illinois, he worked for the Chicago, Burlington, and Quincy Railroad in Rockford for 17 years. When his wife became ill with tuberculosis they moved to Pasadena in 1892 in an effort to restore her health. A collector of books and Oriental art, he sold his fine books to acquire the capital to establish a bookstore that survives to this day.

As an amateur photographer he was intrigued by the landscape of the Southwest. On a trip to Arizona in 1895, he witnessed a Hopi snake ceremony and began to take portraits of the people. His interest in the Southwest included every facet of the indigenous cultures.

He soon started to lecture and write about the Native Americans' way of life and amassed an important collection of Indian arts and crafts. He respected Indian culture and tradition and was an activist who opposed any attempts to assimilate Native Americans into Western, European culture. He also photographed missions of the Southwest and Yosemite. He later traveled to Canada, Asia, and Europe, but his later photographs lack the artistic and historic value of his Native American work.

The Vroman Gallery at the Los Angeles Museum of Natural History houses much of his life's work and exhibits it regularly. His books include *Dwellers at the Source* (1973) and *Photographer of the Southwest, A. C. Vroman 1856–1916* (1961).

Von Gloeden, Wilhelm. *Boy with Hat*, ca. 1910. Courtesy Galerie Bodo Niemann, Berlin, Germany.

A. C. Vroman. *Residents of a Hopi Village.* 1895. Collection of the authors.

Wagstaff, Sam (1921–1987)

American collector

Wagstaff amassed one of the largest private collections of photography in the world, ranging from the images of the earliest nineteenth-century French photographers to cutting-edge contemporary work. His collection of more than 30,000 images included works by **Lewis Carroll**, **Robert Demachy**, **Roger Fenton**, **Adam Clark Vroman**, **Harold Edgerton**, and **Henri Cartier-Bresson**. In 1984 Wagstaff sold his collection to the Getty Museum in Los Angeles reportedly for a sum of about $5 million. Wagstaff was also a patron and is credited with discovering **Robert Mapplethorpe**'s work and bringing it to an international audience.

Born in New York City, Wagstaff came from a well-to-do family of collectors: His father collected ephemera, and his uncle had a large collection of sports-related books. As a child he collected postcards and photographs he tore out of newspapers and magazines. Wagstaff earned a bachelor of arts degree from Yale University in 1944; after graduation he joined the Navy and took part in the D-Day landing at Omaha Beach during World War II.

After the war he worked for Benton and Bowles, an advertising agency, for ten years. Dissatisfied with advertising, he enrolled in New York University's Institute of Fine Arts, where he took the museum training course. In 1961 he was hired by the Wadsworth Atheneum in Hartford, Connecticut where he was an advocate of minimalist art and also of **Andy Warhol**'s early work.

In 1968 he took a job at the Detroit Institute of Arts, again concentrating on avant garde work. He resigned in 1971 after he championed the controversial installation of an earthwork by Michael Heizer that was criticized by the trustees as injurious to the Institute's lawn. After that Wagstaff devoted himself to acquiring art—the recent death of his stepfather had secured his financial situation.

His meeting with Robert Mapplethorpe in 1972 was the beginning of a 15-year personal and professional association. He was so impressed with Mapplethorpe's photography that he took over the management of his career, becoming his mentor and showing his work to collectors and dealers. With their friendship Mapplethorpe's career was launched, and Wagstaff discovered contemporary photography. He sold off his art collection and became an avid collector.

After selling his collection of photographs, Wagstaff embarked on a new interest—collecting silver—which absorbed him until his final illness.

Waldman, Max (1919–1981)

American portrait photographer

Waldman's black-and-white photographs of theater and dance performances were simply composed, yet dramatic in their ability to emphasize the performers' movement or emotion with clarity and sympathy.

Born in Manhattan to Austrian immigrant parents, Waldman worked for the government-sponsored Civilian Conservation Corps, where he started photographing. He later went to Buffalo State Teachers College and the Albright Art School (1939–1943). In 1944 he returned to New York City and studied sculpting at the Art Students League. He became a successful commercial photographer from 1949 to 1965, specializing in fashion, industrial, and advertising photography. In the latter year he established his 17th Street studio, where he started his quest "to photograph only what I wanted." Among his first subjects were his friends the actors Zero Mostel and Morris Carnovsky, and the mime Marcel Marceau. His first published book of photographs, *Zero by Mostel* appeared in 1965.

With the publication of *Waldman on Theater* (1971),

his reputation was established. He was awarded two Creative Artists Public Service grants (1971 and 1976) and a **National Endowment for the Arts** fellowship in 1972. In 1970 *Life* magazine assigned Waldman to photograph Natalia Makarova, prima ballerina of the Kirov Ballet. The assignment sparked his longtime interest in the dance world. His photographs were widely published in photography and general-interest magazines and in *Waldman on Dance* (1977). His dance photographs were his most successful financially.

He exhibited his photographs in numerous group and one-man shows at such venues as the New York Public Library, the LaJolla Museum of Art, and the Rose Museum of Brandeis University. His work is held by major private and public collections, including those of the Metropolitan Museum of Art, the Museum of Modern Art in New York, and the **George Eastman House**.

Walker, Todd (1917–)

American photographer and teacher

After a successful career as a commercial photographer, Walker has concentrated on making his own photographs and teaching full time at the University of Florida, Gainesville. His work, often with nudes as subject matter, makes use of solarization, photo silkscreen, silver and nonsilver printing methods, and other techniques to achieve the aesthetically rewarding effects he seeks.

Born in Salt Lake City, Utah, Walker studied at the Art Center School in Los Angeles. His work has been published in books and portfolios he assembled, and he has been included in numerous private and public collections, including those of the **George Eastman House**, the Museum of Modern Art, and the **Center for Creative Photography** in Tucson, Arizona.

Wall, Jeff (1946–)

Canadian photographer

Wall's work until 1996 consisted of large Cibachrome transparencies mounted in lightboxes, drawing on themes from art history, advertising, film, and documentary photography. In that year he also began to produce black-and-white non-illuminated photographs. His images range from the dreamlike, showing a single figure in a doorway, to the realistic, picturing a piece of cloth being lifted out of a washing machine.

Born in Vancouver, Canada, Wall has been a photographer since the 1960s. He earned a master of fine arts degree at the University of British Columbia (1970) and did doctoral research at the Courtauld Institute in London. Since 1987 he has been an associate professor in the Department of Fine Arts at the University of British Columbia. Prior to taking that post he taught at the Nova Scotia College of Art and Design in Halifax and the Simon Frazer University's Center for the Arts in Vancouver.

His work has been widely exhibited in group and solo shows at such venues as the Hirshhorn Museum in Washington, D.C., the Los Angeles Museum of Contemporary Art, and the Carnegie Museum of Art in Pittsburgh. Among the private and public collections holding Wall's work are the National Gallery of Canada, Ottawa, the Tate Gallery in London, and the Pompidou Centre in Paris. *Jeff Wall* (1996) is a collection of Wall's photographs that includes an essay by Wall about his work.

Ward, Fred (1935–)

American photographer, writer, and publisher

Ward has photographed the people and events of Washington, D.C., since John F. Kennedy was president.

He earned bachelor of arts (1957) and a master of arts (1959) degrees from the University of Florida and in 1960 started a successful freelance career in the nation's capital. In 1962 he joined the **White House News Photographers Association,** winning their top award in 1966 and 1975.

His work has been seen in *National Geographic* (where his writing and photography appeared for 28 years), *Life, Time, Newsweek, Fortune, Paris Match* and elsewhere. He has done stories and pictures on such topics as Tibet, Cuba, coral reefs, gemstones, and computer graphics. He has taught at the University of Florida and St. Petersburg Junior College and directed films for the National Endowment for the Humanities. His work has been exhibited at the **International Center of**

Photography and his work is in many major collections, from those of the Metropolitan Museum of Art to the **Library of Congress**.

Ward's later work is writing, photographing, and publishing a nine-book gem series as well as continuing to create new images on his own computer system using photographs to make realistic illustrations of things that never existed.

His books include *Rubies and Sapphires* (1992, 1995, 1998), *Diamonds* (1993, 1998), *Emeralds* (1993), *Opals* (1997), *Pearls* (1995, 1998), *Jade* (1996), *Inside Cuba Today* (1978), *The Home Birth Book* (1977), and *Portrait of a President* (1975).

Warhol, Andy (1928–1987)
American artist and filmmaker

Arguably the most famous American artist of the late twentieth century, Warhol is best known for his silkscreened Campbell's soup cans and for his dictum that everyone will be famous for 15 minutes. He personified 1960s American pop culture.

Warhol, who grew up in Pittsburgh and was graduated from Carnegie Tech in 1949, came to New York City with his classmate, artist Philip Pearlstein, to pursue a career in art. He started his professional life as a fashion illustrator and window designer for department stores. Early in his career he blurred the boundary between painting and photography. His 1960 photorealistic paintings were the first in an ongoing series of repetitive image art, with subjects that would range from Chairman Mao to Elvis Presley to Marilyn Monroe to Jackie Kennedy to Elsie the Borden's cow. In 1962 he began to use photo silkscreen, which enabled him to mass produce prints as well as create a more photographic, less painted look. He regularly took numerous **Polaroids** of his private portrait subjects to use as reference, rather than working with live models. His work was done in his Factory, a silver-foil-wallpapered studio that remained the epicenter of hip, creative pop culture for decades.

Warhol made scores of avant garde films, usually without a traditional plot line and some stretching on for 24 hours. He also produced the seminal rock band The Velvet Underground. In 1967 Warhol began publishing an innovative new magazine, its contents consisting entirely of interviews with celebrities. *Interview* featured groundbreaking full page portraits, with inventive hand coloring of many of the photos, particularly the cover picture. *Interview* also introduced a section of "celebrity party pictures," a concept that has spread to many newspapers and magazines, ranging from Bill Cunningham's *New York Times* Sunday society shots to *People*'s "Star Tracks" section.

Later in his life, he'd attend parties and other social events with a point-and-shoot camera in hand, documenting where he'd been and often using the shots as a reference point for his art. In 1970 he bought a video camera and started to video much of his life as well. He also found himself on the other side of the camera. A photo of Warhol could usually be found in the "party pictures" section of any New York newspaper or glossy magazine.

He died unexpectedly in New York Hospital, where he had gone for a routine gall bladder operation.

Many books have been written about Warhol; the definitive volume is David Bourdon's *Warhol* (1989). Warhol himself collected two books of his photos, *Andy Warhol's A Party Book* (1988) and *Andy Warhol's Exposures* (1979). The Andy Warhol Museum opened in his native Pittsburgh shortly after his death. His paintings continue to be internationally exhibited, but his photographs are not as highly prized as his other art.

war photography: Photographs made of war and wartime activities. The earliest known war photographs are from the Mexican War of 1846–1847, by an unknown Mexican photographer. The Crimean War was photographed by the English photographer **Roger Fenton** in 1855, and the American Civil War was well documented by the **Mathew Brady** group and others, including **Timothy O'Sullivan** and **Alexander Gardner**. War photography has produced some of the most horrible and memorable images of our time, such as **Joe Rosenthal**'s photograph of the raising of the flag on Iwo Jima ("Old Glory Goes Up On Mount Suribachi, Iow Jima," 1945) to **Nick Ut**'s photograph of a screaming Vietnamese girl, burned by napalm, running on a dirt

One of the first examples of war photography, the interior of one of the Taku forts in China after a magazine explosion, photographed by Felice Beato, August 21, 1860. Paul Walter Collection, Asia House Gallery, New York.

road ("The Terror of War," 1972). Many war photographers, such as **Robert Capa** and **Larry Burrows,** have died on assignment. The Vietnam War was one about which public opinion was largely shaped by the images of war, and as more atrocious pictures were seen, support for the war waned. The military is keenly aware of the power of photographs to shape public perception, and so images of war are generally tightly controlled to the degree possible. Photographers are always escorted and are generally not allowed to speak to soldiers without a military supervisor present, and generally only photographers affiliated with major newspapers, magazines, and news agencies are permitted into the pool. (See **pool photography**.)

warm tones: Black-and-white images that are slightly reddish, brownish, or yellowish in tone, as opposed to cold-tone images that are more blue or cyan or neutral toned.

washing film and prints: Photographic films and papers undergo a chemical process to produce an **image**. This process leaves behind residual chemicals that must be thoroughly washed away or else the image and supporting material may fade, stain, and deteriorate. Proper washing entails an initial bath of running water for around five minutes followed by a treatment of **hypo clearing agent** (or **Perma Wash**) to help remove residual **fixer**. A final wash in running water from five

Carleton E. Watkins. *El Capitan,* ca. 1866. Library of Congress.

minutes for film and 20 minutes for fiber prints is necessary. **RC prints** can be treated as film.

Watkins, Carleton E. (1829–1916)
Pioneering American landscape photographer

Watkins was one of the great pioneers of American **landscape photography**. His surviving photos are highly prized; much of his life's work was destroyed in the great San Francisco earthquake and fire of 1906.

A native of Oneonta, New York, he headed west for the California Gold Rush of 1849. Instead of striking it rich, he found work at a San Jose photo studio. He started making his own pictures in 1854, taking shots of missions and mines. He also documented the rapid growth of San Francisco. His reputation was established after his first trip to Yosemite to photograph in 1861.

Watkins's photos were used to convince Congress to forever protect Yosemite, and they led to President Abraham Lincoln's landmark 1864 signing of the Yosemite Act. In 1867 he opened his Yosemite Art Gallery and issued his first copyrighted photographs. The shots, taken off 15 x 20 **glass plates** from his Yosemite and other expeditions, were exhibited and won a medal at the Paris Exposition of 1867. His photographs are significant because they were the first to present the wilderness as it was before explorers set foot on the land.

For the next 20 years he traveled widely and carried his equipment using mules and a wagon. He participated in numerous surveys, such as the Geological Survey of California. He also photographed in Oregon and Tombstone, Arizona.

In the late 1890s his eyesight began to deteriorate, and by 1903 he had to abandon photography. Oliver Wendell Holmes described his work as "clear yet soft, vigorous in the foreground, delicately distinct in the distance, in a perfection of art which compares with the finest European work."

After the earthquake he was so distraught over losing his work that he was committed to an insane asylum, where he later died. His books include *Carleton E. Watkins: Photographs 1861–1874* (1989), *Era of Exploration* (1975), and *Photographer of the American West* (1983).

Webb, Alex (1952–)
American photojournalist

A member of the **Magnum Photos** agency since 1976, Webb has achieved recognition for his reportage in the South, documenting smalltown life in black and white. Since 1979 he has also produced a body of color work taken in the Caribbean, Mexico, Latin America, and Africa. He has published two books from this work, *Hot Light / Half-Made Worlds* (1986) and *Under a Grudging Sun* (1989). He spent much of 1993 photographing the Amazon River, from mouth to source.

Born in San Francisco, Webb became interested in photography in high school. In 1974 he earned a bachelor of arts in history and literature at Harvard while also studying at the university's Carpenter Center for the Visual Arts. In 1972 he took part in the Apeiron workshops directed by **Bruce Davidson** and **Charles Harbutt**.

Webb has been honored with an Overseas Press Club award for his photos on the U.S.–Mexican border, a **National Endowment for the Arts** grant, and a **W. Eugene Smith** Supplementary grant. His work has been exhibited in the Whitney Museum, the **International Center of Photography,** and the Walker Art Center. Among the collections holding his work are the Fogg Museum, the Museum of Photographic Arts in San Diego, and the University of Massachussetts.

Webb, Todd (1905–)
American documentary photographer

Webb is known for his documentary photographs made in Paris and New York after World War II.

Webb was a gold prospector, Chrysler auto worker, and banker before making his hobby, photography, his work at age 35. He took a class with **Ansel Adams**, who sent him to see **Dorothy Norman** in 1942. Impressed, she published his work in her magazine, *Twice a Year.* Adams, Norman, and **Alfred Stieglitz** all corresponded with and encouraged Webb when he went off to war.

He started to take pictures of New York, and some were included in the annual "U.S. Camera 1948." From 1949 to 1953 he shot in Paris. In 1954 he had a one-man show at the **George Eastman House** in Rochester.

He used a 1955 **Guggenheim fellowship** to travel America, to see the country that the '49ers had seen 106 years earlier. He stayed out west and has lived there since the 1960s, exhibiting and working.

His books include *Gold Strikes and Ghost Towns* (1961), *The Gold Rush Trail and the Road to Oregon* (1963), *Texas Public Buildings of the 19th Century* (1974), and *Texas Homes of the 19th Century* (1966).

Weber, Bruce (1946–)

American fashion photographer and filmmaker

Weber is an inventive fashion and advertising photographer. In the 1980s his creative campaigns for such clients as Calvin Klein, Ralph Lauren, and Banana Republic and his editorial work for *Vogue*, *Details*, *GQ*, and other style-oriented magazines set a new standard for the industry.

His work first appeared in magazines in the 1970s, and since then his individual photos and photo essays have been widely published. In his advertising work, Weber's photographs are frequently made on-location—that is, not in a studio but in a naturalistic setting.

A 1998 book, *Branded Youth and Other Stories*, came out in conjunction with a show of Weber's photographs at London's National Portrait Gallery. A selection of his photographs, *Bruce Weber*, appeared in 1989. He has made several films, one of which, *Let's Get Lost*, was nominated for an Academy Award.

Wedgwood, Thomas (1771–1805)

English inventor

Wedgwood is acknowledged as a pioneering photographer—the first person to make images produced by the direct action of light on paper (or leather) moistened with **silver nitrate** solution.

Born in Stoke-on-Trent, he was the son of the famous potter Josiah Wedgwood and the uncle of Charles Darwin. Wedgwood attended Edinburgh University and spent much time with the Lunar Society, a group of scholars and engineers that met at his father's home. Starting in 1790 he experimented with thermometers and light, heat, and silver nitrate, then colored glass and a microscope.

In 1802 he and Sir Humphrey Davy published

"Account of a method of copying paintings upon glass and of making profiles by the agency of light upon nitrate of silver." The process was similar to what is commonly known as a **photogram**. Unfortunately, Wedgwood was never able to fix his images permanently—they were visible only for a few minutes by candlelight before they faded away. He kept them in a dark closet to lengthen their lifespan and did not expose them to daylight.

Tom Wedgwood, the First Photographer, An Account of His Life, His Discovery and His Friendship with Samuel Taylor Coleridge by R. B. Litchfield (1973, originally published in 1903) is an authoritative account of Wedgwood's life and work.

Weegee (Arthur H. Fellig) (1899–1968)

Austrian-born, American photographer known for his sensational photographs of murders and street life.

He stamped the back of his photographs "Weegee the Famous," and both his pictures and his personality deserved the sobriquet by the time he was 50. He became famous for his hardcore news shots, gritty black-and-white images of violence and brutality on the streets of nighttime New York City; but he also found humor, dignity, and courage in the city streets, as evidenced in his photographs of New Year's Eve at Sammy's Bowery Follies in 1944 or a 1939 study of a black mother with a baby in her arms looking through the broken glass of a window.

Born Usher (later Arthur) H. Fellig in Zloczew, Austria (now Poland), he emigrated with his family to New York in 1910. He attended a public school for three years, leaving at the age of 14 to help support his family. He worked as a **street photographer** and assistant to a commercial photographer, and he took portraits of children astride a pony he had rented.

At the age of 18 he left home and lived in a shelter, doing odd jobs until he was hired to take passport photographs. In 1924 he took a job as a darkroom technician with Acme Newspictures (later United Press International). From time to time he filled in as a backup photographer for breaking news stories, particularly at night. To make extra income he learned to play the violin and

worked intermittently as an accompanist at a silent-movie house.

While at Acme he developed the style and competitive edge that got him to the scene of a crime, fire, or accident before any other photographer. He was known to develop his negatives in his car, and then race to get the photos on the newswires to beat any rivals for a scoop. By 1935 Weegee had sold enough pictures freelance to leave Acme and work alone, out of police headquarters. On his private radio he would monitor police calls, going out to photograph violent crimes, traffic accidents, and fires that found a ready market in the tabloids. He went out with his 4 x 5 inch **Speed Graphic camera** and **flash-bulbs** wherever news was being made. He had official sanction for a police radio in his car, and during the ten years he worked out of police headquarters he claimed to have covered some 5,000 murders.

In recognition of his almost uncanny ability to be first at the scene of a crime, he took the name of Weegee for his credit line—a phonetic rendering of the Ouija board that supposedly foretells the future. In 1940 he signed a contract with the newspaper *PM*. After his first book, *Naked City*, was published in 1945, he was hired by *Vogue*. His second book, *Weegee's People*, was published in 1946. *Naked City* was bought by Hollywood and also inspired a television series. Weegee moved to California in 1947 to act as a consultant for the film. He stayed for seven years, working as a bit player in movies and gathering material for *Naked Hollywood* (1953).

After his return to New York he had become a celebrity, and he worked on various projects and traveled extensively. He never went back to photographing the grisly crime scenes where he first made his mark. His autobiography, *Weegee by Weegee* (1975), recounts his life story, from penniless immigrant to nationally prominent photographer.

Weegee's World, by Miles Barth, was published in conjunction with a major retrospective of his work at the **International Center of Photography** Midtown in 1997. His work has also been shown at such venues as the San Francisco Museum of Modern Art and the Museum of Modern Art in New York. He made several films himself, notably *Weegee's New York* (1948) and *Fun City* (1967).

Weems, Carrie Mae (1953–)
American photographer and artist

In Weems's body of work she has produced art that addresses formal and political issues central to African American culture and concentrates on the ways in which images shape the perception of color, gender, and class. Taking documentary imagery, she has used elements of social and folk history to make photographic installations. In 1998 she exhibited "Who What When Where," at the Whitney Museum of Art. Incorporating neon signs, sculptures built of metal and wood, banners based on her own paintings, and digitally printed photographs and text, the installation refers to the history of art and explores the role of the artist as social activist.

Born in Portland, Oregon, Weems earned a bachelor of arts degree from the California Institute of the Arts in Valencia (1981) and a master of fine arts degree from the University of California at San Diego (1984). She also has a master of arts in folklore from the University of California, Berkeley. As a folklorist, photographer, and poet she has produced a series exploring the Gullah culture of Georgia's Sea Islands.

Her photographic installations have been exhibited in numerous one-person shows at such venues as the Museum of Modern Art in New York, the J. Paul Getty Museum, and the National Museum of Women in the Arts. She has been honored with a **National Endowment for the Arts** fellowship, 1994 Photographer of the Year Award of the **Friends of Photography,** San Francisco, and a Louis Comfort Tiffany award. Her book, *Then What?* was published in 1990.

Wegman, William (1942–)
American photographer known for his humorous
photographs of dogs.

Wegman brings wit and humor, technical finesse, and a surrealistic irony to his well-known pictures of dogs. Beginning in 1970 with his weimaraner Man Ray, he has produced an engaging body of work featuring dogs in various outfits from fur coats to dresses and in such humanistic poses as lying in bed and watching television. In 1998 Wegman exhibited new, large-scale

William Wegman. *Gait,* 1998. © William Wegman; Courtesy PaceWildensteinMacGill, New York

multipanel photographs of dogs standing and lying down.

Born in Holyoke, Massachusetts, Wegman earned a bachelor of fine arts degree from the Massachusetts College of Art (1965) and a master of fine arts degree at the University of Illinois–Champaign (1967). He has exhibited in solo and group exhibitions at such venues as the Museum of Modern Art, the Art Institute of Chicago, and the Victoria and Albert Museum in London.

Among the numerous private and public collections holding his work are the Brooklyn Museum, the Chrysler Museum, and the Los Angeles County Museum of Art. Wegman's work has been honored with two **Guggenheim** awards (1975 and 1986) and two **National Endowment for the Arts** grants (1976 and 1982). He has published several books of his work, including a bestselling children's picture book, *William Wegman Puppies*.

Weiner, Dan (1919–1959)

American photojournalist

When Dan Weiner died in an airplane crash at the age of 39, he left behind a body of work that included New York City scenes, the emergence of Martin Luther King Jr. in the Birmingham bus boycott, the lives of black people in South Africa, and photographs from his travels to Russia, Romania, Italy, and Nova Scotia. He was a dedicated photojournalist committed to portraying with honesty and compassion the lives of his subjects. In 1967 the book *The Concerned Photographer* and accompanying exhibition with work by Weiner and five other photojournalists were produced by the International Fund for Concerned Photographers, which would evolve into the **International Center of Photography**.

Born in New York City, he acquired his first camera, a Voigtlander, in 1934. His ambition was to be a painter, and despite his father's objections he attended the Art Students League and Pratt Institute. He joined the **Photo League** while at Pratt and was influenced by the work of the **Farm Security Administration** photographers and **Lewis Hine**. He worked as an assistant to a commercial photographer from 1940 to 1942, when he joined the Air Force as a photographer and instructor.

He opened his own commercial studio after the war but by 1949 gave up commercial work and devoted himself to photojournalism. He traveled to South Africa with the writer Alan Paton, and they published *South Africa in Transition* in 1956. Weiner covered the Montgomery bus boycott for *Collier's* magazine. He traveled to Russia and eastern Europe, and much of his work was published in *Fortune* magazine.

Wells, Annie (1955–)

American photojournalist

Wells won the 1997 **Pulitzer Prize** for her dramatic photo of a fireman rescuing a teenager from raging floodwaters.

A University of California at Santa Cruz graduate, she earned a bachelor of arts in science writing. She studied photojournalism at San Francisco State. She began her career at the *Herald Journal* in Logan, Utah, before going to the *Greely Tribune* in Colorado. She then worked for the **Associated Press** in San Francisco and joined the *Santa Rosa Press Democrat* in 1989.

Her assignments have included the 1989 Bay Area earthquake, national elections in Mexico, and the 1996 World Cup. Her work is included in the National Museum for Women in the Arts in Washington, D.C.

Weston, Brett (1911–1993)

American art photographer

Brett Weston, the second of **Edward Weston**'s four sons, was a well-regarded photographer in his own right, as well as a master printer.

He first took a picture when his father handed him a camera in Mexico, where they traveled with **Tina Modotti**, when he was 14. He became internationally famous at age 18 when he was included in a Stuttgart show, "Film und Photo," where his work hung alongside photos by **Man Ray**, **Edward Steichen**, **Berenice Abbott**, and his father. His black-and-white nature studies of plants and rocks, noted for their precision and exquisite texture, established his reputation. His work always found a market and he rarely, if ever, took on commercial assignments.

Born in Los Angeles, Weston worked as a sculptor and photographer for the Works Progress Administration

and then as a cameraman for war films being made by 20th Century–Fox. After World War Two, during which he served in New York with the Signal Corps, he devoted himself to photography full time.

In 1948 he moved to his father's home and cared for him for the next decade until Edward died. During that time he was responsible for printing his father's negatives, and it was in that capacity that he established his technical reputation. In the 1960s he traveled extensively in Europe and Mexico.

Since 1932 he has had more than 100 exhibitions of his work at such venues as the M. H. de Young Museum in San Francisco, the **Center for Creative Photography** in Tucson, and the **George Eastman House** in Rochester. In 1947 he was awarded a **Guggenheim fellowship** and in 1973 a grant from the National Endowment for the Humanities to photograph Alaska. Among his books are an Aperture monograph, *Brett Weston: The Photographs from Five Decades* (1980) and *Voyage of the Eye* (1975).

In 1992 Weston destroyed all but 12 of his negatives, saying that he alone could print them the way he intended, and he didn't plan to leave them for someone else to print after his death.

Weston, Cole (1919–)

American landscape photographer

Cole Weston was the longtime assistant to his father, **Edward Weston**, and the executor of his estate. He worked for *Life* magazine as a photographer and is known for his large-format color landscapes. He is also the brother of **Brett Weston**.

Born in Los Angeles, Weston majored in theater arts at the Cornish School in Seattle and began his photographic career in the Navy. After World War II, he started shooting for *Life* until his father asked him to work with him in 1946. He went to Carmel, California, and worked there with his father until Edward's death in 1958. He now runs the Weston Gallery there, in addition to pursuing his own career as a photographer..

His work has been published in *Not Man Apart* (1966) and *The Sea Around Us* (1954). His work is held by such collections as the Fogg Art Museum at Harvard

University and the Philadelphia Museum of Art.

Weston, Edward (1886–1958)

Acclaimed American photographer noted for his images of nature and the human form

Weston is one of the greatest artists of the twentieth century. His medium happened to be photography. His carefully composed, carefully printed images of natural objects and the human body have influenced photographers until the present day. His artistic photos have become the standards by which later photographic practice has been judged.

At age 20, Weston left his job as a Marshall Field's errand boy in his native Chicago for California, where he spent two years as a door-to-door portrait salesman. His father had given him his first camera, a Bulls Eye #2, when he was 16. He then returned home to study at the Illinois College of Photography. In 1911 he returned to California and opened a studio in Glendale. He ran that studio until 1922. It was successful, as was he for his soft-focus **pictorial** style work. He won numerous awards in the 1910s, but changed his style completely in the 1920s to become a leading advocate of **straight photography**.

In 1922 he traveled to New York, where he first met **Paul Strand**, **Charles Sheeler**, and **Alfred Stieglitz**. His photographs of the ARMCO steelworks were turning points. The straight, industrial images would have a deep effect on him.

From 1923 to 1926 he and **Tina Modotti** lived and worked in Mexico. (His son Brett spent some time with them and was introduced to photography there. Another son, Cole, is also a photographer.) Modotti, his apprentice and lover, was a model for many of his nudes. He met and worked with some of the famous muralists of the day there, such as Diego Rivera, José Orozco, and David Siqueiros. He returned to California and started work on what he is best known for: natural-form close-ups, nudes, and landscapes.

In 1929 he opened a studio near Carmel, where he would remain for the rest of his life. In 1932 Weston was a founding member of the **f/64 group** of purist photographers with **Ansel Adams** and others. His first major

book, *The Art of Edward Weston*, was published that same year. The next year he shot for the Works Progress Administration in California and New Mexico.

The first **Guggenheim fellowship** to a photographer went to Weston in 1937, and it was renewed for 1938. He in part used it to take pictures that were used in an edition of Walt Whitman's *Leaves of Grass*. The grants also resulted in the 1940 book *California and The West*. In 1946 a major 300-print retrospective was held at the Museum of Modern Art. At this point Parkinson's disease was settling in and would hamper him for the next 12 years, essentially ending his ability to work. He spent his last decade at home, with his sons Cole and Brett tending to his affairs.

Always working in large formats, he strove to achieve the greatest possible **depth of field** and resolution of detail. He made only **contact prints,** chiefly silver and platinum, although in his later years he did some color work.

Weston was the subject of the 1948 motion picture *The Photographer*, directed by his friend **Willard Van Dyke**. He was also represented in the films *The Naked Eye* (1957) and *The Daybooks of Edward Weston* (1965). Thousands of museums and galleries have exhibited his work, and it is among the most prized for collectors. Among his major books are the large-format 1973 Aperture monograph *Edward Weston Fifty Years*, Abrams' 1995 *Forms of Passion, Edward Weston Omnibus* (1986), and **Beaumont Newhall**'s *Supreme Instant: The Photography of Edward Weston* (1981).

Talking about his fame and influence, he said in 1931, "My work has a vitality because I have helped, done my part in revealing to others the living world around them, showing to them what their own unseeing eyes have missed."

wet plate process: Discovered by **Frederick Scott Archer,** who made the first **collodion** negatives in the autumn of 1848 and introduced his invention in March 1851. The process became so popular that it virtually replaced the **daguerreotype** and **calotype** and was almost exclusively used by photographers for over 30 years. In the wet plate process, a **glass plate** replaced

paper as the support base for a light-sensitive **emulsion**. A solution of collodion and potassium iodide was poured onto the glass plate and allowed to flow evenly over the surface. When it became tacky, as the ether solution evaporated, the plate was dipped in a solution of silver nitrate. The wet plate was then placed in the camera for exposure of from one to 60 seconds, and the resulting still-wet negative developed with pyrogallic **acid** and fixed with hyposulfite of soda. After the negative was dried, it was coated with a layer of varnish to preserve the fragile plate. The process was both cumbersome and delicate, but the results were valued for their extremely fine grain, and clear whites.

Wet plate studio camera used in Mathew Brady's studio in the early 1860s. This camera is believed to have been used by Brady to photograph President Lincoln.

Whipple, John A. (1822–1891)
American inventor and photographer

Experimenting with the possibilities of the medium since the earliest days of the **daguerreotype** process, Whipple explored the use of glass negatives, artificial light, crystallotype prints, and microphotography. With his partner, James Wallace Black (1825–1896), he worked to improve the quality and longevity of their photographic work in portraiture. Whipple was also interested in **celestial photography** and took daguerreotypes of the moon and, using glass negatives, pictures of stars.

Born in Grafton, Massachusetts, Whipple was

immediately interested upon reading of **Daguerre**'s process. He made his own chemicals and was employed from 1840 to 1844 by a chemical manufacturing company, but he was forced to leave when the fumes affected his lungs. He opened his own studio and in 1852 took on Black as apprentice. By 1856 Black had become a partner, and, working together they developed the crystallotype, a process for making paper prints from glass negatives.

Between 1857 and 1860 Black stayed at the studio while Whipple worked at the Harvard College Observatory photographing celestial bodies. One of his most spectacular celestial prints was his picture of a solar eclipse. From 1860 to 1874 Whipple operated his photography gallery on his own. Among his notable achievements were his nighttime photos of Boston Common. He abandoned photography after 1874 to publish religious works.

White, Clarence H. (1871–1925)

American impressionist photographer

A founding member of the **Photo-Secession** group, which centered on the **Pictorialist** movement and **Alfred Stieglitz**'s **291 Gallery**, White produced a body of work that was poetic and romantic, soft in focus and usually metaphorical or subjective rather than descriptive. His career as an active photographer was relatively short, as his considerable talent and energy were directed to teaching from 1907 until his death. A highly influential teacher, he founded the Clarence White School of Photography, and his students included **Laura Gilpin**, **Dorothea Lange**, **Paul Outerbridge**, **Ralph Steiner**, and **Doris Ulmann**.

Born in West Carlisle, Ohio, he spent 16 years as head bookkeeper in a wholesale grocery firm, and at the same time his photography gained recognition. A self-taught amateur photographer whose first exposure to the artistic possibilities of the medium was at the Chicago Exposition of 1893, he joined the Newark, Ohio, camera club and had his first exhibition in 1898. He met **F. Holland Day** and Stieglitz at the Philadelphia Exposition and in 1899 his work was shown at **The Linked Ring** exhibit in London.

He was invited to join that exclusive group the next year.

In 1902 he helped Stieglitz establish the Photo-Secession movement, using aesthetic principles adapted from the painter James Whistler, symbolist literature, and Japanese art. His work was represented in *Camera Work* in 1905. In 1907 he began teaching photography at Columbia University in New York and did little of his own photography after that. Although Stieglitz eventually turned away from Pictorialism and advocated straight photography, White remained an advocate of the former.

White had spent some time in Maine visiting F. Holland Day, and he bought a house there in 1910. With his friends, Day, **Gertrude Kasebier**, and Max Weber, he founded a summer school. Encouraged by the school's success, he opened his school in New York in 1914. White died suddenly on a trip to Mexico; his school was kept open by Mrs. White until 1943.

White, Minor (1908–1976)

American art photographer and teacher

A great thinker and teacher as well as an extraordinarily gifted photographer, Minor White was a universally admired figure. A founder of *Aperture* magazine, as well as friend and mentor to many in the photography community, White used the medium of photography to express his "inner landscape."

Born in 1908 in Minneapolis, he studied botany at the University of Minnesota. He dropped out before graduation but later went to night school and earned a degree in 1933. He moved to Oregon in 1937, and his early interest in photography became more serious. He worked as a photographer for the Works Progress Administration in 1938–1939 and then taught at the WPA Center in Portland. His work was included in a 1941 exhibit at the Museum of Modern Art in New York.

He served in the Army during World War II. After the war he moved to New York City, where he became friends with a circle that included **Alfred Stieglitz**, **Edward Steichen**, and **Nancy and Beaumont Newhall**, who encouraged him to study art history and aesthetics under Meyer Schapiro at Columbia University. He joined the faculty of the California School of Fine Arts, headed by **Ansel Adams**, in San Francisco in

Clarence H. White. *Miss Grace*, ca. 1898. Collection of the authors.

Minor White. *Door and Star, San Juan, Puerto Rico.* 1973. Collection of the authors.

1946. He became friends with Adams, who urged him to use natural light for his pictures, and **Edward Weston**, who advocated he find strong, stark subjects.

He returned to New York in 1952 and began taking photo stills of plays, an activity he continued for many years. He became a cofounder of *Aperture* and began a long-term association with the magazine as an editor. He was hired by the **George Eastman House**, where he was curator of exhibitions, in Rochester; he worked there from 1953 to 1956 and also taught at the Rochester Institute of Technology.

In the late 1950s and 1960s he traveled extensively in the United States, and he began to take color pictures. In 1962 he was a founding member of the **Society for Photographic Education**. He taught at many workshops and joined the faculty of the Massachusetts Institute of Technology in 1965.

White's work is held by numerous private and public collections, including those of the Art Institute of Chicago, the George Eastman House, and the Museum of Modern Art in New York. Among the books featuring his work are *Rites and Passages* (1978), which includes excerpts from his diaries and letters, and *Mirrors Messages Manifestations* (1969), which offers his signature "sequences" of verbal and pictorial insignes of experience—amputations, equivalence, song without words, sound of one hand clapping, and so on.

White House News Photographers Association: Founded in 1921 and having 500 members, it is for professional news photographers who cover the White House, government agencies, and Congress for wire services, newspapers, television, and magazines. This group sponsors an annual seminar for high school students who are interested in photojournalism.

wide-angle photography: Photography using a **lens** with a wide viewing angle. On a 35mm camera, a 50mm lens is "normal," and those under 50mm are wide angle. Wide-angle photography enables a large scene to be captured while the photographer remains relatively close to the subject. Objects are reduced in size to accomplish this. Wide-angle lenses have greater depth of field than normal and telephoto lenses. As the angle of viewing widens, the possibility of distortion, particularly around the edges, increases. The widest lenses are called **"fish-eye lenses"** because of the extremely distorted, circular image effect, which resembles a fish eye.

Williams, Clarence (1967–)
American photojournalist

Williams, a *Los Angeles Times* staff photographer, won the 1998 **Pulitzer Prize** for feature photography for his image of an adult apparently screaming at a boy with his hands over his ears, with their heads turned away from the camera. The photo accompanied the newspaper's "Orphans of Addiction" series. Working with a staff writer, Sonia Nazario, he found subjects by staking out alcohol and drug outreach programs in Long Beach, California, and asking parents for permission to document how their addictions affect their children. The project took five months.

Born in Philadelphia, Pennsylvania, Williams attended Temple University, where he majored in mass communications. He began his career as a photojournalist as an intern at the *Philadelphia Tribune* (1991–1993) and the *York Daily Record* (summer 1993). He worked in Fairfax County, Virginia, for Times Community Newspapers (1993–1994) before moving to the *Los Angleles Times*, where he became a staff photographer in 1996.

In 1998 Williams also received the Pulitzer Prize for feature photography, the Chairman's Award as Times Mirror Journalist of the Year, the Harry Chapin Media Award, the National Association of Black Journalists' Journalist of the Year Award, and the Robert F. Kennedy Award for domestic photojournalism. Among his numerous other awards, he was honored by the **National Press Photographers Association** in 1996 with first place in the 1996 Pictures of the Year category.

Willoughby, Bob (c. 1927–)
American portrait photographer

Willoughby's body of work includes images of the movie industry, including film stills, the world of jazz in the United States and abroad, and picture stories of the lives of people in his native California.

Pages 536 – 537: The New York Yankees seen here photographed with a 16-mm wide angle lens. The Nikkor lens is particularly sharp from end to end. © Fred W. McDarrah.

Born in Hollywood, California, Willoughby was naturally drawn to working in movies. From 1953 to 1971 he was one of the first photographers hired by a studio to work on the set during filming. A radical departure from the glamorous portraits of the past, Willoughby's work captures the real challenges of acting and filmmaking.

His photographs have been published in *The Platinum Years* (1974), *Voices from Ancient Ireland* (1981), and *Jazz in LA* (1990).

Winogrand, Garry (1928–1984)

American art photographer

In his deceptively simple, seemingly spontaneous black-and-white views of normal American lives, Winogrand used his wit and intuitive intelligence to convey his personal voice—by turns comic, harsh, ironic, exuberant, and sometimes even cruel. His work, like that of a great novelist, reveals the human comedy, with all the complexity, narrative interest, and eloquence that are the hallmark of any good story.

Born in New York, he served in the Air Force in 1946 and 1947. With the support of the G.I. Bill of Rights he studied painting at City College and painting and photography at Columbia College, where the camera club gave him 24-hour access to a darkroom. He attended **Alexey Brodovitch**'s classes in photojournalism at The New School in 1951 and worked as a freelance photojournalist and advertising photographer for the next 17 years, publishing regularly in major magazines.

He began to exhibit his work in the early 1960s, a time of great importance in his development as a photographer. In an article by Ted Papageorge in the *New York Times Sunday Magazine*, October 16, 1977, Winogrand said he began to understand how a simple, common gesture, such as a frown or a handshake, could describe a relationship or give new meaning to a scene. He also mentioned the spiritual effect of the Cuban missile crisis of 1962, a time of great public anxiety, when his individual powerlessness became a liberating factor in his life and work.

Clarence Williams. *Kevin Bryan, 8, covers his ears and turns away as his father's girlfriend, Rita Green, screams at him in their Long Beach apartment, a hangout for numerous drug addicts.* Pulitzer Prize for feature photography, 1998. Courtesy *Los Angeles Times*.

Winogrand had his first major show at the Museum of Modern Art in 1963. He taught at several schools, including Cooper Union and the University of Texas at Austin. His first book, *Animals* (1969), was a series of photographs taken in New York zoos and the aquarium. Other books with his work are *Stock Photographs: Fort Worth Fat Stock Show and Rodeo* (1980), *Women Are Beautiful* (1975), and *Public Relations* (1977). The last of these was published in conjunction with a show of the same name at the Museum of Modern Art in 1977. He was awarded three **Guggenheim fellowships** and a **National Endowment for the Arts** grant.

He exhibited widely in solo and group exhibitions, and his work is held by such collections as those of the Seagram Collection, The **George Eastman House**, and the Art Institute of Chicago. The **Center for Creative Photography** in Tucson holds a major archive of Winogrand's negatives, contact sheets, and work prints.

Garry Winogrand. *Untitled.* 1967. © Estate of Garry Winogrand

Wirephoto: A trademark system for electronically transmitting a photograph through the telephone, established by the **Associated Press** in 1934. The photograph transmitted is also called a Wirephoto. Other wire service news agencies such as Reuters, Agence France Press, and United Press International have a similar system for transmitting photographs. These systems have now been replaced by laser systems and digital transmission.

wire service: A news service with photographers and reporters around the world who send their stories in via telephone transmission. The wire service then edits and relays this information to newspapers and other media outlets.

Wise, Kelly (1932–)
American photographer and teacher

Wise is a noted writer on photography and was the longtime photo critic for the *Boston Globe*.

He earned a bachelor of arts degree in creative writing from Purdue University in 1955 and a master of arts degree in contemporary literature from Columbia University in 1959. He then started working as a freelance photographer. From 1960 to 1966 he taught at a private high school. In 1966 he started teaching English at the Phillips Academy in Andover, Massachusetts; he has also served as a department head there and residential dean.

He was a consultant to the Polaroid Corporation from 1970 to 1974 and again from 1985 to 1987. From 1982 to 1993 he was at the *Globe*, and from 1985 to 1987 he was a featured contributor and art commentator on National Public Radio.

Wise's books include 1975's *Lotte Jacobi* and *Still Points*. Wise also edited *The Photographers' Choice*, a compilation of portfolios and critical opinion. His personal work has been exhibited at such venues as the Fogg Art Museum, the Addison Gallery of American Art in Andover, Massachusetts, and the Kresge Art Museum at the University of Michigan. His photographs are held by such collections as those of the **George Eastman House** in Rochester, the Bibliothèque Nationale in

Paris, and Boston's Museum of Fine Arts.

Witkin, Joel-Peter (1939–)

American art photographer

Witkin has produced an unconventional body of work that forms a gallery of the macabre and bizarre. He has photographed people with deformities or missing limbs, heads without bodies and bodies without heads, hermaphrodites, dwarves, pinheads, and other human curiosities.

The Brooklyn native took his first pictures at the Coney Island freak show. After high school, he held a succession of jobs in color labs and photo studios. After three years in the Army, he enrolled at Cooper Union, graduating with a bachelor of fine arts degree in sculpture in 1975. He has a master of arts degree in photography (1977) from the University of New Mexico at Albuquerque, where he studied with **Van Deren Coke** and **Beaumont Newhall**. His early series "Images of Women" was an unsettling look into Witkin's ideas regarding fantasies of sexual perversions and voyeurism.

Until 1983 he worked as a maitre d' in an Italian restaurant to support his photography. After appearing in several group shows, he made his New York debut, at the Pace/MacGill Gallery in 1984 and was a sellout; Charles Saatchi, the advertising mogul and bellwether collector of contemporary art, bought every piece. Witkin's career has been on a parabolic curve upward ever since.

Witkin, who is a very skilled black-and-white printer, has caused numerous controversies with his subject matter (Pat Robertson has called him a "Satanist"), but he has also been awarded four **National Endowment for the Arts** grants and his work is highly prized by collectors. His books include *Joel-Peter Witkin: 40 Photographs* (1986) and *Infinity* (1968).

His work has been exhibited at the Whitney Museum, the San Francisco Museum of Modern Art, and the Museum of Modern Art in New York and is held by numerous private and public collections.

"Either I am a psychopath with a keen aesthetic sense or I'm perfectly healthy," he said in an interview by Richard B. Woodward in the April 1993 *Vanity Fair* magazine. "Whichever, I know that I can't help myself. This is what I was born to do."

Witkin, Lee D. (1935–1984)

American gallery owner and writer

The first New York dealer to achieve success selling photographs, Witkin played an important role in the evolution of the photographic print as a collectible artwork. He exhibited such modern masters as **Ansel Adams**, **Margaret Bourke-White**, **Brassai**, **Imogen Cunningham**, **Jacques-Henri Lartigue**, **W. Eugene Smith**, **Edward Steichen**, and **Edward Weston** and also brought to public attention the work of younger photographers.

Born in East Orange, New Jersey, Witkin was graduated from New York University. He worked as a magazine writer, photographer, and editor for a construction magazine before opening his first gallery in 1969. By 1971 he had begun to attract the attention of collectors and critics and was able to move to larger quarters. In that same year he and Daniel Berley began publishing limited-edition portfolios by photographers shown in the gallery.

Witkin wrote numerous articles, contributed to several books and with co-author Barbara London published the landmark reference work *The Photograph Collectors Guide* (1979). Witkin was a consultant to private collectors and major museums and organized several touring exhibits. He also was a popular lecturer at cultural institutions in the United States and Europe.

At his death, ownership of the gallery he founded was bequeathed to his longtime (since 1976) assistant, **Evelyne Daitz**. The Witkin Gallery became one of the most respected in the world, and it remains an important presence in the international photographic community.

Wittick, George Benjamin (Ben) (1845–1903)

Early American documentary photographer

Wittick was a pioneering chronicler of Native American life, one of the few white men permitted to observe the sacred rites of the Hopi Snake Dance, although a tribal elder predicted that he would die of snakebite—a

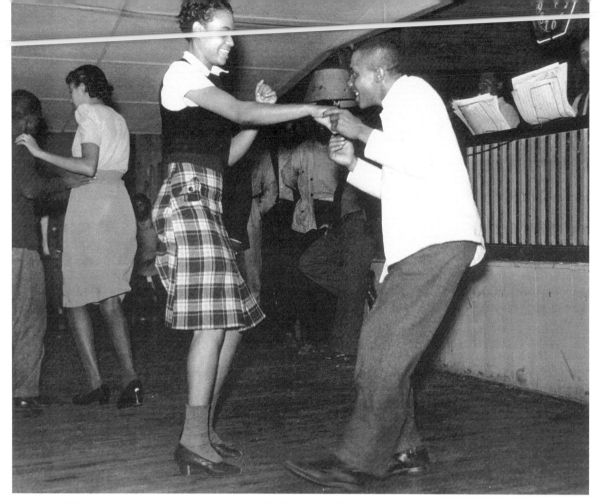

Marion Post Wolcott. *Jitterbugging in a Negro Juke Joint, Memphis, TN*. November 1939. Library of Congress.

prophecy that was borne out 20 years later. His photographs of Native Americans were popular as **cabinet** cards and **lantern slides**.

Born in Huntingdon, Pennsylvania, Wittick was about 18 years old when he worked for a photographer in Moline, Illinois. He served in the Civil War from 1861 to 1863, then returned to Moline and opened a studio. He moved to Santa Fe, New Mexico, where he took a job as photographer for the Atchison, Topeka and Santa Fe railroad. With a partner, R. W Russell, he maintained a studio in Albuquerque. From 1880 to 1884 Russell managed the studio while Wittick worked for another rail line, the Atlantic and Pacific, and was a member of the Stevenson Expedition in Arizona in 1882.

Wittick later operated a studio in Gallup, New Mexico, from 1884 to 1900. An archive of Wittick's work is held by the Museum of New Mexico.

Wolcott, Alexander S. (1804–1844)

American daguerreotypist

Wolcott and a partner opened the first professional

daguerreotypist studio in America when they set up shop in New York City in 1840.

The inventor of numerous devices for improving the daguerreotype process, he is generally considered the first to make a **portrait**, in October 1839. The next year he and John Johnson went into business. With a camera of their own design, they began producing miniatures. Eventually they increased the size of their pictures to a still modest 2 by 2 ½ inches.

When they started using an intricate system of mirrors they found that they could increase the light available to the camera and also make the process more comfortable for the sitter by reducing the amount of glare directed at his or her face.

Wolcott, Marion Post (1910–1990)

American documentary photographer

Wolcott was among the group of **Farm Security Administration** photographers—with **Dorothea Lange**, **Walker Evans**, **Arthur Rothstein**, and **Russell Lee**—who documented Depression-era

America. Unlike many of her peers, she did not receive much acclaim for her work until a landmark 1976 FSA group exhibition at the Witkin Gallery made the art world take notice.

A New Jersey native, she studied at New York University and The New School before her graduation from the University of Vienna in 1934. She got a job with the *Philadelphia Evening Bulletin* after graduation and stayed there for three years until joining the FSA in 1938. Handicapped somewhat by her youth and by traveling alone in the South, she nevertheless managed to make some memorable pictures, like a boy in shoes cut from old tires, or a mother wearing a burlap potato sack for a skirt. Her FSA work documented the New Deal era. She emphasized the contrast between "the fertility and beauty of the U.S., the affluent and the middle class with the areas of poverty."

After leaving the FSA in 1941, she worked as a wife and mother, as well as a farmer (1941–1952), professor of government at the University of New Mexico (1954–1959), and in some government diplomatic posts. She photographed sporadically until retiring to California in the late 1960s, when she resumed photography as a full-time hobby.

Her work was collected by the **Friends of Photography** in 1983's *Marion Post Wolcott: FSA Photographs* and is also in many anthologies featuring work from that period.

Wolf, Daniel (1955–)
American gallery owner

Wolf opened his first photo gallery when he was 22 and established himself as one of the most successful and creative dealers in the country.

His interest in photography dates to his student years at Exeter, when he was given as a gift **Minor White**'s book *Mirrors, Messages, Manifestations*. "It knocked me out," Wolf, a native of Cheyenne, Wyoming, has said. He later became photo editor of his school newspaper at Bennington College, from which he graduated with a bachelor of fine arts in 1975.

As a college student, he made buying trips to Europe during vacations and sold his wares from a card table in front of the Metropolitan Museum of Art. One of his early customers was **Sam Wagstaff**. After graduation he rented space on Madison Avenue to deal privately and a year later opened his own gallery. He was aided by two assistants who went on to successful careers as dealers, **Bonni Benrubi** and Howard Reade.

By 1979 he was vice president of the Association of International Photographic Art Dealers. In the mid-1980s he opened a Los Angeles gallery and also an eponymous imprint.

Wolf has organized exhibitions by scores of young California photographers as well as nineteenth-century masters.

Woodbury process:
An obsolete printing process invented by an Englishman, Walter Woodbury, in 1865. A relief mold was created from a negative in contact with bichromated gelatin that was then inked and printed onto paper.

Woodman, Francesca (1958–1981)
American art photographer

Woodman's powerful and often troubling self-portraiture earned her critical notice at a young age, and her early death, by her own hand, have led critics to compare her to the writer Sylvia Plath, whose career was similarly cut short.

Born in Denver to an artistic family (her father was a painter-turned-photographer, her mother a ceramicist), she displayed an early interest in photography when her father gave her an old camera to play with. Her parents owned a second home near Florence, Italy, and the family divided its time between Colorado and Italy. She was strongly influenced in her development as an artist by her teacher Wendy MacNeil Schneider, whom she met at boarding school and later studied with at Rhode Island School of Design.

Her work shows her interest in **surrealism,** with a series she did of herself with a background of abandoned houses and crumbling walls. After graduation from Rhode Island School of Design she moved to New York, where she worked as a photo assistant. She spent the summer of 1980 as an artist-in-resi-

dence at the MacDowell Colony in Peterborough, New Hampshire, and the following winter took her own life.

She had her first one-person show in Rome in 1978. Interest in her work has been strong in Europe, where there have been several retrospective exhibits. In 1998 the Cartier Foundation in Paris held an exhibit of 100 of Woodman's photos.

Woodfin Camp: An international editorial photography agency with offices in more than 17 countries, representing more than 50 photographers working for major news and entertainment magazines.

World Wide Web: A worldwide **computer** network that links large and small computer systems and individual computers and users with one another. The Web consists of uncounted millions of "web sites" or "home pages," which are pages or documents written in computer language called HTML, which enables creators to post attractive layouts, still and video images, words, songs, and multimedia plus links to other pages that the user can access on a personal computer. They are reached through modem and a telephone line via a service provider like America Online or Earthlink and software such as Netscape that allow your computer to download the information.

Xerography: The form of copy making that is widely used today. The process involves creating an electrostatic latent image that is made visible with toner and then transferred to paper, making the copy.

X-ray photography: A type of ray discovered by Wilhelm Conrad Roentgen in 1895. X-rays are high-energy photons that are able to penetrate solid matter and leave an image on photographic films or other X-ray–sensitive materials. X-rays are widely used in medicine to view bones, organs, and other internal working of living creatures.

Fred Church, *George Eastman on board ship, 1890 taken with No. 1 Kodak,*
identical with one Eastman holds in his hands in photo.

Zeiss, Carl (1816–1888)

German lens manufacturer

Over 100 years after his death, the best camera **lenses** still have Carl Zeiss's name on them.

After a traditional middle class education—some study, an apprenticeship and travel—Zeiss established a workshop in Jena in 1846. Along with his partners Ernst Abbe and Otto Schott, he revolutionized lens design and manufacture. First, they devised the creation of Jena glass, the finest optical-quality glass. The Zeiss company became world famous for its binoculars, microscopes, telescopes, and camera lenses. Paul Rudolph, Zeiss's chief designer, was instrumental in the firm's introduction of the first anastigmat and the still popular **tessar lens,** both introduced shortly after Carl Zeiss's death.

After Zeiss's death his son Roderich took over the firm; the company remains in business today. After World War II a separate Carl Zeiss Works was established in West Germany while the East Germans rebuilt the plant at Jena. Since 1989 both plants have been part of the same company in the unified Germany.

zone focusing: A technique to prefocus the camera with sufficient **depth of field** to allow the subject to be in **focus** during exposure. It is particularly helpful when the subject is moving unpredictably and precise focusing would be difficult. The method is to determine the near and far distances of the object and to use the **lens**'s depth-of-field guide (on most lenses) to find a focused distance and lens aperture that provide the necessary range.

zone system: A system, developed by **Ansel Adams,** for determining and coordinating exposure and **development** of **black-and-white** photographic negatives. The zone system breaks down the tonality of a black-and-white image into ten increments, called zones, ranging from 0 for pure black to 10 for pure white; middle gray is represented by zone 5. Each zone is equal to one **f-stop**. **Light meters** indicate a reading for zone 5. To use this system, which is popular with many photographers using **large-format** equipment today, the photographer first needs to pre-visualize the scene and analyze the shades of gray present with a spot light meter. (A spot light meter takes a reading from a very small area of the scene to be photographed.) A general rule of thumb that zone system practitioners use is to expose for the shadows and develop for the highlights. A light reading is taken from the darkest and brightest areas of the scene that you wish to contain detail and then compared. If the two readings are no more than six f-stops apart with the lowest at no less then zone 2 (the darkest zone with detail) and the highlight no higher than zone 8 (the brightest zone with detail), then an average light reading can be taken and the film can be developed normally. If the difference is greater, place the lowest value at zone 2 (three stops under normal exposure) and see how much higher the highlight reading is. For every zone over 8, reduce the film's development time by 20 percent. (This is called pulling the film; 20 percent of the development time is considered equal to one stop.) The final negative should contain shadow and highlight detail and be suitable for a fine black-and-white print. With practice, this is a highly flexible and reliable system for exposing and developing good negatives. For further reading, see *The Negative* by Ansel Adams (Little, Brown, 1948).

zoom lens: A lens with a variable **focal length** that can be continuously adjusted while in use on the cam-

era according to the picture-taking needs. This is particularly useful for newspaper, sports, and **nature photographers** and **photojournalists,** all of whose subjects are unpredictable. For example, a zoom lens can be set for **wide-angle photography** and if the photographer sees something far away of interest, he or she can instantly adjust the lens to be **telephoto,** allowing for a **close-up** picture of the farther scene.

Awards granted for various achievements in professional and amateur photography and their respective administrators are listed here.

Alfred Eisenstaedt Award
Life Magazine,
1271 Avenue of the Americas, New York, NY 10020-1393

Andrea Frank Foundation Grant Awards
The Andrea Frank Foundation, 151 1st Avenue, Box 39.
New York, NY 10003

Ansel Adams Book Award
American Society of Media Publishers (ASMP), 14 Washington, Road, Suite 502, Princeton Junction, NJ 08550-1033

ARTS (Arts Recognition and Talent Search)
National Foundation for Advancement in the Arts, 800 Brickell Avenue, Suite 500, Miami, FL 33131

Communication Arts Photography Annual
Communication Arts Magazine, 410 Sherman, P.O. Box 10300, Palo Alto, CA 94303

Calumet Emerging Photographer Award
The Friends of Photography, Ansel Adams Center for Photography,
250 Fourth Street, San Francisco, CA 94103

College Photographer of the Year
University of Missouri, 138 Neff Hall Annex, School of Journalism, Columbia, MO 65211

Emerging Talent Award
American Society of Media Photographers (ASMP), 14 Washington Road, Suite 502, Princeton Junction, NJ 08550-1033

En Foco Competition
En Foco, Inc.,
32 East Kingsbridge Road, Bronx, NY 10468

Ernst Haas Award
Maine Photographic Workshops,
2 Central Street, P.O. Box 200, Rockport,
ME 04856

George Polk Awards
Long Island University,
1 University Plaza, Brooklyn, NY 11201

Gordon Parks Photography Competition
Fort Scott Community College, 2108 S. Horton, Fort Scott, KS 66701

Guggenheim Awards
John Simon Guggenheim Memorial Foundation,
90 Park Avenue, New York, NY 10016

Infinity Awards
International Center of Photography,
1150 5th Avenue, New York, NY 10028

International Understanding Through Photography Award
17 Jaca Place, Hot Springs Village, AR 71909-2837

International Wildlife Photo Competition
Rockmountain School of Photography, 210 N. Higgins, Suite 101, Missoula, MT 59802

The John Faber Award
Overseas Press Club of America, 320 E. 42nd Street, New York, NY 10017

Leica Medal of Excellence
Mother Jones International Fund for Documentary Photography, 731 Market Street, Suite 600, San Francisco, CA 94103

Light Work Regional Grant
Light Work,
315 Waverly Avenue, Syracuse, NY 13244

Light Work Artist in Residence Program
Light Work, 315 Waverly Avenue, Syracuse, NY 13244

Maine Photographic Workshop
The Golden Lights Awards for Student of the Year, P.O. Box 200,
Rockport, ME 04856

National Endowment for the Arts (NEA) Grant
National Endowment for the Arts, Nancy Hanks Center, 1100 Pennsylvania Avenue, NW, Washington, DC 20506

Nikon Small World Competition
Nikon Inc., Attn. Small World, 1300 Walt Whitman Road,
Melville, NY 11747

The Oliver Rebbot Award
Overseas Press Club of America, 320 E. 42nd Street,
New York, NY 10017

Philippe Halsman Award for Photojournalism
American Society of Media Photographers (ASMP),
14 Washington Road, Suite 502, Princeton Junction,
NJ 08550-1033

Photographers Fellowship Fund
Center for Photography at Woodstock, 59 Tinker Street,
Woodstock, NY 12498

Photography Competition
The Photo Review, 301 Hill Avenue, Suite 5, Langhorne,
PA 19047

Picture of the Year Awards
University of Missouri/Journalism, 138 Neff Hall Annex,
School of Journalism, Columbia, MO 65211

Press Photo of the Year Contest
World Press Photo Holland Foundation,
Jacob Obrechtstraat 26, 1071 KM Amsterdam,
The Netherlands

Pulitzer Prizes
Pulitzer Prizes, 702 Journalism,
Columbia University, New York, NY 10027

The Robert Capa Gold Medal
Overseas Press Club of America, 320 E. 42nd Street,
New York, NY 10017

Ruttenberg Foundation Award
The Friends of Photography, Ansel Adams
Center for Photography,
250 Fourth Street, San Francisco, CA 94103

Soho Photo Gallery Competition
Soho Photo Gallery Competition, 15 White Street,
New York, NY 10013

The W. Eugene Smith Memorial Fund
International Center of Photography, 1130 5th Avenue,
New York, NY 10028

ABBE, James. *Stars of the Twenties*. Text by Mary Dawn Earley. Introduction by Lillian Gish. Viking, 1975. James Abbe photographed countless idols of the stage and screen, and this book includes superb portraits of such stars as Anna Pavlova, Beatrice Lillie, Helen Hayes, Mary Pickford, Charlie Chaplin, as well as highlights of the Folies Bergère and the Ziegfeld Follies.

ADAMS, Ansel, with Mary Street Alinder. *Ansel Adams: An Autobiography*. New York Graphic Society / Little, Brown, & Co., 1985. Known to the public as a crusading conservationist, ardent environmentalist and sage of the Western landscape, Adams completed his candid autobiography just prior to his death in 1984. A fond memoir of his long friendships with Alfred Stieglitz, Paul Strand, Georgia O'Keeffe, Edward Weston, Minor White, Mabel Dodge Luhan, Nancy and Beaumont Newhall, Dorothea Lange, Imogen Cunningham, and many others. His long and fruitful career is covered in detail, starting with his memories of the San Francisco earthquake in 1906 when he was only four years old.

ADAMS, Robert. *The New West*. Associated University Press, 1974. This photo essay portrays the modern suburban civilization that has been built in the once untouched beauty of the American West. Gas stations, motels, tract houses, trailer camps, form the foreground of a landscape that can still be dwarfed by the majestic Rockies or the open sky.

ADLER, Jeanne Winston. *Early Days in the Adirondacks: The Photographs of Seneca Ray Stoddard*. Foreword by John Wilmerding. Harry N. Abrams, 1997. Like the landscape paintings of the Hudson River School and the hazy scenes depicted by the luminist painters who were his contemporaries, these black-and-white photographs of the Adirondack region of upper New York State by Seneca Ray Stoddard are notable for their poetic effects of light and atmosphere.

AGEE, James, and Walker Evans. *Let Us Now Praise Famous Men*. Ballantine, 1974. In 1936, *Fortune* sent Agee and Evans to Alabama to do a story on share-cropping, but never published the disturbing results of the assignment. Several years later, with additional pictures and text, it was published in book form.

ALABISO, Vincent, Kelly Smith Tunney, and Chuck Zoeller. Introduction by Peter Arnett. *Flash! The Associated Press Covers the World*. Harry N. Abrams, 1998. The world's preeminent news organization has put out a photo compilation worthy of the respected wire service's 1998 sesquicentennial. More than 150 of the AP's world famous images, from the marines planting the flag on Iwo Jima to Marilyn Monroe's skirt billowing up over a subway grate to a handsome young Cassius Clay standing over a beaten Sonny Liston, bring the reader face-to-face with history, with the significant issues and personal and collective achievements of the modern age. The AP's widely seen photos often become iconic symbols of world events. Those images, along with Arnett's visceral introduction, tell a rich story of both a news organization and the way it has covered the world.

ALLAND, Alexander, Sr. *Jacob A. Riis. Photographer & Citizen*. Preface by Ansel Adams. Aperture, 1974. This book is a labor of love. Alland came to America as a penniless immigrant— the exact type of person championed by Riis, the crusading photojournalist. Alland rediscovered Riis's photographs of life in the slums, which had been neglected for more than 50 years. In this volume he reestablished Riis's reputation, showing the best of the photographer's work accompanied by insightful captions and commentary.

ANDERSON, John A., Eugene Buechel, SJ, and Don Doll, SJ. *Crying for a Vision*. Morgan & Morgan, 1976. Encompassing the work of three photographers, this is a unique photographic account of the Rosebud Sioux reservation life and culture from 1886 to 1976.

ARAKI, Nobuyoshi. *Shikijyo—Sexual Desire*. Edition Stemmle / Distributed Art Publishers, 1997. One of Japan's leading contemporary photographers, Araki is tellingly dubbed the Henry Miller of photography in one of the essays preceding this collection of erotic photographs. Many of the images show beautiful women in bondage, which one writer asserts are metaphors for the strict bondage that tradition and rigid codes of behavior represent in Japanese society. There are surrealistic juxtapositions of striking photos—one double page spread features four images: a half-dressed woman shown from the neck down; a couple sitting on a banquette, with the man sticking out his tongue at the photographer; a close-up of white lilies; and a storefront dental clinic. While Araki claims that his photos don't degrade women, and in fact, liberalize concepts of feminine identity by giving women the opportunity to pose, it's unlikely that many women outside Japan would agree with him. Color laser copies of the photos in this collection were first exhibited in an installation at the Frankfurt Museum of Modern Art in 1996, and there are photos of the installation, as well as a chronology of Araki's life and other exhibits, at the "back of the book."

ARBUS, Doon, and Marvin Israel, editors. *Diane Arbus*. Aperture, 1972. Startling portraits of American families and old folks, midgets and giants, homosexuals and transvestites, nudes and fanatics, children and the insane. Includes a text compiled from Arbus' own writings, interviews, and tapes.

ARNOLD, Eve. *Marilyn Monroe: An Appreciation*. Alfred A. Knopf, 1987. A sentimental and sensitive observation by Magnum photographer Eve Arnold, who had six photo sessions with the actress over a period of ten years. She has written an insightful text and includes over seventy photographs—some quite unexpected, like Monroe reading James Joyce's *Ulysses*.

ARROWSMITH, Alexandra, and Thomas West, editors. *Two Lives: Georgia O'Keeffe and Alfred Stieglitz*. Harper Collins/Callaway Editions, 1992. A fascinating book that juxtaposes O'Keeffe's paintings with Stieglitz's photographs. In some instances the painting was done years before the photo was taken (or vice versa), and in others both works were executed in the same year. There are many striking similarities of form, style, and subject matter. O'Keeffe and Stieglitz were both handsome individuals, who together made a perfect match—physically, politically, and culturally. They married in 1924 and frequently exhibited their works together.

AUER, Michael. *The Illustrated History of the Camera*. New York Graphic Society, 1975. The variety of forms the camera has taken from 1839 to the present are discussed in text, detailed captions and an illustrated glossary. More than 600 photographs, engravings, and drawings illustrate cameras from the early pioneers and the Victorian era to military and reporter's cameras, early reflex cameras, and up to the latest tools and gadgets.

AVEDON, Richard. *Evidence 1944–1994*. Edited by Mary Shanahan. Essays by Jane Livingston and Adam Gopnik. Random House, 1994. This book features few of the fashion photos that made Avedon famous. Avedon is also a star photojournalist and has over the years created some politically correct photos to show which side he's on. He has photographed Allen Ginsberg, Willem de Kooning, Jean Genet, William Burroughs, the Chicago Seven, the Warhol Factory crowd, napalm victims in Vietnam, and inmates of the Louisiana State Insane Asylum.

—————. *An Autobiography*. Eastman Kodak/Random House, 1993. This selection of 285 photos encompasses family snapshots, glimpses into the fashion world, documents from the civil rights movement, and portraits of cultural, political, and entertainment icons through four decades.

—————. *In the American West*. Harry N. Abrams, 1985. Avedon, the most celebrated portrait and fashion photographer in New York, went West to truck stops, country fairs, rodeos, mining camps, mill towns, and even slaughterhouses, in 187 cities and nearly twenty states. He photographed 752 people over a five-year period, applying his own vision to this collection of the plain, the long-suffering, and the disenfranchised.

BAILEY, David. *Goodbye Baby and Amen: A Saraband for the Sixties*. Text by Peter Evans. Coward-McCann, 1969. The photographer examines the actions and the attitudes of more than 150 personalities, mostly British, who made the Sixties swing.

BALFOUR, Daryl, and Sharna Balfour. *African Elephants: A Celebration of Majesty*. Abbeville Press, 1998. This handsome book of wildlife photography gives armchair travelers an opportunity to go on safari across Africa, seeing these magnificent creatures in their native habitats. The Balfours, a husband and wife team, spent four years gathering photographs and learning about elephants, and the final result is an impressive testament to these singular animals. Straight-on shots of elephants testify to the photographers' courage in facing these unpredictable creatures.

BANIER, François. *Past Present*. William Morrow & Co., 1996. In this first collection of Banier's work he shows himself to be a master of black-and-white photography, with magnificent portraits of both well-known personalities and unknown passersby. His subjects include Samuel Beckett, Isabelle Adjani, the Queen Mother of England, John Houston, David Lynch, Silvano Mangano, Federico Fellini, and Marcello Mastroianni, each of whom is shown in a stunningly revealing moment that seems to express their real selves.

BARGER, M. Susan, and William B. White. *The Daguerreotype, Nineteenth-Century Technology and Modern Science*. Smithsonian Institution Press, 1991. Stuffed with graphs, tables, charts and illustrations befitting a science textbook, this volume is a comprehensive study of the history and process of the daguerreotype, the first practical method of making photographs. Introduced in 1839 and out of style less than twenty years later, the daguerreotype was produced on polished plates of silver-plated copper, forming jewel-like images. Here you learn how the process came about, why it faded away, and every step of the way in between.

BARNEY, Tina. *Photographs: Theater of Manners*. Text by Tina Barney and Andy Grundberg. Scalo, 1997. Tina Barney's work is deceptively simple, although even a casual viewer of this series of portraits and tableaux of her family and friends will feel uneasy at the strained looking individuals staring into the camera. In this collection she looks back on the people and places that were the stuff of her childhood memories.

BARTH, Miles, editor. *Intimate Visions—Photographs of Dorothy Norman*. Chronicle Books, 1993. Intimate Visions, a beautifully designed book, explores the professional and personal relationship between Stieglitz and Dorothy Norman, who helped launch Stieglitz's American Place Gallery in 1926. Norman was primarily known as a reporter and a writer who began her photographic career with "sensitive" portraits of artists, writers, philosophers, and heads of state she met professionally.

————. *Weegee's World*. Bulfinch/Little, Brown, & Co., 1997. Weegee was the first serious paparazzo, chasing ambulances, fire trucks, and police cars to record the fires, floods, suicides, murders, disasters, and celebrity scenes that eventually made him world-famous. This exceptional monograph by International Center for Photography (ICP) curator Barth is a thorough examination of Weegee's interesting career, which is covered in 265 photos.

BASSHAN, Ben L., editor. *The Theatrical Photographs of Napoleon Sarony*. Kent State, 1978. For twenty-five years, he photographed virtually every New York stage personality and accumulated forty thousand negatives. His life work constitutes the most complete pictorial documentary of late-nineteenth century American theater. Sarony used painted backgrounds, interesting accessories, and a variety of poses, gestures, and expressions during a period when most American and European photo portraiture was dull and lifeless.

BAUM, Timothy. *Man Ray's Paris Portraits: 1921–39*. University of New Mexico Press, 1990. These studio portraits are arranged in chronological order from 1921 to 1939 and include superstars of the 1920s and 1930s from the close-knit social and artistic community in Paris: poet Edna St. Vincent Millay, playwright Ilka Chase, author Kay Boyle, composer Virgil Thompson, art patron Peggy Guggenheim, surrealist André Breton, socialist party leader Leon Blum, and writer Gertrude Stein.

BEATO, Felice, and Baron Raimund von Stillfried. *Once Upon a Time: Visions of Old Japan*. Friendly Press, 1987. Covers Japan's transition from an ancient feudal system to an industrialized modern nation. What Beato saw in the Japan of those early years had never been seen by Europeans, who were prohibited from traveling more than 24 miles inland. Beato created a vast documentary archive of a country in the last years of the medieval period. He had an instinctive talent for photographing typical Japanese scenes that soon vanished forever.

BONI, Albert, editor. *Photographic Literature (1960–1970)*. Morgan & Morgan, 1972. Unique reference book for professional photographers, scientists, students, teachers, authors, librarians, technicians, researchers, and book collectors. Over 2,900 subjects covering inventors, industrialists, photographers, writers, scientists, and historians, plus projects, processes, techniques, theory, chemistry, physics, apparatus, materials and applications, art and aesthetics.

————. *Photographic Literature (1727–1959)*. Morgan & Morgan, 1962. This book brings together over 300 years of important world literature in all fields of photography—from Da Vinci and the camera obscura in the fifteenth century through Daguerre, Land's Polaroid, and Carlson's Xerox. Over two million references in all fields, both general and specialized. An overview of writings on photography from its beginning up to recent listings.

BOSWORTH, Patricia. *Diane Arbus, A Biography*. Alfred A. Knopf, 1984. A riveting look at the life of one of the leading social documentors of her day. From portraits of freaks to Tricia Nixon's wedding, Arbus's work always offered a glimpse into her personal dark world. After her suicide in 1971, she became a cult figure. This well-researched and smoothly-written tome examines what made her go in the directions she did, both professionally and personally.

BOURKE-WHITE, Margaret. *Portrait of Myself, The Autobiography of Margaret Bourke-White*. Introduction by Jonathan Silverman. Simon & Schuster, 1963. The dramatic story of a woman who photographed history and made a lot of it herself. Bourke-White was among the first to write social criticism with a lens. This autobiography shows she was a gifted, natural writer as well as an extraordinary photographer whose apparent good luck combined with aggressive determination to get her what she wanted.

————, and Erskine Caldwell. *You Have Seen Their Faces*. Arno Press, 1975. First published in 1937, this incisive, sensitive document depicting the poverty of the people and the depleted land of the rural South is as timely and eloquent today as it was in the Thirties.

BRANDAU, Robert, editor. *de Meyer*. Alfred A. Knopf, 1976. An English aesthete who photographed his aristocratic and artistic circle of friends in pre–World War I Europe, Baron Adolf de Meyer photographed the rich and fashionable celebrities of the 1920s. His portraits, interiors, and still-lifes form a distinctive body of work that is made even more interesting by the well-written memoir by Philippe Julian of the Baron, his wife Olga (reputedly an illegitimate daughter of King Edward VII), and the elegantly decadent milieu around them.

BREWSTER, Sir David. *The Stereoscope, Its History, Theory, and Construction*. Morgan & Morgan, 1972. Originally published in 1856 in London, this book has been reproduced to its original size and format, complete with illustrations and notes, and with reprints of historic advertisements. The author was the inventor of the kaleidoscope and was known for his optical discoveries.

BROWN, Theodore M. *Margaret Bourke-White, Photojournalist*. Cornell University Office of Publication, 1972. Her career as a pioneer industrial photographer, as a photojournalist, social commentator, and as an artist is well documented with her best known published photos and interesting text. Layouts of her photo essays, a selected bibliography of her books, articles, published photographs, and books about her make this an important as well as interesting book.

BRYAN, C. D. B. *The National Geographic Society*. Harry N. Abrams, 1987. This impressive volume marked the one hundredth anniversary of the National Geographic Society. It is not an anthology of previously published articles but an original work—the first book with *National Geographic* images written and published outside the Society. It covers adventure and discovery and focuses on the personalities behind the Society as well as historic expeditions, from Robert E. Peary's successful struggle to be first to the North Pole to Jane Goodall's life among the chimpanzees.

BUCKLAND, Gail. *Reality Recorded: Early Documentary Photography*. New York Graphic Society, 1974. This book examines the work of men who explored the documentary possibilities of the new medium. The work covers the period up to the advent of the dry plate, around 1884. Includes pictures by the great Victorian photographers of England, France, and the United States.

BUELL, Hal, and Saul Pett, editors. *The Instant It Happened*. Harry N. Abrams, 1976. Selected from the sixty million photographs in the AP files, this book has notable news photographs from the Civil War battlefields to the first man on the moon. Many are Pulitzer Prize winners.

BULLATY, Sonja. *Sudek*. Clarkson N. Potter, 1986. Born in Bohemia, Sudek took up photography in 1918 after his right arm was amputated as a result of a shrapnel wound. Along with photographer Jaromir Funke, Sudek founded the Photographic Society, the nucleus of progressive Czech photography. Most of his early work is divided into two parts: exploration of light and its effects; and documentation of the city of Prague. Sonja Bullaty was Sudek's assistant in Prague after World War II.

BUNNELL, Peter C., editor. *Edward Weston: On Photography*. Gibbs M. Smith, Inc., 1983. A classic text, this chronological anthology of Weston's published writings on photography includes 24 of his photos. Weston, a master of his craft, delineates the fine line between good and great photography, emphasizing the "revelation through heightened awareness" that makes a great photograph.

BURLESON, Clyde W., and Jessica Hickman. *The Panoramic Photography of Eugene O. Goldbeck*. University of Texas Press, 1986. This is a fascinating book of panoramic photographs taken with a Cirkut camera, which produces a panoramic image on the negative up to 60 inches in length. Goldbeck photographed 21,765 men from the Lakeland Air Force Base in which each man wore a color-coded uniform, creating—from a distance—the star and wing insignia of the entire division. He continued to repeat this "living insignia" style, but this was his most spectacular effort. The images in the book, which date from 1911 to 1977, are reproduced with double and triple gatefolds, many appearing in their original size.

CAFFIN, Charles H. *Photography as a Fine Art*. Morgan & Morgan, 1972. Originally published in 1901, this book examines the entire range of photography and its critical problems. Authoritative appraisals of the work of Stieglitz, Clarence H. White, and the other greats.

CALLAHAN, Harry. *Harry Callahan*. Introductory essay by Sherman Paul. Museum of Modern Art, 1967. This survey of Callahan's photography covers many of the people and milieus that appear again and again in his effort to express "my feeling and visual relationships to the life within and about me." Cityscapes, nudes, and landscapes form part of a mysterious world of stillness.

CALLAHAN, Sean, editor. *The Photographs of Margaret Bourke-White*. Introduction by Theodore M. Brown and Foreword by

Carl Mydans. New York Graphic Society, 1972. A major retrospective collection of the renowned photojournalist's work including her early years at *Life* Magazine, industrial photographs, political figures, and war pictures. This is a tribute to an extraordinary photojournalist. It is filled with over 200 of her memorable photographs as well as a complete selection of biographical pictures. Her career spanned the great historical events of the 1930s and 1940s. She photographed floods and famines, droughts and the Depression, war and peace. Her portraits were of some of the most familiar personalities of the century: Roosevelt, Stalin, Madame Chiang Kai-shek, Nehru, the Pope, Goering, Eisenhower, Haile Selassie, and countless others.

CAPA, Cornell, editor. *Behind the Great Wall of China.* Metropolitan Museum of Art, 1972. The land, people, and changing lifestyles in China over the past century. Documentary photos by John Thomson, Edgar Snow, Robert Capa, Cartier-Bresson, Marc Riboud, and Rene Burri are accompanied by statements of the photographers that add further interest to this historical survey.

———. *The Concerned Photographer.* Text by Michael Edelson. Grossman, 1972. There is no doubt that the International Fund for the Concerned Photographer has exhibited and published the work of some of the world's most renowned photographers. When the first volume of this series appeared in 1968, it contained the work of Werner Bischof, Robert Capa, André Kertész, Leonard Freed, David Seymour, and Dan Weiner. This second volume includes the work of Bruce Davidson, Ernst Haas, Hiroshi Hamaya, Donald McCullin, Gordon Parks, Marc Riboud, W. Eugene Smith, and Dr. Roman Vishniac.

———, and Richard Whelan, editors. *Robert Capa Photographs.* Alfred A. Knopf, 1985. Robert Capa invented modern war photography. His photographic legacy has influenced four decades of photojournalists. This book is a compilation of not only his war photographs but also the artists, presidents, and Hollywood stars he shot after creating the Magnum Photos agency. Even after he became recognized as one of the foremost photographers of the century, Capa would tell friends: "I'm not a photographer, I'm a journalist." Indeed, he died when a land mine exploded under him, covering the nascent Vietnam War in Indochina in 1954. These photographs reveal the type of work and type of person that inspired Robert's brother, Cornell, to found the Fund for Concerned Photographers and then the ICP in his memory.

CARLEBACH, Michael L. *The Origins of Photojournalism in America.* Smithsonian Institution Press, 1992. This is a well-researched history of American photojournalism from 1839 to 1880. It begins with the early daguerreotypes made by William and Frederick Langenheim on May 9, 1844, which recorded the first newsworthy event—the military occupation of Philadelphia. Only five years earlier, on Thursday, March 31, 1839, *The Evening Star* in New York had published the news announcing M. Daguerre's invention.

CARTIER-BRESSON, Henri. *The Decisive Moment.* Simon & Schuster, 1952. The classic volume that expresses his disciplined, spontaneous, precise vision, described as a decisive moment. This collection includes life in France during the Occupation, as well as views of China, Spain, Morocco, Mexico, and the Soviet Union after World War II.

CHAMBI, Martin. *Photographs, 1920–1950.* Foreword by Mario Vargas Llosa. Smithsonian Institution Press, 1993. Born in Peru in 1891, Chambi photographed the milieu in which he lived: the people and landscape of Cuzco, the ancient Incan capital. His principal body of work, done from the 1920s to the 1950s, has extraordinary documentary as well as artistic merit.

CLARK, Larry. *Teenage Lust.* Meriden Graveur, 1983. This graphic autobiography of growing up in the midwest may not be suitable for all readers. Clark, who made the controversial film *Kids*, is very consistent in his use of themes, images, and ideas. Consistent or repetitive, that is. Plenty of nudity, some guns, a few police reports and newspaper clippings documenting some youthful transgressions make up the entirety of this work.

———. *Tulsa.* Rapaport, 1971. A sequel to *Teenage Lust*, although it appeared a dozen years earlier. Here the misdeeds are of a more adult nature, with the same subject matter of guns, nudity, and active drug use—arms being punctured by needles—thrown into the mix. The entire text reads as follows: "i was born in tulsa oklahoma in 1943. when i was sixteen i started shooting amphetamine. i shot with my friends everyday for three years and then left town but i've gone back through the years. once the needle goes in it never goes out." Caveat emptor.

COATES, James. *Photographing the Invisible: Practical Studies in Spirit Photography, Spirit Portraiture, and other Rare but Allied Phenomena.* Arno Press, 1973. A detailed account of various spiritual phenomena including spirit photographs, portraiture and writings, which the author classifies under the general

term Psycho-physics. Originally published in 1911.

COKE, Van Deren. *The Painter and the Photograph: From Delacrois to Warhol*. University of New Mexico Press, 1964. Explores the relationship between photography and painting.

COLES, Robert. *The Darkness and the Light: Photographs by Doris Ulmann*. Aperture, 1974. These remarkable portraits of the black people from the Lang Syne Plantation in the Gullah backwater country of South Carolina were taken in the 1930s.

CONRAT, Maisie, and Richard Conrat. *Executive Order 90666: The Internment of 110,000 Japanese Americans*. Introduction by Edison Uno. Epilogue by Tom C. Clark. Photographs by Dorothea Lange and others. California Historical Society, 1972. Photographs which, in their historical context, now focus a new public perspective on the internment of Japanese-Americans following Pearl Harbor.

CONSTANTINE, Mildred. *Tina Modotti—A Fragile Life*. Padding Press, 1975. This is a biography of Tina Modotti, photographer and close associate of Edward Weston, who was involved in left-wing cultural circles in Mexico and Europe in the 1920s and 1930s. Her portraits of friends and scenes of Mexican peasant life, along with Weston's photos of her, illustrate the text.

CUNNINGHAM, Imogen. *Imogen! Imogen Cunningham Photographs 1910–1973*. University of Washington Press, 1974. The first full-length treatment of the work of the First Lady of photography.

CURTIS, Edward S. *Native Nations: First Americans as Seen by Edward S. Curtis*. Foreword by George P. Horse Capture. Bulfinch/Little, Brown, & Co., 1993. A collection of Curtis' "best" images from his landmark 20-volume study, *The North American Indian*. Here are Medicine Crow, Two Bear Woman, Mosquito Hawk, Red Cloud, Slow Bull, Chief Joseph, Black Eagle, and Bear's Belly (the cover photo), all electronically scanned from originals to render superb quality. Curtis began his self-assigned project in 1896 and made over forty thousand glass plates in a span of 30 years.

————. *The North American Indians*. Introduction by Joseph Epes Brown. Aperture, 1973. From 1896 to 1930, Edward Curtis traveled through the Indian territories of the United States, making a vivid record of the Indian people. One of many books on American Indians published by Curtis.

DAGUERRE, Louis Jacques Mandé. *An Historical and Descriptive Account of the Daguerreotype and the Diorama*. Introduction by Beaumont Newhall. Morgan & Morgan, 1971. Daguerre's first instruction manual, complete with step-by-step instructions and diagrams.

DALTON, Stephen. *Borne on the Wind*. Reader's Digest Press, 1975. Masterful photographs of insects in flight, beautifully reproduced, accompanied by detailed captions and essays on the insects and how they fly, as well as an explanation of the special technique used to photograph the insects.

DANIEL, Malcolm. *The Photographs of Edouard Baldus*. Metropolitan Museum of Art/Harry N. Abrams, 1994. In 1855 he was considered the greatest architectural photographer in France, and chosen the official photographer of Napoleon III's construction of the new Louvre. He took thousands of pictures, contact printed from glass negatives, that portray the Louvre with dazzling clarity. One of Baldus's greatest achievements, commissioned by Baron James de Rothschild, president of the Northern Railway, was an album of views taken along the rail line and presented to Queen Victoria, to mark her trip to France.

DANLEY, Susan, and Cheryl Leibold. *Eakins and the Photograph: Works by Thomas Eakins and His Circle in the Collection of the Pennsylvania Academy of Fine Arts*. Smithsonian Institution Press, 1994. Eakins took up photography to aid his understanding of anatomy, motion, and light. He also created many soft-focus images that were romantic and luminous. He used photos as sketches for some of his most famous paintings and also created nude studies for his students at the Pennsylvania Academy, where he taught from 1876 to 1886.

DANZIGER, James, and Barnaby Conrad III. *Interviews with Master Photographers*. Paddington Press, 1977. Interviews with Minor White, Imogen Cunningham, Cornell Capa, Elliott Erwitt, Yousuf Karsh, Arnold Newman, Lord Snowdon, and Brett Weston along with photos by each photographer that reveal individual approaches, techniques, and philosophies. The interviews are candid and insightful; they give an intriguing view of these important photographers.

DAVIS, Barbara A. *Edward S. Curtis: The Life and Times of a Shadow Catcher*. Chronicle Books, 1985. Curtis, the renowned Pictorialist, began a self-imposed assignment in 1896 to photograph the Indians of North America. First using a 14 x 17 view camera, later an 11 x 14, and finally a 6 x 8 reflex camera, Curtis made over 40,000 glass plates in the span of 30 years. He also wrote four books, collected hundreds of Indian folk-tales from 80 different tribes, made 10,000

recordings of Indian speech and music, several films, and, finally, published a colossal 20-volume portfolio, *The North American Indian*, the most ambitious ethnological masterwork ever produced by an individual photographer.

DAVIS, Keith. *George Barnard: Photographer of Sherman's Campaign*. University of New Mexico Press, 1990. These views, mostly of mass destruction, noted battlefields, strategic position, field fortifications, army built bridges, military installations, and numerous bombarded and flattened towns, also show a few tranquil scenes: panoramic views from the top of Lookout Mountain, the Nashville capitol, and the Forsythe Park fountain in Savannah. This famous Civil War album was the most ambitious project of Barnard's career and has long been recognized as a landmark in the history of photography.

DAVIS, Thulani, and Howard Chapnick. *Malcolm X: The Great Photographs*. Stewart, Tabori, & Chang, 1993. Malcolm X has become a cultural icon, a martyred hero, a saint. This picture book shows Malcolm as a moral leader, Black Muslim teacher, rebellious black separatist, husband, father, and as a revered and honored hero to many Americans.

DELANO, Jack. *Photographic Memories*. Smithsonian Institution Press, 1997. This book is a fascinating account of Delano's life and work for Roy Stryker in the Historical Section of the Farm Security Administration from 1940 to 1943. Starting with his birth in the Ukraine, his family's move to the U.S., his travels for the FSA, and his move Puerto Rico with his wife, Irene Esser, are all covered in detail. The book includes some of his FSA work, as well as black and white line and color drawings, which add interest to the story, especially the reproduction of some animated correspondence with Picasso.

DODDS, Gordon, Roger Hall, and Stanley Triggs. *The World of William Notman: The Nineteenth Century Through a Master Lens*. David R. Godine, 1993. His lucky break came in 1858, when the Grand Trunk Railway commissioned Notman to photograph construction of the Victoria Bridge over the St. Lawrence River. His stereograph cards of the bridge were avidly collected, and when Prince Edward, heir to Queen Victoria's throne, visited Canada in 1860 to inaugurate the bridge, Notman presented him with two magnificent albums of the bridge's construction and views of Canadian villages, Niagara Falls, and other natural phenomena.

DOISNEAU, Robert. *Robert Doisneau: Three Seconds of Eternity*. Neues Publishing, 1997. Looking through this fine collection of Doisneau's best known images is like reminiscing with an old friend. Although the reader will find nothing new or star-

tling about such famous photographs as the affecting "Kiss in Front of the Hotel de Ville," or the amusing "Grappling With Venus," or the many street scenes of Paris, it is always a pleasure to encounter them again. These were mostly taken in the 1940s and 1950s and they show Doisneau's affection and empathy for ordinary people. The autobiographical essay chronicles his evolution as an artist and, in addition to the 101 duotone images, an outline of his life and a selected exhibition list is included. Every photo library needs a book on Doisneau and this classic volume, first published in 1979, is the one to get.

DOTY, Robert. *Photographs in America*. Introduction by Minor White. Random House, 1974. Contains 259 works from the exhibition, selected by the Whitney Museum of American Art, providing a record of photography's evolving artistry and a visual history of a century of American life.

DUNCAN, Catherine. *Paul Strand: The World on My Doorstep, 1950–1976*. Essay by Ute Eskildsen. Aperture, 1994. In 1950, Strand and his third wife, Hazel, moved from New York to Orgeval, a tiny village 35 kilometers from Paris. They traveled widely, in France, Italy, the Hebrides, Egypt, Morocco, Ghana, and Romania, and these journeys are the focus of this book, which is divided by region into sections, each with a mini-portfolio and text by various writers.

DUNCAN, David Douglas. *The Private World of Pablo Picasso*. Ridge Press, 1958. This intimate photographic profile of one of the world's greatest artists is a classic document. Duncan stayed at Picasso's villa in the south of France for three months in the 1950s. These photographs of the artist, his works, his studio, and the people he lived with were selected from the thousands taken in that period.

DUNN, Philip, and Thomas L. Johnson, editors. *A True Likeness: The Black South of Richard Samuel Roberts, 1920–1936*. Algonquin Books, 1987. Presents black middle-class life in the Deep South from 1920 to 1936. Almost all of Roberts' studio photos were formal. The subjects stare straight into the lens. They're attired in business suits, cocktail dresses, graduation robes. His glass plates were discovered after more than 40 years in a crawl space under his family home. Exposed to mildew, heat and rain, the plates nevertheless were in good condition.

EDGERTON, Harold. *Stopping Time*. Harry N. Abrams, 1987. This book is a stunning compendium of Edgerton's life's work. An MIT professor and the inventor of the modern electronic flash, he took photos that literally, as the title says, stop

time. His quest to reveal what the unaided eye cannot see revolutionized photography. It also makes for fascinating viewing. A tennis player serving, water spouting from a faucet, a bullet going through an apple, an owl in flight, and a girl skipping rope all appear as you can't imagine them appearing. How does he do it? The very short duration of his flashes stopped the action, while the large amount of light emitted allowed full exposure of each moment in a sequence. There are 138 illustrations and after you've seen them all you're still clamoring for more.

EHRENKRANZ, Anne, Willis Hartshorn, and John Szarkowski. *A Singular Elegance: The Photographs of Baron Adolph de Meyer*. Chronicle Books, 1994. Baron de Meyer was a fashion photographer who spent his early years in Dresden, Paris and London. His beautiful, soft-focus images of celebrities in *Vogue*, *Vanity Fair*, and *Harper's Bazaar* won him a wide reputation in the teens and twenties. Included in this comprehensive survey are his masterpieces of the cultural elite: Coco Chanel, Josephine Baker, Anna Pavlova, John Barrymore, and Charles Chaplin. Among his best works are photographs of his wife Olga looking chic and sophisticated.

EISENSTAEDT, Alfred. *Eisenstaedt on Eisenstaedt*. Introduction by Peter Adam. Abbeville Press, 1985. This book proves that it was Eisenstaedt's great fortune to have been in the right place at the right time for the right event. He truly was a witness to our time. A panorama of events and personalities that shaped history is seen in over a hundred duotones representing only a fraction of his 2,500 assignments. His commentary with each picture makes this a unique diary of a great photojournalist.

————. *Eisenstaedt's Album: 50 Years of Friends and Acquaintances*. Introduction by Philip B. Kunhardt, Jr. Viking, 1976. This fascinating compendium of photographs, autographs, and original sketches drawn from the author's albums runs the gamut from Adolf Hitler to Charlie Chaplin, and Sophia Loren to Clare Boothe Luce.

————. *People*. Viking, 1973. Over 400 photographs spanning the half-century of the photographer who was on the staff of *Life* magazine from its birth in 1936 to its demise in 1972.

EVANS, Walker. *Walker Evans at Work*. Essay by Jerry L. Thompson. Icon Editions/Harper Collins, 1994. Packed with 747 photographs and documentary texts, including letters, memoranda, interviews, and notes, this volume is an in-depth analysis of the creative process of one of America's greatest photographers. Evans's classic images are interspersed with the documents.

————. *First and Last*. Harper & Row, 1978. The purpose of this book is to provide a true understanding of Evans' work through some 220 photographs, culled from more than 20,000 taken over 45 years of continuous activity. Some are world famous, some have never seen the light of day. They include portraits, street scenes, and what critic Hilton Kramer has called Evans's "special landscape . . . the objects and structures and surfaces and spaces of American life, in which he saw something poetic, something to be valued and to be saved."

EWING, William A. *Blumenfeld Photographs: A Passion for Beauty*. Harry N. Abrams, 1996. Blumenfeld was an enormously gifted photographer who was imaginative and creative. He freely borrowed ideas from his Dada buddies, Man Ray, Kerterz, Cocteau, Dali. But he went beyond ordinary photographs by experimenting with reflectors, distortion lenses, solarization, negative manipulation, and multiple exposures.

FAAS, Horst, and Tim Page, editors. *Requiem: By the Photographers Who Died in Vietnam and Indochina*. Introduction by David Halberstam. Random House, 1997. It's hard to imagine a more powerful or affecting tribute to their fallen colleagues than this striking book, assembled by Faas, who photographed Vietnam for the Associated Press, and Page, who covered the war in Laos and Vietnam for UPI and Paris Match. Both were wounded in Vietnam. The photographs are remarkable.

FASANELLI, James. *Lotte Jacobi*. Edited by Kelly Wise. Addison House, 1979. An assemblage of Jacobi's portraits, street scenes, theater, art, and dance photographs. Her most important and memorable works are of the intellectuals who have been connected with her life—Einstein, Karen Horney, W. E. B. Du Bois, Paul Robeson, Martin Buber, Karl Kraus, Constantin Stanislavsky, W. H. Auden, Eleanor Roosevelt, and Thomas Mann.

FEININGER, Andreas. *Andreas Feininger*. Introduction and text by Ralph Hattersley. Morgan & Morgan, 1973. These images from the full range of his work—nature, shells, trees, people, sculpture, masks, bones, cities, industry and motion—make clear the structural elements of photography as a language.

FELLMAN, Sandi. *The Japanese Tattoo*. Introduction by D. M. Thomas. Abbeville Press, 1986. Fellman presents this archaic body art in all its glory. Photographed with a 20 x 24 Polaroid studio camera, these images are stunning documents of the mysterious art applied directly onto the skin of man.

FELSEN, Gregg. *Tombstones: 75 Famous People and Their Final*

Resting Places. Ten Speed Press, 1997. Visiting grave sites throughout the United States and Europe, photographer Gregg Felsen has gone from Los Angeles's memorial parks to picturesque rural cemeteries on the East Coast to old church-yards in England. He has photographed the gravestones of an assortment of celebrities—writers, actors, statesmen, sports figures, scientists, and artists—that he admires. In this slim volume he presents, in chronological order by death date, each of his heroes, with a photo of their grave marker and a brief biographical sketch. Anyone who shares Felsen's fascination with cemeteries and gravestones will enjoy leafing through his book.

FELVER, Chris. *Angels, Anarchists & Gods.* Louisiana State University Press, 1996. Globe-trotting Christopher Felver shows off his collection of contemporary portraits, most taken in the 1980s and 1990s. Pictured in this large-format volume are poets and writers like Lawrence Ferlinghetti, Barbara Guest, Gregory Corso, Allen Ginsberg, and Hettie Jones—all a little plumper, grayer, a bit wrinkled, but all gracefully aged since they first achieved recognition in the 1950s and early 1960s. Felver also includes artists, composers, dancers, novelists, rock stars, and politicians. Although all of his photos are posed, they have a candid, spontaneous look.

FENTON, Roger. *Roger Fenton, Photographer of the Crimean War.* Essay by Helmut and Alison Gernsheim. Arno Press, 1973. Eighty-five plates of the Crimean War, the first war to have photographers.

FINK, Larry. *Social Graces.* Aperture, 1984. Fink's first book invites the reader to enter the social worlds of two very different groups of people. There are the rural, working class families of Martin's Creek, Pennsylvania, and the people in his "Black Tie" series—the urban upper class in all its fineries. In closing the psychic distance between the two social classes, Fink narrows the distance between himself and his subject—in the end to portray the emotional undercurrent of sensuality and anxiety of moments that flicker and pass before the eye can notice.

FORD, Colin, editor. *An Early Victorian Album: The Photographic Masterpieces (1843–1847) of David Octavius Hill and Robert Adamson.* Essay by Roy Strong. Alfred A. Knopf, 1976. Extraordinary scenes of village life, Edinburgh, photos of Scottish notables, fishermen, working people, and children taken barely a decade after the birth of the camera by the pioneer Scottish photographers. This collection was selected for presentation to the British Royal Academy in 1848 and the present volume is a complete, beautifully-reproduced album of the original presentation.

———. *The Cameron Collection.* Van Nostrand Reinhold, 1975. Reproduces all 94 photographs of The Herschel Album, prepared by Julia Margaret Cameron for the man who sent her the first photo she ever saw. Contains incomparable images of her most famous subjects, Tennyson among others; her letter of dedication, and descriptions of the photos, as well as Sir John Herschel's letter of acknowledgment and thanks.

FORESTA, Merry A. *American Photographs: The First Century.* Smithsonian Institution Press, 1996. These photographs, all taken from the Isaacs collection in the National Museum of American Art, include American views, portraits, and scenes of daily life, many by unknown or obscure photographers. Charles Isaacs, a dealer in Philadelphia who sold European photographs, appreciated the American pictures he came across, but there was little interest from collectors or museums. Over the years he amassed a varied collection that included well-recognized artists. This volume showcases Isaacs's collection, covering a wide range of historical images, from Civil War pictures by Alexander Gardner and Mathew Brady and beautiful western landscapes by Timothy O'Sullivan and William Henry Jackson to scenes of everyday life by less familiar names. Informative commentaries on individual photographers, and an afterword by Isaacs on his collection round out this fine work.

FRANK, Robert. *Flamingo.* Foreword by Gunilla Knape. Essay by Mikael Van Reis. Scalo, 1997. This modest volume is a combination of Frank's black and white photos, film stills, and collages, sandwiched negatives, foldout pages, and stained and marked prints. It commemorates his winning the Hasselblad International Photography Prize for 1996. In these pictures, he creates poetic, allegorical artifacts heavy with personal symbolism: "Silence, the sky turns dark. No one lives here anymore. I want to escape."

———. *Moving Out.* Text by Sarah Greenough, Philip Brookman, Martin Gasser, John Hanhardt, and W. S. DiPiero. Scalo/D.A.P., 1994. A spectacular retrospective catalogue accompanying a traveling exhibition of Frank's still photography, film frames, video, and recent experimental work. The widest selection of Frank's images ever published displays his artistic vision from cultural commentary to self-reflection.

———. *The Lines of My Hand.* Pantheon Books, 1989. Originally published in 1972 by Lustrum in a paper edition, this handsome hardcover includes not only his early work when he first came to America but also the photos taken on his famous trip "on the road," later published as a book enti-

tled *The Americans*, with an introduction by Jack Kerouac. This seminal volume inspired many documentary photographers.

————. *The Americans*. Introduction by Jack Kerouac. Grove, 1959. This landmark book of Frank's cross-country trip in the 1950s was first published in Paris in 1958 and is a powerful portrait of America in 83 photos of cowboys, politicians, bikers, waitresses, roadside graves, and honky-tonk roadhouses. It is among the most important books published in the 1950s.

FRAPRIE, Frank R., and Walter E. Woodbury. *Photographic Amusements Including Tricks and Unusual or Novel Effects Obtainable with the Camera*. Arno Press, 1973. This influential and popular text, first published in 1895, details photographic effects considered novel and curious, such as composite, multiple exposure, caricature, the panorama, table-top, photo-anamorphosis, and a variety of printing processes. A later edition in 1931 introduced the European avant garde work of the 1920s to English-speaking readers.

FREED, Leonard. *Photographs 1954–1990*. Introduction by Stefanie Rosenkranz. W. W. Norton & Co., 1992. This Magnum photographer spends time on the road, covering significant cultural, political, and social happenings. Most of these pictures were taken with 50mm lenses because, Freed says, "I want to simplify things and I don't like distortion or exaggeration from wide-angle lenses."

FREUND, Gisele. *The World in My Camera*. Translated by June Guicharnaud. Dial Press, 1974. An interesting autobiography of the celebrated photojournalist, this is a revealing memoir of Freund's thoughts and methods of photography and contains her photos of James Joyce, André Gide, as well as other artistic celebrities from the 1920s to the 1960s.

FRIEDLANDER, Lee. *Lee Friedlander Portraits*. Foreword by R. B. Kitaj. New York Graphic Society/Little, Brown, & Co., 1985. Friedlander is considered the master of artless street photography that frequently features mundane subject matter. He also often incorporated his own shadow or reflection into the picture. His portraits conform to the traditional basics, like good lighting, appropriate environment, and excellent composition.

FULTON, Marianne. *Eyes of Time*. Essays by Estelle Jussim, Colin Osman, Sandra S. Phillips, and William Stapp. Foreword by Howard Chapnick. New York Graphic Society, 1988. A good overview of photojournalism in war and peace from its earliest days of glass-plate cameras used in the Civil War to the

35mm motor-drive cameras used today. Includes work by Larry Burrows, David Burnett, Susan Meiselas, James Nachtwey, Maggie Steber, David Turnley, and Peter Magubane. Detailed captions and excellent biographical sketches.

GALASSI, Peter. *Henri Cartier-Bresson: The Early Work*. Little, Brown, & Co., 1987. From 1932 to 1934, Cartier-Bresson took the 87 black-and-white photos, some now famous, many unfamiliar, that make up this fascinating study. Cartier-Bresson traveled in Italy, Spain and Mexico, seeking to preserve life in the act of living with his hand-held Leica.

GEE, Helen. *A Memoir*. University of New Mexico Press, 1997. Helen Gee opened her Limelight Photo Gallery and Coffeehouse in Greenwich Village in the 1950s. She was the pioneer who in 1954 took an old Sheridan Square garage on Seventh Avenue (formerly the Nut Club) and turned it into the first important exhibition space in New York City for photography. Her enthusiasm attracted photographers who in those years were not exactly household names: Minor White, Brassai, Paul Strand, Edward Weston, W. Eugene Smith, Robert Frank, Lisette Model, Dorothy Norman, and Alfred Stieglitz. It was a time when The Village was a center of creative activity, with actors, writers, painters, sculptors, and photographers part of the coffeehouse scene. Gee's gallery lasted through 70 exhibits and seven years. Her reminiscences make interesting reading.

GERNSHEIM, Helmut. *Julia Margaret Cameron—Her Life and Photographic Work*. Aperture, 1975. An interesting and scholarly monograph on the illustrious Victorian photographer. Illustrated with 60 full-page reproductions of her portraits of some of the important artists and writers of her era.

————. *Lewis Carroll: Photographer*. Dover, 1969. Carroll ranked with the very best of the nineteenth-century photographers; this definitive work is divided between portraits of distinguished people and of children. Text includes an introduction to British photography.

————, and Alison Gernsheim. *The History of Photography: 1865–1914*. McGraw–Hill, rev. ed., 1973. Reference work on the growth of photographic art and techniques from the camera obscura to the beginning of the modern era. Includes European daguerreotypes, early news photography, the fin de siecle esthetic movements, the evolution of color, and modern uses of photography.

————. *L. J. M. Daguerre: The History of the Diorama and the Daguerreotype*. Dover, 1968. This is a definitive account of

Daguerre's life and work, and of the diffusion of the daguerreotype to England, Germany, and America. The text is illustrated with dioramic paintings, photographs made by various early processes, pictures of early cameras, and daguerreotypes.

GILBERT, George. *Collecting Photographica*. Hawthorn Books, 1976. A thorough guide to the equipment, images and literature of photography, with chapters on collecting cameras, prints, daguerreotypes. Includes a detailed chronology of photo history, instructions for dating photo equipment, and a discussion on restoration.

GILMORE, C. P. *The Scanning Electron Microscope*. New York Graphic Society, 1972. Based on the intricate technology of the new electron microscopy, which creates the effect of direct perception of the most minute and complex forms, this book describes the techniques and principles involved along with visually spectacular examples of this research.

GINSBERG, Allen. *Photographs*. Introduction by Gregory Corso. Twelvetrees Press, 1990. From the early 1950s, one of the major figures of modern American poetry walked around with a camera at the ready, shooting very personal snapshots of his counter-culture heroes. Allen Ginsberg, Beat poet extraordinaire, put together a visual history of his time, his cohorts, who range from Beat writers to painters, sculptors, photographers, and filmmakers.

GODWIN, Fay. *Land*. Essay by John Fowles. Little, Brown, & Co., 1986. Godwin's black-and-white photographs emphasize the timeless, elemental quality of nature in remote corners of Britain and represent selections from ten years' work. This book begins with scenic beauty and ends with man-made ugliness, startling and chilling reminders of the land's ecological deterioration.

GOLDBERG, Vicki. *The Power of Photography: How Photographs Changed Our Lives*. Abbeville, Press, 1991. Goldberg examines the actual effects over 100 individual photographs have had in events ranging from the Civil War to the Kent State killings, in the fields of politics, social reform, the creation of celebrity, and the delivery of news. From the *carte-de-visite* to the impact of television, this book offers fresh insight and fascinating information about many famous images, from the Betty Grable pinup portrait to the raising of the flag at Iwo Jima.

————. *Margaret Bourke-White: A Biography*. Harper & Row, 1986. The definitive work on the life of the pioneering woman photographer. Her story is as dramatic as the photos she took

for *Life* magazine. Through India and Gandhi, World War II, Erskine Caldwell and the Depression-era South, Korea and her own battle with Parkinson's Disease, it is all captured here in compelling detail. She became an international celebrity, and this well-researched, easy-to-read volume tells you exactly how and why it happened.

GORMAN, Greg. *Inside Life*. Foreword by John Waters. Introduction by Dave Fulton. Rizzoli, 1997. Covers Gorman's 30-year career as an advertising and publicity photographer. Black-and-white shots include posed studio subjects of movie and music legends that have no unattractive blemishes. A perfect world where the retoucher and air brush artist are kings.

GOSLING, Nigel. *Nadar*. Alfred A. Knopf, 1976. Here is a photographic hall of fame—from Baudelaire to Bernhardt—of nineteenth-century Paris, including the most striking figures of that extraordinary world of art, intellect, and culture recorded by France's great pioneer photographer. Each photo is discussed in an interesting short essay that adds up to a fascinating history of that era.

GRAVES, Ralph and Doris O'Neil. *"Life": The First Decade*. Time, Inc., 1979. For those too young to remember, or old enough to want to remember, this book features the best of the best in photography: *Life* magazine from 1936 to 1945. Hard to say what is more dazzling, the photographers (Mydans, Eisenstaedt, Bourke-White, Capa) or their subjects (Astaire, DiMaggio, Times Square, a bombed out London). A greatest-hits album, an all-star team, and a major museum show all wrapped up in a few hundred glossy pages. This is the best of American photography.

GREEN, Jonathan, editor. *"Camera Work": A Critical Anthology*. Aperture, 1974. This anthology, illustrating the avant garde in American art and photography from 1903 to 1917, is drawn from the 50 issues of the photographic quarterly *Camera Work*, edited and published by Alfred Stieglitz.

————. *Snapshot*. Aperture, 1974. This publication—a series of articles, interviews, and portfolios—examines the vitality and ambiguity of the naive home snapshot and its bearing upon a variety of approaches used by contemporary photographers.

GREENOUGH, Sarah. *Harry Callahan*. Bulfinch, 1996. This handsome book is about one of America's best-known photographers, and is a well-written exposition tracing his career. One hundred photographs in color and black-and-white illustrate his mastery of the medium.

GROOVER, Jan. *Jan Groover Photographs*. Introduction by John Szarkowski. Bulfinch/Little, Brown, & Co., 1993. Painterly still-lifes of kitchenware, green peppers, fruit, small bottles, and architectural elements photographed larger than life make up the bulk of these coolly unemotional images. Although done with meticulous attention to detail, these photos are in no way ground-breaking or original in concept or execution. Empty lots, abandoned buildings, and highway traffic in motion also interest Groover.

HALSMAN, Philippe. *The New Vision: Photography Between the World Wars*. Essay by Christopher Phillips. Metropolitan Museum of Art/Harry N. Abrams, 1989. This book is the first broad historical study of the provocative innovations of European and American photography between the world wars. There are 160 images from the rich Ford Motor Company collection which was donated to the Met in the mid 1980s. Famous and unknown photographers chart the urban, technological, and psychological advances of the modern age.

———. *Halsman: Portraits*. Edited by Yvonne Halsman. Harry N. Abrams, 1983. During his *Life* magazine days, Philippe Halsman photographed over 100 covers, more than any other photographer. Nearly all of these photographs of quintessential twentieth-century figures have become classic examples of portraiture. Few photographers today could rack up such an enormous collection of world leaders, Hollywood luminaries, and various cultural and scientific heroes.

HAMBOURG, Maria Morris, and Pierre Apraxine. *The Waking Dream: Photography's First Century, Selections from the Gilman Paper Company Collection*. Metropolitan Museum of Art/Harry N. Abrams, 1993. This massive volume of photographs from a great private collection is an awesome piece of work. Apraxine is the curator of the Gilman Collection. Divided into six sections, the book begins with Fox Talbot and the birth of photography. Section two is about photography in France. The third part introduces the touring photographer, opening with Maxime Du Camp's stunning view at Abu Simbel in 1850. Part four heralds the arrival of photography in America with classic images of the Civil War, Native Americans, and magnificent landscapes. Part five examines turn-of-the-century photography and part six concludes with modern perspectives.

———, Francoise Heilbrun, and Philippe Neagu. *Nadar*. Harry N. Abrams, 1995. Gaspard-Felix Tournachon was a key figure in the renowned artistic circles of Second Empire Paris. He was most active as a photographer for only a decade, starting in 1854, and took portraits of people like Baudelaire,

Georges Sand, Eugene Delacroix, and Sarah Bernhardt. Also captured are familiar Paris landmarks such as the sewers, the catacombs, and the Arc de Triomphe.

HAMILTON, Peter. *Robert Doisneau: A Photographer's Life*. Abbeville Press, 1995. This large-format, glossy tome handsomely presents 400 of Doisneau's classic Paris images. It is more than half text, giving the reader not only the scholarly presentation of a traditional formal biography, but a visual appreciation of the subject's work, a key to truly communicating the life of an artist like Doisneau. This biography provides an intimate and rich account of the life of the French lensman who captured the streets and people of Paris as it entered the modern era.

HANNAVY, John. *Roger Fenton of Crimble Hall*. David R. Godine, 1976. Fenton's fame rests on his Crimean War photos. In this excellent book that work is placed in its true perspective, accompanied by thousands of his other images of people and landscapes and architectural studies. His contributions to and his place in the history of photography are also described. A comprehensive source with photos drawn from major collections in England.

HARVITH, Susan, and John Harvith. *Karl Struss: Man with a Camera*. Cranbrook Academy of Art/Museum, 1976. This catalogue, prepared for a traveling exhibition of Struss's photos, examines his career in New York and Hollywood as still photographer and movie cameraman and shows examples of his work from early 1900 studies of New York to movie stills of Gloria Swanson in a lion's den.

HAWKINS, G. Ray, editor. *Of Passions and Tenderness: Portraits of Olga*. Essay by Alexandra Anderson-Spivy. Graystone Books/University of New Mexico Press, 1993. A handsome volume in a case-bound limited edition with about 50 photographs taken by Baron Adolph (Gayne) de Meyer of his wife, Olga, reputedly the illegitimate daughter of Edward VII. The Baron was a fashion photographer for *Vogue* and *Vanity Fair* in the 1910s and 1920s. These photos of Olga looking chic, stylish, and sophisticated were among Baron de Meyer's best work.

HAWORTH-BOOTH, Mark, editor. *The Museum & the Photograph*. Clark Art Institute, 1998. This book comprises 75 rare photographic works dating from 1853 through 1900, all drawn from the photography collection of the Victoria and Albert Museum in London, the first museum to create a collection of photographs. *The Museum & the Photograph* explores the dual nature of photography as a tool for reproduction and

as an art form, and examines the ways in which the growth of photography influenced the new museum institutions of the nineteenth century, and how, in turn, photography was changed by museum practice.

————. *The New Vision: Photography Between the World Wars.* Essay by Christopher Phillips. Metropolitan Museum of Art/Harry N. Abrams, 1989. This book is the first broad historical study of the provocative innovations of European and American photography between the world wars. There are 160 images from the rich Ford Motor Company collection, which was donated to the Met in the mid 1980s. Famous and unknown photographers chart the urban, technological, and psychological advances of the modern age.

————, and David Mellor. *Bill Brandt—Behind the Camera.* Aperture, 1985. His unique style gives the appearance of a flash gone berserk, or an underexposed and underdeveloped negative printed on the wrong grade of paper. Brandt created his own darkness, bathing his pictures in black midnight shadows even when he was shooting in bright midsummer sunshine. This is a fine monograph of his most significant work from 1928 to 1983.

————. *The Golden Age of British Photography.* Aperture, 1984. Haworth-Booth, distinguished British author and Keeper of the Photographs at the Victoria and Albert Museum, has edited a magnificent reference book which illustrates the self-conscious image of Victorian society. Contains 200 photographs, featuring the work of about 40 of the Empire's nineteenth-century masters. The ten sections are arranged chronologically to focus on the development of photography and its relationship to the modern world of art, science, and industry, the latter symbolized by streamlined machinery, precision optical instruments, and dazzling architecture.

HENDRICKS, Gordon. *Eadweard Muybridge: The Father of the Motion Picture.* Grossman, 1974. This biography of Muybridge's life and work examines the personality of the nineteenth-century pioneer. It also illustrates the scope and excellence of his photographic career and draws on contemporary sources.

HINE, Lewis W. *America and Lewis Hine: Photographs 1904–1940.* Foreword by Walter Rosenblum. Biographical Notes by Naomi Rosenblum. Essay by Alan Trachtenberg. Aperture, 1977. One of America's greatest documentary photographers, whose images of social conditions brought to light the exploitation of child labor. Hine also took pictures showing the dignity of labor in such amazing shots as his pictures of

the workers who were erecting the Empire State Building. This book shows his rare gifts as artist and social reformer.

————. *Men at Work.* Dover, 1977. This classic was first published in 1932 and reissued in 1977. It is a series of photographic studies of modern men and machines. The striking photographs show building construction workers, coal miners, tire makers, machinists, railroad men, riveters, and others. Hine's productive years were 1903 to 1940. He was one of this country's most renowned documentary photographers, who, as he put it, wanted to show the things that had to be corrected and the things that had to be appreciated. By showing the negative side of life—slum kids eating garbage, for example—he was able to elicit strong emotional reactions that aroused the public to clamor for reform.

HOCKNEY, David. *Hockney on Photography. Conversations with Paul Joyce.* Harmony Books, 1988. Hockney's well known photo collages are vibrant, alive, and much in demand. This book, a series of transcribed conversations with filmmaker and photographer Phil Joyce, shows that in addition to being a gifted artist Hockney has a witty and erudite manner of communicating. Long a subject of controversy, he talks frankly about himself and his art, trying to lay misconceptions to rest. This book provides rare insight into the thought processes and working life of one of the world's most celebrated contemporary artists.

HODGSON, Pat. *Early War Photographs: Fifty Years of War Photographs from the Nineteenth Century.* New York Graphic Society, 1974. Collection of photographs depicting nineteenth-century wars. Includes the 1846 war between the U.S. and Mexico, the Crimean War, the Civil War, the Franco–Prussian War, and the Boer War. Text discusses the photographers, their equipment, methods, and the conditions under which they worked.

HOLMES, Burton. *The Man Who Photographed the World.* Edited by Genos Caldwell. Harry N. Abrams, 1977. Holmes was an extraordinary photojournalist whose productive career spanned 55 years, from 1883 to 1938. He traveled to nearly every country in the world, rode the first Trans-Siberian railroad across Russia, photographed the building of the Panama Canal, the Russo–Japanese War, and the Boxer Rebellion. Holmes crossed the Atlantic thirty times, the Pacific twenty times, and went around the world six times. He had an insatiable curiosity and was totally dedicated to his craft. This marvelous volume is a comprehensive collection of more than 350 of his most dramatic news and travel pictures.

HOMER, William Innes. *Alfred Stieglitz and the Photo-Secession*. New York Graphic Society/Little Brown, & Co., 1983. This is the first and among the best accounts of the legendary movement established to prove that photography was the equal of any of the fine arts. Driven by Stieglitz, the group also numbered Edward Steichen, Gertrude Kasebier, Alvin Langdon Coburn, Clarence White, and Frank Eugene among its members. Active from 1902 through the end of World War I, the Photo-Secessionists waged a battle for individual, creative expression, free of the typically sentimental and commercial style of the day. Drawing upon interviews and previously unpublished material, and illustrated with over 100 halftones, this volume stands as a key source for any discussion of Stieglitz and the Photo-Secession.

HOOBLER, Dorothy, and Thomas Hoobler. *Photographing History: The Career of Mathew Brady*. G. P. Putnam & Sons, 1977. Mathew Brady is identified with photographing Abraham Lincoln, John Adams, Dolly Madison, Edgar Allan Poe, Andrew Jackson, Henry Clay, and Daniel Webster. The story of his rise from obscurity to fame, then subsequent decline to poverty, is told in this biography. There is little doubt that Brady was one of the most prolific and important portrait artists and photojournalists who ever lived. His legacy of an age and his news pictures of the Civil War are priceless gifts to history. The aftermath, when the War Department paid Brady only a quarter of what he asked for his magnificent Civil War pictures, then let most of them decay and deteriorate, is a somber story.

HOOKS, Margaret. *Tina Modotti, Photographer and Revolutionary*. Harper Collins, 1993. This biography, illustrated with a good selection of Modotti's work and Edward Weston's photos of her, tells the story of a remarkable woman and outstanding photographer from her birth in northern Italy in 1896 to her death in Mexico City in 1942. Modotti, who learned the art of photography from Weston, became a pioneer among the few women photographers in the 1920s, and has been a significant influence on many photographers.

HORAK, Jan-Christopher. *Photographers and the Avant Garde Cinema*. Smithsonian Institution Press, 1997. Still photographers who have made motion pictures or have had films made about them discussed by the director of the Filmmuseum in Munich, Germany. The photographers include Robert Frank, Helen Levitt, Danny Lyon, Paul Strand, and Laszlo Moholy-Nagy.

HOSOE, Eikoh. *Ordeal by Roses: Ba Ra Kei*. Aperture, 1985. Japan's legendary post-war writer Yukio Mishima, who killed himself by ritual suicide in 1970, is the subject of this book. Bara means roses and Kei means punishment. The book employs solarized portraits, silk-screens, calligraphy, hand-set type, silver lettering on purpose paper, and stark black-and-white photos, and is a stunning example of avant garde graphics and photography. *Ba Ra Kei* defies explanation in simple Western terms, for it is not a traditional picture book but an exploration of the theme of life and death through Mishima's body and flesh.

———, Shomei Tomatsu, Masahisa Fukase, and Daido Moriyama. *Black Sun: The Eyes of Four*. Text by Mark Holborn. Aperture, 1986. A statement on postwar Japan as interpreted by four photographers, all born during the 1930s, the period when their country began its conquest of mainland China. By 1940, Japan was primed for a major war and these photographers spent their early childhood in the bellicose atmosphere that pervaded the nation, a shared journey of collective experiences and memories.

HOWES, Chris. *To Photograph Darkness*. Southern Illinois University Press, 1990. This unique history of flash photography underground traces the history and technology of underground photography, from the first picture taken in the catacombs under the Paris streets, to the dark interiors of the Egyptian pyramids, to the secret bat caves in Carlsbad Caverns. A fascinating and easy-to-read account of the use of artificial light.

HUGHES, Jim. *The Birth of a Century: Early Color Photographs of America*. Photographs by William Henry Jackson. Tauris Park Books/St. Martin's Press, 1994. Before the technology to take color photographs had evolved, pioneering photographer William Henry Jackson heard about a secret photo-lithographic Swiss process for turning black-and-white photographs into color. Taking some 10,000 of his black-and-white negatives, which he deemed the most important pictures of his collection, Jackson and his wife and daughters moved to Detroit to join up with the Detroit Photographic Company, where he familiarized himself with the Photochrom process and oversaw the color conversation of many of his negatives.

———. *W. Eugene Smith: Shadow and Substance; The Life and Work of An American Photographer*. McGraw—Hill, 1989. This 606-page book—with a 32-page signature of photos—is a brilliant piece of research and writing that provides a clear understanding of W. Eugene Smith's life and work. The issues he confronted were large: life and death, love and hate, good and evil. The thread that ran through all of Smith's work was the indomitability of the human spirit.

HUJAR, Peter. *A Retrospective*. Edited by Urs Stahel and Hripsime Visser. Scallo, 1994. People, animals, landscape. Whatever the subject, Hujar approached them all with the same great respect and level of sensitivity. He recorded his own world, and the outside world, with astonishingly beautiful portraits. He shot cows, geese, and sheep in the country, men exposing themselves on a park bench, portraits of friends like William S. Burroughs, Candy Darling, Divine, and Paul Thek, and men, men and more men, dressed and undressed, awake and asleep, near and far, beautiful and repulsive. Hujar, who died of AIDS, was an outsider in more ways than one, editor Stahel says. With ideas diametrically opposed to the thoughts and spirit of his times, he remained entirely focused on documenting things as he saw them.

———. *Portraits in Life and Death*. Introduction by Susan Sontag. Da Capo, 1976. Portraits of literary and art world figures followed by a portfolio of skeletal remains in the catacombs at Palermo. A sensitive kind of meditation on the human destiny.

IMES, Birney. *Whispering Pines*. Foreword by Trudy Wilner Stack. University Press of Mississippi, 1994. A shabby roadside tavern called Whispering Pines in the Mississippi backwoods; its clientele; its proprietor, Blume C. Trippett; and his collection of relics have inspired a brilliant collection of portraits and jewel box-like still-lifes. The photographer, himself a longtime habitué of the rural saloon, has conjured up a time capsule view of a now-vanished world.

———. *Juke Joint*. Introduction essay by Richard Ford. University Press of Mississippi, 1990. Imes portrays the people of rural Mississippi in the places where they gather to visit and socialize. This brilliant volume (conceptually and colorfully) is the product of photographs he took while traveling the Delta between 1983 and 1989. In his photographs, Imes admits that he strove to preserve the ambient light.

ITURBIDE, Graciela. *Images of the Spirit*. Aperture, 1996. There is a surreal quality to many of these duotone images, principally of Mexican and other Latin American women and children. Even an apparently straightforward shot showing a woman framed by a crudely outlined window and displaying four fish seems to transcend the literal image and invite the viewer to ponder its meaning.

JAMMES, André. *William H. Fox Talbot: Inventor of the Negative-Positive Process*. Macmillan, 1974. Contains selections from *Pencil of Nature*, the first book ever illustrated with photographs. Also includes various photographs by Talbot.

JEFFREY, Ian. *The Photo Book*. Phaidon Press, 1997. An impressive volume, covering 150 years of photography with 500 full-page images, ranging from Louis-Jacques Mandé Daguerre's 1838 "Boulevard du Temple" to Jim Goldberg's 1995 "Tweeky Dave, " and all neatly arranged in alphabetical order. In between there are many famous names and familiar photographs.

———. *Bill Brandt: Photographs 1928–1983*. Thames & Hudson, 1994. This retrospective covers every aspect of the great British photographer's work. Brandt photographed in England during and after World War II, producing brilliant landscapes, nudes, and portraits of, among others, Rene Magritte, Francis Bacon, and Peter Sellers.

JOHNSTON, Frances B. *The Hampton Album*. Introduction and a note on the photographs by Lincoln Kirstein. Museum of Modern Art/Doubleday, 1966. Photographs originally made for the Paris Exposition of 1900 by Frances Benjamin Johnston, demonstrating the contemporary life of blacks in America, especially at the Hampton Institute in Virginia.

JONES, Edgar Yoxall. *Father of Art Photography: O. G. Rejlander, 1913–1875*. New York Graphic Society, 1973. This interesting study has over 80 examples from the wide range of Rejlander's work—tableaux, allegories, Victorian images of children, and portraits of such contemporaries as Alfred Lord Tennyson. His life and art are well-documented in the accompanying text.

KAHMEN, Volker. *Art History of Photography*. A Studio Book/Viking, 1975. Ever since photography's invention in 1839, the debate has raged: Is "Photography" a Legitimate Art Form? In this scholarly tome, Kahmen, an esteemed critic, uses over 350 photographs to present a fascinating history and analysis of the purposes, aesthetics, and other elements that have guided photographers along different paths of discovery. Evoking photographers and thinkers from Ansel Adams to Emile Zola, this book advances theories of all kinds, but comes to a singular conclusion. Art runs like a spine through the development of photography, the medium being a nerve center of creativity.

KAPLAN, Daile. *Photo Story: Selected Letters and Photographs of Lewis W. Hine*. Foreword by Berenice Abbott. Smithsonian Institution Press, 1992. Kaplan, noted curator at Swann Galleries, is the eminent authority on Lewis Hine and has collected and edited an excellent reference work covering his early years. This book includes personal and professional correspondence with such notables as Beaumont Newhall, Walter

Rosenblum, Berenice Abbott, and Roy E. Stryker. Hine's documentary photography covered many subjects: Ellis Island immigrants, child laborers, war refugees, industrial workers, and construction of the Empire State Building.

KARSH, Yousuf. *Karsh Portraits*. New York Graphic Society, 1976. These 48 gravure portraits by the famous Canadian portrait photographer offer an imposing cross-section of public figures from Pope John to Norman Mailer, accompanied by Karsh's recollections of the sittings.

KERTÉSZ, André. *Kertész on Kertész*. Introduction by Peter Adam. Abbeville Press, 1985. Classic pictures annotated with the photographer's own description of the time and place he took the photo.

————. *Distortions*. Introduction by Hilton Kramer. Alfred A. Knopf, 1976. First shown in 1932 in Paris, this surrealist series of images of women is beautifully reproduced in this important publication.

————. *Sixty Years of Photography: 1912–1972*. Edited by Nicolas Ducrot. Grossman, 1972. As the father of candid photography, his pioneering work has inspired and been an enormous influence on more than a generation of artists and photographers. His distortion portraits and nude studies from the 1920s and 1930s have been copied on canvas and film but rarely equaled. The 200 pictures in this volume constitute the most complete assemblage ever published of Kertész's work to date.

KINSEY, Darius and Tabitha May. *Kinsey: Photographer. Volume Three: The Locomotive Portraits*. Chronicle Books, 1984. Before Henry Ford, before Orville and Wilbur Wright, and way before John Glenn and Neil Armstrong, the railroad was an integral part of the American way of life. Political campaigns were conducted on them. Most of the nation's freight was transported on them. There was no other way to get from one end of the country to the other. The lore, lifestyle, and romance of the old engines are captured here in a collection from the cache of the famous Washington state husband and wife team. The beautiful symmetry of the old bridges. The heat from stoking the old coal engines. Coming around a mountain pass. Toot toot!

————. *Kinsey: Photographer. Volume One: The Family Album. Volume Two: The Magnificent Years*. Prism Editions, 1978. This book is two-thirds of a three-volume set encompassing the life's work of the husband and wife team. Husband Darius snapped the shots and wife Tabitha did the processing. What remains are 4,500 negatives in a variety of formats. There are family portraits, stunningly beautiful scenes of the Pacific Northwest, records of expeditions, men logging, reproductions of newspaper ads touting the Kinsey's services and stereo cards of tourist sites. The photos and format are large; this is a history of a family, a time, and a place that the reader is lucky to see survived.

KLEIN, William. *In and Out of Fashion*. Edited by Mark Holborn. Afterword by Martin Harrison. Random House, 1994. This high-impact collection of fashion photos is by one of the world's best photographers. Klein has an extraordinary sense of what makes a great photo: he stands a model precariously on a window sill; another is gesturing to a wax figure of Napoleon. This is a fun trip to Paris, Rome, New York, London, Hollywood, even Coney Island, with some exciting, and very graphic images.

KLUVER, Billy. *A Day with Picasso: 24 Photographs by Jean Cocteau*. MIT Press, 1997. Kluver, a founder of the extraordinary Nine Evenings of Art and Engineering held at the Lexington Avenue Armory in 1966, has produced an unusual and interesting book. Using a set of 24 photos taken by Jean Cocteau of a group of friends during a four-hour period on August 12, 1916, Kluver set out to discover the exact locations and movements of the group while the photos were being shot. The original photos were taken by Cocteau with his automatic Kodak Junior camera and traced the activity of Picasso, Eric Satie, and their friends Valentine Gross, Max Jacob, André Salmon, Moise Kisling, Henri Pierre Roche, Manuel Ortiz de Zarate, Emilienne Paquerette, and Marie Wassilieff. By measuring the shadows and angles in each photo to determine a time frame and using a complete printout of the sun's movement on that day together with the length of shadows, Kluver was able to calculate the exact time of day each photo was taken, thus establishing a sequence of the group's movements from lunchtime at Le Rotonde on the Blvd. Montparnasse until 4:30 p.m. Kluver even established where Cocteau stood while taking each photo and in which direction the camera was pointed.

KOPELOW, Gerry. *How to Photograph Buildings and Interiors*. Princeton Architectural Press, 1998. This fine source book shows how to do architectural photography. Kopelow covers it all—the camera, the film, the processing, the tripods, lighting, and filters.

KOUDELKA, Joseph. *Gypsies*. Aperture, 1975. These are photographs of gypsies taken in Eastern Europe. Koudelka's

profound feelings for the people and their way of life are presented in these strong black-and-white images.

KRAUSS, Rosalind, Jane Livingston, and Dawn Aides. *L'Amour fou: Photography and Surrealism*. Abbeville Press, 1983. This book is erudite, a theoretical textbook that covers a lot of territory. Each author has written an essay on surrealism and its manifestations in France, England, Belgium, and Germany. Their theses uncover the formation and development of the movement in its first two decades and show the critical role photography played in the surrealist movement.

KUNHARDT, Philip B. Jr. *"LIFE": World War II*. Little, Brown, & Co., 1990. A treasure trove of great wartime photographs by such renowned names as Robert Capa, Eugene Smith, Margaret Bourke-White, and Carl Mydans, among many others. *Life* magazine's coverage of the war in Europe, the Pacific, and events on the homefront provides an eagle's-eye view of the war's causes, actions, and effects.

LANG, Gerald and Lee Marks. *The Horse, Photographic Images 1839 to the Present*. Harry N. Abrams, 1991. Photographers ranging from such pioneers as Nadar and Muybridge down to modern day practitioners of photography Andy Warhol and Joel Meyerowitz have produced diverse images of horses. This unique volume pays tribute to the horse, its utilitarian role in the development of transportation as well as agriculture, sport, war, conquest. The images run the gamut from a Victorian child's rocking horse to the proverbial cowboys riding into the sunset. Among the other memorable images are General Robert E. Lee on his faithful horse Traveler, and Cartier-Bresson's "Stud Farm," shot in 1968.

LAUGHLIN, Clarence John. *Clarence John Laughlin: The Personal Eye*. Aperture, 1973. This New Orleans-based photographer relied on his interests in painting, poetry, psychology, and architecture to find mysterious images of balconies, cemeteries, decaying buildings, and surrealistic double images of people and objects.

LEIBOVITZ, Annie. *Photographs 1970–1990*. Harper Collins, 1991. Two hundred and twenty eight images of pop culture icons by the master herself. Some of these are previously unpublished photos, but most were *Rolling Stone* or *Vanity Fair* assignments. They range from a blue-painted John Belushi and Dan Ackroyd to her classic Lennon and Ono embrace, a "Franz Klined" Steve Martin in front of his Franz Kline painting, and all the rest—Jagger, Baryshnikov, Schwarzenegger, Warhol, Ali, Dylan, Springsteen. A good number of all the celebrities and entertainment stars that Liebovitz has captured

over her career as one of America's leading celebrity portrait photographers are here.

LESY, Michael. *Dreamland*. The New Press, 1997. Lesy, a photo historian and professor, has compiled a book chock full of images, most never before seen, of America at the dawn of the twentieth century. There are shots of the Flatiron building, Cincinnati's Eden Park, Eureka Colorado, The Plaza Hotel in New York, Lincoln Park's Shore Drive in Chicago, tennis on Shelter Island and golf in the Adirondacks, and the industrial revolution in cities from sea to shining sea.

LINK, O. Winston. *Steam, Steel, and Stars: America's Last Steam Railroad*. Harry N. Abrams, 1987. A fascinating collection of Link's photographs of the great iron horses of the Norfolk and Western, the last railroad in the United States to use steam power.

LITCHFIELD, R. B. *Tom Wedgwood, the First Photographer. An Account of His Life, His Discovery and His Friendship with Samuel Taylor Coleridge*. Arno Press, 1973. This is an authoritative volume on Wedgwood's experiments, as well as a biography that places this pioneer's work among the other intellectual trends of Romantic England. Originally published in 1903.

LIVINGSTON, Jane. *Lee Miller Photographer*. Thames & Hudson, 1989. When World War II began, Miller became an accredited correspondent for *Vogue*, and covered the London blitz. She was at Dachau and Buchenwald when the camps were liberated, and even photographed herself taking a bath in Hitler's personal tub. Her atrocity photos, among the most horrifying ever made, were published in the June 1945 issue of *Vogue*.

———, and Frances Fralin, editors. *The Indelible Image: Photographs of War, 1846 to the Present*. Harry N. Abrams/Corcoran Gallery of Art, 1985. This anthology of war images was gathered from archives around the world, and includes work by both great (Fenton, Brady, Bourke-White, Hine, Mydans, Smith, McCullin, Peress, Meiselas) and unknown photographers. Text includes Fralin's rationale for the choices of images and Livingston's essay on the picturing of war in various mediums, and brief historical notes on the wars portrayed. Full captions and biographies of the photographers are a plus.

LONGWELL, Dennis. *Steichen: The Master Prints 1895–1914*. Museum of Modern Art, 1978. Here are the master's familiar images—73 plates taken by Steichen, collected for an exhibition at the Museum of Modern Art and faithfully reproduced

in this volume published in conjunction with the show. In addition to the images, there are a good bibliography and notes; a fascinating section on Steichen's printing techniques; a list of Steichen reproductions (mainly in Stieglitz' *Camera Work*); articles by Steichen from 1900–1914; selected articles about Steichen from 1901 through 1975; as well as lists of exhibition catalogs, books on Steichen, Stieglitz, and the Photo-Secession, and books on the symbolist movement.

LOPES, Sal. *The Wall: Images and Offerings from the Vietnam Veterans Memorial*. Introduction by Michael Norman. Collins Publishers, 1987. *The Wall*, with over 75 powerful photographs by 16 award-winning photojournalists, provides an opportunity for everyone to share the collective grief that is associated with the 58,132 dead and missing warriors whose names are chiseled into this cold, somber, black granite slab. Conceived by former Infantryman Jan C. Scaggs and designed by Maya Ying Lin, the memorial was dedicated on Veteran's Day, November 11, 1982.

LORENZ, Richard. *Imogen Cunningham: Ideas Without End, a Life in Photographs*. Chronicle Books, 1993. An icon of twentieth-century American photography, Cunningham was one of the first women to make her living as a photographer. Her long career spanned seven decades. Her photos ranged from still-lifes of plants, to portraits of Hollywood celebrities, to bold, evocative nudes. One hundred of her photographs make this a superb collection of her pioneering work.

LOTHROP, Eaton S., Jr. *A Century of Cameras*. Introduction by Robert Doherty. Morgan & Morgan, 1973. A cross-section of early cameras, showing original illustrations, catalogue pages, pertinent data, related literature and photographs selected from the International Museum of Photography at George Eastman House.

LOWRY, Bates, and Isabel Barrett Lowry. *The Silver Canvas: Daguerreotype Masterpieces from the J. Paul Getty Museum*. Getty Trust Publications, 1998. This is not only a superb compilation of some 80 images chosen from the museum's holdings of 2,000 daguerreotypes. It is also a brilliantly conceived history of the artistic and scientific development of the daguerreotype process and its effect on European and American culture. Using eyewitness descriptions, the authors narrate the public's immediate interest in the new process and how practitioners of the new art form used the medium.

LUCIE-SMITH, Edward. *The Invented Eye: Masterpieces of Photography, 1839–1914*. Two Continents, 1975. A noted art critic surveys the pioneer period of photography and discusses

the works and lives of its most important practitioners. More than 150 photographs form a magnificent record of these photographers' perceptions of the world around them.

LYNCH, Dorothea. *Exploding Into Life*. Photographs by Eugene Richards. Aperture, 1986. A numbing, profound account of one woman's experience with cancer. Lynch's diary and Richards' photos are a synthesis of a shared experience of cancer. It is a record of her strength, her humor, her desperation, and her battle to gain control over her life, as well as an accounting of the archaic health system and the medical bureaucracy that refused to let her visit and write about other cancer patients after she was first released from the hospital.

LYNES, George Platt. *Photographs from the Kinsey Institute*. Essays by James Crump. Introduction by Bruce Weber. Bulfinch, 1993. Lynes, widely known for his surrealist-inspired mythological studies, portraits, and homo-erotic nudes, studied in Paris with Man Ray and was influenced by Jean Cocteau, Gertrude Stein, and Joseph Cornell. Lynes was invited by Lincoln Kirstein of The American Ballet Company to photograph George Balanchine's productions. Other than dance photography, Lynes' main interest was in photographing nudes; these pictures were never seen by the public. This archive of both male and female nudes, portraits, and dance images are the basis for this monograph.

LYON, Danny. *Conversations with the Dead*. Holt, Rinehart, & Winston, 1971. Photographs of convict life in a Texas prison, with the letters and drawings of Bill McCune, a convict serving a life sentence. This is a powerful portrait of the oppression and futility inside Texas prisons.

MADDOW, Ben. *W. Eugene Smith: Let Truth Be the Prejudice*. Aperture, 1985. In this illuminating and eloquent tribute to this great master of photojournalism, the author has drawn on the extensive archives left by W. Eugene Smith to the University of Arizona Center for Creative Photography in Tucson. The book displays his numerous classic icons as well as his many historic *Life* magazine assignments, especially those done during World War II. Smith photographed the battles on Wake Island, Tarawa, Saipan, Guam, Iwo Jima, and Okinawa.

————. *Edward Weston: Fifty Years, the Definitive Volume of His Photo Work*. Aperture, 1974. A comprehensive survey of Weston's development as an artist, from the romantic, soft-focus style of the early twentieth century to a new Weston style that emerged in the early Twenties. Weston's photographs of nudes, peppers and seashells, rocks and clouds have become

classic icons of the sensual beauty of natural objects. In this authoritative volume, the author focuses not only on the work, but also on the life, using Weston's journals and letters, and the memories and written accounts of those who knew him best.

MAGUBANE, Peter. *Vanishing Cultures of South Africa*. Foreword by Nelson Mandela. Rizzoli, 1998. After a fascinating and often painful 45-year career documenting the atrocities and eventual change in his native South Africa, Magubane noticed something no one else did regarding the traditions and customs of the indigenous people of his country. The political, social, and economic changes were transforming, and in some cases eliminating, the social organization that had made each tribe unique. This large and colorful book features ten major ethnic groups and in words and pictures explores their roots, cultural identity, and future. His intimate photos of a culture in transition succeeds on many levels. It records the present for posterity, it educates about the past—beliefs, rites of passage, social organization—and presents possibilities for the future.

———. *Magubane's South Africa*. Alfred A. Knopf, 1978. Magubane covered the Pretoria treason trials of 1956, the Sharpeville Massacre of 1960, and the bloody Soweto riots. This book is a personal account of his struggle against the authorities in a country under apartheid. His enlightening text, accompanied by his documentary pictures, is moving and painful evidence of the cruel and inhuman treatment of blacks. Few books about black life in South Africa have expressed so vividly its pain and abject misery.

MAHOOD, Ruth, I., editor. *Photographer of the Southwest: Adam Clark Vroman*. Ward Ritchie, 1961. Photographs of Hopi Indian life; an important documentary.

MALANGA, Gerard. *Resistance To Memory*. Arena Editions, 1998. A compilation of portraits taken during the 1970s of the legendary cultural artistic, literary, and musical figures of the era, many of them Malanga's friends. His portraits of Abbie Hoffman, Iggy Pop, Lou Reed, Ted Berrigan, John Cage, Jasper Johns, Bucky Fuller, Anne Waldman, Candy Darling, Terry Southern, and Larry Rivers, among others, establish Malanga as a talented photographer, as well as a poet and filmmaker.

———, editor. *Scopophilia: The Love of Looking*. Alfred van der Marck Editions, 1986. In this distinctly offbeat book, Malanga explores the territory between photography and voyeurism in interviews with 32 artists illustrated with previously unpub-

lished photos taken by the artists, among them Elliott Erwitt, Peter Hujar, Jeanloup Sieff, and Andy Warhol. Artist Larry Rivers, for example, tells of his project videotaping his daughter's development, partially so they'd have a record of her growth, partially for his own voyeurist interest.

MALCOLM, Janet. *Diana & Nikon: Essays on the Aesthetic of Photography*. David R. Godine, 1980. Malcolm, the longtime photography critic for *The New Yorker*, tackles the question of where photography fits in relation to the hierarchy and history of the other expressive arts, like painting, sculpture or literature. She discusses several major photographers like Avedon, Steichen, Stieglitz, and Weston, and uses numerous examples of their work to illustrate her complicated and controversial points. Malcolm is a strong advocate for photography and tells you exactly why she feels it deserves such praise.

MANCHESTER, William. *In Our Time: The World as Seen by Magnum Photographers*. Essays by Jean Lacouture and Fred Ritchin. W. W. Norton & Co., 1989. These were tough, hard-news assignments that took courage, discipline and determination. Magnum photographers seem to know what and when to shoot; they have an understanding of the inherent complexities of the subject and the interpretive power to convey a message with their photos.

MANGAN, Terry William. *Colorado on Glass*. Sundance, 1975. A rich record of photography in Colorado from the Gold Rush in 1859 to the beginning of the twentieth century. This fascinating history has been compiled from William Henry Jackson's renowned views of the state and major collections of late nineteenth-century life. Where possible, photographers' own accounts are included and there is a directory of early Colorado photographers.

MAN RAY. *Man Ray: Photographs*. Text by Jean-Hubert Martin, Philippe Sers, and Herbert Molderings. Thames & Hudson, 1997. First printed in 1982 in conjunction with an exhibit of Man Ray photographs at the Pompidou Center in Paris, this collection of 347 duotone plates documents the work of, arguably, the greatest creative photographer of the twentieth century. Although he took up photography in 1915 simply to reproduce his paintings, Man Ray went on to become an extraordinarily creative and inventive master of the medium. He isolated unlikely objects—an eggbeater, for example— and explored the nature of their reality using their shadows to project an infinity of virtual forms playing on the original shape. His portraits of such celebrated friends as T. S. Eliot, Gertrude Stein, and Marcel Duchamp brought him fame and financial stability, but he continued to experiment with his

rayographs, solarizations, and cliché-verres—all done without a camera—and produced unique images. This handsome volume provides a thorough overview of his photography and, in the essays, explains the philosophic underpinnings of his art.

————. *Photographs*. Thames & Hudson, 1982. Said Man Ray: "I paint what cannot be photographed, I photograph the things that I don't want to paint." And: "I would photograph an idea rather than an object, and a dream rather than an idea." Three separate essays and 347 images make up this fascinating look at one of the greats. Prepared in conjunction with a 1981 Pompidou Center retrospective, this volume is a must for any serious student of photography. As much as a book can capture the essence, the aura, the creativity of an individual, this book captures Man Ray.

————. *Photographs: 1920–1934*. Introduction by A. D. Coleman. Text by Paul Eluard, André Breton, Marcel Duchamp and Tristan Tzara. Reprinted from the first edition—published in Paris in 1934—by East River Press, 1975. Outstanding documentation of the body of photographic work by the creative artist who employed many media in his exploration of avant garde artistic theory, especially solarization, camera-less photography, and experiments in double exposure.

MARIEN, Mary Warner. *Photography and Its Critics: A Cultural History 1839–1900*. Cambridge 1997. From the beginnings of the medium there has been an often intense battle among critics, artists, historians and the public over the merits of photography as art. In this easy-to-read, well-documented study, Marien argues that photography was an important cultural and social symbol for modernity and change in art and social reform. The argument is buffered by a nice choice of illustrations, from photos to early illustrated periodicals.

MARK, Mary Ellen. *Mary Ellen Mark: 25 Years*. Essay by Marianne Fulton. Bullfinch, 1991. Photographs of leprosy patients, blind orphans, heroin addicts, retarded women, deformed children, street prostitutes, the homeless, the destitute, and the dying are the tough, gritty realism recorded by esteemed photojournalist Mark. All in black-and-white, printed full-frame, her work shows her desire, her need to get close, to discover, to understand and reveal the complex and rich variations in individual lives.

MARSHALL, Jim. *Not Fade Away: The Rock & Roll Photography of Jim Marshall*. Foreword by Michael Douglas. Bulfinch/Little, Brown, & Co., 1997. Jim Marshall is the premier west coast

photographer of rock and roll. In *Not Fade Away*, Marshall shows his most sought-after collector's items, with each photo annotated by him. Some of his classic images are Bob Dylan rolling a tire down the street, Janis Joplin reclining on a chaise lounge with a bottle of Southern Comfort, Jim Morrison taking a puff on a cigarette, Richie Havens playing on stage at Woodstock on opening day, Jimi Hendrix backstage at Monterrey Pop with Brian Jones, and Sonny and Cher looking like waifs at the Cow Palace. Marshall loads his handsome book with nostalgia for the good old days when photographers had complete access to the stars—backstage, on stage, in the dressing rooms, hotel rooms, on planes, and in their homes to make in-your-face candids. Marshall admits that era is long gone; nowadays it's strictly assembly-line photo ops prepared, staged, and directed by a photo stylist who tells the photographer what and when to shoot. The text describing Marshall's career is disarming and touching.

McADAMS, Dona Ann. *Caught in the Act: A Look at Contemporary Multimedia Performance Photographs*. Introduction by C. Carr. Afterword by Eileen Myles. Aperture, 1996. Dona Ann McAdams has dedicated herself to photographing performance art, and her efforts have resulted in this stunning book designed by Yolanda Cuomo. *Caught . . .* captures the spirit of an art form that most people know little about. McAdams, who never uses flash and shoots with a quiet Leica, documented an elite group of multimedia performance artists who use music, dance, poetry, opera, and/or theatre to transform our perception and understanding of their art. Included among these artists, many of whom contributed text, scores, or drawings to this work, are Blue Man Group, Bill T. Jones, Annie Sprinkle, Tim Miller, Philip Glass, Pat Oleszko, Spaulding Gray, Eric Bogosian, Meredith Monk, and John Cage. One particular highlight is the photo of Allen Ginsberg reading his poem "The Ballad of the Skeletons," which is reprinted next to the picture. This is a remarkable publication documenting a broad selection of work by some of the most spirited creators of our era.

McCARTNEY, Linda. *Roadwork*. Bulfinch/Little, Brown, & Co., 1996. *Roadwork* shows the depth of a talent that was not overshadowed by her superstar husband, Paul. In this volume she produced a wonderful personal diary of people, places, and things. She took her camera into the streets of New York, London, Paris, Barcelona, Tokyo, New Orleans, and Rio de Janeiro. Her selections, dating from 1971, are eclectic, taking in images that caught her eye as she whizzed by a blur of street signs, storefronts, rooftops, anonymous pedestrians, and vehicles. These are unplanned, instantaneous grab shots that show McCartney as an intuitive documentarian who is an astute

visual chronicler of her surroundings.

McCULLIN, Donald. *Sleeping with Ghosts: A Life's Work in Photography*. Introduction by Mark Haworth-Booth. Aperture, 1996. Fearless Don McCullin is among the most celebrated crisis photographers in the world, and this book is a comprehensive document of his life's work in the killing fields. But this volume, all in black-and-white, is more than just catastrophic gun battles. McCullin includes his important pictures of Yorkshire miners, the homeless, anti-fascist demonstrators, and street gangs.

————. *Is Anyone Taking Any Notice?* The M.I.T. Press, 1973. This is a book about the human condition and our responsibility; a brutal comment on wars.

McKENNA, Rollie. *A Life in Photography*. Alfred A. Knopf, 1991. Her life unfolds before you so that you feel you know her intimately. Her captivating photographs reflect her deep interest in poets, artists, writers, and photographers. Her instincts and perceptions are evident in this warm, compassionate, and personal autobiography.

McLUHAN, T. C. *Dream Tracks*. Harry N. Abrams, 1985. McLuhan traces how a massive campaign by the Santa Fe Railroad exploited the Indians while developing the Southwest. The railroad produced lantern slides, posters, magazine ads, and calendars depicting an exotic version of Indian life and promising a picturesque trip to the wilderness of Indian territory. In addition, motor-cruise detours took tourists to Pueblo reservations to see Indians weave blankets and baskets, make pottery, and perform in ceremonial dances. These fascinating events are documented by a collection of original hand-colored lantern slides from the estate of an employee of the railroad.

MELLOR, David, editor. *Cecil Beaton—A Retrospective*. New York Graphic Society, 1986. His name is synonymous with British culture, breeding, authority, and art. Beaton's role as photographer, diarist, designer, fashion expert, dilettante, and friend of the fashionable from the Duchess of Windsor to Andy Warhol is covered in eight essays written by historians, editors, and curators. Each provides a fascinating insight into the career of this globetrotting dandy.

MELLY, George. *Paris and the Surrealists*. Photographs by Michael Woods. Thames & Hudson, 1991. Retraces the Paris streets and sites that inspired the artistic innovators of the 1920s who came to be known as the Surrealists. Poets, writers, and painters, they walked through Paris, seeking the signs and portents concealed beneath the banal surface of everyday life, always hoping for adventures. The author intertwines the story of his own fascination with Surrealism with a thoughtful analysis of the major works of Surrealist literature by André Breton and Louis Aragon. Michael Woods' accompanying black-and-white photos are splendid.

MEYEROWITZ, Joel. *A Summer's Day*. Times Books, 1985. Provincetown, with its sea captains' houses, well-kept lawns, and zigzag streets, are featured in Meyerowitz's classic book in rainbow colors. Here is the bay, the beach, the backyard hammock, the Victorian porch, the sand dunes, the marshes, the cranberry patches. He has created a portrait from dawn to dusk—serene, peaceful, contemplative, simply beautiful.

MICHALS, Duane. *Real Dreams*. Addison House, 1976. Over a decade worth of work of the fantastic sequence stories the author spins off in photos and words that let the reader-viewer join his fantasy world of gentle humor and Kafkaesque transformations.

MILLER, Russell. *Magnum: Fifty Years at the Front Line of History*. Grove, 1998. This is Miller's biography of the world's most glamorous picture agency; a large, unruly, and talented family that has stayed together for fifty years. The British journalist introduces Magnum's founders—Robert Capa, David "Chim" Seymour, Henri-Cartier Bresson, and George Rodger—whose idea was to form a cooperative agency that would give photographers maximum control of their work. Miller draws on interviews with Magnum members and agency files for his solidly documented account of the agency's internal workings.

MILLSTEIN, Barbara Head, and Sarah M. Lowe. *Consuelo Kanaga: An American Photographer*. University of Washington Press, 1993. Her career, which spanned more than 50 years, reflected her eclectic interests ranging from social documentation to near-abstraction, Precisionism, and commercial photography. The portraits show Kanaga's consummate technique. Her images, particularly of African-Americans, are powerful in their sculptural emphasis. This book, with 174 black-and-white images, provides a detailed portrait of Kanaga and her work.

MIROLUBOVA, G. *A Portrait of Tsarist Russia*. Pantheon, 1989. This splendid portrait of the last days of Tsarist Russia is from seven Soviet archives. The earliest daguerreotype shows the Isaac Cathedral in St. Petersburg under construction. A penetrating view of the Russian people, places, and events—from elegant family portraits to simple, everyday snapshots, and from the lifestyle of the aristocracy to the humble struggle of peasants. Russia comes alive in extraordinary battlefield

scenes, ferocious labor demonstrations, and rare views of
Siberian Eskimos.

MISRACH, Richard. *Desert Cantos*. Introduction by Reyner
Banham. University of New Mexico Press, 1987.
Misrach proves that manmade destruction and devasta-
tion can make beautiful photographs and serve as a
useful conservation project. The desert provides the the-
matic focus in this book, which Misrach organizes
around his Cantos. Like an epic poem, each Canto (The
Terrain, The Event, The Flood, The Fires) is an indepen-
dent unit in a larger opus.

MONTI, Nicolas, editor. *Africa Then*. Alfred A. Knopf, 1987.
Rare images taken from 1840 to 1918 provide a spectacular
visual record of Africa during the time when it was domi-
nated and exploited by the British, French, and Germans.
Collected by Monti from obscure archives and private
sources, the photos represent the work of 115 leading pho-
tographers of their day from England, Italy, and Austria. The
most beautiful pictures of the Egyptian pyramids are by the
Germans Rudolph Lehnert and Ernst Landrock, studio pho-
tographers who settled in Tunisia in 1904.

MONTIER, Jean-Pierre. *Henri Cartier-Bresson and the Artless
Art*. Bulfinch/Little, Brown, & Co., 1996. Cartier-Bresson
called his Leica an extension of his eye, one through which he
could perceive and organize a scene with the speed of vision
itself, the "decisive moment." Montier brings all of the details
of this modern master's career into focus in his informative
text, analyzing Cartier-Bresson's artistic efforts in drawing,
cinematography, and photography. Montier discusses the
philosophies that guide the photographer's work, notably Zen
and Surrealism.

MOORE, Charles. *Powerful Days*. Introduction by Andrew
Young. Stewart, Tabori, & Chang, 1991. A remarkable docu-
ment by one of America's leading photojournalists who went
every step of the way in the Civil Rights movement from
1958 to 1965, the period covered in this book. Moore
photographed freedom marches in Montgomery, Selma,
Oxford, and Birmingham; the voter registration campaign,
and the activities of the Ku Klux Klan.

MORA, Gilles, editor. *Photospeak: A Guide to the Ideas,
Movements, and Techniques of Photography, 1839 to the Present*.
Abbeville Press, 1998. Filled with valuable information and
beautifully packaged with easy-to-read type, good illustra-
tions, and a handsome cover, this is a compilation of
photographic terms from abstraction to vortograph. Part of an

Abbeville series that includes Artspeak, ArtSpoke, and
Antiquespeak.

————. *Edward Weston: Forms of Passion*. Harry N. Abrams,
1995. Includes a number of previously unpublished images, all
printed on a beautiful chalk-white stock, printed and bound in
Italy. A combination of biography and critical analysis, this
handsome volume traces the master's career from his early
days, through his formative years in Mexico, and to the onset
of Parkinson's Disease, ten years prior to his death in 1958.
Fans of Weston will find many of their favorite images in this
volume which includes a chronology, bibliography, and list of
exhibitions.

————, and John T. Hill. *Walker Evans: The Hungry Eye*. Harry
N. Abrams, 1993. No broader or more comprehensive view of
this important, innovative, and distinguished photographer has
ever been published. Hill was Evans's longtime friend and
executor of his estate. Mora was the longtime editor of the
important French photo magazine *Cahier de la Photographie*.
They bring unbridled enthusiasm to their subject, who could
not be more deserving of such a feature length project.
Broken down into specific time periods, each section features
an enlightening accompanying text.

MORATH, Inge. *Portraits*. Introduction by Arthur Miller.
Aperture, 1986. An intimate look at Morath's friends and
acquaintances whom she has known with her husband, Miller.
Important visages of the post–World War II era abound:
Alexander Calder, Mary McCarthy, Eleanor Roosevelt, Anaïs
Nin, Igor Stravinsky, and Jean Cocteau, among others. Her
scrapbook is an artistic, literary, and political history of
two decades.

MORGAN, Barbara. *Barbara Morgan*. Foreword by Peter
Bunnell. Morgan & Morgan, 1972. These photographs cover
summer-camp children to photo-montages, symbolic pho-
tographs, light-tracings, and her famous dance pictures of
Martha Graham.

MORGAN, Willard D., and Henry Lester. *Graphic Graflex
Photography*. Morgan & Morgan, 1972. Originally published in
1953, this manual by 30 experts covers the entire large-for-
mat photographic field in 29 chapters. Information ranges
from elementary to the most advanced; a classic training
manual.

MORRIS, John. *Get the Picture: A Personal History of
Photojournalism*. Random House, 1998. In this enlightening
memoir, Morris traces his half-century career from the mail

room at *Life* to executive editor of the famed Magnum Photos agency. Morris worked with the greats and his colorful anecdotes have the authenticity of an insider.

MOYNAHAN, Brian. *The Russian Century: A Photographic History of Russia's 100 Years*. Random House, 1994. An important addition to the annals of world history. This extraordinary volume offers an unprecedented view of a country that has largely been concealed from outsiders. From the last days of the tsar through the Bolshevik Revolution to the Gorbachev-Yeltsin revolution, every aspect of Russian life yields stunning images.

MUIRA, Robin, editor. *John Deakin: Photographs*. Vendome Press, 1997. These physically damaged photos—torn, stained, cracked, dog-eared, paint splattered, and soiled with fingerprints or footprints—were salvaged from the trash files of British *Vogue*. These images of the 1950s cover artists, beggars, fashion models, film personalities, writers, and his drinking buddies, Lucian Freud, Dylan Thomas, and Francis Bacon. He never catalogued his work and did not care what happened to his prints. It is, therefore, a remarkable accomplishment to have these images collected and preserved in this important volume.

MUYBRIDGE, Eadweard. *Animals in Motion*. Introduction by Lewis S. Brown. Dover, 1957. Largest selection of Muybridge's famous animal photos available; more than 4,000 high-speed sequence shots showing 34 different birds and animals in typical actions. Originally published in 1887.

————. *The Human Figure in Motion*. Introduction by Robert Taft. Dover, 1955. More than 4,700 photographs showing stopped-action sequences of men, women, children jumping, lying down, running, sitting down, throwing, wrestling, etc. Among the finest action shots ever taken. Originally published in 1887.

MYDANS, Carl. *Carl Mydans Photojournalist*. Interview by Philip B. Kunhardt, Jr. Harry N. Abrams, 1985. It was Carl Mydans who waded ashore in Lingayen Gulf in Luzon, Philippines with General Douglas MacArthur on January 9, 1945. Mydans got an historic photo of the moment and it is among the most memorable images in photojournalism. This is only one of thousands of great black-and-white photos by Mydans, whose life has been filled with adventure.

NAEF, Weston J. *The Collection of Alfred Stieglitz*. Viking, 1978. Stieglitz collected the work of other photographers with an ardor shared by few of his contemporaries. His selections were highly personal, often bucking the critical trend, but his

was an educated and informed eye. Here are 580 prints which he bequeathed to the Metropolitan Museum of Art, complete with portraits and signatures of the photographers as well as a selected biographical timeline, bibliography, and exhibition list for each of the 50 photographers represented. A must for any serious photo library. Curator Naef spent nearly 10 years compiling this book and his effort is clear to see in this engrossing volume.

————. *Era of Exploration: The Rise of Landscape Photography in the American West*. Albright-Knox Art Gallery / The Metropolitan Museum of Art, 1975. A thorough and well-written account of the birth, development, and fruition of landscape consciousness among American photographers in the West. Beautifully illustrated with photographs by such masters as Timothy O'Sullivan, Eadweard Muybridge, and William Henry Jackson. The landscapes of Yosemite, Yellowstone, the canyons of the Green and Colorado Rivers are well and faithfully reproduced in this important study.

NAME, Billy. *All Tomorrow's Parties: Billy Name's Photographs of Andy Warhol's Factory*. Essay by David Hickey. Interview by Collier Schorr. D.A.P., 1997. This beautifully packaged book comes wrapped in silver Mylar, the same material that covered the walls in Warhol's Factory. Published in London, printed in China, and supported by the Arts Council of England, the book presents photos taken by Andy Warhol's house photographer, Billy Name (Billy Linich) at the second Warhol Factory, 33 Union Square West, in 1968. The snapshots in color show Warhol's entourage at parties, in Max's Kansas City restaurant, hanging out in various poses indoors and out. The camera is tilted in many of the photos, as Billy Name was "interested in using angles to make the structure, like looking at form in an abstract painting." In this case, tilting the camera seems more like a device to add interest to a picture when the subject is less than riveting. Of the 135 pictures in Name's book, only a dozen show Warhol; there is just one of Gerard Malanga, probably the most important figure in the Warhol enterprise. Factory regulars who are pictured include Viva, Brigid Berlin, Taylor Mead, Joe Dallessandro, Fred Hughes, Paul Morrissey, Tally Brown, Edie Sedgwick, and Larry Rivers, in this amusing look back at the downtown scene that revolved around Andy Warhol.

NEEL, David. *Our Chiefs and Elders*. Foreword by Elijah Harper. Afterword by Marjorie M. Halpin. University of Washington Press, 1993. To remind us of the past, Neel brings us two worlds, two cultures in this interesting collection of Native American chiefs and elders, in traditional ceremonial garb that identifies their positions and tribes.

NEUYBAUER, Hendrik, editor. *Black Star: 60 Years of Photojournalism*. Knoemann, 1997. In the 60 years since the Black Star agency was founded, their photographers have viewed world events and every aspect of the human condition, starting with the International Brigade of the Spanish Civil War in 1936, written in English, German, and French. The book has 665 photos. Much of this work is about pain and suffering. There are dead soldiers, starving children, women suffering the pain of loss. This book proves there has been too much misery in the world.

NEWHALL, Beaumont. *Focus: Memories of a Life in Photography*. Little, Brown, & Co./Bulfinch, 1993. Newhall, who died in 1993 at the age of 84, was a pioneering historian of the art of photography, and in this fine autobiography he recollects a rich and varied life beginning with the day he was born, and covering his education, travels, friendships, married life, military service, and illustrious career.

————, editor. *Supreme Instants: The Photography of Edward Weston*. New York Graphic Society, 1986. Nearly 250 images—portraits, still-lifes, city scenes, nudes, sand dunes, and seascapes—taken during Weston's career from the day he acquired a Kodak Bulls-Eye #2 box camera in 1902, until New Year's Day, 1958, when he died in Carmel, California. Weston had an uncanny ability to turn his subjects into poetic images that exuded charm, warmth, and sexuality. He could photograph cyprus trees, seaweed, sand dunes, cloud formations, artichokes, cabbage leaves, and bell peppers, making them all look as voluptuous, sensuous, and inviting as his striking nudes.

————. *Frederick H. Evans*. Aperture, 1973. This monograph brings together a major selection of Evans's photographs in facsimile reproduction and offers a comprehensive study of the retired London bookseller who made a unique contribution to the history of photography by interpreting the mystery and light of the medieval architecture of England and France.

————. *Airborne Camera, the World from the Air and Outer Space*. Hastings House, 1969. From pigeons with cameras strapped to their breasts (patented in 1903) to the most sophisticated space-age photos taken of the earth from the moon, this authoritative and interesting text covers the early history and development of aerial photography.

————. *The History of Photography: From 1839 to the Present Day*. The Museum of Modern Art, 1964. Traces the concept of photography back to the pioneer inventors and delineates the changing ways in which photographers have sought to interpret the world around them.

————, and Nancy Newhall. *Masters of Photography*. George Braziller, 1958. Unforgettable images by such photographers as Atget, Cartier-Bresson, Stieglitz, Steichen, Julia Cameron, and Paul Strand are presented with the photographer's life history and their own words on their approach to the photographic medium. An important document on some of the extraordinary men and women who have worked in photography.

NEWHALL, Nancy. *The Daybooks of Edward Weston: Mexico I, California II*. Aperture, 1973. For more than 15 years, this great photographer wrote down his thoughts about life, criticized his own photographs, and recorded deeply felt experiences in a diary. Volume I covers the years 1923–1926 when Weston lived in Mexico and illuminates the Mexican society and culture of the era. Volume II opens in California in 1927, and describes how he brought to maturity his attitude toward life and his art, as he discovered new forms in the beauty of extreme close-ups of shells and vegetables, the human form, and the incredible Point Lobos landscape.

————, P. H. Emerson: *The Fight for Photography as a Fine Art*. Aperture, 1975. This is a monograph on the significance of the ideas and photographs of P. H. Emerson, the late nineteenth-century Englishman who viewed photography as an art form. Selections from his writings and his photographs of country people and landscapes are included.

NEWMAN, Alan B., editor. *Howes Brothers*. Pantheon, 1981. Small town America is presented in a suite of charming vintage prints by the Howes Brothers, who worked in Ashfield, Massachusetts, from 1882 to 1907. This is a catalogue of the dress, architecture, industry, and social customs of nineteenth-century New England. Tough, grizzled men chop trees down with shiny axes and delicate ruffled women cook, do laundry, and prune the hydrangeas.

NEWMAN, Arnold. *Arnold Newman: Five Decades*. Introduction by Arthur Ollman. Harcourt Brace Jovanovich, 1987. Newman displays his dedication to black-and-white perfection in this retrospective of 114 portraits beginning in 1938: Chagall, Arp, Ernst, Mondrian, Pollock, O'Neill, Picasso, and Calder. These pictures are his Who's Who of world figures, a permanent showcase that marks him as a twentieth-century master.

NORMAN, Dorothy. *Alfred Stieglitz: An American Seer*. Aperture, 1973. Norman was Stieglitz' companion for most of

the last 20 years of his life. During that time, she devotedly chronicled his activities and conversations. Here, she recounts his life, his influence on other artists and their time together. She draws upon her close association with Stieglitz and upon his own words to create a warm portrait of a focal figure of the modern photography movement in America. The many direct quotations preserve in written form the bold, subtle nature of Stieglitz's speech, and the brilliance of his parables and anecdotes. Plus, of course, there is the brilliance of his eye. This book is lavishly illustrated with many of his famous pictures, and many others that are reproduced here for the first time. Together they powerfully attest to the purity and strength of his vision. This book was clearly a labor of love for Norman to produce and the world is a better place for it, as our understanding and appreciation of the work of a true American master is made crystal clear.

OCKENGA, Starr. *Dressup: Playacts and Fantasies of Childhood*. Addison House, 1978. This collection has more social significance than its surface—superb photos of children dressed in wacky costumes and acting like adults—suggests. The author conducted a ten-year experiment in her neighborhood. She would throw out a loaded word like war, wedding, or funeral and have the youngsters respond by dressing up in different costumes and acting out an appropriate fantasy connected to the word. This exploration into the youthful psyche has produced some photos in which the children look strange, at times perverse. Some pictures are eerie and frightening.

O'NEAL, Hank. *Berenice Abbott American Photographer*. McGraw–Hill/An Artpress Book, 1982. More than 250 photographs by Abbott and commentary by the photographer recalling the often bizarre conditions under which she had to work and the people she photographed. Published when Abbott was in her eighties, this was the first major book for which she selected the photographs as representative of her finest work. Includes her portraits of James Joyce, Jean Cocteau, and other cultural icons; landmarks of now-vanished New York; people and places along U.S. 1, the coastal highway from Maine to Florida; a selection of her scientific photographs taken at MIT; and photos of the people and landscape of Maine taken after she moved there in the 1960s.

————. *A Vision Shared*. St. Martin's Press, 1976. During the Depression, Roy Emerson Stryker headed the photography project for the Farm Security Administration and hired a dozen photographers to document for posterity the urban and rural conditions in America during those terrible years of economic hardship. In the eight years of its existence, 1935–1943, FSA photographers made over a quarter of a mil-

lion negatives, now in the Library of Congress, ranging in subject matter from cityscapes to migrant slums, from sharecroppers to rural street scenes. It was one of the most memorable and ambitious portraits of America and its people ever produced.

ORLOFF, Alexander. *St. Petersburg: Architecture of the Tsars*. Text by Dmitri Shvidkovsky. Abbeville Press, 1996. This sumptuous volume does full justice to the remarkably harmonious architectural ensemble of a city that was conceived as an imperial capital by Peter the Great in 1703. Tsar Peter and his heirs commissioned some of the most brilliant representatives of the European schools of art and architecture, from baroque and rococo to neoclassical and art nouveau, to transform the marshy delta of the Neva River into a magnificent port city and Russia's "Window to the West." Orloff's photographic studies capture the splendid facades and interiors of these palaces, mansions, and grand country estates. The informative text traces the evolution of St. Petersburg over the two centuries of its existence. Long known as a symbol of Russian culture, St. Petersburg has now been added to UNESCO's World Heritage List, thus helping to ensure its preservation for the future.

OVENDEN, Graham, editor. *A Victorian Album: Julia Margaret Cameron and Her Circle*. Introductory essay by Lord David Cecil. Da Capo, 1975. This remarkable family album was collected by one of the greatest portrait photographers of all time. Mrs. Cameron's magnificent portraits of some of her friends include Charles Dodgson (Lewis Carroll).

OWENS, Bill. *Our Kind of People*. Straight Arrow Books, 1975. A unique portrait of the rituals and meetings of groups such as the Lions, the Masons, the Rainbow Girls, and lesser-known organizations such as the Military Order of the Louse. The book documents an integral part of suburban American life and offers an insight into the lifestyles and fantasies of contemporary America.

PAGE, Tim. *Tim Page's Nam*. Alfred A. Knopf, 1983. Page has become part of the Vietnam War mythology, except that in his case the myths are reality. He arrived in the jungle at age 20, eager to start reporting on the most controversial and convulsive war of the modern era. He was wounded five times, once very seriously, in pursuit of the photo. The photos in this book are startlingly human. The faces of the young soldiers are presented here as they are nowhere else: Boys at play, boys at war, the suffering of the people whose nation is being destroyed. Page called Vietnam his "adventure sandbox, " but he did not mean it as a good thing. It wasn't.

PANZER, Mary. *Mathew Brady and the Image of History*. Smithsonian Institution Press, 1997. Explores the elusive figure of Brady, the famous Civil War photographer who, as it turned out, was nearly blind by the 1860s and hardly took any pictures of the Civil War. Panzer, a curator at the National Portrait Gallery, charts the most productive years of Brady's career from 1844 as a New York daguerreotypist and his work to create a national portrait gallery of American leaders to his downfall, bankruptcy, and death in poverty and obscurity.

PARE, Richard, editor. *Courthouse*. Horizon Press, 1978. A magnificently photographed document underwritten by Joseph E. Seagram & Sons, and conceived and directed by Phyllis Lambert. Assembled over three years, the book constitutes the largest resource on courthouses and includes more than 8,000 negatives of over 1,000 courthouses in the east, midwest, and far west. The 24 photographers who shot them achieve a remarkable continuity. Most of the photos were taken by William Clift, Tom Dow, Lewis Kostiner, and Bob Thall. Includes color photographs by Stephen Shore.

PARTRIDGE, Elizabeth, editor. *Dorothea Lange: A Visual Life*. Smithsonian Institution Press, 1994. Lange, one of the best-known photographers during the Depression, worked in Roy Stryker's Farm Security Administration, one of a dozen photographers who roamed rural and urban America, taking documentary photographs in the South and West. This biography celebrates her artistic dedication and illuminates her personal relationships as drawn from her diaries and previously unpublished photos.

PENROSE, Antony. *The Lives of Lee Miller*. Holt, Rinehart, & Winston, 1985. She was a fashion model, a war correspondent, world traveler, and Surrealist photographer, a brilliant, self-possessed, confident artist who was the true emancipated woman of the 1920s. In this fascinating book by her son Antony Penrose, we learn about a remarkable twentieth-century photojournalist who knew the greatest names in modern art, journalism, music, and politics but, when she died, was remembered only by a few family members.

————. *Man Ray*. Thames & Hudson, 1975. Penrose was a close friend of the legendary photographer for nearly 50 years. In this first major study of Man Ray, he creates an absorbing narrative about the life of his friend, his work, and his role at the very center of modernism since 1911. As the organizer of the International Surrealist exhibition in London in 1936, where Man Ray's work was shown for the first time in England, and as a Surrealist painter himself, Penrose pro-

vides unique insights into the exciting life and work of a modern genius.

PETERSON, Christian A. *Alfred Stieglitz's "Camera Notes."* W. W. Norton & Co., 1996. In this reference book, all the photogravures that ever appeared in *Camera Notes* are identified. They are arranged alphabetically by photographer, with date of photo, when published in *Camera Notes*, followed by volume number, issue date and page number. There are biographical sketches of all the contributors from C. Yarnall Abbott to Clarence H. White, as well as an index of the articles that appeared.

PHILLIPS, Charles, and Alan Axelrod. *My Brother's Face, Portraits of the Civil War*. Foreword by Brian C. Pohanka. Chronicle Books, 1993. A collection of rare portraits and wide-angle views of battle scenes divided into sections— Shiloh, Manassas, Gettysburg, Vicksburg, Chancellorville, Antietam, Petersburg, Fredericksburg. Each is introduced by historical commentary and accompanied by excerpts from letters, diaries, or first-hand accounts expressing the thoughts of those on the front lines or at home.

PHILLIPS, John. *Free Spirit in a Troubled World*. Scalo, 1996 Accomplished as a photographer and filmmaker, Phillips proves himself a skilled writer as well. His witty and savvy prose brings his subjects and history to life. He explores the differences between American and European cultures (he was born in Algeria and raised in Paris and Nice) from the unique vantage point of being *Life*'s only European staffer. He died as his book was going to press.

————. *It Happened in Our Lifetime*. Little, Brown, & Co., 1985. This book documents the career of John Phillips, who in 1936 became the first overseas staff photographer for *Life* magazine. For five decades he covered world events, starting with the abdication of Edward VIII. Phillips explains in detail how and where his pictures were taken and even quotes his subjects.

PHILIPS, Sandra, Carol Squiers, and Mark Haworth-Booth. *Police Pictures: The Photograph as Evidence*. Chronicle Books, 1997. The subject of photography as a police tool is explored in this interesting collection. Both the text and photos are fascinating. Although these pictures were not taken as works of art, they do express with great power the role of documentary photography in police investigation, evidence gathering and categorization.

POLLACK, Peter. *The Picture History of Photography*. Harry N. Abrams, 1970. Chief emphasis is on the great pho-

tographs made by the most inspired photographers, each using the process available at his own time. Each photographer is profiled.

PRATT, Davis, editor. *The Photographic Eye of Ben Shahn.* Harvard University Press, 1975. This is a beautifully reproduced, comprehensive selection of Shahn's work. It includes early photographs taken during the Depression in New York City, prison studies, FSA pictures and some photos not previously published that indicate the wide range of this gifted photographer's work.

PURCELL, Rosamond Wolff. *Special Cases: Natural Anomalies and Historical Monsters.* Chronicle Books, 1997. *Special Cases* may be a complete turnoff for readers who are squeamish seeing this unusual collection. But the fact is this is an important work of scholarship by Purcell identifying and describing rare medical abnormalities—giants and dwarfs, those with unusual appendages, two-headed freaks, rare skin conditions, all things we hesitate to look at. Searching through rare medical texts and antique scientific books, Purcell adds eerie, evocative photographs to her informative text. She shows "that beauty is not the exclusive territory of the normal."

————. *A Matter of Time.* David R. Godine, 1975. This photographer does not want simply to record subject matter but, rather, the tension inherent within the subject matter itself. Using a Polaroid Land camera, she has produced images and objects that give a surreal quality to everyday people and things.

RAMSAY, Jack C. Jr., *Photographer Under Fire: The Story of George S. Cook (1819–1902).* Historical Resource Press, 1994. This is a dramatic, well-researched account of Cook's adventures during the Civil War, as well as a fascinating family history. It was written by Cook's great grandson, Jack Ramsay, 80 years after his death. Cook, who might be called the Mathew Brady of the Confederacy, emerged as the premier photographer covering the war between the states from below the Mason-Dixon line. While President Lincoln and the Union had Brady and his crew covering the Civil War, the South had no official photodocumentation of the war. Instead, several cities hired their own teams to cover the battles. Cook had worked as a Brady assistant and ran his New York studio. His Civil War photos date back to 1861, when he took his camera to Institute Hall to cover the final vote for secession. He photographed Fort Sumter and other famous battle sites, and the southern leaders. Cook moved to Richmond, Virginia after the war, where he remained until his death, operating a successful photo studio. The

Cook collection of photographs is now owned by the Valentine Museum in Richmond.

RIBOUD, Marc. *Marc Riboud in China, Forty Years of Photography.* Preface by Jean Daniel. Harry N. Abrams, 1997. Famous as a Magnum photographer, Riboud here assembles an impressive selection of black-and-white photographs of life in Communist China from 1957 to the present day. The photos are organized into three chapters—China as he saw it on his earliest visits, juxtaposed images of old and new China under Mao, and modern images of China as it experiences an economic boom.

RICE, Shelley. *Parisian Views.* The MIT Press, 1997. The title is somewhat misleading here, as there are very few photographic views of Paris. Instead, there are essays with some classic views as illustrations. Some of the pictures are wonderful, like the Opera under construction accompanied by a portrait of the finished structure, and Nadar's views of the Place de l'Etoile from atop the Eiffel Tower. During the Second Empire (1852–1870) Baron Hausmann and Napoleon III reconstructed much of Paris, and the government hired many prominent photographers to record the old Parisian architecture and to document the demolition and reconstruction.

RIEFENSTAHL, Leni. *The Last of the Nuba.* Harper and Row, 1974. The famous filmmaker, propagandist, and film actress from Germany—before and during the Hitler years—went to Africa in 1962. Her trip resulted in this photo-documentary of a lost tribe in the hills of Kordofan. The extraordinary pictures are grouped according to situations and events central to the lives of the Nuba: the harvest, the cattle camp, wrestling, death.

RILEY, Chris, and Douglas Niven. *The Killing Fields.* Twin Palms, 1996. These are black-and-white shots of prisoners incarcerated by the Khmer Rouge at Tuol Sleng Prison in Phnom Penh, Cambodia, from 1975 to 1979. All but seven of the people sent to this prison were executed. The Khmer Rouge jailers took these photographs of their prisoners, to document their reign of terror, and the negatives are now in the collection of the Tuol Sleng Museum of Genocide, which is located at the former prison and dedicated to the prisoners' memory.

RIIS, Jacob A. *How the Other Half Lives.* Preface by Charles A. Madison. Dover, 1971. This is the famous journalistic record of the filth and degradation of New York's slums at the turn of the century. An exceptional document of early American photography.

ROBERTS, Richard Samuel. *A True Likeness. The Black South, 1920–1936*. Algonquin Books, 1986. Working in Columbia, SC in the same fruitful years as James Van Der Zee was photographing Harlem, Richard Samuel Roberts photographed a broad view of black middle-class life in the Deep South from 1920 until he died in 1936, during the time the country was faced with the Depression. This remarkable collection of 200 photographs, all with informative captions, may be one of the best documentaries of its kind. A post office custodian who took snapshots in his spare time, Roberts amassed a collection of 3,000 glass plates that after his death lay forgotten for more than 40 years in a crawl space under his family's house. His pictures portray a proud community of well-dressed, educated African-Americans—a segment of society that was virtually unknown to people outside it.

ROBINSON, Henry Peach. *The Elements of a Pictorial Photograph*. Arno Press, 1973. Robinson's photographic art theory is a primary source for late nineteenth-century pictorial esthetics, especially the individual factors in a good photograph. He analyzes contemporary painting as well as photography. Originally published in 1896.

RODRIGUEZ, Joseph. *East Side Stories: Gang Life in East LA*. Essay by Ruben Martinez. Interview by Luis Rodriguez. Powerhouse Books, 1998. Rodriguez spent three years—1992 to 1995—living, documenting, and hanging out in the Los Angeles neighborhoods of East L.A. and South Central, capturing a compelling black-and-white narrative of daily life in the barrio and the 'hood. Text includes real-life stories of kids and their families and the evolution of the gang peace movement.

ROGOVIN, Milton. *The Forgotten Ones*. Interview by Cheryl A. Brutvan. Essays by Robert J. Doherty and Fred Licht. Albright-Knox Gallery/University of Washington Press, 1985. Rogovin was an optometrist in Buffalo before he became a photographer. This survey of his best work is carefully edited and well produced on rich glossy paper. It begins with his first major project, storefront churches, advances to Appalachia, then to Buffalo's slum area, then to France, Scotland, Spain, Chile, and Mexico. His specialty is the working-class from his hometown of Buffalo. His pictures have a grimy, sooty crust that gives men a tough, leathery look, and women the wisdom that comes with a thousand wrinkles.

ROSENBLUM, Naomi. *World History of Photography, 3rd Edition*. Abbeville Press, 1997. This classic photo reference volume is one of the best works on the history of photography. It covers a wide range of topics—early technology, nineteenth-century portraiture, the western landscape, documentation, photojournalism, art photography, street photography, and an up-to-date section on photo manipulation.

————. *A History of Women Photographers*. Abbeville Press, 1994. Women's contributions to photography may have been overlooked in the past, but this massive volume by a noted scholar sets the record straight with an overview of the history of photography that chronicles the achievements of 240 women from Anna Atkins and Julia Cameron to Tina Modotti, Lisette Model, and Cindy Sherman. Numerous plates illustrate the work, and at the back of the book there are detailed biographies of those photographers whose work is illustrated in the text.

ROSENBLUM, Walter. *Photographs by Walter Rosenblum*. Text in English and German. Translated by Elga Abramowitz. Essays by Shelley Rice and Naomi Rosenblum. Aperture, 1990. In this gritty photo-documentary, thematic introductions present 140 black-and-white photographs grouped in series, which the author has titled "Pitt Street," "Krieg War," "Spanish Refugees," "the lyrical Gaspe series," "East 105th Street (Spanish Harlem)," "Hospitals," "Haiti," "Europe," "Long Island City," and "the South Bronx."

ROSTEN, Leo, editor. *The "Look" Book*. Harry N. Abrams, 1975. This nostalgic anthology of photos and stories is from the pages of *Look* Magazine. Picture portfolios include movie stars, political personalities, war scenes, and travel photos taken between February of 1937 and October of 1971, when the magazine folded.

Royal Geographic Society Illustrated. Foreword by Lord Jellicoe. Introduction by Dr. John Hemming. Stewart, Tabori, & Chang, 1997. This fantastic collection drawn from 160 years of exploration, world discovery, and the history of documentary photography focuses on Sir Edmund Hillary, Dr. Richard Leaky, Sir Ranulph T. W. Fiennes, RGS Fellow Christina Dodwell, Sir Wilfred Thesiger, and Dr. John Hemming. Hillary's famous 1953 climb to the summit of Mt. Everest is here.

RUSCHA, Ed. *Ed Ruscha Books: Colored People, 26 Gas Stations, Various Small Fires, Some Los Angeles Apartments, 34 Parking Lots, Royal Road Test, 9 Swimming Pools, Real Estate Opportunities, A Few Palm Trees, Records, Scenes Along the Road, Sunset Strip, Business Cards, Crackers*. Heavy Industry Publications, 1962–1971. An interesting and unusual collection.

SALGADO, Sebastião. *Terra: Struggle of the Landless*. Preface by Jose Saramago. Poetry by Chico Buarque. Phaidon/Chronicle Books, 1997. Salgado continues his brilliantly realized documentation of life among the poor in this pictorial story of squalor and hardship. The "landless" of Brazil are peasants, displaced from the land by the increasing mechanization of agriculture and who migrate to cities in order to find employment. Their rural existence, the enforced migration, and their response to the inhuman conditions they have endured are all brought to life eloquently and dramatically.

————. *Workers: An Archaeology of the Industrial Age*. Aperture, 1993. These images depict the sweat of the cutters hacking sugarcane in the sweltering fields of Cuba and Brazil; tuna fishermen in Italy; coal miners in India; the relentless grind of the remains of the industrial revolution in factories, oil refineries, and archaic steel mills. It is a world of ceaseless human activity, similar in many ways to worker bees or industrious ants. Salgado is the poetic chronicler of a dying breed.

SALOMON, Erich. *Portrait of an Age*. Collier Books, 1975. These are works of a candid camera pioneer in photo-journalism whose life was cut short in a Nazi concentration camp. A tour of history with Roosevelt, Churchill, Hitler, Chamberlain. A noteworthy and important document.

SANDER, Gunther, editor. *August Sander: Citizens of the Twentieth Century*. Text by Ulrich Keller. The M.I.T. Press, 1986. August Sander documented Germanic peoples through the years of the Kaisers, the Weimar Republic, the Nazi regime, and the early Federal Republic. His work first appeared in this country in "The Family of Man" exhibit in the early Sixties. Sander planned his self-conceived archival project to be a lasting contribution to make people aware of the social and cultural levels of German society, creating simple, natural, narrative scenes that show the subject in his or her own environment. He claimed that moral character was reflected in facial types and expressions, and always photographed his subjects—shepherds, dockworkers, farmers, students, lawyers—straight on in natural light.

SANDVED, Kjell B., and Michael Emsley. *Insect Magic*. Viking, 1978. From common house flies and grasshoppers to weevils and alligator bugs, Sandved stalked the bushes and swamps to get close-ups of insects courting, mating, eating, and in camouflage. He mainly used a 55-mm. Micro-Nikkor lens, and the results are awesome to behold.

SANDWEISS, Martha A. *Photography in Nineteenth-Century America*. Harry N. Abrams/Amon Carter Museum, 1991. This book is a must have for any serious photo library. There are six essays by noted scholars that examine the many ways that photographs reflected and influenced American life. Plus, there are 226 stunningly-reproduced and diverse images tracing the birth of the medium. It is fascinating to follow photography as it went from an awe-inspiring new process of fixing an image on a silvered plate to an accepted way of documenting and interpreting the world.

————. *Laura Gilpin: An Enduring Grace*. University of Texas Press, 1986. Gilpin depicted the Indians of the Southwest with empathy, simplicity, and grace, often in family groups and usually in direct relationship with the land. Although her record of life in the Southwest was collected over 60 years, her photographs are not about change, but about the timeless and enduring qualities of the land and its people.

SAUL, Julia, editor. *Jean Cocteau—The Mirror and the Mask*. Essay by Francis Steegmuller. David R. Godine, 1992. Jean Cocteau was one of the most fascinating cultural heroes of the twentieth century, whose creative skills involved acting, writing poetry, filmmaking, print making, book publishing—even modeling for photographs, as seen in this photo-biography. Cocteau is seen by 29 different photographers who manipulate the artist (with his assistance) into every conceivable situation imaginable.

SAVILLE, Lynn. *Acquainted with the Night*. Poetry selected by Philip Fried. Introduction by Joseph Rosa. Foreword by Bill Moyers. Rizzoli, 1997. Saville's photographs, shot in black-and-white, are quietly poetic, roaming from city to country in the United States, India, Portugal, and Greece. The New York City scenes are the most compelling—paired with her evocative photos are poems and various text excerpts about the night, ranging from Gerard Manley Hopkins to Robert Frost.

SAWIN, Martica. *Surrealism in Exile and the Beginning of the New York School*. The M.I.T. Press, 1995. Surrealism burst on the United States in the late Thirties and early Forties, when the European surrealists emigrated to the west. Their work was shown at the Julian Levy Gallery on Madison Avenue, where the gallery roster included such major figures as André Breton, Yves Tanguy, Max Ernst, Salvador Dali, and Jean Cocteau. How the leaders of Surrealism met and influenced the daily lives and works of the artists first identified as the New York School is the fascinating story of this book.

SCAVULLO, Francesco. *Scavullo: Photographs 50 Years*. Introduction by Enid Nemy. Harry N. Abrams, 1997. Pop celebrities, top models, movie stars, clothing designers, and

an assortment of drag queens are all fodder for Scavullo's unstoppable need to make people look beautiful.

SCHARF, David. *Magnifications—Photography with the Scanning Electron Microscope*. Schocken Books, 1977. All of these black-and-white photographs look like surrealistic works of art. The scanning electron microscope allows us to explore the eerie contours of living and inanimate subjects—houseflies, leaves, spiders, ants, flowers. The primary purpose of the book is to provide a visual experience in imagery and technology.

SCHMIDT, Bastienne. *American Dreams*. Foreword by Vicki Goldberg. Editions Stemmle, 1997. In this book there are no Statue of Liberty, no national parks, no Capitol Dome. Schmidt's images are powerful, striking, and memorable. Her journey seems to have been the merciless odyssey of a European photographer let loose in a land that often seems paradoxical by nature. One sees here a strange celebration of the elusive. Through the faces she has photographed, we see a society whose pursuit of dreams is more fantastic than the dreams themselves.

SCHOERNER, Allon, editor. *Harlem on My Mind: Cultural Capital of Black America*. Preface by Thomas P. F. Hoving. Introduction by Candice Van Ellison. Random House, 1968. Documents the struggle to establish this cultural capital in the midst of our twentieth-century industrialized society. Hundreds of photographs with historical interest.

SCULLY, Julia. *Disfarmer: The Heber Springs Portraits: 1939–1946*. Addison House, 1976. These portraits taken in Arkansas by a local photographer have a peculiarly American-farm and small-town character that distinguishes them from ordinary snapshots. Subjects face the camera, and the viewer is face-to-face with the people of rural America.

SHAW, Irwin. *Paris/Magnum: Photographs, 1935–1981*. Aperture, 1981. This photo agency's legendary members—Cartier-Bresson, Capa, Seymour, Riboud, Morath, Arnold, Stock—produced some of the most memorable, dramatic, affectionate images ever put on 33mm film. The organization became an international fraternity of concerned photographers whose daily assignments were war, famine, economic and social strife.

SHUDAKOV, Grigory, Olga Suslova, and Lilya Ukhtomaskaya. *Pioneers of Soviet Photography*. Foreword by François Mathey. Thames & Hudson, 1985. This book covers the period from 1917 through 1940. Its documentary, historic, and artistic value is unique. The most complete collection of pho-tographs from the Soviet Union ever published. Each picture is described in detail with good biographical sketches of the photographers. The most prominent of them was Aleksandr Rodchenko, a Constructivist painter and creative photographer.

SILVERMAN, Jonathan. *The Life of Margaret Bourke-White*. Preface by Alfred Eisenstaedt. A Studio Book/Viking, 1982. A life in pictures of a life of pictures, with most of them appearing in *Life*. From the stunning Industrial Age arty photos—of the Empire State Building and the George Washington Bridge under construction—to the famous portraits, World War II horrors and the Depression, an impressive catalogue of her work is accompanied by an instructive and easy-to-read narrative. Of the many volumes written on the great, pioneering, woman photojournalist, this is perhaps the most complete, at least from an informational standpoint. Everything about her life is presented for the reader in a very appealing manner, both graphically and editorially.

SISCHY, Ingrid. *Annie Leibovitz Photographs: 1970–1990*. Harper Collins, 1991. Leibovitz's photographs of celebrities and rock stars are the carefully planned, dramatic, colorful set-ups that have made her a portrait artist of distinction, notwithstanding her complete immersion in commercial photography, especially her captivating ads for American Express and The Gap. Leibovitz is now as famous as the subjects she photographs.

SLAVIN, Neal. *When Two or More Are Gathered Together*. Farrar, Straus, & Giroux, 1976. Group portraits of clubs, societies, companies and other organizations form an original, unusual, and perceptive insight into America in the 1970s. An intriguing and successful book.

SMITH, W. Eugene, and Aileen M. Smith. *Minamata*. Holt, Rinehart, & Winston, 1975. This classic photo essay documents the story of the horrible effects of industrial pollution in a southern Japanese fishing town and how the people of the area forced those responsible to acknowledge their guilt.

SMOLAN, Rick and Jennifer Erwitt. *24 Hours in Cyberspace: Painting on the Walls of the Digital Cave*. Que (Macmillan), 1996. Rick Smolan, who created the best-selling "Day in the Life" series, has created his most ambitious project, an unprecedented one-day event that employed 150 of the world's top photographers to shoot 900 rolls of film and create a "digital time capsule of online life, " all of which is also on a CD-ROM attached to this book. Using both conventional and digital cameras and computers, the photographers developed,

edited, and transmitted photos the same day to a web site at Mission Control in San Francisco. Over 200,000 images were taken on February 8, 1996, but only 200 were selected to represent this "intimate and emotional" portrait documenting how the Internet and online communications are affecting peoples' lives. The focus is on the way people, work, learn, conduct business, and interact with each other, a concept exactly like that of Smolan's other projects. However, in this cyberspace book, the reader can use the CD-ROM to access more information about the photos in the book. *24 Hours . . .* is indeed an awesome achievement. As Smolan says, cyberspace "is no longer an abstraction; it is now the real world, the marketplace, the battleground, the house of prayer, the secret retreat."

SOBIESZEK, Robert A. *Masterpieces of Photography From the George Eastman House Collections*. Abbeville Press, 1985. This volume weighs 12 pounds, has 466 pages, and over 300 beautiful prints, many never published in book form. The book covers every major development in photography up to computer-generated images of outer space and the latest novelties employing tinsel, glass fabrics, and spray paint. This is a collection of unparalleled richness and density and sets a high standard in artistic and scholarly book publishing.

SOBIESZEK, Robert A., and Odette M. Appel. *The Spirit of Fact*. David R. Godine, 1976. The Boston studio of Albert Southworth and Josiah Hawes produced an extraordinary range of portraits and landscapes from 1843 to 1862. In addition to reproducing over 100 duotone photographs, this book describes the studio's medium, the daguerreotype, the work habits of the two men, and their important contribution to the history of photography.

SOBIESZEK, Robert A., and Deborah Irmas. *The Camera I: Photographic Self-portraits from the Audrey and Sydney Irmas Collection*. Los Angeles County Museum of Art/Harry N. Abrams, 1994. Self-portraits, in this diverse array of images, convey more than the likeness of the photographer. Of the 47 color and 101 black-and-white self-portraits, no two are remotely alike. Each image reveals not only the aesthetic, but also the personality of its maker.

SOBIESZEK, Robert, editor. *The Daguerreotype Process: Three Treatises, 1840–1849*. By Antoine Claudet, Francois Fauvel-Gouraud, S. D. Humphrey, and M. Finley. Arno Press, 1973. Short pamphlets containing information on the early years of the daguerreotype process, such as the first description of a method for taking daguerreotype portraits.

———, editor. *French Primitive Photography*. Introduction by Minor White. Commentary by André Jammes. Aperture, 1969. Documents the innovative photography that flourished from 1850 to 1865, during the Second Empire. Reviews technical innovations in printmaking and the early relationship of art and photography.

SONTAG, Susan. *On Photography*. Farrar, Straus, & Giroux, Inc., 1977. This collection of highly acclaimed essays cemented Sontag's reputation as a critic and fully validated photography as a subject for serious academic study and debate. The book considers the relation of photography to art, conscience, and knowledge. Sontag examines a wide range of problems, both aesthetic and moral, raised by the presence and authority of the photograph as a part of everyone's life.

STALLER, Jan. *On Planet Earth, Travels in an Unfamiliar Land*. Aperture, 1997. This beautiful book transports the reader to locations they may be familiar with, but from a perspective never before seen. Staller presents hauntingly seductive, vividly colored photographs of some forgotten constructions of industrial society. Accompanied by an original Luc Sante story, the square format and panoramic images of abandoned factories, military test sites, high-tech water purification plants, and gigantic urban gas tanks are stunning. For their readers, Staller and Sante share their fascination with urban and industrial wastelands, the history they contain and the mysteries they conceal.

STEICHEN, Edward. *A Life in Photography: Edward Steichen*. Museum of Modern Art/Doubleday, 1963. His was an extraordinary career, and this classic with a diary text by Steichen himself is a breathtaking gallery of personalities, abstractions, and still-lifes by this seminal figure, whose innovative work established the standards for creative photography in the twentieth century. In this volume Steichen identifies over 250 of his images, which today have become a definitive vocabulary of art photography. A chronological outline by the curator of the Department of Photography at the Museum of Modern Art is also included.

———. *The Family of Man*. Prologue by Carl Sandburg. Museum of Modern Art/Simon & Schuster, 1955. The book version of the seminal photography exhibition held at the Museum of Modern Art, in which 270 photographers from 68 countries competed to show their work.

STETTNER, Louis. *Louis Stettner's New York, 1950s–1990s*. Introduction by Barbara Einzig. Rizzoli, 1997. Shot over a 50-year period, Stettner's gritty black-and-white images of New

York—streetscapes, architectural studies, peddlers, pedestrians, night shots, sidewalk scenes, homeless people, subway stations—are brilliantly evocative, conveying both his own feeling for the city and the rhythm of the restless metropolis.

STIEGLITZ, Alfred. *Georgia O'Keeffe, a Portrait by Alfred Stieglitz*. Metropolitan Museum of Art, 1978. Stieglitz began to photograph O'Keeffe when she was about 23. "When his photographs of me were first shown, it was in a room at the Anderson Galleries. Several men—after looking around a while—asked Stieglitz if he would photograph their wives or girlfriends the way he photographed me. He was very amused and laughed about it. If they had known what a close relationship he would have needed to have to photograph their wives the way he photographed me—I think they wouldn't have been interested."

————. *Alfred Stieglitz, Photographs & Writings*. Edited by Sarah Greenough and Juan Hamilton. National Gallery of Art/Callaway Editions, 1983. This massive volume, printed on special archival paper, spans Stieglitz's entire career—his early European studies from the 1880s and 1890s, views of New York from the turn of the century, portraits of the artists and writers he supported, portraits of his wife, Georgia O'Keeffe, clouds, and his final studies of New York and Lake George of the 1930s. Fifty-six letters and articles by this master twentieth-century photographer and Greenough's essay on his commitment to photography as artistic expression illuminate our understanding of his enormous contribution to the medium.

STRAND, Paul. *Paul Strand, Sixty Years of Photographs*. Essay by Calvin Tompkins. Aperture, 1976. A beautiful selection of representative photographs taken throughout his life show the remarkable accomplishment of one of the major photographers of this century. Accompanying the photographs are a profile by Tompkins and a survey of Strand's ideas in his own words from interviews, letters, and articles.

————. *A Retrospective Monograph: Volume 1, The Years 1915–1946. Volume 2: The Years 1950–1968*. Aperture, 1972. Published in conjunction with a major retrospective of Strand's work that opened in 1971, this two-volume work includes photographs that have had a profound effect on the photography and art of the twentieth century as well as many photographs never published before. Whether he was photographing people or nature, Strand infused his work with the characteristic serenity, simplicity, and elegance of an art that is timeless.

STRYKER, Roy Emerson, and Nancy Wood. *In This Proud Land: America 1935–1943 as Seen in the FSA Photographs*. New York Graphic Society, 1973. A portrait of America in 200 photographs taken during the years spanning the depths of the Depression and the beginning of World War II.

SULLIVAN, Constance, editor. *Great Photographic Essays from "Life."* Commentary by Maitland Edley. New York Graphic Society, 1978. *Life* was published from November 23, 1936 to December 29, 1972, nearly 1,800 issues. This volume contains 22 photo essays on such diverse topics as displaced Germans, the Shakers, the Irish, the Spanish, the Mormons, the Chinese in Peking, famous Britons and the country doctor. Three of the essays are by Leonard McCombe. Dorothea Lange, W. Eugene Smith, and Margaret Bourke-White each have two essays, and other famous photographers are included with one each.

————, editor. *Women Photographers*. Essay by Eugenia Parry Janis. Harry N. Abrams, 1990. With 73 photographers included, Sullivan attempts to explore the questions, concerns, and considerations raised in looking at a selection of photography by women, to suggest how that work has affected, influenced, and shaped the language of photography, and to reveal a fascinating episode in the development of the medium.

SZARKOWSKI, John. *Photography Until Now*. Museum of Modern Art/Bulfinch, 1989. Published in conjunction with a show marking the 150th anniversary of the birth of photography, this history of the medium also celebrated the 50th anniversary of the founding of the Museum's photography department. Szarkowski, departing from the conventional pattern of photo history, sees the history of photographs in terms of the dynamic interaction of technological development and individual genius, of social and economic challenge and personal response. In describing the development of photography, the author explores the pictorial implications of the inventions that have shaped the art and craft of photography and the role of the photographer as artist.

————. *Mirrors and Windows: American Photography Since 1960*. Museum of Modern Art, 1978. Published in conjunction with a landmark exhibit that traveled throughout the U.S., this book surveys the changes in American photography over a 20-year period with the work of 127 photographers, ranging from Robert Adam to Garry Winogrand, who Szarkowski considered exemplars of the new. He discusses the influence of Robert Frank's *The Americans*, the demise of the picture magazines, and the increasing potential of color on the medium.

————, editor. *Callahan*. Introduction by John Szarkowski. Aperture, 1976. Magnificent reproduction of a wide selection of images of Harry Callahan's family, pedestrians on Chicago streets, and the beaches of Cape Cod. The photographs are perfect examples of his cool, distinctive style.

————. *Looking at Photographs: 100 Pictures from the Collection of the Museum of Modern Art*. Museum of Modern Art, 1973. An introduction to the esthetics and historical development of photography. The photographs show the achievements of photography as an art medium. Each illustrates a specific fact of photography to answer those esthetic and social questions most central to the photographer's art.

————, and Maria Morris Hambourg. *The Work of Atget*. Museum of Modern Art/Little, Brown, & Co., 4 Vols., 1981–1985. *The Work of Atget*, although published in four volumes, is considered as one book. Volume 1, "Old France," is the French countryside. Volume 2, "The Art of Old Paris," is concerned with the pictures Atget made as he roamed the city. Volume 3, "The Ancien Regime," reflects Atget's deep interest in the region surrounding Paris, the chateaux and parks of the French kings and noble families, and the gardens of Versailles. The fourth volume, "Modern Times," shows Paris street scenes, shopkeepers, artisans at their trade, automobiles and horse carriages, domestic interiors, carnivals and cafés, corset stores and dress shops

TAFT, Robert. *Photography and the American Scene: A Social History, 1839–1889*. Dover, 1964. Illustrated with 322 early photographs, daguerreotypes, tintypes, and stereopticon slides; a complete account of the development of photography as an art and of its profound influence on American society.

TALBOT, William Henry Fox. *The Pencil of Nature*. Introduction by Beaumont Newhall. Da Capo, 1969. A magnificent facsimile of the 1844 original, this document reproduces the inventor's first paper photographs, which he used to illustrate his classic account of his discoveries. The first book ever illustrated with photographs, it describes the experiments that led him to the earliest realization of photography as we know it today.

TCHAKMAKIAN, Pascal. *The Great Retreat*. Chronicle Books, 1976. The story of the Nez Perce Indians who lived in what are now the states of Idaho, Oregon, and Washington and their tragic war with the white settlers. The text is augmented by photographs, some taken before the turn of the century and some contemporaneous with the war, showing the Nez Perces' way of life and also scenes from the final battlefield.

THOMPSON, Jerry L. *The Last Years of Walker Evans*. Thames & Hudson, 1997. An intimate account of the last few years of the great photographer's life by a student who idolized him. This book offers precious insights into the mind and sensibilities of a legend. From his personal interests and intellectual curiosity to the basis of his approach to the art of photography, the reader can be grateful that Thompson was such an attentive and devoted student.

THOMSON, John. *A Window to the Orient*. Text by Stephen White. Preface by Robert A. Sobieszek. Thames & Hudson, 1985. Thomson left England for Singapore in 1863. For the next decade he and his entourage of ten native bearers traveled 5,000 miles throughout the Orient, producing albums showing the culture, geography and architecture of the Far East. This monograph, the first on Thomson to be published in over 100 years, contains a superb representation of his Oriental work depicting scenes of daily life in China, its palaces, temples, and ceremonies.

TICE, George A. *Patterson*. Rutgers University Press, 1972. These pictures present Patterson, New Jersey as it is today, in all its banality. Pictured are the streets, factories, bars, abandoned locations, storefronts, and other subjects of interest to the photographer.

TRESS, Arthur, and John Minahan. *The Dream Collector*. Westover, 1972. Tress has an extraordinary creative imagination and explores with his camera the minds of children, as an analyst with a tape recorder might probe his patient. He literally transforms the child's fantasy into a still photograph of dreams—about falling in space, ferocious demons, sexual encounters, disaster and death.

————. *Shadow*. Avon Books, 1975. A shadow-image odyssey begins with the prisoner, who goes on a journey through a town, a labyrinth, a valley of marvels, views ancestors, undergoes initiations, becomes a pilgrim, sends out messages, is on a magic flight, undergoes transformations, and finally perceives the illuminations of light.

TURNLEY, David. *Why Are They Weeping? South Africans Under Apartheid*. Text by Alan Cowell. Stewart, Tabori, & Chang, 1988. Turnley's photographs expose the tense status quo that had existed against which the violence in South Africa had occurred. His 100 color photos of black funerals, arrests, evictions, and street protests are sickening works of art that document a horrific period in human history. Cowell, the former *New York Times* Johannesburg Bureau Chief, wrote a text that lets the reader begin to understand the reality of life

under apartheid. Both journalists were kicked out of the country in 1987 for their honest reporting. The authors are two dedicated and talented men whom wrong-doers clearly do not want around.

————, and Peter Turnley. *In Times of War and Peace*. Abbeville Press, 1997. The Turnleys are world-class photojournalists. Separately, and sometimes together, they have traveled throughout Africa, Europe, the Mideast, and Far East, photographing most of the great conflicts of the last 15 years. Together they photographed in Tiananmen Square, and their pictures of the student dissidents have become the best known of those tumultuous few days.

UELSMANN, Jerry N. *Silver Meditations*. Morgan & Morgan, 1975. Symbolic composite images express the personal vision of the photographer, who feels that straight photographs are only the beginning for additional complex darkroom techniques to evolve new images.

VAN VECHTEN, Carl. *Generations in Black and White*. Edited by Rudolph P. Byrd. University of Georgia Press, 1994. These dramatic portraits of Paul Robeson, Bessie Smith, Langston Hughes, Josephine Baker, Cab Calloway, Mahalia Jackson, Joe Lewis, and scores of other black notables are from the James Weldon Johnson Memorial Collection of Negro Arts and Letters at Yale University. The fact that there are so few photos of black cultural figures from the Thirties, Forties, and Fifties taken by any photographer, black or white, makes these pictures especially valuable.

————. *The Passionate Observer*. Introduction by Keith F. Davis. Hallmark Cards Inc., 1993. Van Vechten was a leading figure of the 1920s Harlem Renaissance and a strong supporter of black artists, which led people to believe that he, too, was black. The 15,000 photographs he took between 1932 and 1964 constitute a remarkable visual catalogue of the leaders of arts and letters. Photography was a new career for Van Vechten, who had already been a reporter, music critic, drama critic, author of several volumes of music and literary criticism, and novelist.

VIEIRA, Mark A. *Hurrell's Hollywood Portraits: The Chapman Collection*. Harry N. Abrams, 1997. George Hurrell, usually credited with the invention of the Hollywood glamour portraits, took the black-and-white photos in this collection between 1929 and 1943. In this handsome collection his portraits of Joan Crawford, Greta Garbo, Jean Harlow, Clark Gable, and other film stars are beautifully reproduced from archival prints.

VIRGA, Vincent, and Curators of the Library of Congress. *Eyes of the Nation: A Visual History of the United States*. Historical commentary by Alan Brinkley. Alfred A. Knopf, 1997. The Library of Congress's vast collection of historic photos, maps, manuscripts, motion pictures, and posters has been filtered down to 500 images, which are here presented as a visual narrative of the country's history. Divided into five chapters.

VISHNIAC, Roman. *ICP Library of Photographers: Roman Vishniac*. Edited by Cornell Capa. Grossman/Viking, 1974. This book showcases Vishniac's photos of two worlds, the old and the new. The old was the world of Polish Jewry in the 1930s, a people virtually eradicated by Nazis. The new is seen through the microscope; a trained and accredited scientist, Vishniac made beautiful pictures of a universe invisible to the naked eye. From the grub of a Japanese beetle cutting grass in the soil to a street scene in Cracow, these pictures express Vishniac's reverence for life—be it the life that is invisible or the life that vanished. There are also enlightening essays by Eugene Kinkhead and Dr. Vishniac.

VON GLOEDEN, Wilhelm. *Taormina*. Introduction by Roland Barthes. Edited by Jack Woody. Twelvetrees Press, 1986. A landmark document by a daring photographer who took pictures of young boys in Taormina, Sicily—his own personal paradise of beauty and sex. Most of the 87 photos here are dated 1926. Heavy with props like potted plants, olive branches, palm leaves, leopard skins, grape leaves, tunics, tambourines, flutes, and urns, the photos evoke a fascination with Greek shepherds and Christian martyrs.

WALKER, Joseph, Christopher Ursitti, and Paul McGinniss. *Photo Manifesto: Contemporary Photography in the USSR*. Stewart, Tabori, & Chang, 1991. Art photography in the Soviet Union bears the imprint of the politically imposed Social Realism of the Thirties and Forties as evidenced in this landmark collection of works by 50 artists from various regions of the country. Includes still-lifes and poetic evocations of Surrealism. Informative essays on trends in Russian photo art, including one by Alexandesr Lavrentiev, grandson of the USSR's most famous photographer, Alexander Rodchenko, help place the work in context.

WATRISS, Wendy, and Lois Parkinson Zamora, editors. *Image and Memory: Photography from Latin America, 1866–1994*. University of Texas Press, 1998. Remarkably, this book covers 130 years of photography in a dozen countries, everything from street scenes of 1895 São Paulo, to strife-torn 1985 El Salvador, to new art color photography. With compelling images, and English and Spanish text, this book will serve as a

benchmark for future studies of this region and its diverse cultures.

WEAVER, Mike. *Julia Margaret Cameron: 1815–1879*. New York Graphic Society, 1984. Cameron was 48 in 1863, when she took up photography. By chance—or fate—her daughters had given her a camera as a gift. She pursued photography with such energy, passion, and determination that she produced in her short career an extraordinary collection of classic images, many of which are reproduced in this fine monograph.

WEBB, William and Robert A. Weinstein. *Dwellers at the Source: Southwestern Indian Photographs of A. C. Vroman, 1895–1904*. Grossman, 1973. Many people took pictures of Indians. What makes Vroman's work so remarkable, argue the authors here, is that he approached his subjects with the intention of portraying them as human beings, not objects to be described in scientific journals, or inscrutable savages. Even a quick perusal of this book is an eye-opening experience. The views of daily life—cooking, cleaning, various ceremonies and rituals, the interiors of pueblos, tribes bathing and at play—are unlike any other pictures of native-Americans. They are depicted as people. It is a refreshing change.

WEIERMAIR, Peter. *Ralph Gibson: Light Years*. Edition Stemmle, 1996. Gibson's provocative black-and-white poetic metaphors are simple ambiguous fragments of recognizable objects, like telephoto shots that zero in on the subject—an eye staring into a car mirror, a hand grasping a door knob, a dinner fork, a brick wall, a glass of water. His compositions are reduced to bare essentials with all superfluous detail eliminated from the picture frame.

WELLING, William. *Photography in America*. Thomas Y. Crowell, 1978. This book traces the formative years of photography, from 1839 to 1900. In both text and images, Welling easily and entertainingly lays out the history of the medium. There are a list of everyone at the first convention of American Photographers in 1851, photos of the first surgery under ether, photos of the exterior of Brady's Broadway studio, examples of early equipment, and much, much more.

WHELAN, Richard. *Robert Capa, A Biography*. Alfred A. Knopf, 1985. Here are the life story and work of a great photojournalist, a man of remarkable daring and courage who took great risks. Capa was a self-confident individual with charm, warmth, and sly humor. Politics and sympathies drew him to war and, finally, to his own early death.

WHITE, Minor. *Rites and Passages*. Aperture, 1978. A remembrance and testament to the visionary whose grace and dignity were a source of great inspiration to Aperture, where White had been an editor from 1952 to 1975. The book was put together by Michael E. Hoffman and James Baker Hall and is the most beautiful monograph of White's work yet produced. It includes his best pictures, with letters and diary entries. The essence of Minor White's photographs is perhaps best characterized by an excerpt from his writings: "No matter how slow the film, spirit always stands still long enough for the photographer it has chosen . . . meaning appears in the space between the images, in the mood they raise in the beholder."

———. *Mirrors Messages Manifestations*. Aperture, 1969. A synthesis of words and images by the renowned photographer and poet is presented in sequences titled "Amputations," "Equivalence," "With Only a Camera between Us," etc. A meaningful insight into the artistic experience.

WILLIS, Deborah, editor. *J. P. Ball—Daguerrean and Studio Photographer*. Garland Publishing Inc., 1993. This important nineteenth-century African-American photographer lived and worked in Cincinnati and did daguerreotype portraits. He set himself the task of documenting the history of people of African ancestry. Ball was a free black man and an active abolitionist who lectured against the brutality of slavery.

WILLIS-BRAITHWAITE, Deborah. *Van Der Zee, Photographer, 1886–1983*. Biographical essay by Rodger C. Birt. Harry N. Abrams, 1993. One of the great photographic legacies of the Harlem Renaissance is the work of James Van Der Zee, whose documentation of middle-class life in Harlem is seen in this excellent monograph. Although Van Der Zee began his career when he was in his twenties, he remained virtually unknown until at age 82 he was discovered by Thomas Hoving and included in the 1969 "Harlem on My Mind" exhibit at the Metropolitan Museum of Art.

WILSON, Charis and Wendy Madar. *My Years With Edward Weston*. North Point Press/Farrar, Straus & Giroux, 1998. In 1934, Wilson was a 19-year-old model, a subject for the 48-year-old Edward Weston. For the 11 years following, she was his wife, assistant, partner, model, and muse. In these 376 pages, Wilson (with the help of Madar, an Oregon newspaper reporter) looks back on that life. There are many detailed stories that give insight into the technique of the master photographer. Completely devoid of bitterness, the former spouse has revealed Weston's rationalism and terse clarity with a selfless objectivity that befits her subject.

Women of Photography. Introduction by Margery Mann. San Francisco Museum of Art, 1975. First organized as an historical survey exhibit, this collection of photographs is an important overview of the contributions women have made to the medium of photography. There is a full page devoted to each of the photographers' lives and works, with a representative photograph on the facing page.

WOODY, Jack, and James Crump, editors. *F. Holland Day: Suffering the Ideal*. Twin Palms Publishers, 1996. Fred Holland Day was an eccentric, independently-wealthy Bostonian who produced an interesting body of pictorial photography seen here in a handsome monograph. In addition to being a publisher (Copeland & Day) of fine books of poetry and erotica, Day took up photography in the 1880s and later became a member of the Pictorialist Movement—organized by Alfred Stieglitz to advance serious recognition of photography as an additional medium of artistic expression.

YOCHELSON, Bonnie. *Berenice Abbott: Changing New York*. The New Press/Museum of the City of New York, 1997. This is a scholarly volume containing the complete collection of Depression-era photographs of New York City taken by Abbott (1898–1991) under the auspices of the Works Progress Administration's Federal Artists Project. In addition to the 307 duotones, this authoritative work includes an essay on Abbott's life and work, her WPA field notes, and a fascinating section that documents how and why Abbott chose her subjects and explores and updates the history of each site.

ZELLER, Bob. *The Civil War in Depth, History in 3-D*. Chronicle Books, 1997. Many of the images taken of the Civil War were taken in 3-D, a popular format of that period. Here are 130 duotones from that classic conflict, and a stereo viewer included in the book for maximum viewing pleasure. Details that normally would be difficult to discern reveal themselves here in bold definition. Scenes of everything from Fort Sumter through Gettysburg and Sherman's march are included in this compelling view of history through photography.

Booksellers who carry a large inventory of new, used, or out-of-print books are listed here. All provide catalogues on request.

Academy Bookstore
10 West 18th St., New York, NY 10011.
Tel.: 212-242-4848 \ Fax: 212-675-9595
Web Site: http:\\www.academy-bookstore.com.
Out of print, used and rare scholarly books.

A Photographers Place
133 Mercer St., New York, NY 10012.
Tel.: 212-431-9358 \ Fax: 212-941-7920.
America's leading photographic book shop with all types of photo books, 19th century photographica, technical self-help books, camera manuals, monographs of photographer's works and treatises on antiquated process. An eclectic center for photographic ephemera as well as a modernistic haven for hard-to-find books.

Baily/Coy Books
414 Broadway East, Seattle, WA 98102. Tel.: 206-323-8842

The Book Stop
2504 N. Campbell, Tucson, AZ 85719. Tel.: 520-326-6661.

Book Soup
8818 Sunset Blvd., West Hollywood, CA 90069.
Tel.: 800-764-2665 \ Fax: 310-659-3410.

The Booksmith
1644 Haight St., San Francisco, CA 94117.
Tel.: 415-863-8688 \ Fax: 415-863-2540.

Andrew Cahan: Bookseller, Ltd.
3000 Blueberry Lane, Chapel Hill, North Carolina 27516.
Tel.\Fax: 919-968-0538.
Monographs, group exhibition catalogues, periodicals, history of photography, essays and criticism, scarce ephemeral items, original photos, early tipped-in photo-illustrations, and rare technical items.

Calumet Photographic, Inc.
890 Supreme Drive, Bensenville, IL 60106.
Tel.: 800-225-8638 \ Fax: 800-577-3686.

City Lights Books
261 Columbus Ave., San Francisco, CA 94133.
Tel.: 415-362-8193 \ Fax: 415-362-4921.

The Friends of Photography Bookstore
Ansel Adams Center, 250 Fourth St., San Francisco, CA 94103. Tel.: 415-495-7242 \ Fax: 415-495-8517
E-mail fopbooks@aol.com.
Excellent selection of foreign and domestic photographic books, catalogues, posters, calendars, and notecards.

Gallery 292
120 Wooster St., New York, NY 10012.
Tel.: 212-431-0292 \ Fax: 212-941-7479.
Rare and out-of-print photographic books including Klein, Cartier-Bresson, Avedon, Abbott, Frank Weston, Strand, Callahan. Book search service available. Inquiries welcome. Individual books and collections purchased.

George Eastman House/International Museum of Photography and Film
900 East Ave., Rochester, NY 14607.
Tel.: 716-271-3361 \ Fax: 716-271-3970.

Charles A. Hartman Bookseller
2950 Clay St. #101, San Francisco, CA 94115.
Tel.\Fax: 415-440-1680.
Specializing in rare and out-of-print photography books and select photographic images.

Glenn Horowitz Bookseller
87 Newtown Lane, East Hampton, NY 11937.
Tel.: 516-324-5511 \ Fax: 516-324-5796.

Housing Works Used Book Café
126 Crosby St., New York, NY 10012.
Tel.: 212-334-3324 \ Fax: 212-334-3959.

International Center of Photography
1130 Fifth Ave., New York, NY 10128.
Tel.: 212-860-1777 x102.
Midtown: 1133 Ave. of Americas. Tel.: 212-768-4684.
Both locations offer an extensive array of photography books and catalogs, along with T-shirts, posters, and frames.

Leica Gallery
670 Broadway, New York, NY 10012. Tel.: 212-777-3051 \ Fax: 212-777-6960 \ E-mail Leicaphoto@aol.com.
Largest inventory of Leica books and memorabilia. Extensive selection of signed, current and out-of-print monographs including Eisenstaedt, Freed, Gibson, Morath, Uzzle, and Webb.

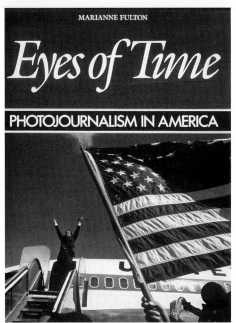

MARIANNE FULTON

Eyes of Time

PHOTOJOURNALISM IN AMERICA

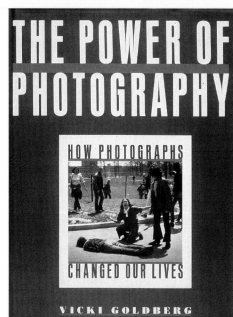

THE POWER OF PHOTOGRAPHY

HOW PHOTOGRAPHS

CHANGED OUR LIVES

VICKI GOLDBERG

Nadar

A photographic pantheon—from Baudelaire to Bernhardt—of nineteenth-century Paris: the most striking figures of that extraordinary world of art, intellect, and culture, recorded by the camera of France's greatest pioneer photographer, FELIX NADAR. By Nigel Gosling

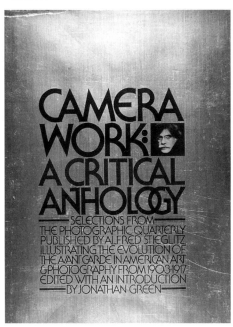

CAMERA WORK: A CRITICAL ANTHOLOGY

SELECTIONS FROM THE PHOTOGRAPHIC QUARTERLY PUBLISHED BY ALFRED STIEGLITZ ILLUSTRATING THE EVOLUTION OF THE AVANT GARDE IN AMERICAN ART & PHOTOGRAPHY FROM 1903-1917 EDITED WITH AN INTRODUCTION BY JONATHAN GREEN

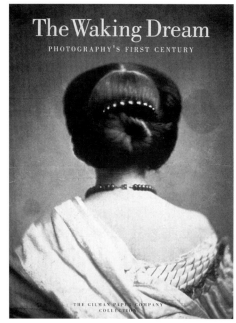

The Waking Dream

PHOTOGRAPHY'S FIRST CENTURY

THE GILMAN PAPER COMPANY COLLECTION

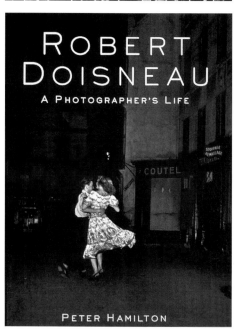

ROBERT DOISNEAU

A PHOTOGRAPHER'S LIFE

PETER HAMILTON

THE GOLDEN AGE

OF BRITISH PHOTOGRAPHY 1839-1900

HOCKNEY ON PHOTOGRAPH

conversations with Paul Joyce

Volker Kahmen

Art History of Photography

THE SILVER CANVAS

DAGUERREOTYPE MASTERPIECES FROM
THE J. PAUL GETTY MUSEUM

Bates Lowry
Isabel Barrett Lowry

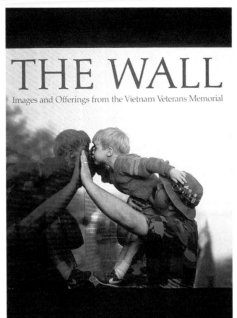

THE WALL

Images and Offerings from the Vietnam Veterans Memorial

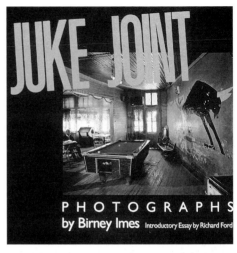

JUKE JOINT

PHOTOGRAPHS
by Birney Imes Introductory Essay by Richard Ford

THE INDELIBLE IMAGE
PHOTOGRAPHS OF WAR·1846 TO THE PRESENT

KERTÉSZ
ON
KERTÉSZ

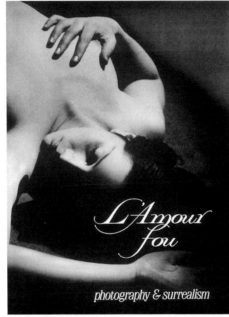

L'Amour fou

photography & surrealism

The
BIRTH of a
CENTURY

EARLY COLOR
PHOTOGRAPHS
OF AMERICA

JIM HUGHES

PHOTOGRAPHS BY
WILLIAM HENRY
JACKSON

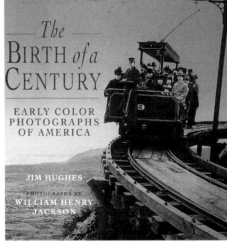

THE WALL

Images and Offerings from the Vietnam Veterans Memorial

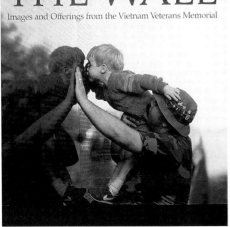

Imogen Cunningham Ideas without End

A Life in Photographs

Richard Lorenz

The Man Who Photographed The World

BURTON HOLMES · TRAVELOGUES 1892-1938

INTRODUCTION BY IRVING WALLACE SELECTED AND EDITED BY GENOA CALDWELL

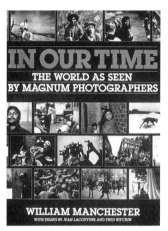

Monographs, Ltd.
124 W 25th St., New York, NY 10001.
Tel.: 212-604-9510 \ Fax: 212-604-0959.
New, out-of-print and rare photography books in all subject
areas for the collector. Signed, limited editions and foreign
titles. Search services and mail order.

Photographs Do Not Bend
3115 Routh Street, Dallas, TX 75201.
Tel.: 214-969-1852 \ Fax:: 214-969-5464
E-mail pdnb@flash.net, web site: www.artphiles.com.
A wide array of collectible, out-of-print, and new books on
photography

Printed Matter
77 Wooster St., New York, NY 10012.
Tel.: 212-925-0325
A wide and eclectic selection of art and photography material
right in the heart of Soho, one of New York's most creative
and artistic neighborhoods.

Sarah Morthland Gallery
225 Tenth Ave, New York, NY 10011.
Tel.: 212-242-7767 \ Fax: 212-242-7799.
Rare and out-of-print 20th-century photography books,
including Sudek, Abbott, Avedon, Winogrand, Lyon.

Photo-eye Books
376 Garcia St., Santa Fe, NM 87501.
Tel.: 800-227-6941.
Specializing in in-print, out-of-print, foreign titles, mono-
graphs, technical resources, exhibition catalogues, and limited
editions.

SF Camerawork
115 Natoma St., San Francisco, CA 94105.
Tel.: 415-764-1001 \ Fax: 415-764-1063 \ E-mail sfcam-
era@sfcamerawork.org, web site: www.sfcamerawork.org.

Strand Book Store
828 Broadway , New York, NY 10003.
Tel.: 212-473-1452 \ Fax: 212-473 2591,
toll-free 800-366-3664.

Visual Studies Book Service
31 Prince Street, Rochester, NY 14607.
Tel.: 716-442-8676 \ Fax: 716-442-1992.

Witkin
415 West Broadway, New York, NY 10012.
Tel.: 212-925-5510 \ Fax: 212-925-5648.
Collectors items, out-of-print titles, and monographs.

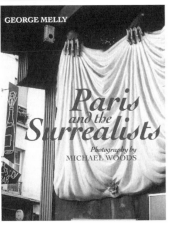

GEORGE MELLY

Paris
and the
Surrealists

Photography by
MICHAEL WOODS

CARL
MYDANS
PHOTOJOURNALIST

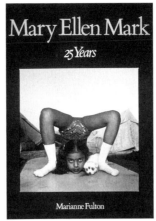

Mary Ellen Mark

25 Years

Marianne Fulton

Miles Barth

WEEGEE'S
WORLD

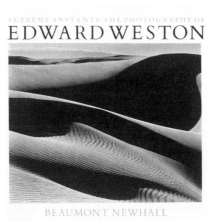

SUPREME INSTANTS: THE PHOTOGRAPHY OF
EDWARD WESTON

BEAUMONT NEWHALL

Berenice Abbott
American Photographer

by Hank O'Neal Commentary by Berenice Abbott
Introduction by John Canaday

MAN RAY'S PARIS
PORTRAITS: 1921-39

TIMOTHY BAUM

ON PLANET EARTH

PHOTOGRAPHS BY JAN STALLER

A
VISION
SHARED

A Classic Portrait Of America And Its People, 1935-1943

Mathew
Brady
and the
Image of History

Mary Panzer

THE LIVES OF LEE MILLER

In all her different worlds
she moved with freedom.
In all her roles
she was her own bold self.

ANTONY PENROSE

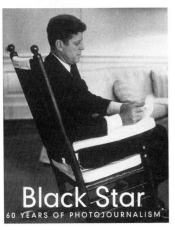

Black Star
60 YEARS OF PHOTOJOURNALISM

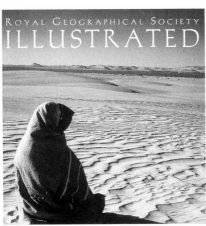

ROYAL GEOGRAPHICAL SOCIETY
ILLUSTRATED

IT HAPPENED IN OUR
LIFETIME

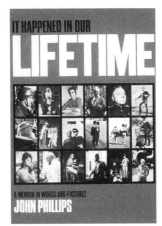

A MEMOIR IN WORDS AND PICTURES
JOHN PHILLIPS

A TRUE LIKENESS
The Black South of
Richard Samuel Roberts:
1920-1936

The Last of the
NUBA
by Leni Riefenstahl

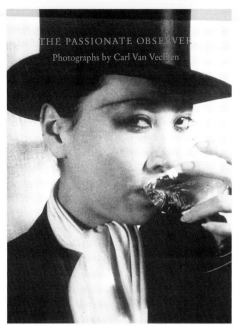

THE PASSIONATE OBSERVER
Photographs by Carl Van Vechten

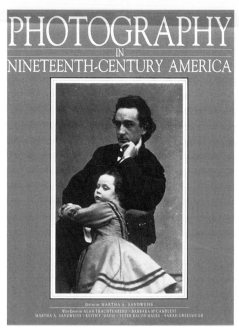

PHOTOGRAPHY
IN
NINETEENTH-CENTURY AMERICA

EDITED BY MARTHA A. SANDWEISS
With Essays by ALAN TRACHTENBERG · BARBARA MCCANDLESS
MARTHA A. SANDWEISS · KEITH F. DAVIS · PETER BACON HALES · SARAH GREENOUGH

T E R R A
Struggle of the landless

SEBASTIÃO SALGADO

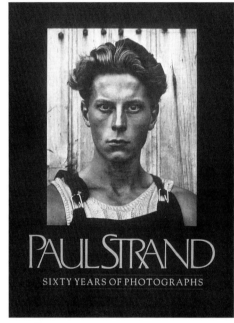

PAUL STRAND
SIXTY YEARS OF PHOTOGRAPHS

ALFRED STIEGLITZ

MASTERPIECES OF
PHOTOGRAPHY
From the George Eastman House Collections

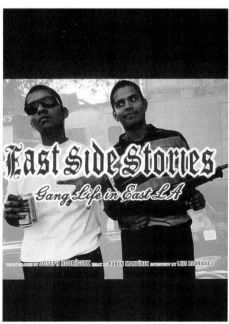

East Side Stories
Gang Life in East LA

PHOTOGRAPHS BY JOSEPH RODRÍGUEZ TEXT BY RUBÉN MARTÍNEZ FOREWORD BY LUIS RODRIGUEZ

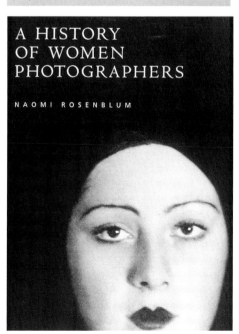

A HISTORY
OF WOMEN
PHOTOGRAPHERS

NAOMI ROSENBLUM

A selection of films by or about photographers was compiled by Artemis Willis.

Berenice Abbott
Berenice Abbott: A View of the 20th Century (1997)

Ansel Adams
Ansel Adams (1982)
Ansel Adams: Photographer (1957)
Ansel Adams: Photographer (1981)
Ansel Adams: Photographer of the American West (1981)
Language of the Camera Eye (1962)
A Moment in Time (1976)
Points of View (1960)
Professional Photography (1960, 1980)

Robert Adamson
In Camera (1984)
Pioneers of Photography: Sun Pictures (1975)

Lucien Aigner
Lucien Aigner: A Life with a Camera (1988)

Richard Avedon
Richard Avedon: Darkness and Light (1997)

Diane Arbus
Going Where I've Never Been: Photography of Diane Arbus (1972)

Eugène Atget
Atget (1967)
Eugène Atget (1963)
Eugène Atget: Photographer (1982)

David Bailey
Andy Warhol (1973)
Beaton by Bailey (1971)
David Bailey (1988)

Hippolyte Bayard
The Inventors (1982)

Peter Beard
Africa: The End of the Game (1979)
Bicentennial Diary (1976)
Hallelujah, the Hills! (1963, actor)
Longing for Darkness (1975)

Cecil Beaton
Anna Karenina (1947)
Beware of Pity (1946)
Dangerous Moonlight (1941)
The Doctor's Dilemma (1959)
Gigi (1958)
An Ideal Husband (1948)
Kipps (1941)
My Fair Lady (1964)
On a Clear Day You Can See Forever (1970)
The Truth about Women (1957)
Young Mr. Pitt (1942)

Ruth Bernhard
Contemporary Photographers: Ruth Bernhard (1981)
Ruth Bernhard (1983)

Ian Berry
Social Documentary (1978)

Samuel Bourne
Camera: Early Photography: World on a Plate (1979)
Pioneers of Photography: Travelling Man (1975)

Margaret Bourke-White
Eyes on Russia (1934)
From the Caucasus to Moscow (1934)
Margaret Bourke-White (1989)

Bill Brandt
Bill Brandt (1982)

Anton Bruehl
The Quarry (1932)

Francis Joseph Brugiére
Danse Macabre (1922)
Light Rhythms (1931)
Theory (1925)
The Way (1923)

Mathew Brady
Mathew Brady: Photographer of an Era (1953)

Brassai (Gyula Halász)
Brassai (1971)

Wynn Bullock
Two Photographers: Wynn Bullock,
Imogen Cunningham (1967)
Wynn Bullock: Photographer (1977)

Rudy Burckhardt

145 West 21st (1936)

All Major Credit Cards (1982)

The Automotive Story (1954)

The Aviary (1954)

Alex Katz Painting (1978)

Bach's Last Keyboard Fugue (1981)

The Bottle of the Bulge (1975)

Caterpillar (1973)

Central Park in the Dark (1985)

Cerveza Bud (1981)

City Pasture (1954)

The Climate of New York (1948)

Dancers, Buildings and People in the Street (1986)

Default Averted (1975)

Doldrums (1972)

Dwellings (1975)

Eastside Summer (1959)

A Fable of Fountains (1955–57)

Good Evening Everybody (1977)

Haiti (1938)

How Wide is Sixth Avenue? (1945)

How Wide is Sixth Avenue? (1963)

In Bed (1986)

Indelible, Indelible (1983)

Inside Dope (1971)

Lurk (1965)

Made in Maine (1970)

Millions in Business as Usual (1961)

Mobile Homes (1979)

Money (1968)

Montgomery, Alabama (1941)

Mounting Tension (1950)

Neil Welliver Painting in Maine (1980)

The Nude Pond (1985)

Nymphlight (1955–57)

Pasture (1974)

The Pursuit of Happiness (1943)

Rads on Wheels (1980)

Rudy Burckhardt (1981)

Saroche (1975)

See Naples . . . and the Island of Ischia (1951)

Seeing the World: A Visit to New York (1937)

Shoot the Moon (1963)

Slipperella (1973)

Sodom and Gomorrah, New York 10036 (1976)

Sonatina and Fugue (1980)

Square Times (1967)

Summer (1970)

Tarzam (1969)

Trinidad (1943)

The Uncle's Return (1940)

Under the Brooklyn Bridge (1953)

Untitled (1984)

Up and Down the Waterfront (1946)

Verona (1955)

What Mozart Saw on Mulberry Street (1956)

Yvonne Jaquette Painting "Autumn Expansion" (1981)

Zipper (1987)

René Burri

After the Six Day War (1967)

Braccia Si, Uomini No! (1968)

The Two Faces of China (1968)

Harry Callahan

Harry Callahan: A Broadcast Exhibition (1985)

Harry Callahan: Eleanor and Barbara (1983)

Harry Callahan: A Need to See and Express (1982)

Motions (1947)

Camera: Early Photography: First Impressions (1979)

Peter Henry Emerson, Frank Meadow Sutcliffe

Camera: Early Photography: World on a Plate (1979)

Samuel Bourne, John Thomson

Julia Margaret Cameron

The Other Observers: The Women Photographers from
1850 to the Present Day (1987)

Pioneers of Photography: Famous Men and
Fair Women (1975)

Cornell Capa

Cornell Capa, Parts I & II (1975)

Now God Speaks Tzeltal (1965)

Who Am I? A Photographic Essay (1971)

Henri Cartier-Bresson

The Eye of Cartier-Bresson (1960)

Le Quebec Vu Par Cartier-Bresson (1969)

Le Retour (1944)

Victoire de la Vie (1937)

Martin Chambi

Martin Chambi and the Heirs of the Incas (1986)

Bill Christenberry

Bill Christenberry's Trip to Alabama (1986)

Lucien Clergue
Delta del Sel (1966)
Drame du Taureau (1965)
Picasso: Guerre, Amour et Paix (1971)
Sables (1968)

Marie Cosindas
The Art of Marie Cosindas (1967)

Imogen Cunningham
Imogen Cunningham at 93 (1978)
Imogen Cunningham, Photographer (1972)
Never Give Up—Imogen Cunningham (1975)
Portrait of Imogen (1987)

Edward S. Curtis
In the Land of the Headhunters (1914)
In the Land of the War Canoes (1931)
The Shadow Catcher (1974)
Walking in a Sacred Manner (1982)

Jacques Louis Mandé Daguerre
Daguerreotypes (1975)
Daguerre: The Birth of Photography (1964)
Keepers of the Light (1988)

Daguerre: The Birth of Photography (1964)
Frederick Scott Archer, Hippolyte Bayard, Jacques Louis
Mandé Daguerre, David Octavius Hill, William Henry Fox
Talbot

Judy Dater
The Woman Behind the Image: Photographer Judy Dater
(1981)

Bruce Davidson
Enemies: A Love Story (1989)
Isaac Singer's Nightmare and Mrs. Pupko's Beard (1973)
Living off the Land (1970)
On Your Way Up (1966)
Zoo Doctor (1971)

Roy De Carava
Conversations with Roy De Carava (1983)

Jack Delano
Desde las nubes (1948)
Jesus T. Piñero (1949)
La gaceta (1966)

La voz del pueblo (1949)
Los peloteros (1951)
Pablo Casals en Puerto Rico (1956)
Sabios arboles, mágicos arboles (1974)

Raymond Depardon
Afriques: Comment ça va avec la douleur? (1996)
Biafra (1968)
Carthagena: Contre l'oublie (1991)
Contacts (1990)
Délits fragrants (1994)
Dix minutes de silence pour John Lennon (1981)
Face á la mer (1993)
Faits divers (1983)
Isola San Clemente (1982)
Israël (1967)
Jan Pallach (1969)
La captive du désert (1989)
Le petit navire (1987)
Les années déclic (1985)
Malraux (1996)
Montage (1994)
New York, N.Y. (1986)
Numéro zéro (n.d.)
Piparsod (1982)
Reporters (1981)
Tchad: L'embuscade (1970)
Tchad 2 (1975)
Tchad 3 (1976)
Tibesti too (1976)
Venezuela (1963)

Robert Doisneau
The Paris of Robert Doisneau (1973)
Robert Doisneau, Baduad de Paris, Pecheur D'Images (1981)

George Eastman
George Eastman: One Man's Vision, Image for All (1981)

Alfred Eisenstaedt
Alfred Eisenstaedt (1982)
Eisenstaedt—Germany (1982)

Elliot Elisofon
African Heritage (1967)
Black African Heritage (1972)
Khartoum (1966)

Peter Henry Emerson
Camera: Early Photography: First Impressions (1979)

Morris Engel
The Little Fugitive (1953)
Weddings and Babies (1960)

Elliot Erwitt
Arthur Penn Films "Little Big Man" (1969)
Beautiful, Baby, Beautiful (1973)
Beauty Knows No Pain (1971)
Czechoslovakia's Last Day of Freedom (1968)
Dustin Hoffman (1969)
The Great Treasure Hunt: Japan (1986)
Red, White and Bluegrass (1973)

Walker Evans
Let Us Now Praise Famous Men; Alabama 40 Years On (1979)
A Moment in Time (1976)
Walker Evans: His Time—His Presence—His Silence (1970)

Andreas Feininger
Andreas Feininger (1978)
Andreas Feininger (1982)

Roger Fenton
Camera: Early Photography: Eyewitness of War (1979)

Robert Frank
About Me: A Musical (1971)
About Us (1972)
Candy Mountain (1987)
C'est vrai (1991)
Chappaqua (1967, camera)
Cocksucker Blues (1972)
Conversations in Vermont (1969)
Date d'échéance (1986, actor)
Energy and How to Get It (1981)
Fire in the East: A Portrait of Robert Frank (1986)
Home Improvements (1985)
Home Is Where the Heart Is (1971, camera)
Hunter (1989)
Keep Busy (1975)
The Last Supper (1992)
Life Dances On (1979)
Life-Raft Earth (1969)
Me and My Brother (1968)
Moving Pictures (1994)
O.K., End Here (1963)
The Present (1996)
Pull My Daisy (1959)
Robert Frank: L'Immagine della poesia (1983)
Romeo Gigli (1991)

Run (1989)
The Sin of Jesus (1961)
This Song Is for You, Jack (1983)

Leonard Freed
Dansende Vromen (1963)
The Negro in America (1966)

Laura Gilpin
Laura Gilpin: An Enduring Grace (1986)

Emmet Gowin
The Photographer's Eye (1981)

John Gutmann
The Chinese Peasant Goes to Market (1949)
Journey to Kinming (1949)
Le palais ideal (1983)

Ernst Haas
To Dream with Open Eyes (1992)

Robert Heinecken
Robert Heinecken (1976)

Fritz Henle
Shango (1954)
The Trinidad Carnival (1952)
Virgin Islands, U.S.A. (1950)

David Octavius Hill
In Camera (1984)
Pioneers of Photography: Sun Pictures (1975)

Lewis Hine
America and Lewis Hine (1984)
Documentarily Thine: Lewis Hine (1977)
A Moment in Time (1976)

David Hockney
David Hockney's Diaries (1970)
Hockney the Photographer (1984)

Horst P. Horst
Horst (1988)

Eikoh Hosoe
Naval and Atomic Bomb (1960)
Tokyo Olympic Games (1966)

George Hoyningen-Huene

Adventures of Ali Baba (1954)

Bhowani Junction (1956)

A Breath of Scandal (1960)

The Chapman Report (1962)

Daphne: The Virgin of the Golden Laurels (1951)

The Five Pennies (1959)

God's Monkey: Hieronymous Bosch (1955)

Heller in Pink Tights (1960)

It Started in Naples ((1960)

Les Girls (1957)

Let's Make Love (1960)

The Loves of Carmen (1946)

Merry Andrew (1958)

A New Kind of Love (1963)

Passion (1946)

The Rains of Ranjipur (1955)

Salome (1946)

A Star Is Born (1954)

Untitled (1927)

Frank Hurley

Advance into Libya (1939)

The Holy Land (1943)

In the Grip of the Polar Ice (1917)

Pearls and Savages, a.k.a. The Lost Tribe (1931)

The Ross Smith Flight (1918)

Siege at Tobruk (1941)

Siege of the South (1931)

With Alenby in Palestine (1917)

With Head Hunters in Papua (1931)

Images of Glory (1986)

Eadweard Muybridge, Timothy O'Sullivan

In Camera (1984)

Robert Adamson, David Octavius Hill

The Inventors (1982)

Hippolite Bayard, Louis Jacques Mandé Daguerre,
William Henry Fox Talbot

Lotte Jacobi

A Conversation with Lotte Jacobi (1977)

Yousuf Karsh

Karsh: The Searching Eye (1985)

Keepers of the Light (1988)

Louis Jacques Mandé Daguerre, Joseph Nicéphore Niepce,
William Henry Fox Talbot

André Kertész

André Kertész (1983)

André Kertész of the Cities (1985)

André Kertész, Photographe Americain a Paris (1981)

André Kertész: A Poet with a Camera (1985)

Everything Is Photograph: Profile of André Kertész (1978)

William Klein

Babilée 91 (1991)

Barcelone (1962)

Broadway by Light (1958)

Cassius le Grand (1964)

Ciné Défense (1989)

Contacts (1983)

Eldridge Cleaver, Black Panther (1969)

Float Like a Butterfly, Sting Like a Bee (1969)

Festival Panafrican de la Culture (1970)

The French (1982)

Grands soirs et petits matins (1978)

Hollywood, California (1977)

How to Kill a Cadillac (1959)

In and Out of Fashion (1993)

La circulation (1963)

Le Business et la Mode (1962)

Le grand Café (1972)

Le grand Hernie (1960)

Le grand Magazin (1962)

Les Elections (1963)

L'Espagne: Tremblement de Ciel (1963)

The Little Richard Story (1980)

Loin du Vietnam (1967)

Mister Freedom (1968)

Mode in France (1985)

The Model Couple (1975)

Muhammed Ali, the Greatest (1975)

Music City (1978)

Qui êtes vous, Polly Magoo? (1966)

Slow Motion (1984)

Who Are You William Klein? (1968)

William Klein (1963)

William Klein (1980)

William Klein (1984)

William Klein Photographer (1965)

Dorothea Lange

Dorothea Lange (1988)

Dorothea Lange: The Closer for Me (1965)

Dorothea Lange: Under the Trees (1965)

A Moment in Time (1976)

Language of the Camera Eye (1962)
Ansel Adams, Henri Cartier-Bresson, Beaumont Newhall,
Edward Weston, Edward Steichen

Edwin Land
Colourful Notions (1986)

Jacques-Henri Lartigue
Jacques-Henri Lartigue (1982)
Jacques-Henri Lartigue (1985)
Jacques-Henri Lartigue:1980 (1980)
Jacques-Henri Lartigue, Peintre et Photographe (1980)

Russell Lee
Photographer: Russel Lee (1986)

Helen Levitt
An Affair of the Skin (1963)
Another Light (1952)
The Balcony (1963)
The Capitol Story (1945)
Here Is China (1943)
In the Street (1946–52)
The Quiet One (1948)
The Savage Eye (1959)
The Steps of Age (1950)

Alexander Liberman
La femme française dans l'art (1936)

Annie Leibovitz
Annie Leibovitz: Celebrity Photographer (1997)

Danny Lyon
Born to Film (1981)
Dear Mark (1983)
The Destiny of the Xerox Kid (1970)
El mojado (1974)
El otro lado (1978)
Little Boy (1977)
Llanito (1971)
Los niños abandonados (1975)
The Media Man (1994)
Social Sciences 127 (1969)
Willie (1985)

Nathan Lyons
Nathan Lyons (1978)

Donald McCullin
Social Documentary (1978)

Robert Mapplethorpe
Lady Lisa Lion (1984)
Robert Mapplethorpe (1988)
Still Moving: Patti Smith (1978)
Underground Films (1965–70)

Etienne Marey
Pioneers of Photography: The Fleeting Image (1975)

Mary Ellen Mark
American Heart (1993)
Mary Ellen Mark: The Searching Eye (1992)
Streetwise (1987)

Susan Meiselas
Living at Risk (1985)
Pictures from the Revolution (1991)
Voyages: Nicaragua (1987)

Duane Michals
Duane Michals (1978)

Gjon Mili
Eisenstaedt Photographs the Tall Men (1955)
Homage to Picasso (1967)
Jamming the Blues (1944)
Raoul Dufy (1951)
Stomping for Mili: Brubeck jazz Quartet (1955)
Tempest: Filming on Location (1958)

Lee Miller
The Lives of Lee Miller (1980)

Tina Modotti
Tina Modotti (1982)

Laszló Moholy-Nagy
Architekturkongress (n.d.)
Berliner Stillleben (1930)
Ein Lichtspeil: Swarz-weiß-grau (1929)
Großstadtzigeuner (1932)
Impression vom alten Marseiller Hafen (1929)

A Moment in Time (1976)
Ansel Adams, Mathew B. Brady, Louis Jacques Mandé
Daguerre, Walker Evans, Edwin Herbert Land, Dorothea
Lange, Leni Riefenstahl, Jacob Riis

Barbara Morgan
Barbara Morgan (1983)
Barbara Morgan: Everything Is Dancing (1983)

Martin Munkacsi
Bob's Declaration of Independence (1954)

Nikolas Muray
Frida Kahlo (1942)

Eadweard Muybridge
Animals in Motions (1968)
Camera: Early Photography: Wheel of Life—Movement (1979)
Connections: 9–Countdown (1978)
Eadweard Muybridge, Zoopraxographer (1975)
Images of Glory (1986)
Pioneers of Photography: The Fleeting Image (1975)

Nadar (Gaspard Félix Tournachon)
Pioneers of Photography: Nadar the Great (1975)

Hans Namuth
Alfred Stieglitz, Photographer (1982)
Balthus at the Pompidou (1984)
The Brancusi Retrospective at the Guggenheim (1970)
Calder's Universe (1977)
Centennial at the Grand Palais (1971)
De Kooning at the Modern (1951)
Henri Matisse: Centennial at the Grand Palais (1971)
Jackson Pollock (1951)
Josef Albers: Homage to the Square (1969)
Louis I. Kahn, Architect (1972)
Willem De Kooning, the Painter (1966)

Arnold Newman
The Portrait (1978)

Helmut Newton
Helmut Newton (1988)
Helmut Newton: Frames from the Edge (1996)

Joseph Nicéphore Niepce
The Inventors (1982)
Keepers of the Light (1988)
Pioneers of Photography: Mirror with a Memory (1975)

The Other Observers: Women Photographers from 1859 to the Present Day (1987)
Julia Margaret Cameron

Gordon Parks
Flavio (1962)
Gordon Parks: Moments without Proper Names (1988)

Leadbelly (1976)
The Learning Tree (1968)
Shaft (1971)
Shaft's Big Score (1972)
The Super Cops (1974)
The Weapons of Gordon Parks (1966)

The Photographer's Eye (1981)
Emmet Gowin, Garry Winogrand

Pioneers of Photography: The Fleeting Image (1975)
Jules Etienne Marey, Eadweard Muybridge

Pioneers of Photography: Mirror with a Memory (1975)
Louis Jacques Mandé Daguerre, Joseph Nicéphore Niepce

Pioneers of Photography: Sun Pictures (1975)
Robert Adamson, Hippolyte Bayard, David Octavius Hill

Pioneers of Photography: Travelling Man (1975)
Samuel Bourne

Professional Photography (1960, 1980)
Ansel Adams

Eliot Porter
Eliot Porter (1983)
Eliot Porter's World (1987)

Man Ray
Anemic Cinema (1924)
Dreams That Money Can Buy (1947, with Hans Richter)
Emak Bakia (1927)
Entr'acte (1924, with René Clair)
Essai de simulation de delire cinématographique
La retour à la raison (1923)
L'étoile de mer (1928–29)
Le mystére de château de des (1928)
Man Ray (1959)
Man Ray (1972)
Man Ray (1984)
Man Ray Photographe (1961)

Leni Riefenstahl
Das blaue Licht (1932)
Olympia: Fest der Völker (1938)
Sieg des Glaubens (1933)
Tag der Freiheit: Unsere Wehrmacht (1935)

Tiefland (1945–54)
Triumph des Willens (1933)

Jacob Riis
A Moment in Time (1976)

Alexander Michailovitch Rodchenko
Al'bidum (1927)
Cimizacija lesa (1927)
Kem Byt? (1927)
Moskva v Oktjabre (1927)
Vasha Znakomaya (1927)
Zurnalistka (1927)

Milton Rogovin
Milton Rogovin (1975)
Milton Rogovin (1985)

Willy Ronis
Le Photographe Willy Ronis (1981)
Willy Ronis ou les cadeaux du hasard (1988)

Edward Ruscha
Premium (1974)
Miracle (1975)

Andrew J. Russell
Andrew J. Russell: A Visual Historian (1983)

August Sander
Homage to August Sander (1977)

Charles Sheeler
Katherine Baird Shaffer (1919)
Manhatta, a.k.a. New York the Magnificent, with Paul Strand (1921)

Cindy Sherman
Cindy Sherman: An Interview (1980)
Office Killer (1997)

Jeanloup Sieff
Jeanloup Sieff (1993)

Laurie Simmons
Laurie Simmons: A Teaser (1980)

Aaron Siskind
Aaron Siskind (1981)

W. Eugene Smith
W. Eugene Smith: Photography Made Difficult (1989)

Lord Snowdon
(Anthony Charles Robert Armstrong-Jones)
Born to Be Small (1971)
Burke and Wills (1975)
Don't Count the Candles (1968)
Happy Being Happy (1973)
Love of a Kind (1969)
Peter, Tina and Steve (1977)
Snowdon on Camera: Parts 1 and 2 (1982)

Social Documentary (1978)
Ian Berry, Donald McCullin

Eve Sonneman
Ann Arbor Film Festival (1974)
The Art Institute of Chicago (1977)
Bard College (1976)
Canyon Cinemateque (1974)
Castelli Graphics (1982)
Films (1973)
Rheinisches Landesmuseum (1982)

Edward Steichen
Edward Steichen (1953)
Edward Steichen (1964)
The Fighting Lady (1944)
The Family of Man (1955)
The Family of Man (1956)
Language of the Camera Eye (1962)
The Photographer (1961)
Master of the Camera: Edward Steichen (1935)
Steichen: A Century in Photography (1980)
This Is Edward Steichen (1965)

Ralph Steiner
Beyond Niagara (1973)
Cafe Universal (1934, unfinished)
The City (1939)
City Film (1927)
Earth and Fire (1950)
G-3 (1933)
Glory, Glory (1970)
Granite/The Quarry (1932)
H2O (1929)
Hands (1934)
Harbor Scenes (1932)
Hooray for Light! (1975)

A Look at Laundry (1971)
Look Park (1974)
May Day in New York (1931)
Mechanical Principles (1930)
Mechanical Principles (1933)
New Hampshire's Heritage (1940)
Of Earth and Fire (1968)
One Man's Island (1969)
Panther Woman of the Needle Trades or the Lonely Life of
Little Lisa (1931)
The People of the Cumberland (1938)
People Playing Croquet (1929)
Pie in the Sky (1934)
The Plow That Broke the Plains (1936)
Ralph Steiner (1983)
Sarah Lawrence (1940)
Seaweed, a Seduction (1960)
Silo (1929)
Slowdown (1975)
Surf and Seaweed (1931)
Troop Train (1942)
The World Today: Black Legion (1935)
The World Today: Sunnyside (1935)
Youth Gets a Break (1941)

Alfred Stieglitz
Alfred Stieglitz: Photographer (1982)
Language of the Camera Eye (1962)

Bert Stern
Jazz on a Summer's Day (1968)

Dennis Stock
British Youth (1991)
Efforts to Provoke (1991)
James Dean Revisited (1991)
One Little Indian (1991)
Quest (1991)

Paul Strand
Betty Behave (1927)
Crackerjack (1925)
Heart of Spain (1937)
It's Up to You (1943)
Janice Meredith (1924)
The Live Wire (1925)
Manhatta, a.k.a. New York the Magnificent, with Charles
Sheeler (1921)
Manhattan (1924)
Native Land (1942)

The People of the Cumberland (1938)
The Plow That Broke the Plains (1936)
Redes (The Wave, 1934–36)
Strand: Under the Dark Cloth (1992)
Tomorrow We Fly (1944)
Where the Pavement Begins (1928)

Peter Henry Emerson
Camera: Early Photography: First Impressions (1979)

William Henry Fox Talbot
The Inventors (1982)
Keepers of the Light (1988)
Pioneers of Photography: The Pencil of Nature (1975)
A Place in the Country: Lacock Abbey, Wiltshire (19??)

John Thomson
Camera: Early Photography: World on a Plate (1979)

George Tice
George Tice (1983)

Phillip Trager
Phillip Trager (1983)
Two Photographers: Wynn Bullock,
Imogen Cunningham (1967)

James Van Der Zee
Black Has Always Been Beautiful (1971)
Uncommon Images: The Harlem
of James Van Der Zee (1977)

Willard Van Dyke
The Photographer (1948)
The Bridge (1942)
Cabos blancos (1954)
The Children Must Learn (1940)
The City (1939)
Conference at Yellow Springs (1945)
Conversations with Willard Van Dyke (1981)
Corbit-Sharp House (1965)
Cowboy (1943)
Depressed Era (1963)
Excursion House (1954)
The Farmer: Feast or Famine (1965)
Frontier of the News (1964)
Frontline Camera (1965)
Hands (1934)
Harvest (1962)
High Adventure with Lowell Thomas (1958)

Ireland—The Tear and the Smile (1960)

Journey into Medicine (1947)

Land of White Alice (1959)

Life of the Molds (1957)

Mount Vernon in Virginia (1949)

Mountains of the Moon (1958)

New Hampshire's Heritage (1940)

New York University (1952)

Oswego Story (1943)

Pacific Northwest (1945)

Pop Buell: Hoosier Farmer in Laos (1965)

Reflections of Boyhood (1954)

Rice (1964)

The River (1937)

San Francisco (1945)

Sarah Lawrence (1940)

Self-Help Cooperatives in California (1935)

The Shape of Films to Come (1968)

Skyscraper (1959)

So That Men Are Free (1962)

Steeltown (1934)

Sweden (1960)

Tall Tales (1941)

Taming the Mekong (1965)

There Is a Season (1954)

Tiger Hunt in Assam (1958)

To Hear Your Banjo Play (1946)

Valley Town (1940)

Willard Van Dyke (1983)

The World Today: Sunnyside (1935)

A Year's Work (1940)

Roman Vishniac

The Big Little World of Roman Vishniac (1972)

The Concerns of Roman Vishniac (1972)

European Jewry (1939)

Living Biology (1964)

The World That Disappeared: The Pictures of
Roman Vishniac (1978)

The Worlds of Dr. Vishniac (1959)

Andy Warhol

Afternoon (1965)

Batman Dracula (1964)

Beauty N 2 (1965)

Bike Boy (1967)

Bitch (1965)

Blow Job (1963–64)

Blue Movie (1968)

Bufferin (1966)

Camp (1965)

The Chelsea Girls (1966)

The Closet (1965)

Couch (1964)

Dance Movie (1963)

Drink (1965)

Eat (1964)

Eating Too Fast (1966)

Empire (1965)

The End of Dawn (1964)

Face (1966)

Fifty Fantastics and Fifty Personalities (1964–65)

Haircut (1964)

Harlot (1964)

Hedy (1965)

Henry Geldzahler (1964)

Horse (1965)

I, a Man. (1967)

Ivy and John (1965)

Kiss (1966)

Kitchen (1965)

The Life of Juanita Castro (1965)

Lonesome Cowboys (1968)

The Loves of Ondine (1968)

Lupe (1965)

Mario Banana (1964)

My Hustler (1965)

Nude Restaurant (1967)

Outer and Inner Space (1965)

Paul Swan (1965)

Poor Little Rich Girl (1965)

Prison (1965)

Restaurant (1965)

Salome and Delilah (1963)

Screen Test N 1 (1965)

Screen Test N 2 (1965)

Shoulder (1964)

Sleep (1963)

Soap Opera (1964)

Space (1965)

Suicide (1965)

Surfing Movie (1968)

Tarzan and Jane Regained . . . Sort of (1964)

Taylor Mead's Ass (1964)

The Thirteen Most Beautiful Boys (1964–65)

The Thirteen Most Beautiful Women (1964–64)

The Velvet Underground and Nico (1966)

Vinyl (1965)

Carleton Watkins

Carleton Watkins (1983)

The Wet Plate Photography Process (1983)

Bruce Weber

Backyard Shift (1992)

Broken Noses (1987)

Let's Get Lost (1989)

Todd Webb

Honest Vision (1951)

Weegee (Arthur H. Fellig)

Cocktail Party (1950)

Fun City (1967)

The Idiot Box (1967)

The Real Weegee (1967–85)

Weegee's New York (1948)

Windjammer (1957)

William Wegman

Blue Monday (1988)

Crooked Finger/Crooked Stick (1970–78)

Deoderant (1970–78)

Growl (1970–78)

The Hardly Boys in Hardly Gold (1996)

Out and In (1970–78)

Milk/Floor (1970–78)

Pocketbook Man (1970–78)

Randy's Sick (1970–78)

Stomach Song (1970–78)

Talking Fish (1970–78)

William Wegman (1980)

The World of Photography (1986)

Edward Weston

The Daybooks of Edward Weston: How Young I Was (1965)

The Daybooks of Edward Weston: The Strongest
Way of Seeing (1965)

Edward Weston: Artist of the Camera (1981)

Language of the Camera Eye (1962)

The Photographer (1948)

Garry Winogrand

The Photographer's Eye (1981)

THE ANSEL ADAMS GALLERY
Inn at Spanish Bay
2700 Seventeen Mile Drive
P. O. Box 1725
Pebble Beach, CA 93953
Tel.: 408-375-7215 \ Fax: 408-375-7302
E-mail: jeffish@adamsgallery.com
Jeff Conley

THE AFTERIMAGE GALLERY
The Quadrangle #115
2828 Routh Street
Dallas, TX 75201
Tel.\Fax: 214-871-9140
E-mail: images@afterimagegallery.com
Web Site: www.afterimagegallery.com
Ben Breard

ALINDER GALLERY
39165 S. Coastal Highway One
P. O. Box 1146
Gualala, CA 95445
Tel.: 707-884-4884 \ Fax: 707-884-9124
E-mail: alinders@men.org
Web Site: www.alindergallery.com
James Alinder
Mary Street Alinder

A.R.C. GALLERY
1040 West Huron
2nd Floor
Chicago, IL 60622
Tel.: 312-733-2787
Julia M. Morrisroe

APERTURE/BURDEN
20 East 23rd Street
New York, NY 10010
Tel.: 212-505-5555 \ Fax: 212-979-7759
E-mail: aperture@ixnetcom.com
Web Site: aperture.org

BANNING + ASSOCIATES, LTD.
16 East 78th St.
New York, NY 10021
Tel.: 212-288-6655 \ Fax: 212-794-4289
E-mail: banning@interport.net
Web Site: photoarts.com/banning
Jack Banning

BANNISTER GALLERY
600 Mt. Pleasant Ave.
Rhode Island College
Providence, RI 02908
Tel.: 401-456-9765 \ Fax: 401-456-8379
Web Site: http://www.ric.edu/home/buildings/
barristerbanister.html.
Web Site: domaly@grog.ric.edu
Dennis O'Malley

BATON ROUGE GALLERY, INC.
1442 City Park Ave.
Baton Route, LA 70808
Tel.: 225-383-1470 \ Fax: 225-336-0943
E-mail: brgal@intersurf.com
Kitty Pheney

BONNI BENRUBI GALLERY, INC.
52 East 76th Street
New York, NY 10021
Tel.: 212-517-3766 \ Fax: 212-288-7815
Bonni Benrubi
Karen Marks

SANDRA BERLER GALLERY
7002 Connecticut Avenue
Chevy Chase, MD 20815
Tel.: 301-656-8144 \ Fax: 301-656-8182
E-mail: DBerler@aol.com
Sandra Berler

JANET BORDEN, INC.
560 Broadway
New York, NY 10012
Tel.: 212-431-0166 \ Fax: 212-274-1679
E-mail: jborden@dorsai.org
Janet Borden
Matthew Whitworth

BOUND & UNBOUND
601 W. 26th St.
New York, NY
Tel: 212-463-7348
Barbara Moore

BRAITHWAITE FINE ARTS GALLERY
Southern Utah University
351 West Center Street
Cedar City, UT 84720
Tel.: 801-586-5432 \ Fax: 801-865-8012

E-mail: museums@suu.edu
Web Site: http://www.suu.edu/webpages/museumgaller
Lydia Johnson

J. J. BROOKINGS GALLERY
669 Mission Street
San Francisco, CA 94105
Tel.: 415-546-1000 \ Fax: 415-357-1100
E-mail: fineart@jjbrookings.com
Web Site: www.jjbrookings.com
Timothy C. Duran

ROBERT BURGE/20TH CENTURY
PHOTOGRAPHS LTD.
315 East 62nd Street
New York, NY 10021
Tel.: 212-838-4108 \ Fax: 212-838-4390
Robert Burge

BUTTERFIELD & BUTTERFIELD
230 San Bruno Avenue at 15th Street
San Francisco, CA 94103
Tel.: 415-861-7500 \ Fax: 415-861-8951
E-mail: info@butterfields.com
Web Site: www.butterfields.com
Amanda Doenitz

THE CAMERA OBSCURA GALLERY
1309 Bannock Street
Denver, CO 80204
Tel.\Fax: 303-623-4059
E-mail: hgould@iws.net
Hal D. Gould

THE CENTER FOR PHOTOGRAPHY
4729 McPherson
St. Louis, MO 63108
Tel.: 314-361-7770 \ Fax: 314-361-2403
Barry Mandel
Tony Carosella

CHRISTIE'S
502 Park Avenue
New York, NY 10022
Tel.: 212-546-1000
Web Site: www.christies.com
Rick Wester
Ellen de Boer
Leila Hill

JOHN CLEARY GALLERY
2635 Colquitt
Houston, TX 77098
Tel.: 713-524-5070 \ Fax: 713-524-4456
John Cleary

STEPHEN COHEN GALLERY
7358 Beverly Boulevard
Los Angeles, CA 90036
Tel.: 213-937-5525 \ Fax: 213-937-5523
E-mail: stephen@stephencohengallery.com
Web Site: www.StephenCohenGallery.com
Stephen Cohen

STEPHEN DAITER GALLERY
311 West Superior Street
Suite 404
Chicago, IL 60610
Tel.: 312-787-3350 \ Fax: 312-787-3354
Stephen Daiter

DALLAS VISUAL ART CENTER
2917 Swiss Avenue
Dallas, TX 75204
Tel.: 214-821-2522 \ Fax: 214-821-9103
E-mail: dallasvisualart@starrtext.net
Katherine Wagner

JAMES DANZIGER GALLERY
851 Madison Avenue
New York, NY 10021
Tel.: 212-734-5300 \ Fax: 212-734-9300
James Danziger

DE HAVILLAND FINE ART
39 Newbury Street
Boston, MA 02116
Tel.: 617-859-3880 \ Fax: 617-859-3973
Web Site: http://www.ArtExplorer.com
Jennifer Gilbert

KEITH DE LELLIS GALLERY
47 East 68th Street
New York, NY 10021
Tel.: 212-327-1482 \ Fax: 212-327-1492
Keith de Lellis

CATHERINE EDELMAN GALLERY
300 W. Superior Street
Lower Level

Chicago, IL 60610
Tel.: 312-266-2350 \ Fax: 312-266-1967
E-mail: ceggal@aol.com
Catherine Edelman

GARY EDWARDS GALLERY
9 Hillyer Court, N.W.
Washington, DC 20008
Tel.: 202-232-5926 \ Fax: 202-232-1523
E-mail: garyedwardsgallery@erols.com
Gary Edwards

CAROL EHLERS GALLERY, LTD.
750 North Orleans
Suite 303
Chicago, IL 60610
Tel.: 312-642-8611 \ Fax: 312-642-9151
Carol Ehlers

ETHERTON GALLERY
135 South Sixth Avenue
Tucson, AZ 85701
Tel.: 520-624-7370 \ Fax: 520-792-4569
E-mail: ethgal@azstarnet.com
Terry Etherton

KATHLEEN EWING GALLERY
1609 Connecticut Avenue, N.W.
Washington, DC 20009
Tel.: 202-328-0955 \ Fax: 202-462-1019
E-mail: ewingal@aol.com
Web Site: artline.com
Kathleen Ewing

FAHEY/KLEIN GALLERY
148 North La Brea Avenue
Los Angeles, CA 90036
Tel.: 213-934-2250 \ Fax: 213-934-4243
E-mail: fkg@pobox.com
David Fahey
Randee Klein Devlin

PETER FETTERMAN PHOTOGRAPHIC WORKS
OF ART
Bergamot Station
2525 Michigan Avenue, A7
Santa Monica, CA 90404
Tel.: 310-453-6463 \ Fax: 310-453-6959
E-mail: pfgallery@earthlink.net

Web Site: www.photoarts.com/fetterman
Peter Fetterman

FOCAL POINT GALLERY
321 City Island Avenue
New York, NY 10464
Tel.: 718-885-1403
Ron Terner

FRAENKEL GALLERY
49 Geary Street
San Francisco, CA 94108
Tel.: 415-981-2661 \ Fax: 415-981-4014
E-mail: fraenkel@sirius.com
Jeffrey Fraenkel

BARRY FRIEDMAN LTD.
32 East 67th Street
New York, NY 10021
Tel.: 212-794-8950 \ Fax: 212-794-8889
E-mail: BFLTDGAL@aol.com
Barry Friedman

GALLERY OF CONTEMPORARY PHOTOGRAPHY
Bergamot Station Arts Center
2525 Michigan Avenue, D-3
Santa Monica, CA 90404
Tel.: 310-264-8440 \ Fax: 310-264-8443
Rose Shoshana
Laura Peterson

GALLERY 825/LA ART ASSOCIATION
825 North La Cienega Boulevard
Los Angeles, CA 90069
Tel.: 310-652-8272 \ Fax: 310-652-9251
Amy Perez

A GALLERY FOR FINE PHOTOGRAPHY
322 Royal Street
New Orleans, LA 70130
Tel.: 504-568-1313
Joshua Mann Pailet
Cindy Saylor

G. GIBSON GALLERY
122 South Jackson Street
Suite 200
Seattle, WA 98104
Tel.: 206-587-4033 \ Fax: 206-587-5751

E-mail: ggibson@halcyon.com
Gail Gibson

FAY GOLD GALLERY
247 Buckhead Avenue
Atlanta, GA 30305
Tel.: 404-233-3843 \ Fax: 404-365-8633
Fay Gold
Alex Barlow

GREAT MODERN PICTURES
17 West 24th Street
New York, NY 10010
Robert Keil
Bonita Y. Lei

HOWARD GREENBERG GALLERY
120 Wooster Street
New York, NY 10012
Tel.: 212-334-0010 \ Fax: 212-941-7479
E-mail: howard.greenberg.gallery@worldnet.att.net
Howard Greenberg
Marla Hamburg Kennedy

THE HALSTED GALLERY
560 North Old Woodward Avenue
Birmingham, MI 48009
Tel.: 248-644-8284 \ Fax: 248-644-3911
E-mail: halsted@Rust.net
Thomas Halsted
Wendy Halsted

O. K. HARRIS
373 West Broadway
New York, NY 10012
Tel.: 212-431-3600 \ Fax: 212-925-4797
Ivan C. Karp

G. RAY HAWKINS GALLERY
908 Colorado Avenue
Santa Monica, CA 90401
Tel.: 310-394-5558 \ Fax: 310-576-2468
G. Ray Hawkins

PAUL M. HERTZMANN, INC.
P. O. Box 40447
San Francisco, CA 94140
Tel.: 415-626-2677 \ Fax: 415-552-4160
Paul Hertzmann
Susan Herzig

HYDE PARK ART CENTER
5307 South Hyde Park Boulevard
Chicago, IL 60615
Tel.: 312-324-5520
Eva Olson

EDWYNN HOUK GALLERY
745 Fifth Avenue
New York, NY 10151
Tel.: 212-750-7070 \ Fax: 212-688-4848
Edwynn Houk

INDIANAPOLIS ART CENTER
820 East 67th Street
Indianapolis, IN 46220
Tel.: 317-255-2464 \ Fax: 317-254-0486
E-mail: inartctr@inetdirect.net
Julia Moore

JACKSON FINE ART
3115 East Shadowlawn Avenue
Atlanta, GA 30305
Tel.: 404-233-3739 \ Fax: 404-233-1205
E-mail: jacksonfineart@mindspring.com
Web Site: www.photogal.com
Jane Jackson

JAN KESNER GALLERY
164 North La Brea Avenue
Los Angeles, CA 90036
Tel.: 213-938-6834 \ Fax: 213-938-1106
Jan Kesner

ROBERT KLEIN GALLERY
38 Newbury Street
Fourth Floor
Boston, MA 02116
Tel.: 617-267-7997 \ Fax: 617-267-5567
E-mail: rlklein@tiac.net
Robert Klein

ALAN KLOTZ/PHOTOCOLLECT
22 East 72nd Street
New York, NY 10021
Tel.: 212-327-2211 \ Fax: 212-327-0143
E-mail: photocol@interport.net
Web Site: www.photocollect.com
Alan Klotz

ROBERT KOCH GALLERY
49 Geary Street
San Francisco, CA 94108
Tel.: 415-421-0122 \ Fax: 415-421-6306
E-mail: rkgal@aol.com
Robert Koch

PAUL KOPEIKIN GALLERY
138 North La Brea Avenue
Los Angeles, CA 90036
Tel.: 213-937-0765 \ Fax: 213-937-5974
E-mail: pkgallery@earthlink.net
Paul Kopeikin

HANS P. KRAUS, JR., INC.
25 East 77th Street
New York, NY 10021
Tel.: 212-794-2064 \ Fax: 212-744-2770
Hans P. Kraus, Jr.
Russell Isaacs

LEICA GALLERY
670 Broadway
New York, NY 10012
Tel.: 212-777-3051 \ Fax: 212-777-6960
E-mail: leicaphoto@aol.com
Web Site: leica-camera.com
Rose and Jay Deutsch

LIGHT FACTORY
809 West Hill Street
P. P. Box 32815
Charlotte, NC 28332
Tel.: 704-333-9755 \ Fax: 704-333-5910
E-mail: tlf@webserve.net
Web Site: http://www.lightfactory.org
Bruce Lineker

LIGHT WORK
316 Waverly Avenue
Syracuse, NY 13244
Tel.: 315-443-1300 \ Fax: 315-443-9516
Web Site: http://sumweb.syr.edu/comdark/lw.htm/
Jeffrey Hoone

GALLERY LUISOTTI (RAM)
Bergamot Station
2525 Michigan Avenue, A2
Santa Monica, CA 90404
Tel.: 310-453-0043 \ Fax: 310-264-4888

E-mail: rampub@gte.com
Theresa Luisotti

ROBERT MANN GALLERY
42 East 76th Street
New York, NY 10021
Tel.: 212-570-1223 \ Fax: 212-570-1699
Robert Mann

METRO PICTURES
519 West 24 Street
New York, NY 10011
Tel. 212-206-7100 \ Fax: 212-337-0070
Janelle Reiring
Helene Winer

LAURENCE MILLER GALLERY
138 Spring Street
New York, NY 10012
Tel.: 212-226-1220 \ Fax: 212-226-2343
E-mail: Laurence.Miller.Gallery@worldnet.att.net
Laurence Miller

ROBERT MILLER GALLERY
41 East 57th Street
New York, NY 10022
Tel.: 212-980-5454 \ Fax: 212-935-3350
Olivier Rénaud-Clement

MORGAN GALLERY
412 Delaware
Suite A
Kansas City, MO 64105
Tel.: 816-842-8755 \ Fax: 816-842-3376
Dennis Morgan

SARAH MORTHLAND GALLERY
225 Tenth Avenue
New York, NY 10011
Tel.: 212-242-7767 \ Fax: 212-242-7799

SCOTT NICHOLS GALLERY
49 Geary Street
Fourth Floor
San Francisco, CA 94108
Tel.: 415-788-4641 \ Fax: 415-788-8438
E-mail: hlsphoto@aol.com
Scott Nichols

NOVOMESZKY
5112-D West Charleston Boulevard
Las Vegas, NV 89102
Tel.: 702-877-5400 \ Fax: 702-877-0990

PACEWILDENSTEINMACGILL
32 East 57 Street, 9th fl.
New York, NY 10022
Tel: 212-759-7999 \ Fax: 212-759-8964
Peter MacGill

PHILLIPS
406 East 79th Street
New York, NY 10021
Tel.: 212-570-4830 \ Fax 212-570-2207
Web Site: http://www.phillips-auctions.com
Nancy Lieberman

PHOTO-EYE GALLERY
376 Garcia Street
Santa Fe, New Mexico 87501
Tel.: 505-988-5852 \ Fax 505-988-4487
E-mail: info@photoeye.com
Web Site: www.photoeye.com
Rixon G. Reed

THE PHOTOGRAPHER'S GALLERY OF PALO ALTO
536 Ramona Street
Palo Alto, CA 94301
Tel.: 650-328-0662 \ Fax: 650-328-7742
E-mail: madameami@aol.com
Amy Saret

PHOTOGRAPHIC IMAGE GALLERY
240 S.W. First Street
Portland, OR 97204
Tel.: 503-224-3543 \ Fax: 503-224-3607
E-mail: photogal@teleport.com
Web Site: www.citysearch.com
Guy Swanson

PHOTOGRAPHIC RESOURCE CENTER
602 Commonwealth Avenue
Boston, MA 02215
Tel.: 617-353-0700 \ Fax: 617-353-1662
E-mail: prc@bu.edu
Web Site: http://web.bu.edu/prc
Robert E. Seydel

PHOTOGRAPHS DO NOT BEND GALLERY
3115 Routh Street

Dallas, TX 75201
Tel.: 214-969-1852 \ Fax: 214-969-5464
E-mail: pdnb@flash.net
Web Site: www.artphiles.com
Burt Finger
Missy Smith Finger

PHOTOGRAPHY GALLERY
Dept. PM
c/o Park School of Communications
Ithaca College
Ithaca, NY 14850
Tel.: 607-274-3088 \ Fax: 607-274-1664
Danny Guthrie

PHOTOGRAPHY: THE PLATINUM GALLERY
551 West 22nd Street
Penthouse
New York, NY 10011-1109
Tel.: 212-352-0070 \ Fax: 212-741-6449
Web Site: www.platinum~gallery.com
John Stevenson

QUEENS COLLEGE ART CENTER
Benjamin S. Rosenthal Library
Queens College
Flushing, NY 11367-6701
Tel.: 718-997-3770 \ Fax: 718-997-3753
E-mail: sb5qc@cunyvm.cuny.edu
Web Site: http://www.qc.edu/Library/Acpage.html
Suzanna Simor
Alexandra de Luise

THE RALLS COLLECTION, INC.
1516 31st Street, N.W.
Washington, DC 20007
Tel.: 202-342-1754 \ Fax: 202-342-0141
E-mail: MARalls@aol.com
Marsha Ralls

ROBIN RICE GALLERY
325 West 11th Street
New York, NY 10014
Tel.: 212-366-6660 \ Fax: 212-366-6664
Web Site: www-nystyle.com/rrice

YANCEY RICHARDSON GALLERY
560 Broadway
Suite 503
New York, NY 10012

Tel.: 212-343-1255 \ Fax: 212-343-0839
E-mail: Yancey@tiac.com
Yancey Richardson

ROBINSON GALLERIES
2800 Kipling
Houston, TX 77098
Tel.: 713-521-2215 \ Fax: 713-526-0763
E-mail: robin@wt.net
Web Site: http://web.wt.net/~robin
Thomas V. Robinson

SAG HARBOR PICTURE GALLERY
66 Main Street
Sag Harbor, NY 11963
Tel.: 516-725-3100 \ Fax: 516-537-6163

SAN FRANCISCO CAMERAWORK
115 Natoma Street
San Francisco, CA 94105
Tel.: 415-764-1001 \ Fax: 415-764-1063
E-mail: sfcamera@sfcamerawork.org
Web Site: Error! Bookmark not defined.

JULIE SAUL GALLERY
560 Broadway
Suite 500
New York, NY 10012
Tel.: 212-431-0747 \ Fax: 212-925-3491
E-mail: saulgall@interport.net
Julie Saul

WILLIAM L. SCHAEFFER / PHOTOGRAPHS
P. O. Box 296
Chester, CT 06412
Tel: 860-526-3870
William L. Schaeffer

SCHEINBAUM & RUSSEK LTD.
369 Montezuma
Suite 345
Santa Fe, NM 87501
Tel.: 505-988-5116 \ Fax: 505-988-4346
E-mail: srltd@nets.com
David Scheinbaum
Janet Russek

HOWARD SCHICKLER FINE ART
560 Broadway
Room 507

New York, NY 10012
Tel.: 212-431-6363 \ Fax: 212-343-2644
E-mail: hsart@interport.net
Howard Schickler

VAKNIN SCHWARTZ
1831 Peachtree Road, N.E.
Atlanta, GA 30309
Tel.: 404-351-0035 \ Fax: 404-351-0451

LISA SETTE GALLERY
4142 North Marshall Way
Scottsdale, AZ 85251
Tel.: 602-990-7342 \ Fax: 602-970-0825
E-mail: sette@getnet.com
Lisa Sette

SHAPIRO GALLERY
250 Sutter Street
Third Floor
San Francisco, CA 94108
Tel.: 415-398-6655 \ Fax: 415-398-0667
Michael Shapiro

ANDREW SMITH GALLERY
203 West San Francisco Street
Santa Fe, NM 87501
Tel.: 505-984-1234 \ Fax: 505-983-2428
E-mail: asgallery@aol.com
Andrew Smith

JOEL SOROKA GALLERY
400 East Hyman Avenue
Aspen, CO 81611
Tel.\Fax: 970-920-3152
Joel Soroka

SOTHEBY'S
1334 York Avenue
New York, NY 10021
Tel.: 212-606-7240 \ Fax: 212-606-7341
Web Site: http://www.sothebys.com
Denise Bethel
Christopher Mahoney

STALEY-WISE GALLERY
560 Broadway
New York, NY 10012
Tel.: 212-966-6223 \ Fax: 212-966-6293
Etheleen Staley
Taki Wise

STUDIO GALLERY SANTA FE
135 West Palace Avenue
Santa Fe, NM 87501
Tel.: 505-983-5999 & 800-290-5999 \ Fax: 505-983-5996
Leah Murawsky

SWANN GALLERIES
104 East 25th Street
New York, NY 10010
Tel.: 212-254-4710 \ Fax: 212-979-1017
E-mail: Swannsales@aol.com
Daile Kaplan

THE TARTT GALLERY
2017 Que Street, N.W.
Washington, DC 20009
Tel.: 202-332-5652 \ Fax: 202-797-9853
Jo C. Tartt, Jr.

THROCKMORTON FINE ART, INC.
153 East 61st Street
Fourth Floor
New York, NY 10021
Tel.: 212-223-1059 \ Fax: 212-223-1937
Web Site: www.artnet.com/throckmorton.html
Spencer Throckmorton
Malin Barth

TROYER FITZPATRICK LASSMAN GALLERY
1710 Connecticut Avenue, N.W.
Washington, DC 20009
Tel.: 202-328-7189 \ Fax: 202-667-8106
Sally Troyer
Sandra Fitzpatrick

VERED GALLERY
68 Park Place
East Hampton, NY 11937
Tel.: 516-324-3303 \ Fax: 516-324-3303
Janet Lehr

VISION GALLERY
18 Yosef Rivlin Street
P. O. Box 2101
91020 Jerusalem, Israel
Tel.: +972-2-622-2253 \ Fax: +972-2-622-2269
E-mail: folberg@netvision.net.il

Neil Folberg
Anna Folberg

VISUAL STUDIES WORKSHOP GALLERY
31 Prince Street
Rochester, NY 14607
Tel.: 716-442-8676 \ Fax: 716-442-1992

WESSEL + O'CONNOR GALLERY
242 West 26th Street
New York, NY 10001
Tel.: 212-242-8811 \ Fax: 212-242-8822
E-mail: wesselocon.aol.com

THE WESTON GALLERY, INC.
P. O. Box 655
Sixth Avenue between Dolores & Lincoln
Carmel, CA 93921
Tel.: 408-624-4453 \ Fax: 408-624-7190
Margaret W. Weston
Ann Flournoy Day

WHITE GALLERY-PORTLAND STATE UNIVERSITY
Box 751/SD
Portland, OR 97207
Tel.: 503-725-5656 & 800-547-8887 \ Fax: 503-725-4882
Dulcinea Myers-Newcomb

WITKIN
415 West Broadway
New York, NY 10012
Tel.: 212-925-5510 \ Fax: 212-925-5648
Evelyne Z. Daitz

GINNY WILLIAMS PHOTOGRAPHS
299 Fillmore Street
Denver, CO 80206
Tel.: 303-321-4077 \ Fax: 303-321-8877
Ginny Williams

ZABRISKIE GALLERY
41 East 57th Street
Fourth Floor
New York, NY 10022
Tel.: 212-752-1223 \ Fax: 212-752-1221
E-mail: zabriskieG@.com
Virginia Zabriskie

pdn's new look
duane michals speaks
pdn's guide to copyright registration
pix: the platform debate

PPA '98
New Orleans!

On Location:
Above & Beyond

Classic Portra

100TH ANNIVERSARY-STATUE OF LIBERTY

SIERRA LEONE Le4

25 Silver
Anniversary
Issue

Quarterly Magazine
of the American Society
of Picture Professionals

ry Issue
lumbers 3 & 4

PSA JOURNA

OFFICIAL MAGAZINE OF THE PHOTOGRAPHIC SOCIETY OF AMERICA

Comput
~10

PSA Is
Camera
~14

Who's Who in
Photography
~16~

GARBAGE # 5 7 M US

RAY GUN

IC + STYLE MASSIVE

ATTACK SEAN LENN

ON JESUS
AND MARY CHAIN BE
RNARD BUTLER LIS
A GERRARD

Art in America

JULY 1997

Guggenheim Bilbao
José Bedia
Yvonne Rainer

Photo Metro

Volume 15, Issue 541 $2.95

VIEWFINDER

JOURNAL OF FOCAL POINT GALLERY NO. 22

Celebrating 24 Years 1974-1998

THE WINNERS OF THE FOCAL POINT GALLERY'S
NINTH ANNUAL NATIONAL JURIED EXHIBITION

COLLECTOR'S EDITION

LIFE

THE EISIE ISSUE

THE BEST MAGAZINE PHOTOGRAPHY OF THE YEAR

THE 1ST ANNUAL ALFRED EISENSTAEDT AWARDS

HUNDREDS OF PICTURES AND THE STORIES BEHIND THEM

E ISSUE
1998/$4.95

YUNTIL APRIL 27

PHOTO

Henri Cartier-Bresson

LE PLUS
GRAND
REPORTER
DU XXe
SIECLE
FETE SES
90 ANS
DANS
PHOTO

CHINE
INDONESIE
JAPON
INDE, URSS
EUROPE
MEXIQUE
USA

ET... SA VIE
SES
SECRETS

Free Fall Vincent Serbin

These consumer and professional magazines publish photographs, features, and information about photography and are available in the United States.

Afterimage Visual Studies Workshop, 31 Prince St., Rochester, NY 14607. Tel.: 716-442-8676 \ Fax: 716-442-1992 \ E-mail: afterimg@servtech.com

Amateur Photographer Specialist Magazine Group, King's Reach Tower, Stamford St., London SE1 9LS, England. Tel.: 44.171.261.5100 \ Fax: 44.144.444.5599.

American Heritage 60 Fifth Ave. New York, NY 10011-8865 Tel.: 212-206-5500/ Fax: 212-620-2332

American Photo Hachette Filipacchi Magazines, Inc., 1633 Broadway, 45th Fl. New York, NY 10019. Tel.: 212-767-6000 \ Fax: 212-333-2439.

American Photography Fadner Media Enterprises, 16 W. 19th St., 9th Fl. , New York, NY 10011. Tel.: 212-647-0874 \ Fax: 212-691-6609.

Aperture Aperture Foundation, Inc., 29 E. 23rd St., New York 10010. Tel.: 212-505-5555 \ Fax: 212-979-7759.

Archive University of Arizona, Center for Creative Photography, Tucson, AZ 85721. Tel.: 520-621-7968 Fax: 520-621-9444 \ E-mail: meissner@ccp.arizona.edu \ Web Site: http://www.ccp.arizona.edu/ccp.html.

Art in America 575 Broadway, New York, NY 10012. Tel.: 212-941-2800 \ Fax: 212-941-2885.

The Art Newspaper P.O. Box 3000, Denville, NJ 07834-9776.

Artforum 65 Bleecker St., New York, NY 10012. Tel.: 212-475-4000 \ Fax: 212-529-1257 E-mail: artforum@aol.com.

Artnews 48 W. 38th St., New York, NY 10018. Tel.: 212-398-1690 \ Fax: 212-819-0934 E-mail: goArtnews@aol.com.

Australian Camera Craft Horowitz Publications Pty. Ltd., 55 Chandos St., St. Leonards, N.W.S. 2065, Australia.

Australian Photography Yaffa Publishing Group, 17-21 Bellevue St., Surry Hills, N.S.W. 2010, Australia. Tel.: 61.2.92812333 \ Fax: 61.2.92812750.

Blackflash P.G. Press Inc., 12-23rd St. E 2nd Floor, Saskatoon SK S7K OH5, Canada. Tel.: 306-244-8018 \ Fax: 306-665-6568.

Blind Spot Blind Spot, Inc., 49 W. 23rd St., New York, NY 10010. Tel.: 212-633-1317 \ Fax: 212-691-5465 E-mail: subscribe@blindspot.com Web Site: www.blindspot.com.

British Journal of Photography Timothy Benn Publishing Ltd., 39 Earlham St., Covent Garden, London WC2H 9LD, England. Tel.: 44.171.306.7000 \ Fax: 44.171.306.7112.

Camera Arts 1400 "S" Street, #200, Sacramento, CA 95814 Tel.: 916-441-2557/ Fax: 916-441-7407 E-mail: 75511.2576@compuserve.com

Camera Austria Edition Camera Austria, Sparkassenplatz 2, A-8010 Graz, Austria. Tel.: 43.316.81555012 Fax: 43.316.8155509 \ E-mail: camera.austria@thing.or.at. Web Site: http://www.thing.or.at/camera.austria.

Camerawork 115 Natoma St., San Francisco, CA 94105. Tel.: 415-621-1001.

Communication Arts P.O. Box 10300, Palo Alto, CA 94303-0807. Tel.: 650-326-6040 \ Fax: 650-326-1648 Web Site: www.commarts.com.

Contents Magazine Waxing Moon Communications, Inc. 129 West Gordon St. Savannah, GA 31401 Tel. 912-232-9889 Fax 912-232-9901 \ E-mail: contents99@aol.com.

Creative Camera C C Pulishing Ltd., 5 Hoxton Sq., London N1 6NU, England. Tel.: 44.171.729.6993 Fax: 44.171.729.7568 \ E-mail: info@ccamera.demon.co.uk Web Site: http://www.artec.orguk/channel/creative.

Doubletake The Center for Documentary Studies at Duke University, 1317 W. Pettigrew St., Durham, NC 27705 Tel.: 919-681-2596 E-mail: dtmag@aol.com Web Site: www.duke.edu/doubletake/

Exposure Society for Photographic Education, Box 222116, Dallas, TX 75222-2116. Tel.: 817-272-2845 \ Fax: 817-272-2846.

European Photography Postfach 3043, 37020 Goettingen, Germany. Tel.: 49.552.24820 \ Fax: 49.551.25224
E-mail: europhoto@equivalence.com
Web Site: http //equivalence.com.

Family Photo Petersen Publishing Co., 110 Fifth Ave., 2nd Fl., New York, NY 10011.
Tel.: 212-886-3600 \ Fax: 212-886-2810.

Flash Art Via Carlo Farini, 68 20159 Milano, Italy
Tel.: 39.2.668.6150 - 668.7341/2/3 \ Fax: 668 01290
E-mail Error! Bookmark not defined.
Web Site: www.artdiarynet.com

Fotophile 28-15 34th St., Ste. 3F, Long Island City, NY 11103 \ E-mail: Error! Bookmark not defined.
Web Site: http://www.sightphoto.com.

Fotomagazin Top Special Verlag GmbH, Nebendahlstr. 16, 22041, Hamburg, Germany. Tel.: 49.40.3470.0
Fax: 49.40.34725588.

Frieze 21 Denmark St., London WC2H 8NA. Tel.: 44.171.379.1533 \ Fax: 44.171.379.1521
E-mail: editors@frieze.co.uk \ Web Site: www.frieze.co.uk.

Gallery Guide P.O. Box 5541, Clinton, NJ 08809.
Tel.:: 908-638-5255 \ Fax: 908-638-8737
E-mail: artmow@gallery-guide.com
Web Site: http://www.gallery-guide.com.

i-D magazine Universal House, 251-255 Tottenham Court Road, London, W1P OAE Tel.: 0171.813.6170
 Fax: 0171.813.6179 \ E-mail: editor@i-Dmagazine.co.uk or advertising@i-Dmagazine.co.uk

Image George Eastman House—International Museum of Photography and Film, 900 East Ave., Rochester, NY 14607.
Tel.: 716-271-3361 \ Fax: 716-271-3970
Web Site: http://www.it.rit.edu~gehouse.

Katalog: A Journal of Photographs & Video
Brandts passage 37 & 43, DK-5100 Odense C, Denmark.
Tel.: +45.6613.7816 \ Fax: +45.6613.7310.
web site: www.brandts.dk/katalog

Leica-Fotographie International Umschau
Zeitschriftenverlag Breidenstein GmbH,
Stuttgarter Str. 18-24, 60329 Frankfurt a.M. Germany.
Tel.: 49.69.2600.0 \ Fax: 49.69.2600.619.

Life 1271 Ave. of the Americas, New York, NY 10020-1393
Tel.: 212-522-1212/ Fax: 212-522-0379
 Web Site: www.lifemag.com
E-mail: lifeedit@life.timeinc.com

National Geographic Magazine 1145 Seventeenth St., N.W., Washington, DC 20036-4701. Tel.: 202-857-7000
Fax: 202-775-6141.

News Photographer National Press Photographers Association, Inc., 1446 Conneaut Ave., Bowling Green, OH 43402-2145. Tel.: 419-352-8175 \ Fax: 419-354-5435
E-mail: jgordon@bright.net; nppanews@aol.com

Web Site: http //sunsite.unc.edu/nppa.

Night Suite 235, The Gershwin Hotel, 7 East 27th St., New York, NY 10016. Tel./Fax: 212-725-9790
E-mail Nightmag@hotmail.com

On Paper 39 E. 78th St., New York, NY 10021.
Tel.: 212-988-5959 \ Fax: 212-988-6107
Web Site: info@onpaper.com/www.onpaper.com.

Outdoor Photographer Werner Publishing Corporation, 12121 Wilshire Blvd., Ste. 1220, Los Angeles, CA 90025-1175. Tel.: 310-820-1500 \ Fax: 310-826-5008.

Parkett 636 Broadway, New York, NY 10012-
Tel.: 212-673-2660 \ Fax: 212-673-2887.

P S A Journal Photographic Society of America, Inc., 3000 United Founders Blvd., No. 103, Oaklahoma City, OK 73112-3940. Tel.: 405-843-1437 \ Fax: 405-843-1438
E-mail: 74521.2414@compuserve.com.

PC Photo 12121 Wilshire Blvd., Suite 1200, Los Angeles, CA 90025-1176.

Petersen's Photographic Petersen Publishing Co., 6420 Wilshire Blve., Los Angeles, CA 90048. Tel.: 213-782-2000
Fax: 213-782-2465.

Photo Filipacci Medias, 151 rue Anatole France, 92598 Levallois Perret Cedex 9, France. Tel.: 01.41.34.71.08
Fax: 01.41.34.71.52 \ Web Site: www.photo.fr.

Photo Competition USA 3900 Ford Rd., No. 18Q, Philadelphia, PA 19121-2047. Tel.: 215-878-6211.

Photo District News 1515 Broadway, New York, NY 10036. Tel.: 212-764-7300 \ Fax: 212-944-1719 Web Site: http://www.pdn-pix.com.

PEI Photo Electronic Imaging 229 Peachtree St. NE, Ste. 220, International Tower, Atlanta, GA 30303 Tel.: 404-522-8600/ Fax: 404-614-6405 Web Site: www.peimag.com

Photo Insider 11 Vreeland Road, Florham park, NJ 07932. Tel.: 973-377-1003.

Photo Life Apex Publications Inc. Toronto Dominion Bank Tower, 55 King St. W., Ste. 2550, Toronto, ON M5K 1E7, Canada. Tel.: 800-904-7468 \ Fax: 800-664-2739 E-mail: apex@photolife.com Web Site: http //www.photolife.com.

Photo Media 19019 Corliss Ave. North Seattle, WA Tel.: 206-364-7068/ Fax: 206-364-7931 E-mail: publisher@photomediagroup.com \ editor@photo-mediagroup.com

Photo Metro Magazizne 17 Tehama St., San Francisco, CA 94105. Tel.: 415-243-9917 \ Fax: 415-243-9919 E-mail: jo@idiom.com Web Site: http://www.photometro.com.

The Photo Review 301 Hill Ave., Ste. 2, Langhorne, PA 19047-2819. Tel.: 215-757-8921 \ Fax: 215-757-6421 E-mail: photorev@libertynet.org Web Site: http://www.libertynet.org/-photorev.

Photo Selection 185 Rue St. Paul, Quebec QC G1K9Z9

Photo Techniques Preston Publications, P.O. Box 43812, 6600 W. Touhy Ave., Niles, IL 60714. Tel.: 847-647-2900 \ Fax: 847-647-1155.

Photograph Collector Photo review, 310 Hill Ave., Ste. 2, Langhorne, PA 19047-2819. Tel.: 215-757-8921 Fax: 215-757-6421 \ E-mail: photorev@libertynet.org.

Photographer's Forum Serbin Communications, Inc., 511 Olive St., Santa Barbara, CA 93101. Tel.: 805-963-0439

Photographica American Photographic Historical Society, 1150 sixth Ave., 3rd Fl. New York, NY 10036-2701. Tel.: 212-575-0483.

Photography Devin-Adair Publishers, Inc., Box A, Old Greenwich, CT 06807. Tel.: 203-531-7755 \ Fax: 203-622-6688.

Photography in New York Photography in New York, Inc., 64 W. 89th St., New York, NY 10024. Tel.: 212-787-0401 Fax: 212-799-3054 \ E-mail: pny@photography-guide.com Web Site: http://www.photography-guide.com.

Photography Quarterly Center for Photography at Woodstock, 59 Tinker St., Woodstock, NY 12498-9984. Tel.: 914-679-9957 \ Fax: 914-679-6337 E-mail: cpwphoto@aol.com Web Site: http://users.aol.com/cpwphoto.

Picture Professional 2025 Pennsylvania Ave. NW No. 226, Washington, D.C., 20006. Tel.: 202-463-5851/ Fax: 202-887-3437

Picture This! Pappas Communications Group, Inc., 771 Boston Post Rd. E., Ste. 181, Marlborough, MA 01752. Tel.: 508-229-2550 \ Fax: 508-229-2551.

Popular Photography Hachette Filipacchi Magazines, Inc., 1633 Broadway, New York, NY 10019. Tel.: 212-767-6000 \ Fax: 212-767-5602.

Practical Photography E M A P-Apex, Oundle Rd., Peterborough, Cambs PE2 9ND, England. Tel.: 44.17.33.8981000 \ Fax: 44.1858.432164.

Professional Photographer Storytellers PPA Publications and Events, Inc. 229 Peachtree St., N.E., Ste. 1600, Atlanta, GA 30303. Tel.: 404-522-8600 \ Fax: 404-614-6406 E-mail: JHopper594@aol.com Web Site: http://www/ppa-world.org.

Rangefinder Rangefinder Publishing Co., Inc., 1312 Lincoln Blvd., Box 1703, Santa Monica, CA 90406. Tel.: 310-451-8506 \ Fax: 310-395-9058.

Ray Gun 2812 Santa Monica Blvd., Suite 204, Santa Monica, CA 90404. Tel.: 800-851-7784 E-mail: raygunmag@aol.com

Shooter's Rag Havelin Communications, Inc., 6100 pine Cone Lane, Austell, GA 30001. Tel.: 770-745-4170 E-mail: 72517.2176@compuserve.com.

Shutterbug's Outdoor & Nature Photography
Patch Communications, 5211 S. Washington Ave., Titusville,
FL 32780. Tel.: 407-268-5010 \ Fax: 407-267-7216.

Spot 1441 W. Alabama, Houston, TX 77006.
Tel.: 713-529-4755 \ Fax: 713-529-9248.

Studio Photography PTN Publishing Corp.,
445 Broad Hollow Rd., Ste. 21, Melville, NY 11747-4722.
Tel.: 516-845-2700 \ Fax: 516-845-7109.

Today's Photographer Magazine American Image, Inc.,
6495 Shallowford Rd., Lewisville, NC 27023.

Tel.: 910-945-9867 \ Fax: 910-945-3711
Web Site: http://www.airpress.com.

View Camera 1400 S. St., No. 200, Sacramento, CA 95814.
Tel.: 916-441-3557 \ Fax: 916-441-7407.

Viewfinder Journal of Focal Point Gallery
Focal Point Press, 321 City Island Ave., New York, NY 10464.
Tel.: 718-885-1403.

Zoom Editrice Progesso s.r.l., Viale Piceno 14, 20129 Milan,
Italy. Tel.: 39.2.70002222 \ Fax: 39.2.713030.

Bell & Howell Co. 5215 Old Orchard Rd. Skokie, IL 60077-1035. Tel.: 847-470-7100

Bogen Photo Corp. 565 East Crescent Ave. P.O. Box 506 Ramsey, NJ 07446-0506. Tel.: 201-818-9500

Calumet International Inc. 890 Supreme Dr. Bensenville, IL 60106-1107. Tel.: 630-860-7447

Canon USA Inc. 1 Canon Plaza New Hyde Park, NY 11042-1119. Tel.: 516-488-6700

Contax—Div. of Kyocera Electronics Inc. 2301-200 Cottontail Lake Somerset, NJ 08873. Tel.: 800-526-0266

Da-Lite Screen Co. Inc. 3100 N. Detroit St. Warsaw, IN 46580-2288. Tel.: 219-267-8101

Eastman Kodak Co. Inc. 343 State St. Rochester, NY 14650-0001. Tel.: 716-724-4000

Focus Camera Inc. 4419 13th Ave. Brooklyn, NY 11219-2039. Tel.: 718-436-6262

Fuji Photo Film USA Inc. 555 Taxter Rd. Elmsford, NY 10523-2314. Tel.: 914-789-8100

Hasselblad USA Inc. 10 Madison Road Fairfield, NJ 07004. Tel.: 973-227-7320

Hitachi Denshi America Ltd 150 Crossways Park Drive Woodbury, NY 11797-2059. Tel.: 516-921-7200

Konica Photo Service USA Inc. 88 Prestige Park Circle

East Hartford, CT 06108-1917. Tel.: 860-289-0300

Leica Camera, Inc. 156 Ludlow Ave. Northvale, NJ 07647. Tel.: 201-767-7500 \ 201-767-7500

Mamiya America Corporation 8 Westchester Plaza Elmsford, NY 10523. Tel.: 914-347-3300

Minolta Corporation 101 Williams Drive Ramsey, NJ 07446. Tel.: 201-825-4000

Nikon Americas Inc. 1300 Walt Whitman Road Melville, NY 11747-3012. Tel.: 516-547-4200

Olympus America Inc. 2 Corporate Center Drive Melville, NY 11747-3114. Tel.: 516-844-5000

Pentax Corp. 35 Inverness Drive East Englewood, CO 80112-5412. Tel.: 303-799-8000

Polaroid Corp. 549 Technology Square Cambridge, MA 02139-3539. Tel.: 617-386-2000

SLIK 300 Webro Road Parsippany, NJ 07054. Tel.: 973-428-9800

Tamron Industries Inc. 125 Schmitt Blvd. Farmingdale, NY 11735. Tel.: 516-694-8700

Vivitar Corp. 1280 Rancho Conejo Blvd. Newbury Park, CA 91320-1403. Tel.: 805-498-7008

Zeiss Carl Inc. 1 Zeiss Drive Thornwood, NY 10594-1939. Tel.: 914-747-1800

These institutions generally have permanent photography collections and feature photography exhibitions from time to time.

THE ACKLAND ART MUSEUM
Columbia & Franklin Streets
University of North Carolina
Chapel Hill, NC 27599-3400
Tel.: 919-966-5736 \ Fax: 919-966-1400
E-mail: ackland@email.unc.edu
Web Site: http://www.unc.edu/depts/ackland
Founded: 1958.

ADDISON GALLERY OF AMERICAN ART
Phillips Academy
Andover, MA 01810
Tel.: 508-749-4015 \ Fax: 508-749-4025
E-mail: addison@andover.edu
Web Site: www.andover.edu/addison
Founded: 1931.

AKRON ART MUSEUM
70 E. Market St.
Akron, OH 44308-2084
Tel.: 330-376-9185 \ Fax: 330-376-1180
Web Site: http://www.akronartmuseum.org
Founded: 1922.

ALBUQUERQUE MUSEUM
2000 Mountain Rd., N.W.
Albuquerque, NM 87104
Tel.: 505-243-7255 \ Fax: 505-764-6546
E-mail: musmsn@museum.cabq.gov
Founded: 1967.

ALLEN MEMORIAL ART MUSEUM
87 N. Main St.
Oberlin College
Oberlin, OH 44074
Tel.: 440-775-8665 \ Fax: 440-775-6841\
E-mail: betsy_wieseman@qmgate.cc.oberlin.edu
Web Site: www.oberlin.edu/campus_map/allen_art.html
Founded: 1917.

AMON CARTER MUSEUM
3501 Camp Bowie Blvd.
Fort Worth, TX 76107-2695
Tel.: 817-738-1933 \ Fax: 817-377-8523

E-mail: ruthann.rugg@cartermuseum. org.
Web Site: http://ww.cartermuseum.org
Founded: 1961.

THE ANDY WARHOL MUSEUM
117 Sandusky St.
Pittsburgh, PA 15212-5890
Tel.: 412-237-8300 \ Fax: 412-237-8340
Web Site: http://warhol.org/warhol/
Founded: 1994.

ANSEL ADAMS CENTER FOR PHOTOGRAPHY
250 Fourth St.
San Francisco, CA 94103
Tel.: 415-495-7000 \ Fax: 415-495-8517
E-mail: seefop@aol.com
Founded: 1967.

ARCHIVES OF AMERICAN ART, SMITHSONIAN
INSTITUTION
8th & G Streets.
Room 331
American Art-Portrait Gallery Building
Washington, DC 20560
Tel.: 202-357-2781 \ Fax: 202-786-2608
TDD: 202-633-9320
Founded: 1954.

ARIZONA STATE UNIVERSITY ART MUSEUM
10th St. & Mill Ave.
Nelson Fine Arts Center at Matthews Center
Tempe, AZ 85287-2911
Tel.: 602-965-2787 \ Fax: -602) 965-5254
E-mail: artmuse@asuvm.inre.asu.edu
Web Site: asuam.fa.asu.edu
Founded: 1950.

THE ART INSTITUTE OF CHICAGO
111 S. Michigan Ave.
Chicago, IL 60603-6110
Tel.: 312-443-3600 \ Fax: 312-443-0849
Web Site: http://www.artic.edu
Founded: 1879.

THE ART MUSEUM, PRINCETON UNIVERSITY
Princeton, NJ 08544-1018
Tel.: 609-258-3788 \ Fax: 609-258-5949.
E-mail: LKFaden@Princeton.edu
Founded: 1882.

ART MUSEUM OF SOUTH TEXAS
1902 N. Shoreline
Corpus Christi, TX 78401
Tel.: 512-980-3500 \ Fax: 512-980-3520
E-mail: stiaweb@www.tamucc.edu \ Web Site:
http://www.tamucc.edu/~stiaweb/
Founded: 1960.

THE BALTIMORE MUSEUM OF ART
Art Museum Dr.
Baltimore, MD 21218-3898
Tel.: 410-396-7100 \ Fax: 410-396-7153
Web Site: www.artbma.org
Founded: 1914.

BAYLY ART MUSEUM OF THE UNIVERSITY OF VIRGINIA
Rugby Rd.
Charlottesville, VA 22903
Tel.: 804-924-3592 \ Fax: 804-924-6321
Web Site: http://www.virginia.edu/~bayly/bayly.html
Founded: 1935.

BIRMINGHAM MUSEUM OF ART
2000 8th Ave., N.
Birmingham, AL 35203
Tel.: 205-254-2565, ext. 3900 \ Fax: 205-254-2714
E-mail: http://www.artsbma.org
Web Site: hanson@dbtech
Founded: 1951.

BOSTON ATHENAEUM
10½ Beacon St.
Boston, MA 02108
Tel.: 617-227-0270 \ Fax: 617-227-5266
Web Site: www.bostanathenaeum.org
Founded: 1807.

BOSTON PUBLIC LIBRARY
700 Boylston St.
Boston, MA 02116
Tel.: 617-536-5400 \ Fax: 617-236-4306
Founded: 1852.

BOSTON UNIVERSITY ART GALLERY
855 Commonwealth Ave.
Boston, MA 02215
Tel.: 617-353-4672 \ Fax: 617-353-4672
E-mail: gallery@bu.edu \ Web Site: http://web.bu.edu/ART
Founded: 1960.

BROOKLYN MUSEUM OF ART
200 Eastern Parkway
Brooklyn, NY 11238-6052
Tel.: 718-638-5000 \ Fax: 718-638-3731
Web Site: http://wwar.com/brooklyn_museum
Founded: 1823.

CALIFORNIA MUSEUM OF PHOTOGRAPHY
3824 Main St.
Riverside, CA 92501
Tel.: 909-787-4787 \ Fax: 909-787-4797
Web Site: http://www.cmp.ucr.edu/
Founded: 1973.

CARNEGIE MUSEUM OF ART
4400 Forbes Ave.
Pittsburgh, PA 15213-4080
Tel.: 412-622-3131 \ Fax: 412-622-3112
Web Site: http:/www.clpgh.org
Founded: 1896.

CENTER FOR CREATIVE PHOTOGRAPHY
University of Arizona
Tucson, AZ 85721-0103
Tel.: 520-621-7968 \ Fax: 520-621-9444
E-mail: oncenter@ccp.arizona.edu
Web Site: http://www.ccp.arizona.edu/ccp.html
Founded: 1975.

CENTER FOR PHOTOGRAPHY AT WOODSTOCK
59 Tinker St.
Woodstock, NY 12498
Tel.: 914-679-7747 \ Fax: 914-679-6337
E-mail: CPWphoto@aol.com \ Web Site:
http://users.aol.com/cpwphoto
Founded: 1977.

THE CHRYSLER MUSEUM
245 West Olney Rd.
Norfolk, VA 23510-1587
Tel.: 757-644-6200 \ Fax: 757-664-6201
E-mail: Chrysler@norfolk.infi.net
Web Site: http://www.whro.org/cl/cmhh
Founded: 1933.

CINCINNATI ART MUSEUM
953 Eden Park Drive
Cincinnati, OH 45202-1596
Tel.: 513-721-5204 \ Fax: 513-721-0129
Founded: 1881.

STERLING AND FRANCINE CLARK ART INSTITUTE
Williamstown, MA 01267
Tel: 413-458-9545 fax: 413-458-2318
E-mail: singalls@clark.williams.edu

THE CLEVELAND MUSEUM OF ART
11150 East Blvd.
Cleveland, OH 44106
Tel.: 216-421-7340 & 7350 \ Fax: 216-421-0411
E-mail: info@cma-oh.org \ Web Site: www.clemusart.com
Founded: 1913.

CLEVELAND STATE UNIVERSITY ART GALLERY
2307 Chester Ave.
Cleveland, OH 44114
Tel.: 216-687-2103 \ Fax: 216-687-2275
E-mail: r.thurmer@csu-e.csuohio.edu
Web Site:
http://math3.math.csuohio.edu/~anderson/gall.html
Founded: 1973.

THE COLUMBUS MUSEUM OF ART
480 E. Broad St.
Columbus, OH 43215
Tel: 614-221-6801 \ Fax: 614-221-0226
Web Site: www.columbusart.mus.oh.us
Founded: 1878.

THE CORCORAN GALLERY OF ART
17th St., & New York Ave., N.W.
Washington, DC 20006
Tel.: 202-639-1700 & 1702 \ Fax: 202-639-1738
Web Site: www.Corcoran.Edu
Founded: 1869.

DAVIS MUSEUM AND CULTURAL CENTER
Wellesley College
106 Central St.
Wellesley, MA 02181-8257
Tel.: 617-283-2051 \ Fax: 617-283-2064
Web Site: http://www.wellesley.edu/DavisMuseum/
davismenu.html
Founded: 1889.

DAVISON ART CENTER, WESLEYAN UNIVERSITY
301 High St.
Middletown, CT 06459-0487
Tel.: 860-685-2500 \ Fax: 860-685-2501
E-mail: edoench@wesleyan.edu
Web Site: http://www.wesleyan.edu/dac/home.html
Founded: 1952.

DELAWARE ART MUSEUM
2301 Kentmere Parkway
Wilmington, DE 19806
Tel.: 302-571-9590 \ Fax: 302-571-0220.
Web Site: http://www.udel.edu/delart
Founded: 1912.

DAYTON ART INSTITUTE
456 Belmonte Park N.
Dayton, OH 45405
Tel.: 937-223-5277 \ Fax: 937-223-3140
Founded: 1919.

DENVER ART MUSEUM
100 W. 14th Ave. Parkway
Denver, CO 80204
Tel.: 303-640-4433 & 2295 \ Fax: 303-640-5627
Web Site: http://www.denverartmuseum.org
Founded: 1893.

M. H. DE YOUNG MEMORIAL MUSEUM
75 Tea Garden Dr.
Golden Gate Park
San Francisco, CA 94108
Tel.: 415-750-3600 & 3615 \ Fax: 415-750-7692
E-mail: guestbook@www.thinker.org
Web Site: www.thinker.org
Founded: 1894.

THE DETROIT INSTITUTE OF ARTS
5200 Woodward Ave.
Detroit, MI 48202
Tel.: 313-833-7900 \ Fax: 313-833-8620
Web Site: http://www.dia.org
Founded: 1885.

DUKE UNIVERSITY MUSEUM OF ART
Buchanan Blvd. at Trinity
Durham, NC 27708
Tel.: 919-684-5135 \ Fax: 919-681-8624
Web Site: http://www.duke.edu/duma/
Founded: 1968.

EVERSON MUSEUM OF ART OF SYRACUSE &
ONONDAGA COUNTY
401 Harrison St.
Syracuse, NY 13202
Tel.: 315-474-6064 \ Fax: 315-474-6943
Web Site: www.everson.org
Founded: 1896.

GEORGE EASTMAN HOUSE/INTERNATIONAL
MUSEUM OF PHOTOGRAPHY AND FILM
900 East Ave.
Rochester, NY 14607
Tel.: 716-271-3361 \ Fax: 716-271-3970
E-mail: go to Web Site for link \ Web Site: www.eastman.org
Founded: 1947.

THE J. PAUL GETTY MUSEUM
1200 Getty Center Drive
Suite 1000
Los Angeles, CA 90049-1687
Tel.: 310-459-7611 \ Fax: 310-440-7749
E-mail: pinews@getty.edu \ Web Site: http://www.getty.edu
Founded: 1953.

GRAND RAPIDS ART MUSEUM
155 Division North
Grand Rapids, MI 49503
Tel.: 616-459-4677 \ Fax: 616-459-8491
Web Site: www.gram.mus.mi.us
Founded: 1911.

THE PATRICK & BEATRICE HAGGERTY
 MUSEUM OF ART
Marquette University
13th & Clybourn
Milwaukee, WI 53233
Tel.: 414-288-7290 \ Fax: 414-288-5415
E-mail: haggertym@vms.csd.mu.edu \ Web Site:
http://www.mu.edu/haggerty
Founded: 1955.

HARVARD UNIVERSITY ART MUSEUMS
32 Quincy St.
Cambridge, MA 02138
Tel.: 617-495-9400, dial 0 \ Fax: 617-495-9936
Web Site: http://www.artmuseums.harvard.edu
Founded: 1895.

HIGH MUSEUM OF ART
1280 Peachtree St., N.E.
Atlanta, GA 30309
Tel.: 404-733-4000 & 4444 \ Fax: 404-733-4502
E-mail: woodruffarts.org \ Web Site: www.high.org
Founded: 1926.

THE HIGH MUSEUM OF ART: FOLK ART AND
PHOTOGRAPHY GALLERIES
30 John Wesley Dobbs Ave.

Atlanta, GA 30303
Tel.: 404-577-6940 \ Fax: 404-653-0916
Web Site: http://www.high.org
Founded: 1986.

HOOD MUSEUM OF ART
Dartmouth College
Hanover, NH 03755
Tel.: 603-646-2808 \ Fax: 603-646-1400
E-mail: hood.museum@dartmouth.edu \ Web Site:
www.dartmouth.edu/acad_support/hood/index.html
Founded: 1772.

HUNTSVILLE MUSEUM OF ART
700 Monroe St., S.W.
Huntsville, AL 35801
Tel.: 205-535-4350 \ Fax: 205-532-1743
E-mail: hma@traveller.com \ Web Site:
http://www.hsv.tis.net/hma
Founded: 1970.

INDIANA UNIVERSITY ART MUSEUM
Indiana University
Bloomington, IN 47405
Tel.: 812-855-5445 \ Fax: 812-855-1023
Founded: 1941.

THE INSTITUTE OF CONTEMPORARY ART
955 Boylston St.
Boston, MA 02115-3194
Tel.: 617-927-6620 \ Fax: 617-266-4021
Founded: 1936.

INTERNATIONAL CENTER OF PHOTOGRAPHY
1130 Fifth Ave.
New York, NY 10128
Tel.: 212-860-1777 \ Fax: 212-360-6490
Web Site: http://www.icp.org
Founded: 1974.

JACKSONVILLE MUSEUM OF CONTEMPORARY ART
4160 Boulevard Center Dr.
Jacksonville, FL 32207
Tel.: 904-398-8336 \ Fax: 904-348-3167
Formerly: Jacksonville Art Museum, Inc.
Founded: 1948.

HERBERT F. JOHNSON MUSEUM OF ART
Cornell University
Ithaca, NY 14853

Tel.: 607-255-6464 \ Fax: 607-255-9940
E-mail: museum@cornell.edu
Web Site: http://www.museum.cornell.edu
Founded: 1973.

THE FRED JONES JR. MUSEUM OF ART
University of Oklahoma
410 W. Boyd St.
Norman, OK 73019
Tel.: 405-325-3272 \ Fax: 405-325-7696
Web Site: www.ou.edu/fjjma
Founded: 1936.

KALAMAZOO INSTITUTE OF ARTS
314 S. Park St.
Kalamazoo, MI 49007-5102
Tel.: 616-349-7775 \ Fax: 616-349-9313
Founded: 1924.

KERN COUNTY MUSEUM
3801 Chester Ave.
Bakersfield, CA 93301
Tel.: 805-861-2132 \ Fax: 805-322-6415
E-mail: kcmuseum@lightspeed.net \ Web Site:
http://www.kruznet.com/kcmuseum
Founded: 1945.

KRESGE ART MUSEUM
Michigan State University
East Lansing, MI 48824
Tel.: 517-353-9835 \ Fax: 517-355-6577
E-mail: kamuseum@pilot.msu.edu \ Web Site:
http://www.msu.edu.unit/kamuseum
Founded: 1959.

THE ALBIN O. KUHN LIBRARY AND GALLERY,
UNIVERSITY OF MARYLAND-BALTIMORE COUNTY
1000 Hilltop Circle
Baltimore, MD 21202
Tel.: 410-455-2270 \ Fax: 410-455-1153
Founded: 1975.

LEHIGH UNIVERSITY ART GALLERIES/MUSEUM
OPERATIONS
Zoellner Arts Center
420 E. Packer Ave.
Bethlehem, PA 18015
Tel.: 610-758-3615 & 4836 \ Fax: 610-758-4580
E-mail: rv02@lehigh.edu \ Web Site: http://www.lehigh.edu
Founded: 1864.

THE FRANCES LEHMAN LOEB ART CENTER
124 Raymond Ave.
Vassar College
Box 23
Poughkeepsie, NY 12604-0023
Tel.: 914-437-5237 & 5032 \ Fax: 914-437-7304
E-mail: jamundy@vassar.edu \ Web Site: http://depart-
ments.vassar.edu/~fllac/
Founded: 1864.

LIBRARY OF CONGRESS
1st St. & Independence Ave., S.E.
Washington, DC 20540
Tel.: 202-707-5000 (-general) & -8000 (-visitor information)
\ Fax: 202-707-5844 \ E-mail: wtab@loc.gov
Web Site: www.loc.gov.
Founded: 1800.

LOS ANGELES COUNTY MUSEUM OF ART
5905 Wilshire Blvd.
Los Angeles, CA 90036
Tel.: 213-857-6000 \ Fax: 213-931-7347 & 936-5755
Web Site: http://www.lacma.org
Founded: 1910.

JOE & EMILY LOWE ART GALLERY
Syracuse University
Shaffer Art Bldg.
Syracuse, NY 13244-1230
Tel.: 315-443-4098
Founded: 1952.

MADISON ART CENTER
211 State St.
Madison, WI 53703
Tel.: 608-257-0158 \ Fax: 608-257-5722
E-mail: mac@itis.com \ Web Site:
http://www.users.aol.com/MadArtCtr
Founded: 1901.

THE MENIL COLLECTION
1515 Sul Ross
Houston, TX 77006
Tel.: 713-525-9400 \ Fax: 713-525-9444
E-mail: menil@neosoft.com \ Web Site: 222.menil.org
Founded: 1980.

THE METROPOLITAN MUSEUM OF ART
Fifth Ave. at 82nd St.
New York, NY 10028
Tel.: 212-879-5500 \ Fax: 212-570-3879

E-mail: http://metmuseum.org.
Web Site: http://www.metmuseum.org
Founded: 1870.

MILWAUKEE ART MUSEUM
750 N. Lincoln Memorial Dr.
Milwaukee, WI 53202
Tel.: 414-224-3200 \ Fax: 414-271-7588
E-mail: mam@mam.org \ Web Site: www.mam.org.
Founded: 1888.

THE MINNEAPOLIS INSTITUTE OF ARTS
2400 Third Ave. S.
Minneapolis, MN 55404
Tel.: 612-870-3000 & 3046 \ Fax: 612-870-3004
E-mail: miagen@artsMIA.org \ Web Site:
http://www.artaMIA.org/MIA
Founded: 1915.

MOBILE MUSEUM OF ART
4850 Museum Dr.
Langan Park
Mobile, AL 36608
Tel.: 334-343-2667 \ Fax: 334-343-2680
E-mail: mmoa01@ci.mobile.al.us
Founded: 1964.

MONTGOMERY MUSEUM OF FINE ARTS
One Museum Dr.
Montgomery, AL 36117
Tel.: 334-244-5700 \ Fax: 334-244-5774
E-mail: mmfa@wsnet.com \ Web Site:
http://www.wsnet.com/~mmfa/
Founded: 1930.

MUSEUM OF ART, RHODE ISLAND SCHOOL
OF DESIGN
224 Benefit St.
Providence, RI 02903-2723
Tel.: 401-454-6502 \ Fax: 401-454-6556
Web Site: ww.risd.edu
Founded: 1877.

MUSEUM OF THE CITY OF NEW YORK
Fifth Ave. at 103rd St.
New York, NY 10029
Tel.: 212-534-1672 \ Fax: 212-423-0758
E-mail: mcny@mcny.org \ Web Site: http://www.mcny.org
Founded: 1923.

MUSEUM OF CONTEMPORARY ART
220 E. Chicago Ave.
Chicago, IL 60611-2604
Tel.: 312-280-2660 \ Fax: 312-280-7311
Founded: 1967.

THE MUSEUM OF CONTEMPORARY PHOTOGRAPHY
OF COLUMBIA COLLEGE CHICAGO
600 S. Michigan Ave.
Chicago, IL 60505-1901
Tel.: 312-663-5554 \ Fax: 312-360-1656
Web Site:
http://www.gallery-guide.com/gg/museum/mcpchcgo/
Founded: 1976.

THE MUSEUM OF CONTEMPORARY ART,
LOS ANGELES
250 S. Grand Ave.
California Plaza
Los Angeles, CA 90012
Tel.: 213-621-2766 \ Fax: 213-620-8674
Web Site: www.moca-la.org
Founded: 1979.

MUSEUM OF CONTEMPORARY ART, SAN DIEGO
700 Prospect St.
La Jolla, CA 92037
Tel.: 619-454-3541 \ Fax: 619-454-6985
E-mail: mcaemail@san.rr.com \ Web Site:
www.mcasandiego.org
Founded: 1941.

MUSEUM OF FINE ARTS
465 Huntington Ave.
Boston, MA 02115-5519
Tel.: 617-267-9300 \ Fax: 617-247-6880
TDD: 617-267-9703 \ E-mail: webmaster@mfa.org
Web Site: http://www.mfa.org
Founded: 1870.

MUSEUM OF FINE ARTS
107 W. Palace
Santa Fe, NM 87501
Tel.: 505-827-4452 \ Fax: 505-827-4473
Founded: 1917.

THE MUSEUM OF FINE ARTS, HOUSTON
1001 Bissonnet
Houston, TX 77005
Tel.: 713-639-7300 \ Fax: 713-639-7399

Web Site: www.mfah.org
Founded: 1900.

MUSEUM OF FINE ARTS-ST. PETERSBURG, FLORIDA
255 Beach Dr. N.E.
St. Petersburg, FL 33701
Tel.: 813-896-2667 \ Fax: 813-894-4638
Founded: 1961.

THE MUSEUM OF MODERN ART
11 West 53rd St.
New York, NY 10019
Tel.: 212-708-9400 \ Fax: 212-708-9889
E-mail: comments@moma.org \ Web Site: www.moma.org
Founded: 1929.

MUSEUM OF NEW MEXICO
113 Lincoln Ave.
Santa Fe, NM 87501
Tel.: 505-827-6451 \ Fax: 505-827-6427
Founded: 1909.

MUSEUM OF PHOTOGRAPHIC ARTS
1649 El Prado
Balboa Park
San Diego, CA 92101
Tel.: 619-238-7559 \ Fax: 619-238-8777
Founded: 1983.

NATIONAL ARCHIVES
700 Pennsylvania Ave.
Washington, DC 20408
Tel.: 202-501-5500 \ Fax: 202-219-1888
E-mail: inquire@nara.gov \ Web Site: http://www.nara.gov
Founded: 1934.

NATIONAL MUSEUM OF AMERICAN ART
8th & G Streets, N.W.
Washington, DC 20560
Tel.: 202-357-1959 \ Fax: 202-357-2528
E-mail: nmaainfo@nmaa.si.edu \ Web Site: www.nmaa.si.edu
Founded: 1846.

NATIONAL MUSEUM OF THE AMERICAN INDIAN,
SMITHSONIAN INSTITUTION
George Gustav Heye Center
One Bowling Green
New York, NY 10004
Tel.: 212-514-3700 \ Fax: 212-514-3800
E-mail: nmai.kawasaki@ic.si.edu \ Web Site:

http://www.si.edu/nmai
Founded: 1916.

NATIONAL MUSEUM OF AMERICAN HISTORY
14th St. & Constitution Ave., N.W.
Washington, DC 20560
Tel.: 202-357-2700 \ Fax: 202-357-1853
Web Site: http://www.si.edu
Founded: 1846.

NATIONAL PORTRAIT GALLERY
F St. at 8th, N.W.
Washington, DC 20560
Tel.: 202-357-1915 \ Fax: 202-357-2307
Web Site: http://www.npg.si.edu
Founded: 1962.

NEVADA MUSEUM OF ART
160 W. Liberty
Reno, NV 89501
Tel.: 702-329-3333 \ Fax: 702-329-1541
Web Site: www.nevadaart.org
Founded: 1931.

THE NEWARK MUSEUM
49 Washington St.
Newark, NJ 07101-0540
Tel.: 973-596-6550 (& 6615 Education)
Fax: 973-642-0459
Founded: 1909.

NEW ORLEANS MUSEUM OF ART
One Collins Diboll Circle
New Orleans, LA 70124
Tel.: 504-488-2631 \ Fax: 504-484-6662
E-mail: NOMA@COMMUNIQUE.NET
Web Site: http://www.noma.org
Founded: 1910.

NEWSEUM
1101 Wilson Blvd.
Arlington, VA 22209
Tel: 703-284-3544 or 888-NEWSEUM Fax; 703-284-3770
E-mail: news@freedomforum.org

NEWSEUM/NY
580 Madison Ave.
New York, NY 10024
Tel: 212-317-7502 \ Fax: 212-317-7587

Web Site: www.freedomforum.org/newseumnews/ny/
welcome.asp \ E-mail: ayoung@mediastudies.org

THE NEW YORK PUBLIC LIBRARY, ASTOR, LENOX AND
TILDEN FOUNDATIONS
476 Fifth Ave.
New York, NY 10018-2788
Tel.: 212-930-0800 \ Fax: 212-930-9299
Web Site: www.nypl.org
Founded: 1895.

NORTON MUSEUM OF ART
1451 S. Olive Ave.
West Palm Beach, FL 33401
Tel.: 561-832-5196 \ Fax: 561-659-4689
E-mail: museum@norton.org \ Web Site: www.norton.org
Founded: 1940.

NORTON SIMON MUSEUM
411 W. Colorado Blvd.
Pasadena, CA 91105
Tel.: 818-449-6840, ext. 238 \ Fax: 818-796-4978
Web Site: www.citycent.com/ccc/pasadena/nsmuseum.htm
Founded: 1924.

OAKLAND MUSEUM OF CALIFORNIA
1000 Oak St.
Oakland, CA 94607
Tel.: 510-238-3404 \ Fax: 510-238-2258
E-mail: dpower@oak2.ci.oakland.ca.us
Web Site: http://www.museumca.org
Founded: 1969.

ORANGE COUNTY MUSEUM OF ART
850 San Clemente Dr.
Newport Beach, CA 92660
Tel.: 714-759-1122 \ Fax: 714-759-5623
Web Site: www.ocartsnet.org/ocma
Formerly: Laguna Art Museum
Founded: 1918.

THE PHILLIPS COLLECTION
1600 21st St., N.W.
Washington, DC 20009-1090
Tel.: 202-387-2151 \ Fax: 202-387-2436
E-mail: phillipsco.@aol.com
Web Site: www.phillipscollection.org
Founded: 1918.

PHOTOGRAPHIC ARCHIVES
University of Kentucky
Special Collections & Archives
King Library North
Lexington, KY 40506
Tel.: 606-257-8371 \ Fax: 606-257-8379
Founded: 1978.

PHOTOGRAPHIC ARCHIVES, UNIVERSITY OF
LOUISVILLE LIBRARIES
Ekstrom Library
University of Louisville
Louisville, KY 40292
Tel.: 502-852-8730 \ Fax: 502-852-8734
Founded: 1967.

PHOTOGRAPHIC RESOURCE CENTER
602 Commonwealth Ave.
Boston, MA 02215
Tel.: 617-353-0700 \ Fax: 617-353-1662.
E-mail: prc@bn.edu \ Web Site: http://www.bu.edu/PRC/
Founded: 1976.

PORTLAND ART MUSEUM
1219 S.W. Park Ave.
Portland, OR 97205
Tel.: 503-226-2811 \ Fax: 503-226-4842
E-mail: PR@pam.org \ Web Site: www.pam.org/pam/
Founded: 1892.

PORTLAND MUSEUM OF ART
Seven Congress Square
Portland, ME 04101
Tel.: 207-775-6148 \ Fax: 207-773-7324
E-mail: portlandmuseum@maine.com
Web Site: http://www.portlandmuseum.org
Founded: 1882.

HARRY RANSOM HUMANITIES RESEARCH CENTER AT
THE UNIVERSITY OF TEXAS AT AUSTIN
21st & Guadalupe
Austin, TX 78705
Tel.: 512-471-8944 \ Fax: 512-471-9646
E-mail: info@hrc.utexas.edu
Web Site: http://www.lib.utexas.edu/libs/hrc/hrhrc
Founded: 1957.

ROSE ART MUSEUM, BRANDEIS UNIVERSITY
415 South St.

Waltham, MA 02254
Tel.: 617-736-3434 \ Fax: 617-736-3439
Web Site: http://www.brandeis.edu/rose
Founded: 1961.

THE SAINT LOUIS ART MUSEUM
Forest Park
St. Louis, MO 63110
Tel.: 314-721-0072 \ Fax: 314-721-6172
E-mail: infotech@slam.org \ Web Site: www.slam.org
Founded: 1906.

SAN ANTONIO MUSEUM OF ART
200 W. Jones Ave.
San Antonio, TX 78215
Tel.: 210-978-8100 \ Fax: 210-978-8134
E-mail: info@samuseum.org \ Web Site: www.samuseum.org
Founded: 1981.

SAN FRANCISCO CAMERAWORK INC.
115 Natoma St.
San Francisco, CA 94105
Tel.: 415-764-1001 \ Fax: 415-764-1063
E-mail: sfcamera@sfcamerawork.org
Founded: 1974.

SAN FRANCISCO MUSEUM OF MODERN ART
151 Third St.
San Francisco, CA 94103
Tel.: 415-357-4000 \ Fax: 415-357-4037
E-mail: jlane@sfmoma.org \
Web Site: http://www.sfmoma.org
Founded: 1935.

SAN JOSE MUSEUM OF ART
110 S. Market St.
San Jose, CA 95113
Tel.: 408-271-6840 \ Fax: 408-294-2977
E-mail: info@sjmusart.org
Web Site: www.sjmusart.org
Founded: 1969.

SANTA BARBARA MUSEUM OF ART
1130 State St.
Santa Barbara, CA 93101-2746
Tel.: 805-963-4364 \ Fax: 805-966-6840
Founded: 1941.

THE SCHOMBURG CENTER FOR RESEARCH
IN BLACK CULTURE

The New York Public Library
515 Malcolm X Blvd.
New York, NY 10037-1801
Tel.: 212-491-2057 \ Fax: 212-491-6760
Web Site: http://www.nypl.org/research/sc/sc.html
Founded: 1925.

SEATTLE ART MUSEUM
100 University St.
Seattle, WA 98101-2902
Tel.: 206-625-8900 \ Fax: 206-654-3135
Web Site: http://www.seattleartmuseum.org
Founded: 1917.

SHELDON MEMORIAL ART GALLERY AND SCULPTURE
GARDEN/ UNIVERSITY OF NEBRASKA-LINCOLN
12th and R Streets
Lincoln, NE 68588-0300
Tel.: 402-472-2461 \ Fax: 402-472-4258
E-mail: pjacobs@unlinfo.unl.edu
Web Site: http://www.sheldon, unl.edu/
Founded: 1963.

SMITH COLLEGE MUSEUM OF ART
Elm St. at Bedford Terrace
Northampton, MA 01063
Tel.: 413-585-2760 & 2770 \ Fax: 413-585-2782
E-ail: artmuseum@ais.smith.edu
Web Site: www.smith.edu/artmuseum
Founded: 1920.

SMITHSONIAN INSTITUTION
470 L'Enfant Plaza, S.W.
Suite 7103
Washington, DC 20024
Tel.: 202-287-2020 \ Fax: 202-287-3528
Web Site: www.si.edu.nmai
Founded: 1846.

THE SNITE MUSEUM OF ART,
UNIVERSITY OF NOTRE DAME
University of Notre Dame
Notre Dame, IN 46556
Tel.: 219-631-5466 \ Fax: 219-631-8501
Web Site: http://www.nd.edu/~sniteart/
Founded: 1842.

SOUTHWEST MUSEUM
234 Museum Dr.

Los Angeles, CA 90065
Tel.: 213-221-2164 \ Fax: 213-224-8223
Founded: 1907.

SOUTHEAST MUSEUM OF PHOTOGRAPHY
1200 W. International Speedway Blvd.
Daytona Beach, FL 32114
Tel.: 904-254-4469 \ Fax: 904-254-4487
E-mail: nordsta@dbcc.cc.fl.us \ Web Site:
http://www.dbcc.cc.fl.us
Founded: 1979.

SPENCER MUSEUM OF ART
University of Kansas
1301 Mississippi St.
Lawrence, KS 66045
Tel.: 913-864-4710 \ Fax: 913-864-3112
E-mail: srhayden@falcon.cc.ukans.edu
Web Site: www.cc.ukans.edu/~sma/index.html
Founded: 1928.

STANFORD UNIVERSITY MUSEUM OF ART
Lomita Dr. & Museum Way
Stanford, CA 94305-5060
Tel.: 415-725-0462 \ Fax: 415-725-0464
Web Site: http://www.-leland.stanford.edu/dept/suma/
Formerly: Stanford University Museum and Art Gallery
Founded: 1885.

STERLING AND FRANCINE CLARK ART INSTITUTE
225 South St.
Williamstown, MA 01267
Tel.: 413-458-9545 \ Fax: 413-458-2336
Web Site: www.clark.williams.edu
Founded: 1950.

THE TOLEDO MUSEUM OF ART
2445 Monroe St.
Toledo, OH 43620
Tel.: 419-255-8000 \ Fax: 419-255-5638
E-mail: information@toledomuseum.org.
Web Site: www.toledomuseum.org
Founded: 1901.

UNIVERSITY OF ARKANSAS AT LITTLE ROCK
ART GALLERIES
Dept. of Art
2801 S. University
Little Rock, AR 72204-1099
Tel.: 501-569-3182 \ Fax: 501-569-8775

E-mail: sdmitchell@ualr.edu
Web Site: http://www.ualr.edu/artdept/index.html
Founded: 1972.

UNIVERSITY ART MUSEUM, THE UNIVERSITY
OF NEW MEXICO
UNM Fine Arts Center just north of Cornell & Central N.E.
Albuquerque, NM 87131-1416
Tel.: 505-277-4001 \ Fax: 505-277-7315
E-mail: lbahm@unm.edu
Founded: 1963.

UNIVERSITY OF IOWA MUSEUM OF ART
150 N. Riverside Dr.
Iowa City, IA 52242
Tel.: 319-335-1727 \ Fax: 319-335-3677
E-mail: blamoa@blue-weeg.uiowa.edu
Web Site: http://www.edu/~artmus
Founded: 1967.

UNIVERSITY GALLERY, UNIVERSITY OF DELAWARE
Main Street at N. College Ave.
Newark, DE 19716
Tel.: 302-831-8242 \ Fax: 302-831-8251
E-mail: belena.chapp@mvs.udel.edu
Web Site: http://seurat.art.udel.edu
Founded: 1978.

THE UNIVERSITY OF MICHIGAN MUSEUM OF ART
525 S. State St.
Ann Arbor, MI 48109-1354
Tel.: 734-764-0395 \ Fax: 734-764-3731
E-mail: umma@umich.edu \ Web Site:
http://www.umich.edu/~umma/
Founded: 1946.

THE UNIVERSITY GALLERIES
Fisk University
1000 17th Ave., N.
Nashville, TN 37208-3051
Tel.: 615-329-8720 & 8500 \ Fax: 615-329-8544
Founded: 1949.

UNIVERSITY GALLERY,
UNIVERSITY OF MASSACHUSETTS AT AMHERST
Fine Arts Center
Room 35d
U. of Massachusetts
Amherst, MA 01003
Tel.: 413-545-3670 \ Fax: 413-545-2018
Founded: 1975.

THE UNIVERSITY OF TEXAS INSTITUTE
OF TEXAN CULTURES
801 S. Bowie at Durango Blvd.
San Antonio, TX 78205-3296
Tel.: 210-458-2300 \ Fax: 210-458-2205
E-mail: lcatalin@itcpostl.utsa.edu
Web Site: http://www.utsa.edu/itc
Founded: 1968.

VIRGINIA MUSEUM OF FINE ARTS
Boulevard & Grove
Richmond, VA 23221-2472
Tel.: 804-367-0800 \ Fax: 804-367-9393\
E-mail: webmaster@vmfa.state.va.us
Web Site: www.vmfa.state.va.us
Founded: 1934.

WALKER ART CENTER
Vineland Place
Minneapolis, MN 55403
Tel.: 612-375-7600 & 7656 \ Fax: 612-375-7618
Web Site: http://www.walkerart.org/
Founded: 1879.

THE BRETT WESTON ARCHIVE
P. O. Box 268822

Oklahoma City, OK 73126
Tel.: 405-478-5022 \ Fax: 405-478-5823
E-mail: JonB919407@aol.com
Web Site: Error! Bookmark not defined.

WHITNEY MUSEUM OF AMERICAN ART
945 Madison Ave.
New York, NY 10021
Tel.: 212-570-3600 \ Fax: 212-570-1807
Web Site: www.echonyc.com/whitney
Founded: 1930.

WILLIAMS COLLEGE MUSEUM OF ART
Main St.
Williamstown, MA 01267-2566
Tel.: 413-597-2429 \ Fax: 413-458-9017
Web Site: http://www.williams.edu:803/WCMA/menu.html
Founded: 1926.

YALE UNIVERSITY ART GALLERY
1111 Chapel St.
New Haven, CT 06520
Tel.: 203-432-0660 / Fax: 203-432-7159 & 8150 \ Web Site:
http://www.cis.yale.edu/yups/yuag
Founded: 1832.

1942 **Milton Brooks,** *Detroit News.* Wins the first Pulitzer Prize in Photography for his photograph of Ford Motor Co. strikers being clubbed.

Frank Noel, *Associated Press.* An Indian sailor, whose World War II ship has just been torpedoed, begs for water from a lifeboat. The sailor is later lost at sea.

Earle L. Bunker, *Omaha World-Herald.* Lt. Col. Robert Moore returns from the war and is greeted by his family.

1944 **Frank Filan,** *Associated Press.* His winning photo, taken on the island of Tarawa, shows the bloody reality of war.

Joe Rosenthal, Associated Press. He won for his famous shot of the Marines raising the flag on Mt. Mirabachi after their victory at Iwo Jima.

1947 **Arnold Hardy,** Freelancer. He won for a dramatic photo of a woman in mid air leaping to her death from the Wincroft Hotel fire in Atlanta. (Distributed by AP.)

1948 **Frank Cushing,** *Boston Traveler.* A 15-year-old boy holds another boy hostage at gunpoint.

1949 **Nathaniel Fein,** *New York Herald Tribune.* This famous photo shows Babe Ruth, his back to the camera, standing alone in Yankee Stadium. It was taken 17 years after he retired from baseball, two months before his death.

1950 **Bill Crouch,** *Oakland Tribune.* Two planes in an air show at Oakland airport almost collide in midair.

1951 **Max Desfor,** *Associated Press.* He won for his coverage of the Korean War, especially for a photo of refugees crossing a wrecked bridge over the Teadong River.

1952 **John Robinson and Don Ultang,** *Des Moines Register and Tribune.* This duo won for their sequence of six pictures of the Drake-Oklahoma A&M football game in 1951, during which Johnny Bright's jaw was intentionally broken.

1953 **William Gallagher,** *Flint Journal.* This winning

photo was taken during the 1952 presidential campaign and shows Gov. Adlai Stevenson sitting down, a hole visible in the sole of his shoe.

1954 **Virginia Schau,** originally published in the *Akron Beacon-Journal,* and serviced by the Associated Press. This amateur from San Anselmo, CA, snapped a photo with her Brownie of a truck and its driver dangling from a bridge over the Pet River in Redding CA after the truck crashed through the protective railing.

1955 **John L. Gaunt, Jr.,** *Los Angeles Times.* He won for a poignant and profoundly moving photo of a young couple standing together at Hermosa Beach beside a raging surf in which their year-old son had drowned.

1956 **Collective staff award led by George Mattson,** *New York Daily News.* For the news pictures taken Nov. 2, 1955 of a B-26 bomber that crashed into suburban houses in East Meadow, Long Island.

1957 **Harry A. Trask,** *Boston Traveler.* Trask's dramatic photo sequence is of the sinking of the ocean liner Andrea Doria off the coast of Nantucket on July 25, 1956, in which 46 passengers lost their lives.

1958 **William C. Beale,** *Washington Daily News.* His photo showed a policeman patiently reasoning with a child trying to cross a street during a Chinese New Year celebration.

1959 **William Seaman,** *Minneapolis Star-Tribune.* A dramatic photo recording the sudden death of a child on the street, his wagon is crushed and his body lies covered with a sheet.

1960 **Andrew Lopez,** *United Press International.* Lopez took a series of photos of a corporal formerly of Batista's army who was executed by a Castro firing squad. The main photo is of the condemned man receiving last rites in the courtyard at San Severino castle at Metanzas, near Havana.

1961 **Yasuhi Nagao,** *Mainichi* newspaper, serviced by United Press International. This memorable spot news photo shows a 17-year-old student stabbing Socialist Party chairman Inejiro Asanama on stage during a political rally.

1962 **Paul Vathis,** Harrisburg (Pa.) bureau of the *Associated Press*. This photo taken at Camp David shows Presidents Eisenhower and Kennedy, deep in discussion, walking away from the camera down a wooded path.

1963 **Hector Rondon,** *La Republica* (Caracas, Venezuela). A priest holds a wounded soldier during the 1962 Venezuelan insurrection.

1964 **Robert H. Jackson,** *Dallas Times-Herald*. Among the most historic of all news photos is the one taken in the basement of the Dallas City Jail of Jack Ruby shooting Lee Harvey Oswald.

1965 **Horst Faas,** *Associated Press*. Combat photography in South Vietnam.

1966 **Kyoichi Sawada,** *United Press International*. Sawada, a combat photographer in Vietnam, won for his war pictures.

1967 **Jack R. Thornell,** New Orleans bureau, *Associated Press*. His pictures of a roadside rifleman shooting of James Meredith on Highway 51 in Mississippi managed to include the numerous rounds of ammunition.

Starting in 1968 prizes were awarded in two categories, Spot News and Features.

1968 **Toshio Sakai,** *United Press International*. Feature prize for a combat photo showing a soldier sleeping through monsoon rains.

1968 **Rocco Morabito,** *Jacksonville Journal*. Spot News prize for the image of a worker struggling to revive another worker who hangs lifeless after being stunned by a live power line.

1969 **Moneta Sleet, Jr.,** *Ebony* magazine. Feature award for a photo of Coretta King taken at Martin Luther King Jr.'s funeral at Ebenezer Baptist Church in Atlanta.

1969 **Eddie Adams,** *Associated Press*. The Spot News award for his dramatic photo showing the street execution of a suspected leader of a Viet Cong commando unit.

1970 **Dallas Kinney,** *Palm Beach Post*. Kinney's feature award was given for a portfolio showing the squalid living and working conditions of Florida migrants.

1970 **Steve Starr,** Albany (NY) bureau of the *Associated Press*. Starr's Spot News photo, taken at Cornell University, shows students with shot guns and ammo belts leaving the Student Union after a two day protest.

1971 **Jack Dykinga,** *Chicago Sun-Times*. His Feature award is for photos taken in Illinios at the Lincoln and Dixon State schools for the retarded.

1971 **John Paul Filo,** *Valley Daily News* and *Daily Dispatch*. Filo was a Kent State student and won the Spot News award for his photo of the National Guards shooting at Kent State students, an incident in which 4 students died and five were severely wounded.

1972 **David Hume Kennerly,** *United Press International*. His Feature award was for dramatic photographs covering the Vietnam War in 1971; an American soldier approaching a Viet Cong bunker being the key photo.

1972 **Horst Faas and Michel Laurent,** Associated Press. They won the Spot News award for their picture series "Death in Dacca."

1973 **Brian Lanker,** *Topeka Capitol Journal*. Lanker's feature prize was for his sequence on childbirth.

1973 **Huynh Cong "Nick" Ut,** *Associated Press*. His memorable Spot News award was for his shot depicting terrified and screaming children in flight from a Napalm bombing.

1974 **Steve Veder,** *Associated Press*. Veder's Feature award shows an America POW returning from captivity in North Vietnam being greeted by his family at Travis Airforce base in California.

1974 **Anthony K. Roberts,** Freelance. This Spot News award was for a series of shots in which an alleged kidnapper was killed in a Hollywood parking lot.

1975 **Matthew Lewis,** *Washington Post*. This Feature award recognized the continuity and consistency of Lewis's lifestyle photos in the Potomac magazine over a long period of time.

1975 **Gerald H. Gay,** *Seattle Times.* This Spot News award winner depicted four exhausted firemen taking a break after battling five hours attempting to save a house that eventually burned down.

1976 **Twenty-seven Photographic Staff Members,** *Louisville Courier-Journal & Times.* This shared Feature award was for a comprehensive 70-picture portfolio on school busing that included a KKK cross burning.

1976 **Stanley Forman,** *Boston Herald American.* This Spot News award was for a remarkable dramatic sequence of people jumping from a burning building.

1977 **Robin Hood,** *Chattanooga News-Free Press.* Hood won this Feature award for his photo of a disabled veteran and his child at an Armed Forces Day parade.

1977 **Stanley Forman,** *Boston Herald American.* Forman won his second Spot News award for a photo showing a youth thrusting an American flag as a lance in a protest against school busing.

1978 **J. Ross Baughman,** *Associated Press.* Disguised in a Rhodesian soldier's uniform, Baughman took three Feature award winning shots during guerilla action in Rhodesia.

1978 **Neil Ulevich,** *Associated Press.* This Spot News award was for a series depicting brutality and atrocities on the streets of Bangkok.

1979 **Staff Photographers,** *Boston Herald American.* This collective Feature award was for coverage of the great blizzard of 1978.

1979 **Thomas J. Kelly III,** *Pottstown Mercury.* Kelly's Spot News award was for a series called "Tragedy on Santoga Road."

1980 **Erwin H. Hagler,** *Dallas Times Herald.* This Feature award recognized Hagler's series on the American cowboy.

1980 **Unnamed photographer,** *United Press International.* No name was attributed for this Spot News award shot of the execution of a Kurdish soldier.

1981 **Taro M. Yamasaki,** *Detroit Free Press.* This Feature award was for a series on Jackson (Michigan) State Prison.

1981 **Larry C. Price,** *Fort Worth Star-Telegram.* Price's dramatic photos taken in Liberia won this Spot News award.

1982 **John H. White,** *Chicago Sun-Times.* This Feature award recognized White's consistently excellent work on a variety of subjects.

1982 **Ron Edmonds,** *Associated Press.* Edmonds won the Spot News award for his pictures of the assassination attempt on President Ronald Reagan.

1983 **James B. Dickman,** *Dallas Times-Herald.* Dickman's portrayal of life and death in El Salvador earned him this Feature award.

1983 **Bill Foley,** *Associated Press.* This Spot News award winner depicted, in series, the victims and survivors of a massacre in the Sabra refugee camp in Beirut.

1984 **Anthony Suau,** *Denver Post.* Suau won the Feature award for his series showing the tragic effects of starvation in Ethiopia, the key photo was of a woman at her husband's grave.

1984 **Stan Grossfeld,** *Boston Globe.* This Spot News award recognized Grossfeld's series of photos of the famine in Ethiopia and his pictures of illegal aliens at the Mexican border.

1985 **Larry C. Price,** *Philadelphia Inquirer.* Price's series taken of war-battered peoples in Angola and El Salvador won this Feature award.

1985 **Photography Staff,** *Orange County Register.* This Spot News award was for the complete coverage of the 1984 Olympic games.

1986 **Tom Gralish,** *Philadelphia Inquirer.* A series depicting Philadelphia's homeless won this Feature award.

1986 **Carol Guzy and Michel DuCille,** *Miami Herald*. This shared Spot News award recognized photos of the devastation caused by the volcanic eruption of Nevado del Ruiz in Colombia.

1987 **David Peterson,** *Des Moines Register*. This Feature Award was for photos revealing the shattered dreams of American farmers.

1987 **Kim Komenich,** *San Francisco Examiner*. Coverage of the fall of Philippine dictator Ferdinand Marcos won this Spot News award for Komenich.

1988 **Michel DuCille,** *Miami Herald*. DuCille's second Pulitzer, a Feature award, recognized his portrayal of the decay and then rehabilitation of a housing project overrun by drug addicts.

1988 **Scott Shaw,** *Odessa American*. This Spot News award was for a photograph of the child Jessica McClure being rescued from a well into which she had fallen.

1989 **Manny Crisostomo,** *Detroit Free Press*. Crisostomo won the Feature award for a series depicting student life at Southwestern High School in Detroit.

1989 **Ron Olshwanger,** Freelance. Olshwanger, an amateur photographer and furniture dealer, won a Spot News award for a picture published in the *St. Louis Post-Dispatch* of a firefighter giving mouth-to-mouth resuscitation to a child rescued from a burning building.

1990 **David Turnley,** *Detroit Free Press*. This Feature award recognized Turnley's work covering political uprisings in China and Eastern Europe.

1990 **Photo Staff,** *Oakland Tribune*. The photo staff won the Spot News award for photographs of the devastation caused by the Bay Area earthquake of October 17, 1989.

1991 **William Snyder,** *Dallas Morning News*. Snyder won the Feature award for photos of orphaned children living in appalling conditions in Romania.

1991 **Greg Marinovich,** *Associated Press*. This Spot News award was for pictures showing the brutal slaying of a man in South Africa believed to be a Zulu Inkatha supporter.

1992 **John Kaplan,** *Block Newspapers*, Toledo, Ohio. Kaplan won the Feature award for photographs depicting the diverse life-styles of seven 21-year-olds across the United States.

1992 **Staff,** *Associated Press*. Olga Shalygin, Liu Heung Shing, Czarek Sokolowski, Boris Yurchenko, and Alexander Zemilianichenko won the Spot News award for a series on the attempted coup in the Soviet Union and the collapse of the Communist regime.

1993 **Staff,** *Associated Press*. This Feature award was won collectively by Scott Applewhite, Richard Drew, Greg Gibson, David Longstreath, Doug Mills, Marcy Nighswander, Amy Sancetta, Stephan Savoia, Reed Saxon, and Lynne Sladky for a series of pictures from the 1992 U.S. presidential campaign.

1993 **Ken Geiger and William Snyder,** *Dallas Morning News*. A shared Spot News award for dramatic photos of the 1992 Summer Olympics in Barcelona.

1994 **Kevin Carter,** Freelance. Carter's Feature award photo, which was published in the *New York Times*, showed a vulture hovering near a starving Sudanese girl who has collapsed on her way to a feeding center.

1994 **Paul Watson,** *Toronto Star*. Watson won the Spot News award for his dramatic photo of a U.S. soldier's body being dragged through the streets of Mogadishu by a mob of jeering Somalis.

1995 **Staff,** *Associated Press*. Javier Bauluz, Jean-Marc Bouju, Jacqueline Arzt Larma, and Karsten Thielker shared the Feature award for photos of the ethnic conflicts in Rwanda, Zaire, and Tanzania.

1995 **Carol Guzy,** *Washington Post*. Guzy won her second Pulitzer, a Spot News prize, for photographs illustrating the crisis in Haiti and its aftermath.

1996 **Stephanie Welsh,** Freelancer. Welsh's shocking photos, published by Newhouse News Service,

depicted a female circumcision rite in Kenya and won her the Feature award.

1996 **Charles Porter IV,** Freelancer. Porter's Spot News award-winning photos, taken after the Oklahoma City bombing, were distributed by AP and showed a one-year-old victim handed to, then cradled by, a local fireman.

1997 **Alexander Zemlianichenko,** *Associated Press*. This Feature award photo shows Russian President Boris Yeltsin dancing at a rock concert in Rostov during his campaign for reelection.

1997 **Annie Wells,** *Santa Rosa Press Democrat*. Wells won the Spot News award for her photograph of a firefighter rescuing a teenager from raging floodwaters.

1998 **Clarence Williams,** *Los Angeles Times*. Williams won the Feature award for his series depicting the plight of young children whose parents are drug addicts.

1998 **Martha Rial,** *Pittsburgh Post-Gazette*. Rial's Spot News award photo showed a mother and father bathing their adopted son in the Mtendeli Rufugee Camp near Kibondo, Tanzania.

Nicéphor Niepce's first camera. Hulton-Deutsch Collection/Corbis

This time line was compiled by
Renate and Tom McGovern.

5th Century, BC
Greek philosophers describe the optical principles of the camera obscura.

c. AD1200 Simple glass lenses are introduced.

1342 An unnamed Jewish philosopher-mathematician in Arles, France, writes a description in Hebrew of a camera obscura intended for viewing an eclipse.

c.1500 Leonardo da Vinci describes two camera obscuras, one in his famous Codex Atlanticus and the other in manuscript D—documents both now owned by William Gates's Corbis Images.

1558 Giovanni Battista della Porta describes the camera obscura in his book *Natural Magic*.

1664–66 Isaac Newton discovers that white light is composed of different colors of light.

1694 Wilhelm Homberg exhibits an example of the blackening of silver exposed to sunlight.

1727 Johann Heinrich Schulze publishes the results of observations that it is light rather than heat that darkens a solution of silver nitrate.

1773 Josiah Wedgwood orders a camera obscura. (The Wedgwood family will become famous for its pottery.)

1775 A British patent is granted for drawing profiles by throwing a shadow of sunlight through an aperture.

1787 On November 18, Louis Jacques Mandé Daguerre is born—the man most frequently cited as the Father of Photography.

1802 Thomas Wedgwood and Sir Humphry Davy announce the results of experiments that produce an image by laying objects on the prepared surface of paper or leather and exposing it to sunlight.

1806 The camera lucida is invented by William Hyde Wollaston.

1826 Nicéphor Niepce makes the first photograph on a pewter plate coated with bitumen of Judea and exposed to the sun for eight hours.

1829 Niepce enters into partnership with Louis Jacque Mandé Daguerre to discover a practical application for the heliographie process.

1833 Niepce dies and Daguerre continues the experiments.

1835 William Henry Fox Talbot produces the first of his images on paper of actual views. Made with a tiny camera, the images are one-inch square and have an exposure of half an hour.

1837 Daguerre produces the first of his daguerreotypes that have survived to this day, with exposures from three to eight hours.

c.1838 The first photographic image (daguerreotype) including a person is made by Daguerre on the Boulevard du Temple in Paris.
Sir Charles Wheatstone, an English scientist, invents the stereoscope.

1839 Fox Talbot presents his findings on photogenic drawing to the Royal Society of London. Talbot's images on paper from paper negatives are called calotypes. His process employs a paper negative, which makes unlimited paper positives—the basis of the photography that we use today.
Daguerre's photographic process is announced by François Arago to the Academie des Sciences in Paris. Daguerre's process makes a one-of-a-kind image on polished metal, called a daguerreotype.
Sir John Herschel discovers that hyposulphite of soda will "fix" photographs, thereby rendering them stable and fade-resistant. Herschel offers this information without charge.
Hippolyte Bayard produces the first direct-positive print on paper.
By September, the daguerreotype process reaches the United States and Professors John Draper and Samuel Morse, both of New York University, begin making daguerreotypes.

1840 The first daguerrean studio in America is established in New York City by Alexander Wolcott and John Johnson.

The Yale class photo is taken by Samuel F.B. Morse, the first image of its kind.

John William Draper produces daguerreotypes of the moon.

1841 Frederich Voightlander begins manufacturing a camera with the first portrait lens, designed by Joseph Max Petzval.

Fox Talbot patents his process for making the calotype, also called the talbotype. He severely restricts use of the process, hindering its further refinement for many years.

1843–48 David Octavius Hill and Robert Adamson collaborate to produce over 1500 calotypes, considered some of the finest photographic portraits.

1844 Mathew Brady opens the "Daguerrean Miniature Gallery" in New York.

1844–46 Fox Talbot's six-part book, *The Pencil of Nature*, is published containing original photographs.

1847 First photographic record (daguerreotype) of a battlefield is made. It pictures the Mexican–American War of 1846–48, and is attributed to an unknown local daguerreotypist in Saltillo, Mexico.

The Photographic Club is founded in London.

1848–50 Maxime Du Camp photographs monuments along the Nile in Egypt.

1850 L. D. Blanquart-Evrard introduces the use of albumen-coated paper for photographs, which becomes the standard until gelatin-coated paper is introduced in the late 1880s.

F. Scott Archer introduces the wet-collodion process for making photographic negatives on glass. This new process quickly supplants the daguerreotype and calotype, making possible the ambrotype, the tintype, and a reproducible photographic negative of great clarity which is printed on albumen paper. This process leads to the carte de visite and cabinet photograph, and marks the beginning of the world-wide practice of collecting photographs and photographic albums.

Manufacture begins of the stereoscope, an instrument for simultaneously viewing two photographs taken from slightly different positions, giving the illusion of depth.

Self-portrait by Hippolyte Bayard, ca. 1850.
Hulton-Deutsch Collection/Corbis

The Langenheim brothers of Philadelphia introduce commercially-made stereographs.

Mathew Brady, a prominent photographer in Washington, D.C., publishes his *Gallery of Illustrious Americans*.

The *Daguerreian Journal*, the first photographic periodical, is published in New York.

1851 The showing of photographs at the Great Exhibition at the Crystal Palace in London generates a wave of interest in photographic techniques and encourages photographers to think of their work as art.

In New York City Robert H. Vance exhibits over 300 full-plate daguerreotypes of California scenery, the earliest examples of photographs of the American west.

George N. Barnard makes a daguerreotype of a burning mill in Oswego, New York, perhaps the first instance of photography of a spot news event.

The Société Héliographique is founded by the

Daguerreotype camera. Michael Freeman/Corbis

William Fox Talbot with his camera, ca. 1865. Hulton-Deutsch Collection/Corbis

French government to record the country's monuments. This is the first governmental photographic organization.
Daguerre dies on July 10.

1852 F. Scott Archer and Peter W. Fry announce an adaptation of the wet-collodion process that produces a positive image on glass, called the ambrotype. By 1854 the ambrotype has replaced the daguerreotype as the popular means for portraiture.
Fox Talbot relaxes his restrictions on the calotype process, which helps renew interest in the process for a short time. It proves unable to compete with the wet-collodion on glass process.
Eliphalet Brown is the first photographer on an American government expedition, accompanying

Roger Fenton. *Croat Soliders in Crimean War*, 1855. Library of Congress/Corbis

Commodore Perry's to Japan on November 24.

1853 Manufacture begins in England on a stereoscopic camera.
The Photographic Society of Great Britain (now the Royal Photographic Society) is founded.
J. M. Stanley is the first photographer to accompany the surveys sent out by direction of Congress to locate the best railroad route to the Pacific.

1854 John Warren publishes the first American book illustrated with a photograph (a salt print).
André Disderi patents the carte de visite form of

photography in France. By 1860 the carte de visite is an international fad, beginning the hobby of collecting photographs of friends and celebrities in an album.
Attempts are begun to develop a dry-collodion process.

1855 Alphonse Louis Poitevin introduces the carbon printing process, leading the way for the illustration of books with photographs.
Roger Fenton photographs the events of the Crimean War. This is the first extensive record of war and Fenton is the first accredited war photographer.

1856 The ferrotype (commonly known as the tintype, also called melainotypes) is patented in the United States by Hamilton Smith. This process uses a thin sheet of japanned metal upon which a wet-collodion emulsion is laid, then exposed and packaged to appear like an ambrotype (which was packaged to appear like a daguerreotype).
Francis Frith makes his first photographic trip to Egypt.
Lewis Carroll first photographs Alice Liddell, his inspiration for Alice in Wonderland.

1857 Oscar Gustave Rejlander, a master of allegorical photography and the first to employ composite printing, makes "Two Ways of Life." This work inspires Henry Peach Robinson to attempt composite printing and the following year he makes "Fading Away."
First patent issued for a photographic enlarger.

1858 The photographer Nadar makes the world's first aerial photograph, from a balloon manned by the Goddard Brothers.

1859 C. L. Weed makes stereographic photographs of Yosemite. These images help start the fad of collecting and viewing stereographs.
Edward Anthony in New York City and George Washington Wilson in Edinburgh, make "action" photographs, the earliest "street photography."

1860 Tintypes of presidential candidates, including Abraham Lincoln, are the first use of photography in a national election, and the first use of a metal button with a candidate's image worn to show

one's preference.

James Wallace Black makes the first series of aerial photographs in America, of Boston, Massachusetts.

1861 The first color photography process is demonstrated by Sir James Clerk Maxwell.

At lease two photographers are present at the first major engagement of the Civil War, at Bull Run, Virginia, on July 21—one of them is Mathew Brady. Brady recruits other photographers to work for him photographing the war, including Timothy O'Sullivan and Alexander Gardner.

Carlton Watkins makes his first photographs of Yosemite with a mammoth wet-plate camera, measuring 18 x 22 inches, which he made himself. He also makes stereographs of the region.

Nadar uses artificial light to photograph the sewers and catacombs of Paris.

1863 Julia Margaret Cameron begins photographing her family, friends, and notables of her time

The first photography magazines are published, *El Propagador de la Fotografia* in Spain and *La Camera Obscura* in Italy.

1864 Sir Joseph Wilson Swann perfects the carbon printing process.

Walter Bentley Woodbury introduces his Woodburytype process suitable for copying photographs for book illustration.

A tax stamp was required on photographs from September 1, 1864, until August 1, 1866. This two-cent stamp is affixed to the back of card photographs and can still be found on carte de visites from the period.

Cabinet photographs become popular.

1865 On April 9, 1865, five days before the president's assassination, the last photograph of Abraham Lincoln is made by Alexander Gardner.

Alexander Gardner photographs the conspirators responsible for the assassination of President Lincoln and documents their execution. This appears to be the first instance of a "picture story," sequential images depicting an important event and a true forerunner of photojournalism.

Alexander Gardner's *Photographic Sketch Book of the Civil War* is published.

George Barnard accompanies General Sherman's army, photographing its devastating march through Georgia.

The Civil War ends.

1866 The United States Government begins sponsoring photographic surveys of the unsettled American west, primarily to facilitate the expansion of the railroad and to analyze the region's mineral wealth.

1867 The United States Geological Exploration begins in western Nevada on July 1, with photographer Timothy O'Sullivan.

1869 Andrew J. Russell photographs the meeting of the railroad at Promontory Point, Utah.

1870 David Octavius Hill dies.

1871 Dr. Richard Leach Maddox invents a gelatin-silver bromide dry plate. While still less than perfect, his invention leads the way to practical dry-plate photography by 1878.

William Henry Jackson takes first photographs of Yellowstone National Park. His photographs are shown to the Congress and are credited with helping to pass the first National Parks bill in the U.S. This is the first example of the role of photography as an influence on social legislation.

French police use photography to capture the Paris Communards.

1872 Eadweard Muybridge accepts a commission from Leland Stanford to photograph the race horse, Occident, in motion in an attempt to discover if at one point all four of the horse's hooves are off the ground.

President Ulysses S. Grant signs a bill making Yellowstone a national park, influenced by William Henry Jackson's photographs of the region.

1873 Timothy O'Sullivan photographs in Canyon de Chelly, New Mexico.

William Willis, a British inventor, patents the platinum print process.

Bromide photographic paper is invented and produced by Peter Mawdsley.

1877 Eadweard Muybridge and Leland Stanford collaborate to provide visual information about animal and human movement. The results are first published in newspapers, and the following year in scientific

Nadar in the gondola of his balloon, preparing to photograph Paris by air.
Corbis-Bettmann

Refreshing—Unter den Linden Cafe, Berlin, Germany.
Series 1894, by Bert Underwood.

Stereoscopic view. Underwood and Underwood Stereograph Collection of the authors.

journals, making Muybridge an international celebrity. The collaboration ended in 1883.

1877 George Eastman becomes interested in photography.

1878 Dry plates become the norm after Charles Harper Bennett refines the process to increase their speed.
William Henry Jackson photographs scenes in Yellowstone with dry plates.
Eadweard Muybridge makes panoramic photographs of San Francisco.

1879 George Eastman applies for a patent for his photographic dry plate and begins production the next year.
The photographic surveys of the American West are consolidated under one agency, the United States Geological Survey, headed by Clarence King.

1880 The *New York Daily Graphic* publishes the first newspaper photograph on March 4. The 1880 Census reports that 10, 000 Americans earn their living as professional photographers.

1882 Timothy O'Sullivan dies of tuberculosis.

1883 The "Detective Camera" is introduced. Called that because it is hand-held and makes photographing easier and less obvious than with previous models.

1885 Peter Henry Emerson begins his series "Life and Landscape on the Norfolk Broads" and leads a movement back to naturalism in photography, opposing the trend in "high-art" photography that relies on sentimental subjects and contrived prints (from the Rejlander and Robinson examples). His theory of naturalism holds that photographs should be soft focus and uncontrived (for the time) and inspires an entire movement, Pictorialism (a term he coined), which lasts until the end of World War I.
Frenchman S. Moessard invents the panoramic camera.
A photo process for printing in colors is patented.

1886 Nadar and son invent the technique of the photo-interview with their combination of pictures and text from a conversation with the French chemist Chevreul.

George Eastman patents a simple box camera.
A concealed vest camera is introduced. It hangs from the neck and the lens protrudes through a buttonhole in a vest.

1887 Eadweard Muybridge publishes the seminal *Animal Locomotion*, his sequential photographs of animal and human movement.
The New York Camera Club is established.

1888 George Eastman markets the Kodak #1 with the slogan, "You press the button, we do the rest." It inaugurates the separation of the act of photographing from film processing.
Thomas Edison invents the kinetoscope (patented in 1893), for moving photographic images.
Jacob Riis photographs slum conditions in New York City.

1889 Peter Henry Emerson publishes *Naturalistic Photography*, his theory of photography and argument for why it is a fine art.
George Eastman applies for a patent for transparent roll film.
The Protar-f, an antistigmatic lens, is invented.

1890 Photography becomes a rapidly-growing pastime

Advertisement for the first Kodak camera. Corbis-Bettman

for amateurs and is increasingly seen as a viable profession. Women are increasingly involved in photography, especially in the U.S.
Jacob Riis publishes his photographic exposé of New York City's slums titled, *How the Other Half Lives*.
Peter Henry Emerson publishes *The Death of*

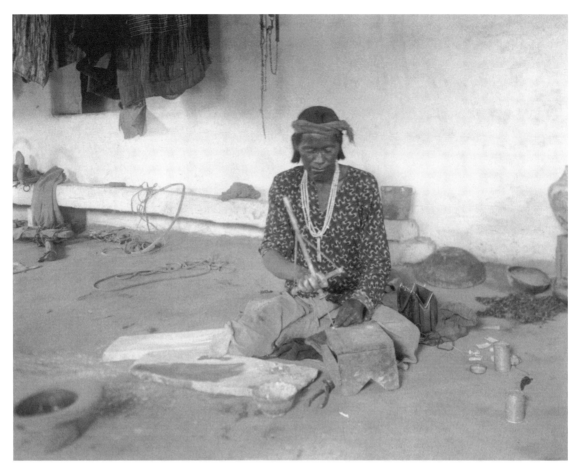

Adam Clark Vroman. *Zuni Woman drilling turquoise*, ca. 1900. Library of Congress/Corbis

Naturalistic Photography, refuting his previous claim that photography can be a great art form.
Fred Church photographs George Eastman holding a Kodak aboard the S.S. *Gallia*.

1892 The Linked Ring, a group of pictorialist photographers dedicated to promoting fine-art photography, is formed in England by former followers and enemies of Peter Henry Emerson.
Frenchman Louis Boutan makes the first successful underwater photographs.

1893 Thomas Edison perfects 35mm film.
Stieglitz is the first American elected to the Brotherhood of the Linked Ring, an English association of artistic photographers.

1895 Auguste and Louis Lumière present their cinema to a paying audience and patent an apparatus for making and showing movies.
Adam Clark Vroman (and other photographers) begin ethnographic photography of Native Americans.
Stieglitz exhibits at the Royal Photographic Society in London.

1896 Arnold Genthe uses a concealed camera to photograph San Francisco's Chinatown.
Mathew Brady dies in New York.

1897 Through the Camera Club of New York, Alfred Stieglitz becomes the editor of *Camera Notes* (which continues publication until 1902).
Gertrude Kasebier opens a photographic studio in New York. She is one of the first successful professional woman photographers.

1898 French photographer Eugène Atget begins pho-

Gertrude Kasebier. *Blessed Art Thou Among Women*, 1899. Collection of the authors

tographing Paris (he continues until 1927).

1899 Frances Benjamin Johnston photographs black
 students at the Hampton Institute in Hampton, VA.

1902 Alfred Stieglitz, along with Edward Steichen, leads
 the Photo Secession as a breakaway movement of
 pictorialism that advocates sharp focus and contem-
 porary subject matter.

1903 Alfred Stieglitz begins publishing *Camera Work*.
 Andrew J. Russell, photographer of the Civil War
 and American West, dies in Brooklyn, New York.
 Frederick Evans, a member of The Linked Ring,
 photographs Wells Cathedral in England.

1904 Lewis Hine begins photographing social conditions
 in New York City and incoming immigrants at Ellis
 Island.
 Eadweard Muybridge dies in England.

1905 Alfred Stieglitz opens the Little Galleries of the
 Photo Secession at 291 Fifth Avenue in New York
 City.
 Imogen Cunningham acquires a 4 x 5 camera from
 a mail-order correspondence school.

1906 While his own studio and equipment burn, with
 a borrowed camera Arnold Genthe photographs
 the burning of San Francisco after a massive
 earthquake.

1907 Autochrome, a color photography process invented
 by the Lumière brothers, becomes commercially
 available.
 Alfred Stieglitz photographs ship passengers in a
 work entitled *Steerage*.
 Edward Curtis begins publication of *The North
 American Indian* (completed in 1930).
 Imogen Cunningham works in the Seattle portrait
 studio of Edward S. Curtis, learning to retouch
 negatives and print with platinum.

1910 Stieglitz, with the help of other Photo
 Secessionists, arranges an exhibition of internation-
 al pictorialist photography at the Albright Art
 Gallery in Buffalo, N.Y.

1911 Jacques-Henri Lartigue begins photographing in

Paris.

1913 The Amory Show in New York City introduces
 Americans to modern art from Europe.
 E. J. Bellocq photographs prostitutes in New
 Orleans.

1914 The Clarence White School of Photography opens
 in New York City.
 World War I begins.

1916 James Van Der Zee opens his photography studio in
 Harlem, New York.
 Paul Strand's work is shown at 291 and helps plant
 the seed of modernism in American photography.
 Stieglitz meets Georgia O'Keeffe.
 Carlton Watkins dies in an asylum.

1917 Final issue of *Camera Work* is published. By this time
 the Photo Secession and its members have become
 the most influential group of photographers in
 America and lead photography away from pictorial-
 ism.
 Alvin Langdon Coburn makes his "vortographs,"
 a series of cubist-inspired, abstract photographs.

1918 Man Ray and Christian Schad make camera-less
 images directly on photo paper (rayographs and
 photograms).
 August Sander begins photographing social types
 in Germany.

1920 From this point on, modernist conventions such as
 collage, montage, unusual angles, abstraction and
 close-ups are employed by photographers. Freudian
 theory and modern art become increasingly used
 by photographers to interpret their work.
 Alexander Rodchenko and Laszlo Moholy-Nagy
 lead the way in seeing the world through a radically
 modernist vision.
 Keystone Photo Agency is founded.
 Edward Weston in Los Angeles meets Tina
 Modotti, who later becomes his mistress and
 favored model. Also meets Imogen Cunningham
 and Dorothea Lange.

1922 Weston travels to New York, where he meets
 Stieglitz, Paul Strand, Clarence White, Gertrude
 Kasebier, and Charles Sheeler.

1923 First wirephoto transmission is made.

Lewis Hine. *Addie Laird, 12 years old, spinner in a cotton mill*,
February 9, 1910. National Archives, Washington, D.C.

1924 The Boston Museum of Fine Arts becomes the first American museum to accept photography into its collection. They accession photographs by Alfred Stieglitz.
Stieglitz and O'Keeffe marry.

1925 The Leica 35mm camera is introduced, enabling photographers to work spontaneously in available light, transforming reportage and street photography.
The flashbulb is invented in Germany.

1927 Eugène Atget dies and Berenice Abbott purchases many of his negatives and prints from André Calmette the following year.

1928 Rolleiflex twin-lens camera is introduced.
Kodak produces color film for movie cameras.
German photographer and modernist pioneer, Albert Renger-Patzsch publishes *The World is Beautiful*.
American photographer Walker Evans begins to photograph in New York City.
Erich Salomon begins photographing the rich and powerful German elite in a reportage style with available light.
Metropolitan Museum of Art accessions some Stieglitz photos.

1929 August Sander publishes *Face of our Time*, the first volume of his project, Man in 20th Century Germany.
Berenice Abbott returns to New York with Atget's work and begins her own urban documentation, which is published in 1939 as *Changing New York*.

1930 F/64 Group begins in San Francisco to promote precisionism in photography with members Edward Weston, Ansel Adams, Imogen Cunningham, Consuelo Kanaga, and Willard Van Dyke
The Julian Levy Gallery, the first devoted to photography, opens in New York.
Edward Weston makes his famous photograph of a bell pepper.
The first Leica with interchangeable lenses is introduced. The first precision miniature camera has arrived.
Paul Outerbridge experiments with carbro color.

1932 Photoelectric cell light meter is introduced.
Hungarian photographer Brassai publishes *Paris at Night*.
Roman Vishniac begins photographing Eastern European Jews and their communities.
Man Ray shows photographs in the Surrealist exhibition at the Julian Levy Galley in New York.

1933 Introduction of the tiniest of American made all-plastic cameras: the Univex A. At 39 cents (later 50 cents), it will sell 3 million units in three years.
Edward Weston acquires a 4 x 5 Graflex camera.
Walker Evans gives first solo photography show at the Museum of Modern Art, New York.

1934 Weston meets Charis Wilson. Weston employed by Public Works of Art project.
Rolleicord camera introduced.

Rolleicord camera

1935 Farm Security Administration (initially the Resettlement Administration) begins an extensive photo documentation of Depression and dust bowl conditions in the United States, revolutionizing the use of photography and defining the mode and scope of the documentary style in photography.

Jack Delano. Farm Security Administration photograph of a coal miner, near Penfield, Pennsylvania.
Library of Congress

The famous photograph of the Hindenburg explosion, May 6, 1937, Lakehurst, NJ. UPI/Corbis-Bettmann

Lead by Roy Stryker, the photographers include Walker Evans, Dorothea Lange, Ben Shahn, Arthur Rothstein, Russell Lee, Jack Delano, Marion Post Wolcott, John Vachon, Gordon Parks, Carl Mydans, Theo Jung, Paul Carter, and John Collier.
Publisher Morgan & Morgan is founded by Willard and Barbara Morgan; it lasts until 1972.
Weegee (Arthur Fellig) begins photographing for newspapers in New York City.
Kodachrome film introduced.

Argus C3, the first mass-produced American-made camera to use 35-mm film in a full-frame format. © Fred W. McDarrah

1936 *Life* magazine begins publication with a cover photograph by Margaret Bourke-White of the Fort Peck Dam in Montana. *Life's* first photo editor is Willard Morgan.
The Photo League is founded in New York City to document social conditions and advocate social reform. Members include Sid Grossman, Sol Libsohn, Willard Morgan, Barbara Morgan, Aaron Siskind, Harold Corsini, Morris Engel, Jack Manning, Walter Rosenblum, W. Eugene Smith, Bernard Cole, Arthur Leipzig, and Dan Weiner.
Kodak introduces Kodachrome transparency film.
Dorothea Lange photographs "Migrant Mother, Nipomo, CA".
Peter Henry Emerson dies.
Robert Capa photographs a soldier having just been shot during the Spanish Civil War, the image is entitled, "Death of a Loyalist Soldier."
Arthur Rothstein photographs a dust storm in Cimaron County, Oklahoma while working for the Farm Security Administration.
Bill Brandt's book, *The English at Home* is published.

1937 Single-lens reflex camera is made in Germany.

Robert Taft's *Photography and the American Scene* is published.
Edward Weston receives a Guggenheim Foundation award, the first for a photographer.
Museum of Modern Art in New York mounts the exhibit, "Photography 1839–1937," organized by Beaumont Newhall.
Margaret Bourke-White and Erskine Caldwell publish *You Have Seen Their Faces*.
The New Bauhaus headed by Laszlo Moholy-Nagy at the Institute of Design in Chicago adds photography to its curriculum.
Lisette Model photographs people on the French Riviera.
The burning Hindenberg zeppelin is photographed in still and moving pictures, becoming the most spectacular photographed news event of the pre–World War II era.
Stieglitz gives up photographing because of ill health.

One photograph from the series published in *Let Us Now Praise Famous Men* by Walker Evans and James Agee.
Library of Congress/Corbis

1938 Walker Evans's work is shown at the Museum of Modern Art and accompanied by the publication *American Photographs*.
Beaumont Newhall publishes *Photography: A Short Critical History*.
Roman Vishniac photographs in the Jewish ghetto in Poland.
At the Massachusetts Institute of Technology Dr. Harold Edgerton develops the electronic flash tube, the basis of electronic flash photography. The

Dr. Harold Edgerton with strobe lights, c. 1950. Library of Congress/Corbis

this invention and through motion studies and stop-action imagery photographs things once imperceivable to the human eye.

1939 Hitler invades Poland, starting World War II.

1940 Museum of Modern Art in New York opens its photography department, with Beaumont Newhall as its curator until 1945.
Ilford Photographic Company introduces multi-grade photographic paper.

1941 Pearl Harbor is bombed by the Japanese.
Ansel Adams makes his most famous photograph, "Moonrise, Hernandez, New Mexico."
Let Us Now Praise Famous Men is published by James Agee (text) and Walker Evans (photographs).
In New York City the Museum of Modern Art acquires Stieglitz photos.

1942 Photographic files from the Farm Security Administration are transferred to the Library of Congress.
Five photos by Weegee are acquired by New York's

Museum of Modern Art and included in their "Action Photography" exhibit.
William Henry Jackson dies after a fall. At ninety-nine years old he was the last of the nineteenth-century expeditionary photographers.

1944 Kodacolor negative film is introduced.
Robert Capa photographs D-Day
W. Eugene Smith photographs in Saipan.
Aaron Siskind photographs a dirty glove titled, "Gloucester, Massachusetts."
Barbara Morgan photographs dancer Martha Graham in a work titled, "Letter to the World."

1945 Joe Rosenthal receives a Pulitzer Prize for his photograph, "Old Glory Goes Up on Mt. Suribachi, Iwo Jima."
World War II ends.
American newspaper photographer Weegee publishes *Naked City*.
Alfred Eisenstaedt photographs a couple kissing in Times Square, New York, on V.J. Day.

1946 Ektachrome, a slide film that can be processed at home, is introduced.
Ansel Adams establishes the department of photography at California School of Fine Arts, San Francisco.

1947 Edwin Land invents the Polaroid camera.
Magnum Picture Agency is founded in Paris by photographers Robert Capa, Henri Cartier-Bresson, George Rodger, David Seymour, and Bill Vandivert.
The Photo League was labeled as subversive by the U.S. Department of Justice.
Robert Frank hired by Alexey Brodovitch to take fashion photos for *Harper's Bazaar* and *Junior Bazaar*.

1948 Nikon 35mm camera is introduced.
Victor Hasselblad invents the Hasselblad medium-format camera.

1949 The International Museum of Photography is established at George Eastman House in Rochester, New York.

1950 First Xerox copy machine is introduced.

1952 Photographers Minor White, Ansel Adams,

Weegee at the New York World's Fair, posing with his camera wearing a mask and holding a toy gun. May 24, 1965. UPI/Corbis-Bettmann

Nikon F, the first SLR camera. © Fred W. McDarrah

Dorothea Lange, and Barbara Morgan along with curator and historian, Beaumont Newhall, establish the photography journal *Aperture*.
Henri Cartier-Bresson publishes *The Decisive Moment*.

1954 High-speed Tri-x film is introduced by Kodak.
 Helen Gee's Limelight Gallery opens in New York, closing in 1961.

1955 Edward Steichen organizes "The Family of Man" exhibit at the Museum of Modern Art in New York.
 Helmut and Alison Gernsheim publish *The History of Photography*.
 The Sweet Flypaper of Life is published as a study of life in Harlem, New York, with photographs by Roy DeCarava and text by Langston Hughes.
 Collector Georges Sirot donates a huge collection

of photographs to the Bibliothèque Nationale in Paris, forming the basis of its collection.

1956 William Klein publishes "Life is Good" and "Good for You" in *New York: Trance Witness Reveals*.

1958 Robert Frank's *The Americans* is published in Paris with an introduction by Jack Kerouac.
 Edward Weston dies in Carmel, California.

1959 New York's Museum of Modern Art mounts the exhibit, "Abstraction in Photography."
 Nikon SLR camera is introduced.

1960 Polaroid introduces high-speed film.
 The first operational laser is made, enabling holographic imagery.

1961 *The Daybooks of Edward Weston*, volume 1, is

published.

1962 Society for Photographic Education is founded.
Astronaut John Glenn carries a camera with him
on the first manned space flight, and takes the first
photographs from space.
John Szarkowski succeeds Edward Steichen as
director of photography at the Museum of Modern
Art in New York.
Edward Ruscha publishes *Twenty-Six Gasoline
Stations*.

1963 Kodak instamatic camera is introduced.
Charles Moore photographs civil rights protesters
and police during the riots in Birmingham,
Alabama.
Cibachrome process is introduced.

1964 University of Texas at Austin acquires the
Gernsheim Collection, one of the largest private
collections of photography, which includes the
earliest known photograph from Niepce.
Dr. Harold Edgerton at MIT photographs "Bullet
through an Apple" with stop-action photography
utilizing his electronic flash.

1965 Flash cube is introduced.
Massachusetts Institute of Technology opens the
Creative Photography Laboratory, headed by
Minor White.

1966 *The Daybooks of Edward Weston*, volume 2, is
published.

1967 "New Documents" show opens at New York's
Museum of Modern Art with photographs by
Diane Arbus, Lee Friedlander, and Gary
Winogrand.
Cornell Capa, brother of photographer Robert
Capa, founds the Fund for Concerned Photography
in New York; which later changes its name to the
International Center of Photography

1968 Weegee (Arthur Fellig) dies in New York.
Eddie Adams photographs "General Loan Executing
a Vietcong Suspect," which the *New York Times* runs
on its front page on February 1st.

1969 The Metropolitan Museum of Art in New York
mounts the exhibit, "Harlem on My Mind."

Witkin Gallery opens in New York.
First photograph of the earth from the moon is
made.
Nathan Lyons establishes the Visual Studies
Workshop in Rochester, New York.

1970 The first significant auction specifically for photos
and photo equipment is held at Sotheby-Parke
Bernet Galleries, New York City.
John Filo photographs a screaming woman kneeling
over the body of a slain anti-war protester on the
campus of Kent State University; titled, "God-
Awful Scream."

Diane Arbus commits suicide.

1972 Polaroid SX-70 is introduced.
Nick Ut photographs a naked Vietnamese girl run-
ning down a road, burning from napalm; titled
"The Terror of War."
Diane Arbus's work is published by Aperture; and
becomes the first American photographer's work
to be included in the Venice Biennale.

1973 John Szarkowski's book *Looking at Photographs* is
published.
Polaroid introduces an instant film that produces
both a black and white print and a usable negative.

1975 W. Eugene Smith and Aileen Smith publish
Minamat.
The University of Arizona establishes The Center
for Creative Photography.
The exhibit, "New Topographics: Photographs of a
Man-altered Landscape" opens at the International
Museum of Photography at George Eastman House
in Rochester, New York.
Walker Evans dies in New Haven, Connecticut.

1976 William Eggleston's color photographs are shown
at the Museum of Modern Art in New York.
Paul Strand dies in France.
Imogen Cunningham appears on *The Tonight Show*,
with Johnny Carson and is profiled in a CBS docu-
mentary. She dies the same year.

1977 Susan Sontag's collection of essays *On Photography* is
published.
The Apple home computer is introduced.

Apple II-C computer, c. 1982. Corbis/Bettmann

1977–80	Cindy Sherman produces her "Untitled Film Stills" series.
1980	Canon introduces the autofocus 35mm camera. Sony demonstrates the first consumer camcorder. Robert Mapplethorpe photographs "Man in Polyester Suite," one of his most infamous, sexually explicit images.
1981	Cindy Sherman's work is shown at Metro Pictures, in an exhibit that established her reputation. MTV begins broadcasting.
1984	Apple introduces the Macintosh computer. The Getty Museum in Los Angeles opens its Photography Department with a large and important collection. Naomi Rosenblum's *A World History of Photography* is published.
1985	Richard Avedon's *In the American West* is published. André Kertész dies in New York.
1986	Nan Goldin's *Ballad of Sexual Dependency* is published.
1988	Electronic scanners for film and photographs are introduced. First all-digital cameras are introduced. A $15, 000 grant to Andres Serrano from the National Endowment for the Arts is nearly revoked due to opposition from Senator Jesse Helms (R., North Carolina) in regard to the photograph, "Piss Christ." Electronic imaging is increasingly used by commercial and industrial companies.
1990	An exhibit of photography by Robert Mapplethorpe, "The Perfect Moment," at the Cincinnati Art Museum, is shut down by local authorities and charged with being obscene. At trial, the photographs are deemed artwork and the charges are dismissed. The previous year, the Corcoran Gallery of Art in Washington, D.C. cancelled an exhibit of Mapplethorpe's work due to the sexually explicit content.

Olympus XA manual focus, 35-mm camera is small enough to fit into a shirt pocket. © Fred W. McDarrah.

the sexually explicit content.
Adobe Photoshop, a practical digital imaging software, is introduced.

1991 Bernice Abbott dies in Monson, Maine.

1994 *Time* Magazine runs a digitally-altered police department photograph of former football star O. J. Simpson on its cover. The cover photograph is much darker, and some say "more sinister," than the original photograph. Simpson is a suspect in the murder of his ex-wife and her friend and the altered cover photograph ignites a controversy over

whether altering a news photograph is ethical. (The "mug shot" was altered by illustrator Matt Mahurin.)

1998 The photography book *Radiant Identities* by Jock Sturges, which includes some photographs of nude children, ignites a controversy over the 1st Amendment and child pornography laws. Barnes and Noble bookstore, a nationwide chain, is indicted in Alabama under child pornography laws for selling the book and Borders Bookstore, another nationwide chain, is investigated for the same thing in Pennsylvania.

Fred W. McDarrah

As the original picture editor of the countercultural alternative weekly *The Village Voice,* Fred W. McDarrah has photographed virtually every political, cultural, entertainment, art world, sports, or social icon who has lived in or passed through New York for more than four decades.

Born in Brooklyn, McDarrah started taking pictures as a World War II paratrooper. He was graduated from New York University after returning to New York and began attending art, political, and other events, camera in hand. As the *Voice*'s primary photographer in the turbulent 1960s, he built up huge libraries of photos of literary figures (Jack Kerouac), pop artists (Andy Warhol), civil rights and other activists (Dr. Martin Luther King Jr.), musicians (The Doors), and politicians (Robert F. Kennedy), as well as those of European street scenes and of urban and rural America.

His work has been widely exhibited at institutions like the Whitney Museum and the Guggenheim. McDarrah has won several awards, including Front Page awards for spot news from the Newspaper Guild and a 1972 Guggenheim Foundation grant.

McDarrah remains with *The Village Voice* as the consulting picture editor.

Gloria S. McDarrah

Gloria McDarrah has had a long career as an author and editor and also collaborated with her photographer husband, Fred W. McDarrah, on several book projects chronicling their days on the Beat scene in New York in the 1950s and 1960s.

Born in the Bronx and raised in rural Pennsylvania, McDarrah earned a bachelor of arts degree in French from Penn State and a master's degree from New York University. She has worked as an editor at Collier's Encyclopedia, Grosset & Dunlap, and Simon & Schuster.

Now, in addition to being a busy free-lancer, McDarrah is also a regular book reviewer for several influential publications.

ABOUT THE AUTHORS

In addition to *The Photography Encyclopedia,* Fred and Gloria McDarrah have collaborated on *Beat Generation: Glory Days in Greenwich Village* (1996), *The Artist's World* (2 ed., 1989), *Greenwich Village* (1967), *New York, NY* (1967), and *Museums in New York* (5th ed., 1990). Gloria McDarrah's books include *Frommer's Guide to Atlantic City and Cape May* and Frommer's *Guide to Virginia.* Fred W. McDarrah's books include *The Beat Scene* (1960), *Photography Marketplace* (1976), *Stock Photo & Assignment Sourcebook* (1978), *Kerouac & Friends, Gay Pride: Photographs from Stonewall to Today* (1994) (with Timothy McDarrah), and *The Greenwich Village Guide* (1991) (with Patrick McDarrah).

Timothy McDarrah

Timothy McDarrah is an award-winning journalist. He grew up in Greenwich Village, graduating

from PS 41, Stuyvesant High School, the State University of New York at Purchase, and Columbia University's School of Journalism. He joined the New York *Post* in 1985, becoming the youngest accredited daily newspaper reporter in New York City. He worked a variety of cityside assignments before becoming editor of "Page Six," the newspaper's infamous syndi-cated gossip column. Concurrently, he also was heard on WABC-AM 770, the nation's most-lis-tened-to talk radio station. After the *Post,* he joined News Communications Inc., a New York media company, in a senior management role. McDarrah has also worked as a senior writer at the *Los Angeles Daily News.* He is currently working on a memoir.

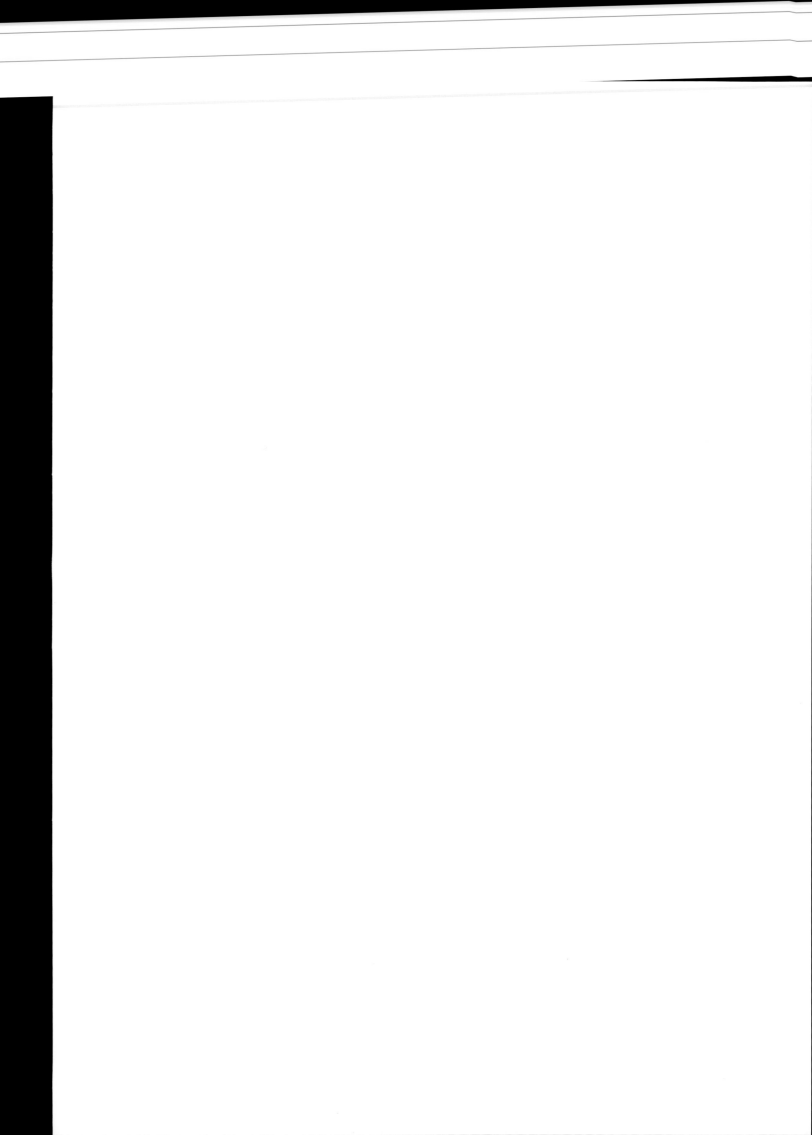